Against the Grain

Against the Grain

THE NEW CRITERION
ON ART AND INTELLECT
AT THE END OF
THE TWENTIETH CENTURY

edited by
Hilton Kramer
and Roger Kimball

CHICAGO Ivan R. Dee 1995

Library of Congress Cataloging-in-Publication Data:
Against the grain: The New Criterion on art and intellect at the end of the twentieth
 century / edited by Hilton Kramer and Roger Kimball.
 p. cm.
 ISBN 1-56663-069-X (alk. paper). — ISBN 1-56663-070-3 (pbk. : alk. paper)
 1. Arts and Society—History—20th century. 2. Arts, American.
I. Kramer, Hilton. II. Kimball, Roger, 1953– . III. New Criterion (New York, N.Y.)
NX180.S6A32 1995
700'.1'030904—dc20 94-31977

Contents

Introduction ix

I. THE CULTURE IN CRISIS

The Treason of the Intellectuals
 by Roger Kimball 3
The Culture of Classical Music Today
 by Samuel Lipman 13
Has Success Spoiled the Art Museum?
 by Hilton Kramer 34
Robert Hughes and the Flaying of America
 by James Bowman 45
Literature and Politics in Latin America
 by Mark Falcoff 51

II. THE ACADEMY IN THE AGE OF POLITICAL CORRECTNESS

What Is at Stake in the "Battle of the Books"?
 by Christopher Ricks 67
Studying the Arts and the Humanities: What Can Be Done?
 by Hilton Kramer 74
Back to the Sixties with Spin Doctor Graff
 by James W. Tuttleton 82
The Case against Martin Bernal
 by David Gress 91
Houston Baker, Jr.: Another Sun Person Heard From
 by Terry Teachout 101
The Sobol Report: Multiculturalism Triumphant
 by Heather Mac Donald 109
When Reason Sleeps: The Academy *vs.* Science
 by Roger Kimball 123

III. THE ARTS TODAY

Willem de Kooning at 90
by Hilton Kramer 137
A Dissent on Kiefer
by Jed Perl 144
Other People's Music: Corigliano at the Met
by John Simon 153
Jennifer Bartlett and the Crisis of Public Art
by Eric Gibson 165
Stuffed: Mike Kelley at the Hirshhorn
by Jed Perl 169
The Trouble with "Angels"
by Donald Lyons 173
The Best and the Worst of Louise Bourgeois
by Karen Wilkin 179
Betraying a Legacy: The Case of the Barnes Foundation
by Roger Kimball 186

IV. REPUTATIONS RECONSIDERED

The Perversions of Michel Foucault
by Roger Kimball 195
G.B.S.: The Life of George Bernard Shaw
by Brooke Allen 208
Raymond Williams in Retrospect
by Maurice Cowling 222
Tough Buttons: The Difficult Gertrude Stein
by Guy Davenport 233
The Many Lives of Frederick Douglass
by James W. Tuttleton 236
John Maynard Keynes: The Nietzsche of Economics
by David Frum 251
The Importance of T. E. Lawrence
by David Fromkin 258
Max Beerbohm: A Prodigy of Parody
by John Gross 276
Walter Gieseking Plays Ravel and Debussy
by Samuel Lipman 282
Mary McCarthy and Company
by Hilton Kramer 287

A Footnote for Housman
 by Brad Leithauser 295
Vladimir Nabokov: The Russian Years
 by John Simon 307
The "Ecstasy" of Jean Baudrillard
 by Richard Vine 322
Andrew Motion's Philip Larkin
 by Christopher Carduff 336
C. P. Cavafy: A Poet in History
 by Joseph Epstein 343
The Poetry of Robert Graves
 by Robert Richman 355
Jean Genet: The Apostle of Inversion
 by H. J. Kaplan 366
The Career of Harold Laski
 by Edward Shils 372

V. RECAPTURING TRADITIONS

Arnaldo Momigliano and the Human Sources of History
 by Donald Kagan 385
"The Two Cultures" Today
 by Roger Kimball 391
Selling Henry James
 by Joseph Epstein 400
O Pioneers! Picasso and Braque 1907–1914
 by Karen Wilkin 416
A Defense of Translation
 by Martin Greenberg 425
Returning to the Founders: The Debate on the Constitution
 by Harvey C. Mansfield, Jr. 438

Contributors 447
Index 451

Introduction

It has been the purpose of *The New Criterion* since its founding in 1982 to provide a monthly forum for the critical discussion of the arts and the social, philosophical, and political issues that impinge directly on the conduct of cultural life. We came to this discussion at a time when the debate about art and culture—what subsequently came to be called the "culture wars"—was dominated by the political Left. The "long march through the institutions" that had been promised by the radicals of the 1960s was nearing its completion. In the universities, in our leading arts institutions, in the media, in federal and state agencies concerned with funding the arts and humanities, and in most private foundations, the legacy of 1960s radicalism—now wearing the mask of a benevolent bureaucratic liberalism—was everywhere apparent. Dissent from this Left-liberal orthodoxy was virtually nonexistent.

It was—and is—one of the chief aims of *The New Criterion* to provide an independent critical voice to challenge that orthodoxy. This has meant several things. From its inception more than twelve years ago, *The New Criterion* has been, as promised, a critical journal of the arts. As such, we have commented regularly on a broad range of creative endeavor, from literature, painting, music, and architecture to theater, dance, and performance art.

But *The New Criterion* has perforce also been partly a journal of dissent, challenging the entrenched pieties of received opinion about cultural and intellectual life. That these pieties are now everywhere formulated in the shopworn jargon of a nonexistent "avant-garde" is one of the governing ironies of our age. Often ignorant of the past, today's "avant-garde" artists and cultural commissars insist that they are bravely forging novel "non-traditional" responses to an oppressively traditional society and artistic heritage. The truth is, however, that traditional strictures about artistic achievement—as, indeed, about social decorum and moral integrity—have been seriously undermined throughout elite and popular culture. It is increasingly the case that the only tradition now honored as such is the tradition of revolt. Consequently, the really vital artistic or intellectual

movements today are without exception movements of recovery, efforts to recapture and reanimate aspects of the tradition that have been excoriated, jettisoned, or forgotten. The Karen Finleys and Robert Mapplethorpes of the art world, and their many champions, are not disenfranchised outsiders, railing against the establishment: on the contrary, they *are* the establishment. There is a similar situation in the academy. The professors declaiming against Western culture, patriarchy, and the tyranny of Eurocentrism are not staunch iconoclasts: they are the dominant, in many cases virtually the only, voices being heard on campus.

One of the primary casualties of this radical assault on cultural life has been the integrity and independence of artistic activity. We have, therefore, consistently attempted to deal with the arts on their own terms, according to aesthetic rather than political criteria. This alone has been a daunting task. It is an unhappy hallmark of our age that cultural life has been systematically subjected to the leveling imperatives of political tests. Indeed, if our artistically fallow age can claim any real originality, it is perhaps chiefly in the realm of what we might call creative ideology. Afrocentrism, feminism, homosexualism, ecologism, anti-white-Eurocentrism: a florid and unlikely parade of special interests—essentially *nonartistic interests*—has turned contemporary artistic life into a squalid battleground of competing ideological fiefdoms.

The politicization of the arts—of the way that they are produced, administered, judged, financed, and understood by the public—has affected not only new or marginal endeavors. It has also deeply compromised important established institutions as they, too, scramble to accommodate themselves to the latest politicized trends. For critical observers, the situation is not without elements of paradox. At a moment when politics has insinuated itself into the center of artistic and cultural life, the first step toward reclaiming the aesthetic dimension of artistic achievement will often involve anatomizing the myriad ways in which the arts have become hostage to ideology. Thus it is that, today, a principled opposition to the politicization of culture entails the essentially political task of criticizing the process of politicization.

It includes something else, too, of course: something affirmative. In the end, the politicization of art and culture does not rest on the triumph of any particular ideology, however prominent a particular *ist* or *ism* may be at the moment. Rather, it rests on the contention that nothing is meaningful or valuable *in itself*: that everything, from literary texts and paintings to personal relations, must be understood as an interchangble token for the exercise or expression of power. This idea has been expressed in many guises. It fuels the cynical obscurities of deconstruction as well as the aggressive efforts to rewrite history that proceed under the banner of "cultural studies." And of course it stands behind the Marxist dictum that the entire realm of cultural affairs is "really" an expression of economic in-

terests. Perhaps the bluntest formulation of this creed that we have en-
countered recently was vouchsafed us by the well-known literary theorist
Stanley Fish: "there is no such thing," Professor Fish has written, "as in-
trinsic merit."

This is the core supposition—what we might call the guiding non-
belief—that has animated the left-wing assault on culture and standards in
the 1980s and 1990s. It is a powerful solvent. Indeed, at bottom it is a ver-
sion of nihilism and a license for sophistry. For if there is no such thing as
intrinsic merit, then no judgment of quality can be anything more than a
veiled political commendation or a statement of personal partisanship.
Without the idea of intrinsic moral, intellectual, and artistic value, criti-
cism and scholarship degenerate into a species of propaganda, and
morality becomes little more than a cynical calculus aimed at increasing
personal advantage. *The New Criterion* takes categorical exception to such
beliefs. We proceed on the conviction that there *is* such a thing as intrinsic
merit, that it can be discerned and rationally argued for, and that its rejec-
tion is a prescription for moral and cultural catastrophe.

Of course, the cultural scene has changed greatly over the last decade. In
1982, "political correctness" and "multiculturalism" were still phenomena
waiting to be named. There was already plenty of politically correct be-
havior, to be sure, just as the effort to revise history and dilute standards
for the sake of "diversity" was well underway in the art world, the aca-
demy, the government, and the workplace. But these imperatives had not
yet achieved the canonical status they were to attain in the late 1980s and
early 1990s. It was not until then that the enforcement of political correct-
ness and multicultural quotas suddenly became both a national joke and a
serious threat to basic democratic freedoms.

In many respects, things are considerably worse today than they were
ten or twelve years ago. The codification of political correctness and the
corresponding demand for multiculturalism have had a chilling effect on
cultural life. In the academy, we have seen the propagation of inane and
tyrannical speech codes; we have seen efforts to transmute the disciplines
of history and literary studies into instruments of political "empower-
ment"; even the natural sciences have lately come under attack for being
insufficiently "diverse" and sensitive to issues of race, gender, and class. In
the art world, we have seen attacks on the very idea of aesthetic quality as
a racist, classist, sexist conspiracy designed to exclude minority artists
from the perquisites of worldly success; at the same time, we have wit-
nessed the dramatic rise of a kind of psycho-political theater in which
"artists," often funded partly by taxpayer dollars, act out their political and
sexual obsessions in gruesome, ritualistic scenarios whose chief aim is to
shock and outrage.

Elsewhere in society the effects of political correctness and multicul-

turalism are if anything even more disturbing. Increasingly, businesses hire or promote not the person best qualified for the job but the one who comes closest to fulfilling that week's criteria for diversity or victimhood. More and more, the law is used as an instrument of ideological redress to enforce quotas and provide penalties for breaches of political purity.

This brings us to another paradox: What began in the 1960s as a demand for greater and greater freedom has evolved into a cult of conformity and constraint. The liberal establishment, once a staunch champion of free speech, has become increasingly illiberal as it colludes in the effort to scrutinize all forms of speech and behavior for their adherence to certified politically correct standards. The English historian Paul Johnson has called this peculiar amalgam of radicalism and intolerance "liberal fascism." As of this writing, the rise of liberal fascism poses a serious if still unorganized threat to basic democratic freedoms such as free speech and freedom of assembly. But the effect of liberal fascism on the realm of culture has been immense and uniformly disastrous. When even the idea of high art is proscribed as politically inadmissible, then the cultivation of artistic talent for its own sake becomes exceedingly difficult and therefore exceedingly rare. When the idea of historical truth is reinterpreted as a malleable fund of political booty and the ideal of disinterested scholarship is rejected, then genuine scholarship becomes all but impossible.

Not all of the news is bad, however. If the partisans of political correctness and multiculturalism have made great inroads, so, lately, have their opponents. While there can be no doubt that the forces militating for political correctness are still ascendent in the academy, the art world, and the media, there are now frequent signs of confusion and disenchantment in these quarters. Public patience with the often disgusting antics of a decadent and coddled art world is clearly wearing thin. One wonders how much longer willful displays of perversity will be protected and publicly subsidized. In the academy, too, there are signs that parents are becoming increasingly exasperated with the diet of politicized obscurantism on which their children are being fed at exorbitant fees; and there are also signs that alumni—a major source of support for many institutions— are becoming ever more alarmed about the transformation of their alma maters into centers for ideological indoctrination. Even some liberal commentators have taken up the cudgels against political correctness, brazenly employing arguments originally formulated by the Right even as they make an elaborate show of distancing themselves from the dread label "conservative." The resulting intellectual contortions are often comic.

It is hardly surprising that political correctness has begun to attract criticism from so many sources. Perhaps the greatest mistake that the partisans of liberal orthodoxy made was allowing themselves to appear ridiculous. They will find that it was far easier to deal with the outrage of

their opponents than with their justified ridicule. The public will tolerate a great deal of dour political humbug; the patently ludicrous, however, is greeted with instant dismissal. As is often the case, laughter has proven to be a powerful corrective. When the phrase "political correctness" began bringing an incredulous smile to people's lips, we knew that the cultural landscape had begun to change.

But only begun. The struggle against political correctness and multiculturalism is far from finished. Nor is the struggle against the depredations of our increasingly degraded and increasingly powerful pop culture anywhere near an end. For more than twelve years, *The New Criterion* has been on the front lines of these and other battles. Our efforts have won us many enemies and even, alas, lost us a few friends. We regret the lost friends; but we ruefully acknowledge that such is the price of vigorous criticism. Writing about the literary world of his day, William Dean Howells once remarked that the real problem was not making enemies but keeping them. For better or worse, one's roster of enemies tends to provide an index of honesty in the realm of cultural criticism. By this measure, anyway, *The New Criterion* has been remarkably successful.

In selecting the forty-five essays that compose this volume we have not attempted to represent the entire range of writings that have appeared in *The New Criterion*. For example, we have reprinted none of the hundreds of poems that we have published since the mid-1980s. The many purely historical or biographical essays we have published, too, have largely been left out of account. We have concentrated instead on those reflections that go against the grain of the prevailing cultural orthodoxy. Even within these constraints we have had to leave out a great deal. There are aspects of the culture wars that have been dealt with in the pages of *The New Criterion* that are not represented here; and there are several writers whose work we should have certainly included had we had the space. We regret both sorts of omissions. We particularly regret not being able to include any work by Bruce Bawer, who for over ten years contributed essays on literary subjects to *The New Criterion* but who preferred not to be represented in this anthology.

Most of the essays we have collected here were occasioned by a particular event—an exhibition, a performance, the publication of a new book. Naturally, such essays bear the stamp of their original inspiration, though all are more than routine reviews. Some are distinctly polemical; some offer a drastic reassessment of an inflated reputation; some attempt to rescue an overlooked or under-appreciated figure. There are as many voices and points of view represented in this anthology as there are writers contributing to it. But although it will be easy to discover a substantial diversity of opinion while perusing this volume, we believe that the reader will also discover significant unities. Above all, perhaps, there is a unifying commitment to the life of high culture and the critical habits of mind that

nourish and support it: intellectual probity, clear writing, independent judgment, and, not least, a sense of humor. Such resources of civilization are much besieged today, all too often by people and institutions that have been entrusted with the responsibility of preserving them. *The New Criterion* was founded to oppose the degradation of our cultural life, partly by exposing what is fraudulent and pernicious, partly by celebrating what is genuine and lasting. This volume is a record of those engagements.

It goes without saying that an enterprise such as we have undertaken here is a collaborative effort, depending foremost on the many writers whose talents and energies we have been privileged to attract over the years. What must not go unsaid is an expression of thanks to our collaborators: to all the writers who have made *The New Criterion* the respected, authoritative journal it has become, and to our dedicated colleagues, Robert Richman, Christopher Carduff, and Marjorie Danser. Without their constant and responsible efforts neither *The New Criterion* nor this anthology would have been possible.

We should also like to take this opportunity to thank our several devoted supporters, who in amounts large and small have made our work possible. *The New Criterion* has been fortunate indeed in its benefactors, who have consistently understood the magnitude of the threat facing culture today and who have responded generously over the years to our requests for help. Although limitations of space preclude listing everyone who has contributed to our cause, we do want to mention our particular gratitude to the Lynde and Harry Bradley Foundation, the John M. Olin Foundation, and the Sarah Scaife Foundation. We are also pleased to take this occasion to thank Richard M. Scaife, as well as Michael S. Joyce at Bradley, James Piereson at Olin, and Richard M. Larry at Scaife, and the trustees of these foundations.

We are also grateful to Mr. Robert Goldfarb, who made a special grant to help support the publication of this anthology.

Finally, we wish to express our sorrow at the passing of Samuel Lipman, the publisher and co-founder of *The New Criterion*, who died in December 1994 just as this anthology was going to press. All of us at the magazine owe him a large debt, intellectual and personal. Without his stewardship, *The New Criterion* would never have existed; without his incisive music criticism, its cultural commentary would have been much diminished; without his savvy counsel and friendship over many years, we would ourselves be much the poorer. We gratefully dedicate *Against the Grain* to his memory.

HK
RK
December 1994

I. The Culture in Crisis

The Treason of the Intellectuals and "The Undoing of Thought"

Roger Kimball

When hatred of culture becomes itself a part of culture, the life of the mind loses all meaning.
— Alain Finkielkraut, *The Undoing of Thought*

Today we are trying to spread knowledge everywhere. Who knows if in centuries to come there will not be universities for re-establishing our former ignorance?
— Georg Christoph Lichtenberg (1742–1799)

In 1927, the French essayist Julien Benda published his famous attack on the intellectual corruption of the age, *La Trahison des clercs*. I said "famous," but perhaps "once famous" would have been more accurate. Today, only the title of the book, not its argument, enjoys currency. "La trahison des clercs": it is one of those phrases that bristles with hints and associations without stating anything definite. Benda tells us that he uses the term "clerc" in "the medieval sense" to mean "scribe"—someone we would now call a member of the intelligentsia. Academics and journalists, pundits, moralists, and pontificators of all varieties are in this sense *clercs*. The English translation, *The Treason of the Intellectuals*,[1] sums it up neatly.

The "treason" in question was the betrayal by the "clerks" of their vocation as intellectuals. From the time of the pre-Socratics, intellectuals, considered in their role *as* intellectuals, had been a breed apart. In Benda's terms, they were understood to be "all those whose activity essentially is *not* the pursuit of practical aims, all those who seek their joy in the practice of an art or a science or a metaphysical speculation, in short in the possession of non-material advantages." Thanks to such men, Benda wrote, "humanity did evil for two thousand years, but honored good. This contradiction was an honor to the human species, and formed the rift whereby civilization slipped into the world."

1 *The Treason of the Intellectuals,* by Julien Benda, translated by Richard Aldington, was first published in 1928. This translation is still in print from Norton.

According to Benda, however, this situation was changing. More and more, intellectuals were abandoning their attachment to the traditional panoply of philosophical and scholarly ideals. One clear sign of the change was the attack on the Enlightenment ideal of universal humanity and the concomitant glorification of various particularisms. The attack on the universal went forward in social and political life as well as in the refined precincts of epistemology and metaphysics: "Those who for centuries had exhorted men, at least theoretically, to deaden the feeling of their differences . . . have now come to praise them, according to where the sermon is given, for their 'fidelity to the French soul,' 'the immutability of their German consciousness,' for the 'fervor of their Italian hearts.'" In short, intellectuals began to immerse themselves in the unsettlingly practical and material world of political passions: precisely those passions, Benda observed, "owing to which men rise up against other men, the chief of which are racial passions, class passions and national passions." The "rift" into which civilization had been wont to slip narrowed and threatened to close altogether.

Writing at a moment when ethnic and nationalistic hatreds were again threatening to tear Europe asunder, Benda's diagnosis assumed the lineaments of a prophecy—one that continues to have deep resonance today. "Our age is indeed the age of the *intellectual organization of political hatreds*," he wrote. "It will be one of its chief claims to notice in the moral history of humanity." There was no need to add that its place in moral history would be as a cautionary tale. In little more than a decade, Benda's prediction that, because of the "great betrayal" of the intellectuals, humanity was "heading for the greatest and most perfect war ever seen in the world," would achieve a terrifying corroboration.

Julien Benda was not so naïve as to believe that intellectuals as a class had ever entirely abstained from political involvement, or, indeed, from involvement in the realm of practical affairs. Nor did he believe that intellectuals, as citizens, necessarily *should* abstain from political commitment or practical affairs. The "treason" or betrayal he sought to publish concerned the way that intellectuals had lately allowed political commitment to insinuate itself into their understanding of the intellectual vocation as such. Increasingly, Benda claimed, politics was "mingled with their work as artists, as men of learning, as philosophers." The ideal of disinterested judgment and faith in the universality of truth: such traditional guiding principles of intellectual life were more and more contemptuously deployed as masks when they were not jettisoned altogether. Benda castigated this development as the "*desire to abase the values of knowledge before the values of action.*"

In its crassest but perhaps also most powerful form, this desire led to that familiar phenomenon Benda dubbed "the cult of success." It is summed up, he writes, in "the teaching that says that when a will is suc-

cessful that fact alone gives it a moral value, whereas the will which fails is for that reason alone deserving of contempt." In itself, this idea is hardly novel, as history from the Greek sophists on down reminds us. In Plato's *Gorgias*, for instance, the sophist Callicles expresses his contempt for Socrates' devotion to philosophy: "I feel toward philosophers very much as I do toward those who lisp and play the child." Callicles taunts Socrates with the idea that "the more powerful, the better, and the stronger" are simply different words for the same thing. Successfully pursued, he insists, "luxury and intemperance . . . *are* virtue and happiness, and all the rest is tinsel." How contemporary Callicles sounds!

In Benda's formula, this boils down to the conviction that "politics decides morality." To be sure, the cynicism that Callicles espoused is perennial: like the poor, it will be always with us. What Benda found novel was the *accreditation* of such cynicism by intellectuals. "It is true indeed that these new 'clerks' declare that they do not know what is meant by justice, truth, and other 'metaphysical fogs,' that for them the true is determined by the useful, the just by circumstances," he noted. "All these things were taught by Callicles, but with this difference; he revolted all the important thinkers of his time."

In other words, the real treason of the intellectuals was not that they countenanced Callicles but that they championed him. To appreciate the force of Benda's thesis one need only think of that most influential modern Callicles, Friedrich Nietzsche. His doctrine of "the will to power," his contempt for the "slave morality" of Christianity, his plea for an ethic "beyond good and evil," his infatuation with violence—all epitomize the disastrous "pragmatism" that marks the intellectual's "treason." The real problem was not the unattainability but the disintegration of ideals: an event that Nietzsche hailed as the "transvaluation of all values." "Formerly," Benda observed, "leaders of States practiced realism, but did not honor it; . . . With them morality was violated but moral notions remained intact; *and that is why, in spite of all their violence, they did not disturb civilization.*"

Benda understood that the stakes were high: the treason of the intellectuals signaled not simply the corruption of a bunch of scribblers but a fundamental betrayal of culture. By embracing the ethic of Callicles, intellectuals had, Benda reckoned, precipitated "one of the most remarkable turning points in the moral history of the human species. It is impossible," he continued,

> to exaggerate the importance of a movement whereby those who for twenty centuries taught Man that the criterion of the morality of an act is its disinterestedness, that good is a decree of his reason insofar as it is universal, that his will is only moral if it seeks its law outside its objects, should begin to teach him that the moral act is the act whereby he secures his existence

against an environment which disputes it, that his will is moral insofar as it is a will "to power," that the part of his soul which determines what is good is its "will to live" wherein it is most "hostile to all reason," that the morality of an act is measured by its adaptation to its end, and that the only morality is the morality of circumstances. The educators of the human mind now take sides with Callicles against Socrates, a revolution which I dare to say seems to me more important than all political upheavals.

The Treason of the Intellectuals is an energetic hodgepodge of a book. The philosopher Jean-François Revel recently described it as "one of the fussiest pleas on behalf of the necessary independence of intellectuals." Certainly it is rich, quirky, erudite, digressive, and polemical: more an exclamation than an analysis. Partisan in its claims for disinterestedness, it is ruthless in its defense of intellectual high-mindedness. Yet given the horrific events that unfolded in the decades following its publication, Benda's unremitting attack on the politicization of the intellect and ethnic separatism cannot but strike us as prescient. And given the continuing echo in our own time of the problems he anatomized, the relevance of his observations to our situation can hardly be doubted. From the savage flowering of ethnic hatreds in Eastern Europe and the former Soviet Union to the mendacious demands for political correctness and multiculturalism on college campuses across America and Europe, the treason of the intellectuals continues to play out its unedifying drama. Benda spoke of "a cataclysm in the moral notions of those who educate the world." That cataclysm is erupting in every corner of cultural life today.

In 1988, the young French philosopher and cultural critic Alain Finkielkraut took up where Benda left off, producing a brief but searching inventory of our contemporary cataclysms. Entitled *La Défaite de la pensée*[2] ("The 'Defeat' or 'Undoing' of Thought"), his essay is in part an updated taxonomy of intellectual betrayals. In this sense, the book is a *trahison des clercs* for the post-Communist world, a world dominated as much by the leveling imperatives of pop culture as by resurgent nationalism and ethnic separatism. Beginning with Benda, Finkielkraut catalogues several prominent strategies that contemporary intellectuals have employed to retreat from the universal. A frequent point of reference is the eighteenth-century German Romantic philosopher Johann Gottfried Herder. "From the beginning, or to be more precise, from the time of Plato until that of Voltaire," he writes, "human diversity had come before the tribunal of universal values; with Herder the eternal values were condemned by the court of diversity."

2 *La Défaite de la pensée*, by Alain Finkielkraut (Gallimard). It is available in English, in a translation by Dennis O'Keeffe, as *The Undoing of Thought* (The Claridge Press, 1988).

Finkielkraut focuses especially on Herder's definitively anti-Enlightenment idea of the *Volksgeist* or "national spirit." Quoting the French historian Ernest Renan, he describes the idea as "the most dangerous explosive of modern times." "Nothing," he writes, "can stop a state that has become prey to the *Volksgeist.*" It is one of Finkielkraut's leitmotifs that today's multiculturalists are in many respects Herder's (generally unwitting) heirs. True, Herder's emphasis on history and language did much to temper the tendency to abstraction that one finds in some expressions of the Enlightenment. In his classic book on the philosophy of the Enlightenment, Ernst Cassirer even remarked that "Herder's achievement is one of the greatest intellectual triumphs of the philosophy of the Enlightenment." Nevertheless, the multiculturalists' obsession with "diversity" and ethnic origins is in many ways a contemporary redaction of Herder's elevation of racial particularism over the universalizing mandate of reason. Finkielkraut opposes this just as the mature Goethe once took issue with Herder's adoration of the *Volksgeist*. Finkielkraut concedes that we all "relate to a particular tradition" and are "shaped by our national identity." But, unlike the multiculturalists, he soberly insists that "this reality merit[s] some recognition, not idolatry." In Goethe's words, "A generalized tolerance will be best achieved if we leave undisturbed whatever it is which constitutes the special character of particular individuals and peoples, whilst at the same time we retain the conviction that the distinctive worth of anything with true merit lies in its belonging to all humanity."

The Undoing of Thought resembles *The Treason of the Intellectuals* stylistically as well as thematically. Both books are sometimes breathless congeries of sources and aperçus. And Finkielkraut, like Benda, tends to proceed more by collage than by demonstration. But he does not simply recapitulate Benda's argument. The geography of intellectual betrayal has changed dramatically in the last sixty-odd years. In 1927, intellectuals still had something definite to betray. In today's "postmodernist" world, the terrain is far mushier: the claims of tradition are much attenuated and betrayal is often only a matter of acquiescence. Finkielkraut's distinctive contribution is to have taken the measure of the cultural swamp that surrounds us, to have delineated the links joining the politicization of the intellect and its current forms of debasement.

In the broadest terms, *The Undoing of Thought* is a brief for the principles of the Enlightenment. Among other things, this means that it is a brief for the idea that mankind is united by a common humanity that transcends ethnic, racial, and sexual divisions. The humanizing "reason" that Enlightenment champions is a universal reason, sharable, in principle, by all. Such ideals have not fared well in the twentieth century: Herder's progeny have labored hard to discredit them. Granted, the belief that there is

"Jewish thinking" or "Soviet science" or "Aryan art" is no longer as wide-spread as it once was. But the dispersal of these particular chimeras has provided no inoculation against kindred fabrications: "African knowl-edge," "female language," "Eurocentric science": these are among today's talismanic fetishes.

Then, too, one finds a stunning array of anti-Enlightenment phantas-magoria congregated under the banner of "anti-positivism." The idea that history is a "myth," that the truths of science are merely "fictions" dressed up in forbidding clothes, that reason and language are powerless to dis-cover the truth—more, that truth itself is a deceitful ideological construct: these and other absurdities are now part of the standard intellectual diet of Western intellectuals. The Frankfurt School Marxists Max Horkheimer and Theodor Adorno gave an exemplary but by no means uncharacteristic demonstration of one strain of this brand of anti-rational animus in the mid-1940s. Safely ensconced in Los Angeles, these refugees from Hitler's Reich published an influential essay on the concept of Enlightenment. Among much else, they assured readers that "Enlightenment is totali-tarian." Never mind that at that very moment the Nazi war machine—representing what one might be forgiven for calling *real* totalitarianism—was busy liquidating millions of people in order to fulfill another set of anti-Enlightenment fantasies inspired by devotion to the *Volksgeist*.

The diatribe that Horkheimer and Adorno mounted against the con-cept of Enlightenment reminds us of an important peculiarity about the history of Enlightenment: namely, that it is a movement of thought that began as a reaction against tradition and has now emerged as one of tradition's most important safeguards. Historically, the Enlightenment arose as a deeply anti-clerical and, perforce, anti-traditional movement. Its goal, in Kant's famous phrase, was to release man from his "self-imposed immaturity." The chief enemy of Enlightenment was "superstition," an omnibus term that included all manner of religious, philosophical, and moral ideas. But as the sociologist Edward Shils has noted, although the Enlightenment was in important respects "antithetical to tradition" in its origins, its success was due in large part "to the fact that it was promul-gated and pursued in a society in which substantive traditions were rather strong." "It was successful against its enemies," Shils notes in his book *Tradition* (1981),

> because the enemies were strong enough to resist its complete victory over them. Living on a soil of substantive traditionality, the ideas of the En-lightenment advanced without undoing themselves. As long as respect for authority on the one side and self-confidence in those exercising authority on the other persisted, the Enlightenment's ideal of emancipation through the exercise of reason went forward. It did not ravage society as it would have done had society lost all legitimacy.

It is this mature form of Enlightenment, championing reason but respectful of tradition, that Finkielkraut holds up as an ideal.

What Finkielkraut calls "the undoing of thought" flows from the widespread disintegration of a faith. At the center of that faith is the assumption that the life of thought is "the higher life" and that culture—what the Germans call *Bildung*—is its end or goal. The process of disintegration has lately become an explicit attack on culture. This is not simply to say that there are many anti-intellectual elements in society: that has always been the case. "Non-thought," in Finkielkraut's phrase, has always co-existed with the life of the mind. The innovation of contemporary culture is to have obliterated the distinction between the two. "It is," he writes, "the first time in European history that non-thought has donned the same label and enjoyed the same status as thought itself, and the first time that those who, in the name of 'high culture,' dare to call this non-thought by its name, are dismissed as racists and reactionaries." The attack is perpetrated not from outside, by uncomprehending barbarians, but chiefly from inside, by a new class of barbarians, the self-made barbarians of the intelligentsia. This is the undoing of thought. This is the new "treason of the intellectuals."

There are many sides to this phenomenon. What Finkielkraut has given us is not a systematic dissection but a kind of pathologist's scrapbook. He reminds us, for example, that the multiculturalists' demand for "diversity" requires the eclipse of the individual in favor of the group. "Their most extraordinary feat," he observes, "is to have put forward as the ultimate individual liberty the unconditional primacy of the collective." Western rationalism and individualism are rejected in the name of a more "authentic" cult.

One example: Finkielkraut quotes a champion of multiculturalism who maintains that "to help immigrants means first of all respecting them for what they are, respecting whatever they aspire to in their national life, in their distinctive culture and in their attachment to their spiritual and religious roots." Would this, Finkielkraut asks, include "respecting" those religious codes which demanded that the barren woman be cast out and the adultress be punished with death? What about those cultures in which the testimony of one man counts for that of two women? In which female circumcision is practiced? In which slavery flourishes? In which mixed marriages are forbidden and polygamy encouraged? Multiculturalism, as Finkielkraut points out, requires that we respect such practices. To criticize them is to be dismissed as "racist" and "ethnocentric." In this secular age, "cultural identity" steps in where the transcendent once was: "Fanaticism is indefensible when it appeals to heaven, but beyond reproach when it is grounded in antiquity and cultural distinctiveness."

To a large extent, the abdication of reason demanded by multicultur-

alism has been the result of what we might call the subjection of culture to anthropology. Finkielkraut speaks in this context of a "cheerful confusion which raises everyday anthropological practices to the pinnacle of the human race's greatest achievements." This process began in the nineteenth century, but it has been greatly accelerated in our own age. One thinks, for example, of the tireless campaigning of that great anthropological leveler, Claude Lévi-Strauss. Lévi-Strauss is assuredly a brilliant writer; but he has also been an extraordinarily baneful influence. Already in the early 1950s, when he was pontificating for UNESCO, he was urging all and sundry to "fight against ranking cultural differences hierarchically." In *La Pensée sauvage* (1961), he warned against the "false antinomy between logical and prelogical mentality" and was careful in his descriptions of natives to refer to "so-called primitive thought." "So-called" indeed.

In a famous article on race and history, Lévi-Strauss maintained that the barbarian was not the opposite of the civilized man but "first of all the man who believes there is such a thing as barbarism." That of course is good to know. It helps one to appreciate Lévi-Strauss's claim, in *Tristes Tropiques* (1955), that the "true purpose of civilization" is to produce "inertia." As one ruminates on the proposition that cultures should not be ranked hierarchically, it is also well to consider what Lévi-Strauss coyly refers to as "the positive forms of cannibalism." For Lévi-Strauss, cannibalism has been unfairly stigmatized in the "so-called" civilized West. In fact, he explains, cannibalism was "often observed with great discretion, the vital mouthful being made up of a small quantity of organic matter mixed, on occasion, with other forms of food." What, merely a "vital mouthful"? Not to worry! Only an ignoramus who believed that there were important distinctions, *qualitative* distinctions, between the barbarian and the civilized man could possibly think of objecting.

Of course, the attack on distinctions that Finkielkraut castigates takes place not only among cultures but also within a given culture. Here again, the anthropological imperative has played a major role. "Under the equalizing eye of social science," he writes,

> hierarchies are abolished, and all the criteria of taste are exposed as arbitrary. From now on no rigid division separates masterpieces from run-of-the-mill works. The same fundamental structure, the same general and elemental traits are common to the "great" novels (whose excellence will henceforth be demystified by the accompanying quotation marks) and plebian types of narrative activity.

For confirmation of this, one need only glance at the pronouncements of our critics. Whether working in the academy or other cultural institutions, they bring us the same news: there is "no such thing" as intrinsic

merit; "quality" is only an ideological construction; aesthetic value is a distillation of social power; etc., etc.

In describing this process of leveling, Finkielkraut distinguishes between those who wish to obliterate distinctions in the name of politics and those who do so out of a kind of narcissism. The multiculturalists wave the standard of radical politics and say (in the words of a nine-teenth-century Russian populist slogan that Finkielkraut quotes): "A pair of boots is worth more than Shakespeare." Those whom Finkielkraut calls "postmodernists," waving the standard of radical chic, declare that Shakespeare is no better than the latest fashion—no better, say, than the newest item offered by Calvin Klein. The litany that Finkielkraut recites is familiar:

> A comic which combines exciting intrigue and some pretty pictures is just as good as a Nabokov novel. What little Lolitas read is as good as *Lolita*. An effective publicity slogan counts for as much as a poem by Apollinaire or Francis Ponge. . . . The footballer and the choreographer, the painter and the couturier, the writer and the ad-man, the musician and the rock-and-roller, are all the same: creators. We must scrap the prejudice which restricts that title to certain people and regards others as sub-cultural.

The upshot is not only that Shakespeare is downgraded, but also that the bootmaker is elevated. "It is not just that high culture must be demystified; sport, fashion and leisure now lay claim to high cultural status." A grotesque fantasy? Anyone who thinks so should take a moment to recall the major exhibition called "High & Low: Modern Art and Popular Culture" that the Museum of Modern Art mounted a few years ago: it might have been called "Krazy Kat Meets Picasso." Few events can have so consummately summed up the corrosive trivialization of culture now perpetrated by those entrusted with preserving it. Among other things, that exhibition demonstrated the extent to which the apotheosis of popular culture undermines the very possibility of appreciating high art on its own terms. When the distinction between culture and entertainment is obliterated, high art is orphaned, exiled from the only context in which its distinctive meaning can manifest itself: Picasso *becomes* a kind of cartoon. This, more than any elitism or obscurity, is the real threat to culture today. As Hannah Arendt once observed, "there are many great authors of the past who have survived centuries of oblivion and neglect, but it is still an open question whether they will be able to survive an entertaining version of what they have to say."

And this brings us to the question of freedom. Finkielkraut notes that the rhetoric of postmodernism is in some ways similar to the rhetoric of Enlightenment. Both look forward to releasing man from his "self-imposed

immaturity." But there is this difference: Enlightenment looks to culture as a repository of values that transcend the self, postmodernism looks to the fleeting desires of the isolated self as the only legitimate source of value. Questions of "lifestyle" (ominous neologism!) come to occupy the place once inhabited by moral convictions and intellectual principles. For the postmodernist, then, "culture is no longer seen as a means of emancipation, but as one of the élitist obstacles to this." The postmodernist regards the products of culture as valuable only to the extent that they are sources of amusement or distraction. In order to realize the freedom that postmodernism promises—freedom understood as the emancipation *from* values that transcend the self—culture must be transformed into a field of arbitrary "options." "The post-modern individual," Finkielkraut writes, "is a free and easy bundle of fleeting and contingent appetites. He has forgotten that liberty involves more than the ability to change one's chains, and that culture itself is more than a satiated whim."

What Finkielkraut has understood with admirable clarity is that modern attacks on elitism represent not the extension but the destruction of culture. "Democracy," he writes, "once implied access to culture for everybody. From now on it is going to mean everyone's right to the culture of his choice." This may sound marvelous—it is after all the slogan one hears shouted in academic and cultural institutions across the country—but the result is precisely the opposite of what was intended. "'All cultures are equally legitimate and everything is cultural,' is the common cry of affluent society's spoiled children and of the detractors of the West." The irony, alas, is that by removing standards and declaring that "anything goes," one does not get more culture, one gets more and more debased imitations of culture. This fraud is the dirty secret that our cultural commissars refuse to acknowledge.

There is another, perhaps even darker, result of the undoing of thought. The disintegration of faith in reason and common humanity leads not only to a destruction of standards, but also involves a crisis of courage. "A careless indifference to grand causes," Finkielkraut warns, "has its counterpart in abdication in the face of force." As the impassioned proponents of "diversity" meet the postmodern apostles of acquiescence, fanaticism mixes with apathy to challenge the commitment required to preserve freedom. Communism may have been effectively discredited. But "what is dying along with it . . . is not the totalitarian cast of mind, but the idea of a world common to all men." Julien Benda took his epigraph for *La Trahison des clercs* from the nineteenth-century French philosopher Charles Renouvier: *Le monde souffre du manque de foi en une vérité transcendante*: "The world suffers from lack of faith in a transcendent truth." Without some such faith, we are powerless against the depredations of intellectuals who have embraced the nihilism of Callicles as their truth.

December 1992

The Culture of Classical Music Today

Samuel Lipman

Let me begin with the good news. Over the past decade, classical music —Western, dead-white-European-male music, if you will—has become more popular in America than ever. The evidence of this popularity is to be found everywhere. There are more composers, more performers, more new works being written, more new and old works being played, and more students studying to be performers. There are more symphony orchestras, more opera companies, more professional choruses, and more large music schools. Audiences for live concerts and operas have been steadily increasing for many years; it is also demonstrably true that the so-called CD revolution has resulted in the sale of extra millions of classical-music recordings to millions of music listeners both young and old. Along with all the purchases of CDs (and video cassettes and laser discs), of course, go sales of billions of dollars' worth of new and newer hi-fi hardware, some of which at least is used to play classical music. Nor can the extraordinary reach of opera broadcasts on public television, and on various cable channels too, be ignored; PBS broadcasts from the Metropolitan Opera are seen by millions of viewers in the United States, and now by millions abroad on their own government-run TV channels. Furthermore, the Met now has ambitious plans for gala pay-per-view television broadcasts, from which it is hoped that the company will draw large revenues. Even in the trend-conscious academy, the study of great music, not just as notes and sounds but as ideas and influences, has become the rage in all the most prestigious schools.

And then there is the pervasion of classical music as an integral part of the ambiance of our daily lives. What used to be derogated as elevator music has become *classical* elevator music; no visit to a pricey restaurant is complete without a sonic background of the *Four Seasons* of Vivaldi or any of several particularly familiar piano concertos of Mozart. Bach turns up frequently in television commercials, and has even been known to provide an accompaniment to scoreboard displays on televised baseball games. What is true in restaurants, TV commercials, and baseball games is equally true in department and specialty stores, and all manner of business offices.

Then, too, there are the commercial indicia of popularity. It may all be put crassly, but not inaccurately: never has more money been made from classical music by its practitioners, and from music by those who arrange for its commercial exposure. Performers' fees, like ticket prices, are very high. The most famous conductors earn in excess of $1,000,000 each year; it is not uncommon for guest conductors to earn well in excess of $20,000 for each week they conduct. The tenor Luciano Pavarotti, it is said, can command a fee of more than $100,000 for a single concert appearance, and a favorite instrumentalist like Itzhak Perlman can receive $35,000 or more for each of his concerts. Columbia Artists Management, Inc., the largest arranger of classical concerts and media events in the world, seems a veritable paragon of year-to-year growth. Administrative salaries in the nonprofit organizations that solicit contributions from the public (as well as sell tickets) are high too: salaries of top orchestra managers (now called "Managing Directors") often reach, with benefits, perquisites, and expense accounts, levels well above $200,000 annually.

In recounting all the good news, it would hardly be fair to omit the fact that over the past two decades even large American corporations have flocked to supporting orchestras and opera companies, and have in many cases taken great pride in associating their good corporate names with musical culture. In an even larger way, senior business executives have been, and are today, willing to sit on musical boards and contribute their economic expertise to the running of these cultural enterprises. In general, contributions to music, not just from business but from foundations and private sources, have been going up, and even the present recession has not noticeably reduced these gifts.

I have just defined popularity in market terms. Large scale of activity, wide availability of product, increasing level of expenditures, existence of powerful institutions, stable base of support: all these testify to the kind of success that comes only from providing a lot of people with what a lot of people want. Viewed in this way, I can do no better than return to the statement with which I began—undoubtedly, classical music is more popular today than ever.

Should we then not rejoice? After all, something that is beautiful—by the most elevated criteria one of the enduring monuments of Western civilization—has become a part of the lives of countless people, filling their hours by beguiling their ears. Great music—and we can be in no doubt that, for example, Vivaldi, Bach, and Mozart are great music—has become diffused throughout much of American society and life. What more could music, and therefore those who love music, ask?

But if we go beyond this notion of popularity as an end in itself, and ask just *what* is now so popular about classical music, we begin to find bad news rather than good. What if we ask, not about the popularity of the

constituent elements of music, but about the quality of their achievement and the health of their condition? What, in other words, if we attempt an artistic evaluation of the state of classical music today?

Perhaps the best place to start this evaluation is with new music. Here the situation is now, and has been for many years, in the highest degree hypertrophic: untold numbers of new works are indeed being written, and have been written, by untold numbers of composers. A remarkable percentage of these new works receive performances, and a remarkable percentage of the composers who write them manage to make a living out of pursuits—usually teaching—associated with composition. Alas, the result of all this activity, all the grants for new music, all the publicity surrounding its public performance, all the passionate encomia new music receives not just as sound but even more as ideology, is—nothing. Absolutely nothing.

Merely describing the musical repertory—the pieces the best musicians want to play and the most musically committed audiences want to hear—says it all. The slightly less than 250 years from the rise of Bach to the end of World War II contains, with remarkably few exceptions, our entire musical repertory of choice. Even the exceptions—chiefly late Prokofiev and Shostakovich—now seem more than ever to have been fully rooted in the musical life of the earlier years of our century. Of the myriad composers who have grown up since World War II, nothing remains but entries in our ever-larger musical encyclopedias, along with listings of compositions played once and, very likely, nevermore.

During this period of almost a half-century since 1945, there have been numerous highly touted developments in musical composition. In these years, we have seen and heard total serialism—the extension of Arnold Schoenberg's twelve-tone method to all the parameters of music, including duration, dynamics, and timbre; compositions full of screeches, whistles, and roars, produced and reproduced on magnetic tape; chance music, in which the performer was called upon to be the composer as well; conceptual music (a close relative of chance music), in which written instructions for performance replaced any notes at all; the use of Oriental chanting and instruments; minimalism, in which the ceaseless repetition of simple chords and rhythms served to produce works of extreme length and utter boredom; and most recently, I suppose, neo-romanticism, the notion that anytime a composer said, "Let there be melody and harmony," lo, there was melody and harmony. The most famous names among the protagonists of these compositional schools have been such stars as Karlheinz Stockhausen, Pierre Boulez, John Cage, Philip Glass, and now John Adams; so far as their compositions are concerned, all their reputations, and all their long-lived careers, have not sufficed to put a single one of their works into the repertory of mainstream classical music.

Sadly, so complete has been the failure of all these new compositions

that they have dragged down with them one of the true bright spots of twentieth-century music—American compositions of the 1930s, 1940s, and early 1950s. The objections of both musicians and audiences to the prevailingly amelodic and perversely dissonantal characteristics of the European music of the post–World War II period—and of the American music from the mid-1950s on written under this European influence—have placed even the great achievements of (to name only a few) the Americans Roy Harris, Samuel Barber, Howard Hanson, Walter Piston, William Schuman, and David Diamond under the cloud of what is derisorily called "modern music." The only exception to this summary rejection of American music has been Aaron Copland, and even his position in the repertory now seems ever more exclusively based on his easy-to-take ballet scores rather than on his concert music. And what is true of these well-known American composers whose work is now in a condition of desuetude is vastly more true of such immensely gifted later composers as (again to name only two) Andrew Imbrie and William Bergsma.

A special word is in order for the condition of new opera. Here, in this most problematic and expensive of musical forms, there have been two "stars" since World War II: the English Benjamin Britten and the American Philip Glass. Yet Britten's two most successful works, *Peter Grimes* (1945) and *Billy Budd* (1951), go back at least forty years; none of his later works, very much including *Death in Venice* (1973), has been anything more than a *succès d'estime*. In the case of Glass's several works, only *Einstein on the Beach* (1976), his collaboration with the director/designer Robert Wilson, has managed to stick in the memory, vastly more for Wilson's staging than for Glass's music. Elsewhere with Glass, the Gandhi pageant *Satyagraha* (1980) and the incredibly static *Akhnaten* (1984) seemed more like *tableaux mortes* than flesh-and-blood operas. The current hotshot, of course, is John Adams, whose *Nixon in China* (1987), a collaboration with the avant-garde director Peter Sellars, appealed to an audience of "cutting-edge" dance and theater types; as always with trendy new music, the missing element in the audience was music lovers.

Though new operas are commissioned and usually performed by the company doing the commissioning, by far the largest number of opera companies in this country—including the giant of them all, the Metropolitan Opera—concentrate their efforts on the standard works by the same few composers that have always made up their repertories. The winners, now as before, are the most-celebrated operas of Mozart, Verdi, and Puccini, and, of course, "*Cav* and *Pag*"—*Cavalleria rusticana* and *Pagliacci*. The way these winners are sold, by small opera company after small opera company, is vulgar in the extreme: every opera, whatever its particular plot and mood, is described as an exciting story of love and intrigue, guaranteed to keep the audience on the edge of their seats.

From composers and their compositions, it is but a short jump to performers. Here a sharp distinction must be drawn between Americans and Europeans. Early in his career, it seemed that the meteoric rise of Leonard Bernstein would pave the way for a new generation of American masters of the baton. But despite the existence of Bernstein as a role model, the number of American conductors leading major American orchestras remains vanishingly small: David Zinman in Baltimore, Leonard Slatkin in St. Louis, Gerard Schwarz in Seattle, and, in opera, James Levine at the Metropolitan. Elsewhere, the list of conductors, in place or appointed, is totally European (or, in one case, Asian): New York (Kurt Masur), Boston (Seiji Ozawa), Philadelphia (Wolfgang Sawallisch), Cleveland (Christoph von Dohnányi), Chicago (Daniel Barenboim), Los Angeles (Esa-Pekka Salonen), and Washington (Mstislav Rostropovich). In San Francisco, the American-born Herbert Blomstedt is entirely a product of European musical life, and in Pittsburgh Lorin Maazel, though trained in this country, made his initial conducting reputation entirely abroad.

At least in our best orchestras, symphony musicians are now remarkably well paid; in these major ensembles, annual incomes of more than $50,000 (with benefits extra), and with substantially more for solo players, are the rule rather than the exception. And yet there is everywhere a feeling of discontent with the orchestral player's lot. Conductors are in general not highly respected; management is often seen as the enemy, plotting to get more work out of the musicians, with diminished job security and worsened working conditions. Though orchestra players now live well, their job satisfactions seem low. They resent the routinized nature of their tasks, and they have little feeling that they are making great music. One telling sign of their discontent is the small amount of time the finest orchestral players now give to the study and playing of great chamber music—not for money, but for their own pleasure. All in all, membership in an orchestra is now seen as a dead-end street—a well-paid job, to be sure, but nevertheless a dead-end.

Among singers, the story is rather more encouraging. Since the nineteenth century, American vocal artists have found it possible to make national and even international careers; one thinks of such past greats as Rosa Ponselle, Lawrence Tibbett, Richard Crooks, Richard Tucker, and Leonard Warren. In recent years, one thinks immediately of Leontyne Price, Sherrill Milnes, Samuel Ramey, and now Thomas Hampson. Less famous American singers are busy, and actually much in demand. But despite their justified successes, it cannot be said that any American singer since World War II has placed a personal stamp on any single role in a standard European opera, let alone on any great opera composer's *oeuvre*. Whether one thinks of Verdi or Puccini or Wagner, the commanding interpretations—the interpretations in which the singers place their mark on our perception of the characters they portray—remain those accomplished

by such European singers of the fairly recent past as (again to name only a few) Maria Callas, Tito Gobbi, Hans Hotter, and Elisabeth Schwarzkopf.

Our instrumentalists have hardly fared so well as our singers. Our only analogue to Leonard Bernstein in his role as a conductor has been the pianist Van Cliburn. This once-young Texan, trained entirely in this country, rocketed to stardom with his unexpected victory in the 1958 Tchaikovsky Competition in Moscow; by this triumph he inherited the mantle of the leader of the American school of piano playing from the tragically short-lived William Kapell, who had perished in an airplane crash in 1953. But it was already unsettling that the chief critical praise lavished on Cliburn emphasized not how he sounded like an American pianist—steely fingered, sharp-rhythmed, and clangorous in tone—but how his playing was a throwback to an older European style, riper, richer, and more romantic—that is, less materialistic. But Cliburn's great start quickly took him in the direction of becoming a popular entertainer, of no influence over his fellow pianists and other musicians. And since Cliburn, only Murray Perahia among American pianists has made a truly important international career—and Perahia's career is almost entirely the result of his long residence in London.

Among string players in America, the great names that came forward in the 1960s and 1970s were those of the Israeli violinists Itzhak Perlman and Pinchas Zukerman; though both are American residents and trained here, they seem additions to American musical life rather than constituents of it. Much the same can be said of the Japanese violinist Midori, a successful concert artist before her teens and now, about twenty years old, seemingly at the top of her career. Of the most successful string players now in this country, only the American cellist of Chinese parentage Yo-Yo Ma seems a truly functioning part of our musical life.

For many years, American music lovers were justly proud of their great orchestras. In the 1920s and 1930s, Leopold Stokowski's Philadelphia Orchestra and Serge Koussevitzky's Boston Symphony Orchestra were of world-class stature; in the first half of the 1930s, the same could be said of Arturo Toscanini's New York Philharmonic and then, a bit later, of his NBC Symphony. Though the Philadelphia retained its beautiful sound under Stokowski's successor, Eugene Ormandy, much of the musical excitement engendered by Stokowski was soon dissipated; the Boston Symphony's unique combination of brilliance and depth of sonority did not survive Koussevitzky's supersession by Charles Munch in the 1940s. Only George Szell's Cleveland Orchestra of the 1950s and 1960s joined the class of immortals, and indeed to date it has been the last American orchestra to do so.

As a whole, American orchestral life over the past two or three decades, and very much continuing into the present, has been a sad story of a rough-hewn efficiency in performance, achieved at the cost of tonal re-

finement, ensemble precision, individual character, and musical vitality. Zubin Mehta's long tenure at the Philharmonic, now fortunately concluded, seemed disastrous in its coarseness and vulgarity, both for the orchestra itself and for the Philharmonic's core audience. The Philadelphia, under Riccardo Muti during the 1980s, almost completely lost its hitherto jealously guarded tonal profile. The Boston Symphony, giving one routine performance after another, has ceased to be a factor on the international scene, despite its supposedly charismatic leader, Seiji Ozawa. Of the greatest American orchestras of the past, only the Cleveland under Christoph von Dohnányi manages to sustain a deserved reputation for interesting programs played in an interesting manner.

In the world of opera, I can only speak of the Metropolitan and the New York City Opera. In this age of the cheap American dollar, the Metropolitan is now a prime tourist attraction. Many, if not most, performances are sold out, and good seats for any performance, at whatever price, are hard to come by. Its shop and mail-order sales are booming, and the Met's house magazine, *Opera News*, now under the strong editorship of Patrick Smith, has no fewer than 120,000 subscribers. Furthermore, with the excellent players Levine has brought in, the Met orchestra has become under his training a force to be reckoned with not only in the opera house but as a distinctive ensemble ranking with the best orchestras in the world today. The result of this new-found power of the Met has been a spate of artificial-sounding Met opera recordings, conducted by Levine, appearing on the German Deutsche Grammophon and the Japanese Sony Classical labels. Because of its ability to record, the Met is able to engage on a long-term basis the most successful singers in the world, including Luciano Pavarotti and Plácido Domingo. But all this activity and prosperity cannot hide the fact that the Met's performances are in large measure undistinguished vocally, without any permanently redeeming value provided by the Met's growing indulgence in gargantuan and costly new productions. Although Levine insists on conducting the most important works and new productions himself, the level of conducting on most non-Levine nights at the Met—despite an occasional visit from someone like Carlos Kleiber—is remarkably uninteresting. When Levine is on the podium, his conducting often seems narrowly self-indulgent: for example, his infatuation with slow tempos went far to destroy the Met's *Ring* cycle of the past several years. Though it will indeed be doing a very few new works in the coming seasons, the rules of safety and sameness in repertory, direction, and performance all combine to make the Met a dull, albeit deluxe, company. And as serious listening to the weekly Met radio broadcasts proves, even safety and sameness cannot guarantee minimally acceptable performances in terms of security of intonation and solidity of vocal production.

By contrast, the New York City Opera now gives the impression of fighting for its life. Left in uncertain artistic condition by Beverly Sills when she turned the company's general directorship over to conductor Christopher Keene, the City Opera is saddled with the New York State Theater, an inconvenient and accoustically unattractive place in which to perform opera. Its long-term financial problems, which had some years ago forced a serious rearrangement in the dates of its seasons, have hardly been eased by Beverly Sills's triumphant entry onto the Metropolitan Opera board; here, her main task will likely be fund-raising for the Met, but not for the New York City Opera, the company which so many years ago gave her operatic birth and for so many years sustained her career. City Opera performances, despite the best efforts of Christopher Keene and a host of other dedicated people, remain very much in the shadow of the Met's vaunted opulence. The City Opera's recent ventures into new opera—one thinks immediately of Anthony Davis's *X*, Dominick Argento's *Casanova*, and Jay Reise's *Rasputin*—have hardly borne fruit. Of all the City Opera initiatives in the past few years, only one—but a big one it was—seemed to make its proper mark: the strikingly well-received production in the fall of 1990 of Schoenberg's *Moses und Aron*, a central work of pre–World War II modernism that the Met should have done long ago but has sedulously avoided these many years.

For some years now, all these signs of decline in American musical (and operatic) life have been quite clear to all but those optimistic souls who make their meager livings by praise. The answer to this negative perception has been—in addition to various attempts by powerful arts advocates and *apparatchiki* to kill the messengers—to concentrate attention on supposedly authentic modes of performance. Through this device, it was hoped that two inconvenient and highly disturbing facets of contemporary musical life might be elided and thus obscured: the lack of new music and the lack of interesting new performers.

This new way of performing old music has drawn sustenance—inspiration seems too honorific a term—from the rediscovery of seventeenth- and eighteenth-century composition so characteristic of our own century. This unearthing of past musical treasures was important, under the name of neo-classicism, for the creative efforts of such estimable composers as Igor Stravinsky and Richard Strauss. At the hands of such distinctive personalities as the English old-instrument-builder and theorist Arnold Dolmetsch and the magnificent harpsichordist Wanda Landowska, this reclamation unearthed a forgotten genre of masterpieces, and thus enriched our musical vocabulary and sensibility; even the poet Ezra Pound and his friend the violinist Olga Rudge, through their work on behalf of the music of Vivaldi, deserve credit for some of this achievement.

But what started as an artistic crusade by immensely gifted individuals

had become, by the 1950s, what might be called the "Business of Baroque"; what increasingly seemed to count was not the quality of the music being rediscovered and performed, or the distinction of the way it was being performed, but rather the worship of musical quaintness and the cultivation of stylistic difference for its own sake. By the 1960s, it had become unfashionable in intellectual circles to play Bach on the piano; even Glenn Gould's marvelous recorded performances of Bach were chiefly admired for how little the instrument he played sounded, at his hands, like a flesh-and-blood piano.

The 1970s and the 1980s saw the growth in England of orchestra-sized ensembles dedicated to playing not just Bach on period instruments and in period style but also Haydn, Mozart, and Beethoven. At first the leader in this pursuit was the very drab and unexciting Christopher Hogwood, leading a pick-up group appropriately called the Academy of Ancient Music. Soon Hogwood was succeeded by the rather more sparky Roger Norrington, leading yet another pick-up group labeled the London Classical Players, and making a great impression, at least on the critics, with fast, light, and inflexible performances of all the Beethoven symphonies. Everywhere there were cries that this was Beethoven as Beethoven had heard his own music: so applauded was Norrington's approach that he even applied his talents to the *Symphonie fantastique* of Berlioz. But as the *réclame* settled, as by now it most certainly has, Norrington's performances stood revealed as made up of equal parts scrawny and out-of-tune strings and pinched and aggressive winds and brass. In New York, an important sign of the times was the abysmal failure both with public and press in its initial season of the Classical Band, our own instance of the authentic-performance phenomenon, led by the English baroque specialist Trevor Pinnock.

The ups, and perhaps now downs, of the movement to play old music in such a way as to make it sound new-old, have not been without their influence on the academic study of musicology. On the one hand, the professoriate has leapt into the study of (to use Hogwood's appellation) "ancient music." Theses, dissertations, and published articles and treatises on proper performance style of music written before 1775 or thereabouts have been pouring out of the educational mill. Furthermore, this concern with how the music written around and before the time of Bach and his sons should be performed has moved forward into the nineteenth century. Not just Mozart but Beethoven, too, has become fair game for musicology. In particular, a thriving scholarly industry has been established in the study of Beethoven's sketchbooks; in this study, particular attention is given to the use of watermark analysis to date the paper on which these sketches were written, and thus to establish the chronological order of the sketches in order to reveal the process of composition. Now all the

analytic techniques of musicology are being applied to later music, in particular to Chopin, who has gone in intellectual estimation in only a few decades from rejection as a vapid salon composer to acceptance as the worthy subject of rigorous scholarly-musical analysis. Similarly, a new Verdi edition, closely associated with the musicologist Philip Gossett of the University of Chicago, is laying claim to the establishment of a truly scholarly text, and a proper style of performance, for these core operas of the Italian romantic tradition.

But there is much more going on now in academic musicology than the mere study of how notes should be played and sung. Musicology has become very much a part of semiotics, with such words as "signifier" and "signified" liberally strewn over the newest studies of famous composers. Furthermore, the new rage in musicology is called cultural studies—the placing of music squarely in the politics and sociology of its creation and the condition under which it became available to the public. Taking over from what used to be called the sociology of knowledge, these new musicologists are not content with discussing the origins of great works of music in their own terms, but go beyond what composers thought they were writing, musicians thought they were performing, and audiences thought they were hearing—and, especially, what patrons thought they were supporting—to see the past of this art in the light of radical contemporary notions of economics and gender.

Thus in *Music and Society: The Politics of Composition, Performance, and Reception*, published in 1987 by the august Cambridge University Press and edited by Richard Leppert and Susan McClary, one finds such articles as "The Ideology of Autonomous Art," "Towards an Aesthetic of Popular Music," "Music, Domestic Life and Cultural Chauvinism: Images of British Subjects at Home in India," and "Music and Male Hegemony." In "The Blasphemy of Talking Politics during Bach Year," Susan McClary, described as "Associate Professor of Musicology and a member of two research centers (Center for Advanced Feminist Studies and Center for Humanistic Studies, for which she was Acting Director, 1985–86) at the University of Minnesota," explains (or rather explains away) the achievement of Bach in the following manner:

> [A]t the same time that this music shapes itself in terms of bourgeois ideology (its goal orientation, obsessive control of greater and greater spans of time, its willful striving, delayed gratification and defiance of norms), it often cloaks that ideology by putting it at the service of an explicit theology. The tonal procedures developed by the emerging bourgeoisie to articulate their sense of the world here become presented as what we, in fact, want to believe they are: eternal, universal truths. It is no accident that the dynasty of Great (bourgeois) Composers begins with Bach, for he gives the impression that *our* [emphasis in the original] way of representing the world

musically is God-given. Thereafter, tonality can retain its aura of absolute perfection ("the way music goes") in its native secular habitat. This sleight of hand earned Bach the name "the fifth evangelist" . . .

McClary concludes her long article by putting all her cards on the table:

> I would propose the age-old strategy of rewriting the tradition in such a way as to appropriate Bach to our own political ends. Just as Renaissance mannerists justified their subjective excesses by appealing to principles of ancient Greek theory, so each group since the early nineteenth century has found it necessary to kidnap Bach from the immediately preceding generation and to demonstrate his affinity with the emerging sensibility. My portrait of Bach presented earlier clearly exhibits characteristics of the postmodern eclectic, of the ideologically marginalized artist empowering himself to appropriate, reinterpret, and manipulate to his own ends the signs and forms of dominant culture. His ultimate success in this enterprise can be a model of sorts to us all. In actively reclaiming Bach and the canon in order to put them to our own uses, we can also reclaim ourselves.

One of the most interesting aspects of the current trends in musicology is the extent to which it has invaded music criticism. In this century and in our country, music criticism has been the essentially journalistic coverage in venues large or small, popular or elite, of developments in music composition and performance. As the specific gravity, not to mention the attractiveness, of new works dwindled and then vanished, music criticism found itself increasingly focused on performance. And as by the end of the 1960s, traditional performances, along with traditional performers, more and more resembled each other, music criticism began to appear an exercise in making pointless distinctions between identical products or an exercise in nostalgia, in which current performances were held up against past recordings and invariably found wanting.

To some extent, the authentic-performance movement, by bringing a new (though really old) musical product into view, did provide critics with something new to write about. But because the authentic-performance movement was so much a creation of academic and quasi-academic thought rather than of autochthonous musical impulses, writing about it, even in the daily press, increasingly required musicological training and a musicological bent: of the two, the bent was by far the more important. And so music critics found themselves writing Sunday think-pieces on ornamentation in baroque music, as advocated in the latest academic treatise, or perhaps a music-magazine article discussing Brahms's style of piano-playing, as demonstrated on an almost inaudible Edison cylinder recording made by the composer before his death in the 1890s.

Perhaps more significantly, a trend has emerged of late in the bringing

into musical journalism of the concerns of the cultural studies so beloved of the new wave of academic musicologists. An outstanding example of this new attempt to write about music by writing about something else very much not music is the spate of articles in *The New York Times* by the University of California music professor Richard Taruskin. This past April, Taruskin questioned the place in the repertory of such beautiful Prokofiev works as *Alexander Nevsky* (1939), the Cello Sonata (1949), and the Seventh Symphony (1951–52) — because they were composed, and officially supported, during the Stalin terror. Then, in June, Taruskin claimed that Tchaikovsky's music, seemingly so admired and beloved, was actually under a critical cloud in that "[a]ll of the prejudices commonly directed against woman composers have been directed at him." Taruskin's article then asks, without adducing any evidence to the contrary, ". . . is there any other explanation save latent homophobia for the amazing progress of that notorious tissue of hearsay concerning Tchaikovsky's death (pederastic affairs, threatened exposure, suicide at the behest of some old school chums) in the musical press and even in the scholarly community . . . ?" Here is the bringing up to date of great music with a vengeance, as if all music were present politics.

Underlying this turn to the musicological discussion of performance practice and the bringing into music of the new cultural studies, is an appalling constriction of the market for music criticism and, not surprisingly, a loss of any conviction on the part of the critics themselves that there is anyone out there actually reading them. The death of major American music magazines, those dealing both with live performances and with recordings, is now complete; the last to go was the once-distinguished monthly *Musical America*, which has now become what is delicately described as a consumer-oriented trade publication. The space given to daily music-reviewing has in many places become exiguous; even *The New York Times*, long the last courageous holdout against the pressures to limit the coverage of classical music, has drastically reduced its coverage of debut recitals and concerts given in smaller halls, while at the same time devoting more space to pre-concert booster pieces.[1] The once-proud *Washington Post*, for many years the home of the redoubtable critic Paul Hume, has now come very close to being a newspaper without influence in the musical world. *Time* and *Newsweek* now rarely cover classical music, and then only when something of presumably piquant interest occurs.

And then, despite all the glorious numbers, there is the continuing and worsening problem of the musical audience. Perhaps more people indeed

1 To keep the record straight, I should add that I myself have written one of these upbeat articles, on the 1991 Waterloo Music Festival, of which I am the artistic director.

are going to classical-music concerts and operas, but even this brute assertion seems hard to take at face value, given the total unreliability of attendance figures so characteristic of arts institutions, arts advocates, and arts poll-takers. However many people there actually are in the seats, and however many people *say* they want to, and do, attend concerts and operas, the fact remains that audiences everywhere are increasingly unsophisticated and uncommitted. Subscription series offered to the public have fewer events on them each year; mini-series are popular, and with their popularity goes the fractionating of musical experience, as fewer people hear an extensive representation of either the work of the musicians they are hearing or the works that constitute the repertory of great music. Then, too, the young seem curiously absent from musical events, and the audience that does come is ever grayer and will, if not renewed, inevitably disappear.

It is precisely this absence of the young from live classical events that seems most ominous for the future. The music of choice for the upwardly mobile Yuppie young is "easy-listening" music: the stupefying docilities of New Age sounds, the less distinctive forms of minimalism, the more emotionally flattened forms of jazz, and especially the sewing-machine inanities of the lesser baroque composers. Indeed, it is hard to avoid the impression that what appeals to the young about the classical music that does in fact interest them is not this music's contrast and variety, not its attempts to storm the heavens, but rather its sameness. It seems clear that what is precisely so attractive about the baroque music now so much in fashion is its unending surface patterns and repeated, and only slightly altered, harmonic and rhythmic sequences.

Performers everywhere are aware that in order to gain the attention of the audience, it is necessary for them to do ever more, not just *with* the music, but *to* the music. Subtle musical gestures, whether made by instrumentalists, singers, or conductors and orchestras, now have little effect; the music can no longer be allowed to speak for itself and to make its points by clarity, refinement, and structural rigor. Instead, each note must be emotionally milked, each tempo made either much too slow or much too fast, each dynamic made either much too loud or much too soft, each contrast of mood made sharper, and the climax of each phrase exaggerated. Sadly, all these attempts at exaggeration have merely served to further deaden audience reaction, producing, as in the case of Zubin Mehta at the New York Philharmonic, a sense of tiredness and ennui. In a more fundamental sense, the very harmonic code of Western music—the tonal system—now seems to have lost both its power, with unsophisticated audiences, to shock and its former ability, with audiences both knowing and unknowing, to compel attention. Faced with this aural vacuum in their listeners, performers now find the key to success in fancy garb, clothing men in ruffled shirts and women in *louche* pants suits;

among young performers, moussed hair is rapidly becoming the coiffure of public notice for both sexes.

It is difficult to know exactly what has caused the current weakened condition of the audience. Doubtless there are several factors at work: the destruction of classical-music education in elementary and secondary schools; the shift in colleges and universities away from the old, unjustly maligned music-appreciation courses to supposedly rigorous, scholarly courses in music history, theory, and analysis; the calamitously large availability of meretricious pop music, enforced in its circulation by engulfing peer pressure and the unresolved psychosexual yearnings of parents come to maturity in the 1960s; the immense competition for what is now so crassly called the "entertainment dollar" among music, opera, ballet, theater, film, and television.

There is also the current vogue for multiculturalism, the artificial, wholly ideological, and ultimately patronizing urge to advance the cultural products of others at the expense of one's own. In music, this trend has very much weakened the position of the classic masterpieces, in effect forcing a wholesale redefinition of just what one is allowed to call by this term. Doubtless much of the liking for what is now called "world musics" comes from the disaffected young, anxious to break what they see as the shackles of home and nation. In my own experience, the most avid proponents of multiculturalism are those who are paid to promote this cause by public and private funding bodies eager to win publicity and a high reputation for being "politically correct" and on the "cutting-edge" of art. A recent example of this organized attempt to reconstitute the body of culture—in this case, great music—is to be found in *Public Money and the Muse*, a book published this past spring by the American Assembly, a public-policy group headquartered at Columbia University.[2] In this book, funded by the Rockefeller and AT&T foundations, Gerald D. Yoshitomi, executive director of the Japanese American Culture and Community Center in Los Angeles, writes (in a chapter on "Cultural Equity"): "All of our children must hear the music of the world's great composers played by outstanding symphony orchestras; yet we must also broaden our standard definitions of who is to be included in that 'great composers' list." In one sense, though hardly a helpful one, Yoshitomi is right: it is much easier to expand the definition of the word "great" than to produce great art.

It is difficult not to feel that the real life of classical-music lovers now takes place in the privacy of their homes as they listen to the enormous variety

2 *Public Money and the Muse: Essays on Government Funding for the Arts*, edited by Stephen Benedict (The American Assembly and W. W. Norton, 1991).

of great music available on recordings. Compared to live concerts, recordings are inexpensive; listening to recordings in one's living room is correctly perceived as both a safer and a more comfortable activity than venturing out at night into the center cities where the great concert halls are still located. On new recordings, through splicing and other kinds of doctoring, performances can easily be made to give the impression—though only the impression—of perfection; by comparison, live concerts, by their very nature, are often technically messy affairs. And then, for more knowledgeable listeners, there is the enormous overhang of recordings from the past, made newly available on CDs in quite extraordinary-sounding transfers. These new-old recordings do indeed provide music lovers with some of the greatest—that is, most moving—vocal and instrumental performances of which we can have any knowledge. With the scales thus loaded against new performances and performers, it is no wonder that true music lovers are now so rarely to be found at live concerts.

Given the present importance of records in our musical life, a sad word must be said here for the present condition of classical recording in the United States. RCA, responsible through Victor, its predecessor company, for the recordings of Enrico Caruso made in the first two decades of this century, and then, under its present name, for making Arturo Toscanini and Vladimir Horowitz—among many others—available to millions of music lovers, is now owned by Bertelsmann, a German conglomerate; CBS Records, responsible for the wonderful recordings of—again among many others—the Budapest Quartet and Bruno Walter, is owned by Sony, the Japanese electronics and media giant. All the other major record labels available in this country, including Deutsche Grammophon, Philips, Angel, and London, are owned in Europe. The result of this foreign ownership is, quite simply, that the major decisions about what is to be recorded of American music and musicians are made abroad, to satisfy commercial criteria, also determined abroad.

I suppose that the best place to wind up this dreary story is with the institutions and the patrons that make possible the existence and presentation of classical music in America. Classical music has always been a money-losing activity, requiring massive contributions, not to pay the stars but to support the intellectual and artistic infrastructure that has undergirded the Western tradition. Now, despite the massive sums being taken out of classical music by its most successful practitioners, this art is more than ever dependent on contributed income. It is contributed income that in large measure makes possible all the the nonprofit institutions of classical music: these institutions include not only orchestras and opera companies, but also performing-arts centers, music schools, colleges and universities with music departments, and public television and radio.

What can be said about the present condition of these institutions, institutions devoted either wholly or in part to presenting music, or to training its practitioners? So far as the presenting of music is concerned, it might be helpful in this regard to look at what is going on in New York City, which is still, despite its current shaky social and financial condition, America's cultural capital. Here in New York one need do no more than look at Lincoln Center, the exemplar of all the attempts made in the 1960s and thereafter to centralize the performing arts in new buildings containing adequate and sometimes luxurious facilities and providing through their community status easy access to old and new funding sources both public and private.

As America's premier presenter of the performing arts, Lincoln Center houses the New York Philharmonic, the Metropolitan and New York City operas, and the Chamber Music Society of Lincoln Center, in addition to the New York City Ballet and the Vivian Beaumont Theater. I have discussed above the current state of the Philharmonic, and the Metropolitan and New York City operas; it is significant that just this past May the City Opera publicly discussed the possibility of leaving the Lincoln Center umbrella and moving its performances at some point in the future to an old theater on West Forty-second Street. The City Opera's reasons for such a revolutionary departure from the philosophy and practice of the way the musical arts are run in New York are many, and likely include competition from the vastly richer Metropolitan Opera,[3] scheduling pressure from the New York City Ballet, with which the City Opera shares the New York State Theater, and a mounting dissatisfaction with the facilities and acoustics of the State Theater itself. It must be mentioned also that the Chamber Music Society of Lincoln Center, directed for many years by the charming and musically gifted pianist Charles Wadsworth, was not long ago put under the direction of the cellist Fred Sherry. It was widely suspected that the reason for Wadsworth's replacement by Sherry was a desire for concerts that would appeal in style and repertory to the young rather than, as in the past, to the graybeards that form the backbone of the chamber-music public. Yet Sherry's tenure apparently failed to achieve its goals, and he too is now gone, leaving the Chamber Music Society rudderless.

But more important is the increased concentration of Lincoln Center on the independent production of public events. Though its constituent groups largely determine their own policies, Lincoln Center has always been something more than the sum of its constituents. In the past, Lin-

3 Just how much richer the Metropolitan Opera is than the New York City Opera is shown by a well-founded story that the Met, at a time when the City Opera is concerned with raising year-to-year operating funds, is considering a several-hundred-million-dollar endowment-fund campaign.

coln Center had mostly contented itself with the winter "Great Perform-ers" concert series at Fisher Hall and with the highly successful summer "Mostly Mozart" series, also at Fisher. Of late, however, Lincoln Center, founded to be a showcase of the high performing arts, has begun to feel the hot breath of demands that it be socially and politically relevant to what is going on around it in New York City. High culture is not a very popular idea around the rhetorically populist administrations of Governor Cuomo and Mayor Dinkins. In this time of financial insecurity and raised taxes, the publicly funded arts must be seen to reach out to the entire public, not just to an elite suspected of being both undemocratic and rich. The implication is clearly that if the arts—and in this case classical music—cannot so reach out, then so much the worse for the arts and for classical music.

Thus Lincoln Center has set about a massive campaign to recast its image. Under the rubric of "Serious Fun!" it has introduced summer theatrical presentations, constituted (though as yet with little success) so as to reach the new-life-style public sympathetic to the spicy delights of the aesthetic avant-garde. With maximum fanfare, it has introduced jazz presentation as a Lincoln Center department, to the enthusiastic praise of the once-staid *New York Times*. Indeed, a July full-page Lincoln Center ad in the *Times* said it all: out of the nine attractions featured, only three—"Mostly Mozart," "Live from Lincoln Center," and "Great Performers"—could be called classical attractions. Six of the presentations Lincoln Center chose to feature had nothing to do with high culture at all—"Midsum-mer Night Swing," recommended as a way to "Come dance with us beneath the summer stars"; "Serious Fun!", described in a quote from *New York Newsday* as "the most ambitious commissioning program in the history of Lincoln Center"; "Lincoln Center Out of Doors," described in a quote from the New York *Daily News* as "an outstanding array of events presented in the open air"; "Classical Jazz," described in a quote from *The New York Times* as "the most important jazz program in America"; "More Jazz," described, again in the *Times*, as "promis[ing] to give jazz its proper place in the American artistic pantheon"; and finally "Community Holiday Festival," described simply as "free performances [that] capture the holiday spirit." And as if to give teeth to the new Lincoln Center image, William Lockwood, the long-time head of programming for the "Mostly Mozart" and the "Great Performers" series, has now resigned; informed opinion has it that those responsible for Lincoln Center policy are requiring that Lockwood's replacement must be "more than a classi-cal-music person."

Public television and radio seem ever more concerned with the twin problems of money and ratings; unfortunately, money is not easily avail-able for classical-music broadcasting, and the audience for classical music on television and radio, though perhaps sizable in absolute numbers, is

only a small fraction of the audience of tens of millions that now constitutes the only acceptable criterion of media success. In this connection, the three prime-time evening slots that PBS devoted this past winter to Peter Sellars's productions—or rather distortions—of *The Marriage of Figaro, Don Giovanni,* and *Così fan tutte* was an ominous sign of the network's increasing efforts to appeal to a young, new, and classically unsophisticated audience. On radio, public broadcasting, for all the excellence of the work being done by small stations serving areas of low population density, seems to be giving up its attempt to present serious and extended classical-music concerts in metropolitan markets. Like public television (and like Lincoln Center), public radio appears to have decided to make its pitch to the new trends of gender, ethnic, and sexual multiculturalism; in this shift, classical music can hardly avoid being the loser.

In this discussion of today's musical institutions, it is hardly possible to avoid the problem of music education. Colleges and university music departments across the country, along with music schools, are now turning out thousands upon thousands of graduates each year. As performers, these graduates are facing what is at best a bleak job market; in the better symphony orchestras, there are quite frequently hundreds of applications for each opening. Solo careers, especially for Americans, are practically non-existent. The plain fact is that more musicians are being educated than can possibly find employment; the pressure to find positions for them is one of the major factors causing the proliferation of performing groups, all competing with each other for an ever less committed audience. It is also true that music schools are now drawing an increasing percentage of their students—often, I might add, the best ones—from the Orient. It remains unclear exactly what the motivation is for this enormous influx of Asians into our music schools. What is certain is that, given their limited acquaintance with Western culture, they have special educational needs, needs that are now being ignored. As for musicology graduates, they now find themselves thrown into a hiring world in which tenure-track positions in general are declining and for white males hardly exist.

The last element in the current cultural situation of music to be considered is patronage—who pays for music, above and beyond what is taken in at the box office. This patronage has four components: government, corporations, foundations, and individuals. The lines between these components are not always clear, for each component exerts major influence on the other three, and contributions from one tend to draw contributions from the others.

Nevertheless, it is possible to make some general comments about the present state of these components. At the federal level, government sup-

port for music has peaked, and is in all likelihood now dropping; by destroying the so-called "Good Housekeeping Seal of Approval" of NEA grants and by causing the Congress to shift funds from NEA to state disbursement, the recent scandals at the National Endowment for the Arts have hit serious music particularly hard. Furthermore, over the past few years the NEA itself has made increasingly stringent demands that its serious music grants be spent for "new," "exciting," "innovative," "cutting-edge" programs, all with increased attention to the encouragement of ethnic minorities and such formerly "underserved" areas as rural communities and inner cities. The states, suffering from severe budget crises, have taken advantage of the general loss of prestige for the arts produced by the NEA scandals to cut their own subsidies; the cuts in New Jersey and New York state, for example, have been draconian, not so much causing institutions to go out of business as forcing them to popularize their offerings in the hopes of bringing in a larger paying public. Multiculturalism, too, is now being urged upon government funding sources, and this recommendation—I have mentioned above the ukase from the American Assembly—cannot but fall on political ears quite happy to appeal to organized gender, ethnic, and sexual constituencies.

One assumes—or rather one is repeatedly told—that corporate funding of music remains at much the same level as in the recent past. But it must always be remembered that corporate funding exists not for the sake of music (or the other arts) but for the sake of the image of the corporation. It will be remembered just how generous the oil companies were in supporting public television during the years of oil shortages and consequent high oil prices; though this support has largely disappeared with the decline of OPEC, we are still witnessing the presence of the cigarette industry in arts patronage as a way of ameliorating its very bad public-health reputation. Large corporate cultural grants go exclusively to high-image programs, a category that includes, in New York, both the Metropolitan Opera and the Next Wave Festival at the Brooklyn Academy of Music. Whatever the object of support, the requirement is not that the programs and institutions helped by corporations hold out the promise of being self-supporting; it is rather that they promise maximum publicity to the sponsor, and that the publicity be demonstrably targeted to politically, socially, and economically influential constituencies. In the case of small programs and institutions, corporate funding is low, and cannily calculated to spread the minimum amount of money around to the largest number of recipients.

Foundation patronage of music continues to be important, though it must be made clear that great foundations, despite their equivocations and denials, are no longer interested in ongoing support of classical music. Increasingly, foundations, if they concern themselves with music at all, are more interested in capital drives than in operating grants. A corol-

lary of this policy is a disinclination to keep on supporting the same serious musical activities year after year: more than ever, variety is now the spice of foundation life.

And so the discussion naturally comes down to individual patrons. Gone are the days when such figures as Henry Lee Higginson at the Boston Symphony for several decades before World War I, Otto Kahn at the Metropolitan Opera in the 1920s, Clarence Mackay at the New York Philharmonic also during the 1920s or, somewhat later, Mrs. Lytle Hull, again at the Philharmonic, would take major responsibility for the survival of institutions to which they had devoted their lives. Now musical boards are increasingly populated by people who represent either corporate funding sources or powerful community interests, or who are thought to be capable of raising money from others. There are in this matter no statistics available, so far as I am aware; but the widespread impression in the musical world is that, apart from the great institutions, individual gifts from board members are down, and that in order to get these gifts at all much more is required in the way of accurate balance-sheet projections than of musical excellence. Then, too, following the lead of colleges and universities in the past four or so decades, musical institutions are now seen by their boards as businesses, to be run with financial considerations first in mind and art second. It must be said, too, that hanging over this entire discussion of individual music patronage is the shift in the criterion for giving from the serious taste of the giver to the expectation of some popularity to be gained by the giver in the media and from the public recipients of his largesse.

Good news and bad news: an enormous human activity, performing much wonderful old music for great numbers of people, performing new music only under pressure and then to persistent failure, with everything done at great financial expense and with uncertain prospects both for the existence of sophisticated audiences and for financial survival. We should make no mistake: the issue before us is the survival, not of the classical music of the past (for great art can be preserved to come back another day), but of the place classical music has occupied in the cultural life of the West over the past two hundred years and perhaps more. During that time, classical music was the transmitter, through its preternatural beauty, of some of the major values of the West. Some of these values, like religion, truth, love, heroism, and honor, were communicated through a collaboration between great music and the extra-musical words and symbols carried by and made more powerful through the music. Others of these values, like order, clarity, complexity, rationality, and the worth of individual creation, were communicated more abstractly by the music in the very process of making its greatness manifest.

"All art constantly aspires towards the condition of music," Walter Pater

wrote in the latter half of the century that believed art to be the successor to religion as the true salvation of human life. The classical music that we have celebrated has been for us the culmination of our civilization. Unrenewed, properly honored only in private, forced to justify itself to every demagogic politician, editorial-page writer, corporate mogul, and foundation executive, classical music now stands, for the first time in the modern world, on the periphery of culture. No matter how great the worldly success it may enjoy, no matter how high the hype that can be purchased, no matter how large the paying audience can be made to seem, classical music is today in deep trouble. It is not clear whether we can do more than bear witness.

September 1991

Has Success Spoiled the Art Museum?

Hilton Kramer

Of all the institutions of high culture that have undergone significant change in recent decades, none has been more radically transformed than the art museum. In every aspect of its function, its atmosphere, and its scale of operations, in the character and number of the events that it encompasses, in the nature and size of the public it attracts, and in the role it plays in codifying—and at times deconstructing—our ideas about what art is, the museum has been so dramatically altered in our lifetime that in many important respects it can no longer be said to be the same institution we came to in our youth. And of all the changes that have overtaken the art museum in our time, the most crucial has been the elevation of change itself to the status of a governing principle.

In the past we looked to the art museum for our touchstones of artistic quality and achievement. It was in the museums that we learned to become connoisseurs of artistic accomplishment—to become intimate with and knowledgeable about works of art over the long term; to acquire a sense of judgment and discrimination about their special attributes, about their differences and resemblances, and their complex relation to one another and to ourselves. It was through this process that our pleasure in art was deepened and our understanding of it enlarged, and this was as true for the amateur public, which we are all a part of at the outset, as for the professional. "The Louvre," wrote Cézanne, "is the book in which we learn to read," and it was understood that learning of this sort could not be hurried by crash courses, superficial entertainments, or overnight conversions. Like all learning that is serious, that becomes a personal and permanent acquisition and thus a part of our lives, it required time and application, and one of its essential preconditions was a certain stability in the museum itself—the kind of stability that precludes precipitous change and a fickle, continual tampering with the objects of our scrutiny. We did not look to the art museum for news, but on the contrary, for what remained vital and enduring after it had ceased to be news.

Nowadays, however, we expect of our museums that they will be dynamic rather than stable, that they will no longer be guided by fixed

standards or revered traditions, but just the reverse—that they will shed convention, defy precedent, and shatter established values as often and as eagerly as the most incendiary avant-gardist of yesteryear. We demand of our museums that they bring us news as regularly as the media itself, and this inevitably entails a shift of attention from the permanent to the temporary—a shift now everywhere in evidence in the museum world and officially codified in the name of the museum facility in Los Angeles that calls itself the Temporary Museum of Contemporary Art, or the Temporary Contemporary, as it is better known. It is thus one of the paradoxes of the art museum as a cultural force that as the reign of the avant-garde has drawn to a close as far as the creation of new art is concerned, its program of incessant and omnivorous change has been enthusiastically embraced—some would say promiscuously embraced—by the institution that was long thought to be the principal counterweight to the restless avant-garde spirit.

The art museum thus finds itself at the end of the twentieth century in the curious position of having supplanted art itself as the leading advocate and agency of innovation in our artistic affairs. What was formerly a highly individualistic impulse has now become an established bureaucratic practice, and there can be no question but that the museum's adoption of this radical role has been accompanied and indeed accelerated by widespread approbation and applause. There are dissenting voices, of course, but if the command of money, resources, publicity, prestige, and sheer numbers of people is a measure of success in the life of an institution, then the transformation of the art museum into a vehicle of headlong cultural change must be pronounced a resounding success.

Yet, just as Braque once observed that in the making of art every acquisition involves an equivalent loss, it may be appropriate to ask what this huge success has cost us. While there is little likelihood that the momentum that has propelled our museums on their present course will soon be reversed, it nonetheless behooves us to see as clearly as we can where this course is taking us and what further sacrifices are to be exacted as the price of developments still to come. For certain sacrifices have already been made, as almost anyone whose experience of museums goes back a few decades will readily attest, and we may be sure that an institution that has so irreversibly tethered its fate to the principle of dynamic change will be called upon to make a good many more.

One thing is beyond dispute. As a result of the immense growth of museums and their embrace of the principle of dynamic change, more people than ever before have been induced to take some sort of interest in art, or induced at least to take an interest in matters that have the appearance of being somehow related to art. It must also be said that this new multitudinous public has access to a program of events, exhibitions,

entertainments, publications, etc., far more various and far more numer-
ous than any that was offered by museums in the past. Many of these
activities are not, to be sure, what I have heard described by museum offi-
cials as "object-oriented."

That is, they are not concentrated on specific art objects. But then,
museums have long ceased to be places that people visited solely or
primarily for the purpose of looking at works of art. They are now the
venue of all sorts of other activities that can be described as museum ac-
tivities only in the sense that they take place under the roof, or at least
under the auspices, of the museum. Yet with serious artistic matters, with
learning or intellectual improvement or aesthetic enlightenment of any
sort, these activities often have little or nothing to do. They come under
the general heading of social diversions.

We now take it for granted that the art museum is an appropriate place
in which to order lunch or dinner, buy something to wear, do our
Christmas shopping, see a movie, listen to a concert, attend a lecture on
anything under the sun, possibly even art, and also on occasion participate
in a wedding party, a cocktail party, a charity benefit, a business reception,
a fashion show, or some other lavish social event for which the museum is
deemed a suitably prestigious facility. In the museums that now offer such
services and distractions, it is still possible, of course, for people to look
at works of art, and many do. Yet except in the highly publicized special
exhibitions that draw the crowds, the galleries containing works of art are
likely to be emptier of visitors, even on weekends, than they were a
generation ago. This is no doubt some consolation to the beleaguered
connoisseur looking for a quiet corner in which to have an unimpeded
view of a favorite masterwork, but it is not exactly a happy index of the
museum's interest in cultivating a loyal public for its greatest treasures.
The overall atmosphere in our big museums, anyway, does not really lend
itself to the cultivation of such a public, which cannot be expected to
prosper in an environment of hubbub and hucksterism. In lieu of this
public the museum now has members, who avail themselves of the social
diversions and add to the hubbub without in any way constituting a
serious public for art.

This development is no longer to be regarded as a peculiarly American
phenomenon, by the way. We may have pioneered the move toward a
broad diversification of the art museum's interests and functions, but the
phenomenon itself is now widespread. When we enter the Louvre now-
adays through the famous glass pyramid, we descend by escalator into a
vast, bright, sprawling space that resembles, more than anything else, the
interior of a huge international airport in the busy holiday season. There
are lines everywhere—a line to enter the pyramid itself, and then more
lines at the cloakroom, the washrooms, the ticket booth, and the cafeteria.

(Except in the immediate vicinity of the famous tourist attractions—the Victory of Samothrace, the *Mona Lisa*, et al.—the crowd is considerably thinner in the galleries, where most of the art is.) And at this "new" Louvre or Grand Louvre, as it is now to be called, there is worse yet to come. According to an interview with Michel Laclotte, the director, "in the future, a shopping mall and a substantial underground parking lot will complete the new underground areas of the Louvre." We are assured that despite this vast expansion of the Louvre's functions and facilities, "in Michel Laclotte's mind, no concessions have been made to mere trends or fashions"—a statement which, if it means anything, can only mean that the director of the Grand Louvre is oblivious to what is going on under his own authority.[1] For at every turn in the labyrinthine sprawl of the new Louvre we are in the grip of every trend and fashion that has beset the art museum for several decades now.

Adding a huge underground shopping mall to the airport-like entrance to the new Louvre will have the virtue, I suppose, of carrying the logic of the new museology to its ultimate conclusion. Martin Filler, writing in a recent issue of the London *Times Literary Supplement*, gave us an excellent account of where this logic was heading even before the Grand Louvre was on the drawing boards. "I. M. Pei's East Building for the National Gallery of Art in Washington, completed in 1978," wrote Mr. Filler, "is dominated by a vast, glass-roofed atrium—replete with escalators and potted ficus trees that give it the aspect of an upmarket shopping mall—while the oddly shaped galleries relegated to three towers on the periphery of the central courtyard and the subterranean changing-exhibition spaces seem like grudging afterthoughts. Intentional or not, the architect's adaption of the imagery of the contemporary market place reinforces the notion of museum-going as yet another consumer activity."[2] In this respect, at least, it must be acknowledged that the French, albeit with some help from us—Mr. Pei is also, of course, the architect in charge of the Grand Louvre—have outdone even American efforts in this direction by uniting the shopping mall and the art museum in a single gargantuan facility. Alas, one is reminded that Andy Warhol's joke about the many things that department stores and museums have in common is turning out, as so many of Warhol's jokes have, to be a deadly prophecy.

It would be difficult to say whether this rampant commercialization and consumerization is only a symptom or a primary cause of the altered relationship that now obtains between the art museum and its public, but

1 See Raoul Ergmann's interview with Michel Laclotte in *The New Louvre: Complete Guide* (Connaissance des Arts, 1989).

2 "Money-changers in the Temple," by Martin Filler, in *The Times Literary Supplement* for July 19, 1991.

there can be no question that this relationship is now the main issue facing the art museum as an institution. It determines much of its budget, its program, its choice of personnel, and its general ethos. To a larger extent than is commonly supposed, the museum has become a captive of its own success, and what is so striking now about its relation to its public is the extreme degree of anxiety and uncertainty that has come to characterize every aspect of it. Often the problem comes down to catering—in every sense—to a public that does not know exactly what it has come to the museum to do or see. This public wants, at one level or another, to be amused, instructed, gratified, edified, or otherwise diverted. Nowadays, too, with the toxin of multiculturalism threatening the intellectual integrity of arts institutions of every kind, the public may also come to the museum in search of political satisfaction. The experience of art is likely, in all too many cases, to be entirely peripheral to what is looked for in the museum.

With museum-going now separated in this way from a genuine interest in art—and by this I do not mean only a professional interest, for it is the amateurs of art who have traditionally constituted the true museum public—it was inevitable that the art museum would be obliged to devise new stratagems for attracting its public and retaining its loyalty. That these stratagems have, for the most part, less to do with education than with marketing is a reflection of the museum's low estimate of the public it has won for itself with such great effort. Hence the sometimes extreme measures that even great museums are driven to in their quest for the high attendance figures that are now needed to justify the expense of major events. When, a few years ago, I heard the radio commercials for the Caravaggio exhibition at the Metropolitan Museum of Art—commercials that attempted to make the show sound as much as possible like an X-rated movie—I knew that we had entered a new period in the relation of the museum to its public. This was, after all, advertising aimed at the "educated" segments of the public, and it was not only the appeal to a prurient interest that was obnoxious. It was also the cynicism implicit in the whole endeavor, for the museum officials responsible for this advertising campaign surely knew that the exhibition they were touting in this unseemly manner was incapable of satisfying the kind of sexual curiosity the ads were designed to arouse. As a result, the art was demeaned, the public misled, and the institution degraded. This was not an isolated case, either. The same advertising strategy was used by the same museum to promote a showing of Balthus's paintings, too. In other words, a policy had been established to cope with a pressing need—the need to entice a public in whose artistic judgment the museum has no confidence whatever.

This low estimate of the public's interests and appetites, with its corollary reliance on marketing rather than education as a means of recruiting

new constituencies, is even more vividly in evidence in the kinds of new museum architecture that have been created at such vast expense in recent decades. The field of museum architecture has in fact emerged in this period as a cultural battleground of considerable significance, for in the debates that the new museum architecture has prompted, as well as in the particular buildings it has produced, virtually all the most contentious issues concerning the future of high art in our democratic society have been broached, and in them we have been given a glimpse of the way these issues are likely to be resolved, or left even more conflicted and unresolved, for many years to come.

The first thing we notice about a great deal of the new museum architecture—and this is as true of the refurbished Los Angeles County Museum of Art as it is of the new Louvre or the East Building of the National Gallery in Washington—is that the palace-of-art, or temple-of-art, ambiance has been dramatically supplanted by the atmosphere of an emporium, a recreational facility, or a transportation center. This isn't the whole story of the new museum architecture, to be sure—the Kimbell Art Museum in Fort Worth and the Picasso Museum in Paris afford a very different order of experience—but it is the largest part of the story, and the part most likely to be emulated in the future. The grandest of the new museum spaces tend to be allotted not to the contemplation of art objects but to the activity of the crowd—*as* a crowd. The debate that has attended the creation of the new museum architecture is, moreover, almost wholly shaped by this shift from an environment of reverence, as it may be called, to an atmosphere of activity and consumption. And while it is less a debate about the philosophy of art than about the philosophy of leisure, it nonetheless has grave implications for the place to be accorded high art in our culture.

Like all cultural questions these days, this debate about museum architecture also has an important political dimension. In the policy disputes governing the new museum architecture, no less than in other branches of the arts today, we have been witnessing the struggle—sometimes it seems as if it were the final struggle—between those who, on the one hand, believe that the future of our civilization depends on safeguarding the integrity of high art from the leveling imperatives of popular culture and populist politics, and those who, on the other hand, are dedicated to destroying—in the name of democracy and equality, of course—all sense of hierarchy and all distinctions of quality in the life of culture itself. The latter have been especially concerned to discredit the idea of the museum as a "temple" or "palace" of art, which in their view is not only an outmoded museological paradigm but a politically vicious one, and they argue in favor of the kind of design, the kind of program, and the kind of technology that will shatter forever the entire range of museum practices

traditionally used to re-enforce the sense of hierarchy and the distinctions of quality they so intensely despise. Needless to say, connoisseurship at any level is dismissed as an interest identified with the odious elitism of the past. In the brave new world of the new museum—the populist museum, as it may be called—every interest, including a lack of interest in art, is to be on an equal footing with every other interest. The art object is thus to be denied its traditionally "privileged" place in the institution that was originally created to preserve and celebrate its existence.

The most respectable exponents of this populist museum model—Mr. Pei is, I suppose, the outstanding example among the architects—bear no grudge against art objects, of course, but they tend, all the same, to favor the kind of consumerist museum plan described by Martin Filler and so enthusiastically embraced by Michel Laclotte. But there is also a more radical faction in this debate that takes as its primary goal the downgrading—or, as they say, the desanctifying—of the art object in favor of technological simulacra that can now make images of the art object instantly accessible to ever larger numbers of people. Not the experience of art but the consumption of "information," not the ideal of high culture but the easy, ephemeral pastimes of entertainment, are what now, in this view, should be made the museum's top priority.

It is from this perspective—best described, perhaps, as that of a technocratic populism—that we have lately been given a glossy book called *The Museum Transformed*.[3] Its author is Douglas Davis, who was for many years a writer for *Newsweek*; its subtitle is "Design and Culture in the Post-Pompidou Age"; and its foreword is by Jack Lang, the French cultural minister, who is himself a champion of the technocratic populism Mr. Davis espouses. *The Museum Transformed* is, as an intellectual artifact, a perfect example itself of the way the appeal to fashionable consumption is nowadays combined with the denigration of the art object and the advocacy of radical cultural policy in discussions of museum matters. The format of the book is that of the upscale coffee-table picture book, with its many color plates and its lavish use of decorative typography, yet in the nearly two hundred illustrations to be found in *The Museum Transformed*, which surveys a good many of the art museums that have been recently built or significantly altered, we are afforded very little sense of what it is like to look at works of art in these structures. You can turn many pages of this big book without having a glimpse of an art object, and this, I think, tells us most of what we need to know about the author's view of the museum's real function today. It is scarcely a surprise, then, that Mr. Davis's allegiance turns out to be clearly committed to what he calls the "post-object" role of the museum, which, owing to

3 *The Museum Transformed: Design and Culture in the Post-Pompidou Age,* by Douglas Davis (Abbeville Press, 1991).

what he also calls the "post-contemporary condition" of our culture, is
—or at least ought to be—in the happy position of dispensing with the
traditional obligation to provide, as he says, "first-hand access to the
sacred object."

While it may still be necessary for the museum to provide such access to
the art object, it is Mr. Davis's view that "the evolving museum must see
itself as a medium of information and pleasure." This, in any case, is the
direction in which "the audience and the program of the museum" are
said to be moving, and ought to be moving, and an institution that
remains "committed to posing as the cathedral of the irreplaceable object"
is merely pursuing a lost cause. Instead of a concern for what Mr. Davis
calls "unique totems sanctified by scholars and historians"—one of the
author's many sneering epithets for the accumulated aesthetic achieve-
ments of an entire civilization— museums are advised to look to technol-
ogy and the theories of Walter Benjamin for proper guidance in these
matters. Why should the actual art object matter, anyway, when technol-
ogy has already rendered its physical presence obsolete? He thus invokes
"the presentation of information about the world's authentic treasures,
now easily recalled for our eyes and minds by electronic media or by
holography, in media varying from the television set to the home com-
puter . . . or to monitor terminals installed in the museum itself," and this
development is acclaimed as the happy realization of Benjamin's theory of
the desanctified art object.

> Long ago [Mr. Davis writes] the German critic Walter Benjamin prophesied
> that the mechanical reproduction of works of art through photography and
> film would diminish our insistence on confronting the "aura" of art only in
> its original state. . . . Now we have the means to "move" any treasure in a
> matter of seconds from the vault of the Louvre to a terminal in Columbus,
> Ohio, before a viewer conditioned by now to intuit the lost "aura" of a
> work of art in its duplicate state.

But is it really the "aura" of the work of art that we go to a museum to
have an experience of, or is it something else, something far more con-
crete that cannot be experienced in "its duplicate state"? This refusal to
make a distinction between aesthetic experience and what is now called
"information" is central, of course, to this utopian—or should I say dys-
topian?—vision of the museum of the future. In his chapter on "The
Museum in the Next Century," Mr. Davis writes:

> Because the possibilities for instantaneous transmission of visual and textual
> information are now almost limitless thanks to computer systems of instan-
> taneous retrieval . . . each museum is now potentially every museum.

The awful thing is that Mr. Davis is by no means alone in believing in this chimera—nor alone, either, in his eagerness to see this museum of the future quickly and fully realized. Almost nothing that the new museum architects have so far produced for us comes close enough to the ideal he envisions. The Pompidou Center in Paris is the closest approximation, but its futuristic mission has been subverted, in Mr. Davis's view, by old-fashioned curators who persist in their benighted attachment to the art object and to devising sympathetic ways of exhibiting it—admittedly, an uphill task at the Pompidou Center. Certainly the art object is nowhere mentioned in Mr. Davis's evocation of what the "next" museum will ideally offer us:

> The grand staircase, the broad walkable corridors, the honeycombed asymmetrical galleries, and of course the elegant theaters and restaurants are the obvious interior elements that define the potential of the "next" museum.

The curious thing is, except for the remaining presence of those "unique totems sanctified by scholars and historians," this sounds to me a lot like the museum buildings we have lately seen erected, but Mr. Davis is apparently the kind of purist who will not be satisfied until the museum is entirely object-free.

Is that day close at hand? I frankly doubt it. The art object is not going to be eliminated from the museum, but what is already upon us in the museum is an altered attitude toward the work of art. It is no longer trusted to speak for itself. It needs, so to say, to be brainwashed. It must now be seen to speak for, or about, something else. The way in which the art object is presented in the museum, the way in which it is interpreted, deconstructed, "contextualized," politicized, and otherwise de-aestheticized, reflects a loss of confidence on the part of museum professionals in art itself.

It is also a reflection of the shift that has taken place in the academic study of art—the shift from connoisseurship to theories and methodologies derived from the social sciences. The immense influence of structuralist and post-structuralist theory has also played a crucial role in this trend among museum professionals to de-aestheticize the interpretation of art and treat the art object as if it were just another artifact in what is now called material culture. Aesthetic categories are now shunned in the museum in favor of sociological and political categories. The charge of "formalism" is now almost as dreaded in the museum world as it used to be in the Communist world. While militant Marxists remain a small minority among museum professionals, the Marxist notion of relegating art to the so-called "superstructure," where it is seen to be an embodiment of social and economic forces more profound than itself, has now become

part of the conventional intellectual wisdom of a great many curators who have never read a line of Marx himself.

Often entire exhibitions are now organized on the basis of such ideas. The show called "The West as Art," which caused such a furor at the National Museum of American Art in Washington last season, was but one of many recent examples, and most of them cause no furor at all. And this changed attitude toward art is also beginning to be reflected in the way museums present their permanent collections to the public. This summer at the Whitney Museum of American Art in New York, for example, the seasonal "Selections from the Permanent Collection" exhibition was mounted under the title "American Life in American Art, 1950–1990," and it was billed as a survey of "postwar paintings and sculpture exploring themes from prosperity to critiques of the American Dream." When one ascended to the third floor of the museum to see what had been selected to represent this documentation of "prosperity" and "critiques of the American Dream," there were familiar paintings by Milton Avery, Richard Diebenkorn, and Lee Krasner, and sculptures by David Smith, among many other objects, that had nothing whatever to do with these subjects.

I don't suppose that most visitors to the Whitney were even aware that these and the other works of art in the exhibition were intended by the museum staff to be "read" as social documentation and criticism. But that will change. With the announcement in July that Benjamin H. D. Buchloh, a left-wing stalwart of the *October* magazine circle, has been appointed to a position that makes him, in effect, the Whitney's chief political ideologist, you may be sure that we shall be seeing a good many more "critiques" of this sort far more aggressively pursued. According to David A. Ross, the new director of the Whitney, Mr. Buchloh "will have a key role in providing an environment that encourages critical study and theoretical inquiry into the practices, institutions and discourses that constitute the field of culture." This, you may be sure, sounds the death knell to whatever remained of a remnant of a serious and disinterested attitude toward art at the Whitney. From now on it will be more and more politics and less and less art, though the politics will be presented, of course, in the name of art.

And this political, anti-art course at the Whitney will be pursued in tandem with a revivified emphasis on consumerism at the museum. Mr. Ross's other big initiative this summer was the refurbishment of the Whitney's restaurant and the installation of a new chef. If you think that consumerism and political radicalism represent conflicting polarities in the new museum world, you are mistaken. Nowadays they live on very easy terms with each other, for each conforms to a fashion of the moment, and they are alike in diverting the museum from its real function. Neither contributes anything whatever to our understanding of art. That is what makes them so attractive to the new breed of museum director. You will

see the same program of consumerism and left-wing ideology in command at the expanded Guggenheim Museum whenever its director gets around to reopening it. In the new museum there is no need to eliminate the art object. You may instead render it socially and intellectually invisible.

Of the art museum at the end of the twentieth century it may truly be said that nothing has failed like success.

September 1991

Robert Hughes and the Flaying of America

James Bowman

In the culture wars, Robert Hughes, the formidable art critic for *Time* magazine, has taken upon himself the role of culture warlord: an independent force whose power grows as the principal combatants exhaust themselves fighting each other. He harries the flanks of Left and Right as they discharge their heavy ordnance at one another—and sometimes he creeps onto the battlefield after nightfall to cut the throats of the wounded. It is a rhetorically liberating position to be able to cry a plague o' both your houses, as Hughes does in his new book, *Culture of Complaint: The Fraying of America*, and he is occasionally in fine form doing it.[1] His bark is worse than his bite, but he is one of those people whose bark *is* their bite, as Randall Jarrell once wrote: and many a bite has lain awake nights wishing it were half as fearsome as his bark.

Or at least as his bark is when, more or less by chance, he manages to find something to bark about. Hughes is much better at complaining than he is at finding worthwhile objects of complaint. The style is promising, but substance is not one of his strengths. Substantively his purpose is like that of the old "peace" brigade back in the days when politics was about firepower instead of bookpower. That is to say, he tries to duck the fight by pretending to live in some ideal world where the fight would not be necessary. Thus cut loose from the need to argue responsibly, Hughes can choose targets of opportunity from among the rich variety afforded him by both sides without regard to questions of rationale, whether moral or strategic. To him, one half suspects, his victims are merely occasions to show off the capabilities of his rhetorical arsenal.

These, as I say, are not small, and few will shed any tears when it is the likes of Karen Finley being reduced to a smoking ruin. Of Miss Finley, the well-known "performance artist" who once cited as evidence of her oppression the fact that she could never become Pope, Hughes writes:

1 *Culture of Complaint: The Fraying of America*, by Robert Hughes (The New York Public Library/Oxford University Press, 1993).

I came to see that there is, in fact, a reason why Karen Finley should be ineligible for the Papacy. The Pope is only infallible part of the time, when he is speaking *ex cathedra* on matters of faith and morals. The radical performance artist, in her full status as victim, is infallible all the time. And no institution, not even one as old and cunning as the Catholic Church, could bear the grave weight of continuous infallibility in its leader. This, even more than the prospect of a chocolate-coated Irishwoman whining about oppression on the Fisherman's Throne, is why I should vote against her, if I were a member of the College of Cardinals, which I am not likely to be either.

No indeed! But he has a fine, Australian sense of the ridiculous which comes into play especially when he is inspired by the tired Puritanism of the Left:

> In the late 1980s the editor of the Presses Universitaires de France, Nicos Poulantzas, was struggling to complete an expansive series of books on Marxism and contemporary life that had been started in the 1970s: Marx-and-cooking, Marx-and-sport, Marx-and-sex, Marx and anything you cared to mention. But it was unfinishable: long ago, Poulantzas had run out of Marx-fixated French writers. "Our only hope is America," he confided gloomily to a colleague, shortly before he committed suicide.

Toward the Right, however, Hughes's attitude is less lightly satirical, more serious and even bitter. If he is one of those rare liberals who have partially freed themselves from the tendency to see *pas d'ennemi à gauche*, he is not above apologizing for the silly Left's exhibition called *The West as America* at the National Museum of American Art two years ago on the grounds that "my enemy's enemy is my friend." Thus he is committed to what appears to be the new, perhaps kinder and gentler maxim of the anti-anti-progressive tendency: that there is, notwithstanding the occasional stinker on the Left, at least *pas d'ami à droite*. Thus this book, which ends with a plea against the conversion of an art-museum world of "high artistic and intellectual standards" into "an arena for battles that have to be fought— but fought in the sphere of politics," begins with a gratuitous attack on those who have been chiefly concerned with the preservation of such standards—and solely on account of their politics.

Let us notice from the start that whatever may be Robert Hughes's qualifications as an art critic, a historian, or a rhetorical paladin, his political judgments are informed by nothing but the most predictable kind of New York cocktail-party liberalism. His opinions on politics are somewhat less interesting than those of Jesse Helms on art, if you assume that at least Senator Helms knows what he likes. Hughes only knows what he

doesn't like. The main thing he doesn't like is Ronald Reagan and George Bush. He flails away at them with a well picked-over selection of blunted and chipped weapons, chosen from the Left's arsenal of clichés—about "infrastructure" and "trickle-down theory" and "racially divisive" or "rigidly ideological" policies—for all the world as if he hoped to get a job as a Democratic speechwriter.

As political analysis, his book is about on the level of partisan speech-ifying too, for you can usually tell what fashionable guru's ideas are being tortured into Hughesian prose every time another slogan falls with a leaden thud onto the page. Even J. K. Galbraith's demonstrably false as-sertion that Republicans are elected because the poor don't vote finds its way into this book without any attribution to the master. But Hughes himself understands little of the substance behind his borrowed slogans, for when he grows expansive and attempts a little ad lib sloganeering of his own he comes a cropper with some such nincompoopery as accusing Reagan of having caused "the widest gap between high and middle in-come ever to afflict America." If he reads all his books as carelessly as he has read his Kevin Phillips (who got it wrong anyway) we had better be careful about trusting what he has to say on other subjects.

And what a lot of books he has read! Besides the political books he has so imperfectly understood but so uncritically swallowed there are many, many monuments of Western (and Eastern!) culture that Hughes is con-cerned to make sure his readers know he has at his fingertips. You would think that an Australian with an old-fashioned Jesuit education and enough street smarts to tell Robert Mapplethorpe to go pee up a rope when the latter asked him to write an introduction to a collection of his work—you would think that such a man would not suffer from the sort of academic insecurity that requires a parade of learning to make a few simple points. New York has got to him, I guess.

What he really wants is to hear heads all over America being slapped as culture warriors say to themselves: "What were we thinking of?" and "Of course!" and "Why didn't I think of that?" and "Hughes has done it!" and "Brilliant!" Who would have thought that the solution to the whole problem of multiculturalism was so simple? Why, you just do *both*, you see: read all the canonical stuff and then read all the multicultural stuff, too. Or vice versa. All the fighting has been unnecessary, all on account of the fact that "in the literary zero-sum game of Canon talk, if you read X it means that you don't read Y." Unfortunately, it is not the *literary* zero-sum game—which has never in fact existed (what conservative opposes reading about other cultures? what liberal reading about our own?)—that has got so many people so excited but the *academic* zero-sum game. For when it comes to designing curricula, it is regrettably but precisely true that "if you read X it means that you don't read Y."

The Right's argument against multiculturalism is not that the whole

wide world ought not to be so well-read as Robert Hughes but that college freshmen, who are as innocent of learning as babes and who have got to start somewhere, should start with their own culture—which is inevitably Eurocentric if only because of the language they speak. You can't do that by reading a play by Shakespeare one week and *I, Rigoberta Menchu* the next. Four years spent on the English classics alone is hardly enough to make an adequate start, given that we have virtually written off the high-school years for a generation now. Anyone who thinks that the hard work of assimilating and understanding the writings of the past is educationally equivalent to browsing the multicultural smorgasbord in order to confirm our own prejudices is dishonoring the memory of those Australian Jesuits whose wiser heads made Robert Hughes what he is today.

Yet all his learning and all his rhetorical flair are too seldom employed here to any greater end than the enthusiastic demolition of various strawpersons dressed in the traditional fascist attire—like William Bennett, whose jackboots are apparently legend on the Left. "Lay aside Plato and pick up a copy of Rigoberta Menchu, and suddenly there's William Bennett, with his big black boots on, announcing that it's closing time in the gardens of Western Civ," writes Hughes. Really? This happens just by picking it up? Well, no, that's a little exaggeration for reading it. Really? Just reading it? Well, no, that's a little exaggeration for liking it. Really? Just liking it? Well, no, that's a little exaggeration for liking it so much that you make your young people read it instead of Plato, so much that you make it into what Plato used to be—namely, one of those central texts whose ideas anyone with any claims to education must be able to traffic in.

And that's *not* closing time in the gardens of Western Civ?

If you are erecting a satirical structure, it had better be more soundly constructed than this or someone is going to come along and point out that it will only stand up with the help of a wild distortion of the other side's position at every joint. Nowhere does such distortion appear more blatantly than with respect to abortion—a subject that Hughes treats with a macabre sense of fun that might make even Planned Parenthood blush. Did you know, for example, that "the new Sacrificed Body of American conservatism"—that is, replacing the Eucharist—was the fetus? Yuck! Or that the kitschy "Whatizit" adopted as the official mascot of the 1996 Olympic Games in Atlanta was also a fetus—the product of "fetus overload in popular culture." *Fetus overload*? What is the man talking about? The context makes clear Hughes's own enthusiasm for aborting fetuses, so it seems strange, to say the least, to lay any "overload" there may be of the pathetic little homunculi (the image is repellent in the extreme) to the charge of the anti-abortion Right.

The disconnection at times between such rhetoric and reality becomes

so great that you have got to wonder where else the polished phrases might hide a shameful disregard for the truth. Hughes, for instance, is an intellectual name-dropper, which may account for his view that books are pretty much interchangeable. It never occurs to him that anyone but a right-wing nut could object that the exchange of Plato for Rigoberta Menchu is a pretty poor trade, or that the two must be judged on the grounds of what is actually in their books. He never considers the argument one way or the other that what you find inside a volume of Plato may be better, truer, even more interesting than what you find in the story of Rigoberta Menchu. It would probably astonish him that anyone could still think in such primitive terms. But he should at least try to make the case against such thinking, because that and not the caricature of their representation here is how the Right really does think.

Hughes begins by invoking the name of George Orwell against political language "designed to make lies sound truthful and murder respectable, and to give an appearance of solidity to pure wind." But his pleas for a more concrete, simpler language of political discourse are at odds with his own practice of keeping a high rhetorical profile without much scrupulousness about representing his opponents fairly. Orwell earned the right to be taken seriously by all political persuasions because he concentrated on the truth behind the slogans of both Left and Right. Hughes, by contrast, is a dedicated sloganeer. He even manages to make sure that Alger Hiss is exonerated in his pages, if not in the confused and contradictory statements of General Volkogonov.

Among Hughes's own outrageous distortions are charges that Reagan/Bush did not treat blacks as Americans or that Republican "morality" turned a blind eye to thievery in the Savings and Loan Associations in the 1980s. He seems to think it consistent with Orwell's injunctions about the language of politics to say that Patrick Buchanan's speech to the Republican convention last August "might not have been out of place in the Reichstag in 1932," and he overinterprets Ronald Reagan's misattribution of a quotation to Abraham Lincoln at the same convention into a contemptuous dismissal of those among "Reagan's fans" for whom "the idea that there ought to be, or even might be, some necessary relationship between utterance and source seemed impertinent to the memory of his Presidency." Huh? *Which* fans were those again?

Orwell would not have been proud of such sloppy thinking, or of the unthought processes involved in merely parroting the official line of the cultural elite, as Hughes does here, on the man who had the temerity to identify it as such. Just like Sidney Blumenthal—or Jay Leno—he affects to believe that Dan Quayle was guilty of the stupidity of not knowing the difference between fiction and reality when he criticized the television program "Murphy Brown"—even though, as a critic himself, Hughes is in a better position than most to know what real people's smug, yuppie

values are encoded and sold every week in that program. Likewise, he takes up the *pro forma* denial of the cultural elite that there is any such thing as a cultural elite (Well, who are they then? Go on, Dan, name them!)—and this in a book entirely conceived as a critique of the cultural elite as well as those who oppose it!

Most of this offensive and dishonest stuff is to be found in the first two of the three lectures that make up this book, "Culture and the Broken Polity" and "Multi-Culti and Its Discontents." The third, "Moral in Itself: Art and the Therapeutic Fallacy," deserves to be taken more seriously because of its accurate identification of one of the principal reasons for the corruption of the terms of the cultural debate, namely the assumption by many on both Left and Right that art has a fundamentally therapeutic or moral function. But instead of using this insight to redefine those terms, Hughes couples it with an attack on Senator Helms and other proponents of what he insists on calling "censorship" and a plea for more government subsidy for the arts. He does not see how this line of arguing involves him in a self-contradiction.

For if it is true that "we know, in our heart of hearts, that the idea that people are morally ennobled by contact with works of art is a pious fiction," then on what grounds can we justify subsidizing art from the public purse? Why should ordinary working people be asked to pay their tax dollars for the non-moral, non-therapeutic, non-ennobling artistic amusements of a few of those who, for the most part, are far better able to afford them than they are? How justify even the present trifling expenditure of 68¢ per taxpayer on the arts, let alone the $25 or $30 per taxpayer that Hughes admires the French and Germans for spending, if there is no clear public benefit? But this is a question for political philosophy, and all Hughes has to work with is political slogans—such as that "there is no civilization without taxation." Even if it is true (which I doubt), what that assertion has to do with the NEA, not to mention Robert Mapplethorpe, remains far from clear.

A little of the concreteness of language that Hughes calls for in homage to George Orwell would have saved him from such an egregious overgeneralization—and one implying a normative sense of the word "civilization" which is born of precisely the same belief in the moral properties of art that he elsewhere decries. It is not the only place where he falls short of the Orwellian ideal. He appears to believe that Orwell's fierce integrity and independence can be bought at no higher a price than mere willingness to attack both sides. It is not true. That willingness is held in common with those who have no intellectual principles at all. If Hughes has any, this book shows them to be consistent with a lot of rhetorical sharp practice.

April 1993

Literature and Politics in Latin America

Mark Falcoff

The task of the writer in Latin America has never been an easy one. In some countries literacy hardly surmounts functional levels; in others, where it far exceeds them, there still is not much of a public for which one can write. There are few serious universities or literary reviews, and the book trade is one of the most perilous occupations imaginable, subject to the anomalies of paper supplies, exchange controls, price controls, and a minuscule market. It is perhaps unflattering to say so, but Latin Americans are not great readers of books: instead, they consume huge quantities of newsprint, café gossip, and conspiracy theories. This is so notwithstanding the fact that the region has also produced some world-class writers, and shows every indication of continuing to do so.

In some ways, of course, the foregoing merely describes the situation of literature in any area of the Third World. But in one important regard, Latin America is quite different from, say, Africa, the Middle East, or South Asia: Latin Americans are more firmly situated within the Western literary tradition. Even so, one should not make too much of this: in some ways the region has more in common with other non-Western areas than we think. This leads to much confusion on the part of American and Western European readers, who are often taken in by false labels, and misunderstand the spirit underlying much of Latin American literary work. Nonetheless, Latin American literature has succeeded in gaining a foothold in mainstream Western culture, as a kind of exotic cousin whom we feel obliged to admit to our table. The relationship is sometimes based more on courtesy, guilt, and misunderstanding than on genuine affinity, but the writers themselves would be foolish indeed not to take advantage of it.

The subject of literature and politics in Latin America is, of course, extraordinarily broad. Yet a few ruthless generalizations will serve as a point of departure. The image of the writer as an independent critic of society and power, or as a voice in the wilderness defending humanistic and liberal values against an established order of violence and greed, is greatly exaggerated. Indeed, most writers in Latin America have been unusually

drawn to power, for reasons both of economic necessity and cultural predisposition. Further, at least since the turn of the century, they have been particularly attracted to non-liberal or anti-liberal ideologies. More recently, their anti-liberal bias has been positively encouraged by the literary establishments in Western Europe and the United States. And finally, a new generation of liberal voices has succeeded in making itself heard in Mexico, in Peru, in the Southern Cone republics. But the future of this generation remains extremely problematic. In this article I propose to comment at length on each of these propositions.

Popular tradition places the roots of censorship in Latin America deep in the colonial period, when the Spanish authorities forbade the importation of works of creative imagination. It is true that Latin Americans were expected from the very start to subsist on a steady diet of sermons, writings of the Church fathers, and lives of the saints (some of which, actually, were very nearly pornographic). There was also, however, from the very beginning an underground trade in other books; the first copies of Cervantes's *Don Quixote*, for example, were smuggled to the New World in crates supposedly containing bottles of wine. This serves as a useful illustration of the limits of censorship, which—like almost every other aspect of government in the region—has never worked the way it is supposed to.

To be sure, over the years there have been instances in which individual titles have been prohibited, or even physically destroyed, sometimes with considerable brio. These episodes have captured the momentary attention of the Western cultural public. For example, copies of Mario Vargas Llosa's first novel, *The Time of the Hero* (1963), were publicly burned at the military academy in Peru where much of its action takes place. The incident was seized upon by its American publisher to promote the work of a (then) unknown writer. The junta in Chile staged a widely reported (and photographed) book-burning episode shortly after the coup in 1973, and has seized and destroyed several book shipments since then. Despite such incidents, however, censorship has been a less serious threat to literature in Peru, Chile, and elsewhere than other things, including indifference, popular taste, and economic constraints. Only in Cuba and (until yesterday) Nicaragua has literature been conscripted into service to the state.

Dramatic individual instances of censorship mask a more important fact about the literary estate in Latin America—namely, that in most cases the relationship between writers and power has been symbiotic. During the first century of independence, literary skills of any kind were a monopoly of urban elites who dominated national affairs. Many writers were also presidents, generals, ministers, ambassadors, or prefects. While individual writers were persecuted and sometimes driven into exile, this was due to their affiliation with the party out of power, not to the allegedly subversive content of their work.

Moreover, in the absence of a broad economic base to support an independent or semi-independent intellectual class, writers had no choice but to recur to the State for economic subsistence. This point is particularly well established in Doris Meyer's recent anthology, *Lives on the Line: The Testimony of Contemporary Latin American Authors*.[1] Starting in the nineteenth century, but continuing well into the twentieth, many Latin American governments maintained writers on the national budget, often as consuls or even ministers at overseas legations; for example, Rubén Darío, the greatest voice of Spanish American poetry, was happy to edit the official daily of the oligarchical regime in neighboring El Salvador, and, later, to represent the dictator of his own country, José Santos Zelaya, at the Court of Madrid. "He lived side by side with idiotic and reactionary politicians," Cuban novelist Alejo Carpentier later observed, "whoring generals whom he found agreeable and even interesting." (The comment loses none of its impact by the fact that Carpentier himself later did exactly the same thing for Fidel Castro, for whom he served as ambassador to France.)

The Colombian poet José Santos Chocano served as a diplomatic agent for the Mexican bandit-*cum*-revolutionary Pancho Villa, and, even more deplorably, for Manuel Estrada Cabrera, ruthless dictator of Guatemala from 1905 to 1920. Successive Chilean governments maintained another great poet, Pablo Neruda, by offering him minor diplomatic postings in the Netherlands Indies and in Spain, and they did the same for his colleague, also a Nobel laureate, Gabriela Mistral. Jorge Luis Borges for years worked at the Buenos Aires Public Library, and subsequently became the director of Argentina's National Library.

The phenomenon is by no means limited to "conservative" Latin American governments or to military dictatorships of the Right. Indeed, the first Latin American government to recruit writers and artists systematically for specifically political purposes was a government of the Left—revolutionary Mexico of the 1920s and 1930s. The Mexican phenomenon deserves more than passing reference because it embodies the finished model to which so many other Latin American governments and political parties secretly aspire: a one-party state that dominates both its military institutions and its labor movement; that elevates corruption to a system; that deftly conjugates a left-wing foreign policy with a right-wing domestic policy; and that pre-emptively eliminates criticism from abroad by accusing skeptical foreigners (particularly Americans), of racism, imperialism, or "lack of mutual respect."

In some respects what historians call the Mexican revolution (1910–1940) was not notably different from other struggles for power in that

1 *Lives on the Line: The Testimony of Contemporary Latin American Authors*, edited and with an introduction by Doris Meyer (University of California Press, 1988).

country save for its duration, geographical extent, and the degree of physical and human damage inflicted upon a helpless population. But the new Mexican authorities understood (as their predecessors did not) that in order to create enduring institutions, it was necessary to conscript cultural workers, particularly writers and artists. These in turn could be used to create a façade of broad philosophical meaning or what in many ways was nothing but a pillaging expedition which culminated in the creation of a new class of "revolutionary" millionaires.

By nationalizing large sectors of the nation's economy, the new government evidently acquired vast control over culture; no newspaper could survive without advertising from state enterprises, or even go to press without newsprint from paper companies that were also now "socially owned." But the revolutionary political class in Mexico went well beyond negative sanctions—it created new opportunities for writers on state-subsidized literary magazines and periodicals, or for government agencies. It also created a state book-publishing house (Fondo de Cultura Económica), the first such in the history of Latin America.

Most important of all, the Mexican government mastered the use of house intellectuals in order to counteract unfavorable news stories abroad. The efficacy of the new system was first demonstrated in 1929, when José Vasconcelos, one-time minister of education (who was, in fact, responsible for creating many of the revolution's new cultural institutions), was defeated for the presidency of Mexico. Himself an honest man who abhorred violence and corruption, Vasconcelos was labeled by the regime as a "reactionary"—a damning accusation which had immediate resonance on both sides of the border. After a fraudulent election, his followers all over Mexico were set upon; many were murdered, and several dozen were buried in a mass grave. The candidate himself was lucky to escape to the United States with his life.

The intellectual class, however, kept silence or repeated the allegations of the government, while the American liberal community (*The Nation* and *The New Republic*) saved its disapproval for Vasconcelos, whom it saw as a backslider who had abandoned his revolutionary faith. Since then Mexico has enjoyed a unique immunity from criticism by American liberals otherwise so interested in the conduct of other repressive Latin American governments. This undoubtedly reflects, at least in part, the lengthy quiescence of Mexico's own literary and intellectual community—the crowning achievement of the triumphant revolutionary state.

While no other Latin American country has fully replicated the Mexican model, elements of it have appeared and reappeared periodically across the continent. Perón in Argentina (1946–55) and Allende in Chile (1970–73) used control of the economy to bankrupt potential advertisers in the opposition press (the latter failing to extinguish the independent *El Mercurio* only because of a covert subsidy from the CIA). Another recent

example is the self-styled "left-wing" military government of Peru (1968–79) which in 1974 "transferred to the national majorities" all of the daily newspapers of Lima, throwing five hundred journalists and press workers into the streets for having allegedly worked for the "oligarchy" and "imperialism." For novelist Mario Vargas Llosa, this was the moment of a great epiphany; up to that time he thought of the intellectual as a kind of moral reserve of the nation. Instead,

> I recall my stupefaction upon seeing with what indecent haste legions of lawyers and philosophers, literati and sociologists jumped at the chance [for employment on the papers]. Among their number there was, naturally, the usual quota of rogues and professional opportunists, hacks that had served other, no less shady employers in times past. And there was also a tiny group of militants of the Communist party granted permission by their leaders to prostitute themselves—to infiltrate these places of power and put them to their own use before the adversary could do so.

To a man (and a woman) they accepted "the lie of the 'transfer to the social sectors' and went to work in the dailies to fulfill a function about which, from the very first, there could be no doubt whatsoever." Some were surely driven by economic necessity, Vargas Llosa continues, but given the wretched salaries they were paid, this can hardly have been the principal motivation. At issue was an appetite for power, "a fascination even greater in a country like ours, where, given the cultural poverty of the environment, intellectual life tends to be replete with frustrations."

These developments in Peru are characteristic of the explosion of urban centers in Latin America since World War II, an explosion that expanded the number of writers (or potential writers) well beyond the capacity of any state to absorb or co-opt fully. Even with greatly enlarged government payrolls, the safety valve of emigration to Western Europe or (particularly) the United States, the ubiquitous grants from foreign foundations and United Nations agencies, the supply still far exceeds the demand. Vargas Llosa's point remains valid, however: the difference between "ins" and "outs," "haves" and "have-nots," divides the literary community far more than any devotion (or lack of it) to democratic principle, commitment to freedom, tolerance for other people's ideas, or preference for an open political and social order. This does not prevent individual writers from producing very good work, often of no particular political import; but in their public role as repositories of the national culture, they are not, as a group, democratic exemplars.

If further proof were needed, there is the evident attraction that anti-democratic and anti-liberal ideologies have long held for the Latin American literary class. In the nineteenth century the reigning notion was positivism, which in its Latin American version justified rule by the en-

lightened few—the *científicos*, as they were known in Mexico; in the twentieth, it has been fascism, Communism, or both. Some have moved from one extreme to the other without difficulty; the most notable case was Argentine novelist Julio Cortázar, an early supporter of Franco who switched sides in the Fifties, participated in the Russell Tribunal on "American War Crimes" in Stockholm, and subsequently supported leftist police states in Cuba and Nicaragua; another example is Nicaragua's José Coronel Urtecho, a former admirer of Mussolini who until recently was the chief literary apologist for Comandante Daniel Ortega.

The number of Latin American writers who have been attracted to Marxism at one time or another, or have actually joined Communist parties, is legion, including Neruda, Guatemala's Miguel Angel Asturias (another Nobel laureate), Brazil's Jorge Amado, Argentina's Ernesto Sábato, Cuba's Nicolás Guillén. As in Western Europe and the United States, most of these men made their commitment in the Thirties and Forties, under the double impact of the Depression and the Spanish Civil War; some abandoned Communism later on, out of disillusionment with either the Hitler–Stalin Pact or the Khrushchev revelations of the crimes of the Stalin era. But unlike Marxists in Western Europe and the United States, they did not necessarily gravitate toward a liberal democratic vocation; more often, their Marxism became a bit like other people's Catholicism—a religion one continued to profess but no longer practiced. Paradoxically, with the exception of Neruda (and not always him), their work reflects little familiarity with the canons of Socialist Realism; rather, they tended to borrow their aesthetics from Zola and the French naturalists.

Another generation emerged in 1968, inspired by the Cuban revolution, the Vietnam war, and the example of Ché Guevara. These writers could be regarded more as "New Left" than Marxist or Marxist-Leninist; while their work is more explicitly political in content, it is demagogic or melodramatic rather than doctrinal in tone, utilizing set-piece techniques of social protest, nationalism, and anti-Americanism, often writing with an eye to the European and American book-buying public than to national audiences. By and large it has produced fewer writers of genuine quality—the best-known being the Uruguayan Eduardo Galeano (just now being discovered in translation by New York's radical-chic literary community) and his compatriot Mario Benedetti, Chile's Ariel Dorfman, and Nicaragua's Omar Cabezas and Sergio Ramírez. Of course, the most famous member of this group is Nobel laureate Gabriel García Márquez. Unlike the others, however, García Márquez's novels have no political content whatsoever; in spite of this (or perhaps because of it), his political pronouncements (on behalf of Castro and, later, the Sandinistas) are unusually shrill.

The generation of 1968 also reflects a more cosmopolitan trend in Latin

American letters—the internationalization, as it were, of certain formerly local themes, which in this case are protest, revolution, repression, solidarity, and also the supposed "authenticity" of native cultures threatened by North American consumerism. The "dirty war" against urban guerrilla subversion in Argentina (1976–83), but even more, the coup which deposed Allende in Chile, followed later by the Sandinista revolution in Nicaragua and the struggle in the FMLN guerrillas in El Salvador, led an emerging generation of Western Europeans to discover a special affinity with what they imagined Latin America to be. The point of convergence was a common hatred of the United States and the conviction that the real enemy of humanity was not Communism but a renascent fascism and American economic interests and mass culture (seen as one and the same thing). Of course, not all Latin American writers responded to this situation by plunging into political themes; but the more ambitious (or unscrupulous) among them could not help noting that revolutionary posturing was the most expeditious route to success in the North Atlantic publishing and literary worlds.

Again, Vargas Llosa gives us the best picture of this new kind of Latin American writer:

> Although he rarely belongs formally to a revolutionary party or engages in the difficult sacrifices required of a genuine militant, he calls himself a Marxist and on all occasions broadcasts to the four winds that American imperialism—the Pentagon, the monopolies, Washington's cultural influence—is the source of our underdevelopment.
>
> He has a keen sense of smell, which allows him to detect CIA agents, whose tentacles he finds everywhere, including Boy Scout camps, tours of the Boston Symphony, Walt Disney cartoons, or anywhere or any time someone questions state-controlled economies or one-party states as a social panacea.
>
> Meanwhile, while polluting the air of his own country with these sulphurous pronouncements, he is a permanent candidate for grants from the Guggenheim and Rockefeller foundations (which he almost always receives), and when—thanks to local dictatorships—he is exiled or chooses to exile himself, it would serve no purpose to seek him in the countries he supposedly admires and broadcasts as models for his own—Cuba, China, or the Soviet Union—since the place he selects to continue his revolutionary struggle is New York University, or the University of Chicago, or California, or Texas, where he is a visiting professor only pending his appointment to a richly endowed permanent chair. Who is this person? This, dear friends, is the progressive intellectual.

The proliferation of such "progressive intellectuals" says even more about developments in the United States over the last twenty years—and

particularly, developments in American culture and higher education—than about Latin America. It is obviously unfair to require a minimal coherence between thought and action by intellectual visitors to the United States, when native practitioners of philosophy and letters see no reason for it themselves. It is also unrealistic to expect writers in countries with limited economic resources to be insensitive to demands of the international market. It is perhaps worth noting, however, the degree to which the "long march through institutions" has created an alternative American culture, with its own requirements which at least conceivably shape the composition and design of its imports.

In any event, certain expectations on American university campuses (derived mainly, it seems, from such often-exhibited movies as *State of Siege*, *The Battle of Chile*, *Missing*, and *Salvador*) must be met. For example, one Chilean novelist (himself a former supporter of the Allende regime) experienced some difficulties on an American lecture tour in 1980; the discovery that he had accepted an airplane ticket and per diem expenses from the United States Information Agency profoundly troubled several students and faculty at one university in the San Francisco Bay Area at which he spoke; but the fact that he resided in his own country—to which he had finally been permitted to return from Spain the previous year—rather than in exile was what finally convinced some in the audience that his anti-Pinochet bona fides were not in order. It may be a coincidence, but so far his novels, though well known and highly regarded in Spain, France, and Germany, have yet to appear in the United States.

Not only are many Latin American writers not political at all; others have become intensely anti-political as the result of their own experiences, particularly with "revolutionary" governments in Cuba and Nicaragua; still others—a small but distinguished company—have made the journey back from the authoritarian left to the democratic center. The late Argentine novelist Manuel Puig (*Kiss of the Spider Woman*) is perhaps the best example of the first. As a student of film-writing in Rome in the 1950s, he was astounded to discover that intellectual circles in Italy were pervaded by a kind of left-wing McCarthyism. "Emotionally, I was split. On the one hand, a popular cinema of protest appealed to me; but on the other, I also liked cinema with a story, and this apparently classified me as a die-hard reactionary." Puig persisted, though, and eventually developed his own style and themes, which have to do with the confusion of sex roles and cultural models that afflict contemporary Argentine society—a subject so daring as to prevent his first novel, *Betrayed by Rita Hayworth* (1968), from being published in Argentina until after it had already succeeded in a French translation.

Other novelists had their fling with revolution, and lost their taste for it. The best example is Guillermo Cabrera Infante, a rising star of Cuban literature, who worked on *Lunes de Revolución*, the cultural supplement of

Castro's official daily, until he ran into problems with the censor. He eventually defected from his post as cultural attaché in the United Kingdom, and continues his work in England today. His novelistic work reconstructs Havana in the late Forties and early Fifties—the last moment of the old regime—and maps the parameters of cultural dislocation, in this case, the enormous influence of American culture in Cuban life, against the impossibility of fully replicating the foreign model. Though Cabrera Infante has done much to puncture the balloons of the English literary Left in their love affair with Castro—his remarks, when interviewed, are extremely astringent—he could hardly be said to have any strong political views of his own.

Chilean novelist José Donoso introduces a special variant, which might be called "post-political." His newest work, *La desesperanza* (1985; English version, *Curfew*, 1988), recounts the experiences of a left-wing folk singer who returns to Chile in the early 1980s after spending nearly a decade in Western Europe cashing in on European guilt and solidarity; he discovers that many of the people on the Left who stayed behind and faced the dictatorship in its most ferocious period are resentful of his success. For his part, he discovers a Chile entirely different from the one he left, exhausted spiritually from the ideological wars of the 1960s. Donoso's narrative style is droll and ironic, reflecting a cynical world view evocative of Cabrera Infante. A somewhat similar spirit pervades the magnificent novel of his compatriot Jorge Edwards, *Los convidados de piedra* (1978), which provides a long and somewhat skeptical perspective on Chilean political life, moving back and forth between the prewar period and the Allende years.

The most important development in recent Latin American letters has been the emergence of a new group of writers who have made a decisive liberal and democratic commitment, explicitly denouncing totalitarian regimes and utopian ideologies. The most important, and certainly the best known, is Octavio Paz, the Mexican poet, anthropologist, diplomat —and now Nobel laureate—whose magazine *Vuelta* has become the vehicle whereby a new generation of Latin American writers dare to experiment with dangerous ideas—dangerous, that is, to the Latin American literary-cultural establishment and its numerous and well-placed foreign allies.

Paz himself has been a dominant figure in Mexican letters for two generations. His own left-wing credentials leave little to be desired. His father was the Washington representative of the famous revolutionary General Emiliano Zapata; he himself rushed to Spain in the 1930s to demonstrate his solidarity with the beleaguered Second Republic; and in the later part of the decade he was close to the Trotskyite movement in Mexico. In 1968, he resigned his post as ambassador to India to protest

the shooting of protesting students at the Plaza of Three Cultures in Mexico.

For some years now, however, Paz has been moving away from his earlier militance. As early as 1950, he wrote an article condemning the concentration camps in Stalinist Russia—a daring act for an intellectual in Mexico, where the enemy of one's enemy is automatically one's friend. As it was, the piece had to be published in Victoria Ocampo's literary quarterly *Sur*, in faraway Argentina.[2] He was almost alone among Mexican intellectuals in expressing reservations about the Cuban revolution during the Sixties and Seventies. And he publicly objected to his country's support of a 1976 United Nations resolution equating Zionism with racism; since his view happened to coincide with that of the United States, he was widely accused of treason to the Mexican nationality.

Neither then nor now, however, could Paz be regarded as a man of the Right. He has denied ever being an "anti-Communist," and in fact *Vuelta* conspicuously opposed U.S. policy in Vietnam, publishing pieces by Noam Chomsky and I. F. Stone. At a forum at Harvard University in 1972, he declared that given Mexico's dependence on the United States, its "transformation into a more just, freer, and more human society—a democratic socialism founded on our history—is inevitably linked to the United States." As such, he told his audience, "your struggle is our struggle. Our friends are your friends because your enemies are ours. . . . We must join together—Mexican and American dissidents, to change our two countries!"

The major turning-point in his thinking seems to have been reached a little over ten years ago. As he told a Mexican journalist,

> The situation of 1977 is very different from 1937. After thousands of accounts by eye-witnesses—from Trotsky and Victor Serge at one extreme, to Souvarine and Solzhenitsyn at the other, with Khrushchev's secret speech in the center—it is impossible to close our eyes . . . it seems to me inexcusable to ignore or remain silent in the face of the reality of the USSR and the other "socialist" countries.

Even more to the point, while still embracing socialism as "the only rational solution for the West," this could only be the case if it were "inseparable from individual liberties, democratic pluralism, and respect for the rights of minorities and dissidents." In any event, he continued,

> for Latin America, socialism is not on the agenda. Socialism is not a method of developing more rapidly, but a consequence of development. Socialism in underdeveloped countries, as the experience of our century demonstrates,

2 See my article "Victoria Ocampo's *Sur*" in *The New Criterion* for October 1988.

is rapidly transformed into state capitalism, generally controlled by a bureaucracy that—in the name of an idea—governs in a despotic, absolutist manner.

From here it was but a small step to openly condemning the Sandinista regime in Nicaragua as an effort to establish "a bureaucratic-military regime inspired by the Cuban model" in a now-famous speech at the Frankfurt Book Fair in 1984. That speech—which had repercussions throughout Western Europe and Latin America—did nothing more than state the obvious; nonetheless, since then, Paz has found himself accused of being a right-winger. His political and economic views are still somewhat to the left of center, but his liberal democratic convictions are no more in doubt than they ever were. Most revealingly, when asked to enumerate the obligation of Mexican writers to their country, he replied, "I do not believe that writers have specific obligations to their country. Their obligations are to the language—and to their consciences." Contrast that with the statement of Nicaraguan writer Claríbel Alegría in *Lives on the Line*: "if there is no place [in Central America] for 'pure art' and 'pure literature' today, then I say so much the worse for pure art and literature."

Mario Vargas Llosa is some twenty years younger than Paz. He belongs more properly to the generation of 1968, but has, evidently, separated himself from it. Unlike Paz, he was unreservedly enthusiastic about the Cuban revolution in its earlier days; conversely, he has moved further away from his original ideas. In the first volume of political essays published under the evocative title *Against Wind and Tide* (*Contra viento y marea*, 1986), he reproduces at the very beginning an article on Cuba which originally appeared in the early Sixties in French, as a way of charting the ideological distance he has since traveled.

The articles in *Against Wind and Tide* suggest a very gradual process of movement. The great watershed seems to have been his appointment by President Fernando Belaúnde Terry to a national commission to investigate the conduct of the Peruvian army after an encounter between it and the Shining Path guerrillas in the high Andes. The commission eventually absolved the army of charges of wanton abuse of human rights, and Vargas Llosa defended its findings in an article in *The New York Times Magazine*. Since then he has customarily been referred to as a "right-winger," a label which no longer bothers him.

Like Paz, Vargas Llosa claims to have been influenced by the conduct of Marxist regimes in practice; as he has said, "policies designed to correct injustices are significantly less effective than [those inspired by] liberal and democratic doctrines and ideas—that is to say, those who do not sacrifice freedom in the name of justice." Unlike Paz, however, he has actively embraced liberal economics, and recently ran for the presidency of Peru as an advocate of drastic reform along free-market lines.

Pablo Antonio Cuadra is the grand old man of Nicaraguan letters—one of the most highly regarded poets in Latin America. For some years he has also been the editor-in-chief of *La Prensa*, the voice of the Nicaraguan opposition under both the Somoza dictatorship and the Sandinista regime. A self-confessed Nicaraguan nationalist, Cuadra is also an outspoken defender of liberal values. As he told a radio interviewer recently, "I think a nation has a basic human right: the right to the truth." When asked "what do you think the news media law should be?", he replied, "I have been asked that question for 50 years. . . . The answer is very simple: The best news media law is the one that does not exist." As for the "situation of contemporary literature in Nicaragua," he replied,

> Our work is to publish someone else's works, particularly independent writers, and—in a way that could be described as negative—create the proper climate for true, apolitical literature. To strip literature of political influence is one way to restore its freedom.

Nicaragua, of course, is one country in which literature has recently been understood to have a concrete political purpose. As Cuadra's compatriot Claríbel Alegría—one of the Sandinistas' favorite literary figures—puts it, "I do not know a single Central American writer who is so careful of his literary image that he sidesteps political commitment at this crucial moment in our history, and were I to meet one, I would refuse to shake his hand." Though the Sandinistas were often praised in the foreign press for such cultural innovations as poetry workshops for the army and police (!), during their decade of rule political or anti-political writers had considerable difficulty getting published. As Cuadra told an Associated Press reporter two years ago, "Some of our best young poets are in exile—in Texas, in Venezuela." In *Lives on the Line* he adds an ironic observation: "several of my friends who flaunted their independence in front of the right-wing dictatorships have happily bent over backwards to all of the demands of the [Nicaraguan] revolutionary leaders."

All of that may change in Nicaragua now, as it has in Mexico, where a new generation of writers now has at least the opportunity to be heard. Significantly, there is now a South American edition of *Vuelta*, edited in Buenos Aires by the Uruguayan writer Danubio Torres Fierro, who spent a number of years as a political exile in Mexico, where he came under the influence of Paz and his circle.

Though not a novel, Jorge Edwards's book *Persona non grata* (1977) deserves mention in this context. Though primarily a writer, Edwards was for many years a career diplomat in the Chilean foreign service. Because of his socialist convictions, he was selected to be Allende's chargé d'affaires in Havana in the first months of 1971. A long-time sympathizer with the Cuban revolution, he had made short trips to the island in the past, and

even served on prize committees for Castro's state publishing house, Casa de las Américas. Nonetheless, the experience of living there and witnessing the regime's treatment of individual Cubans, particularly his writer friends, was a shattering experience. *Persona non grata* is a compelling memoir of his months in Cuba, and, with Milovan Djilas's *Conversations with Stalin*, ranks as a classic contribution to the literature of disillusionment. Significantly, Ariel Dorfman, who understandably did not like *Persona non grata*, could think of no greater insult to Edwards than to accuse him of treason to—of all places—Chile. Edwards remains a social democrat—closer in his views to Octavio Paz than to his friend Vargas Llosa— hugely admired by the democratic forces in Chile, whose man-of-letters laureate he has, perforce, become.

How successful will this tendency be? In large part, it depends upon two developments, one proceeding from abroad, the other at home. The death of socialism (or, rather, the death of the idea of socialism), particularly in Europe, has so far not made much impact upon Latin American intellectual life. Old habits die hard; so does the notion of the writer-as-militant. As Paz recently wrote, "Their grandfathers swore by St. Thomas and they swear by Marx, yet both have seen in reason a weapon in the service of Truth with a capital 'T,' which is the mission of intellectuals to defend. . . . Thus there has been perpetuated in our lands an intellectual tradition that has little respect for the opinion of others, that prefers ideas to reality, and intellectual systems to the critique of systems." It remains to be seen how long such a concept of intellectual citizenship can endure an ideological vacuum or a crisis of faith. Insofar as Marxism is concerned, one or the other (or both) are coming, whether or not the Latin American intellectuals are prepared for it.

It remains to be seen, also, what trends prevail in American intellectual life, particularly as they are reflected in the New York publishing world. Not to put too fine a point on the matter, the titles offered to American readers reflect to a disproportionate degree the ideological preferences of editors in the major book publishing houses, as opposed to either judgments of literary quality or the interest of readers. As a result, there now exists something of an artificial market for Latin American literature, one that encourages writers to produce work mainly with an eye to a public that will read them in translation. As the Mexican critic Enrique Krauze has shown in a controversial study of Carlos Fuentes, this threatens the authenticity of their work. It is easy to imagine a situation in which Latin American literature could exist in a kind of ideological cocoon for some years to come—or, perhaps, artificially maintained on a life-support system made up of, say, *The New York Times Book Review*, *Harper's* magazine, and Pantheon Books. It would constitute the literary equivalent of the current situation of higher education in the United States—a series of cultures scattered across a society which actually have little or nothing to

do with it. In short, if revolutionaries wielding machetes and spouting the clichés of liberation theology is what the American book-buying public is thought to want, it is hard to imagine they will not get it. At any rate, they may not be able to buy any other kind of Latin American literature at their local bookstore.

In the end, everything depends upon events within Latin America itself. If, for example, there is a new round of right-wing military governments, a new generation of leftist writers will certainly emerge in response, with or without the quasi-incentive of foreign translations. At the same time, if the region succeeds in joining the liberal economic revolution spreading in Eastern Europe, that will change the local environment in many important ways, including literacy, patterns of consumption, and, inevitably, the role of the writer in society.

If, however, the republics simply continue on their present course, avoiding either reform or revolution, but failing to hold their ground as viable economic entities, then Latin American writers may find themselves in the position of their counterparts in the Arab world, where themes of suicide, frustration, and death repeat themselves in endless (and monotonous) variation. In that event they would not constitute a serious threat to liberal society, but then, there would be little for them to threaten. One can only hope that the future, both for Latin America and for its republic of letters, holds out a more hopeful prospect.

December 1990

II. The Academy in the Age of Political Correctness

What Is at Stake in the "Battle of the Books"?

Christopher Ricks

A quarter of an hour, on matters of such moment and such complexity, is not long enough to substantiate an argument but it should permit of relating some convictions. The most that such a relating can hope for is that it manifest a readiness for argument unpursued. But the polemics of travesty may be avoided by proposing not *the* but *an* answer to the question "What is at stake in the 'Battle of the Books'?" My wish is to identify a prime consideration insufficiently admitted.

What follows is in three parts. First, one person's sense of what is usually and rightly held to be, not at stake exactly, but at issue. Second, my expressing an objection to what is probably the best recent commentary on all this, an objection to the rhetoric in which the argument has been conducted. And third, my questioning not of the rhetoric but of the terms of the argument, to make clear a fundamental reservation about any such solely professional conduct of the debate.

But first an acknowledgment of one strong and even perhaps agreed answer to the question of what is at issue. This, which is the link between my three points, is what it has always been: the limited possibility of disinterestedness. "Critics," wrote our greatest critic, "like all the rest of mankind, are very frequently misled by interest." To proceed as if there were every possibility of disinterestedness—despite what power is and always has been—would be to be a sentimental gull. To proceed as if there were no possibility of disinterestedness would be to be a cynical dog. In this, as in so much else, the words of William Empson might carry our

This paper was originally presented at a symposium organized by the Whitney Humanities Center at Yale University in April 1989 on the subject of "'Moral Education': The Humanities and the Question of Values in Education." The members of the panel were invited to address the question: "What is at stake in the 'Battle of the Books'?" Among the other speakers at the Yale symposium were Martha Nussbaum, Hilton Kramer, James Atlas, Catharine Stimpson, Benjamin Barber, Norman Birnbaum, and Alasdair MacIntyre.

conviction: Life involves maintaining oneself between contradictions that cannot be solved by analysis.

The particular contradictions have long been known. On the one hand, Dr. Johnson argues cogently in defense of "the privilege of established fame and prescriptive veneration"; but on the other hand, Johnson's other hand, there is his acknowledgment that "approbation, though long continued, may yet be only the approbation of prejudice or fashion." No one is ever going to be absolved from the necessity of distinguishing responsibly between that which is established because it has been found true and that which is found true because it has become established. Injustices have—cannot but have—occluded or excluded certain writers (though not only for reasons of color, gender, or class), but it is true too that there are writers, past and present, who are not "marginalized" but marginal.

For to this ancient siege of contraries there has been added in our day an exacerbated awareness that time, history, and institutions, being powers, have always been open to the abuses of power, and that it will forever suit people of every stripe to claim for what are social arrangements the status of the nature-given or the God-given—or, on the other foot, the guru-given:

> Nature and nature's laws lay hid in night,
> God said "Let Foucault be," and all was light.

> It could not be—the Devil bawling "Ho,
> Let Lacan be," restored the status quo.

So "relativism" rears its head, at once hydra and chimera. Criticism feels impelled to become meta-criticism, and duly corrugates itself, very like those nineteenth-century agonizers confronting the dreadful possibility that, if God is dead, all is permitted.

"Question authority," says the health-food T-shirt, making an exception of its own authority. "She doubts everything," says Barthes of Kristeva, doubting everything except the desirability of doubting everything. Given the strains, it is not surprising that so much recent criticism has substituted for the stringency of skepticism the complacency of Pyrrhonism.

But an instance of the problem and of the difficulty. There is a crucial variant in the wording of the prefatory note to Mary Douglas's *Rules and Meanings*:

> Each person confronted with a system of ends and means (not necessarily a tidy and coherent system) seems to face the order of nature, objective and independent of human wishes. But the moral order and the knowledge which sustains it are created by social conventions. If their man-made origins were not hidden, they would be stripped of some of their authority.

The last two sentences found themselves quoted on the book's jacket—with one small alternation for drama and sales. "If their man-made origins were not hidden, they would be stripped of much of their authority." But if "some" can be silently upped to "much," why cannot "much" be upped to "all"? What is at stake is both the judgment of authority and the authority of judgment, and to say—*tout court*—that knowledge is created by social conventions is to leave no safeguard against the further escalation, after "some" becomes "much," to this: If their man-made origins were not hidden, they would be stripped of all of their authority.

I now take as an authority on these matters not a straw man but a respected figure, from a respected university, writing recently in a respected journal: John Guillory, and his 1987 essay in *ELH* (*English Literary History*) on "Canonical and Non-Canonical: A Critique of the Current Debate." If Guillory is not *representative* exactly, that is mostly because he has taken unusual trouble in the prosecution of these arguments. He is persuasive in his contention that any discussion of "the canon" has to be placed within the largest context, "nothing less than the systematic regulation of reading and writing," and that therefore literacy itself must figure saliently. But I must put an objection to his highly professional essay, to suggest why it and its siblings should be resisted. In a word, its words—and I don't mean jargon but rhetoric, a rhetoric both entirely representative of the professionalized "current debate" and manifesting an insufficient effort at disinterestedness.

For there is a betraying discrepancy between the essay's impetus and its rhetoric. Its impetus, explicitly and not unexpectedly, is to repudiate anybody who might find things, in its indispensable word, "unproblematic"; and from its first paragraph on, it endorses the obligatory word "demystifying" and deplores anything "mystified." But the trouble is that this bracing program is everywhere couched in rhetoric of the massively unproblematic.

Not since Dr. F. R. Leavis (no talk of "problematics" from him) tuned his proems ("It takes no unusual sensitivity to see that . . ." "It would be of no use to try to argue with anyone who contended that . . .")—not since Leavis has a reader been pressed by so ubiquitously indubitable a rhetoric, about as problematic (except morally) as *peine forte et dure*. "It would be pointless to . . ."; "all too easy to demonstrate . . ." (and "only too easy to demonstrate"); "It is certainly the case that . . ."; "it is unquestionably the case that . . ."; "this is certainly the case . . ."; "It would not be difficult to prove that this practice of writing is founded on nothing but . . .": these are not from several books by Leavis but from the one essay by Guillory. "Surely," "doubtless," "no doubt," "undoubtedly," "must certainly," "quite evident" . . . "In fact" must make for good old unproblematics, I'd have thought, and Guillory deploys it all the time (and compounds it: "in fact,

as is well known . . ."; "the very fact that . . ."; "This fact is made quite obvious . . ."; "This fact is quite apparent . . ."). And so he does (of course) with "of course," and indeed with "indeed." Whenever the ranks of his argument are about to waver, he rallies them with "only" (not in this usage a word compatible with authentic problematics): "can only be seen through . . ."; "can only be conceived as . . ."; "can only be posed when . . ."; "can only be recovered in relation to . . ."; "Only as such can . . ."; "One need only . . ."; "Only in this way can one explain . . ."; "One had only to place . . ."; "can only be defined . . ."; "It is only to remark the obvious to point out. . . ." And there is the related (and thrice occurring) "nothing other than. . . ." All these, plus the old-fashioned browbeatings: "it would not be inaccurate to say . . ."; "It is important to remember"; "It is worth emphasizing that. . . ." (That's for us to say, as I am often obliged to write in the margins of the young.) So that when in the penultimate sentence of Guillory's essay I twice read the acclamatory noun "problematic," I ask myself whether, even apart from the dubiety of so prostrating oneself before the problematic, there *could* be an incitement to a critique of a genuine "problematic" constituted of such a rhetoric.

Perhaps this would not much matter if the rhetoric were Guillory's own and only his (an *ad hominem* argument, then?); but no, this is the professionally widespread and collusive rhetoric of a hermeneutics of suspicion which never suspects itself of being open to contamination. What is proclaimed as "the delegitimation of the canon" stands in need of a much greater vigilance about the illegitimacies of its own rhetoric. By their rhetoric shall ye know them. The famous composer refuses, for political reasons, the Legion of Honor. "Ah, but all his music accepts it." The authority of the canonical institution may be, as they say, "refused"; ah, but all their rhetoric accepts it. Authoritarianism, shown the door, sidles back in through the window. The enveloping pre-emption is sacrosanct, despite the argument's urging that nothing be so.

For by now, such a word as "demystification" has become no more exempt from mystificatory manipulation than anything else. So, for instance, Geoffrey Hartman has hearteningly turned to protect the two things closest to his conscience against the very possibility that they might valuably or honorably be demystified. In Wordsworth's great poetry there is "something which cannot be demystified," a "quality . . . which resists overconsciousness and demystification." And in "the memorial books of Polish Jewry" there is not historiography, the fictive, but history, the real. Such *de*-demystification is to be welcomed, and it will certainly be assisted, at the opposite extreme from Hartman's fastidiousness, by the vulgar success of this exploited and exploitative word, a vacant victory evident in the farcical inertia of phrasing with which *The New York Times* announced last month that the sex-shop at Stanford hopes "to demystify condoms."

"The defense of the non-canonical may justly take as its epigraph," Guillory pre-emptively strikingly says, "Walter Benjamin's remark that 'there is no document of civilization which is not at the same time a document of barbarism.'" It would be one sign of disinterestedness if those quoting, yet once more, this remark of Benjamin's would be as attentive to the civilization half of it as to the barbarism half; but no, it is from this wing ideologically correct to invoke barbarism but not to invoke civilization. (Guillory, when he approaches "the 'ideals of Western civilization,'" feels obliged to add "whatever that means.")

Yet even more central professionally than the rhetoric of the critique is the matter of its terms. The profession of the pedagogue is an honorable one, but the honor of any profession consists in its not arrogating to itself more than a profession should claim. In being a profession, it inevitably suffers indurations and partialities. Doctors are not only more but less sensitive to suffering than others; judges, to justice; journalists, to truth; soldiers, to slaughter. A profession ceases to be honorable when it makes too little effort to minimize such losses and, complementarily, when it fails to acknowledge them disinterestedly. Guillory's essay is entirely and explicitly bent upon the classroom, upon pedagogic practice, upon "the whole enunciative apparatus of pedagogy." Nothing intrinsically wrong with that, provided it is imaginatively granted that this is because of pedagogy's intrinsic interests. The word "curriculum" is a faithful flat word: it declares an interest. But "canon" does not. For "canon" claims, with insinuating misrepresentation, the scriptures' especial authority (which yet did not claim a monopoly of worthy books), and moreover "canon" at once makes a more than professional claim and yet is an obdurately professional word. Those outside the profession, with good cause too, do not conceive of books as divided into the "canonical and non-canonical"; and the organic formation which books constitute would be described by them not as a canon but as literature. See T. S. Eliot's consummate study "Was There a Scottish Literature?"

Guillory, like the profession generally, now makes much of, and italicizes, the word *exclusion*. If we in turn ask what or who gets excluded, "marginalized," or "disempowered" by the terms of the debate when it is conducted with such solely professional aims, with so narrowed a notion of the disinterested (for professions should acknowledge that they are interested parties), the answer is, first and not surprisingly, all *writing* other than that conducted under the auspices of pedagogy. The confidence that there is no reading outside the aegis of the university is misplaced, and it distorts the debate, as if no books were ever—whether justly or unjustly— alive in a literature unless they were part of a curriculum. But the marginalizing of creative writers (or, as they used better to be known, writers) to the point of their exclusion is an even more unworthy hubris of our profession.

Nowhere in such a "critique of the current debate" is any attention paid to the creation of, or the creators of, works of literature. We hear repeatedly and balefully of "a hegemonic tradition," "hegemonic values," "a hegemonic bourgeoisie," "hegemonic paradigms," and "a hegemonic sociolect," but there could not be a more unremitting hegemony than that which is so unmisgivingly circumscribing what is called "the production of texts" to something in which writers apparently play no part.

David Bromwich pounced recently on some betraying words in the 1989 ACLS manifesto "Speaking for the Humanities": "Professionalism makes thought possible. . . ." The previous sentence had urged that we "assert the value not just of specialization but of professionalization." But the value of the profession will be in direct proportion to its rising above *folie de grandeur*. The achievements of art put up some valuable resistance to the very words "profession" and "professional"; it is, for instance, clearer that Stephen King is a *professional* writer than that Samuel Beckett is. David Bromwich seems to me to despair too promptly, and even too lightheartedly, when he says that "like any other faith, professionalism cannot be argued with." I believe that all faiths can and should be argued with; the chances of persuading are not high, but nowhere else are they so either. Giving reasons for the faith that is in one: such was Hazlitt's un-professionalized conviction.

No one is going to deny that a great many books live, come back to life, and are imaginatively attended to because of their presence in the curricula. But the most important and enduring rediscovery or re-invention of a book or of a writer comes when a subsequent creator is inspired by it to an otherwise inexplicable newness of creative apprehension. John Skelton became again a living presence as a poet not because professors and professionals decided that he had been "marginalized" but because Robert Graves and W. H. Auden showed, in very different ways, what possibilities of new life there were in the old dog yet. The poignant beauty of William Barnes would be unattended to were it not for more than the praises, the creations, of Hardy and Larkin, and Meredith's *Modern Love* if it were not for what Robert Lowell did with and for its mastery of marital misery in his sonnet sequence *The Dolphin*. Ivy Compton-Burnett essentially did more even for so acknowledged a writer as Jane Austen than even Mary Lascelles did.

Such new creation does not lend itself to an attempt such as Guillory's "to theorize in a new way the question of the canon," but it raises a question of principle, and one which is professionally urgent: that an honorable profession be one which does not vaunt. The crucial constituting of what is tendentiously called the canon is effected not by academics and critics but by creative writers (the obscuring of the distinction having therefore been for some time a professional or trade-union necessity for professors), and the crux is the conviction that works of literature must

live, not in the formation of the cunning canon or the candid curriculum, but in their fecundating of later works of literature.

But getting recognition for this truth will not be easy, especially at a time when the profession understandably closes ranks against its external enemies. Hubris harmonizes with whistling to keep our courage up. It is a pity that Harold Bloom, who genuinely loves literature, has countenanced for his latest book this professional aggrandizement: "Self-styled the 'Yiddisher Doctor Johnson,' [Bloom's] productivity rivals that of the good doctor" (the good doctor, smiled down upon, like the "little man" who reads the electricity meter)—but "Bloom, unlike Johnson, needs no Boswell." The author of "The Vanity of Human Wishes" and *Rasselas* did not *need* Boswell. But this is the pass to which things have come, the insecure overclaim of a profession which feels itself, and is in some ways, undervalued. The most signal thing about the fourteen of us speaking on the humanities here today is this: that because of the misguided assumption that a professional occasion should be peopled exclusively by professionals, not one of us is a writer, an artist.

September 1989

Studying the Arts and the Humanities: What Can Be Done?

Hilton Kramer

For those who have followed the problem with the attention it demands, both the nature and the scale of the crisis that has overtaken the study of the arts and the humanities in our universities have now been made vividly and painfully manifest. The subject has become a matter of (albeit muddled) debate in the media, it has won the attention of government agencies, it has produced some best-selling books, and—it is my impression, anyway—it has caused a more acute feeling of anxiety, at times amounting to panic, among the educated parents of high-school and college-age students than anything that has occurred in American life since the Vietnam war. (It is this widespread feeling of panic among educated parents that accounts, I believe, for the huge sales of such books as *The Closing of the American Mind* and *Cultural Literacy*.) Not even the fears generated by the onset of the sexual revolution of the Sixties had quite this effect on American middle-class society, for—correctly or not—the hazards of sexual liberation were generally not seen to constitute an impediment to either a successful career or a good life. Just the contrary, in fact—except, of course, among the diehards who still refused to give up the idea that morals should somehow play a crucial role in such matters. On the campus itself, this crisis over what is being taught in the name of the arts and the humanities has likewise caused a greater degree of demoralization and conflict among faculty members than any development since the Vietnam war, and among gifted students it has probably already resulted in a greater number of defections from the professional study of the arts and the humanities than the war itself caused. This issue is such that it has now raised a fundamental question as to whether the universities in this country will have any but a negative, disabling, and destructive role to play in the formation of the intellectual life—and hence

This article is based on a lecture given at the 92nd Street YMHA in New York in a program, jointly sponsored by *The New Criterion*, called "The Humanities and Education Today: A New Barbarism?" The other speaker of the evening was Lynne V. Cheney, Chairman of the National Endowment for the Humanities.

the social character—of the generation now entering higher education.

In the report *Humanities in America* recently issued by Lynne V. Cheney, Chairman of the National Endowment for the Humanities in the second Reagan administration, Professor Walter Jackson Bate of Harvard University is quoted as having declared in 1982 that the humanities were then, in his view, "plunging into their worst state of crisis since the modern university was formed a century ago." Yet the situation is far worse today—and not least, by the way, at Harvard—than it was seven years ago, and going downhill at an ever increasing rate of speed. One important sign of this rapid deterioration can be seen in the extent to which the study of the arts and the humanities is no longer distinguishable from the study of the social sciences proper, which nowadays bear little, if any, relation to the spirit of scientific inquiry and are more than ever an openly acknowledged program of political indoctrination. Among the many current attacks on the arts and the humanities in the American academy, none in fact is more conspicuous or successful than the assault that has been mounted on these fields from the politicized social sciences. That the social sciences have met with so little resistance in their imperious drive to annex the arts and the humanities to their own domain is now, more often than not, the most distinguishing feature of entire disciplines—literary study, art history, history itself—that were formerly so fiercely jealous of their intellectual autonomy and so rigorous in defending it.

So advanced and widespread indeed is this surrender of the arts and the humanities to the social sciences—and to the radical political agenda of the social sciences—that we now have reason, I believe, to look upon the social sciences as a kind of academic Gulag to which, on one campus after another and in one learned journal after another, the arts and the humanities have been sent for what, in other parts of the world, it is customary to describe as "re-education" or "rehabilitation"—in other words, brainwashing. There are, to be sure, certain pockets of resistance to this runaway trend, but by and large what we are seeing in the academy in America is a wholesale capitulation to an idea and an ideology that has as its goal the complete destruction of the arts and the humanities as independent and autonomous fields of study which derive their standards, their methods, and their vision from the artistic and humanistic achievements that called these intellectual disciplines into existence in the first place.

It is not my purpose here, however, to provide another detailed description of the melancholy fate that has befallen the arts and the humanities in academic life and in the larger cultural and intellectual world outside the academy. Most of us have already heard enough and read enough about the horrors that are being visited upon these critical and scholarly disciplines as a matter of academic routine, and every day

the newspapers and magazines bring fresh news from anguished friends and colleagues who cry out to us for help in warding off the still greater horrors that they see in store for them. The courses that now substitute Hollywood movies for classic texts, that scrap the study of Western civilization for a whole variety of politicized ethnic, racial, and gender studies—that systematically liquidate the very concept of art and scholarship in favor of a so-called materialist, which is to say economic and political, analysis of the conditions of their production—news of these developments reaches us every day in accelerating numbers, and all too often we follow these news reports with the same kind of sinking feeling, and feelings of helplessness, that we experience in following the news of devastating hurricanes and volcanic eruptions. We know very well what kind of destruction follows in the wake of these disasters, whether they occur at celebrated institutions like Harvard and Yale and Princeton and Columbia and Stanford and Duke or at many other less celebrated schools where the corpses of the defeated are buried without notice or regret.

Describing these ghastly developments is important, for with any plague that threatens to destroy something vital to our existence our first obligation is to gather as much intelligence about it as we can and issue information about the means of surviving it. But speaking for myself, anyway, and for some of my colleagues both at *The New Criterion* and elsewhere—for we are not *entirely* alone in this struggle—I think the time has come to move the discussion to another stage—the stage at which we must come to grips with the question of what can be done to reverse this spirit-destroying menace to the life of the mind itself—to the life of the mind as we in the West have traditionally understood it.

What, then, can be done?

I want to try to answer this question—or at least suggest the direction in which the answers are, as I think, to be found—by dividing the question into two parts: into what must, for obvious reasons, be called *politics*, and what, for reasons that might not be so obvious or agreeable to everyone, must in my view be called *art*.

At least as a strategy for intellectual combat, if not in other respects, the easier part of the question to discuss is politics. We all know—and certainly our enemies know—that the assault on the study of the arts and the humanities we are discussing is, above all, a political assault—an attempt on the part of the radical Left first to discredit and then to do away with what in our most exalted artistic and humanistic traditions may be seen to offer resistance, either directly or by implication, to the total politicization of culture and life. We know the assault is at bottom political, no matter under what other temporary banners the assault may at times be mounted and regardless of what unexceptionable virtues it may at times be mounted in the name of.

We know it is political, and if we have any sense of what is involved in the assault itself, we will also know that political means must be found to struggle against the goals that our enemies wish to see achieved. No one, I think, can accuse me of entering into the discussion of this question without a keen appreciation of its political dimension. My own enemies—whose attacks upon me, by the way, I cherish, if only because they confirm my conviction that I am heading in the right direction—have been vocal in underscoring my political approach to the question, and on this matter, anyway, they have not always been wrong. Yet I want to say here that I do *not* believe, and have never believed, that the real solution to the crisis we are facing, which, I repeat, *is* a political crisis, is to be found in politics alone, or even perhaps in politics primarily. The defense of what I wish to call *art*—a word I shall use here to represent what it is that the creators of high culture in every field achieve in all the arts and the humanities—the defense of what I am calling art can never be successful on any terms worth fighting for if it is completely and irreversibly subordinated to politics, even our own politics.

Art, as I wish to understand it—and this includes scholarship, too—must be defended and pursued and relished not for any political program it might be thought to serve but for what it *is*, in and of itself, as a mode of knowledge, as a source of spiritual and intellectual enlightenment, as a special form of pleasure and moral elevation, and as a spur to the highest reaches of human aspiration. Art must be savored and preserved and transmitted as the very medium in which our civilization either lives and prospers—prospers intellectually and spiritually—or withers and dies. To subordinate art to politics—even, as I say, to *our* politics—is not only to diminish its power to shape our civilization at its highest levels of aspiration but to condemn it to a role that amounts to little more than social engineering.

In the situation that we are facing today in the study of the arts and the humanities, the temptation to emulate our enemies in subordinating art to politics will inevitably be great, because such a course offers—or at least gives us the illusion of offering—the shortest route to short-term victories. But if it is our civilization that we believe to be at stake in this struggle, then this temptation to grasp at whatever short-term victories might be achieved must be resisted in favor of the longer-term objectives. Otherwise, I believe we shall merely find ourselves collaborating with our enemies on the destruction of the very thing we have set out to defend and preserve. Art must be defended and pursued and preserved for what it is rather than as a political instrument in the service of some other cause. The defense and advancement of art cannot be deferred to some hypothetical future when, as we might prefer to believe, the struggle will be less arduous and the conditions more propitious. The defense of art must not, in other words, be looked upon as a luxury of civilization—to be in-

dulged in and supported when all else is serene and unchallenged—but as the very essence of our civilization.

If we approach the defense of art from this perspective, then the really compelling question at the moment is: How do we begin to do it? And in dealing with this very large question, we must be prepared to argue even with our friends, for it is my impression that there is no unanimity of outlook on this issue. The most we can hope for is that something useful and effective will emerge from an effort at argument and dialogue.

I want, in any case, to direct my own suggestions to the fields I know best—the study of the arts and the humanities in college and university education; and the field of criticism outside the colleges and universities. About the first, the study of the arts and the humanities in the colleges and universities, I want to begin with a modest but radical practical proposal: that we get the movies out of the liberal-arts classroom. We've simply got to throw them out. There is no good reason for the movies to be there, and there is every reason to get rid of them. They not only take up too much time, but the very process of according them serious attention sullies the pedagogical goals they are ostensibly employed to serve. The students are in class to read, write, learn, and think, and the movies are an impediment to that process. Students are going to go to the movies anyway, and to bring them into the classroom—either as objects of study or as aids to study—is to blur and destroy precisely the kind of distinction—the distinction between high culture and popular culture—that it is now one of the functions of the sound liberal education to give our students.

Following from this, I believe that all forms of popular culture should be banned from courses in the arts and the humanities. Typically today students arrive on college campuses already besotted with the trash of popular culture, and it must now be one of the goals of a sound liberal education to wean them away from it—or, if that is asking to much (I don't think it is, but if that really is too much), then we can at least hope to educate our students to perceive what the differences are between high culture and the trash that impinges on so much of their leisure time. The study of popular culture may legitimately belong to the realm of the social sciences—that, at least, can be argued—but it has no legitimate place in the arts and the humanities. This field of study—the study of popular culture—is a curse we have inherited from Marxist-oriented sociology, where it began, anyway, as a means of studying evidence of the way capitalist society corrupted its members. The Marxists might not even be wrong about that—that is not the question I wish to pursue at the moment. But for the arts and the humanities to surrender to this concept—a social-science concept—of our civilization is a guarantee of failure for what it is the study of the arts and the humanities ought to give our students.

It follows from this, moreover, that we must make an effort—though it

is uphill work to do so—to rescue the study of the arts and the humanities from the baleful influence that the social sciences themselves continue to wield with such devastating results. This effort to draw the line between high culture and the social sciences will be, if anything, even more difficult to achieve than any attempt to expel the movies and other forms of popular culture from liberal education. For many critics that we admire, from Taine and Arnold in the nineteenth century to Edmund Wilson and Lionel Trilling in ours, have done important work—work that is central to our understanding of modern culture—by introducing the ideas drawn from the social sciences into literary study. We have all learned much from them—I certainly have—and they often offer us a kind of intelligence about life, if not always about literature, we would not want to do without. Yet I think we now stand in such a radically different relation to our artistic and humanistic traditions than these critics did—our students, and probably much of our faculty, too, if the truth be told, are now so distant from and so ignorant of the central artistic and humanistic works that constitute those traditions—that I believe we must revise our ideas about the place to be accorded the social and economic history of the arts and the humanities, and concentrate a far greater emphasis on a study of the works themselves. The truth that must now be recognized, I believe, is that the social history of art can mean nothing *but* politics to minds that are basically ignorant about what art is in itself, and what it isn't. It is the tendency of the social sciences to reduce the arts and the humanities to a level of materialist culture where distinctions between high art and popular culture and between art and politics are meaningless—and at that level what art is itself can no longer be discussed, for it is seen to consist of nothing but the sum of its social and economic attributes.

To speak specifically of the two fields I am myself closest to—the study of art history, and the study of literature—the approach I am advocating will entail a return to the very disciplines that have been so much under attack in recent years—so much under attack that in many of our leading academic institutions they have all but disappeared. In art history, it means the revival of training in connoisseurship—the close, comparative study of art objects with a view to determining their relative levels of aesthetic quality. This is a field in which our country could once boast of great achievements. From Bernard Berenson to Alfred Barr to Sydney Freedberg, we have indeed produced some of the greatest connoisseurs of Western art the world has seen, and their achievements and influence have greatly enriched our institutions and our lives—enriched them, I hasten to add, with aesthetic intelligence of the highest order. But these great names represent a dying intellectual enterprise. It isn't dead yet, but the prognosis is grave. In this respect, Sydney Freedberg's departure from Harvard earlier in this decade was for many of us a symbolic event, for it marked something more than the exit of a single individual from the institution

that had virtually created the concept of connoisseurship in American cultural life. It represented the collapse of a tradition and the takeover of that institution by minds determined to transform the study of art into a form of social science. Which meant nothing less than the annexation of art history to the political service of the radical Left.

In the study of literature, the situation is equally grim—perhaps even grimmer, in some respects—and in this field there must also be a revival of what constituted, I believe, the closest analogue we have had in literary study to the tradition of connoisseurship in the visual arts, the New Criticism. It used to be said of the New Criticism—it was a favorite war cry of the Marxists—that in the emphasis it placed on studying the internal structure and meaning of the literary work it woefully neglected the role played by history in the formation of literary style. From my own studies with Allen Tate, Randall Jarrell, and others, I know this not to have been true, and it would be nonsense to claim that Southern writers like Tate or Robert Penn Warren, who themselves wrote nonfiction historical prose works early in their careers, were insufficiently aware of the role of history in the creation of great literature. The distinction that the New Criticism insisted upon—and which I believe the future integrity of literary study will depend upon—is the distinction that must always be made between text and context, between an understanding of the poem the poet creates (and I mean a line by line, word by word understanding) and an understanding of the world in which the poem is created and has its career. Without a revival of something like the emphasis, the priority, that the New Criticism placed on the analysis of the individual literary work and on works of the highest literary distinction, the study of literature in our universities can be little more than a study of rumor, reputation, and ideology. Without that emphasis on understanding the internal working of great literature, its content—including its moral content—can only be taken on faith; and in the present context of literary study, that faith will inevitably be a political faith. It was for this reason that Brooks and Warren called their great textbook *Understanding Poetry*, for without a close, studied understanding of what the poem is and says, what is it that we can pretend we have understood about it? The New Criticism taught us to read the great works of our time and of all time, and in literary study there is simply no alternative to it.

In turning to the field of criticism of the arts and the humanities outside the classroom, however, the situation we face is even more complex though no less dismal. For there is first of all so little that can legitimately be called criticism. Instead there is an avalanche of political discourse masquerading as criticism of the arts and the humanities. This being the case, I believe that criticism must be obliged to fight a two-front war—to advance the interest of connoisseurship and quality in its analysis of par-

ticular artists, writers, and scholars, and *also* to engage in whatever critical combat may be required to set the record straight about the way politics has been allowed to distort artistic judgment and destroy whole areas of intellectual inquiry. Once again, I am not suggesting that this problem of political discourse masquerading as serious criticism will be solved by substituting our politics for those of our enemies on the Left. Our task, wherever it may be possible, is to try to expel the politicization of the arts and the humanities in order to allow them enough free intellectual air in which to breathe and grow. But to the extent that our own criticism must perforce be a political criticism, too, we need to be acutely conscious of the fact it is not by political means alone, or even primarily, that the recovery of the arts and the humanities in our society will be achieved. Politics *is* the problem, but it is only *in part* the solution.

February 1989

Back to the Sixties with Spin Doctor Graff

James W. Tuttleton

I like to think I have a certain advantage as a teacher of literature because when I was growing up I disliked and feared books.

—Gerald Graff

The profession of literary studies in the university has become so risible a subject in newspaper and magazine articles that tremors are beginning to be felt in the academy. What, professors want to know, is going wrong? It does no good to tell them that they have corrupted the rich curriculum of literature in English into a mind-numbing, monotonous replication of the same old left-wing ideological harangue—the race-class-gender victimization thing. And it is pointless to tell them that their preoccupation with the jargon of incomprehensible theory is driving students away from literature classes. Allan Bloom in *The Closing of the American Mind: How Higher Education Has Failed Democracy and Impoverished the Souls of Today's Students* (1987), Dinesh D'Souza in *Illiberal Education: The Politics of Race and Sex on Campus* (1991), and Roger Kimball in *Tenured Radicals: How Politics Has Corrupted Our Higher Education* (1990) took the problem seriously, suggested various remedies, and—in the critical quarterlies and at literary conventions—were savaged for their pains.

However, these books had the effect of clarifying a wide range of disturbing phenomena about higher education. And out of their work has emerged a general consensus, which goes something like this: *"Nothing can or will change in the academy in the near future. Those within the academy who might have acted to reintroduce reason into the management of the curriculum—presidents, chancellors, and deans—have been, on the whole, impercipient, pusillanimous, and mum: unwilling, for whatever reason, to risk their place or popularity with the radicals among the professoriate. Many faculty members in law and sociology appear to have been infected with the virus. Professors of the hard sciences, medicine, and business haven't been, but they seem to want little to do with the whole issue, as they see humanists as wacko spokespeople for NOW, Queer Nation, the transcendent superiority of Third World*

ways, or the wisdom of 'Dr. Ruth.' Since the wackos get nasty at the first sign of any disagreement, cultivate your own garden but don't, under the present circumstances, get drawn into the Lit-Crit Follies."

The attitude I am describing is not resignation, even though the Clinton administration promises to radicalize the national endowments and other institutions that have heretofore supported genuine literary studies. No, it is now widely believed that—since the university is in the hands of the Sixties radicals, who have attained senior professorships and risen to institutional power—a generation or more will have to pass before the aims and purposes of a genuine liberal education can be reasserted and achieved. As lit-profs are a national laughingstock, the only proper response is to ignore the freaks or, if necessary, simply give a straight-faced description of what they are saying and doing. No exaggeration for satiric effect is necessary.

If lit-crit professors, like Rodney Dangerfield, don't get no respect, a few of them are sentient enough to want to know why. Enter Gerald Graff, George M. Pullman Professor of English and Education at the University of Chicago. He has appointed himself the oleaginous and ingratiating intermediary between the professorial left wing and those (whether within or without the university) who think in traditional terms about the aims of education. The subtitle of his new book—*Beyond the Culture Wars: How Teaching the Conflicts Can Revitalize American Education*—conveys his thesis in a nutshell.[1] If we have differences about what constitutes the canon, a work of literature, or the meaning of a text, let's make those differences the basis for a curriculum. Let's stage an argument about our differences in the presence of the students.

I shall return to this thesis and to its implications for higher education in a moment. First, it seems useful to reflect on Graff's rhetoric and implied audience. It would appear that at least some of his remarks are addressed to Outsiders (parents, politicians, the curious reading public) who want to know what the culture wars inside the university are all about. For them, he has a simple unctuous message: Things in the university are not as bad as you have seen in the newspapers and magazines. The "well-publicized horror stories about intolerant political correctness on campus" are really exaggerations. There aren't really any left-wing totalitarians in the university. And if there seem to be, well, heck, it's because complex intellectual matters on campus get oversimplified in the popular press. "A doctrinaire assault on 'dead white males' can be easily summarized in a column inch or two, whereas it would take many pages to describe intellectual movements that are complex, diverse, and rife with

1 *Beyond the Culture Wars: How Teaching the Conflicts Can Revitalize American Education*, by Gerald Graff (Norton, 1993).

internal conflicts." What we find in the press are therefore "glib falsifications." Graff's message to uninitiated Outsiders: "the critics have not been telling the truth."

It is part of the slick quality of this book that Professor Graff undertakes to persuade Outsiders that, really, it's all a misunderstanding and is, in fact, the academics' fault:

> Academics have given journalists and others little help in understanding the more difficult forms of academic work. As this work has become increasingly complex and as it increasingly challenges conventionally accepted forms of thinking, the university acquires an obligation to do a more effective job of popularization.

It's really, don't you see, simply a matter of poor public relations, which would be managed better if only academics wrote more helpful books like *Beyond the Culture Wars*. To an Insider, one within the university, Graff's work will be seen as pathetic pleading, and the tone is that of a prolonged whine. *These cultural arguments are too complex for you Outsiders . . . we're not that bad . . . why can't you respect us?* Graff would have the Outsiders "stop listening to those who tell us that controversy is a symptom of barbarism and that education was better in the past. . . ."

Graff says that those who complain of left-wing totalitarians in the university aren't even academics, so what can they really know about the university situation? George Will, a persistent critic of higher education today, is really just a newspaperman who has never sat in a faculty meeting and never debated in committee what should go into a syllabus. Lynne Cheney and William Bennett are or were, well, fronts for the government. Roger Kimball is merely a journal editor. And Dinesh D'Souza *only graduated* a couple of years ago—what can he, or any of them for that matter, know of grave faculty deliberations? In fact, Graff would have the Outsider believe that *Tenured Radicals* and *Illiberal Education* reflect a "polarity" between "intellectuals and nonintellectuals, or between those who have been socialized into the intellectual community and those who have not and are not sure they want to be." In descending to this *ad hominem* argument, Graff wants Outsiders to believe that the criticism against university radicalism leveled in these books is the result of anti-intellectualism, invidiousness, snobbishness, and social condescension.

But of course Outsiders are not fools. They know that this stuff about the culture wars comes directly from faculty members who are protesting coercion by the race-class-gender totalitarians who control the institution. Graff does not confront at length Insiders like Allan Bloom in *The Closing of the American Mind*, E. D. Hirsch in *Cultural Literacy*, or Robert Alter in *The Pleasures of Reading in an Ideological Age*. On the whole, his tactic is to call conservative academics ignorant or to nitpick with them over minor

matters. A literalist when he wants to be, Graff gives pages to *proving* that Alice Walker's *The Color Purple* has not bumped Shakespeare from the reading lists. But of course the real issue, of which *Purple* is the transient symbol, is busting the canon with second-rate works for the sake of making a political argument on behalf of some aggrieved minority. In any case, Graff complains to Outsiders, if *Purple* is in the curriculum, it's usually there as an add-on. But of course, as Insiders know, in any tight fifteen-week term, add-on reading can be introduced only if something canonical is dropped.

The most offensive of Graff's tactics is to say that traditional professors, like his sometime colleague at Northwestern, Joseph Epstein, don't know what they're talking about.

> It would be tedious to try to document all the attacks on politically oriented literary theories and approaches that could not conceivably be based on any firsthand knowledge of their subject. Attacks on deconstruction, for example, have come routinely from writers who have never read the work of Jacques Derrida and Paul de Man and haven't a clue as to what deconstruction is about. (The determined anti-PC warrior is not deterred by the knowledge that he has no clue to what something is about; after acknowledging that he finds Derrida incomprehensible, Joseph Epstein proceeds to ridicule deconstruction for saying, supposedly, "that literature [is] itself inherently false, corrupt, in need of destruction.")

In defense of Epstein, it should be said that deconstructionism *is* at times incomprehensible—for at least three reasons. First, Derrida's whole method stresses the indeterminacy of meaning in language, and those gaps, ruptures, and fissures in discourse that complicate univocal meaning. I recently asked Derrida about a course he was teaching in my department. Its subject, he would only say, was "Secrets." Applied, his method deals with revealing the secrets of the text. That which is hidden and concealed, that which rhetorical analysis can unmask, is his subject. But, second, Derrida as a rhetorician is in the business of *creating* linguistic complications. It is my impression that he would not be caught dead making an unequivocal statement. Consequently, his prose style puts darkening pressures on the capacity of language to communicate; it "em[bed]s [see]crets" in his prose for the acolyte to find. Yet the result is that sometimes not even his acolytes understand him. And we must add a third point. No longer is Derrida in control of the meaning of deconstruction in the American university. So many people are saying so many contradictory things in the name of deconstructionism that Derrida has become alarmed at the lit-crit crowd. In a recent remark in Gary A. Olson's *(Inter)views: Cross-Disciplinary Perspectives On Rhetoric and Literacy,*

Derrida comes close to disavowing his literary followers for corrupting his method. Very possibly there is somebody out there, writing under the banner of deconstruction, who really thinks that "literature is itself inherently false, corrupt, in need of destruction." Epstein can hardly be blamed if even some of Derrida's followers find him incomprehensible or misinterpret him. The fact is that English departments are now full of people who hate literature and regard it as a privileged instrument of class oppression, racial discrimination, and sexual tyranny.

Yet, in fact, Derrida and de Man have been read *quite closely* and intelligently by a number of Insider critics who are indeed philosophically and intellectually equipped to understand deconstructionism, despite the sometimes "barbarous, ideologically loaded jargon" that Graff defends as "just another critical vocabulary" with its own valuable "shorthand." In a plea for sympathy from the Outsider, Graff remarks that "even the most clearly written criticism will be gibberish to people who have not been socialized into the literary or intellectual community." But, as one Insider who has read a great deal of this material—in connection with my graduate course in the history of literary criticism—I can say that much of what is published in books and quarterlies *is* just gibberish. And the claim that Outsiders and traditionalist Insiders like Professor Epstein cannot understand it because of its gnostic difficulty is intellectual snobbishness at its worst.[2]

I shall pass over the very skimpy personal parts of this book—sections that retail Graff's growing up as a Jewish boy in a tough mixed neighborhood in Chicago, where he got beat up; his early aversion to books; his preference for popular culture over high culture; and his gradual discovery that books have something to say. None of this is of any importance except as a way to build up Outsider sympathy for Graff as just a regular guy who wants to be a peacemaker between contending departmental factions and has figured out a way to do it.

How will he do it? How does *Beyond the Culture Wars* propose to create an "intellectual community" where there is now departmental wrangling? Graff's answer sounds simple:

> the best solution to today's conflicts over culture is to teach the conflicts themselves, making them part of our object of study and using them as a new kind of organizing principle to give the curriculum the clarity and focus that almost all sides now agree it lacks.

2 It should be noted that Professor Epstein is the editor of *The American Scholar*, a superior journal of intellectual reflection and the publication of Phi Beta Kappa, the principal university society for honoring distinguished intellectual work.

Of course some changes in thought and practice would have to be made. In the first place, we would have to dump the conservative idea that we have a common culture and accept, in its place, the idea that there is only a common discourse (the purpose of which, Graff makes it appear, is wholly polemical): "Instead of pretending we can eliminate political conflict from teaching, we should start making use of it." (A great many of us Insiders will part company with Graff here, but let us hear him out.) Second, we would have to dispose of our fetish of the Great Teacher, the master of the solo presentation; for the single course prevents "community" with other courses and their professors. Professors who disagree with each other—traditionalists and Marxists, feminists and deconstructionists, gays, and new or old historicists—are, in Graff's scheme, to be thrown together and told to work out their arguments in the form of a syllabus. (As I reflect on my college experience, it was the Great Teacher who most mattered to me. But let us go on.)

Graff proposes several "curricular innovations" to replace the individual teacher. He is keen to have two or more instructors exchange classes. Several courses, he thinks, could be clustered around a theme—like feminism, naturally. A faculty Mediator could be installed on the floor to translate and interpret to the groundlings what the onstage antagonists (who are socialized in the relevant critical jargon) are really saying. Even a "transcourse symposium"—a sort of mini-MLA convention—could be created around a topic like, say, multiculturalism. All the teachers would be involved! He calls this procedure the "conflict model"; and Graff believes that it will get faculties to marshall their evidence, sharpen their arguments, and *demonstrate to students* the urgency of these cultural issues. No longer would there be "some lone professor mumbling over his lecture notes about Emily Dickinson's dates of birth and death." No longer would the university be able to "quarantine" intellectual life into the class hour, constrict it into the single course. Alienated students, energized by the spectacle of their disputatious professors, will come streaming back to literature classes. They would get into the argument themselves. *The humanities would be saved.*

To me, Graff's bright idea sounds like a Sixties "Teach-In," except that here the radical interruptive disputants have the classroom floor and can *legitimately* shout down the traditionalist. The "university without walls" is now within the door. In this new *Freiuniversität*, everybody will "rap" together until "new sociological truths" emerge. (They are already evident in the quarterlies: "The System Stinks." "Black Is Beautiful." "Multicultural Is Ba-aa-dd" (that is, Go-oo-od). "Sisterhood Is Powerful." "Gay Is Grand." "DWEMS Are Dorky." Finally, "Hey Hey, Ho Ho, Western Culture's Gotta Go.") The only thing lacking in Graff's "new classroom agenda" is retiring afterwards to the faculty lounge to pass around a joint and sing "We Shall Overcome."

James W. Tuttleton

While we contemplate the return of Joan Baez, there are of course some serious kinks in Graff's reprise of the Sixties. Some Insiders, like me, will say that one's primary classroom task is that of teaching the student a subject, not staging a counterculture debate with colleagues: I for one don't want a radical mucking in—especially over a transient critical methodology. These "brilliant new critical methodologies" (as they are always being called) succeed each other at such a rapid rate that we condemn our students to faddism when we waste class time on them. Structuralism, which so exercised the avant-garde twenty years ago, is now defunct; reader-response discourse has already collapsed of its own subjectivity; deconstructionism has been *passé* for some time; "phallogocentrism" and the "clitoral imagination" are quaint reminders of long-forgotten epiphanies. Feminists tell us that Freud is finito; but even Lacan's days are numbered. Meanwhile, what remains? Chaucer, Shakespeare, Milton, Dickinson, Ellison, Poe, Faulkner, and Eliot—the canon of permanently interesting texts.

The problem with Graff is that he believes that the aim of education is only to make one think, when, in fact, there is also a body of literature out there that ought to be read experientially before any discussion of extraneous abstract methodologies by figures like Foucault, Derrida, or Lacan is even contemplated. But even on the level of cognition, students have to have something to think about, and the canon is that which, as literature professors, we can give them. Any reading *about* literature competes with and displaces the direct reading of literature itself and so deprives students of their precious heritage. Of course, some of our colleagues will be arguing with us that there isn't any literature, only texts, all of equivalent interpretive and polemical value, blah, blah, blah.

But in these staged debates over a text, what if the novel doesn't have an explicit politics? Not to worry. Graff quotes with fulsome approval a remark of Chinua Achebe, the Nigerian novelist, that "even the attempt to say nothing about politics is a big political statement. You are saying, then, that everything is OK." This is a point of view that only an activist political ideologue of some stripe could hold; it naturally conduces to the view that any novel or poem without an explicit politics has "repressed" its hidden, reactionary assumptions (about race or class or gender) and must therefore be demystified and condemned.

For Graff it is "not just the object of study but *the kind of question being asked about it*" that is important. In fact, finding a way to force the right kind of question, the political question, is more important to Graff than the object of study. And if the object of study—the great poem, or novel, or play—isn't explicitly political or if it doesn't naturally provoke the right kind of political question, Graff advises Insiders to substitute a lesser text. The logic here is quite explicit: "it does not follow that culturally acknowledged great works generate a more substantial, challenging, and

interesting critical or pedagogical discourse than do less valued works"; if so, there is no reason to hang onto them: dump the classics in favor of texts that make for slam-bang classroom political contention.

John Searle has properly advised university professors to keep personal politics out of the classroom and not to use it as the scene of indoctrination. But for Graff, to raise political issues in the classroom is not necessarily a "corrupting intrusion." Perhaps not in theory, but in fact, in colleges, universities, learned societies, and journals of criticism and scholarship, the manifest scorn for the canon of great books and the agitation to dump the classics in favor of second-rate texts that support politically correct attitudes have already corrupted the literary enterprise. This has been achieved by the political takeover of key committees, by browbeating the traditional scholar into departmental silence, and by sneering at the conventional textual critic.

Having taken over the committees, got the political power, and browbeaten their conservative colleagues, however, what have Graff and his left-wing allies discovered? They have discovered that there is a large number of traditional professors of literature out there who don't and won't read every literary work in terms of some political litmus test. Each one has his own class, his own students, his own personal platform from which he launches his distinctive aesthetic and critical exploration. *Each of them has academic freedom!* The problem for the left-winger is, then: How to offset the academic freedom of the lone professor? How to get into his classroom? How to neutralize him, get at and indoctrinate his students? Graff's book is a *vade mecum* for radicals on the topic of "what is to be done with those teachers and students who do not wish to be radicalized." And here things really get scary.

Graff's various curriculum proposals—team teaching, courses clustered around an idea, obliging faculty to debate each other—are really devices to coerce a departmental political focus favorable to the Left. The most horrifying aspect of the book is the description of two new radical programs —one at Syracuse University, the other at Carnegie Mellon. The new Syracuse major, called English and Textual Studies, effectively "replaces 'a traditional pluralism,' in which different viewpoints are separately presented, with a framework in which each position 'acknowledges its allied or contestatory relation to other positions.'" In the Carnegie Mellon Literature and Cultural Studies program, the goal is "to bring into debate a host of epistemologies, distinctive methodologies, issues, problems, and challenges" with the understanding that "some will not survive the battle or that we will find ourselves led into conversations we didn't expect."

What is not going to survive the contestation, I suspect, is the traditional professor, the man or woman who thinks that literature is an art rather than a branch of politics or sociology and who wishes to present it

to students as a rich, complex experience not reducible to the objectives of the radical Left. Graff reassures Outsiders:

> No teacher at Syracuse is *forced* to enter the departmental dialogue. However, according to Steven Mailloux, the department chair who led the installation of the new program (he has since left the university), because the program is organized as a dialogue, any teacher's refusal to enter can be interpreted by students as itself a meaningful choice (not necessarily a discreditable one). Under the Syracuse plan, Mailloux writes, "a faculty member simply continuing to teach his course in a traditional, isolated way does not undermine the curricular 'conversation' because the curriculum causes his action to be read as a move in the conversation. Since students will be helped to 'read' their courses side-by-side, when they take a traditionalist course they will be able to read it through the grid of the new major." It remains to be seen how well the conception will translate into practice, but the principle seems to me sound.

Sound? It is a recipe for punishing the independent thinker. First, the departmental boss tells the lone professor that he is not *forced* to collaborate; then his non-cooperation is noted as intentional; then there is the insinuation that his non-cooperation is possibly discreditable; students are then instructed by the cooperators in how to view the traditionalist and his non-cooperative course. I have no doubt about the fate of the lone non-cooperator: first, the salary cut, then discriminatory course assignments, then the impossible schedule—and before and above all else, chairmanly and departmental contempt. Since the Department is now a Commune for promulgating left-wing sociological arguments, with a view to politically correct indoctrination, the lone professor can be expected to undergo group "Re-education" and "Rehabilitation."

Is this a paranoid scenario? I submit that coercion is built into the structure of these two programs and that unless both departments are wholly composed of leftists, coercion has already occurred or will soon do so. Further, I submit that the success of Graff's ideas portends the loss of academic freedom and the liberty of the lone professor to define his subject. Graff's deceit in this book is to pretend to present himself as a moderate who diplomatically negotiates cultural differences. But elsewhere he has described himself as "a leftist" who finds it "tempting to try to turn the curriculum into an instrument of social change." The purpose of the book is frankly left-wing damage control in the public-relations area, and Graff is the spin doctor. Under the guise of teaching the conflicts so as to educate the student, his agenda is really to seize the classroom of the lone, dissenting professor so as finally to make it too an instrument of social transformation.

March 1993

The Case against Martin Bernal

David Gress

Who would have thought it possible to enlist Bronze Age Greece in the current academic war against Western civilization? This is precisely the situation within the profession of classics, a discipline that has certainly been familiar with political polemics in the past. There is a substantial and respectable Marxist contingent of British and Italian classicists, headed by the touchy and irascible Geoffrey de Sainte Croix, who for four decades has tried to browbeat us into accepting that the class struggle is the key to understanding ancient society. Classicists impatient with the slow pace of social change in Italy felt obliged to support the cultural hegemony of the Communist party. From the 1950s to the 1970s, with the exception of the great scholar Arnaldo Momigliano, most work of grand scope in Italian classics came from Marxists like Santo Mazzarino, Francesco de Martino, and Sebastiano Timpanaro. Despite their crude metaphysics and simplistic sociology, however, these scholars were ultimately, like their non-Marxist peers, loyal to their subject. They would have been shocked and dismayed to learn that classical scholarship would eventually provide propaganda for distorting and dismantling higher education.

Just this is Martin Bernal's objective in his recent book, *Black Athena*, subtitled *The Afroasiatic Roots of Classical Civilization.*[1] Bernal, professor of government at Cornell University, a former Sinologist, and, like many of his fellow academics, a supporter of the Communist side during the Vietnam War, tells his readers candidly that "the political purpose of *Black Athena* is, of course, to lessen European cultural arrogance." Apart from the fact that this charge has become a straw man—the chief problem in the academy today isn't European cultural arrogance but its opposite— Bernal's account, and the political circumstances in which it appears, raise some important questions about scholarship and propaganda in the academy and, *a fortiori*, in what remains of the general culture.

The provocative, even sexy title *Black Athena* promises proof that the

1 *Black Athena: The Afroasiatic Roots of Classical Civilization. Volume I: The Fabrication of Ancient Greece 1785–1985*, by Martin Bernal (Rutgers University Press, 1987).

foundation of Greek culture, its philosophy, art, literature, and historiography—all, in short, that traditional humanists have held up as archetypes and models of Western greatness—was not, after all, the work of white Europeans but of Egyptians and Levantines. In fact the book does not prove or even argue anything of the sort. Its appeal to the anti-intellectual activists on America's campuses is based on a deception. Bernal nowhere discusses Greece of the classical period; rather, he contends that Bronze Age Greece, of the second millennium B.C. (that is, a thousand years before the age of Sophocles, Phidias, and Pericles), was heavily influenced by, and perhaps even a colony of, Egypt and/or Phoenicia. This is an interesting argument, present-day ideology apart, but it offers no logical support whatsoever for the claim that "classical civilization" has "Afroasiatic roots." What Bernal does is to announce that he is about to fire a devastating broadside at the intellectual and moral edifice of traditional classical scholarship and at the political uses to which it has supposedly been put. What follows is indeed a broadside—but one aimed at a completely different (and undefended) target. The original target remains intact, though Bernal and his admirers proclaim that it has been destroyed.

Bernal offers two reasons to support his argument that the second millennium is relevant to the achievements of the classical period a thousand years later. First, he writes that the so-called Dark Age of Greece—from 1100 to 750 B.C., between the end of the Mycenaean and the beginnings of the classical period—did not, as almost all classicists claim, mark a complete break in culture. According to Bernal, population, language, literacy, religion, and culture all survived essentially unchanged. Because there is no evidence for this view, Bernal cannot provide any. Rather, he defiantly proclaims his impatience with "positivists" who incessantly demand "proof." One of these narrow-minded scribblers is Oswyn Murray, the tutor in ancient history at Balliol College, Oxford, who in his book *Early Greece* states the consensus as follows: "Discontinuity with the past was virtually complete: later Greeks were unaware of almost all the important aspects of the world that they portrayed in heroic poetry. . . . The Greek world from the eighth century onwards is a product, not of Mycenae, but of the Dark Age."[2] In fact, the only conceivable reason that Bernal asserts continuity of culture through the Dark Age is that by doing so he can claim that there is a link between Afroasiatic Bronze Age Greece and a putatively Afroasiatic classical Greece. Such a link, of course, is necessary to his larger political purpose.

Bernal's second argument concerns linguistics. The vocabulary of ancient Greek is 50 percent non-Indo-European, and classical Greek grammar, he avers, shows a language "worn down" and streamlined by long

2 *Early Greece* was published by Fontana in London in 1980 and was reprinted by Stanford University Press in 1983.

use in a sophisticated culture. Bernal is right about Greek vocabulary (though his figure of 50 percent may be a bit high), but the point is not relevant. Even if there were cultural continuity from the Bronze to the classical ages, the lexicon of a language is no evidence for the cultural or ethnic composition of its speakers, as any good linguist or anthropologist knows.

Moreover, vocabulary elements and place names aside, the Greek language is one of the most obviously Indo-European features of the culture. Two brief examples: the Greek verb is an archetypally Indo-European structure in that it displays both main types of verbal system found in that language family: the aspectual, which emphasizes duration and frequency of action (as in Russian verbs), and the multi-tensual, which locates an action in time (as in Spanish verbs). Second, most linguists consider *ablaut* (a change in the root vowel to denote changes in tense, as in English strong verbs like sink/sank/sunk, or in word type, as in bear/burden) to be a basic feature of Indo-European languages; Greek displays it to a high degree, more so than Latin. Bernal's argument that Greek grammar was worn down because it had been used on a literate level for a millennium without interruption is simply absurd. Latin lost about a third of its inflections and numerous archaic features in the space of two hundred years. There was plenty of time between the Dark Age and the era of frequent surviving inscriptions for Greek to do the same. These points may seem minor, but they are sufficient to show that Bernal simply does not make the case he claims to make and that his supporters believe he has made.

"Who were the Greeks?" has been a fundamental question for classicists for at least the last two centuries. Few have dared to provide a clear answer. Ancient Greek mythology, religious practices, political and social institutions, philosophy, language, and historiography do not tell a single, easily decipherable story about Greek ethnic or cultural origins, nor do they contain a simple civilizational code that would permit modern scholars to locate the Greeks in comparative perspective. If, for example, one studies religious beliefs and customs in isolation, one discovers evidence of Greeks who could not possibly have co-existed with those revealed by an examination of literature or political institutions. Greek civilization, it seems, was a mix of radically different, incompatible forms.

This diversity of basic elements is, of course, a major reason that Greek civilization remains the greatest and most fascinating of all high cultures. It also explains why many of the most distinguished students of comparative culture and mythology have been wary of Greek evidence. The late Georges Dumézil, for example, argued that all Indo-European-speaking peoples looked at society and the cosmos in terms of a tripartite division of both divine and human functions, such as the priest, the warrior, and the laborer who respectively served religious, political, and productive

functions. Dumézil had no trouble in fitting the Romans into this scheme, but he found problematic variations in Greek culture.

Good scholarship on Greek origins requires a range of skills that few have the ability or the time to acquire. Since the early years of this century, moreover, classical studies have lost their formerly central place in Western liberal education. We find it almost inconceivable today that three years of Greek and five of Latin were standard requirements in college preparatory schools throughout the United States before 1914. As late as the 1970s, the standard grammar used in my Greek courses at the University of Copenhagen was one written by an American scholar a hundred years earlier. By contrast, few people calling themselves educated today expect to be able to sprinkle their writings with classical allusions or quotations, nor do they expect to recognize them in older works. And, I might add, the classics are but one of many threatened branches of academic learning.

In this era of galloping anti-intellectualism, virtually the only works in the classics to gain notice beyond the narrow confines of the profession are those that, by design or by accident, serve some contemporary political purpose. The main objective in the American university today is to attack and abolish core curricula on European thought and history on the grounds that they have nothing to offer the multicultural society of the future, tainted as they are with the ineradicable sins of sexism, racism, and chauvinism. (Forget for the moment the inconvenient fact that the very idea of attacking sexism, etc., is an artifact of Western culture.) In recent years, politicizing academics and their student followers have added a curious twist to this charge. Going one step further than maintaining that there are, in principle, no objectively great cultural achievements that all educated people should know about, these academics tell us that, if any such achievements do exist, they are under no circumstances the accomplishment of "Dead White European Males." Rather, all greatness is due to women, blacks, and other groups whose true prerogative has been wrongfully suppressed by these same white European males. Thus they add the charge of false indoctrination in the past to that of irrelevance in the present; together, these two charges are meant to justify the practical policy of reverse indoctrination for the future.

One minor example of the alarming consequences of this agitation was the episode last year at Stanford University in which two white students were heavily penalized and forced to exercise ritual public self-criticism for blackening the picture of Ludwig van Beethoven on a poster after some black students had claimed that Beethoven was Negro. Clearly the black students had no interest in Beethoven's place in European music and civilization, but only in the immediate political capital to be gained from annexing him to their own campaigns. A much more significant example of this agitation, however, is the shameless politicization of culture that is encouraged by the author of *Black Athena*.

If Bernal's first claim is that Bronze Age Greece was an Egyptian and Semitic colony, his second main claim, to which he devotes the first volume of *Black Athena*, is that the ancient Greeks of the classical period and, indeed, most classicists until the early nineteenth century knew of and accepted the fact of these Egyptian and Levantine roots. According to Bernal, it was only in the era of European colonialism and racism that classicists decided, for ideological reasons, that the ancient Greeks, as the forefathers of Europe, had to be Indo-European and white, and that they could not owe anything of importance in their culture to Africans or Semites. As for Egypt, he writes that "after the rise of black slavery and racism, European thinkers were concerned to keep black Africans as far as possible from European civilization." Bernal is not willing to state categorically that ancient Egypt was in fact a civilization of black Africans. Rather, he is content to imply that the Egyptians may have been partly or predominantly black, which in today's climate is more than enough to annex Egypt, like Beethoven, to the dossier of hitherto suppressed black achievement. Bernal also supports the speculative theory that classical Egyptian derives from a common East African tongue that is also the ancestor of Semitic languages (including, of course, Hebrew). Politically, this theory permits the argument that Semites, too, owe their language and culture to blacks. I can't help thinking, in regard to Egypt, that it would be salutary if those activists who want to infuse core curricula with the contributions of "persons of color," women, and non-Europeans would indeed take the trouble to study Egypt and its cultural influence. By taking Egypt seriously, these activists might learn those things about high culture that they refuse to learn from Europe, and they might also come to realize, however dimly, the immeasurable gulf that separates their own complaints and resentments from the cultural achievements of Egypt.

I should at this point declare my own interests in the matter. I work on the periphery of a university that is currently suffering severely from anti-European cultural arrogance, or, to speak frankly, from black racist attempts to impose indoctrination in the place of teaching and scholarship. I consider it harmful for Bernal to title his work *Black Athena*, since he well knows how this will be read by the audience for which he is writing, namely as an argument that Greek culture was black culture. The black activists who have seized on Bernal's book could not care less about the serious ethnographic, linguistic, and anthropological questions that Bernal's argument raises. They have no interest in learning classical Greek or in understanding the problems and issues involved in the study of Greek religion in order to discuss competently what the Greek language might owe to the Egyptian or Phoenician languages, or what elements of Greek religion might derive from Afroasiatic roots. They will use *Black Athena*

the same way they used the claim that Beethoven was black: as a truncheon in their battle against the place of European thought and history in the academic curriculum. For them, and I regret to say for Bernal, Greek civilization is interesting not because it contains lessons of abiding value, but because it retains a certain, albeit etiolated, symbolic value in the public mind and therefore must be controlled by those who are now in the business of political indoctrination.

My second interest lies in the fact that I was a classics undergraduate and should therefore, if Bernal is right, have been exposed to the white European view of ancient Greece, what he calls the "Aryan Model." At Cambridge I heard the lectures of, among others, F. H. Stubbings, Denys Page, J. E. Raven, Moses Finley, Pat Easterling, and Arnaldo Momigliano. I can assure Bernal (if he has any honest doubts) that none of these scholars was in the least concerned with the Aryan or any other "model" of the Greeks. On the contrary, for all that distinguished these scholars intellectually and temperamentally, they shared a love of and commitment to texts, to the real evidence of what the ancient Greeks believed, felt, and said about themselves. As I mentioned, Bernal states that he has no patience with "positivists" and their irritating habit of demanding "proof" of assertions. No doubt studying the records and painstakingly deciding what these records might or might not mean, and what conclusions one can legitimately draw from them, is infinitely less exciting than denouncing all those who perform such work as racists and ideologues. What is ironic, given the contrast in method, is that every one of the scholars I have mentioned was capable of broad, synthetic, and often provocative interpretations. The difference between them and Bernal is that they told you something new about the ancient world, whereas Bernal merely modernizes old anti-Western commonplaces.

What, precisely, is Bernal's ideology? Behind his fashionable, anti-Western façade lurks a very traditional Marxism. After all, Bernal dedicates his work to his father, the well-known scientist and Communist fellow traveler John Desmond Bernal, "who taught me that things fit together, interestingly." They certainly do. I must say that in my own moral scale Bernal senior ranks very low indeed, somewhere between Pol Pot and Jean-Paul Sartre. J. D. Bernal was one of those who voluntarily surrendered his intellect and scholarly integrity to the cause of the greatest mass murderer in the history of mankind: that of Joseph Stalin.[3] Bernal junior,

3 Postscript 1994: In the preface to Volume II of *Black Athena* (1991), Martin Bernal took note of my reference to his father. In a surprisingly temperate tone, he agreed that his father had been an influence. Regrettably, however, Martin Bernal neither mentioned nor responded to my main criticism. Indeed, all of Volume II consists of further dicussion of the Bronze Age Near East, which remains entirely irrelevent to Bernal's central ideological claim.

ever the loyal red diaper baby, glories in this affiliation. He must, therefore, expect to have his work judged in the political context within which he operates. For Bernal senior, the context was Stalin's attempt to subjugate Europe and exterminate all those he defined as his enemies. For Bernal junior, it is the post-1968 context of Third World liberationism and Marxist anti-imperialism. Speaking of the modern Middle East, for example, Bernal puts the word *terrorists* in sneer quotes and says that the Western image of the violent Arab or Iranian is the product of pure racism. Elsewhere, he refers naïvely to "the American repression" in Vietnam, as though it were a fact that needs no evidence. Not a word, of course, about the real repression and mass murder committed by Bernal's Communist heroes after their victory in 1975.

This first volume of *Black Athena*, then, is not about ancient Greece at all, whether classical or Bronze Age. Entitled *The Fabrication of Ancient Greece 1785–1985*, it is an indictment of the past two centuries of classical scholarship for allegedly rejecting the "Ancient Model" of Greek culture, which stated that its roots were Egyptian and Eastern, and for imposing instead a racist "Aryan Model," stating that the Greeks were entirely European and owed nothing to Africa or Asia.

The history of scholarship, including its politics, can be a fascinating subject if honestly presented. Bernal's account is not honest. It suffers from a virulent case of the disease that afflicts all Marxist writing, a disease that manifests itself as an attitude of fundamental suspicion according to which no one (except the author) can do or understand anything correctly at all; rather, everyone (except the author) is blinkered, willfully or negligently stupid, prejudiced, and racist. The author and those with whom he agrees, on the other hand, are uniquely privileged to be free of all material and intellectual interests; living in the realm of pure objective insight, they alone have the tools to unmask the stupidity and nefarious plans of their political enemies.

Thanks to this disease, Bernal acknowledges no need to be fair, comprehensive, or accurate in his account of the history of classical scholarship. For example, *Black Athena* includes a section entitled "Developments in Classics, 1945–65." This twenty-year span comprises a tenth of the entire period he covers in his volume, one that is full of important and exciting developments, not least in the field of Mycenaean and early Greek history. Does Bernal devote a tenth of his text to this period, examining the work, say, of Oswyn Murray on society, Walter Burkert on religion, John Boardman and James Cook on Greek overseas trade and colonization, Kenneth Dover on literature—to name but a few? Of course not. He offers three pages on Michael Ventris's decipherment of Linear B, a system of writing and record-keeping used in Mycenaean Greece. In 1952 Ventris proved that the language of Linear B was an early form of Greek. According to Bernal, while many classicists immediately recognized the proof as

a major discovery, they were dismayed by evidence that the Mycenaeans used Greek, because Mycenaean culture was derived from that of Minoan Crete which was in turn influenced by Egypt and Asia. If there was continuity of Greek language from Mycenaean to classical times, Bernal argues, then there was also continuity of Afroasiatic influence.

The truth is that the classicists had no problem whatsoever with Linear B, nor with Egyptian influence on Mycenae. What they could not and cannot accept, however, is continuity of Afroasiatic influences across the Dark Age—not because they are racists, but because all the evidence is against it. Bernal believes that he has a political, ideological, and moral obligation to assert such influence, but this does not make it real. What the classicist Peter Kidson wrote remains true: "When the Greeks emerged from the shadows of their Dark Age, they had shed almost all the political and religious institutions that might have linked them with Egypt."[4]

Elsewhere in his attack on postwar scholarship, Bernal states his belief that the "Aryan Model" is losing support and that classicists will soon have to admit that a black and African Egypt did indeed contribute essential features to Greek culture. Bernal offers no evidence for these contributions, preferring to stay on the safe ground of the second millennium, where lack of evidence permits the most egregious assertions. But let us for a moment take his point seriously. If Bernal is right, we would expect to find Egyptian influence not just on the peripheries of Greek vocabulary or religious practices but on the central elements themselves, on what was most unique in classical culture. Do the institutions of classical civilization resemble those of Egypt or the ancient Near East?

Perhaps the two most characteristic and lasting achievements of classical civilization are political democracy and the writing of history. In the political sphere, the Athenians invented the strict concept of absolute equality (*isonomia*) among citizens, discovered the virtues of unrestrained free speech (*parrhesia*) and of innovation in politics, and believed that genuine democracy required that the chief offices of the state be distributed by lot and not by election according to merit. These beliefs were unique in history. No other people believed in and upheld for so long the Periclean notion that the survival of the state depended not on mere physical force but on the participation in government of its citizens, since only the freedoms guaranteed by such participation provided the reason and the motivation required to preserve the city.

Egypt was a noble culture, but to assert that it had anything at all to do with Greek democracy is ludicrous. The Greeks believed passionately in free human will—even, or especially, when that will conflicted with that

4 In his essay "The Figural Arts" in *The Legacy of Greece*, edited by M. I. Finley (The Clarendon Press of Oxford University Press, 1981).

of the gods. Politically, they rejected hierocracy and priestly rule before recorded history begins. Egypt, by contrast, was a theocracy in the most literal sense throughout its long history: the king was god, and by his divinity upheld the land and all its inhabitants. "Pharaoh was not mortal but a god," according to Henri Frankfort, who goes on to write about the Egyptian view of change: "The ancient Near East considered kingship the very basis of civilization. Only savages could live without a king. Security, peace, and justice could not prevail without a ruler to champion them. . . . Egypt viewed the world as essentially static. It held that a cosmic order was once and for all established at the time of creation. . . . Nature itself could not be conceived without the king."[5] The Greek, always asking "what's new in the city?" ("ti neon ep'astu;"), seems like an alien creature by contrast. And alien of course he was: alien to the traditional course of human history. In this regard, the Egyptians were far more typical. An Egyptian minister of around 1000 B.C. said: "What is the king of Upper and Lower Egypt? He is a god by whose dealings one lives, the father and mother of all men, alone by himself, without an equal." A more un-Greek thought would be hard to imagine.

Regarding history, the Greeks' crucial discovery—one that permitted them to invent the writing of history as the account of the interaction of human affairs over time—was the discovery of time as the destroyer of all things "except the gods," as Herodotus put it. Because things of this world come to be and pass away, each according to its nature, the only possible account of the events of this world is one that examines each entity—person, nation, or empire—in its individuality. The purpose of Greek history was to give an account of individuality, whereas that of Near Eastern and Egyptian chronicles was to reduce all events to the uniform and ceremonial pattern of the cosmic order.

Bernal makes much of the arguments of a German Egyptologist, Siegfried Morenz, who allegedly supports the notion of the Egyptian influence on Greece. But unfortunately for Bernal, Morenz in fact emphasizes how different Egyptian ideas were from those of the Greeks. As he notes, "History in Egyptian might be translated as *irw*, that which must be done again and again, because historical action occurs according to norms that bind the actor to ceremonial repetition."[6] In traditional cultures like Egypt, reality and ritual, legend and history coincided. The king became real by incessantly repeating the archetypal actions that founded the world. It is very possible that Mycenaean kings thought and acted the same way; classical Greeks emphatically did not. They discovered a new way to examine the political and social world and to orient themselves in

5 *Kingship and the Gods*, by Henri Frankfort (University of Chicago Press, 1948).

6 Quoted in Christian Meier, *Die Entstehung des Politischen bei den Griechen* (Suhrkamp, 1980).

it. Some scholars argue, convincingly in my view, that this new approach had a political cause, namely the Persian Wars in which Greece came close to extinction. But this point is no help to Bernal, because Egypt, too, underwent crises without developing either democracy or historiography.

The Greeks developed both because they wanted to master the world rather than be mastered by it. It was a noble effort, beyond the understanding of those who want to prevent today's students from learning about it—an effort that often failed, but one that continued to provide the inspiration for us to struggle against the barbarians.

Black Athena is pernicious because it serves a political purpose hostile to the culture of scholarship. (Its very title is deceptive, because the author offers no evidence that the goddess Athena was considered to be black. He says, rather, that her great-aunt may have married an African or a Phoenician, which no one doubts.) The interesting arguments that one might have with Bernal on Bronze Age settlement, the introduction of the alphabet, Egyptian or Semitic elements in the lexicon of classical Greek, or even on the history of classics are unfortunately vitiated from the start by his resentful and truculent tone. Placing himself "in the spectrum of black scholarship" rather than "within the academic orthodoxy," he assumes throughout the book that many professional scholars who see no evidence of strong Egyptian influence on classical civilization suffer from "passionate and systematic racism." This is to misrepresent grossly the ethos and requirements of scholarship. Specialists on early Greece face specific problems that cannot be wished away. Evidence for important areas of ancient Greek life simply does not exist. These scholars have, therefore, developed a technically complex, consistent, and highly productive set of methods for testing evidence and proposing hypotheses where evidence is lacking. It happens that these methods yield results that Bernal, for political reasons, does not like. His reaction is to denounce this scholarship as politically tainted in order to justify his own anti-scholarship. Bernal's denunciations, delivered with a uniformly spiteful tone, give his work the same moral and scholarly status as the Aryan science of the Third Reich or the Lysenkoite genetics of Stalinist Russia; that is, none whatever.

December 1989

Houston Baker, Jr.:
Another Sun Person Heard From

Terry Teachout

The antics of Leonard Jeffries, chairman of the black-studies department at City College of New York, noted Afrocentrist, and originator of the terms "sun people" (i.e., blacks) and "ice people" (i.e., whites), were widely reported in the press last spring. Nominally removed from his chairmanship in 1992 for incompetence, Jeffries was in fact dismissed for engaging in gross, flagrant, and—most important—public anti-Semitism. His formal evaluations by college officials had been satisfactory right up to (and, incredibly, after) the day he gave a taxpayer-supported speech at the Empire State Black Arts and Cultural Festival in which he explained, among other things, how Jews financed the African slave trade, a revelation he had previously vouchsafed to his students. Jeffries promptly sued the City University of New York, of which CCNY is a part, claiming he had been given the boot not for being a bad chairman but for having lawfully exercised his constitutionally protected right to free speech. In May, a federal jury agreed with Jeffries, ordering CUNY to fork over four hundred thousand dollars in recompense, and Judge Kenneth Conboy subsequently ordered him restored to his chairmanship.

One of the interesting things about Jeffries is the fact that he has so few respectable defenders. Most of what has been written about him in the mass media since he lurched into the spotlight four years ago (Jeffries helped draft "A Curriculum of Inclusion," the now-infamous report on multicultural education commissioned by New York State Education Commissioner Thomas Sobol) has been contemptuous in the extreme. Even *The New Yorker*, which normally devotes itself to the reflexive praise of all things politically correct, took time out from sucking up to Bill and Hillary Clinton to devote eleven pages of its June 7 issue to a brutally frank profile of Jeffries. The piece, written by James Traub, was full of quotes from prominent black academics who hastened to distance themselves from Jeffries's ravings. Michele Wallace, a professor in CCNY's English department, went so far as to suggest that his conduct threatened to undermine the legitimacy of black studies itself:

Leonard Jeffries is not rational. It's not possible to absorb sun people and ice people into a rational view. My view of Leonard Jeffries is that he's a maniac—and you can't assimilate a maniac. Jeffries should be marginalized. . . . A lot of students are confused. They don't understand the difference between Edmund Gordon [Jeffries's temporary replacement as chairman] and Leonard Jeffries. And I think a number of us need to take on this task if black studies is ever going to be a serious area.

A few days after James Traub's profile of Leonard Jeffries was published, I read Houston A. Baker, Jr.'s *Black Studies, Rap, and the Academy.*[1] Viewed from one angle, Houston Baker is everything that Leonard Jeffries is not. So far as is known to the fact checkers of *The New Yorker*, Jeffries has published nothing; Baker is the author of numerous books. Save among his Afrocentric buddies, Jeffries is disreputable; Baker is not only reputable but fashionable, or so one gathers from the dust jacket of *Black Studies, Rap, and the Academy*, on which can be found snippets of praise from such publications as *The New York Times Book Review*, *Washington Post Book World*, and the *Village Voice Literary Supplement* ("If one person could embody the trajectory of black literature and literary theory in the post-apartheid era of American higher education, Houston Baker is that person"). He is even a past president of the Modern Language Association. But Jeffries and Baker have two relevant things in common: both are black, and both are in charge of black-studies departments. Baker directs the Center for the Study of Black Literature and Culture at the University of Pennsylvania, where he is professor of English and Albert M. Greenfield Professor of Human Relations.

Looking at Houston Baker's résumé, one naturally supposes him to be the sort of person Michele Wallace has in mind when she speaks of black studies as a "serious area." His books, for example, are published by the University of Chicago Press, which is also, a glance at my bookshelves reminds me, the publisher of Leslie Marchand's *Byron: A Portrait*, Richard Posner's *The Essential Holmes*, Leo Strauss's *Natural Right and History*, Anthony Powell's *Miscellaneous Verdicts*, and Clement Greenberg's *Collected Essays and Criticism*, to pick five titles at random. That is fast company, but the University of Chicago Press is plainly unafraid of the implicit comparison. Indeed, *Black Studies, Rap, and the Academy* is the first volume in the series "Black Literature and Culture," edited by none other than Houston A. Baker, Jr. To top it all off, the book is, according to the preface, "the result of a short-term visiting fellowship at Princeton University. Professor Arnold Rampersad of American Studies and Professor Victor Brombert of the Council of the Humanities graciously invited me

1 *Black Studies, Rap, and the Academy*, by Houston A. Baker, Jr. (University of Chicago Press, 1993).

to present lectures as a Whitney J. Oates Fellow during the spring of 1992." Morris Zapp couldn't have put it better.

I didn't know much about Houston Baker prior to reading his latest book, though I had run across his name more than once.[2] Nor do I know much about black studies as an academic discipline, other than what I read in the magazines; it was still getting off the ground when I was going to school. I do, however, know something about rap, partly because I live in Manhattan, where it is ubiquitous, and partly because I mugged up the subject a couple of years ago at the request of an editor, producing in due course an article from which Baker quotes (without comment) on page 49 of his book. More to the point, I know serious scholarship when I see it, having consumed a carload of it in my time. The arrival of *Black Studies, Rap, and the Academy* thus seemed to me in the highest degree opportune—a chance to find out at first hand about one of the "serious" practitioners of black studies whose reputation Leonard Jeffries is allegedly damaging.

The argument of *Black Studies, Rap, and the Academy* can be summed up briefly: (1) Black studies is an indispensable part of American higher education. (2) Rap is a creative and authentic expression of the urban black experience and should thus be taken seriously by academics, particularly those working in the field of black studies. (3) Anyone who disagrees with (1) or (2) is a racist. Mind you, Baker doesn't actually call critics of black studies (or rap) "racists"—he's too smart for that. There are subtler ways to sling the mud:

> The late Allan Bloom's influential *The Closing of the American Mind* commences with a sullen and dyspeptic account of the arrival of Black Studies [the term is always capitalized in *Black Studies, Rap, and the Academy*] at Cornell. This arrival is described by Bloom in darkly Miltonic terms as Paradise Lost, an expulsion from the academic garden of White Male Philosophical Privilege.
>
> From a Black Studies perspective, the past twenty-five years have been a journey from bare seasons of migration to the flowering of scholarly innovation. From a conservative white male perspective, these same years must have seemed an enduring crisis, each new day and work of Black Studies bringing fresh anxieties of territorial loss.

Forgive me for not wheeling out the big guns, but life is too short to waste time wrangling over this kind of prattle, or the ideology that drives it. Neither is it worth summarizing Baker's views on rap, since they are,

2 Some of Baker's earlier activities were discussed in this magazine's "Notes & Comments" for February 1993, as well as in Roger Kimball's *Tenured Radicals: How Politics Has Corrupted Our Higher Education* (Harper & Row, 1990).

controlling for polysyllables, mostly indistinguishable from those of the average thirteen-year-old, and are in any case asserted rather than demonstrated. Instead, I want to concentrate on certain stylistic aspects of *Black Studies, Rap, and the Academy* which reveal far more about Houston Baker than any respectful parsing of his ideas ever could.

Baker shifts into high rhetorical gear on the very first page, informing us that black studies is "a narrative of Hagar's children redeemed from exile by the grace of affirmative action and the intentionality of Black Power. It is a vernacular tale, resonant with rhythm and blues." Having read the remaining 109 pages of *Black Studies, Rap, and the Academy* with some care, I can assure you that this one is wholly representative. Indeed, the book is a veritable *omnium gatherum* of latter-day academic clichés. Here are a few of the more noteworthy varieties:

Loud, flatulent praise of the Sixties. "In the midsixties, the quiet of the American university—whether garden or factory—was shattered forever by the thundering 'NO' to all prior arrangements of higher education in America issued by the Free Speech Movement (FSM)."

Even louder and more flatulent denunciation of the Eighties. "Most of the population of the United States is financially hard-pressed, crippled by the absence of justice in everyday life, and distressingly aware that an unseemly white-male profittaking during the 1980s has brought the United States to the precipice of human disaster."

Pseudo-heterodoxy. According to the dust jacket, "the book's most controversial moment" comes when Baker supports the banning by Florida's Broward County of 2 Live Crew's album *As Nasty as They Wanna Be*, which Henry Louis Gates, Jr., praised on the op-ed page of *The New York Times* for its "exuberant use of hyperbole." (One wonders how Gates would react were one of his white students to stand up in class and deliver himself of an exuberantly hyperbolic speech in praise of rape consisting mainly of the words *bitch* and *motherfucker*.) Says Baker, striding fearlessly into single combat with the grand panjandrum of black studies:

> I believe 2 Live Crew's album was understandably banned. And I believe [wait for it] that if women and minorities were empowered to assume genuine agency in American society, other such albums would probably be banned, along with Andrew Dice Clay, *Hustler, Penthouse,* and peep shows. Though social scientists and policy analysts are fearful of declaring a correlation between the volume of violent, obscene, antiwoman drivel available in the United States and the incidence of violence against women, common sense alone suggests such a correlation. . . . I am certainly *not* suggesting that the criminal prosecution of popular artists should become a United States norm. Nor am I advocating the institution of a kind of State PC (in this instance, "popular culture") police force to roam the land instituting "standard" words and works in lieu of popular idioms. . . . I believe Tipper

Gore *is* a puritanical busybody who should not be listened to by anyone under the age of 135.

Now *that's* controversial.

Preening. "I recently (February 1990) had the experience of crossing the Atlantic by night, followed by a metropolitan ride from Heathrow Airport to North Westminster Community School in order to teach Shakespeare's *Henry V* to a class of GCSE (General Certificate of Secondary Education) students. . . . To make an exciting pedagogical story brief, we took off—as a group. I showed them how Henry V was a rapper—a cold dissing, def con man, tougher-than-leather and smoother-than-ice, an artisan of words. . . . eight or nine of the students surrounded me after class seeking, as they put it, 'scholarships' to go back with me to America— 'now, Sir!'"

Incessant use of tin-eared jargon. "*Black Studies* became a sign of conjuncture that not only foregrounded the university as a space of territorial contest, but also metaphorized the contest itself in a way that allowed the sign to serve as a simulacrum."

Embarrassing use of teenage slang. "It seems high time, then, for those of us who are inside to get seriously busy about the business of Black Studies for the nineties—to bust a move and rigorously bring the scholarly noise for a new generation." (Get down, Grandpa.)

Simple ignorance. Among the names Baker misspells: S. I. Hayakawa, Carol Iannone, Catharine MacKinnon, Salman Rushdie.

Plain old bad writing. "Then perhaps we would not only see the horror of that black woman who was forced to a Brooklyn rooftop, raped, and murdered in the same time frame as the Central Park jogger assault, a rape and murder that were very much unreported [if so, how did Baker hear about them?]; we might also find in our new public concern both exacting and effective ways to channel the transnational capital of everyday rap into a spirited refiguration of black urban territories—a refiguration that would foreclose even the possibility of such horrendous black woman victimization as that in Brooklyn, and a refiguration that certainly would prevent the veritable silencing of such obscenity."

Here we arrive at the heart of the matter. Put aside Baker's politics for a moment and concentrate on the *aesthetics* of that last sentence, and the hundreds of others like it with which *Black Studies, Rap, and the Academy* is stuffed to the eyeballs. Can there really be any doubt that a man capable of publishing such prose is demonstrably unworthy of being entrusted with the education of English majors, whatever their race, creed, color, or sexual orientation?

As I said earlier, I know very little about black studies as a formal discipline, though I'm not especially sympathetic to it in the abstract. I don't

see that it makes a great deal of sense to study "black history," or "black art," in ghettoized isolation. This approach, taken to the lunatic extremes to which academics take everything nowadays, is at once condescending and destructive. If Richard Wright is worth taking seriously as an artist, surely it is because he was, to borrow Bruce Bawer's formulation, a gifted writer who happened to be black, not a Black Writer who happened to be gifted. Least of all does he profit from being yoked with the woozy likes of, say, Alice Walker.

Who gains from *that* comparison? At the same time, I recognize that black studies is, at least in theory, a coherent concept. It is not at all difficult to imagine what an intellectually responsible black-studies department might choose to teach, and how it might go about doing so. But black studies in practice is too often the product not of responsible intellectual inquiry but of far baser motives. Consider the case of the black-studies department at City College of New York, which was founded two decades ago in response to—what else?—student protests. (*Though we know we should defeat you, we have not the time to meet you. / We will therefore pay you cash to go away.*) Leonard Jeffries was hired straight out of graduate school to head the department and immediately granted tenure, presumably as a condition of his hiring, after which he was left almost entirely to his own devices. "It was never much of a department," a lawyer for City University of New York claimed at Jeffries's trial. "In the last fifteen years or so, you could count the published scholarly works of City College's black-studies department on the fingers of two hands."

Yet no one at CCNY was willing to challenge Jeffries on the merits—to openly assert that he and his colleagues (virtually all of whom he hired) were incompetent hacks—until he forced the issue by dragging his employers to court. Not that CCNY officials subsequently leapt to the defense of academic standards. Indeed, it was precisely because their testimony was so half-hearted, and because Jeffries's formal evaluations had all been satisfactory, that Joseph Fleming, Jeffries's lawyer, was able to persuade a jury in essence that his client was fired not because he was incompetent but because he was anti-Semitic.

Arguing in court last spring against Jeffries's reinstatement as chairman, New York Assistant State Attorney General Kathie Ann Whipple played what she doubtless assumed to be the ultimate trump card by claiming that Jeffries "does not grasp the sensitivities and sensibilities essential for working in an ethnically diverse environment." This statement is worth a closer look. In CCNY's eyes, Leonard Jeffries's besetting sin was *insensitivity*. (That is a pretty flossy word for the man who once called Diane Ravitch "the ultimate, supreme, sophisticated debonair racist . . . a sophisticated Texas Jew," but never mind.) His scholarship, or lack of it, was viewed as a purely secondary consideration. And so it was, at least to the cynical administrators who built the bully pulpit from which Jeffries

continues to cram the gospel of Afrocentrism down the throats of ignorant undergraduates who know no better.

One would like to think this sordid tale an exception to the rule. But, as James Traub explains in his *New Yorker* profile, it is in fact characteristic of many, perhaps most, black-studies departments:

> Black students at campuses all over the country began demanding separate programs and living facilities; above all, they demanded the establishment of programs of black studies—in effect, a department of their own. For many scholars, black and white, such ultimatums represented an assault on the intellectual integrity of the university. But college officials found that a black-studies department was a relatively cheap way to buy campus peace. The Marxist historian Eugene Genovese accused these administrators of practicing "a benevolent paternalism that is neither more or less than racist." The subsequent neglect of conventional academic standards in many black-studies departments suggests that Genovese was right.

So, I hasten to add, does the fact that the University of Chicago Press chose to publish *Black Studies, Rap, and the Academy*, a vulgar, stupid, and totally unscholarly book that is "literate" in precisely the same sense that a man who tarts up his prose with two-dollar words gleaned from *Roget's* is literate. If I were an editor at a publishing house, and this book had been submitted to me by an unknown author, I would have rejected it without a second thought. But, of course, it is not the work of an unknown author. It is the work of a specialist in black studies who has been deemed worthy of an endowed chair, a book series of his own, and—I would venture to bet—a six-figure contract that doesn't require him to teach very much.

To be sure, Houston Baker, Jr., is no worse than the rest of his fellow literary-theory racketeers. He commits no literary offenses that cannot be found in a hundred other equally stupid books published by a hundred other professors of other colors. More important, he is no Leonard Jeffries. But these things are beside the point. Everybody admits that Jeffries is the living embodiment of black studies at its worst. If the author of *Black Studies, Rap, and the Academy* is truly representative of the *best* black studies has to offer, then it necessarily follows that black studies is a joke, a pitiful and preposterous burlesque of scholarship foisted on the academy in the holy name of diversity.

Which brings us back to the anguished words of Michele Wallace: "A lot of students are confused. They don't understand the difference between Edmund Gordon and Leonard Jeffries. And I think a number of us need to take on this task if black studies is ever going to be a serious area." Well, Ms. Wallace, I have news for you: the marginalization of Leonard

Jeffries is not the only task you need to take on if black studies is ever going to be a serious area. There is something else you and your colleagues need to be saying, loudly and clearly: *What* we *do is not what Houston Baker and his ilk do. If we are scholars, they are something else.* The day I see those words published in *The New York Times Book Review* under the byline of a tenured professor of black studies is the day I read another book by a tenured professor of black studies. Until then, I'll take my Richard Wright, Louis Armstrong, Romare Bearden, E. Franklin Frazier, and B. B. King neat, thank you very much.

September 1993

The Sobol Report:
Multiculturalism Triumphant

Heather Mac Donald

The emerging line of defense in the debate over multiculturalism is the charge of "exaggeration." Multiculturalists accuse their critics and the press of overstating the movement's impact and distorting its demands. The opposite is the case. Years before multiculturalism became controversial, its advocates were introducing racial quotas into history writing and literary studies. Public awareness has yet to catch up with the extent to which high-school and college education have already been transformed.

More critically, those who mediate between the activists and the public —the press, educators, and administrators—regularly muffle the more radical aspects of the multiculturalist platform in a blanket of normalizing rhetoric. This ill-conceived diplomacy results in a gap between the public face and the reality of multiculturalism. The debate has been presented in terms of how many pages a history textbook should devote to Cree culture, as opposed to the Bill of Rights, when what hangs in the balance is our culture's commitment to rationalism and objective standards of knowledge.

A prime example of the repackaging of multicultural extremism as moderate academic reform is the public presentation of the Sobol Committee Report. The Sobol Committee was appointed in 1990 by New York State's Education Commissioner, Thomas Sobol, to review the state's history and social-studies curricula. It was widely understood that the impetus behind the review was the demand to make New York's curriculum more multicultural—the present committee was formed after its predecessor issued a diatribe against Eurocentric education that was too extreme for even the liberal Regents to stomach. The committee presented its findings to New York's Board of Regents in June of 1991; in July, the Regents adopted its recommendations.

The committee's work received extensive coverage in *The New York Times*. A careful reader of our newspaper of record would have come away with the following impressions of the report and its subject matter: First, that the report represents "a new emphasis on multicultural education." While the rest of society has been learning to value non-Eurocentric

points of view, New York's history and social-science curricula, it seems, have remained largely untouched by multiculturalism: in Troy and Schenectady, Columbus still "discovers" America. The *Times's* coverage left the impression that a new curricular era was dawning in which New York would finally recognize America's cultural diversity, and, in the words of one of the drafters, no longer force individuals to "sacrifice their ethnic identity to be educated."

Second, the *Times* conveyed the idea that the report itself is judicious in its diagnosis and reasonable in its remedies, avoiding the racial virulence of the earlier report while paving the way for much-needed change. According to the *Times's* reporter, its "recommendations seem relatively innocuous." The *Times's* editorialists praised the committee as "scholarly and balanced," and reassured their readers that the report "offers mostly reasonable remedies." Adopting the terminology of one of the report's two dissenters, historian Arthur M. Schlesinger, Jr., of the Graduate Center of City University of New York, the *Times* framed the central issue confronting the committee as finding the proper balance between "pluribus" and "unum"—between, that is, cultural diversity and cultural unity. Unlike Schlesinger, however, the paper concluded that the balance had been struck. In fact, the committee had transcended the apparent zero-sum relation between diversity and unity to give us "*more* pluribus [and] *more* unum."[1]

The *Times's* coverage fits the archetypal narrative pattern of an eruption of disorder followed by the restoration of order. After the first Sobol Committee's report was rejected, it was all but inevitable that the second's would be greeted as the very soul of moderation. However aesthetically satisfying such a denouement may be, in the present instance it is a complete whitewash. The report is radically incoherent. It contradicts itself on nearly every page. Far from representing a "new emphasis on multicultural education," it duplicates a series of reforms that, according to the report itself, have already wreaked havoc on the curriculum. Rather than balancing unity and diversity, as the *Times* claimed, the report pays only lip service to the value of cultural cohesion. It invokes America's democratic ideals rarely, in boiler-plate, and only as a prelude to criticizing their imperfect realization.

But the most disturbing aspect of the report does not even register on the *Times's* "pluribus-unum" scales, and is barely alluded to by the paper. The committee proposes unleashing on schoolchildren the relativist theory of knowledge currently in vogue in higher education. This proposal would only increase the already legendary ignorance of American students while providing a fancy theoretical justification for it.

1 Emphasis added. The emphases in all other quotations from the Sobol report are in the original.

The *Times*'s presentation of the Sobol report typifies the response of the liberal elite to the demands of academic and political extremists. The establishment shrinks from pointing out the logical contradictions, racist assumptions, and misrepresentations in those demands, for fear of being branded racist itself. That fear has resulted in minority-hiring quotas in universities and the professions even though there are insufficient or no qualified minority candidates to fill those quotas; it has given us institutionalized segregation on campus in the form of separate racial student centers, dormitories, graduation ceremonies, and academic programs; and it has led to racial tests of fitness for teaching. It also induces the press to bury racial or racist aspects of current events when those events might reflect poorly on minorities, as witness the coverage of recent riots in the Adams Morgan section of Washington, D.C., and in Brooklyn's Crown Heights.

The Sobol Committee report opens on a note of alarm: "By most acceptable standards of fairness and equitable treatment of the many cultural currents in our nation, the existing syllabi are found wanting." The tone is measured, but the message is urgent, and the condemnation sweeping. New York's curriculum embodies a model of cultural assimilation that is no longer acceptable. That model "required" people to "shed their specific cultural differences in order to be considered American." This forced assimilation may once have been necessary "to shape a unified nation." But the civil-rights struggle, the increase in non-European immigration over the last two decades, and the "recognition of our nation's indigenous heritage" have "put [the goal of unification] in question." (The report does not explain why a unified nation is any less important today than before the Sixties.) It may come as a surprise to students of the American Constitution, but it is thanks solely to multiculturalism that we are "progressing . . . toward a . . . respect for pluralism." It is in spite, not because, of "mainstream cultural ideals commonly identified as American" that "recent decades" have witnessed the emergence of "a more tolerant, inclusive, and realistic vision of American identity."

Unfortunately, the report continues, New York's curriculum has yet to respond to this breakthrough in democratic values. Its failure to do so has serious educational consequences. The "lack of attention to . . . diversity and the absence of referents to one's indigenous culture in the curriculum" make "the problems of teaching and learning [geography and history] more difficult." The committee therefore calls on the state "to inaugurate a curriculum that reflects the rich cultural diversity of the nation."

The report's drafters apparently believe that frequent repetition is an adequate substitute for corroborating evidence. Having stated their claim that New York's curriculum fails to reflect cultural diversity, they repeat it

at least once per page of a sixty-odd-page report. But the examples of the curriculum's alleged insensitivity to cultural diversity are so few and so trivial as to undermine the charge they are intended to support. The most egregious examples of cultural bias are definitional: the use of "Oriental" instead of "Asian," "slave" instead of "enslaved person," the incorporation of Northern Africa into the Middle East, and the occasional use of "Latin America" without the qualification that many Latin American nations "trace their traditions" to Africa, India, and Indonesia.

The report also alleges, without supporting evidence, that the curriculum "inadequately addresses" the loss of lives and culture due to the European colonization of Africa, and that the pre-colonial history of India is "not properly treated." The "focus on celebrations such as Thanksgiving and Columbus Day" in grades kindergarten through 6 shows "disregard . . . for indigenous peoples." The discussions of slavery "frequently omit [its] economic basis," and the syllabi for grades 7–8 and 11 "do not adequately address the incarceration of Japanese Americans" or the deportation of Mexicans in the 1920s. The solution to these curricular enormities is to study "the shortcomings of U.S. policy."

The final examples of Eurocentrism and other forbidden "isms" require an exquisite sensitivity to slur. The syllabi describe the African continent as possessing "few jungle environments" and consisting of "nearly 45% . . . desert or dry steppe," while Western Europe's environment is described as "exhibit[ing] great diversity in terms of physical geography and climate, [with] easy access to warm water ports." These formulations "betray . . . real bias." The statement in the curriculum that "[i]nventions . . . in the 19th century were often the product of individual genius . . . , including that of lesser known, minority inventors," and the recommendation that students "also examine the roles of women and racial/ethnic minorities" in labor history are racist and sexist, according to the Sobol Committee, because they imply "that all the remaining content must not be about . . . women and people of color."

This last objection poses quite a dilemma. If the only acceptable histories are those which *are* "about" women and people of color, then either we're going to have a drastically slimmed-down history curriculum or we will have to rewrite history entirely from the perspective of those groups. That such a perspective will radically alter the past goes without saying. Since an analysis of the drafting and ratifying of the U.S. Constitution would "not be about" women and people of color, would it belong in a multicultural curriculum? Likely one could slip it in via the diary of a delegate's wife, or by focusing on the slavery question. But finding a multicultural hook for the doings of other dead white males will not always be so easy.

The hair-splitting quality of the examples suggests that the allegations of Eurocentric bias and cultural exclusion in New York's curriculum are

unfounded. Most of the criticism is directed at the depth of treatment of multicultural topics, not at their exclusion. But the amazing thing about the Sobol report is that it refutes itself. It explicitly contradicts its central thesis that New York's curriculum lacks a multicultural perspective. It acknowledges that the Regents have issued an annual statement supporting multicultural education for the last twenty years, and that the curriculum was completely overhauled in 1989 in accordance with the multicultural imperative. So successful were those most recent revisions that the curriculum simply buckled under the additional weight. The curriculum now contains "too much subject matter." It presents "ever-increasing amounts of information, without adequate organizing and supporting frameworks."

There is a certain poignancy in the authors' account of their self-created dilemma. To correct the "tendency to tell the story of U.S. and global history from the perspective of males and whites, . . . we quickly began to add important information about women and people of color." But then the multicultural principle backfired: "We must [then] in fairness go to [*sic*] lists of contributions of the many other national, ethnic, religious, cultural and other groups; and as we did so, it became clear that this encyclopedic approach would never fit in the syllabus, let alone the classroom." Though one may be sure that the multicultural principle was never taken to so absurd a length as to encompass Western European "ethnic, religious, and cultural groups," its application to more politically correct groups defeated its own purpose: "It [did] not serve the fundamental goal of helping students of all backgrounds and abilities understand and appreciate the concept of cultural diversity within national identity. In this sense, *the information-dominant approach to the social studies curriculum fails as a vehicle for multicultural education in the same way it fails in a full treatment of any other topic.*"

The picture of an already overloaded multicultural curriculum that emerges from the Sobol Committee report matches the conclusions reached in 1983 by Harvard sociologist Nathan Glazer and Tufts historian Reed Ueda. In a study of six major American-history textbooks, *Ethnic Groups in History Textbooks*, Glazer and Ueda exploded the myth that textbooks remain bastions of Eurocentrism. They found that blacks and Hispanics received over four times as much coverage as European immigrant groups, which are treated as a monolithic entity. African and Native American civilizations are portrayed as creative, in harmony with nature, peaceful, and cooperative, whereas European cultures are vicious and aggressive. The authors charged that by representing the United States as "exploitative, unequal, and almost unredeemable in its general nastiness," the typical multicultural textbook obscures the "considerable institutional and social achievements of the American polity." Were the study conducted today, its conclusions would only be bleaker.

The report's answer to the educational failure created by multiculturalism's success is breathtaking in its simplicity. Since it is impossible to master all the gender, race, ethnic, and sexual information that multiculturalism suddenly makes relevant to world history, the solution is obvious—discard the mastery of information as one of education's goals: "It is recommended that the approach to the social studies, K-12, shift the emphasis from the mastery of information to the development of fundamental tools, concepts, and intellectual processes that make people learners who can approach knowledge in a variety of ways and struggle with the contradictions." Rather than calling into question the use of education as therapy, the panel rejects whatever in the traditional concept of education is incompatible with that use. The authors assert that their educational program is motivated not by expediency, but by profound epistemological changes: "The nature of our knowledge and the criteria for being judged an educated person are changing. . . . [W]e are beginning to realize that understanding and the ability to appreciate things from more than one perspective may be as important as is factual knowledge in the goals of education."

There is much that is ludicrous in this proposal. Surely foremost is the recommendation that in an age when Americans' ignorance of history and geography is nearly complete, schools de-emphasize the "mastery of information" even further. The report is a textbook case of rationalizing the real: since students know nothing anyway, let's declare that the mission of education is not the acquisition of knowledge, but rather the "development of fundamental tools," etc.

But almost equally silly is the notion that grammar- and high-school students are ready to sit down with the high priests of poststructuralism and postmodernism for a big meal of linguistic skepticism and epistemological relativism: "The subject matter content should be *treated as socially constructed* and therefore tentative—as is all knowledge." Eight- and fourteen-year-olds want answers to their questions; after being told a few times that there are no answers, but just different social constructs, they will stop asking questions in the first place.

The *Times* barely alluded to the committee's recommendation that our schools shift from "information-based" to "conceptual" education. The two co-chairmen, psychologist Edmund W. Gordon of Yale University and Francis Roberts, Superintendent of Schools, Cold Springs Harbor School District, considered it important enough, however, to merit fuller treatment in a separate statement appended to the report. Gordon and Roberts argue that knowledge of history (or, as they disparagingly put it, "consensus history") is not an "intellectual competency" necessary for democratic government. Nor is "training in established traditions, values and beliefs." Rather, a civic education should "occur in the context of ex-

posure to diverse opinions, multiple perspectives and situated histories, where the learning tasks involve comparative analysis, contextual validation, heuristic exploration and judicious reflection." It is not easy to guess what this prescription might mean for, say, a fifth-grade teacher of the Civil War. But there is no ambiguity about what the report is ruling out—an intensive study of the history of liberal democracy.

Gordon and Roberts's claim that such a study is not necessary for democratic participation is dangerously wrong. Constitutional government is not self-sustaining. It requires citizens to preserve it. But the concepts of the rule of law, limited government, and individual rights cannot be fully understood or appreciated apart from their history. People with little or no knowledge of how those concepts emerged from the tradition of absolute monarchy are less than ideal guardians.

Gordon and Roberts acknowledge that not everyone on the Sobol Committee shared the majority's low opinion of "hegemonic" knowledge: "Although we were generally in agreement that histories tend to reflect the interests and perspectives of those who write them, there was a ubiquitous undercurrent of concern for the recognition of historical and other truth." Such "undercurrents," however antiquated and regrettable, pose an obstacle to the march of multiculturalism: "It may well be that it is this concern for truth that will be most difficult to reconcile with our conception of education as being directed at the development of intellect and understanding." Multiculturalism, in other words, is incompatible with a commitment to truth and knowledge. The two co-chairmen explain the problem with "facts [and] knowledge structures": they are "insufficient and often so situation-bound as to limit their utility in understanding and problem-solving." We have seen what such jettisoning of "facts and knowledge" leads to in practice. Many people, including attorney William Kunstler, held that it was irrelevant whether Tawana Brawley had *actually* been abducted and raped by a group of white men—the fact that the story had "contextual validity" and was compatible with the "situated knowledge" of many blacks was sufficient to confer upon it political power. A similar indifference to fact spurred the rioting in Crown Heights in 1991 over the death of a black child struck by a motorcade escorting the Hassidic Grand Rabbi. The rioters asserted that the child was ignored by both city and Jewish paramedics, but neutral eyewitnesses confirmed that the child did receive medical help at the scene of the accident. The rioters chose to ignore that evidence, because the charge that Jews had received preferential treatment and were indifferent to black suffering matched rioters' preconceptions, or, in the terminology of the Sobol report, their "interests and perspectives." In 1989, a New York Regent, Adelaide L. Sanford, accused current Assistant Secretary of Education Diane Ravitch of having grandparents who owned African slave ships. Ravitch informed Sanford that her grandparents were poor

Jews in Poland, not ship owners. Rather than apologizing for the slur, Sanford defended it on the ground that she was "speaking ethnically." Truth does not matter when ethnicity is at play.

The growing popularity of conspiracy theories among blacks to explain the spread of AIDS, drugs, and violence in the inner city also reveals a willingness to substitute one's "situated knowledge"—i.e., ideologically motivated conjecture—for facts.

These cases reveal a frightening chasm between white and black standards of credible evidence, refutation, and verification. The Sobol Committee's disdain for facts can only open that chasm wider. Though the report offers relativism as a way of defusing racial tensions and increasing understanding between cultures, in fact relativism can only exacerbate such tensions. In denigrating the appeal to objective truth as a relic of outmoded thinking or a tool of hegemonic control, the report destroys the only ground on which cultural mistrust and animosities can be resolved—reason. If reason is denied, the only way to resolve disputes is through physical or political force.

There is considerable incongruity between the committee's educational and political philosophy on the one hand, and its exercise of power on the other. Though it endlessly reiterates its commitment to "diversity" and its opposition to "hegemonic" knowledge and power, in practice it has little tolerance for differing views and local autonomy. The committee displays the usual multiculturalist disdain for local school boards and teachers, whom it accuses of derailing the multicultural agenda. To keep unruly school boards in line, it demands that all adopt a resolution in favor of multiculturalism. The boards must also institute "attitude"-retraining programs for staff at all levels, including bus drivers and clerical workers. Such programs would inculcate "attitudes supportive of the proposed changes" such as "the beliefs that (a) diversity is desirable, [and] (b) both the content and the process of teaching should reflect and respond to diversity." In other words, the committee denies local school boards their ability to determine the needs of their student population. Though the report justifies multiculturalism as a way for students to "recognize the fullness of their identity and heritage," it demands that "districts [of] predominantly one culture" adopt the multicultural curriculum as well.

The proposal to shift from an "information-based" to a "conceptual" education has at least the advantage of being so vague and hedged round by contradictions that it is likely to founder in execution. But the report contains another proposal that is perhaps an even more ominous threat to education, for it is much easier to implement. The committee takes aim not just at the content of textbooks, but at their very role in the classroom: A "multicultural education with multiple perspectives requires that we . . . *move away* from focusing on textbooks as the major sources, a practice that unfortunately treats other, non-text materials as supplemen-

tary rather than essential." Among the "non-text materials" which are now to be put on a par with books are "pictures and posters, updated maps that accurately portray the sizes of land masses, videos, music, books that are not texts, inexpensive artifacts and woven materials." It is a revelation to learn that Western cartography has been inaccurately portraying land masses all these years. "Inexpensive artifacts" and "woven materials" are undoubtedly euphemisms for African crafts of the sort which a consultant to the Sobol Committee Georgia State University educational psychologist Asa Hilliard III peddles at conferences on Afrocentric education. It is unlikely that samples of eighteenth-century brocades from Lyons will be an integral part of the multicultural classroom; Surinam quilts could well be. Note that the report does not call for the *introduction* of these non-text materials into the classroom. Apparently their role in the curriculum is already secure and merely needs bolstering.

The committee offers no rationale for this proposal (to which the *Times* devotes only one line) to elevate "non-text materials" to the status of books. But the denigration of the book is already official policy among the politically correct. The 1992 president of the Modern Language Association, University of Pennsylvania professor Houston Baker, views reading and writing as "technologies of control," and charges that literacy perpetuates "Western hegemonic arrangements of knowledge." It is difficult to decide which is more surreal—the head of the nation's literature professors trashing reading or the leaders of a barely literate school population adopting a proposal to replace the already spectral presence of books in the classroom with videos and other amusements.

From a multicultural perspective, there are several problems with books. First, the West's principal philosophical and political ideas have been transmitted by writing. If you want to suppress Western culture, you've got to start with the book. Books play a far less important role, if any, in the Native American and African cultures which have been nominated to supplant Western dominance. The second problem with books is that minorities have an even harder time reading them than whites. On the same principle that rejects as biased tests on which minorities score lower than whites, there must be something wrong with reading, if illiteracy among blacks and Hispanics is high. Rather than requiring more reading to correct the problem, we destroy the offending evidence so that we can perpetuate the myth of absolute equality of achievement among the races and cultures.

Unfortunately, the recommendation to de-emphasize books is almost superfluous. Textbooks have already mutated into something akin to the "non-text materials" that the report champions. Pictures have replaced narrative—in the books Glazer and Ueda examined, no two consecutive pages of text lacked an illustration. In an otherwise sympathetic review of

California's 1991 textbook revisions, a reporter for *The New York Times*'s Sunday magazine compared the look of the new multicultural textbooks to *USA Today*.

How will the substitution of "woven materials and inexpensive artifacts" for books, of "situational concepts" for facts, and of gender and disability studies for American political history affect the knowledge and skills of New York's students? We will never know for sure. The report calls for the development of "appropriate and relevant assessment procedures" that are "supportive of the goals and purposes of the revised social sciences curriculum, and reflective of the diversity of the student population." In other words, testing procedures, too, must conform to the multicultural agenda. They must be purged of anything that smacks of Western imperialism and racism, such as the valuation of literacy, communication skills, rationality, and historical knowledge. Instead, assessment procedures should measure both "canonical and non-canonical knowledge and techniques" and "identify from indigenous experiences examples of core concepts, knowledge and skills." Translation: Knowledge of the *Odyssey* is out; knowledge of, say, how to navigate your way around the streets of Bed-Stuy is in. Tests must assess "competence in knowledge, skill and understanding that is not dependent on communicative competence in a single language." Translation: Don't worry about learning standard English—double negations and the lack of subject–verb agreement will do just fine.

These vague prescriptions set the stage for a reprise of the charade that has recently played itself out again and again. Any test that yields a politically unpalatable result must be revised until it yields the proper one. In the process, the definition of essential knowledge inevitably changes. Our society has turned the purpose of testing completely on its head. We no longer use tests to evaluate achievement or competence for a position, but rather to rubber-stamp a result pre-ordained by politics. As our population grows ever more illiterate and uneducated, tests, too, will be dumbed down to conceal that fact. It would be a lot cheaper to simply do away with testing altogether and openly institute the quotas for which tests now front.

One of the most puzzling and disheartening events in the wake of the Sobol report is the role of Nathan Glazer as apologist for the academic Left. Glazer served on the Sobol Committee, a position for which his classic study of American ethnicity, *Beyond the Melting Pot* (1963), co-authored with Daniel Patrick Moynihan, and his 1983 study of multiculturalism eminently qualified him. But the Glazer of those two works bears little resemblance to the Glazer that emerged after the report.

Reading Glazer's preface to the second edition of *Beyond the Melting Pot* (1970) is like entering a time warp. He decries the complicity of the

white intelligentsia in the self-defeating demands of black militants, such as the dismantling of the meritocratic admissions system at City College. Long before the ironies of the blacks-only schools movement, he warns against rejecting the Northern model of ethnic incorporation in favor of Southern separatism. While acknowledging the right to celebrate black culture, he finds the refusal to participate in the common state "frightening." And while granting that there is a place for ethnic studies as a form of self-celebration and group reassurance, he calls for "a true, historical, sociological effort."

By the time of the Sobol Committee report, a transformation in Glazer's outlook seems to have occurred. He had initially planned to dissent from the report, but ultimately signed on and appended a comment instead. Adopting the *Times*'s approach, he praises the report for having avoided the extremes of "forceful Americanization and assimilation" on the one hand and a "parcelling out of American history into a different and incompatible story for each group" on the other. His acknowledgment that "the first danger is scarcely a present one" is quite an understatement. Merely to raise "forceful Americanization" as a possibility resurrects the very myth about Eurocentric curricular bias that Glazer's own research exploded. Glazer's only misgiving about the report is that it "offers some support" to the "danger of the hypostatization of race, ethnic group, culture, people."

Glazer's upbeat evaluation of the report is a far cry from his earlier debunking of the multiculturalist platform. But his comments still leave one unprepared for his article in the September 2, 1991, *New Republic*, subtitled, "Why the Sobol Commission Was Right." Glazer there abandons principle in favor of political accommodation. He adopts the position that if enough people are clamoring for a policy, however misguided, it would be churlish to oppose it on such weak grounds as educational excellence or a respect for history.

The article is a strange mix of honesty and complacency. He points out that the real impetus for multiculturalism is the low academic and economic achievement of American blacks. Multiculturalism has few advocates among immigrant groups, who would for the most part be content with the Anglo-American education that past immigrants received.

Glazer admits outright that "in the big cities, in many schools, an unbalanced, indeed distorted view of American and world history is prevailing." His response to that distortion is to shrug his shoulders and invoke demographics:

[W]hen set against the reality of majorities of black and Latino students in these schools, the political dominance of black and Latino administrators, the weak preparation of teachers and administrators in history, and the responsiveness of textbook administrators to organized pressure, the weight

of the truth of history, as determined by the best scholars, is reduced to only one interest.

Glazer justifies caving in to the distortion of history on the ground that history "has always played a socializing, nationalizing function." But even if such a function was accomplished by known distortions in the past, that is no reason to tolerate them today. Glazer poses the question: "What does one do in the face of these [demographic and political] trends?", and answers: "One thing is to fight the errors, distortions, untruths, imbalances," as did "some of the comments attached to the report." He is obviously not very impressed by that option. He castigates the "sharper critics of the report" for "fail[ing] to recognize that demographic and political pressures change the history that is to be taught." It is unlikely, however, that the two dissenters, Professor Schlesinger and historian Kenneth T. Jackson of Columbia, are blind to the demographic changes that are fueling the rewriting of history.

For those of us who are not so easy with the prospect of rewriting history to suit the alleged emotional needs of minorities, Glazer offers the following consolation: "While multiculturalism and Afrocentrism race ahead in some schools and systems, others may happily continue to be the schools many of us remember and approve of, with only some modest modifications to prepare students for tests with a surprisingly high content of questions dealing with blacks and women, and particularly black women." This solution borders on the cynical. If one version of history is truer to fact than another, why should only some children be exposed to it, while others receive convenient myth? And such disparate presentations of history guarantee an explosive clash in the future. Some students are learning that Graeco-Roman civilization was pilfered from "black" Egypt. When they discover that the rest of society thinks otherwise, will they, in the spirit of the Sobol report, attribute the difference to "multiple perspectives and situated histories"? Unlikely. Instead, they will see a racist conspiracy, and their alienation will only grow.

If this promise of a dual educational system fails to satisfy, Glazer tries a stronger claim:

> The skeletal structure [of American history] will remain, because we still live under the polity established by the Constitution, and it is in that polity, under that Constitution, that racial and ethnic and minority groups and women seek to expand their rights. It will be quite a job to keep nonsense and exaggeration and mindless ethnic and racial celebration out of the schools, but the basic structure of instruction in history will survive.

Glazer assumes that because the groups advocating revisionist history avail themselves of constitutional rights, they will somehow be either un-

able or unwilling to alter American history. But the more extreme of the Afrocentrists are hostile to the American polity and the Constitution, so even if they are "in it," how does that limit their ability to rewrite history? The only limits on that ability are political. If the multiculturalists amass enough power, they could find not just Iroquois but Egyptian influence on the Constitution.

However dubious Glazer's rationalizations of multiculturalism, his predictions about its likely course are wholly persuasive. Despite the multiculturalists' furious posturing as underdogs, their grip on the educational agenda is firm. Since their power depends on the stridency of their demands, however, they dare not acknowledge their own success—hence the paradoxes of the Sobol report, simultaneously berating the curriculum for lack of diversity while struggling to cope with the problems created by the surfeit of diversity.

What is finally at stake in the attack on the curriculum and canon is not only the truth of history and the viability of political union, but the grounds of human understanding as well. In a forum on multiculturalism in *The New York Times*, Stanford anthropologist Renato Rosaldo posed to the reader what he obviously considered a patently absurd situation: a typical California class of Asian-Americans, African-Americans, native Americans, and Chicanos, asked to "learn our heritage . . . from Plato and Aristotle to Milton and Shakespeare." Rosaldo asked: "Must [our students] continue to look into the curricular mirror and see nothing?" The question is chilling. To say that Plato, Aristotle, Shakespeare, and Milton offer "nothing" to an ethnically diverse class is to say that ideas are nothing, that complex, sensuous language is nothing, that imaginative exploration of fundamental human dilemmas is nothing, and that the only things that are not nothing are race and ethnicity.

The multicultural principle cuts both ways, however. If an African-American cannot be expected to see anything in Milton, how can a white student be expected to see anything in Frantz Fanon or Alice Walker? And how can students see anything in each other? Despite this inexorable tendency toward cultural apartheid, multiculturalists loudly proclaim themselves the first theorists to value the "Other." They thereby expose their own ignorance. The Renaissance humanists, for example, discovered in the classical world a pre-Christian Other, whose vision of politics and ethics deeply challenged the medieval order. Their struggle to understand that classical Other has provided us with a tradition of engaged scholarship that makes a mockery of multiculturalism's shallow theorizing. The passion with which they approached their study is embodied in Petrarch's Letters to the Ancients. In an act of supreme hermeneutic imagination, Petrarch wrote loving letters to the classical authors, questioning, sometimes criticizing, them, struggling to overcome the distance that separated himself from them.

Multiculturalism's pigeonholing of authors and historical actors by race and gender is antithetical to this humanist tradition. It elevates ignorance and philistinism to a moral principle. No one who has caught even a glimmer of the complexity of Plato and Milton could reduce them to co-efficients of race and gender. But students have always sought tools for simplifying the past, for reducing its vastness to a manageable scale. Deconstruction was particularly appealing, because negation always seems more powerful than affirmation. Multiculturalism continues in deconstruction's tradition of negation, but cuts a wider swath. With a single slogan, such as "Hey hey, ho ho, Western culture's gotta go!", students can dismiss an entire civilization. The effect is intoxicating. Yet it is a high that will leave us spiritually impoverished. Our public and private language is becoming increasingly inarticulate. When our language shrinks, so does our world. The works of Western civilization offer not just the foundations of liberalism but voices of unparalleled eloquence and beauty. They challenge us to respond. By silencing them we are ultimately silencing ourselves.

January 1992

When Reason Sleeps:
The Academy *vs.* Science

Roger Kimball

The first professor I saw was in a very large room, with forty pupils about him. After salutation . . . he said perhaps I might wonder to see him employed in a project for improving speculative knowledge by practical and mechanical means. . . . Every one knows how laborious the usual method is of attaining to arts and sciences; whereas, by his contrivance, the most ignorant person at a reasonable charge . . . may write books in philosophy, poetry, politics, law, mathematics, and theology, without the least assistance from genius or study.
—Jonathan Swift, *Gulliver's Travels*

El sueño de la razon produce monstruos.

—Francisco Goya

An English friend of mine tells the story of reviewing a book about the history of Russian Marxism for a major national newspaper here in the States. In the course of his review, he observed that G. V. Plekhanov was "the father of Russian Marxism." Minutes before the issue closed, an obtuse sub-editor took it upon himself to challenge this judgment. Surely it was Lenin, not Plekhanov, who deserved that august epithet. It just wouldn't do to call Plekhanov the father of Russian Marxism. My friend remonstrated; the sub-editor insisted; the minutes ticked by . . . Finally, they reached for a reference work that was handy: *pachysandra, Persia, pit viper, Pleiad,* . . . "PLEKHANOV, GEORGI VALENTINOVICH, 1857–1918. Russian revolutionary and social philosopher. . . . Often called the 'Father of Russian Marxism.'" The sub-editor digested this and, bloodied but not beaten, said petulantly, "Well, all right. You can leave it. *But it is a cliché.*"

I often think of this story when I consider the unedifying spectacle of academics in the humanities and social sciences attempting to deal with the barrage of criticism that has been leveled against them over the last decade. The first salvo came in 1984. In that year, the National Endowment for the Humanities, then directed by William J. Bennett, published *To Reclaim a Legacy*, a pointed attack on the way that the humanities were

being taught and a call to reshape the curriculum "based on a clear vision of what constitutes an educated person." The response to this report in the academy was a combination of disbelief and rage: disbelief that anyone could still seriously speak of such things as "civilization's lasting vision" and "its highest shared ideals and aspirations," rage that a mere government official (albeit one with a Ph.D. in philosophy) should dare to criticize the state of liberal education. If one were to judge from the long list of imprecations formulated to revile Mr. Bennett, one would have to conclude that he represented a monstrous threat to the survival of academic freedom, scholarly creativity, and true culture.

But the contempt showered on Mr. Bennett was mild compared to the apoplexy that greeted Allan Bloom when he published *The Closing of the American Mind* in 1987. Condescension turned to shock and, once again, to rage, as this impassioned exposé of the spiritual degradation of America's elite students shot up the best-seller list, lingering for months in the number one slot. Additional assaults on the academy followed: my own book, *Tenured Radicals*, Dinesh D'Souza's *Illiberal Education* (another best seller), David Lehman's *Signs of the Times*, Charles Sykes's *Profscam*, Camille Paglia's stinging essays on women's studies programs and kindred follies. Whether the subject was the institutionalization of Sixties radicalism on campus, political correctness, professorial dereliction, or the moral and intellectual fatuousness of deconstruction, the message was clear: something was very, very wrong with liberal education in American colleges and universities.

Again and again, the response in the academy to such criticism began in an access of panic, denial, and denunciation. But when it gradually became clear that nothing much was going to change—that the public was too uninterested and most college and university administrators were too pusillanimous to challenge the trendy imperatives of political correctness —then the response quickly modulated into one of hostile indifference. As with the officious sub-editor pontificating about Plekhanov, what began in denial ended with a shrug: what supposedly didn't exist yesterday is now routinely dismissed as old news, a "cliché."

This complacency may soon be upset. The publication of *Higher Superstition: The Academic Left and Its Quarrels with Science*[1] marks a vigorous new chapter in the attack on academic inanity. If any book can hope to re-ignite public outrage over the debacle that has been visited upon higher education in the humanities and social sciences, *Higher Superstition* is it. The Roman statesman Cato was fond of ending his speeches and letters with the admonition *Carthago delenda est*: "Carthage must be destroyed."

1 *Higher Superstition: The Academic Left and Its Quarrels with Science*, by Paul R. Gross and Norman Levitt (The Johns Hopkins University Press, 1994).

Cato would have liked this book. It is a devastating and minutely described portrait of politicized intellectual corruption. The story it tells is one of arrogance, ideological posturing, and breathtaking pretentiousness. Embarrassment often competes with disgust as we follow professor after professor through the jargon-littered maze of half-baked pronunciamentos, wild generalizations, and fatuous political "criticisms" of subjects that are preposterously misunderstood. The effect is both deeply satisfying and deeply disturbing: satisfying in that so many would-be debunkers are definitively debunked, disturbing in that many of the targets are big-name professors at some of the best universities in the country. One is left with a host of depressing questions: Is this really what tenure was instituted to guarantee, permanent intellectual irresponsibility? Is this what counts as a "liberal arts" education these days? Is this what one gets in exchange for $25,000 per annum in college fees?

Anyone acquainted with the controversy over political correctness on campus will find himself initially on familiar territory in *Higher Superstition*. The authors avail themselves of the same carnival of specimens that other critics of the academy have visited for their examples. All our old friends are here: deconstruction, postmodernism, multiculturalism, eco-feminism, Afrocentricism, animal-rights activism—the whole menagerie. And the criticism launched against these fads and fashions is cognate with the criticism put forward in other books critical of these trends in the academy. There are, however, several things that distinguish *Higher Superstition* from other recent books critical of the academy.

In the first place, there is the distinctive focus of *Higher Superstition*. Where other books have dealt primarily with the way that the left-wing politics and intellectual chicanery of professors in the humanities and social sciences have disfigured the teaching of their disciplines, this book concentrates on the way that the left-wing politics and intellectual chicanery of professors in the humanities and social sciences have impinged upon and disfigured the reputation and prestige of science. In recent years, more and more literary critics, historians, sociologists, and anthropologists have turned their attention to the "discourse" of science. It may almost go without saying that they have done this not in order to understand science, but to "deconstruct" its claims to truth and objectivity. They have applied to science the same techniques of textual criticism, gender-analysis, and ethnic grandstanding that won them such delicious notoriety when applied to literature, sociology, philosophy, etc. Intellectually and pedagogically, the results have been just as disastrous as they have been with literary criticism—just as disastrous and, if possible, even more absurd. Witness the existence of articles with titles like "Toward a Feminist Algebra," about which more below.

Higher Superstition is a guide to these absurdities. Written with clarity, wit, and passion, it is accessible to any educated layman. But, unlike other

books of the genre, it is addressed first of all to scientists. Appropriately, both of the book's authors are themselves scientists. Paul R. Gross, former director of the Woods Hole Marine Biological Laboratory, is University Professor of Life Sciences and director of the Center for Advanced Studies at the University of Virginia; Norman Levitt is professor of mathematics at Rutgers University. Unlike the vast majority of professors they write about, then, Professors Gross and Levitt actually know something about science from, as it were, the inside.

Perhaps the thing that most distinguishes *Higher Superstition* from kindred attacks on the academy is its political orientation. That, at any rate, is what Professors Gross and Levitt would have us believe. Hitherto, the best-known attacks on the academy have been described as "conservative." Never mind that without exception they were written in the hope of salvaging such classical liberal values as objectivity, impartial criticism, and the ideal of advancement according to merit: all have been widely excoriated by academics as "conservative," "reactionary," "fascist." And that is on a good day. Professors Gross and Levitt are extremely, even comically, anxious to avoid being tarred with the brush marked "conservative." One of them, they announce in a footnote, is a member of Democratic Socialists of America. They agonize at very great length over their unhappiness with their choice of the phrase "academic Left." Again and again they assure readers that, had any other term filled the bill, they would have used it. They let us know that some of their best friends are feminists. They support affirmative action. Really, they insist, they are writing not about "enemies" but (wayward) "friends." In what is perhaps the low point of this sort of hand-wringing, they complain that debates between liberals and conservatives today "often provide a right-of-center, nominally Democratic neoconservative as representative of the former, and a neofascist as spokesman for the latter." All one can say is that the debates Professors Gross and Levitt watch are different from those available to the rest of us.

Fortunately, all this ideological throat-clearing is beside the point. It may salve the political consciences of the authors; but they will soon discover that it does nothing to absolve them in the eyes of their left-wing colleagues. And there is no reason that it should. *Higher Superstition* is as sharply polemical in its dissection of left-wing academic blather as anything yet written. Although they go out of their way to distance themselves from other attacks on political correctness, Professors Gross and Levitt are perfectly aware of the shameful way that the Left employs moral intimidation to disarm criticism and silence opponents. This indeed is a subtheme of their book:

> If you decry the feminist critique of science, you are guilty of trying to preserve science as an old-boy's network. If you take exception to eco-

apocalyptic rhetoric, you are an agent, witting or otherwise, of the greed of capitalist-industrialist polluters. If you reject the convoluted cabalistic fantasies of postmodernism, you are not only sneered at for a dullard, but inevitably told that you are in the grip of a crumbling Western episteme, linked hopelessly to a failing white-male-European hegemony.

Sometimes the intimidation becomes blatant. A surgeon teaching at the University of California at San Diego used animals in one of his postgraduate classes; one day he received the following telephone message from an animal-rights activist: "Either Dr. Moossa stops the course or I will shoot him in the head." Dr. Moossa canceled the course, and that group of students was presumably left to perfect its surgical skills on human patients.

It must also be said that, whatever their own political sympathies, Professors Gross and Levitt are refreshingly forthright about the privileged place that left-wing ideology now enjoys in the academy. What we might call the "myth of marginalization" is very dear to the Left; believing that one is part of an oppressed minority is a great aid to solidarity; but the idea that women or blacks or homosexuals or any other recognized "victim group" is discriminated against in the university today is ludicrous. The "only widespread, *obvious* discrimination today," Professors Gross and Levitt note, "is against white males." Although the academic Left subscribes to a long list of radical sentiments, their subsidized radicalism is in fact a "radicalism without risk." Indeed,

> left-wing thinkers have never enjoyed anything remotely close to the current hospitality. Prestige-laden departments in the humanities and the social sciences are thickly populated—in some by now well-known cases we might say, without opprobrium [?!], "dominated"—by radical thinkers. Despite all protestations to the contrary, entire programs—women's studies, African-American (or Latino or Native American) studies, cultural studies—demand, de facto, at least a rough allegiance to a leftist perspective as a qualification for membership in the faculty.

Professors Gross and Levitt are equivocal about this entrenched leftism: they seem to want to endorse some of its sentiments. But they are pellucid and unremitting in their attack on the "peculiar amalgam of ignorance and hostility" characteristic of the academic Left's attitude toward science. They describe one book as "unalloyed twaddle," another as a "turgid and opaque tract"; the arguments put forward by their subjects are by turns "hallucinatory," "an irrelevant botch," "philosophical styrofoam," "interpretive contortion and hermeneutic hootchy-koo." Nor is their attack confined to employing a panoply of colorful epithets. Indeed, the great strength of their book is the unparalleled patience with which they

anatomize their opponents' arguments. Dozens of representative texts are quoted at length and then carefully analyzed into oblivion. Taken all in all, *Higher Superstition* is the most damaging indictment of the left-wing academic establishment in the humanities yet to appear.

The book begins with a historical sketch of the relation between the academic Left and science. As Professors Gross and Levitt point out, one of the oddities of the current attitude of hostility toward science on the part of the academic Left is that, since before the Enlightenment, progressive intellectuals have tended to look to science and technology as instruments of emancipation. There is a good reason for this:

> The dissecting blade of scientific skepticism, with its insistence that theories are worthy of respect only to the extent that their assertions pass the twin tests of internal logical consistency and empirical verification, has been an invaluable weapon against intellectual authoritarianisms of all sorts, not least those that sustain social systems based on exploitation, domination, and absolutism.

Professors Gross and Levitt cite Romanticism—Romantic sentimentality might be the better term—as one source of the academic Left's hostility toward science. A more important source is the radicalism of the 1960s: that potpourri of attitudes and attitudinizing that includes a hankering after irrationalism, various bits of left-wing ideology, a generalized anti-bourgeois animus, and a strong dose of cultural and epistemological relativism. It is this last—relativism—that perhaps more than any other ingredient undergirds the academic Left's hostility toward science. Plucking a tag from Nietzsche, Professors Gross and Levitt speak in this context of "perspectivism"—the idea that there are "no truths, only perspectives." This is the sacred dogma, the core creed of *bien pensants* academics today. It is endlessly repeated in articles and books, declamed loudly at conferences and in the classroom. Simply assumed, rather than argued for, the doctrine of perspectivism licenses the blasé rejection of empirical truth and nudges the academic Left toward its current epistemological incontinence. Like most forms of radical skepticism, perspectivism quickly involves its adherents in contradiction and absurdity. It is nonetheless difficult to criticize systematically, partly because we are dealing here not with a coherent doctrine but with "a congeries of different doctrines, with no well-defined center."

Professors Gross and Levitt's shorthand for this hodge-podge is "postmodernism." "As much as anything can be," they note, "postmodernism is the unifying doctrine of the academic Left." Its chief value is not as an explanatory tool—"postmodernism" in this sense betokens rather the despair of coherent explanation—but as "a heaven-sent device for avoiding close argument and the analysis of particulars."

Once a postmodern critic has at hand a license to read every proposition as its opposite when it suits his convenience, analytic skills of the more traditional sort are expendable and logic is effaced in the swirling tide of rhetoric. Once it has been decided that determinate meaning is chimerical and not worthy of the slightest deference from the well-honed poststructuralist postmodernist, the entire edifice of hard-won truth becomes a house of cards. Once it has been affirmed that one discursive community is as good as another, that the narrative of science holds no privileges over the narratives of superstition, the newly minted cultural critic can actually revel in his ignorance of deep scientific ideas.

If this description of intellectual irresponsibility seems overstated, try the experiment of listening in on the humanities and social-science faculties at almost any prominent college or university. You will encounter the postmodernist ethos in all its exotic efflorescence. There will be Marxists decrying "bourgeois science," environmentalists palpitating about ozone and radioactive waste, deconstructionists chanting about the tyranny of phallologocentricism; there will be devotees of cultural studies telling you that the truths of science—like all truths—are "culturally constructed," a sentiment seconded by feminists skirling that science is shot through with gender bias; you will find animal-rights activists denouncing "speciesism," multiculturalists castigating the "privileging" of "Western science," and Afrocentrists complaining about the under-privileging of African "ways of knowing."

As Professors Gross and Levitt observe, one important thing that enables these disparate, sometimes contradictory, allotropes of left-wing rebellion to coexist peacefully is their "shared sense of injury, resentment, and indignation against modern science." At the center of this gospel of victimhood is fury at the success and achievements of Western culture. Since science is perhaps "the single aspect of Western thought and social practice that defines the Western outlook and accounts for its special position in the world," it has come to epitomize for the academic Left everything that is wrong with the West: its reliance on so-called "linear thinking," its belief in objective truth, its glorification of technology. Nor is the distinctively Western character of science something that any amount of affirmative action can change. "In a hundred years, the greatest theoretical physicist in the world may well be Maori or Xhosa by descent," Professors Gross and Levitt note; "he—or she, as may well be the case—will nonetheless be a Westerner in the most important aspect of his or her intellectual temperament."

The insurmountable problem confronting our new academic "critics" of science is the dazzling success that science has had in explaining and manipulating the world. In brief, science *works*. Its speculations about the world are put to the test daily; daily they pass muster: the planes fly, the

bridges stay up, the vaccines save lives. And when they fail—when a bridge collapses or a vaccine ceases to protect—the solution is not a retreat to alchemy or eco-feminism or a special dance to appease the gods but more—and better—science.

Professors Gross and Levitt are the opposite of naïve. But, like anthropologists visiting some strange and backward tribe, they repeatedly betray a hint of bemused wonder as they catalogue the bizarre and outrageous opinions of their subjects. Consider: Sandra Harding, author of *The Science Question in Feminism*, describes Isaac Newton's *Principia* as a "rape manual." The Afrocentricist Hunter Adams assures readers that that "early African writings indicate a possible understanding of quantum physics and gravitational theory." A young scholar named Tim Dean writes in the journal *October* that "the discourses of philosophy, linguistics, and sociology must be supplemented in a truly psychoanalytic account of AIDS by concepts drawn from the discourse of mathematics, principally post-Euclidean geometry, which provides for topologic mappings based on a non-Euclidean concept of space." Poor Mr. Dean. In a note, Professors Gross and Levitt observe that his use of "topologic" seems to have its source in an article by the psychoanalytic guru Jacques Lacan. "Since the citation is from a piece of Lacan's called 'Desire and Interpretation of Desire in *Hamlet*,' it is pretty clear that someone has been getting literary *topoi* mixed up with the subject matter of mathematical topology. Whether the confusion is Lacan's or Dean's, we can't say. If Dean's, it is probably free of arrant fakery; but on the other hand, it then crosses the line from mere confusion into the realm of actual stupidity."

Wittgenstein spoke of metaphysics as "the idling of language." But the examples Professors Gross and Levitt adduce are something worse: they are language used as a deliberate affront to meaning and intelligibility. In short, they are a kind of sub-rational nonsense. But perhaps that is the point: after all, is not reason a bulwark of Western bourgeois respectability? What better way to subvert all that than to pervert reason deliberately by reducing language to a kind of ignorant babble? Professors Gross and Levitt observe with amazement that "we have the sense, encountering such attitudes, that irrationality is courted and proclaimed with pride. All the more shocking is the fact that the challenge comes from a quarter that views itself as fearlessly progressive—the veritable cutting edge of the cultural future."

One of the chief services performed by *Higher Superstition* is to have laid bare, once and for all, the breathtaking ignorance that the academic Left betrays in its "critique" of science. It is almost as if specific knowledge were held to be an impediment to insight. The assumption is that all one needs to criticize science is the correct moral outlook, the correct "stance" on science: actual knowledge just gets in the way. One finds

books that pontificate about the intellectual crisis of contemporary physics, whose authors have never troubled themselves with a simple problem in statics; essays that make knowing reference to chaos theory, from writers who could not recognize, much less solve, a first-order linear differential equation; tirades about the semiotic tyranny of DNA and molecular biology, from scholars who have never been inside a real laboratory.

And on and on.

An extraordinary arrogance often accompanies the ignorance. Typical is the case of Andrew Ross, a trendy professor of "cultural studies" who has just moved from Princeton to New York University. Professor Ross dedicates his new book, *Strange Weather: Culture, Science, and Technology in the Age of Limits*, to "all of the science teachers I never had. It could only have been written without them." Who could doubt it? Consider Professor Ross's blithe rejection of the effort to distinguish between authentic science and pseudo-science: "In the wake of Karl Popper's influential work . . . falsifiability is often put forward as a criterion for distinguishing between truly scientific work and the pseudo-scientific. But . . . falsifiability is a self-referential concept in science inasmuch as it appeals to those normative codes of science that favor objective authentication by a supposedly objective observer." Professors Gross and Levitt comment: "So much, then, for three thousand years of struggle to develop a systematic method for getting reliable information about the world!" What Professor Ross is really saying, they note, is that "science backs up its claims, whereas pseudo-science doesn't, but I don't care about the difference." No wonder Princeton and New York University have been eager to obtain Professor Ross's services.

In many ways, the feminist assault on science is the most preposterous. As with Afrocentrism, the grip of feminist ideology is often so strong that adherents frequently lapse into gibberish. Thus we find feminists incensed that biologists should have been so sexist as to describe spermatozoa as actively pursuing and penetrating the ovum. The authors of one influential feminist study group sniff that such descriptions demean women by picturing conception as "a kind of martial gang-rape" in which the ovum is portrayed as "a passive victim, a whore." Gee.

I have already mentioned "Toward a Feminist Algebra." The point of this influential article, by Maryanne Campbell and Randall K. Campbell-Wright, is that gender-bias in mathematical word problems has discouraged women from learning mathematics. Yes, really. Hence they object to a problem in which a girl is running toward her boyfriend because it portrays *heterosexual* involvement (one about "Sue and Debbie" buying a house together gets their seal of approval); they object to a problem involving construction workers because the workers are assumed to be male; and so on. What they want are problems "presenting female heroes

and breaking gender stereotypes." And this is algebra? As Professors Gross and Levitt point out, there is no such thing as a "feminist mathematics." To dwell on the incidental details of a word problem is to misunderstand what math is all about. It matters not a whit whether Sam is selling hotdogs to Martha or Alice is peddling brownies to Gertrude. To miss this is to miss everything. One of the worst effects of such performances—and again the analogy with "Afrocentric science" comes to mind—is that they cheat students of really learning anything about the subject at hand. Instead of encouraging women to learn mathematics—a laudable ambition—Campbell and Campbell-Wright's paper is used "to justify the use of mathematics classrooms as chapels of feminist orthodoxy."

If such drivel were the rare exception, it might be overlooked. Unfortunately, it has become the norm in feminist treatments of science. Take the work of N. Katherine Hayles. Professor Hayles holds an endowed chair at a major university; she is the recipient of a fellowship from the Guggenheim Foundation; she has been the president of the Association for Science and Literature, chairman of the Literature and Science Committee of the Modern Language Association. Her book, marvelously titled *Chaos Bound*, is published by a distinguished university press. Professors Gross and Levitt describe the book as an attempt to draw parallels between chic literary theory (deconstruction, etc.) and the mathematics of chaos. The problem is that, mesmerized by the word "chaos," Professor Hayles has failed to learn anything about the subject she is writing about. The result is indeed chaos, but of a rather more pedestrian variety than she intended. "The special theory of relativity," Professor Hayles intones, "lost its epistemological clarity when it was combined with quantum mechanics to form quantum field theory. By midcentury all three had been played out or had undergone substantial modification." But this is hooey. Professors Gross and Levitt observe that, far from having lost "epistemological clarity," "special relativity and quantum mechanics are as solidly confirmed as it is possible for physical theories to be." They continue:

> While there may be some lingering doubts whether general relativity is quite the right model on the cosmological scale, the special theory has always triumphantly passed every empirical test. However physics develops in the future, any modification must subsume rather than displace special relativity, just as special relativity subsumed Newtonian mechanics. . . . As for quantum field theory, one mathematical aspect of the great project to provide a truly unified framework for both relativity and quantum mechanics, this is an ongoing project that engages the deepest and liveliest intellects in physics and mathematics. "Played out?" The best that can be said for Hayles is that she confuses the fact that physics is very much a continuing discipline, and, therefore, has fascinating foundational problems left to

solve, with some kind of philosophical and spiritual exhaustion. If anything is played out, it is the postmodernist's pretension to have something interesting to say about physics.

Professors Gross and Levitt have a lot more to say about Professor Hayles, none of it pretty. Particularly sobering is the realization that she presents a relatively mild case. Another big name in the feminists-deconstruct-science industry is Donna Haraway, a professor in the history of consciousness program at the University of California at Santa Cruz. Professor Haraway has it all: stupifying ignorance, slavish reliance on feminist and other ideologically correct clichés, reflexive spouting of "radical" slogans, and a mind-boggling inability to distinguish between verbal and conceptual similarity. Writing recently in *Configurations: A Journal of Literature, Science, and Technology*, Professor Haraway informs us that she wishes "to suggest how to refigure—how to trope and how to knot together—key discourses about technoscience."

> Rooted in the (sometimes malestream and maelstrom) cross-stitched disciplines of science studies, this short essay is part of a larger, shared task of using antiracist feminist theory and cultural studies to produce worldly interference patterns. Because I think the practices that constitute technoscience build worlds that do not overflow with choice about inhabiting them, I want to help foment a state of emergency in what counts as "normal" in technoscience and in its analysis. Queering what counts as nature is my categorical imperative. Queering specific normalized categories is not for the easy frisson of transgression, but for the hope for livable worlds. What is normal in technoscience, and in its analysis, is all too often war, with all its infinitely ramifying structures and stratagems.

Remember that this woman is not some crank dredged up from the shadows: she is a professor at a distinguished university and one of the leading lights of contemporary "women's studies."

The real problem with feminist notions of science is that the object of their attack is a total figment: there is no such thing as "male science," any more than there is a "white science" or an "African science." Fired by a generalized resentment against "patriarchy," besotted with misunderstood technical jargon (savor, for example, Professor Haraway's use of "categorical imperative" above), these scholars have succumbed to a species of language mysticism. Phrases like "paradigm change," "chaos theory," "the uncertainty principle" are intellectual catnip to them: a source of intoxication and befuddlement.

It is not surprising that the academic Left denies the universality of scientific truth. This has long been a favorite gambit of mystagogues, including

some eminent ones. Professors Gross and Levitt quote Philipp Lenard, a Nobel laureate in physics who was also an ardent supporter of the Nazis. Here is Lenard denouncing Albert Einstein:

> German physics? one asks. I might rather have said Aryan physics or the physics of the Nordic species of man. The physics of those who have fathomed the depths of reality, seekers after truth, the physics of the very founders of science. But, I shall be answered, "Science is and remains international." It is false. Science, like every other human product, is racial and conditioned by blood.

Or gender. Or skin color. Or ethnicity. Or ideological affiliation. Take your pick.

Professors Gross and Levitt conclude by arguing for the "necessity of seeing to it that whatever is labeled as 'science education' in our colleges and universities *deserves* that designation." To this end they suggest that scientists participate in conferences and symposia where scientific issues are the ostensible subjects; they suggest likewise that scientists be consulted on promotion and tenure decisions for colleagues in the humanities who claim a professional expertise in the "discourse" of science. (Fare thee well, Andrew Ross! So long, Donna Haraway!) Naturally, such proposals will be unacceptable to the "humanists" whose follies are dissected in this book. But have they not forfeited their authority along with their credibility? And, indeed, should we not require "equal treatment" for the humanities, demanding that whatever is labeled as 'humanities education' in our colleges and universities also *deserves* that designation?

It will be said that Professors Gross and Levitt are sterile rationalists, unattuned to the literary or speculative temperament. That is piffle. The problem is not the literary temperament but pernicious nonsense. Professors Gross and Levitt use the tag from Goya quoted at the beginning of this essay as one of their epigraphs: "When reason sleeps, monsters are born." As they note, the dictum has always been ambiguous. On one reading, it is a slogan for the Enlightenment: without reason, mankind is helpless before the arbitrary imperatives of superstition. On another, it cautions against the hubris of reason: the sleep of reason yields extravagant, often dehumanizing dreams. The academic Left has the peculiar distinction of exhibiting both vices: irrationalism and a hyper-rationalism unchastened by common sense. These are the failings that Professors Gross and Levitt attack. Toward the end of their book, they write that "the humanities, as traditionally understood, are indispensable to our civilization and to the prospects of living a fulfilling life within it. The indispensability of professional academic humanists, on the other hand, is a less certain proposition." It is difficult to disagree.

May 1994

III. The Arts Today

Willem de Kooning at 90

Hilton Kramer

Fame is like a river, that beareth up things light and swollen, and drowns things weighty and solid.

—Francis Bacon, in *Essays* (1625)

No American painter of his generation—the generation that gave us the New York School—has been the object of more adulation, imitation, interpretation, and sheer unbounded admiration than Willem de Kooning, whose work is currently the subject of an exhibition marking the artist's ninetieth birthday. None has enjoyed greater critical acclaim, either. Long before the public was given its first glimpse of his work, he won the support of artists and writers—among them, John Graham, Arshile Gorky, Edwin Denby, Rudy Burckhardt, and Fairfield Porter—who recognized his exceptional talent and accorded it a special esteem. In 1936, exactly a decade after de Kooning's arrival in the United States as an immigrant from the Netherlands, Holger Cahill included a work of his in the exhibition "New Horizons in American Art" at the Museum of Modern Art, which had been founded in New York only seven years earlier. In 1942 —the year he met Jackson Pollock and Marcel Duchamp—de Kooning made his gallery debut in the company of Bonnard, Matisse, and Picasso in an exhibition, "American and French Paintings," organized by John Graham, and two years later Sidney Janis included the artist in his book *Abstract and Surrealist Art in America*. Which was not a bad start for an artist unknown to the public, unwritten about in the press, and without connections in the world of money and fashion. The New York art world was then a smaller and more private place than it is today, and it followed a slower pace. Yet within its avant-garde ranks, which the public knew little or nothing about, de Kooning seems to have been nominated for a position of greatness almost as soon as his presence became known, and that position was confirmed—at least for the cognoscenti—with the artist's first one-man exhibition at the Egan Gallery in the spring of 1948. Writing about the show in *The Nation*, Clement Greenberg promptly

hailed the "largeness and seriousness" of de Kooning's art. He straight-away placed de Kooning among "the four or five most important painters in the country," and pronounced the exhibition itself "magnificent." Six months later, the Museum of Modern Art acquired its first de Kooning for the permanent collection. The artist was forty-four, and still living hand-to-mouth, but he was already a star in what was coming to be known as the New York School.

It was in the Fifties that de Kooning's commanding reputation became a public phenomenon for the first time. For the so-called "second-genera-tion" painters of the New York School, he was a sovereign figure, presid-ing over the downtown art scene with an unquestioned authority in a do-main largely defined by his example and influence. Every possibility which the artists of the "second generation" wished to pursue seemed to be con-tained and sanctioned in his own pictorial practice. With that celebrated first solo exhibition in 1948, de Kooning had emerged as a leader of the Abstract Expressionist movement. Then, in 1953, he created a sensation as the champion of a new figurative Expressionism with the exhibition of "Paintings on the Theme of the Woman" at the Sidney Janis Gallery. By 1956, he had turned again to abstraction—a looser, more chaotic, more colorful mode of Abstract Expressionism than anything he had attempted in the late Forties. It was in a review of those Fifties abstract paintings, when they were shown at the Janis Gallery in 1956, that Thomas B. Hess wrote in *Art News* that de Kooning had now "replaced Picasso and Miró as the most influential painter at work today."

This claim may have been true at the time, but it was also the sign of a disaster. "The fabrication of synthetic de Koonings had become a Tenth Street industry, and one of the games people played in those days was to see how many times Mr. de Kooning's name would turn up in each month's issue of *Art News*," I wrote of this period a few years later.[1] By 1959, however, even the editors of *Art News* were moved to ask "Is There a New Academy?", and Hess spoke ruefully of de Kooning's influence having reached a "high comic point as young artists [made] whole one-man shows out of a studio idea swallowed whole from still unfinished de Kooning paintings." Except for a few dissenting voices, my own among them, the artist himself was exempted from such criticism. As I wrote in the article already cited, "The cult of personality seemed to increase in exact ratio to the decline of the artist's work." And decline it did, more and more disastrously in my opinion, as the artist lapsed into self-parody and joined the ranks of his most facile imitators. Almost as soon as de Kooning emerged, with the paintings of the 1946–1950 period, as one of

[1] This article appeared in *The New York Times* on November 19, 1967, and was reprinted in my book *The Age of the Avant-Garde* (1973).

the most accomplished abstract painters of his generation, he became, in effect, the chief academician of the Abstract Expressionist movement—the *chef d'école* of its decadence who would never again produce anything to equal the splendor of *Painting* (1948), *Attic* (1949), *Excavation* (1950), and the other abstract masterworks that won him his first public acclaim.

Yet no matter how weakened and mannered and parodistic the paintings became, the juggernaut of canonization persisted in accelerating its claims, and continued to do so even in the face of the debacle that overtook the man himself from the Seventies onward, when his faculties were clearly failing—first as a result of uncontrollable drinking and the quantities of valium he was taking to cope with it, and finally as he succumbed to the mental occlusions of Alzheimer's disease. One hardly knows whether to laugh or to cry as we are asked to believe that these impairments imposed no discernible disability upon the artist's creative faculties —a claim that is, in any case, emphatically belied by the vacuous character of the paintings themselves. At ninety, and despite the immense inventory of failed paintings that now bears his name, Willem de Kooning is still being presented to us as an artist exemplary in his every endeavor. Thus the tragedy of a fallen talent is rewritten to read as a triumph over adversity, and the transformation of a very limited achievement into an art of epochal dimensions continues unabated.

It was not to be expected that the exhibition which has now been organized to mark the artist's ninetieth birthday would represent any change in this process of mythification, and it doesn't.[2] The only difference is that the chorus singing his praises has been supplied with a revised libretto for its rituals of celebration. Whereas in the past de Kooning was hailed by his partisans as the pre-eminent master of the New York School, now he is exalted as a kind of honorary European master whose late works, as the English critic David Sylvester writes in the catalogue for the current exhibition, "belong with the paintings made at the same age by artists such as Monet and Renoir and Bonnard and, of course, Titian." This is only the most grotesque of the many claims advanced by Mr. Sylvester, who collaborated on the selection of the exhibition, to suggest that the magnitude of de Kooning's achievement can be fully understood only from a European perspective. He sets about this task of critical relocation in the very first sentence of his essay, which serves as the introduction to the catalogue and sets the hyperbolic tone for everything that follows.

2 "Willem de Kooning: Paintings," selected by Marla Prather, David Sylvester, and Nicholas Serota, at the National Gallery of Art in Washington, D.C. (May 8–September 5, 1994). A catalogue of the exhibition, with essays by Mr. Sylvester and Richard Shiff, was published by the National Gallery and Yale University Press.

The Dutch masters of the seventeenth century worked at home [he writes], the Dutch masters of modern times worked abroad. Van Gogh first left Holland when he was twenty and was elsewhere for all but five of his remaining seventeen years; Mondrian first left at forty, was elsewhere for all but five of his remaining thirty-two years; de Kooning first left at twenty, has been elsewhere for all but one of seventy years.

Never mind that it was only in America that de Kooning became a serious artist, or that it was under the influence of Gorky, among others, and in the context of the New York School that the painter produced his first major works. By the time we get to the bottom of the first page of Mr. Sylvester's essay, de Kooning has been whisked in and out of New York in a fast-forward trajectory that lands him, at the top of the second page, in "a landscape by Van Goyen" (which just happens to be part of Long Island), where "the emigrant was still at home."

This is quickly followed by a brief attempt to discredit the importance of the Abstract Expressionist movement for de Kooning, while at the same time Abstract Expressionism itself is characterized as having been "not a movement like Impressionism . . . where a work by one of its leading members can easily be thought to be by another"—an observation that nicely manages to misapprehend the nature of both Impressionism and Abstract Expressionism in a single sentence. (You need only place the largely black-and-white abstract paintings that de Kooning produced in the late Forties in the company of the other largely black-and-white abstractions of the period to see the complete falsity of Mr. Sylvester's specious distinction.) The point of all this, anyway, is less to disparage the Abstract Expressionist movement in any categorical way—for you can be sure that Mr. Sylvester will return another day to praise it in the highest terms, if properly commissioned to do so—than to free de Kooning from the burden of his reputation as an American painter in order to relocate him among the European artists this critic has long upheld as his special idols—Alberto Giacometti and Francis Bacon.

Having accomplished that critical feat, which also entails linking de Kooning with Giacometti and Bacon as fellow Existentialists, Mr. Sylvester then goes on to claim that "de Kooning and Bacon and Giacometti are all somewhat in the line of Degas." Whether Degas is now to be forgiven for his participation in the Impressionist movement, where it is alleged by Mr. Sylvester that "a work by one of its leading members can easily be thought to be by another," the writer does not say. Nor does he bother to tell us if this reference to "the line of Degas" means that Degas, too, is now to be thought of as some sort of Existentialist *avant la lettre*. Of course it is all nonsense. The real "line" to be observed in Mr. Sylvester's preposterous essay is the line of hokum that certain English critics have made a specialty of in writing about American art. Until now, I

thought the prize specimen of that hokum was the monograph on Jackson Pollock (another of Mr. Sylvester's candidates for Existentialist honors, by the way) written by Bryan Robertson some years ago, but with his essay for the de Kooning catalogue Mr. Sylvester has now moved into first place. It is really a scandal for our National Gallery to have sponsored such a distorted account of our own art history.

This is not to say that de Kooning's American panegyrists have not also disgraced themselves and the whole field of contemporary art criticism by making similarly preposterous claims on the artist's behalf. In an essay for the catalogue of the current exhibition that is even longer and more pretentious than Mr. Sylvester's, Professor Richard Shiff says of de Kooning that "the artist has taken the timelessness of Zen, Existentialism, Heidegger, Kierkegaard, Wittgenstein, Gertrude Stein, and whoever else circulated through the Manhattan-to-Springs art community—taken this timelessness and rendered it as ordinary as the trees left over in a back yard." He then quickly adds: "As always, de Kooning asserts the ordinary, corny view of things over intellectual, political, and social pretensions." But why, we may ask, if what really interested de Kooning was the "ordinary, corny view of things," should we attribute to him, as Professor Shiff does, some mysterious linkage with the ideas of "Heidegger, Kierkegaard, Wittgenstein," et al., which the artist surely never had and which, in any case, is not easily acquired by way of gossip or osmosis—the two possibilities that suggest themselves by the reference to the talk that is alleged to have "circulated through the Manhattan-to-Springs art community"? There are whole passages in Professor Shiff's essay where he seems to take it for granted that the content of de Kooning's mind bore a distinct resemblance to that of the published utterances of his friend Harold Rosenberg—itself a hilarious notion. This, in turn, prompts Professor Shiff to advance the proposition that de Kooning's painting might also have harbored some kind of "politics," though when we examine this proposition the "politics" in question are little more than a gloss on Rosenberg's ideas and are said, anyway, to have their origin in the artist's decision to escape the restrictive influence of his strong-minded mother. Thus, when de Kooning's mental life isn't made to sound like a graduate seminar in modern thought, it is placed on the couch for evidence of a Freudian family romance. This is a feat of speculative fantasy that makes it impossible to say anything cogent or verifiable or even interesting about the art of painting as de Kooning practiced it—or, indeed, failed to practice it.

There is, to be sure, a discernible project at work in this concerted effort to press de Kooning into service as Existentialist saint or as cousin to the Old Masters. The latter point, by the way, has now ascended to a new plateau of shameless rhetorical silliness. For Adam Gopnik, writing about the current exhibition in *The New Yorker*, de Kooning qualifies as both

"the Rubens of regression" and "a cross between Frans Hals and Tom Sawyer." And not wanting to be outdone, I suppose, by Mr. Sylvester, who compares de Kooning's "drollery" to that of Shakespeare, Mr. Gopnik also alleges that the artist's late paintings are "radiant the way the songs in *The Tempest* are radiant." Professor Shiff, on the other hand, settles for a resemblance to Baudelaire because of what is claimed to be a shared interest in fashion "from costume and coiffure to gesture, glance, and smile." Does this, too, place de Kooning in "the line of Degas"? Mercifully, Professor Shiff doesn't say—possibly because what he does have to say on the subject makes de Kooning sound less like Baudelaire or Degas than like Constantin Guys, a far lesser historical eminence.

It hardly matters, however, whether we are invited to think of de Kooning as an embodiment of the deepest currents of contemporary philosophical thought or as the modern equivalent of your favorite Old Master or as some super-colossal combination of both—a kind of late Titian or Rubens of the Hamptons who spoke the language of Jean-Paul Sartre with a New York (read: Harold Rosenberg) accent. The point of all this is to shift the discussion of de Kooning from the aesthetics of abstraction—specifically the abstract painting of the New York School— in order to make the *content* of all those failed late paintings the locus of the artist's true achievement. In this reading of the de Kooning *oeuvre*, the artist is scarcely an abstractionist at all. He is presented to us as, above all, a traditional figure and landscape painter even in those paintings, which constitute the bulk of the later work, in which no figures or landscapes are discernible or intended.

The exhibition that has been selected by David Sylvester, Nicholas Serota, and Marla Prather for this occasion is expressly designed to support such a distorted view of de Kooning's career. The paintings that established the artist as one of the masters of the New York School—the Abstract Expressionist paintings of 1946–1950—are treated as little more than a prologue to later and greater glories. Which is why, presumably, the catalogue essays by Mr. Sylvester and Professor Shiff virtually ignore the Forties abstractions and concentrate on transforming the pictorial dross of the later paintings into something that might pass for pure gold.

For that purpose, Professor Shiff goes so far as to depict de Kooning as a painter *opposed* to abstraction. (Mr. Sylvester does the same thing, albeit more discreetly, by placing de Kooning in the company of Francis Bacon and Alberto Giacometti.) While acknowledging that de Kooning, in one of his very few cogent statements on the subject, once dismissed the whole role of "content" in his painting as "tiny"—"It's very tiny—very tiny, content," he said—Professor Shiff nonetheless plunges headlong into an attempt to invest the artist's later paintings with a "content" so enormous that it diverts all attention away from the fate that has befallen pictorial form in those paintings. "Of all movements, I like Cubism most," de

Kooning once declared. Yet Professor Shiff's fixation on the supposedly momentous "content" of the later paintings obliges him to overlook the formal catastrophe that overtook the artist's work when, beginning with those vacuous abstractions of the mid-1950s, the Cubist substructure of the late Forties pictures gave way to a kind of painterly meltdown in which a lot of routine brushwork and paint splashing was made to serve as a substitute for pictorial thought. Cubism had always been de Kooning's refuge in the stormy sea of Abstract Expressionist painting, and without it he was lost. But to account for that loss, you have to be more interested in pictorial form than in some fantasy about a "content" so elusive that every one of the artist's admirers is obliged to invent it for himself. So intent are these admirers on this task of invention that they are utterly indifferent to the ghastly paradox they have imposed upon the public's perception of de Kooning's achievement—namely, the idea that as the artist's mental faculties have progressively failed him he gave greater and greater priority to the content of his art. It is only in the debased discourse of art-world advocacy that such triumphs of a failed mind are believed to be possible.

How, then, are we to account for this effort to turn a personal tragedy into an artistic triumph of world-class importance? The best attempt at an answer that I have seen is to be found in the article that Peter Plagens devoted to the subject in *Newsweek* March 7, 1994. Mr. Plagens brings to the discussion of de Kooning's work a high degree of admiration—he claims at the outset that he regards the artist as "the greatest American painter since Thomas Eakins"—yet he remains a writer for whom the realities of life, as distinguished from the vested interests of the art world, still count for a lot. Thus he wrote:

> Most of the late work is held by the de Kooning Conservancy—a kind of estate before-the-fact overseen by de Kooning's daughter and sole heir, Lisa, 37, and attorney John Eastman, son of de Kooning's one-time lawyer, Lee. Prices for a 1980s de Kooning have reached $3.5 million, and a 1955 painting sold for $20.7 million in 1989. When members of the art world approach the gravitational pull of such large sums, they start blowing smoke like State Department spokesmen explaining an invasion. The tendency is exacerbated by the fact that big bucks in art derive not from millions of critic-impervious little people paying $16.95 per CD, but from a collector elite. Whispers of doubt can dissuade an important client and drive the whole market south. But chances of a crash for the late paintings will be lessened considerably if de Kooning can be established as America's one true 20th-century master.

This isn't exactly art criticism, but it tells us a lot more of what we need to know about the exhibition "Willem de Kooning: Paintings" than anything to be found in the show itself or its catalogue.

June 1994

A Dissent on Kiefer

Jed Perl

Half a century after *Kristallnacht*, the Holocaust is a treasure trove of superstrength imagery that artists are inclined to adapt with little apparent hesitation. In some cases, there's an honest if dangerous effort to bring the unimaginable into line with the needs of the contemporary imagination; elsewhere images are presented in such a way that their precise relation to Hitler's Final Solution is veiled, even obfuscated. The Anselm Kiefer retrospective, currently at the Museum of Modern Art on the final leg of a four-city, nationwide tour, is a phenomenon that has brought an aestheticized fascination with Nazi Germany to the attention of an enormous public.[1] Kiefer's mammoth images of charred tracks of earth are if nothing else a *tabula rasa* upon which many critics have inscribed their own overheated associations. And these associations have been abetted by curator Mark Rosenthal's text for the catalogue, which marshals the forces of art-historical scholarship to lend Kiefer's jazzy reputation as a contemporary tragic hero some weight, some dignity, some mythic resonance. Meanwhile, for those of us who are disinclined to take our *Zeitgeist* readings from the media or the Museum of Modern Art, the appearance of the Holocaust as a motif in half a dozen shows by contemporary Americans suggests that Kiefer is hardly alone as he stirs the once irreducible facts of annihilation into a modern artist's metaphorical stew.

Despite all the attention that's been focused on Anselm Kiefer, people seem uncertain about how to react to his use of modern German—and modern Jewish—history. Because he's creating Art, people assume they have to suspend all (or at least most) reservations. Jews seem to feel almost guilty about their discomfort, as if they would expose a lack of cultural refinement by concluding that the obliteration of their not-too-distant ancestors was a dubious occasion for exercises in the Beautiful or

1 "Anselm Kiefer" was on view at the Museum of Modern Art, New York, from October 17, 1988, through January 3, 1989. A catalogue, by Mark Rosenthal, was published by the Art Institute of Chicago and the Philadelphia Museum of Art in association with Prestel-Verlag.

the Sublime. Moreover, art critics, unlike literary critics, have rarely tackled the many aesthetic and extra-aesthetic questions that bear on the Holocaust.

Perhaps the best place to look for some insight into the contemporary fascination with fascist ideology is Saul Friedländer's extraordinary book *Reflections on Nazism: An Essay on Kitsch and Death* (published in France in 1982 and in the United States by Harper & Row two years later). Friedländer is a Jew who spent his childhood hidden in Nazi-occupied France (this part of his life is related in a widely acclaimed book of reminiscences, *When Memory Comes*); he has also published a number of scholarly works on the Holocaust. In *Reflections on Nazism* he brings to a very difficult subject an impassioned yet somehow cool intelligence. The book is rather unusual in the literature that deals with artistic responses to the Final Solution in that, unlike most studies, which analyze works created by survivors, it focuses on the image of the Holocaust in literature and movies since the Sixties. Though Kiefer isn't mentioned, many of Friedländer's observations throw a light on Kiefer's art and reputation.

"Attention," Friedländer writes,

> has gradually shifted from the reevocation of Nazism as such, from the horror and the pain—even if muted by time and transformed into subdued grief and endless meditation—to voluptuous anguish and ravishing images, images one would like to see going on forever. . . . In the midst of meditation rises suspicion of complacency. Some kind of limit has been overstepped and uneasiness appears: It is a sign of the new discourse.

Reflections of Nazism is difficult to summarize, probably because much of the beauty of this brief book rests in the elusive, circuitous manner of Friedländer's reasoning, his willingness to simplify or to tie together ends better left loose. It's the very porousness of his effects that enables him to suggest some of the strange ways in which "the endless stream of words and images becomes an ever more effective screen hiding the past." Through quotations from Joachim Fest's biography of Hitler and the memoirs of Nazi architect Albert Speer, Friedländer demonstrates how Hitler succeeded in projecting himself as a German hero and his cause as a German cause by swathing Nazi ideals in a kitsch imagery that had a strong hold on the middle-class imagination. Kitsch—which Friedländer, quoting Abraham Moles, calls that "pinnacle of good taste in the absence of taste, of art in ugliness"—still appeals; and Friedländer's central insight is that the contemporary avant-garde's fascination with Nazi images echoes the original appeal of the Nazi mystique. The contemporary artist's response to the symbolic power of Nazism may not be so different from the response of the German of fifty years ago. About this mirroring of the past in the present Friedländer is obviously ambivalent: it's dangerous,

but at the same time certain contemporary works may help us to understand something about the overwhelming attraction of a hideous ideology. "In effect," Friedländer writes, "by granting a certain freedom to what is imagined, by accentuating the selection that is exercised by memory, a contemporary re-elaboration presents the reality of the past in a way that sometimes reveals previously unsuspected aspects."

Over and over again Freidländer emphasizes how ambiguous a role Hitler has in contemporary art. Hans-Jürgen Syberberg's movie *Hitler, a Film from Germany* is perhaps the central piece of evidence—a movie that intermingles fascist kitsch, as in the sentimental memoirs of Hitler's valet, with the avant-garde infatuation with kitsch. Of Syberberg's effort, Friedländer writes, "It may result in a masterpiece, but a masterpiece that, one may feel, is tuned to the wrong key." "In facing this past today," Friedländer says later on, "we have come back to words, to images, to phantasms. They billow in serried waves, sometimes covering the black rock that one sees from all sides off the shores of our common history." Aestheticism, he says, is a defense against reality. This, it seems to me, is a perfect description of the appeal of Anselm Kiefer. In Kiefer's work, as in many of the works Friedländer discusses, the Nazi past has become a potent but also elusive presence—a sort of texture, made up of the burnt grays and blacks that evoke charred bodies, a sensuous texture, a texture that seduces more than it illuminates. And this seduction serves to divert our attention from the hard facts.

Mark Rosenthal, the curator at the Philadelphia Museum of Art who wrote the catalogue for the Kiefer retrospective, isn't unaware of some of the problems that Saul Friedländer raises. Rosenthal's essay, however, grows out of a desire to operate in sync with Kiefer, and this ultimately amounts to something like collusion. The Holocaust is barely mentioned; and so the central fact of modern German history, the fact that makes it qualitatively distinct from all other histories, is lost in the misty art-historical analysis.

Kiefer's *March Heath* (1974) depicts the wide-open perspectives and dappled birch trees of an area southeast of Berlin that's long been admired by Germans for its natural beauty. Rosenthal tells us that "the area is happily recalled for many Germans in Theodor Fontane's *Walking-Tours through the Brandenburg March*, written in the nineteenth century"; but this wistful, rather literary nostalgia is hardly the point when, as Rosenthal explains, the March Heath that Kiefer presents is layered with metaphoric importance. According to Rosenthal, this is an area "which in this century was lost first to Russia and later to East Germany." And "adding to the multiple associations of the painting is [the fact] that 'Märkischer Heide, märkischer Sand,' an old patriotic tune of the region, became a marching song for Hitler's army." To say, as Rosenthal does, that the territory

depicted in *March Heath* "has become a sad memento mori of the Nazi experience and the separation of Germany" is both to aggrandize the meaning of a fairly ordinary landscape and to engage in Holocaust control. "Sad memento mori" softens the past, pretties it up; and the equation of "the Nazi experience" with "the separation of Germany" suggests a capitulation to the idea that the Holocaust is merely one calamity among others. Elsewhere, Rosenthal speaks of "the more difficult aspects of [Kiefer's] German heritage"—again, a euphemism. And of how Kiefer "drifted further back in German history"—again, calamity as an atmosphere one floats through.

Also disturbing are some comparisons that Rosenthal makes between Kiefer and other modern or contemporary artists. These art-historical sallies have the effect of deflecting attention from the uniqueness of Kiefer's situation. "In *Cockchafer Fly*," Rosenthal observes, "Kiefer became a kind of war poet, and the blackened, scorched earth his central motif, his Mont Sainte Victoire, as it were, showing the province of the landscape to be human suffering, not the glory of nature." "A kind of war poet" is again a case of prettying things up. The comparison to Cézanne casts Kiefer in a cleansed, elevated, modern-masterish context. To say that Kiefer makes the landscape "the province of . . . human suffering" only points up the way he sanitizes suffering. After all, how much easier it is to imagine a landscape "suffering" than to imagine a person suffering.

Another comparison, this one to Warhol. Speaking of Kiefer's *Ways of Worldly Wisdom*—a painting that includes portraits of figures out of German history "taken from either dictionaries or books about the Third Reich"—Rosenthal says, "Kiefer's depictions recall Gerhard Richter's '48 Portraits' series of 1971–72 and Andy Warhol's many celebrity portraits from the 1960s onward. Like the American artist, Kiefer looks at the heroes of his country in a deadpan way . . ." No, no. To associate the tongue-in-cheek glamour of Warhol's high-society gang with Kiefer's origins-of-totalitarianism motifs is to make a muddle, and finally to reassure viewers that all subject matter is equal. Here aestheticism is a leveler. And so, a couple of pages later, we're informed that "Kiefer offers art as a theoretical antidote for the terror of human history and the failure of mythic figures." Art as a theoretical antidote to the Holocaust?

In the past few years, Kiefer has visited Israel and begun to take some of his subjects from Old Testament history—he seems to have a particular fondness for Moses and the story of the crossing of the Red Sea. Perhaps some will see in this new twist of Kiefer's career a desire to escape the chronology of modern European history. But his tendency to mythologize everything (and Mark Rosenthal's tendency to use art-historical references to further muddy the waters) denies us exactly what we need when we confront Hitler—which is absolute, total clarity. The Kiefer who

now memorializes ancient Jewish history was, twenty years ago, going around Europe taking photographs of himself dressed up in Nazi-style gear while giving the Nazi salute. These photographs were put together in a suite called "Occupations," which was published in the magazine *Inter-funktionen* in Cologne in 1975. It's the nadir of neo-Nazi campiness. "I do not identify with Nero or Hitler," Kiefer is quoted by Rosenthal as saying, "but I have to re-enact what they did just a little bit in order to understand the madness. That is why I make these attempts to become a fascist." Rosenthal underlines this. "He assumed the identity of the conquering National Socialist. . . . In the flamboyance [!] of the Nazi *Sieg heil* he spares neither the viewer nor himself since he serves as the model for the saluting figure." And: "Kiefer tries on the pose of inhuman cruelty, plunging into a state of spiritual darkness in which he can coolly and almost dispassionately ponder one of the most. . . ." It's amazing that this museum catalogue has been greeted with such mildness, with such appreciation.

I very much doubt that Kiefer's early conceptual "*Sieg heil*" works would have earned him a show at the Modern; voices might have been raised. And yet it's exactly the same love–hate relation to the German past that's earned him his retrospective; only now the same attitudes are packaged in the trappings of high modernist art. As Rosenthal puts it, by 1980 "Kiefer had, in effect, integrated his ongoing thematic concerns with the outsize proportions of Abstract Expressionism and the modernist insistence on the literal qualities of the object." The secret of Kiefer's fame is that a sensational and even I would say pornographic obsession with Nazi atrocities is welded to a mainstream modernist aesthetic.

Kiefer's paint is said to evoke rock and earth, the soil of Germany; and Kiefer tries to heighten our sense of earthiness through the inclusion of handfuls of straw, or the thickening of the paint with sand. This surface is the alpha and omega of Kiefer's art, and yet it's hardly the metaphoric miracle it's been claimed to be. Kiefer treats the canvas as if it were an upended track of land; he wants to imbue the flatness of the support with the lyric physicality of a nature poem. But his strong formalist leanings —and his infatuation with Abstract Expressionism—are in collision with what may or may not be a genuine gift for lyric evocation. Rosenthal has compared Kiefer to Pollock—he sees echoes of Pollock's *Blue Poles* in *The Mastersinger* and *Margarete*. This is Pollock with metaphysical and metaphorical trimmings, and the trimmings seem to come unglued as easily as Kiefer's hunks of straw. Strip away the fancy titles and the little representational doodles and you find paintings that look uncannily like post-Pollock formalist abstraction—especially the recent sensuous yet austere work of Olitski and Poons, both of whom, like Kiefer, paint with acrylic and like to build up the surface until it projects fairly far off the wall. In Kiefer's *The Book*, the surface is thickened with acrylic; and the translucent

acrylic, after it has dried, is dusted with a dark tone. The effect is Olitski-ish—a kind of optical shimmer. Precisely what the painting lacks is the tactile gravity that we would expect in a painting that invokes earth—the weight that we know from some of the great modern Expressionist landscapes, from certain Soutines and de Staëls, the late landscapes of Georges Braque, and the canvases of the English contemporary Leon Kossoff.

Kiefer is easy for current taste to assimilate because his sensibility is, at heart, a postwar American sensibility. His sizes are Ab Ex sizes; and, like an Abstract Expressionist, he articulates the surface only insofar as articulation reinforces homogeneity. The perfunctory lines of perspective which Kiefer inscribes here and there do little to create dynamism, or variety, or surprise. There's really next to nothing in these vast paintings. (Some of the smaller ones are more nearly credible.) This is metaphysical formalism, and I didn't think the artist I went to the opening with was far from the truth when she commented that "six million Jews had to die so all these people could wear black tie." To claim for a reductive pictorial structure all the meanings that have been claimed for the Kiefers is to conflate the old formalism and the new taste for narrative in the most extreme and disastrous manner.[2] It's fifty years ago that Clement Greenberg declared the absolute separation of high and low taste in his essay "Avant-garde and Kitsch." Now, with Kiefer, the sort of optically alluring surface that characterizes what has been called Greenbergian abstraction is joined to a voyeuristic sentimentalizing of Jewish history we'd normally expect to encounter in a TV miniseries or a trashy novel. The end result of Green-bergian taste—the heavily impastoed acrylic surfaces of Olitski and Poons—has been joined to a romantic infatuation for Nazi Kitsch.

Just after I saw the Kiefer retrospective, I read *The Drowned and the Saved*, the book Primo Levi completed before his suicide in 1987. It's quite different in tone from Levi's earlier memoirs in that he has now left behind the narrative made up of anecdotes and portraits-in-miniature in favor of a

2 Jean Baudrillard, the French thinker whose books all the fashionable artists want to have in their studios, has said, "We are witnessing the end of perspective; and panoptic space (which remains a moral hypothesis bound up with every classical analysis of the 'objective'), and hence *the very abolition of the spectacular.*" Kiefer's work, flirting as it does with perspective and panoptic space, aims precisely to be spectacular. This, no doubt, is part of Kiefer's appeal at the moment when the very idea of life as an interesting spectacle can appear endangered. Nazism, come to think of it, is the perfect field of study for fashionable artists who are both nostalgic for spectacle and obsessed with its deconstruction. The Nuremberg rallies and the nightmare of the camps can be viewed as the ultimate anti-spectacle spectacle—inimitable, sui generis.

severe essay style. Gone for the most part is the comfortable, consoling effect of painted scenes; here there are only a few hard facts, presented without halftones. It's a purified, skeletal book; and after I'd started it, I couldn't put it down, and found myself staying up late, both hands clutching the pages very tight, until I'd gotten to the end. In the closing chapter, "Letters from Germans," Levi describes some of the correspondence he received after *Survival in Auschwitz* was published in Germany. In particular, he details a long exchange of letters with a woman, Mrs. Hety S. of Wiesbaden, who came from a family of leftists, had kept clear of the Nazis, and was, as he says, of all his correspondents "the only German 'with clean credentials' and therefore not entangled with guilt feelings." In one of the letters that Levi quotes, Mrs. S. writes, "For many among us words like 'Germany' and 'Fatherland' have forever lost the meaning they once had: the concept of the 'Fatherland' has been obliterated for us." It's exactly this concept that Kiefer is trying to reinstate.

But if Kiefer's staggering success tells us something about Germany today, it may tell us even more about how desperately people in the art world want to believe that art has content, always more content, and how willing they are to believe that content exists not so much within the work as in a drama that's grafted onto the work. It's an overpowering sense that the Holocaust is the ultimate *event* of modern history that attracts artists now. Robert Morris, for instance, used photographs of piles of corpses in the concentration camps as one of the raw materials in a series of mixed-media wallworks on apocalyptic themes that were shown at the Castelli and Sonnabend galleries last season. Almost fifteen year ago, in her essay "Fascinating Fascism," Susan Sontag observed: "The poster Robert Morris made for his recent show at the Castelli Gallery is a photograph of the artist, naked to the waist, wearing dark glasses, what appears to be a Nazi helmet, and a spiked steel collar, attached to which is a stout chain which he holds in his manacled, uplifted hands. Morris is said to have considered this to be the only image that still has any power to shock." Now, using photographs of the death camps, Morris has topped himself.

Within a few months of Morris's show, there was a painting in Jerome Witkin's show at the Sherry French Gallery called *Terminal*, which represented a young Jewish man, a huge star of David on his lapel, sitting in a cattle car; and there was a collage in Joan Snyder's show at Hirschl & Adler Modern called *Women in Camps*, which included photographs of Jewish women, also wearing the Jewish star. This fall the Starn Twins have weighed in with Holocaust imagery. The *Lack of Compassion Series*, in the Castelli Gallery half of their two-part show, consisted of a photograph of concentration camp dead mounted on a large board of pale blond wood with, ranged around it, narrower planks of wood, each bearing a black-and-white photograph of the face of a martyred hero—from Gandhi to

J.F.K. to Steve Biko. The *Lack of Compassion Series* had a cool, knowingly Age-of-Mechanical-Reproduction look; perhaps the Starns thought it would be as easy to illuminate the Holocaust as to flick on a light switch upon entering a darkened room. And if all this hadn't been enough, in October the abstract painter Gary Stephan included in his show, at Hirschl & Adler Modern, paintings entitled *The Stacks* and *Ashes*, and let it be known, via Lisa Liebmann's catalogue essay, that "they have to do with the Holocaust."

Relative to the size of the New York art world, something like half a dozen shows may not seem very many; but the range and diversity of artists apparently drawn to similar themes—from an academic realist such as Jerome Witkin to the internationally acclaimed subject of a MOMA retrospective such as Kiefer to darlings of the next wave such as the Starns—is pretty impressive. Witkin's brand of narrative painting (which is finicky about naturalistic detail and attuned to spectacle as sentiment) may have no connection whatsoever to Joan Snyder's experiments in collage (which walk a tight-rope between the aestheticizing and the politicizing) except that there seems to be, all over town, this reach into the central catastrophe of modern European history. In the spectral bodies of concentration camp victims some will see resemblances to the contemporary ravages of AIDS; while others, especially Jews approaching middle age, may believe the time has come to confront the most essential and painful aspects of their communal past. Trying to hold in one's mind such diverse impulses expressed at such different levels of artistic seriousness is difficult, perhaps impossible.

Recently, in the catalogue of Judy Rifka's show at the Brooke Alexander Gallery, Robert Pincus-Witten observed that many artists want to restore "our strained belief in transcendence." Nothing strains the belief in transcendence quite like the Holocaust. And, perhaps, no event bears so immediately on the possibility for transcendence. To admit the Holocaust into contemporary art is to admit experience in its most extreme, uncontrollable, and incomprehensible form. It's a subject no artist may be equal to; certainly most who attempt it will be defeated even before they begin.

As for Anselm Kiefer, we can say for sure that no artist has gambled more on the appeal of the Holocaust as a symbol. I would argue that Kiefer's troubles begin right there, because to treat the Holocaust as a symbol is to belittle it, to make it bearable. Maybe that's what people really like about his work. The advertisements that the Museum of Modern Art is running for the Kiefer show present him as a special case, an *interesting* case. "Something big," the headline informs us, "is happening at the Museum of Modern Art." Kiefer, we're told, "paints public memories mixed with, private dreams—as he shuns the comfort of custom and fashion. Only 43 years old, he has already challenged the tradi-

tional ideas of what an artist is and does . . . Kiefer's work demonstrates that boundaries of time and place need not be barriers to creativity." I'm not exactly clear on what this all means, except that the Modern knows it has a-hit-that's-much-more-than-an-art-show on its hands and feels no compunction about milking it for all it's worth. One thing is for sure: new-style content has never had so sweet a revenge on old-style formalism as right now, when they're hyping the Holocaust at, of all places, the Museum of Modern Art.

December 1988

Other People's Music: Corigliano at the Met

John Simon

Comme c'est long!

<div style="text-align: right;">—Tristan Corbière, "Grand Opéra"</div>

Long in gestation and long in duration, *The Ghosts of Versailles* has arrived at the Metropolitan Opera as one of the most sumptuous productions I have seen on any operatic stage. With music by John Corigliano and a libretto by William M. Hoffman, it is the first new opera commissioned by the Met in a quarter century, or since Samuel Barber's *Antony and Cleopatra* and Marvin David Levy's much worse *Mourning Becomes Electra* proved failures. It was twelve years ago, in 1979, that James Levine suggested to Corigliano at a dinner party that he write an opera for the Met's centenary season, 1983–84; the three-hour work did not get written and produced till December 17, 1991, amid considerable hoopla and fanfare. (It had become, along the way, a joint commission with the Chicago Lyric Opera, where it will be seen during the 1995–96 season.) Was it worth the effort, the wait, and the reported four-million-dollar cost?

Corigliano told Levine that he wanted to write an opera buffa; when Levine pointed out that comic operas sometimes get lost in that vast house, Corigliano promised a "grand opera buffa," presumably a new genre. He turned to his long-time friend Hoffman for the text, and made two stipulations: that it lend itself to the use of melody, and that it contain a Turkish scene. There was a craze in late-eighteenth-century and early-nineteenth-century music for things Turkish—the Turcomania whose summit achievements were Mozart's *Die Entführung aus dem Serail* and Rossini's *L'Italiana in Algieri*. The request still sounds to me rather like saying "What I want from a friend is good character and bushy eyebrows."

The reason Corigliano wanted to write a funny opera was that "a lot of contemporary opera is for the orchestra; the singer holds a note while the orchestra goes crazy. By definition, if you're writing an opera buffa, you're going to write melodically." Perhaps—although Orff, in *Die Kluge* and *Der*

Mond, managed to write comic operas far more rhythmic than melodic. I suspect that the real reason is that Corigliano likes to play musical games—allusion, parody, pastiche—that clearly work only in comedy. Moreover, he and Hoffman wished to make an opera out of Beaumarchais's third Figaro play, *L'autre Tartuffe ou la Mère coupable*, because the two previous plays of the trilogy, *The Barber of Seville* and *Figaro's Marriage*, had done so well by Rossini and Mozart, whose styles Corigliano could spoof.

The authors were disappointed both because *The Guilty Mother* turned out to be not a comedy but a melodrama, and because it proved very bad. It concerns the Almavivas twenty years later, when the Count's illegitimate daughter, Florestine, by an unnamed noblewoman, and the Countess's son, Léon, by her one deviation from the straight and narrow with Cherubino while her husband was long absent as governor of Mexico, are living in the Almaviva household in Paris, where the Count is the Spanish ambassador. He hates his good and loving Rosina for her one misstep, ignoring his own misbehavior and love child. Léon and Florestine, moreover, are in love, in defiance of what may look like incest.

This fraught family circle is infiltrated by the villainous Irish major Patrick Honoré Bégearss, former secretary to Almaviva and now his false friend who intends to marry Florestine and fleece and ruin the rest of the household. The naïve Count is putty in his hands, but Figaro and his faithful Susanna, after numerous pathetic and melodramatic twists, succeed in unmasking Bégearss, reconciling the Count and Countess, and enabling the young lovers—no blood relations—to marry happily. Even the editor of the *Pléiade* Beaumarchais, Pierre Larthomas, comments that this inferior work is "no longer played, and will doubtless never be." What may have appealed to Corigliano, who, as Michael C. Nott has remarked in *Opera News*, "tends . . . to draw on a wide range of styles—in his view 'techniques'—rather than making any single one the basis of his music," is that the hybrid genre of melodrama, which contains blackly comic evil as well as lily-white sentimentality, could allow him to indulge his penchant for parody or, to put it less kindly, derivativeness. Ambiguity of various kinds can even be read out of Beaumarchais's remark in the preface to his play that he "composed with a straightforward and pure intention: with the cool head of a man and the burning heart of a woman, as has been said of Rousseau. . . . This moral 'hermaphroditism' is less rare than one might think."

I can see where hermaphroditism, moral or other, might appeal to Corigliano and Hoffman, who would perceive it as a justification for trying out their wide range of styles—sorry, techniques. They could thus not only allude to Mozart and Rossini, but also indulge in any verbal and musical hanky-panky to which male heads with female hearts might be prone.

But given the sorry plot, an overplot was needed: Beaumarchais in heaven falls in love with Marie Antoinette, still unresigned and disconsolate, and proposes to write a play to cheer her up, a play that is roughly *La Mère coupable*, with which he undertakes to rewrite history as it should have been: Marie Antoinette escaping the guillotine with the help of Beaumarchais—or his acknowledged alter ego, Figaro—and ending up forever Beaumarchais's beloved. Yet since the Figaro of the play is at first a good Republican and unwilling to help a monarch, Beaumarchais must—at the peril of his eternal salvation, it seems—enter his own creation, the play-within-the-play he has entitled *A Figaro for Antonia*, and take matters into his own hands. This means getting hold of the Queen's famous necklace, which keeps changing hands throughout, and turning it into cash to buy Marie Antoinette's escape. Confusing? Yes. Silly? Definitely.

Three casts intermingle: the ghosts of the dead aristocrats, the characters from *La Mère coupable*, and the populace and soldiers of the Revolution. This means juggling with afterlife (the ghosts), life (the French Revolution), and the life of the drama (Beaumarchais inventing or rewriting his play, trying to change history through art). What is rotating through the air here may be inspired juggling or just plain balls.

Consider, first, this heaven or limbo from which, in the prologue, ghosts are floating down to Versailles. There is nobody here but these dead aristocrats flying, floating, lolling about. There is the odious Woman with Hat, a busybody, and Louis XVI, who keeps playing cards with the Marquis, his confidant, while under his very nose Beaumarchais courts his wife, the Queen, who is called Antonia when that suits the meter of the verse passages, Antoinette when that facilitates the rhyme. After expressing his indifference to the goings-on, and long ignoring them, Louis suddenly challenges Beaumarchais—a commoner—to a duel. They run each other through, but of course cannot die, whereupon the entire ghostly company merrily falls to skewering one another.

So these *ci-devant* aristocrats and human beings require a couple of centuries to discover there is no carnage in heaven? License, sure; but how poetic? Even fantasy must have its own kind of sense. What good is a chorus of blasé ghosts expressing ennui by takings turns to say they're as bored "as a rug," "as an egg," "as a potato"? Just how bored can a rug get? Eggs, in fact, are full of yolks. Yet these similes, later reduced to mere tags ("rug . . . egg . . . potato") keep cropping up as a refrain any sensible librettist would refrain from.

Marie Antoinette rejects Beaumarchais, whereat he sings, "Orion, Orion,/ Even the moon moves/ And is laced gently by leaves." What has this to do with the price of eggs, or potatoes? It is pseudo-poeticism for its own debilitating sake. Now Marie Antoinette sings the aria of her tragic destiny, including the stanza about earlier, sweeter memories:

> Once there was a golden bird
> In a garden of silver trees.
> From the garden could be heard
> The laughter of women at their ease.

This provides one of the opera's principal leitmotives, as Patrick J. Smith informs us, especially in the three notes of "golden bird."

Yet how facile and primitive those lines are, what with the simplistic juxtaposition of golden bird and silver trees, and the blandness of it all, with that laughter of *women's* voices, as if men only cackled. Compare this to the real thing, James Agee set by Samuel Barber in *Knoxville: Summer of 1915*: "It has become that time of evening when people sit on their porches, rocking gently and talking gently and watching the street and the standing up into their sphere of possession of the trees, of birds' hung havens, hangars . . . voices gentle and meaningless like the voices of sleeping birds."

And to Hoffman's insipid words Corigliano provides a tuneless melody where soaring is needed. The melisma on "laughter" is effective but predictable, as are the bits of parlando strewn into the aria, notably the counting of steps to the scaffold, which Teresa Stratas delivered with chilling raucousness: "Three steps. Four. . . . Seven. Eight." But with the horror of those numerals there came across at the Met also the crudeness of Miss Stratas's Bride-of-Frankenstein delivery.

Beaumarchais offers a sample of his play on a stage-within-the-stage. Figaro is dodging pursuing creditors and unwed mothers of his making until he locks them all into a closet and proceeds to deliver a feeble knock-off of the Rossini "Largo al factotum" (which Patrick J. Smith calls "damn near . . . outdoing the Swan of Pesaro"): the patter song of a panting, nearly petered-out Figaro, twenty years older: "My money is low,/ My status less than quo./ I'm poor, I'm weak,/ My future's rather bleak./ I'm stooped, I'm spent./ I'm almost impotent." Note the flimsy filler words *rather* and *almost*; note also the silliness. Why is Figaro's future rather bleak? Because the librettist says so.

But then an equally arbitrary reversal: "My spirit—/ A vapor deliquescent,/ An effervescent liquid/ Pervading, invading, taking my body,/ Making me fluid, light, buoyant./ I'm sunlight, a moonbeam,/ And carefree I fly to the stars." Notice how Hoffman runs out of rhyme where it could be most sustaining, most buoyant. He falls back instead on self-indulgent jingles, "deliquescent-effervescent," "pervading-invading," and—again!—on the good old gold-and-silver standard: "I'm sunlight, a moonbeam." Forthwith Figaro, who has just described himself as "A man for the ladies/ And father of babies," becomes a star-trekker as he flies past a litany of star monikers: "Capella, Carmina,/ Spica, Auriga,/ Libra, Lyra,/ Andromeda,/

Fornax, Phoenix,/ Bellatrix, Pollux. Joy! Joy!" Hear especially the sala-
cious echoes in Fornax, Fel . . . er . . . *Bel*latrix, and the joy-filled ejacula-
tion, "Pollux."

At this point Corigliano's music does come to life. Having begun the
opera with eerily inchoate sound sequences, serial rows, glissandos,
quarter tones, various kinds of inversion—just like the beginning of his
Clarinet Concerto—Corigliano, inspired by this journey to the stars, lets
go with shimmering, high-register, astral music, reminiscent (this time, I
suspect, unintentionally) of the apotheosis music in Strauss (*Ariadne auf
Naxos*, *Die Frau ohne Schatten*, *Daphne*) where a transfiguration takes
place.

But let us say the Strauss evocation is deliberate pastiche. Such pastiche
is a very sly maneuver; if you are skillful about it, your position is impreg-
nable. Familiar-sounding? Of course. Imitative? Why not? Too close for
comfort? On the contrary, the comfort is in the closeness, the cleverness of
the pastiche, the wit of parody. Indeed, the three chief echoers in the
music—Mozart, Rossini, Strauss—keep popping up everywhere, often in
direct quotations, but this is made to devolve to Corigliano's credit: What
difference is there between playing with notes and playing with other
composers' groups of notes? Right?

The Ghosts of Versailles tries to have it every which way. It means to be
both grand and buffa, both profound and irreverent, both didactic and
campy. "We're dealing with the ghosts of our own cultural tradition," says
Hoffman, "Versailles representing the heritage of well-made objects, of
beauty. We're dealing with the ghosts of beauty in our Western culture."
Yet even while he and Corigliano were working on *Ghosts*, Hoffman (until
then best known for his work in soap opera) produced his one claim to
fame, the AIDS play *As Is* (1985), in which an aspiring actress posing for
publicity shots says to the photographer, "I want that role so bad. I play
the ghost of Marie Antoinette. (*taking a tits-and-ass pose*) How do you like
this, hon? 'Let them eat . . .'" This smutty joke about its heroine hardly
suggests an opera in the making whose preoccupation is with beauty in
Western culture.

"As a lyric poet," Hoffman continues, "I was thinking of my goal of
beauty, of nobility, as well as fun. . . . This wasn't a romp-through opera.
It's not anarchic at all. I was writing lyrics that were meant to be com-
pared to the great lyrics of the past." Which great lyrics? Sappho? Keats?
Hofmannsthal? Irving Berlin? And how seemly is it for the music to in-
dulge itself to the extent that where Bégearss exclaims angrily about the
success of his rival, "Léon? Léon? LEON!" the music replicates the notes
from Ravel's song cycle *Histoires naturelles*, where the peacock utters his
cry, "Léon! Léon!"?

Hard upon this follows Bégearss's dastardly credo, "Aria of the Worm,"
suggested, we are told, by an epic poem by Boito (more scavenging), but

which seems to be an attempt to outdo Mussorgsky's "Song of the Flea," while also providing Bégearss with something comparable to Iago's "Credo" in Verdi's *Otello*. Here is what we are to compare to the great lyrics of the past:

> . . . Cut him in two,
> Each part'll renew.
> Slice him to bits,
> The worm persists.
> He still crawls on.
> Scales walls on
> Sheer will, and
> Burrows burning sand.
> Long live the worm.
> He travels on by
> The poor man's sty,
> Groveling past
> The royal palace . . .

Slant rhyme (e.g., "bits-persists") is perfectly fine, but "past-palace" is not slant, or scant, or any kind of rhyme. And what of the subliterate "each part'll renew," without an object, *itself*? And why, except for assonance with *travel*, would the worm *grovel* past the royal palace when the point is the supremacy of the victorious worm?

In the duet where Rosina and Cherubino make love—a retrospect Beaumarchais offers Marie Antoinette as an aphrodisiac—Hoffman emulates the geographical preciosity of Mlle de Scudéry's *Carte de Tendre*, rather too academic for a seduction scene, but the real problem, again, is the lyricism: "Come now, my darling, come with me,/ Come to the room I have made for thee./ Let us strew the bed with flowers—/ There we will spend the hours." But the fearless challenger of the great doggerel of the past follows this with even better: "Yes, yes, my darling. I'll come with thee,/ Come to the room that is made for me," whereupon they fall to coupling *al fresco*.

Be it noted in passing that a favorite Hoffman trick is to make a line applicable simultaneously to the Almaviva characters and the commenting ghosts, so both can sing it in unison—a trick that palls quickly. It is, however, as nothing to the cuteness of the entire reception scene at the Turkish embassy, where the Count tries to sell the necklace of the Queen to the British ambassador for money to be used for her rescue. Bégearss and his oafish servant, Wilhelm, try to get the necklace away from him, but it is Figaro, in drag as a dancing girl importunately rubbing against the Count, who eventually spirits the necklace away in a scene calculated to delight equally connoisseurs of camp and guileless simpletons.

Indeed, this Turcomanic scene unleashed the evening's noisiest ecstasies. Be it said that the British director, Colin Graham, improved on the authors' campiness with an added layer of his own. The Pasha (Turkish ambassador) was converted into a huge automaton atop a platform in the back, manipulated by five men from below. The doll, thirty feet tall even sitting cross-legged, could roll its eyes, part its lips, clap its hands, and tap one foot as the voice of a basso below (truly *profundo!*) was piped into it. A live page sat in its lap, and at the scene's climax Figaro climbed up on the Pasha's turban, made it explode spectacularly, and escaped in the melee. The scene opened with two enormous, pasha-sized figures of scimitar-wielding swordsmen entertaining the guests; these expensive props were promptly wheeled off and never seen again. Later, when Figaro is supposed to be pursued by soldiers, Graham gave us instead six six-foot-tall heads, six spheres inside which a live operator was pushing a sort of wheelbarrow. This conspicuous waste, featuring 120 people running around the stage, must have made a single scene cost the price of an entire, more modest and better, opera.

But to get the full measure of Mr. Graham's intellect, consider his note in the program, wherein he states that Bégearss "represents what Wilde called 'the worst excesses of the French Revolution.'" Now, that flat little tag makes sense only if you quote Lady Bracknell's entire, funny sentence: "To be born, or at any rate bred, in a handbag, whether it had handles or not, seems to me to display a contempt for the ordinary decencies of family life that reminds one of the worst excesses of the French revolution." To quote merely the seven last words of Lady Bracknell is like proudly saying "Bégearss represents what Shakespeare called 'O what a rogue.'"

Even unenhanced, though, what Hoffman contrived is bad enough. There are interpolations of Turkish dialogue that are totally otiose, while Corigliano comes up with an Egyptian belly dancer, Samira, who sings both a cavatina and a cabaletta (we don't do things by halves!) to words that are the lowest of low camp and begin:

> I am in a valley and you are in a valley.
> I have no she- or he-camel in it.
> In every house there is a cesspool.
> That's life.

The fact that Marilyn Horne, who does Samira, looks rather like a she-hippopotamus makes the scene even campier, especially when you consider her suggestive gestures with her veils, and her singing a couple of bars while pinching and releasing her nostrils to achieve, as a *New York Times* article quotes her, "the high, warbling sound . . . crowds of Arabic women" make. Throughout this, as also elsewhere, there is a sizable,

fully-costumed onstage orchestra, complete with conductor, playing little, but greatly adding to the confusion.

Meanwhile our transvestite Figaro does obscene things with a banana and more and more (somewhat suspect) Turkish enters the text, with the cabaletta sung entirely in that language. There are double-entendres as when Figaro *en travesti* offers the Count and the British ambassador fruit (*"figi, figi"*), and authorial self-congratulation as Marie Antoinette cheers, "Bravo, Beaumarchais! It's wonderful!" even as the ghosts do their rug-potato-egg noodling again. Then a bunch of peripatetic rheita players invades the scene, the rheita being a North African oboe, although Corigliano specifies that the rheitas be "disguised kazoos." At the climax of the scene, the Woman with Hat from the opening scene (atrociously sung by Jane Shaufuss) exclaims, "This is not opera! Wagner is opera!!" The director improves on this by bringing her on in full Valkyrie regalia: horned helmet, breastplate, spear. Chaos rules supreme as Act I ends.

Corigliano has, of course, written musical persiflage for the entire scene—this, after all, is the composer who stuck a tango by Albéniz into his AIDS symphony. Yet one is forced to wonder whether the opera and its production don't do as much disservice to camp as they do to opera. For camp, like pastiche, is funniest when it is small and sassy; make the takeoff as lavishly elephantine as what is being spoofed, and the joke turns sour. Deflation with a pin is amusing; with a steamroller, it isn't.

Act II begins with elaborate counterpointing of the ghosts' and the Beaumarchais characters' dialogue and music, and climaxes in a big laugh: *"Marie Antoinette*: I want to live again. Can you do that, Beaumarchais? *Beaumarchais*: Yes! We shall live in Philadelphia. . . . *Louis*: If you can call that living. *Woman with Hat*: Every day I thank God that I'm dead." Buffa is all very well, but this is more like the old buffola. Then, as Figaro refuses to use the necklace for the Queen's salvation, Beaumarchais enters his own play to bring his recalcitrant gracioso back in line. This is to make "history as it should have been" and enable Beaumarchais to make Marie Antoinette.

The idea of having the author get involved with the creatures of his imagination is not new. It is all over Pirandello and crops up even in Lewis Carroll when Alice dresses down her tormentors as just a pack of cards. It is the central device in a musical such as *City of Angels*, and something like it also governs Schnitzler's one-acter *The Green Cockatoo*, which, moreover, also uses the French revolution as backdrop. But there are two whopping absurdities in the handling of the conceit here. First, the notion that rewriting your artifact can rewrite history (the *Back to the Future* syndrome), and second, that Beaumarchais, by entering his play, somehow sacrifices his eternal salvation for love. Why shouldn't he exit the play as he entered it?

Yet everything hinges on this specious sacrifice: it is what makes Marie Antoinette fall in love with Beaumarchais. This is the weakest aspect of a weak libretto and music: neither verbally nor musically are we made to believe in and care for this love story. But if we don't believe and care, how are we to buy what Hoffman calls the "philosophical basis of the opera," that it is "a spiritual reconciliation between the legitimate desire to improve things, which represents the revolution [i.e., is represented by the revolution], and the spirit of the ancien régime. So my marriage between the two is after death, in the afterworld, between the two leading proponents of both [i.e., the leading proponents of each]." What disingenuous nonsense! If this were "the motivation for the whole thing," as Hoffman also says, the piece would not be flagrant camp, and the two main characters would be more complex and more real. *This* Marie Antoinette, who reminds me of nothing so much as the Beggarwoman in *Sweeney Todd*, is not a leading proponent of anything: she moons, moans, sulks, and gripes, and has not one idea in her glued-on head. And Beaumarchais is merely the constant lover from start to finish, which is very nice but of little symbolic or philosophical value.

And once inside his play, poor Beaumarchais loses any resemblance to a real character. When it suits the authors, he becomes a magician able to conjure up the trial of Marie Antoinette with himself as the judge and a whole crowd of jeering extras, but when he should really stop Bégearss and his minions, he is completely without power. Where, I repeat, is the consistency even fantasy cannot dispense with? Tennis, for example, is an arbitrary construct; but it remains tennis; it does not change in mid-game into ice hockey.

Andrew Porter, writing recently in *The New Yorker*, has gone farther than anyone into listing the sources of the music. The Act I quintet "begins with the first strains of 'Voi che sapete.'" Susanna and Rosina's memory duet in Act II "is spun over an accompaniment of the *Così fan tutte* 'Soave sia il vento.'" Almaviva's palace band plays "a minuet drawn from 'Se vuol ballare.'" In the scene in which Beaumarchais frightens the rebellious Figaro, he "confronts him with the Statue music from *Don Giovanni*." We have already noted Figaro's entrance aria as an "homage to Rossini's 'Largo al factotum.'" The first-act finale contains some "exchanges of the *Barbiere* quintet." "Bégearss's second dull aria"—in which he stirs up the *tricoteuses* of Paris to storm Almaviva's farewell party by likening the aristocrats to rats (aristrocRATS?) to the accompaniment of musical scurrying and squealing—"has origins in Corigliano's own flute concerto 'Pied Piper Fantasy,'" and "the tangy, microtonal . . . sound of the oboes in the first finale . . . was also used in his Oboe Concerto."

But, for the most part, Act II is musically becalmed. At such times the director overcompensates, as when he proffers four concentric prosceniums: the Met's own and, behind it, receding into the distance and

getting smaller and smaller, three others—a set of Chinese stage boxes. At the Almavivas' farewell ball, three huge skulls in Napoleonic hats look down on the scene. And here we get the first of several set pieces in which we are supposed to be moved by the music becoming slow, very slow; the model, barely approached, seems to be the final trio from *Rosenkavalier*. Here are four lines from Hoffman's (not Hofmannsthal's) quartet:

> *Léon*: Remember the fragrance of mushrooms in the air?
> *Rosina*: I remember a shimmering light.
> *Almaviva*: I remember a star-filled night.
> *Florestine*: I remember there were raindrops in your hair.

You can't get much closer than that to the great lyrics of the past.

The prison scene where the Almavivas have one night in which to decide whether to face the guillotine or yield up Florestine to Bégearss (and then, most likely, go to the guillotine anyway) has some of the opera's best music, but again desperately capitalizes on being slow, very slow, as if languor guaranteed deep emotion. Still, the alternation between tremolando strings, mostly in a low register, with solo woodwinds is pretty enough, which leads us, slower than slow, into the opera's pièce de résistance, the Quintet and Miserere. While Figaro and Beaumarchais are away trying to get help, the Almavivas and Susanna sing: "Storm and fire overwhelm me,/ Fear and death are at my door,/ But the thought of those dear faces/ Brings me rest in this time of war." *War* is hardly the *mot juste*, but it does provide a rhyme. But why the *thought* of those dear faces when they're all right there? *Sight*, surely?

At this point, in an upper-tier cell of the Conciergerie, we see the shadow of the Queen, and hear her sing a Miserere that eventually blends adroitly with the Almavivas' Quintet. Slowness here wreaks its masterpiece. Beaumarchais and Figaro arrive, having intrigued their way into the Almavivas' cell, but the key to Marie Antoinette's, alas, resides with the crass Wilhelm, Bégearss's man. The women—Rosina, Susanna, and Florestine—manage to vamp it away from him in a kind of modified gang-bang scene, while Almaviva watches in indignant incomprehension—a fellow too thick even for a thin operatic character. And we hear stuff like: "*Beaumarchais*: Your wife is bold but never mannish. *Figaro*: Her dad was Welsh, her mother Spanish." Again: "*Beaumarchais*: A woman free is man's delight. *Figaro*: What's a bitch without a bite?" This could successfully compete in any non-sequitur championship.

Beaumarchais can now release the Queen, but Bégearss pops in with the soldiery. Figaro denounces him as a counterrevolutionary who wants to keep the necklace for himself; it is found on him, and he is carted off to his end. As the others escape, Beaumarchais offers the Queen her freedom. She refuses to change history, somehow feeling that only in death can she

remain with her beloved playwright. This makes very little sense, but after three hours, who cares? Her final aria, rewritten to the specifications of Miss Stratas, is very different from what is printed in the libretto, but, again, who cares? The music, yet again slow, very slow, turns totally pseudo-Mozartian for the finale. We see in the distance the blade falling on Marie Antoinette's head, while overhead a small Mongolfier brothers' hot-air balloon carries the miniaturized version of the *Mère coupable* characters off to the safety of England.

Meanwhile poet and queen ascend into the air. As Andrew Porter puts it, "in the gardens of Aguas Frescas (according to the score) or in Paradise (according to the Met synopsis) the ghosts of Marie Antoinette and Beaumarchais find peace," and the opera that began with a serial tone row ends while, to quote Patrick J. Smith, "the orchestra cadences on a serene A-major pianissimo." The applause on opening and subsequent nights was fortissimo, however. But what, really, was being applauded? No doubt a generally fine cast in which, among twenty-three soloists, only Judith Christin (Susanna) and the aforementioned Jane Shaufuss were bad. Miss Stratas, aside from lacking class as always, is beginning to lose her lower register, while her upper one has a disturbing steely edge, but oh, how she tries, both vocally and histrionically! The rest of the cast, though, shines, with Gino Quilico (Figaro), Renée Fleming (Rosina), Håkan Hagegård (Beaumarchais), Tracy Dahl (Florestine), and Graham Clark (Bégearss) especially impressive. Marilyn Horne, although ludicrous as Samira, still has enough of her once-mighty voice for the undemanding tessitura of her part.

Applauded, too—perhaps above all— were John Conklin's ostentatious sets and costumes. The scenery was not exactly uncluttered, but, opulent and versatile, it achieved kaleidoscopic effects. One could see where those millions of dollars went—or, rather, sashayed, capered, tripped, and thronged. Surely, what was being applauded was trappings and tumult. One could see the Met audience, usually ready to join the chorus of ghosts here as they sing, "another evening at the opera. . . . I'm so bored, bored, bored," stirred up by the whirling spectacle to the point where I wondered whether the *mise-en-scène* without a single note of music might not have been applauded and cheered just as vigorously.

The abiding question is: Do camp and pastiche mix with alleged high seriousness? The main model here, as Hoffman has admitted, was the Strauss-Hofmannsthal *Ariadne auf Naxos*. But the difference—aside from the very great one in quality—is that in *Ariadne* the drama and the vaudeville, though juxtaposed, never really blend, which is precisely the point: in the end, the high and the low do not mix, however effectively they offset each other. In *Ghosts*, everything gets slapped together: buffa and seria are the same thing in or out of drag: Figaro becomes a dancing

girl, Bégearss turns into a puppeteer, Corigliano masquerades as Mozart or Strauss. An ascent to heaven and an escape in a hot-air balloon are the same hot air, but at least the Met can laugh all the way to the bank and justify itself with Samira's "In every house there is a cesspool."

February 1992

Jennifer Bartlett
and the Crisis of Public Art

Eric Gibson

Imagine for a moment that New York is not the overbuilt metropolis so painfully familiar to us today, but a city still in formation. You have moved into an apartment overlooking a rubble-strewn lot—to be called Central Park—precisely for the opportunity its landscaped spaces will offer for walking, playing with the children, or otherwise temporarily sloughing off life's cares.

Only after you move in do you discover that the developers haven't hired a landscape architect to do the job, but an artist, one who boasts of her ignorance of gardens but who nonetheless (working with an architect and a landscape architect) proposes to turn it into a kind of gigantic environmental sculpture made of flowers and hedges—something, in other words, that makes a mockery of the idea of taking one's ease in a city park.

Welcome to the Jennifer Bartlett's *South Gardens*, the most unpopular public-art idea since Richard Serra's *Tilted Arc*.

Jennifer Bartlett's project would occupy a three-and-one-half-acre site at the southern-most end of Battery Park City and adjacent to one of the high-rise apartment complexes whose residents it is intended to serve. Considering the isolated location of the complex in terms of ordinary urban amenities, its residents are justified in expecting that this plot of land would be landscaped to provide, well, a *park*, an oasis within the surrounding desert of concrete and glass. After all, hadn't the Battery Park City Authority, at every moment in the project's development, been scrupulous about taking into account the needs of the people who were actually supposed to live there? Apparently not, for now those people are well on the way to getting an outrageously expensive monument to artistic ego and bureaucratic intransigence.

In its original form, Miss Bartlett's design called for organizing the plot according to a grid plan (one of her favorite devices) in order to create twenty-four "rooms," each one fifty feet square and filled with plants of all varieties shaped into such objects as television sets, missiles, and pianos. In other words, Miss Bartlett's horticultural conceit would so overwhelm the space that there would be virtually no place in it for the public, for

whom, nominally, it is intended, and who through their tax dollars have provided some of the funds for its creation. Her "rooms" would be bordered by hedges high enough to keep sufficient daylight from reaching the plants and so keeping them alive. The whole plot would be surrounded by a concrete sea-wall high enough to obscure any view of New York Harbor and the Statue of Liberty—arguably one of the few good reasons for moving into that neighborhood. *The Wall Street Journal* has reported that the firm of Bruce Kelly/David Varnell Landscape Architects, one of Miss Bartlett's original partners in the project, was fired from it after calling her design "arbitrary and amateurish." What's more, the cost of laying out the gardens, according to *The New York Observer*, would be $12 million, while its upkeep would run between $250,000 and $400,000 each year.

In every respect, the *South Gardens* controversy is of a piece with the larger controversy surrounding the role of public art today. At the heart of both is a debate about what is more important, art or amenities. It is not surprising that Miss Bartlett's design is admired by critics (Paul Goldberger of *The New York Times* among them) while being disliked by the people who are going to have to use it—or rather accommodate themselves to it. (The project is so unpopular that, for a time last year, Miss Bartlett was the target of an anonymous poster campaign in lower Manhattan.) Nor is it surprising that Miss Bartlett's proposal is full of the sort of egoistic arrogance that informs the creation of public art nowadays, an arrogance one had thought might be tempered by Richard Serra's experiences with *Tilted Arc.*

First, there is the scale and cost of the project, both of which testify to the lopsided conception of the importance of these projects in the eyes of their promoters. Then, of course, there is the arrogance of the artist herself. In a much-quoted statement, Miss Bartlett said, "The only thing I was interested in doing was a very complicated garden, which would cost an enormous amount of money and be very expensive to maintain." It's all rather reminiscent of Mr. Serra, who insisted (and came to grief because of it) that he wanted his sculpture to be confrontational. The only difference is that Miss Bartlett was speaking in jest, at least partly. In the same interview she said that, being basically uninterested in undertaking such a project, she had come before the Battery Park City Authority only after numerous appeals to do so, hoping to discourage its members from hiring her by making extreme demands. It inspires little faith in the way such projects are managed to note that she was awarded the commission in any case.

The Bartlett commission also illustrates the arrogance of the public-art lobby, which, bloated by its success over the last two decades, has, like all bureaucracies, come to regard the task of preserving its prerogatives as more important than serving the public. The main agent of its success has been the so-called "one-percent law," which mandates that the federal

government—as well as scores of state and local governments—allot one percent of a new building's construction cost to original works of art. This law has, of course, let loose a tidal wave of public art, a great deal of it mediocre or worse. And it has not been without its more comical moments. In the early 1980s King County in Washington State decided to build a new jail. Because the county had a one-percent law on the books, it found itself in the position of setting aside $600,000 of the facility's $6 million cost from art commissions. Horrified legislators managed to reduce the budget to a mere $165,000, but the commissions were still awarded.

The one-percent laws have done something besides blanket our cities with works of art. They have promoted the idea that public-art commissions are *necessary*, something the public must benignly accept—and pay for. I remember my astonishment a few years ago at a conference on public art when I discovered that the delegates weren't interested in exploring any real issues but rather in devising ways to overcome all obstacles, present and future, to the installation of art in public places.

Yet, it is in no small measure ironic that this latest brouhaha should involve Battery Park City, a project that aimed from the very beginning to be a model of intelligent urban development, and that made it a point to avoid the mistakes of others. One such "mistake" would have been to commission "plop art"—sculptural monoliths placed in front of buildings with no thought to the relationship between the two or of their impact on the public. Though the Authority took it for granted that works of art would be installed at Battery Park, it also determined that a new approach to their creation would be adopted: collaboration—one of the new buzzwords in the public art lexicon. Instead of going their separate ways, architects and artists would work together to produce an integrated, harmonious ensemble in which the buildings would not overwhelm the works of art, and in which the art would make no attempt to upstage the architecture or antagonize the pedestrians. What resulted was a complex notable for the blandness of its public art. R. M. Fischer is present at Battery Park City, but his penchant for glitzy light- and fountain-sculptures has been socialized into a ceremonial arch reminiscent of something out of Fritz Lang's film *Metropolis*. Richard Artschwager, known for his camp, Pop-Minimalist furniture-objects, is represented by a bench. And so on. Neither Fischer nor Artschwager is a particularly good artist, and Artschwager in particular is an odd one to ask for a public piece. His ironic constructions are too private, too hermetic to function successfully out of doors.

To see clearly that the Battery Park City Authority has sought to chart a new course in public art, one needn't walk over to the World Trade Center to study the blunders of the Bad Old Days; one need only proceed south, near the site of the Bartlett garden, for a look at another of the Authority's

commissions. Titled *South Cove*, this work by Mary Miss is an enormous wooden jetty built out into the river but curving in on itself (a reference to Robert Smithson's *Spiral Jetty*, perhaps?). It is topped by a lookout shaped to recall the crown of the Statue of Liberty, which is visible from that spot. Both in scale and physical reach—upward and out—it is by far the most assertive work of art anywhere in the complex. Yet one can't help thinking that it is only here, safely out in the water where it couldn't intrude the way *Tilted Arc* did in Federal Plaza, that such a work could be allowed. At least, that's what one thought until Jennifer Bartlett's proposal came along.

There's an irresolvable conflict embedded at the center of the whole public-art idea: the demands of modern artistic self-expression leave little room for the sort of compromises and accommodations necessary for it to be successful aesthetically and publicly. This does not mean good public art is impossible. The best recent examples of it are those that have a definite character yet join disparate—even abstract—elements into a whole. The swaying vertical needles of *Three Red Lines*, George Rickey's sculpture outside the Hirshhorn Museum in Washington, are a distinct and welcome presence on the Mall. Their motion simultaneously evokes urban motion and criticizes its frenzied pace with an unhurried, breeze-initiated rhythm. Noguchi's plazas and public playgrounds succeed both as works of large-scale sculpture and as urban amenities. They are examples of an artist addressing himself to the way a city is used.

Looking backward, there is, of course, that old standby, the fountain. In Rome, for example, the fountain performs several useful functions. It acts as a symbolic climax to the pedestrian's journey into the space of the square in which it sits, telling him that he has arrived. It draws that square together, giving it a focus. It provides a congenial backdrop for the activity of the square, even as the continuous play of water mirrors the constant human traffic about and through it. Measured against that venerable standard—and why shouldn't it be?—Jennifer Bartlett's *South Gardens* fails miserably.

September 1990

Stuffed: Mike Kelley at the Hirshhorn

Jed Perl

On the first warm spring day all the young men of SoHo appeared at Dean & DeLuca's café on Prince Street in generic white T-shirts. A couple of years ago, the T-shirts were black and they were worn with an air of swaggering angst. Now the look is one of squeaky-clean early adolescence. The gallery assistants and artists just out of art school are all impersonating the smooth-cheeked kid next door. With their hair cut to show their ears, these guys look freshly hatched. They cultivate a bit of nerdish gawkiness. This is the new, passive, do-with-me-what-you-will sexiness.

SoHo on a weekday morning is pretty good theater; it's a spontaneous fashion tableau. Only when everybody has finished their cappuccinos does the work of the day begin: turning fashion statements into marketable art. In SoHo, where street style becomes gallery style as fast as you can say "*Artforum*," the boys (and girls) who favor the twelve-year-old look are the same ones who are creating and promoting the new early-adolescent look in art. In the past year or so the galleries have been full of the products that early adolescents think they're too old for (stuffed animals, cartoons) and the things that they want to be old enough for (beer, motorcycles). The entire art scene is backtracking from *Rebel without a Cause* to "Leave It to Beaver"—an X-rated "Leave It to Beaver." The question on everybody's mind is, "What did Beaver do after he turned out the lights?" As a style statement, I find the question amusing. As an artistic statement, I find it fatuous.

One of the newer galleries in SoHo, American Fine Arts, is dedicated to early-adolescent sneers. The front desk is kept purposely Slobovian —it's the mess the kid will never clean up. And the shows at American Fine Arts are so casually tossed together—it's often hard to tell if you're seeing the show or the debris that's been left in the gallery between the shows. The I-don't-give-a-fuck attitude is a matter of pride. It's probably an attitude that these young artists picked up in the art schools, where I-don't-give-a-fuck is being presented as the next logical step in the style parade. You stack up your beer cans or hang your dirty stuffed animals on the wall and get an NEA grant. That's a career starter. Then, if you fart loud

enough, the distinguished gentlemen of the press will begin to imagine that they're hearing beautiful music.

Mike Kelley, who in the spring of 1990, at Metro Pictures, exhibited slightly soiled stuffed animals on slightly soiled baby blankets, is the latest beneficiary of this process. This spring, the Hirshhorn Museum mounted a small show of his stuffed animals,[1] and Michael Kimmelman, the chief art critic of *The New York Times*, wrote about it in the Sunday "Arts & Leisure" section. "Beneath the stage-managed adolescent comic exterior," Kimmelman explained, "can be sensed sorrow. This is the strength of the art and its soul. Mr. Kelley is perfectly aware of the treacly, garish quality of the work, and means for it to be considered ridiculous. Hieronymus Bosch is an obvious source of inspiration for his carnivalesque scenarios." This highfalutin commentary on a bunch of dirty stuffed animals is insane; more insane than one can possibly imagine unless one has actually seen a Mike Kelley show. We have no reason to presume that the mainstream press speaks with special intelligence; but we do, no matter what the evidence, tend to believe that the mainstream press is a voice of reason. That's what's so horrifying about Kimmelman on Kelley: the review makes this sniveling opportunist of an art star sound like a reasonable subject to write about.

In the early 1980s, Julian Schnabel and David Salle came on like artsy hip college kids—they wanted to show us how wild and smart they were, how many art-historical illusions they could toss around in their work. The art stars who've appeared in the past couple of years—Jeff Koons, with his polychrome cartoonish statuary, and Mike Kelley, with his stuffed-animal assemblages—often take their imagery from the lives of grade-school and preschool kids. I don't want to overemphasize the difference between the work of these early-Eighties and late-Eighties artists. Basically it's all art-school Dadaism. Schnabel does cut-and-paste jobs with Caravaggio and Kabuki theater, Koons commissions statues of Michael Jackson and the Pink Panther. The artists present imagery, but they don't shape it, and we can't respond. The difference between the heavily hyped products of the early Eighties and the early Nineties might be said to be one of presentation. Schnabel and Salle want to turn their presentations into overwhelming performances—they want to be the Marlon Brando (Schnabel) and the James Dean (Salle) of the art world. Koons and Kelley want to control the art gallery—they want to be Hollywood directors. That Koons is a publicity hound who frequently features himself in his art events doesn't make him any less the director.

Why the subject matter has slipped in the past few years from the concerns of eighteen-year-olds to (sometimes) the concerns of eighteen-

1 "Mike Kelley: 'Half a Man'" was on view at the Hirshhorn Museum and Sculpture Garden, Washington, D.C., from February 20 through May 19, 1991.

month-olds, I can't say for sure. In part it's probably just the wheel of fashion, turning in response to a shift in demographics: baby-boomers are having their own babies. But childhood may have a particular attraction for the poststructuralists, with kids or without. The late-adolescent persona, with its screaming "I," is harder to deconstruct than the young child, who can be made to look, at least by the adult who wants to present a postmodern indictment of our times, like a totally passive, receptive being. In the current downtown mythology, American suburbia is the factory where people are mass produced. Basically, the new view of youth isn't nostalgic, it's sensationalist. Like the TV docudramas about rape and child abuse that pander but claim to fulfill an educational purpose, the artists who use X-rated children's imagery present erotic titillation as the politically correct thing. Frankly, I don't think a lot of these artists know where kiddie porn ends and consciousness-raising begins. And why should they, when an oily opportunist like Jeff Koons is hailed as a genius by people who claim to be intellectuals? All the artists know is that there's an audience that has a taste for this sleazeball stuff.

Eric Fischl was first. He threw the kid into bed with Dad, and painted the whole thing in a trash-realist style. Jeff Koons was next. He turned Junior and Sis into porn polychrome garden ornaments. So kiddie porn was already a SoHo staple when Metro Pictures mounted the Mike Kelley show that consisted of stuffed animals arranged on baby blankets in poses that might or might not be X-rated. The difference between Koons and Kelley is a matter of technique, so to speak. Koons, who has his work fabricated at considerable expense, is into investing money in order to make money—he's the happy capitalist. Kelley, who's part of the I-can't-be-bothered-to-put-together-a-show crowd, proves that you can invest virtually no money and still make money: as he has explained in interviews, he buys his stuffed animals and crocheted afghans at thrift shops. The Koons show at Metro Pictures gave a gallerygoer pause: presented in that space, it was the most outrageously inconsequential exhibition that I saw last spring in SoHo. But I didn't feel that there was any need to write about it. Dadaist gestures aren't, so far as I'm concerned, newsworthy; and I would rather let somebody else explain that Mike Kelley's crocheted blankets are a kitsch variation on Carl Andre's Minimalist floor pieces.

In the past twelve months, however, Mike Kelley has gone from being regarded as an up-and-coming artist to being regarded as an important artist. It has not hurt his reputation that he has become the subject of NEA controversy. The Institute of Contemporary Art in Boston is planning a Kelley show for fall 1992. This past fall, after one of the panels at the National Endowment for the Arts recommended a grant of $40,000 to support the ICA show, John E. Frohnmayer, chairman of the NEA, refused to approve the grant. The art community was up in arms, and though I can't share the community's sense of outrage, I can't say that I support the

chairman's actions, either. My feeling is that if one of the NEA peer panels approves a grant for a Kelley show, it is our misfortune that this is what the experts deem significant, but the grant must be given. The NEA was set up to support what the professionals think is serious art, and if the curators of the NEA in Boston and the Hirshhorn in Washington along with the chief art critic of *The New York Times* think that Mike Kelley is worthwhile, so be it. The reversal of peer-panel decisions by the chairman of the NEA does nothing to return aesthetic sanity to the art scene. And, in any event, artists like Mike Kelley know how to make hay out of their conflicts with the NEA. The culture wars have given a considerable boost to artists who exercise their all-American right to freedom of speech to the meretricious raunch hilt.

Mike Kelley's career illustrates a bizarre phenomenon in the contemporary scene. It often seems that the less an artist gives, the more attention an artist gets. I think that our increasingly bureaucratized art establishment likes clever, empty packages. The members of the art establishment can fill these packages with any significance they please. Once the sales pitch is perfected, everything falls into place. The dealers put on astronomical price tags, the critics pontificate about the dirty underside of American life, the museum curators look like heroes because they're fighting for the artists' constitutional rights.

Let me describe a few of the works in the Kelley show at the Hirshhorn. *Arena #11* (*Book Bunny*): a crocheted blanket on which are arranged two cans of different varieties of RAID insect repellent and a stuffed rabbit bent over a book (I think it's a grammar). *Arena #4* (*Zen Garden*): a crocheted blanket in a brown, yellow, and beige zigzag stripe that is tossed over four lumps (which are, presumably, stuffed animals doing illicit things). *Fruit of Thy Loins*: a wall piece that consists of a giant stuffed bunny to the front of which are sewn a dozen or so other stuffed animals. In the brochure for the show, Amada Cruz, an assistant curator at the Hirshhorn, says that "Mike Kelley's art is confrontational." I can't really see that: I don't feel "confronted" by these dirty stuffed animals, I just don't want to look at them, a different thing entirely. But apparently some people do want to take a long look. And many people who are intelligent enough to know better than to admire this nonsense nevertheless find the phenomenon of Mike Kelley interesting—as a cultural happening, a fashion freak show. What's going on here gives "Go stuff it" unimagined meanings. It has its comic side. And the comedy has its limits. Every time I go to the galleries I see work by many artists who, whether they succeed in what they set out to do or not, are far more deserving of our attention and encouragement than Mike Kelley. And then I think: These artists don't have a chance in a world where everybody's rushing to embrace the X-rated bunnies.

June 1991

The Trouble with "Angels"

Donald Lyons

The name of the thing is *Angels in America: Millennium Approaches: A Gay Fantasia on National Themes* and that ain't the half of it. What is now at the Walter Kerr Theatre is only the *first* three and a half hours; a further three and a half hours, called *Perestroika*, will arrive in the fall. It is the brainchild of Tony Kushner, whose earlier play, *A Bright Room Called Day*, was an explicit and loud attempt to equate Reagan's America with Hitler's Germany. So one kind of knew what to expect from this cumbrously titled opus. It has been hailed with a rapture unheard in decades. It got the Pulitzer. "The finest drama of our time," said *The New York Observer*, "It asks: Where is God? And yearns for an answer, a prophet, a messiah, or salvation. It is, in its searing essentials, about love." Golly. This language might be thought excessive for the *Oresteia*. Cleverer in expression but no less smitten was Frank Rich of the *Times*, who spoke of "the most thrilling American play in years."

As will perhaps become clear, the huzzas occasioned by *Angels* are not really about this slender, derivative, and vulgar play; they are rather victory chants in celebration of the takeover of a culture. But first, the play. It is directed by George C. Wolfe, new head of the New York Shakespeare Festival, where *Angels* was scheduled to open until Mr. Kushner thought better of that arrangement (surely not, however, out of Eighties, Reaganite greed) and took it to more lucrative pastures uptown. Mr. Wolfe is the ideal director for a weak script like this: he knows how to keep things moving, how to milk every laugh, how to dramatize every beat. Set in 1985 and 1986, the story centers on the parallel dissolution of two couples: a yuppie Mormon lawyer and his wife; a Jewish clerk and his lover. The Mormon couple is torn asunder by the husband's growing inability to stop cruising parks for men at night and by the wife's consequent paranoia, loneliness, and pill-popping. By the end of *Millennium*, the husband has still not quite accepted his gaiety but is doing mucho handholding in bushes. The wife is having hallucinations in which she is transported to Kingdoms of Ice by unorthodox travel agents. This narrative seems unable to settle on an attitude toward the wife: it is, of course, the hubby's duty

to embrace his homosexual impulses and thus to wound this woman; it is her duty to suffer, and suffer is about all she does here. The atmosphere is drearily reminiscent of 1950s melodramas of repressed longings à la *Cat on a Hot Tin Roof*. Maybe, of course, the wife will get a lesbian mate in *Perestroika*; it seems the only solution in Kushnerland.

One half of the other couple is a Woody Allen whiner and would-be epigrammatist given to utterances like "Catholics believe in forgiveness, Jews believe in guilt" and "You're nice, I can't believe you voted for Reagan" and "Jeane Kirkpatrick, what does the word freedom mean when she talks about it?" And this guy is the most articulate and cutting spokesman for Kushner's political wit. His lover, a man called Prior Walter, contracts AIDS and declines throughout the play, dying at the moment of the close. Funny, flamboyant, campy, Prior is at least a character within Kushner's creative range. As played by Stephen Spinella, he owes a lot to the bravura style of Charles Ludlum's Theater of the Ridiculous and similar companies. In his illness, Prior is deserted by the politically correct lover and is left to suffer alone. These scenes of pathos, in and out of hospital rooms, are affecting, but their affectingness is more a function of the horror they are signifying than of any special power in Kushner's writing.

The character of Prior is called on to do more than to die bravely and merrily. He must somehow intimate the coming of "another America of truth and beauty" (in Frank Rich's words) or indeed the coming of a messiah of some kind. Of *what* kind we cannot guess, for Kushner's toying with religious imagery and rhetoric is both frivolous and (since he is an admitted Marxist) insincere. *Perestroika* will doubtless offer details of the redemptive scenario (have I read or did I dream that Gorby and Prior join hands to redeem everybody?).

But we get a glimpse of things to come in a huge kitsch angel that hovers over Prior at the finale proclaiming, "the great work begins, the messenger has arrived." "Very Steven Spielberg," quips the moribund but ever-sharp Prior at the sight of this tacky apparition, in allusion to the descent of the spaceship in *Close Encounters of the Third Kind*. He might better have said, "Very Andrew Lloyd Webber" or "Very Cameron Mackintosh," for this campy angel is really the bastard child of the saucer in *Cats* or the chandelier in *Phantom* or the helicopter in *Miss Saigon*. It is only the glitzy imagery of a degenerate Rialto that Kushner is able to wield when attempting to convey his notion of spiritual beauty or significance.

But, if Kushner's gestures toward utopia and love are singularly unconvincing, he *is* able to hate. Roy Cohn figures as the all-purpose villain in *Angels*, trying to convince the Mormon lawyer to join the Meese Justice Department, sophistically redefining homosexuality and AIDS so as to exclude himself (the best of this stuff is cribbed right from various biographies), being forced to accept succor at the moment of death from the

ghost of Ethel Rosenberg (whose death sentence he had declared his proudest achievement). Despite Ron Liebman's Volpone-like energy in the role, the Cohn character becomes in fact less interesting and less coherent as it goes along; his first appearance—a virtually unideological manipulation of power and influence on simultaneous phone lines—is his best. Like Prior—but in an antithetical sense—Cohn is loaded with too much symbolic weight by the clumsy dramaturgy of Kushner; he must be McCarthyism, closetedness, Reaganism, conservatism, and ultimately meanness and not-niceness in general. (Mr. Kushner has said that "progressive people, in my opinion, are deeper and more sensitive than people on the right.") Frank Rich, employing an unsavory locution, dubbed this Cohn "an Antichrist" and also spoke of this Cohn's "shamelessness worthy of history's most indelible monsters." Roy Cohn was an unlovely character, but this is hysterically and tendentiously disproportionate language to use about him—even this shrilly one-note version of him—in a time that witnessed Hitler and Stalin (Ethel Rosenberg's master).

The fineness of Mr. Kushner's moral judgment may be best gauged neither by his handling of the dead Cohn nor even by his refusal to distinguish between Cohn and Jeane Kirkpatrick but by his solicitation of a nasty and homophobic laugh from the complaisant Broadway audience at the expense of President Reagan's son. In a word, Tony Kushner is someone no wise person would choose as a guide to utopia. His agenda is brutally and artlessly familiar: to indict conservative governments of the United States for the sins of anti-Communism and (don't ask how, please) responsibility for AIDS.

And there is, as many commentators have noted, a new glow of triumphalism around *Angels* since the Democratic election victory. The play is seen as the very voice of the New Age. And in its ludicrous pretensions to greatness that barely mask a corrupt cynicism and a smug didacticism, it does seems exquisitely Clintonian to me. Come to think of it, that descending female angel may have a health-care scheme tucked up her wing.[1]

1 Postscript 1994: *Perestroika* duly arrived this spring; it was as jerry-built, dishonest, and verbose as the Soviet experiment. The wife found, if not a lesbian lover, then a warm friend in an old Mormon woman somewhat improbably become that figure beloved of gay kitsch: the all-permissive mother (cf. "Tales of the City"). The Moscow scenes had vanished, replaced by episodes in heaven. For Kushner, the difference between the two places is small; his surrogate character praises Lenin and Gorbachev and finds villainy only in American anti-Communism. Ethel Rosenberg functions as an angel of forgiveness. One long tantrum, *Perestroika* was even more morally repugnant, structurally elephantine, and linguistically turgid than its predecessor. A talentless propagandist addicted to compensatory overkill in presentation, Tony Kushner is the Oliver Stone of theater.

The Royal Dramatic Theater of Sweden's production of Ibsen's poetic masterpiece *Peer Gynt*, staged by Ingmar Bergman, was imported to BAM for a brief run. This long work is famous for wide-flung meditations on life's meaning, and one vaguely expected heavy Nordic breathing and brooding. But, with the audacity and surprise of supreme genius, Bergman drew forth from *Peer Gynt* a satyrlike coarseness and tough ribaldry.

The first part, "Tales and Dreams," set high in Peer's native mountains, was populated by hostile neighbors doing savage wedding dances in angry-red costumes and wooden clogs and by lasciviously welcoming trolls sporting tails. Amid these trolls, who are Peer's permissive fantasies, he rides a pig, wears a phallos—in short, runs the gamut of male irresponsibility. In counterpoint to this is Peer's rough and funny but immensely moving relationship with his mother, Ase. The magnificent Börje Ahlstedt played Peer as an oafish everyman out of Aristophanes and Beckett and Keaton—or rather he found all this in Ibsen. The sublime Bibi Andersson brought a Mother Courage hardness to Ase.

In the second part, "A Foreign Land," Bergman gave us exotic kingdoms marked by calculating sensuality and madness in fierce, geometrical white. A Rubenesque temptress, Anitra, rolled about, legs up, in orange, but the dominant shade was the White of Self-Interest. In the third part, "The Return Home," a terrific sea storm deposits Peer on the shore of a long examination of conscience. A Button Molder who echoes Mozart's Commendatore vies for Peer's soul with a loving madonna-figure who cradles the sinner in a *pietà* pose. She is a redaction of Goethe's Gretchen, as indeed *Peer Gynt* itself amounts to a reworking of *Faust*. Bergman, one of this century's great artistic thinkers about Eros and Thanatos and God, has displayed a wonderful array of visual and spiritual *Gestalts* in realizing the nineteenth century's greatest play. To be nourished by the likes of *Peer Gynt* after junk *Angels* food is to despair of America's diet.

The spirit of Thornton Wilder, miniaturist, expressionist, experimentalist, sentimentalist, remains elusive after all these years. The recent revival of three short Wilder plays—"The Long Christmas Dinner," "The Happy Journey to Trenton and Camden," and "Pullman Car Hiawatha"—by the Willow Cabin company at the Circle in the Square Theatre helps to clarify the artist's case. These three plays, performed here under the title *Wilder, Wilder, Wilder*, were published in 1931, together with three slighter efforts, as *The Long Christmas Dinner and Other Plays in One Act*. *Our Town* (1938) and *The Skin of Our Teeth* (1942) still lay ahead.

"The Long Christmas Dinner" takes the Bayard family through ninety years of Christmas dinners. The setup is expressionist: the family sits in chairs and mimes eating whilst its old folks (or a boy off to World War I or a still-born baby) shuffle out through a gate of death and babies are

brought in by a nurse in starched white through a gate of life. The commonplaces of familial discourse—weather, health, food, the day's sermon, neighbors—recur in generation after generation. But father quarrels with son, children leave, the family disintegrates, and at last a spinster cousin is left alone in possession of the house. A family has run its lifespan. "The Long Christmas Dinner" has a place in a tradition of American writing that includes *The Magnificent Ambersons* by Booth Tarkington, *Winesburg, Ohio* by Sherwood Anderson, and *One of Ours* by Willa Cather—chronicles of change, decay, joy, and sorrow in the heartland of the country in the early decades of this century. This little play has not the stature or wisdom of such works, but neither is it meretricious or false. It gets, too, a fine, brisk production under the direction of Willow Cabin head Edward Berkeley, who alertly avoids sentimentality. Wilder's mild enough expressionism is further accentuated in Miguel Lopez-Castillo's set, which dispenses with tables and turkeys and wigs, as well as with Wilder's prescribed "black velvet" and "garlands of fruits and flowers" around the twin portals, and which adds a sort of heavenly loft where the deceased climb to sit. This production makes, indeed, the most comfortable, sensible, and imaginative use I've seen of the awkward oval thrust of the Circle stage.

In the second play, the Kirby family of four—mother, father, son, daughter—are in a Chevrolet driving from Newark to Camden to visit a married daughter who has, we eventually discover, just given birth to a still-born baby. The play is without scenery and features a Stage Manager, who reads from a script the lines of minor characters "with little attempt at characterization, scarcely troubling himself to alter his voice, even when he responds in the person of a child or a woman." "Happy Journey" belongs to the mother, superbly played by Maria Radman: a fussy chatterbox bursting with banal commonplaces, quick to take offense and quick to forgive, a finally delightful presence, the very incarnation of bourgeois American motherhood. Her moral landscape is unapologetically simple: "I guess I can take my children out of school for one day without having to hide down back streets about it"; "The world's full of nice people"; "I'm glad I was born in New Jersey. I've always said it was the best state in the Union. Every state has something no other state has got"; "If people aren't nice I don't care how rich they are. I live in the best street in the world because my husband and children live there." The kids read billboards and ask for everything on them; the father quietly drives; they pause for a funeral; they get hot dogs; they sing songs. It is, despite the sad occasion for the trip, a picture of a reasonably happy family in a country where happiness is possible. The overall effect is a successful elevation of the Jersey quotidian that has affinities with the work of another Jersey lyricist, William Carlos Williams, and that recalled to me those mysterious lines that end Rilke's Tenth Duino Elegy:

And we, who have always thought
of happiness as *rising*, would feel
the emotion that almost overwhelms us
whenever a happy thing *falls*.
(*trans. Stephen Mitchell*)

The third play, "Pullman Car Hiawatha," takes a random assembly of passengers on the New York–Chicago night train run on December 21, 1930. There are two organizing personalities present: a stage manager again and a porter. The actors bring in their own chairs to simulate the car. Of the dramas among the passengers, the gravest is the death of a young married woman, Harriet. As the train glides through the night, various symbolic personages address us briefly: the town of Grover's Corners, Ohio; a field; a tramp ("I have a right to be in this play"); a German railway worker killed long ago in the building of the track; a watchman; a mechanic. Above this, a cosmological parade of pretty hours and planets sashays on the loft space above. This is perhaps Wilder in a facetious vein, neither serious enough nor quite light enough. But at the end the dead woman has a long, valedictory monologue that suddenly swoops us, as Wilder's lyrical theater at its best can, into the heart of America. "Goodbye," she sighs, "Emerson Grammar School on the corner of Forbush Avenue and Wherry Street."

Premonitions, formal and thematic, of *Our Town* occur in the first and third of these plays; premonitions of *The Skin of Our Teeth* can be found in the second. But the value of the shorter works is far from just that of pointing to later accomplishment. Indeed, it could almost be said that, in their gracility of shape and lightness of emphasis, they are superior to the full-length plays to come. While sounding chords dear to Wilder— American rectitude, American sadness, the evanescence of things—they largely avoid that heavy eschatological sentimentalizing he was to fall into. In them we can see Wilder's theatrical talent at its purest and sweetest and least strained.

June 1993

The Best and the Worst of Louise Bourgeois

Karen Wilkin

Over the years, I've been both convinced and irritated by Louise Bourgeois's sculptures, compelled and repulsed, fascinated and enraged, often at the same time and, on occasion, by the same piece. I remember being puzzled, at her 1983 retrospective at the Museum of Modern Art, by the contradiction between the single-mindedness of her themes and the scattiness with which she found ways of embodying them. The range of conceptions was fairly narrow, the range of materials, both traditional and non-traditional, very wide, and the range of invention, to put it delicately, erratic. At times, Bourgeois seemed to have tapped deep wells of feeling and to have given them form in ways that made ideology irrelevant. At others, her reputation appeared to have more to do with her presentation of herself as what might be called a marginalized, victimized female artist than with any achievement as a sculptor.

It's not entirely Bourgeois's fault, of course, that her lifelong (and frequently stated) obsessions—her own sexuality, her own body, her relationship to her parents, her sense of isolation and oppression—have been claimed by feminist critics as paradigmatic of their concerns, any more than it is her fault that her longtime interest in materials as disparate as latex, wax, marble, bronze, and scavenged wood has been hailed by postmodernist commentators as a rejection of modernist practice. It hasn't hurt, mind you—although I suppose that it is churlish to begrudge Bourgeois, who is now eighty-two, the attention and recognition that she has been accorded in the past decade or so. And however modish her preoccupations appear today, it's clear that she has been obsessing about her anatomy and her lot in life since long before such female self-absorption became fashionable.

None of which changes the fact that Bourgeois is a wildly uneven artist, almost a schizophrenic one, who swings between expressive metaphor and flat-footed literalness with bewildering ease. At the Museum of Modern Art, in 1983, it was difficult to believe that the woman who made those suggestive, vertical "totems" in the late 1940s and 1950s was the same one responsible for those sleek agglomerations of sliced cylinders

179

and swelling lumps from the 1960s and 1970s. The totems, cobbled to-
gether from scraps of wood and battered objects, were like the potent vo-
tive symbols of some impoverished, primitive culture, while the marble
clusters, presumably "bi-gendered" conflations of breast and phallus with
seed-pod overtones—*pace* Georgia O'Keeffe—were, in fact, more note-
worthy for the morbid slickness of their execution than for their all-too-
predictable imagery.

Since then, in Bourgeois's subsequent exhibitions, the same dichot-
omies obtained. Apparently deeply felt, thoughtful constructions that
transformed banal materials into highly charged places coexisted with
repellently finished marble objects that evoked nothing more stirring than
the commercial stoneyard. I recall my fascination with her *Articulated Lair*
(1986), now in the collection of the Museum of Modern Art and currently
on view there, a slightly claustrophobic enclosure made of folded metal
screens strung with clusters of soft, elongated biomorphic forms made of
matte black rubber. The sense of place was dramatic and curiously am-
biguous. The structure seemed both temporary and timeless, and what
was even more odd, it suggested both a building and the body. You
slipped between the folds of the "screen" and entered a narrow space
defined by zig-zag walls, punctuated by pendant "organs," and thought of
the permanent and the makeshift, of the architectural and the biological,
all at once. But remember those cloying virtuoso marbles at Robert Miller
Gallery a couple of years later—the pristine geometric forms rimmed with
mottoes and questions, waving horribly lifelike little arms, legs, and
hands? The first lot of these occupied a territory somewhere between a
pile of dismembered china dolls and the nastier kind of nineteenth-cen-
tury polychrome sculpture. (I keep thinking, too, of those creepy Vic-
torian formal portraits of dead children, common currency in an era
notable for both a staggeringly high rate of infant mortality and the in-
vention of photography.) Bourgeois's slightly later variants on the motif
substituted the hands, forearms, legs, and feet of an elderly adult for the
babies' limbs, while preserving their excruciating naturalism, with all its
overtones of mass production, the nineteenth-century sculpture industry,
and the Academy.

The tribute to Bourgeois currently at the Brooklyn Museum, "The
Locus of Memory, Works 1982–1993,"[1] does nothing to revise these im-
pressions. An expanded version of her exhibition at the 1993 Venice Bien-
nale, it contains works ranging from the mysterious to the trivial, from
the poetic to the kitschy. The full spectrum of the sculptor's capabilities is

1 "Louise Bourgeois: The Locus of Memory, Works 1982–1993" at the Brooklyn
Museum (April 22–July 31, 1994). A catalogue, by Charlotta Kotik, Terrie Sultan,
and Christian Leigh, has been published by the Brooklyn Museum and Harry N.
Abrams.

represented in this somewhat oddly selected and oddly installed show. (Word is that Bourgeois herself had a great deal to do with both the choices and how things are presented, confirming once again the truism that artists are not always the best judges of their own work.) Her strengths are evident in many of the installation-type structures, particularly the "house-front," "entrance" constructions from the late Eighties, and some of the recent cage-like *Cells*. But her weaknesses are equally evident: her self-indulgence, her apparent lack of self-criticism, and, curiously, given her seeming sensitivity to the particular qualities of a great many diverse materials, her reliance on ideas, rather than on their physical manifestations, for expression. Yet what comes through, even in the wildly self-indulgent pieces, is an evident honesty. No matter how much you wish she had found a less obvious metaphor for male-female relations than those phallus-breast clusters, there is always something whole-hearted about the work. The struggle to find images for sexuality and femaleness feels *real*. If this seems worth pointing out, it is only because it is in marked contrast to the aggressive self-consciousness of the work of a kind of male Louise Bourgeois, the British painter of fleshy "naked people" whose recent efforts packed them into the Metropolitan earlier this spring. Bourgeois's work has none of the gleefully malicious "look how naughty I can be" quality of her male colleague's, none of what might be called "Lu-*schad*-ian Freud."

Perhaps the biggest problem with Bourgeois's Brooklyn show is that it begins badly. The rather ill-proportioned dark lobby space, frequently given over to specially conceived projects, is occupied, dead center, by one of Bourgeois's "house-front" type constructions, a fairly intimately scaled assemblage of roughly carved wooden balls against a delimiting "wall." It's probably a good piece, but it is dwarfed by the lobby. I've seen related works in smaller, more readily apprehended spaces, where the setting became an active part of the whole, exerting pressure on the various elements to create much needed tension. But the ample and incoherent Brooklyn Museum lobby drains the sculpture of tension, so that the scattering of robust, chunky balls seems arbitrary, and the piece reads as atypically tasteful, elegant, and a little lost.

The introductory, or at least the most accessible portion of the show, a group of about two dozen drawings and a single sculpture installed in the galleries to the left of the main entrance, is similarly problematic. The most recent of Bourgeois's works on view, the sculpture and all but five of the drawings were executed this year. The theme is the spider and the spider-woman, which, we are told by the abundant text panels, is for Bourgeois a potent symbol of "the maternal principle and social intercourse." And as the artist declares, her mother, her "best friend," was as "delicate, discreet, clever, patient, soothing, reasonable, dainty, neat, and useful as a spider."

The drawings that spring from these feelings, alas, are far less engaging than this unexpected list. Uniformly executed in a stylish Schiaparelli shocking pink gouache and black ink, they fuse spider-doll-figure images into agile mannequins, distilling the particularities of each into a shorthand of skinny, generalized forms. When the figures (or the spiders, for that matter) are rendered more explicitly, however, they're pretty inept. Clearly it's the *idea* of spider and of woman that interests Bourgeois, not the way spiders or figures look or move or occupy space. As is often typical of sculptors' drawings, the act of rendering something potentially buildable takes precedence over adjusting that depiction to a two-dimensional surface, so that the placement of images seems arbitrary and expedient, and fails to activate the page. When some kind of coherent, organizing space is indicated, it is, as a rule, both slack and conventional. Undeniably, such drawings offer clues to Bourgeois's thinking and insights that help us to read the generalized, simplified forms of her sculptures, but in Brooklyn the cumulative effect of those two rooms full of spiky little hot pink "characters," especially since they are virtually the first thing of hers you see, is to diminish the artist rather than to enhance your conception of her achievement.

What makes things more difficult is that the drawings serve as preamble to a large and not very thrilling sculpture, installed in the last room of the suite of galleries: an oversized, mostly metal spider that completely fills the oval space. It's an awfully literal piece, with something that looks like a pair of giant knitting needles stuck into one of the "knee joints" (just in case you didn't get the connection with the artist's mother) and not much sculptural presence. Like the drawings, it seems to be more about the *idea* of spider than about expressive form, mass, or volume. It is interesting, though, to watch people enter the room, hesitating, at first, to walk between the outstretched, over-arching legs of the creature, even though there is plenty of space to pass beneath them. If you do walk through, you are rewarded. The rather uninspired, skinny-legged insect transforms itself into a schematic shelter, like the ribs of a tent, or the bones of a thorax, with a massive, cauldron-like breast-body above. It is oddly comforting to be inside the sculpture—something like being a small child playing under a grown-up's large umbrella—but the pleasure has little to do with the piece's sculptural qualities. I'm having trouble, as I write this, remembering how the legs are articulated and modulated, even when I reread my notes; what I can conjure up is the sensation of being within the delimited space.

The main part of the show, in the fourth-floor galleries, is far stronger. There is the usual complement of over-wrought, finely crafted bronze or marble body-part concretions, and a number of the kind of ambiguous anatomical drawings that younger artists such as Kiki Smith have gotten

such mileage from. But there are also pieces that give us Bourgeois at her best. *No Exit* (1989, Ginny Williams Family Foundation, Denver) was noteworthy when it was shown at Galerie Lelong, New York, in the spring of 1989, and it looks provocative and powerful in Brooklyn. A weathered wooden staircase leads nowhere, from a loosely sketched space enclosed by folding screens, like a portable entrance hall. A pair of overscaled, rough wooden balls—actually egg-shapes, like human heads—flank the stair, reinforcing the formality of the implied action—ascending a staircase—but, at the same time, holding the viewer at bay. Occupying our normal space but rigidly symmetrical and ultimately non-functional, the stair simultaneously offers an invitation to penetrate and refuses the possibility of forward motion. The weathered surfaces of the wood clearly have a history, provoking thought about the passage of time, aging, experience, memory, the vulnerability of materials, and more.

The series of *Cells* from the 1990s, some of which were exhibited in Venice, are among the most potent works in the show. Each consists of a cage-like cubicle, furnished with objects that often seem to refer to one of the senses: a carved marble ear for hearing, a leg and an image of brutal cutting—pain made visible—for touch, mirrors and "eyeballs" for sight, and so on. There are precedents for this in seventeenth-century painting, where an apparently straightforward genre portrait—a man holding a flower or an onion, say, or playing a musical instrument, or eating a dish of beans—was intended as an emblem of smell, hearing, or taste. Bourgeois clearly makes similar kinds of allusions (as well as many others) in the *Cells*, but not as ends in themselves; the allusion is only part of the meaning of these pieces. The cage-like enclosures suggest imprisonment, isolation, detachment from the sensory, and possibly even from the sensual, world. Rather than celebrating the senses, Bourgeois seems to examine the possibilities and effects of deprivation, although whether she does so from a position of protest—as a victim—or of advocacy—as an ascetic—is open to discussion.

Old wooden doors, diagonally woven wire-mesh fencing, old industrial steel sash windows, complete with broken panes—suspiciously like the windows in the Dean Street, Brooklyn, building where Bourgeois has her studio—variously form the enclosures. Some we can look into from all sides, while others require us to peer in from fixed points of view. As in Bourgeois's work in general, the most literal of the *Cells* are the least successful; in them, the association of objects within the "cage" seemed at once random and forced, and the enclosure wall that incorporated a guillotine blade seemed, to put it kindly, a little obvious. But others allow for an enriching flux of interpretation, calling up associations as diverse as the schoolroom and the prison cell, the doll's house and the rural cabin. In *Cell (Glass Spheres and Hands)* (1990–93, collection of the artist), the juxtaposition of clunky wooden stools and chairs, greenish glass spheres, a

padded canvas-covered table, and a set of carved marble hands is both un-expected and richly suggestive. The glass spheres—Japanese fishing floats? —seem about to evaporate, to vanish from the sturdy peasant chairs on which they rest. In any other context, the meticulously rendered marble hands would be just another of Bourgeois's ventures in the outer limits of taste, a questionable demonstration of the likeness between pale pink marble and human flesh, their combination of realism and fragmentation suggestive of some sort of mutilation. But lying on the canvas-topped table in the tiny "room," the hands become quite simply a piece of sculp-ture, and, by extension, a metaphor for art and making. The specific for-mal qualities of the carving are subsumed by the role of the marble hands and forearms, as a version of a found object, in relation to the whole.

These pieces depend upon what Michael Fried calls "theatricality." They wait for the viewer to attach meaning to what are, often, essentially neutral and not particularly expressive objects in the sculptural sense. That is to say, the way elements touch, the way forms are articulated in space, the way the structure meets the ground plane are not of primary impor-tance. The object is, in itself, passive, mute; given Bourgeois's statements about the role of women, this is quite possibly deliberate, of course.

Despite this, however, intention is not what determines the success or failure of Bourgeois's work. Associative power, no matter how rich, is not enough to rescue a visually unsatisfying work, any more than the sheer technical excellence of the "mechanically" carved marbles is enough to redeem them from emotional vapidity. By themselves, the most edifying association you might make with, say, the fiercely naturalistic marble hands would be with Rodin's fragments. (If nothing else, the slippery surfaces of Bourgeois's body parts would serve to emphasize the rough-ness and directness of Rodin's modeling.) But context and placement, in *Cell* (*Glass Spheres and Hands*), effects a transformation of this essentially trite image of the artist's body. Something similar occurs in *Cell II* (1991, The Carnegie Museum of Art, Pittsburgh), where virtually the same gnarled, clasped hands and forearms are placed on a mirrored table top, beside a collection of empty bottles of Shalimar perfume; the hands are again transformed, reading less as a ghastly, sentimental bit of statuary than as a surrogate self-portrait, a fragmented icon of mature femininity.

What else is outstanding? *Le Défi* (1991, Solomon R. Guggenheim Mu-seum, New York), a giant blue packing crate on wheels, fitted out with glass shelves and lined with rows of glass objects: decanters, jars, wine flasks, laboratory vials, and the like. The play of light on the rows of clear glass is seductive, the metaphor for fragility and peril, effective. Curiously, among all the recent pieces, this is the one that reminds me most, in spirit, of the Fifties totems, which remain some of my favorite of Bourgeois's works. In these ramshackle constructions, the artist threaded chunks of

found and recycled wood onto vertical supports, sometimes painting them, sometimes not, to form lively, insistent little "figures." These columns of angular chunks of wood forcibly remind you of how they were made, with the almost random repetition of a single action. The repetition wasn't wholly random, of course, any more than Pollock's pours were random, or than Bourgeois's own gathering of glass objects in *Le Défi* was random, but depended upon choice, upon accumulation, repetition, and organization according to intuitive notions of likeness and unlikeness.

The work of Bourgeois's erstwhile colleague, Louise Nevelson, comes to mind, in relation to these principles. There are other similarities, as well. Like Bourgeois, Nevelson was often best when she was improvising, scrabbling, before success permitted her virtually unlimited access to materials and to whatever technical extravagances seemed desirable. When Nevelson constructed her walls with scavenged, worked-over debris, with elements that had a visible past despite their new context and the unifying black (or white) paint, she made some of her best sculpture. Once she stopped combing the streets for her materials and started ordering new doorknobs by the gross, her work lost a good deal of its edge. The evidence of Bourgeois's saccharine marble sculptures suggests that she, too, can succumb to failure in the face of limitless possibilities; the *Cells*, which seem improvised, made of whatever was at hand, but which also incorporate rather elaborately "manufactured" elements, like the marble hands, suggest that Bourgeois is finding new ways of using a wide variety of forms, of exploiting processes and objects that have resonance for her, without losing the qualities that distinguished the best of her early work.

The catalogue for the exhibition is a very curious document. It is abundantly illustrated, but there isn't quite the coherent relation between what is illustrated and what is in the exhibition that you expect in an exhibition catalogue. (I suppose I am slightly prejudiced by the cover's reproducing, in full color, one of my least favorite rose-marble baby's-leg sculptures, one bearing the extraordinarily subtle message, "Do you love me? Do you love me?") The catalogue texts are even more peculiar. There's a clear-headed, intelligent essay by Charlotta Kotik, "The Locus of Memory: An Introduction to the Work of Louise Bourgeois," and two rather more predictable, admiring essays in the most up-to-the-minute mode, Terrie Sultan's "Redefining the Terms of Engagement: The Art of Louise Bourgeois" and Christian Leigh's "The Earrings of Madame B . . .: Louise Bourgeois and the Reciprocal Terrain of the Uncanny." But then there is a whole section of statements, starting with one by the artist herself, who has never trusted her work to get her meaning across unassisted, and a raft of testimonials from the (mostly) famous and besotted: Lynne Cooke of the DIA Foundation, Jenny Holzer, Arthur Miller, Adrian Piper, Richard Serra, and others. As I said, it's odd.

June 1994

Betraying a Legacy:
The Case of the Barnes Foundation

Roger Kimball

After the Donor's death no picture belonging to the collection shall ever be loaned, sold or otherwise disposed of except that if any picture passes into a state of actual decay so that it is no longer of any value it may be removed for that reason only from the collection.
> —from the By-Laws of the Barnes Foundation, December 1922

One of the most striking things in America is the Barnes collection, which is exhibited in a spirit very beneficial for the formation of American artists. There the old master paintings are put beside the modern ones . . . and this bringing together helps students understand a lot of things that academics don't teach.
> —Henri Matisse, 1930

The headline of a press release from the National Gallery in Washington, D.C., put it with disarming frankness: "World Tour of Great French Paintings from the Barnes Foundation."[1] To be sure, the paintings *are* great. Among the eighty-odd canvases from the legendary Barnes Foundation in Merion, Pennsylvania, that were on view at the National Gallery were masterpieces by Renoir, Cézanne, Seurat, Matisse, and Picasso, as well as important works by Gauguin, Henri Rousseau, Vincent Van Gogh, Chaïm Soutine, Amedeo Modigliani, and others. Renoir's *Leaving the Conservatoire* (1877), Cézanne's *The Card Players* (1890–92), Seurat's *Models* (1886–88), Matisse's *Le Bonheur de vivre* (1905–6), *Seated Riffian* (1912–13), and *Merion Dance Mural* (1932–33): these and other works—including the first public showing of a stunning early version of Matisse's dance mural

1 "Great French Paintings from the Barnes Foundation: Impressionist, Post-Impressionist, and Early Modern" was on view at the National from May 2 through August 15, 1993; later venues included the Musée d'Orsay, Paris, the National Museum of Western Art, Tokyo, and the Philadelphia Museum of Art. A catalogue of the show, with essays by several hands, was published by Alfred A. Knopf and Lincoln University; a paperbound edition was available from the National Gallery.

that was only recently discovered in Nice—made the exhibition one of the most spectacular samplings of late-nineteenth- and early-twentieth-century French painting anywhere.

Of course, it all sounds marvelous. Never mind that the installation at the National Gallery was rather sterile: is it not terrific that this was only the first of several stops on a worldwide, money-making tour that, as of this writing, included museums in Paris, Tokyo, and Philadelphia? Think of the crowds: they will almost certainly number in the hundreds of thousands. All those art lovers, hitherto unable to make it to the Barnes Foundation—with its limited hours and out-of-the-way location in a comely suburb of Philadelphia—were at last able to buy a ticket and shuffle past these masterworks *en masse*. Richard H. Glanton, president of the Barnes Foundation, estimated that the tour would bring about $7 million to the Foundation's coffers. Is this not a splendid example of shrewd financial management combined with "cultural democracy" in action? The National Gallery wants you to think so. With some notable exceptions, the press wants you to think so, too. Likewise the current administration of the Barnes Foundation.

But no. The spectacle of the Barnes Foundation in the last couple of years has been anything but encouraging. The public-relations apparatchiks would have us believe that, after decades of "elitism," the Foundation is finally opening its doors and dispensing its treasures to "the people." In fact, the recent behavior of the Foundation's trustees, in collusion with several other institutions and individuals, raises a host of troubling questions: questions about the proper place of art and aesthetic values in a democratic society, first of all, but also questions about the future of private philanthropy in this country. This is hardly the only occasion on which such questions have come to a head. Indeed, the struggle between the prerogatives of artistic excellence and the claims of popular appeal have featured prominently in the recent history of American arts institutions. But the case of the Barnes Foundation adds several new elements to this long-playing drama: a maverick, largely self-taught connoisseur with a genius for business, art, and making enemies; a long and tangled legal battle in which undeclared rivalries have masqueraded as matters of high principle; and, last but not least, large dollops of populist demagoguery.

The protagonist of this saga is Dr. Albert C. Barnes. Born in Philadelphia in 1872, Barnes was brought up in a working-class family, the son of a butcher. He was a talented athlete, boxing and playing baseball semi-professionally to help pay for his schooling. He was also a diligent student, earning a B.S. in 1889 and, from the University of Pennsylvania, an M.D. in 1892 at the age of twenty. After his internship, he traveled to Berlin and Heidelberg to study pharmacology and philosophy. In 1902, he mar-

ried and, with the German chemist Hermann Hille, started the company Barnes and Hille, which manufactured a proprietary antibiotic compound called Argyrol. Especially useful in fighting infant eye infections, Argyrol was to make Barnes's fortune. In 1907, he bought out Hille's interest in Barnes and Hille, and the following year established the A. C. Barnes Company, which manufactured and marketed Argyrol worldwide.

In addition to his skills as a businessman, Barnes had prodigious intellectual gifts. The philosopher John Dewey, a close friend with whom he corresponded and collaborated for over thirty years, once remarked that for "sheer brain power" he had not met Barnes's equal. His fortune assured, Barnes increasingly turned his attention to the world of art and ideas. His intellectual tastes, like his artistic tastes, proved to be daring, individual, and supremely self-confident. From boyhood, he was fascinated by American black culture—camp meetings, revivals, and the like —and he later acknowledged the indelible impression that black culture had made on his life and outlook. He also became deeply interested in psychology, including the startling new methods propounded by Freud and William James. Pragmatism, especially, with its emphasis on the experiential basis of human values, attracted him.

Barnes began collecting art in the early Teens. At first, his high-school friend, the artist William Glackens, helped him buy works. Barnes sent Glackens to Paris in 1912. Together with the artist Alfred Maurer, Glackens purchased for Barnes works by Cézanne, Van Gogh, Picasso, Renoir, Pissarro, and others. Barnes later traveled to Paris to make his own purchases from dealers and auction houses. He eventually assembled one of the most dazzling collections of modern French painting anywhere in the world. By the time of his death, in 1951, he had acquired 180 works by Renoir, sixty-nine by Cézanne, sixty by Matisse, forty-four by Picasso, fourteen by Modigliani, twenty-one by Soutine, eighteen by Henri Rousseau, seven by Van Gogh, six by Seurat, as well as a handful of Gauguins, Toulouse-Lautrecs, Braques, Monets, Manets, and others. But Barnes's taste was hardly confined to French art. He was also an avid collector of Old Master paintings, American Impressionists, Greek and Egyptian antiquities, intricate wrought ironwork, Native American art, and African tribal sculpture. Altogether, the Barnes collection totals nearly twenty-five hundred works of art.

Interested though Barnes was in art, his first passion was education. Deeply influenced by Dewey's theories on education and democracy, he looked to art and aesthetic experience as a primary, if as yet imperfectly tried, means of educating the human spirit in modern democratic society. As he put in the Indenture of Trust that created the Barnes Foundation, he was particularly keen that "plain people, that is, men and women who make their livelihood by daily toil in shops, factories, schools, stores, and similar places," have free access to the sustenance that art offers. As the

scholar Richard J. Wattenmaker points out in his excellent essay for the catalogue that accompanied this exhibition, Barnes began by instituting a six-hour work day at his factory. He installed dozens of artworks at the A. C. Barnes Company and established discussion groups for both white and black workers to ponder the paintings as well as books by Dewey, Bertrand Russell, William James, George Santayana, and others. He started a circulating library and even allowed interested outsiders not associated with the company to attend lectures and discussion groups.

In fact—and this detail is worth bearing in mind—it was out of these informal factory seminars that the Barnes Foundation with its formal roster of classes and research evolved. Convinced that he was on to something, in 1922 Barnes decided to create and endow a foundation "to be maintained perpetually for education in the appreciation of the fine arts." This cannot be overemphasized: the Barnes Foundation was not created as an art museum; Barnes created it "as an educational experiment under the principles of modern psychology as applied to education."

One of the great strengths of Barnes's taste was its breadth. Of course, it is easy to disagree with some of his judgments about particular works or particular artists: but that can be said of any important critic. What matters in a critic are not so much particular likes and dislikes (though the quality of Barnes's collection shows that he did pretty well on this score, too) but the principles of judgment he employs. At the center of Barnes's philosophy was the effort to understand the distinctively *aesthetic* features of works of art no matter what their period or provenance. He sought, as he wrote in *The Art in Painting* (first edition, 1925), the "intelligent appreciation of paintings from all periods of time."

In this, Barnes resembles critics like Roger Fry, who also attempted to delineate "experimentally" (as Fry put it in his book *Transformations*) the experiences we have "in the face of different works of art of the most diverse kinds." Barnes wished to emphasize the aesthetic qualities of art—the emotional coefficients of line, form, color, texture, and so on. This led him to arrange his collection unchronologically in tableaux designed to highlight the aesthetic, rather than the narrative or thematic, affinities among the works. Many visitors to the Foundation have found this—and the absence of wall labels identifying the works—off-putting. But such were Barnes's strategies to coax students (and visitors) into *looking*. Simple chronological organization and wall labels—to say nothing of that contemporary bane, the "audio tour"—serve to distract the viewer from, well, *viewing*. They encourage him to substitute reading or listening for the harder work of attentive scrutiny. Not that the name of the artist and title of a picture are unimportant; but one should be able to assume that anyone really interested in what he is looking at will go to the trouble to ascertain such historical information beforehand. As Barnes noted in *The Art in Painting*,

To see as the artist sees is an accomplishment to which there is no short cut, which cannot be acquired by any magic formula or trick; it requires not only the best energies of which we are capable, but a methodical direction of those energies, based upon scientific understanding of the meaning of art and its relation to human nature.

"The meaning of art and its relation to human nature": One should keep this desideratum in mind when the oft-made charge of "formalism" is hurled at Barnes. The truth is, if by "formalism" one means an abstract inventory of artistic technique, then Barnes was the opposite of a formalist. As Mr. Wattenmaker notes in his catalogue essay, "What Barnes sought to convey in front of the painting itself, rather than from a reproduction, was a means of sorting out the varieties of human experience embodied in a painting." The term "formalism" is nowadays unthinkingly used as a negative epithet. But it is worth remembering that what separates good works of art from the bad or mediocre is always in some sense form and never "content." What makes a depiction of the Virgin Mary or a bowl of irises a great work of art is not the Virgin or the flowers but the handling of those subjects by the artist.

All this is by way of background to the current controversy over the future of the Barnes Foundation—a controversy in which the touring exhibition of French masterpieces played an integral role. At the center of the controversy is the contention that the Barnes Foundation, while it poses as an educational institution, is "really" an art museum that, in exchange for its tax-exempt status, should be more accommodating to the public. This battle is not new. It began shortly after Barnes's death in 1951 when *The Philadelphia Inquirer*—then owned by one of Barnes's chief antagonists, Walter Annenberg—initiated litigation and an editorial campaign against the Foundation in an effort to transform it into a public art museum. As Gilbert M. Cantor notes in his meticulous and informative book, *The Barnes Foundation: Reality vs. Myth*,[2] the *Inquirer*'s campaign against the Barnes Foundation "was not a passing fancy but a ten-year program of harrassment which has not ended even today." Mr. Cantor was writing in 1963; all that needs to be emended is the phrase "ten-year."

As owner of *The Philadelphia Inquirer*, Walter Annenberg had a large hand in directing the attack against the Barnes Foundation. In this context, it is illuminating to compare Mr. Annenberg's activities as a collector with Barnes's. From the Teens—when it was still unpopular—through the Forties, Barnes collected French Impressionist and Post-Impressionist art: Mr. Annenberg began assembling his collection of Impressionist and Post-Impressionist art in the late Fifties when every museum in the

2 Consolidated/Drake Press, 1963; second edition 1974.

country was clamoring for the stuff. Barnes used his self-made fortune to found an educational institution based on aesthetic principles that he had painstakingly thought through for himself; in the 1970s, Mr. Annenberg offered the Metropolitan Museum of Art in New York some $20 million to establish an educational program that would bear his name, even if it could hardly be said to represent his ideas. Barnes stipulated that the artworks he bequeathed to the Barnes Foundation not be sold, moved, or lent; Mr. Annenberg, when he recently promised to leave his collection of paintings to the Met, stipulated that the works not be sold, moved, or lent. Extraordinary coincidences, to say the least.

One of the most disagreeable features of the effort to destroy the Barnes Foundation has been a campaign of character assassination directed at its founder. This, too, has a long history. Barnes made many enemies. He was aggressive, impatient, and could be overbearing to the point of brutality. He harbored a particular dislike for the academic art-establishment, which he regarded as effete, snobbish, and essentially uninterested in the vital aesthetic core of art. (This indeed was one reason that, near the end of his life, he arranged to cede eventual control of the Barnes Foundation to Lincoln University, a predominantly black college in Pennsylvania. Mr. Glanton, incidentally, served as counsel to Lincoln before being appointed president of the Barnes Foundation.)

Today it is routinely assumed that Barnes was eccentric to the point of irresponsibility. One journalist, writing recently in a major newspaper, described him as "loony." Paul Richard, chief art writer for *The Washington Post*, went even further. In an extraordinarily ignorant article called "An Imprisoned Collection Breathes at Last," Mr. Richard castigated Barnes's view of art as "doggerel-like." Admitting that the Foundation's collection is "among the strongest" American collections of paintings, he nevertheless insisted that it was also the "silliest, and strangest." "Few American museums have ever been as selfish, as scornfully unwelcoming, as is the Barnes Foundation," Mr. Richard wrote, snidely adding that it "isn't really a museum, but a gallery-cum-school for promulgating Barnes-think." In fact, Mr. Richard has it exactly wrong. The Barnes Foundation is not a gallery-cum-school; it is a school whose resources include art galleries. The public has not been given free access to the Barnes Foundation facilities, but then the public is not given carte-blanche to wander around classrooms at Yale or Harvard, either. And as for "Barnes-think," well, Mr. Richard gives us a good sense of the quality of his own thinking about art when he goes on to criticize Barnes for acquiring so many Renoirs because Renoir's women "all look much alike." Perhaps Mr. Richard should have taken time out for a course at the Barnes Foundation.

Journalists such as Mr. Richard have unfortunately lent themselves to the attempt to destroy the Barnes Foundation by voiding its charter and forcing it to become a public art museum. As Gilbert Cantor noted in his

book, should this effort succeed, it would be "tantamount to confiscation of an art collection." The ironies are manifold. When he established the Foundation, Barnes wrote that "the purpose of the gift is democratic and educational in the true meaning of those words." Now, under a barrage of populist and anti-elitist slogans, the "true meaning" of democracy and education are rejected for the sake of a grotesque counterfeit.

Before the court granted permission for the world-tour of paintings from the Foundation, Mr. Glanton had proposed selling off various works to finance renovation of the Foundation buildings. So far, that provision of Barnes's trust document has survived the assault. Yet anyone considering the charitable disposition of his own property must be given pause by the cavalier treatment accorded Barnes's Indenture of Trust. The Indenture specifies that "at no time shall there be any society functions commonly designated receptions, tea parties, dinners, banquets, dances, musicales, or similar affairs" held at the Barnes Foundation. But last fall Mr. Glanton gave an elaborate reception and lunch party there at which not only the press but also various society figures, including Mrs. Walter Annenberg, were present. The Indenture specifies that the administration building attached to the gallery "be used as classrooms"—and so it was until Mr. Glanton moved the Foundation's offices into the building, converting Mrs. Barnes's former sitting room into his private office. The Indenture specifically prohibits the "copying of any of the works of art in the Barnes Foundation by any person whatsoever." Barnes was particularly opposed to color reproductions of works of art because they give a distorted impression of the original. And yet the exhibition catalogue, published by Alfred A. Knopf, contains hundreds of illustrations, "154 in full color," as a press release boasts. Another fascinating coincidence: Samuel I. Newhouse happens to own Knopf and the Newhouse Foundation happened to make a $2 million grant to Lincoln University just before Knopf was granted permission to publish the catalogue. And of course the Indenture prohibits lending any works from the collection: that provision, too, has obviously been egregiously violated.

Albert Barnes gave his fortune to perpetuate the idea that democracy was not inimical to high culture. Mr. Glanton and many others are determined to prove him wrong, even if it means making a travesty of his ideas and trampling on the principle of private property. It is disheartening to behold.

June 1993

IV. Reputations Reconsidered

The Perversions of Michel Foucault

Roger Kimball

Since it is difficult, or rather impossible, to represent a man's life as entirely spot-less and free from blame, we should use the best chapters in it to build up the most complete picture and regard this as the true likeness. Any errors or crimes, on the other hand, which may tarnish a man's career and may have been com-mitted out of passion or political necessity, we should regard rather as a lapse from a particular virtue than as the products of some innate vice. We must not dwell on them too emphatically in our history, but should rather show indulgence to human nature for its inability to produce a character which is absolutely good and uncompromisingly dedicated to virtue.

—Plutarch, in the life of Cimon

I am no doubt not the only one who writes in order to have no face. Do not ask who I am and do not ask me to remain the same: leave it to our bureaucrats and our police to see that our papers are in order.

—Michel Foucault, *The Archaeology of Knowledge*

Looking back on our arrogantly skeptical age, future historians are likely to regard the rebirth of hagiography in the 1980s and 1990s with bemused curiosity. For one thing, these decades witnessed a notable dearth of likely *hagioi* or saints available for the honor of such commemoration. Then, too, the debunking temper of our times is ill-suited—or so one would have thought—to the task of adulation. Yet James Miller's ambitious new biography of the French historian-philosopher Michel Foucault[1] (né Paul-Michel, after his father) demonstrates that the will to idolize can triumph over many obstacles.

Foucault, who died of AIDS in June 1984 at the age of fifty-seven, has long been a darling of the same super-chic academic crowd that fell for deconstruction, Jacques Derrida, and other aging French imports. But where the deconstructionists specialize in the fruity idea that language

1 *The Passion of Michel Foucault*, by James Miller (Simon & Schuster, 1993).

refers only to itself (*il n'y a pas de hors texte*, in Derrida's now-famous phrase), Foucault's focus was Power. He came bearing the bad news in bad prose that every institution, no matter how benign it seems, is "really" a scene of unspeakable domination and subjugation; that efforts at en-lightened reform—of asylums, of prisons, of society at large—have been little more than alibis for extending state power; that human relationships are, underneath it all, deadly struggles for mastery; that truth itself is merely a coefficient of coercion; &c., &c. "Is it surprising," Foucault asked in *Surveiller et punir* (English translation: *Discipline and Punish*, 1977), "that prisons resemble factories, schools, barracks, hospitals, which all resemble prisons?" Such "interrogations" were a terrific hit in the graduate seminar, of course. And Mr. Miller may well be right in claiming that by the time of his death Foucault was "perhaps the single most famous intel-lectual in the world"—famous, at least, in American universities, where hermetic arguments about sex and power are pursued with risible feck-lessness by the hirsute and untidy. In all this, Foucault resembled his more talented rival and fellow left-wing activist, Jean-Paul Sartre, whose stun-ning career Foucault did everything he could to emulate, beginning with a stint in the French Communist Party in the early 1950s. He never quite managed it—he never wrote anything as original or philosophically sig-nificant as *Being and Nothingness*, never had the public authority that Sartre, alas, enjoyed in the postwar years. Yet he had eminent and devoted cheerleaders, including such well-known figures as the historian Paul Veyne, his colleague at the Collège de France, who declared Foucault "the most important event in the thought of our century."

Be that as it may, he remains an unlikely candidate for canonization. But the very title of this new biography—*The Passion of Michel Foucault*— puts readers on notice that, in Mr. Miller's opinion, anyway, his subject presents us with a life of such exemplary, self-sacrificing virtue that it bears comparison with the Passion of Jesus Christ. (Nor is the reference to the Passion adventitious: Mr. Miller makes the connection explicit.) The eager reception of *The Passion of Michel Foucault* suggests that Mr. Miller, a prolific cultural journalist who teaches at the New School for Social Research, is not alone in his estimation. To be sure, there have been a few dissenting voices, mostly from academic homosexual activists who feel that Mr. Miller was insufficiently reverential. But most critics, including such luminaries as Alexander Nehamas, Richard Rorty, and Alasdair MacIntyre, have been falling over themselves to express their admiration and "gratitude" for Mr. Miller's performance.

What is novel about that performance is Mr. Miller's neglect of Plutarch's admonition, quoted above, that one ought to concentrate on "the best chapters" of a life and cover over "any crimes or errors" when writing about a great man. While this might be questionable advice for a biographer, for a hagiographer it would seem to be indispensable. Not

that anyone familiar with the outlines of Foucault's life is likely to think him an angel. Mr. Miller describes him as a "new type of intellectual," "modest and without mystifying pretense." But this is at best disingenuous. True, Foucault occasionally indulged in some ritualistic false modesty before delivering a lecture or when disparaging earlier work in favor of his present enterprises. But as the French journalist Didier Eribon has shown in an earlier biography (and as Mr. Miller unwittingly shows in his own), arrogance and mystification were two hallmarks of Foucault's character and writing.[2] Eribon notes that at school, where Foucault decorated his walls with Goya's horrific etchings of the victims of war, the future philosopher was "almost universally detested." Schoolmates remember him as brilliant, but also aloof, sarcastic, and cruel. He several times attempted—and more often threatened—suicide. Self-destruction, in fact, was another of Foucault's obsessions, and Mr. Miller is right to underscore Foucault's fascination with death. In this, as in so much else, he followed the lead of the Marquis de Sade, who had long been one of his prime intellectual and moral heroes. (Though, as Miller notes, Foucault felt that Sade "had not gone far enough," since, unaccountably, he continued to see the body as "strongly organic.") Foucault came to enjoy imagining "suicide festivals" or "orgies" in which sex and death would mingle in the ultimate anonymous encounter. Those planning suicide, he mused, could look "for partners without names, for occasions to die liberated from every identity."

Mr. Miller describes Foucault as "one of the representative men—and outstanding thinkers—of the twentieth century." But his great innovation in this book is to seize what was most vicious and perverted about Foucault—his addiction to sadomasochistic sexual practices—and to glorify it as a courageous new form of virtue—a specifically *philosophical* virtue, moreover. Note well: Mr. Miller does not attempt to excuse or condone or tolerate Foucault's vices; he does not, for instance, claim that they were the human, all-too-human foibles of a man who was nevertheless a great thinker. Such attitudes, after all, carry an implied criticism: we excuse only what requires exculpation; we tolerate only what makes demands upon our patience or broad-mindedness.[3] What we fully approve of we certify

2 Didier Eribon's biography, *Michel Foucault*, was published in France in 1989. An English translation, by Betsy Wing, appeared from Harvard in 1991. See Richard Vine's review in the *The New Criterion* for January 1992.

3 The eclipse of tolerance as a liberal virtue, by the way—the widespread belief that tolerance must now be considered a symptom of reaction—is one of the most insidious by-products of the campaign for political correctness. Among other things, it sharply narrows the space for open debate by requiring allegiance to values or ideas one had hitherto had the luxury of acknowledging without affirmation.

and celebrate; and celebration of Foucault and all he stood for is at the top of Mr. Miller's agenda in this book.

Mr. Miller claims that Foucault's penchant for sadomasochistic sex was itself an indication of admirable ethical adventurousness. Indeed, in his view, we should be grateful to Foucault for his pioneering exploration of hitherto forbidden forms of pleasure and consciousness. In his preface, Mr. Miller suggests that Foucault, "in his radical approach to the body and its pleasures, was in fact a kind of visionary; and that in the future, once the threat of AIDS has receded, men and women, both straight and gay, will renew, without shame or fear, the kind of corporeal experimentation that formed an integral part of his own philosophical quest." In other words, Mr. Miller attempts to enroll in the ranks of virtue behavior and attitudes that until fifteen minutes ago were universally condemned as pathological.

Many of his critics have cheerfully followed suit. For example, the prominent Nietzsche scholar Alexander Nehamas, in the course of his long and fulsome review of Mr. Miller's book for *The New Republic*, readily agrees that "sadomasochism was a kind of blessing in Foucault's life. It provided the occasion to experience relations of power as a source of delight." Consequently, Nehamas concludes, "Foucault extended the limits of what could count as an admirable human life." Again, Isabelle de Courtivron, head of the department of foreign languages and literatures at MIT, assures readers in a front-page review for *The New York Times Book Review* that Foucault "expanded modern knowledge in profoundly important and original ways." She then commends Mr. Miller "for dismissing cliché-ridden concepts about certain specific erotic practices, and for offering a clear and nonjudgmental (even supportive) analysis of the tools and techniques of what he considers a mutually consensual theater of cruelty."

A great deal might be said about this effort to welcome sadomasochism as a bracing new "lifestyle" option. Above all, perhaps, it demonstrates the kind of spiritual and intellectual wreckage that can result, even now— and even for the most educated minds— from the afterwash of the radicalism of the 1960s. Make no mistake: behind Professor de Courtivron's anodyne commendation of a "nonjudgmental" approach to human sexuality and Mr. Miller's dream of "corporeal experimentation" that proceeds "without shame or fear" stands the vision of polymorphous emancipation that helped turn the 1960s into the moral and political debacle it was. Among the many articulations of false freedom that sprouted in those years, none was more influential than Herbert Marcuse's Marxist-Freudian tract, *Eros and Civilization* (1966). Eagerly embraced by countercultural enthusiasts who wanted to believe that heating up their sex lives would hasten the demise of capitalism and bring forth the millennium, it outlines a portentous struggle between "the logic of domination" and the "will to gratifica-

tion," attacks "the established reality in the name of the pleasure principle," and fulminates against "the repressive order of procreative sexuality." Very Foucauldian, all that. As indeed is Marcuse's splendid idea of "repressive tolerance," which holds that "what is proclaimed and practiced as tolerance today"—Marcuse was writing in 1965 and had in mind such institutions as freedom of speech and freedom of assembly—"is in many of its most effective manifestations serving the cause of oppression." In plain Orwellian language: Freedom is tyranny, tyranny is freedom.

The aroma of such Sixties radicalism pervades Mr. Miller's book and everywhere undergirds his sympathy for Foucault. With this in view, it seems only natural that among Mr. Miller's other credits are *The Rolling Stone Illustrated History of Rock and Roll*, which he edited, and *"Democracy Is in the Streets": From Port Huron to the Siege of Chicago* (1987). I am unfamiliar with the former work, but *"Democracy Is in the Streets"* is a straightforward paean to the New Left and its "collective dream" of "participatory democracy." In that book, Mr. Miller was already memorializing crucial "breakaway experiences"—"during sit-ins, in marches, at violent confrontations"—and the Sixties' "spirit of ecstatic freedom." In some ways, *The Passion of Michel Foucault* is a revival of that earlier book, done over with a French theme and plenty of black leather.

Hence it is not surprising that when Mr. Miller gets around to *les événements*, the student riots of 1968, his prose waxes dithyrambic as gratified nostalgia fires his imagination. It is as if he were reliving his lost —or maybe not-so-lost—childhood.

> The disorder was intoxicating. Billboards were ripped apart, sign posts uprooted, scaffolding and barbed wire pulled down, parked cars tipped over. Piles of debris mounted in the middle of the boulevards. The mood was giddy, the atmosphere festive. "Everyone instantly recognized the reality of their desires," one participant wrote shortly afterward, summing up the prevailing spirit. "Never had the passion for destruction been shown to be more creative."

Foucault himself, unfortunately, had to miss out on the first wave of riots, since he was teaching at the University of Tunis. But his lover Daniel Defert was in Paris and kept him abreast of developments by holding a transistor radio up to the telephone receiver for hours on end. Later that year, Foucault was named head of the department of philosophy at the newly created University of Vincennes outside Paris. The forty-three-year-old professor of philosophy then got a chance to abandon himself to the intoxication. In January 1969, a group of five hundred students seized the administration building and amphitheater, ostensibly to signal solidarity with their brave colleagues who had occupied the Sorbonne earlier that day. In fact, as Mr. Miller suggests, the real point was "to explore, again,

the creative potential of disorder." Mr. Miller is very big on "the creative potential of disorder." Foucault was one of the few faculty who joined the students. When the police arrived, he followed the recalcitrant core to the roof in order to "resist." Mr. Miller reports proudly that while Foucault "gleefully" hurled stones at the police, he was nonetheless "careful not to dirty his beautiful black velour suit."

It was shortly after this encouraging episode that Foucault shaved his skull and emerged as a ubiquitous countercultural spokesman. His "politics" were consistently foolish, a combination of solemn chatter about "transgression," power, and surveillance, leavened by an extraordinary obtuseness about the responsible exercise of power in everyday life. Foucault was dazzled by the thought that the word "subject" (as in "the subject who is reading this") is cognate with "subjection." "Both meanings," he speculated, "suggest a form of power which subjugates or makes subject to." Foucault posed as a passionate partisan of liberty. At the same time, he never met a revolutionary piety he didn't like. He championed various extreme forms of Marxism, including Maoism; he supported the Ayatollah Khomeini, even when the Ayatollah's fundamentalist cadres set about murdering thousands of Iranian citizens. In 1978, looking back to the postwar period, he asked: "What could politics mean when it was a question of choosing between Stalin's USSR and Truman's America?" It tells us a great deal that Foucault found this question difficult to answer.

One thing that is refreshing about Foucault's political follies, however, is that they tend to make otherwise outlandish figures appear comparatively tame. In a debate that aired on Dutch television in the early Seventies, for example, the famous American radical and linguist Noam Chomsky appears as a voice of sanity and moderation in comparison to Foucault. As Mr. Miller reports it, while Chomsky insisted "we must act as sensitive and responsible human beings," Foucault replied that such ideas as responsibility, sensitivity, justice, and law were merely "tokens of ideology" that completely lacked legitimacy. "The proletariat doesn't wage war against the ruling class because it considers such a war to be just," he argued. "The proletariat makes war with the ruling class because . . . it wants to take power." Of course, this has been the standard sophistical line since Socrates encountered Thrasymachus, but these days one rarely hears it so bluntly articulated. Nor were such performances rare. In another debate, Foucault championed the September Massacres of 1792, in which over a thousand people suspected of harboring royalist sympathies were ruthlessly butchered, as a sterling example of "popular justice" at work. As Mr. Miller puts it, Foucault believed that justice would be best served "by throwing open every prison and shutting down every court."

Although he came of age in the 1940s and 1950s, the "public" Foucault was fundamentally a child of the Sixties: precocious, spoiled, self-ab-

sorbed, full of jejune political sentiments, wracked by unfulfillable fantasies of absolute ecstasy. He became expert at straining the narcissistic delusions of the Sixties through the forbidding, cynical argot of contemporary French philosophy. And it is primarily to this, I believe, that he owes his enormous success as an academic guru. In Foucault's philosophy, the "idealism" of the Sixties was painted a darker hue. But its demand for liberation from "every fixed form," as Mr. Miller repeatedly puts it, remained very much in force. In an interview from 1968, Foucault suggested that "the rough outline of a future society is supplied by the recent experiences with drugs, sex, communes, other forms of consciousness and other forms of individuality. If scientific socialism emerged from the *utopias* of the nineteenth century, it is possible that a real socialization will emerge in the 20th century from *experiences*."

Drugs, in fact, were one aid that Foucault freely availed himself of in his search for "experiences." He battened on hashish and marijuana in the Sixties, but it was not until 1975 that he had his first encounter with LSD. Mr. Miller considers it crucial to the philosopher's development, and so apparently did Foucault, who described it in what were clearly his highest words of praise. "The only thing I can compare this experience to in my life," he is reported to have said at the time, "is sex with a stranger. . . . Contact with a strange body affords an experience of the truth similar to what I am experiencing now." "I now understand my sexuality," he concluded. In light of Foucault's fate, it seems grimly significant that this pharmacological fête took place in Death Valley. In any event, so galvanizing was Foucault's first experience with hallucinogens that he set aside drafts of the unpublished volumes of *The History of Sexuality*—what a loss! As Miller notes, there were hundreds of pages "on masturbation, on incest, on hysteria, on perversion, on eugenics": all the important philosophical issues of our time.

Nineteen seventy-five was clearly Foucault's *annus mirabilis*. It marked not only his introduction to the pleasures of LSD, but also his first visit to California's Bay Area and introduction to San Francisco's burgeoning sadomasochistic subculture. Foucault had "experimented" with S&M before—indeed, his proclivities in this matter cost him his relationship with the composer Jean Barraqué. But he had never encountered anything so exorbitant as what San Francisco offered. According to Mr. Miller, the philosopher, now nearing his fiftieth birthday, found it "a place of dumbfounding excess that left him happily speechless." The city's countless homosexual bathhouses, he explained, allowed Foucault to grapple with his "lifelong fascination with 'the overwhelming, the unspeakable, the creepy, the stupefying, the ecstatic,' embracing 'a pure violence, a wordless gesture.'"

As always, Mr. Miller presents Foucault's indulgence in sexual torture

as if it were a noble existential battle for greater wisdom and political liberation. Thus while sadomasochism is a topic that Mr. Miller discusses early and often, his fullest exploration of the subject comes in a chapter called, after the title of one of Foucault's books, "The Will to Know." "Accepting the new level of risk," Mr. Miller writes, Foucault

> joined again in the orgies of torture, trembling with "the most exquisite agonies," voluntarily effacing himself, exploding the limits of consciousness, letting real, corporeal pain insensibly melt into pleasure through the alchemy of eroticism. . . . Through intoxication, reverie, the Dionysian abandon of the artist, the most punishing of ascetic practices, and an uninhibited exploration of sadomasochistic eroticism, it seemed possible to breach, however briefly, the boundaries separating the conscious and unconscious, reason and unreason, pleasure and pain—and, at the ultimate limit, life and death—thus starkly revealing how distinctions central to the play of true and false are pliable, uncertain, contingent.

Much of the time, Mr. Miller appears as a sober investigative journalist. But just mention the word "transcendence" and he goes all gooey. I suspect it's a reflex, acquired from too much Alan Watts and other quasi-mystical confections. Just as Pavlov's dog could not help salivating when he heard the bell ring, so Mr. Miller can't help spouting nonsense whenever anyone mentions Dionysus.

Noting sadly that we may "never know" exactly what Foucault did while exploding the limits of consciousness and effacing the boundaries between pleasure and pain, Mr. Miller is nevertheless gruesomely particular in his descriptions of the sadomasochistic underworld that Foucault frequented, a world that featured, among other attractions, "gagging, piercing, cutting, electric-shocking, stretching on racks, imprisoning, branding. . . ." "Depending on the club," he dutifully reports, "one could savor the illusion of bondage—or experience the most directly physical sorts of self-chosen 'torture.'" Foucault threw himself into this scene with an enthusiasm that astonished his friends, quickly acquiring an array of leather clothes and, "for play," a variety of clamps, handcuffs, hoods, gags, whips, paddles, and other "sex toys."

Mr. Miller's discussion of sadomasochism is certainly grotesque; it is also comical at times. Despite everything, Mr. Miller is a careful scholar, and so he feels obliged to supply readers with a full list of sources. In his compendious notes, he informs us that his discussion is based on such works as "The Catacombs: A Temple of the Butthole," *Urban Aboriginals: A Celebration of Leathersexuality*, and *The New Leatherman's Workbook: A Photo Illustrated Guide to* SM *Sex Devices.* "For the techniques of gay s/M in these years," he explains, "I have relied on Larry Townshend, *The Leatherman's Handbook II.*" It's the deadpan delivery that does it.

Unintended comedy aside, however, Mr. Miller's whole depiction of sadomasochism is a maze of contradictions, veering wildly between the worst sort of pop psycho-babble and pompous "philosophical" sermonizing. Addicted to countercultural platitudes about sexual liberation and psychic emancipation, he can't understand why "s/m is still one of the most widely stigmatized of sexual practices." Still, after all these years! On the one hand, to help overcome the stigma, he is desperate to de-toxify the subject, to make the perversion seem "generally benign" and normal. On the other hand, he also feels constrained to present the practice of sexual torture as something brave, "exploratory," and "challenging." The whips and chains are really just "props"; the encounters are "consensual"; the pain is "often mild"; the devotees of s&m are, "on the whole, . . . as nonviolent and well-adjusted as any other segment of the population." But even as he is telling us about the the the pillows he found in an s&m "dungeon" to make it cozy, he also quotes the expert who, while insisting that "the real trip is mental," freely acknowledges that "there is certainly pain and sometimes a small amount of blood." Only a small amount, though.

One of Mr. Miller's frequent explanatory strategies involves a trip down the slippery slope. When was the last time you had a violent impulse? Well, then: aren't we all closet sadists? "After all," Mr. Miller argues, "s/m on one level merely makes explicit the sadistic and masochistic fantasies implicitly at play in most, perhaps all, human relationships." Ah yes, "on one level." It never seems to occur to Mr. Miller that, even if it were true that such fantasies were "implicitly" at play in most human relationships (itself a dubious proposition), the difference between "implicit" and "explicit" is exactly the difference upon which the entire world of moral behavior is based. Furthermore, the question of "relationships" hardly enters, for as Foucault himself stressed, the anonymity of the encounters formed a large part of their attraction: "You meet men [in the clubs] who are to you as you are to them: nothing but a body with which combinations and productions of pleasure are possible. You cease to be imprisoned in your own face, in your own past, in your own identity."

Even Mr. Miller recognizes—though he doesn't come right out and say it—that at the center of Foucault's sexual obsessions was not the longing for philosophical insight but the longing for oblivion. "Complete total pleasure," Foucault correctly observed, is "related to death." The unhappy irony is that this apostle of sex and hedonism should have wound up, like the Marquis de Sade before him, exiling pleasure from sex. In one of the innumerable interviews that he gave in later years, Foucault praised sadomasochism as "a creative enterprise, which has as one of its main features what I call the desexualization of pleasure." What is pathetically revealing is Foucault's belief that this was an argument *for* sadomasochism. He continued: "The idea that bodily pleasure should always

come from sexual pleasure, and the idea that sexual pleasure is the root of *all* our possible pleasure—I think *that's* something quite wrong." Well yes, Michel, there is something quite wrong about that. But who believes that "bodily pleasure should always come from sexual pleasure"? Had a good meal lately? Enjoyed a walk in the sunshine? It is part of the relentless logic of sadomasochism that what begins as a single-minded cultivation of sexual pleasure for its own sake ends by extinguishing the capacity for enjoying pleasure altogether. Indeed, it might be said that the pursuit of ever more extreme sensations of pleasure, which stands at the heart of the sadomasochistic enterprise, drains the pleasure out of pleasure. The desire for oblivion ends up in the oblivion of desire.

Foucault's sexual adventures in the early 1980s also inevitably raise the question of AIDS. Did Foucault know he had the disease? Mr. Miller engages in a fair amount of hand-wringing over this question. He begins by saying no, Foucault probably didn't know. But he also quotes Daniel Defert, who thought his friend "had a real knowledge" that he had AIDS. "When he went to San Francisco for the last time, he took it as a *limit-experience*." This puts Mr. Miller in a tough position. He thinks that "limit experiences" are by definition a good thing. "It is not immoral to be convulsed by singular fantasies and wild impulses," he writes, summarizing the "ethical" point of Foucault's book *Madness and Civilization*: "such limit-experiences are to be valued as a way of winning back access to the occluded, Dionysian dimension of being human." But what if pursuing the limit involves infecting other people with a deadly disease? What if the pursuit of some "limit experiences" implicates one in what amounts to homicidal behavior? In the end, Mr. Miller waffles. He is all for allowing those who "think differently" to engage in "potential suicidal acts of passion" with consenting partners. But homicidal acts? It is pretty clear, in any event, what Foucault himself thought. As he put it in Volume 1 of *The History of Sexuality*, "The Faustian pact, whose temptation has been instilled in us by the deployment of sexuality, is now as follows: to exchange life in its entirety for sex itself, for the truth and the sovereignty of sex. Sex is worth dying for."

Foucault is admired above all for practicing an exemplary suspicion about the topics he investigated. He is supposed to have been a supreme intellectual anatomist, ruthlessly laying bare the hidden power relations, dark motives, and ideological secrets that infect bourgeois society and that fester unacknowledged in the hearts and minds of everyone. It is curious, though, that Foucault's acolytes bring so little suspicion to the master's own claims. Consider the central Foucauldian contention that objective truth is a "chimera," that truth is always and everywhere a function of power, of "multiple forms of constraint." Some version of this claim is propagated as gospel by academics across the country. But wait: is it *true*?

Is it in fact the case that truth is always relative to a "regime of truth," i.e., to politics? If one says: Yes, it is true, then one plunges directly into contradiction—for haven't we just dispensed with this naïve idea of truth?—and the logical cornerstone of Foucault's epistemology crumbles.

Or consider the proposition that Michel Foucault is a kind of latter-day avatar of Friedrich Nietzsche. It is not so much argued as taken for granted that Foucault, like Nietzsche, was the very epitome of the lonely but profound philosophical hero, thinking thoughts too deep—and too dangerous—for most of us. (Except of course for Foucault's followers: for *them* it is the work of a moment to dispense with "Western metaphysics," "bourgeois humanism," and a thousand other evils.) Foucault himself assiduously promoted the idea that he was a modern-day Nietzsche, and Mr. Miller has elevated the comparison into a central interpretive principle. In his preface, he announces that his book is not so much a biography as an account "of one man's lifelong struggle to honor Nietzsche's gnomic injunction, 'to become what one is.'" Never mind that thirty pages later we find Foucault insisting that "One writes to become someone other than who one is": the Foucault industry thrives on such "paradoxes." Anyway, who has time for such niceties as logic when engaged on a risky "Nietzschean quest," something we find Foucault pursuing in Mr. Miller's book every fifty pages or so?

In fact, the comparison between Foucault and Nietzsche is a calumny upon Nietzsche. Admittedly, Nietzsche has a lot to answer for, including the popularity of figures like Foucault. But whatever one thinks of Nietzsche's philosophy and influence, it is difficult not to admire his courage and single-minded commitment to the philosophical life. Wracked by ill-health—migraines, vertigo, severe digestive complaints—Nietzsche had to quit his teaching position at the University of Basel when he was in his mid-thirties. From then on he led an isolated, impoverished, celibate life, subsisting in various cheap *pensioni* in Italy and Switzerland. He had but few friends. His work was almost totally ignored: *Beyond Good and Evil*, one of his most important books, sold a total of 114 copies in a year. Yet he quietly persevered.

And Foucault? After attending the most elite French schools—the lycée Henri IV, the Ecole Normale Supérieure, the Sorbonne—he held a series of academic appointments in France, Poland, Germany, Sweden, and Tunisia. The jobs were low-paying, but the budding philosopher was aided in his program of resistance by generous subsidies from his parents. In the 1950s, when he was a lowly instructor at the University of Uppsala, he acquired what Didier Eribon calls "a magnificent beige Jaguar" (it is white in Mr. Miller's book) and proceeded to drive "like a madman" around town, shocking staid Uppsalian society. Talk about challenging convention! Eribon reminds us, too, that Foucault was an accomplished academic politician, adept at securing preferment for himself and his

friends. This is not to say that he concealed his contempt for narrow, bourgeois scruples, however. Attempting suicide and hurling stones at the police were hardly his only efforts to "transgress" accepted academic protocol. While he was teaching at Clermont-Ferrand in the early 1960s, for example, he gave an assistantship to his lover, Daniel Defert. In response to a faculty-council query about why he had appointed Defert rather than another applicant, a woman who was older and better qualified, he replied: "Because we don't like old maids here." Moreover, Foucault enjoyed the esteem of gullible intellectuals everywhere. His book *Les Mots et les choses* (*The Order of Things* in English) became a best-seller in 1966, catapulting him to international fame. The crowning recognition came in 1970 when, at the unusually young age of forty-four, Foucault was elected to the Collège de France, the very pinnacle of French academic culture. Mr. Miller, like most academics who write about Foucault, praises Foucault's philosophical daring and willingness to put himself at risk for his ideas. "For more than a decade," Mr. Miller writes about Foucault's reputation at the time of his death, "his elegant shaved skull had been an emblem of political courage—a cynosure of resistance to institutions that would smother the free spirit and stifle the 'right to be different.'" Ah yes, what resistance to bourgeois society!

But Foucault differed from Nietzsche in more than such outward trappings. The fundamental world outlooks of the two men were radically different. Basically, Foucault was Nietzsche's ape. He adopted some of Nietzsche's rhetoric about power and imitated some of his verbal histrionics. But he never achieved anything like Nietzsche's insight or originality. Nietzsche may have been seriously wrong in his understanding of modernity: he may have mistaken one part of the story—the rise of secularism—for the whole tale; but few men have struggled as honestly with the problem of nihilism as he. Foucault simply flirted with nihilism as one more "experience." Mr. Miller is right to emphasize the importance of "experience," especially extreme or "limit" experience, in Foucault's life and work; he is wrong to think that this was a virtue. Foucault was addicted to extremity. He epitomized to perfection a certain type of decadent Romantic, a type that Nietzsche warned against when he spoke of "those who suffer from the *impoverishment of life* and seek rest, stillness, calm seas, redemption from themselves through art and knowledge, or intoxication, convulsions, anaesthesia, and madness." Foucault's insatiable craving for new, ever more thrilling "experiences" was a sign of weakness, not daring. Here, too, Nietzsche is a far better guide than Foucault. "All men now live through too much and think through too little," Nietzsche wrote in 1880. "They suffer at the same time from extreme hunger and from colic, and therefore become thinner and thinner, no matter how much they eat.—Whoever says now, 'I have not lived through anything'—is an ass."

Mr. Miller is not entirely uncritical. About *Madness and Civilization* (English translation, 1971), for example, he acknowledges that "the author's own convictions are insinuated more than argued." About *The Order of Things*, he points out that the writing is "awkward, disjointed, elliptical to a fault." But such local criticisms do not go nearly far enough. At the beginning of his book, Mr. Miller mentions in passing J. G. Merquior's incisive critical study, *Foucault* (1985). Readers acquainted with that book know that Merquior, who is identified as "a Brazilian diplomat who studied with Ernest Gellner," has politely but definitively exploded almost every significant claim that Foucault made. Merquior typically begins each chapter with a ritual nod to Foucault's brilliance. He then proceeds to show that his arguments rest on shoddy, if extensive, scholarship, distorted history, and untenable generalizations. Whatever "new perspectives" Foucault's work may have opened up, Merquior concludes, its "conceptual muddles and explanatory weaknesses . . . more than outweigh its real contribution." The truth is, Foucault specialized in providing obfuscating answers to pseudo problems. "We have had sexuality since the eighteenth century, and sex since the nineteenth," he writes in *The History of Sexuality*. "What we had before that was no doubt flesh." Yes, and "Sexual intercourse was invented in 1963," as Philip Larkin memorably put it.

Foucault once described his writing as a "labyrinth." He was right. The question is, why should we wish to enter it? It may be the case that, as Mr. Miller insists, Foucault's writing expresses "a powerful desire to realize a certain form of life." But is it a *desirable* form of life? Foucault's personal perversions involved him in private tragedy. The celebration of his intellectual perversions by academics continues to be a public scandal. The career of this "representative man" of the twentieth century really represents one of the biggest con jobs in recent intellectual history.

March 1993

G.B.S.:
The Life of George Bernard Shaw

Brooke Allen

Seldom can any author have taken Horace's dictum that the artist should delight and instruct as seriously as did Bernard Shaw. The notion of art for art's sake, the guiding principle for so many writers of his generation, repelled him, and he insisted that he "would not lift a finger to produce a work of art if I thought there was nothing more than that in it." All of his plays, novels, and essays are intensely conceived political statements.

It is, of course, a paradox of Shavian dimension that these serious sociological tracts in fact delight even more than they instruct, that they continue to delight, indeed, in an age when the historical setting of Shaw's theories and political credenda has receded into the past. One by one the mainstays of Shaw's worldview—the Fabian creed of "permeation," eventually his Stalinism, his faith in "Creative Evolution" and the "Life Force"—have been toppled; but the iconoclasm, the lacerating common sense, the passionate social conscience, and the insistence upon man's common responsibility for the state of his world live on because of the incomparable wit with which they are served up. "Why should humour and laughter be excommunicated?" Shaw once asked Tolstoy. "Suppose the world were only one of God's jokes, would you work any the less to make it a good joke instead of a bad one?"

The final volume of Michael Holroyd's biography of Shaw has just been published.[1] The work in its entirety is an exhaustive one, and if the use of that adjective implies that perusal of the book is exhaust*ing*, well, that is sometimes true too. This is more or less inevitable, for Holroyd's aim was to write as detailed and fully researched a study as possible, and Shaw spent the better part of his ninety-four years writing—plays, essays, speeches, novels, letters, letters, and more letters. He neither drank nor smoked nor ate meat nor, except when his wife insisted, took holidays. He was practically celibate for the last fifty years of his life. Work was his principal, perhaps his only, pleasure. When Holroyd took up his for-

1 *Bernard Shaw: Volume IV. The Last Laugh: An Epilogue, 1950–1991*, by Michael Holroyd (Random House, 1993).

midable task in the 1970s, he actually feared that Shaw could write more in a day than he, Holroyd, could read, and that he would never even finish the necessary research, much less write the biography.

Fortunately that fear proved unfounded, and Holroyd's stupendous accomplishment in marshaling his thousands of documents is enough, in itself, to warrant high praise. Shaw's life is covered with a scholarly thoroughness that still retains the lightness of touch without which any treatment of this brightly plumed subject would be intolerable. If one tends to bog down in the mire of detail, one is nonetheless grateful for the rich array of information. Whether Holroyd succeeds in making Shaw live is another question. "I never knew what a vivid personality meant until I met Shaw," said the actress Lillah McCarthy. "He, of all men, is most alive; not only on grand occasions but all the time." Holroyd captures the man's industry but loses among the great catalogue of achievements something of the vitality that enabled an unloved, ill-educated, and obscure youth to turn himself into the most famous sage and jester of his time, a celebrity to whom an American newspaper offered one million dollars for his final words.

After a monumental study of fifteen hundred pages, Holroyd hazards few speculations about Shaw's place in posterity. The final volume is a little anticlimactic as a result. But perhaps it is just as well, after providing such a quantity of material, to let the reader decide for himself. Holroyd devotes his final, brief volume to a study of Shaw's will and the way in which his wishes were circumvented. Of the four institutions chosen by Shaw to benefit from his royalties (royalties that were unexpectedly multiplied upon the opening of *My Fair Lady* in 1956), only one, the National Gallery of Ireland, received its full legacy and used it in the manner Shaw had intended. The Royal Academy of Dramatic Art, the Reading Room of the British Museum, and an association for the establishment of a British phonetic "alfabet" were all cheated of their endowments through chicanery or legal fiddling, in a series of lawsuits that Holroyd likens to *Bleak House*'s *Jarndyce v. Jarndyce*. The remainder of Volume IV is devoted to the source notes for the entire biography. Though Holroyd tries to justify the delay that forced readers of the first three volumes to wait until now for any clue as to sources, it is still an inefficient and cumbersome method, and the notes themselves are frequently incomplete and faulty, not to say stingy in the information offered. Holroyd also omits the appendix that would be most useful: a chronological listing of Shaw's plays with details of their first productions.

In looking at the life in its entirety Holroyd chooses a Freudian model that is summarized in the successive titles of the first three volumes: *The Search for Love*, *The Pursuit of Power*, *The Lure of Fantasy*. "In his early years," writes Holroyd in Volume III, "he had looked for love but rejecting

this as impractical for himself . . . he then attempted to replace it, through imaginative wordplay, with the exercise of beneficent political power. But here too he had been disappointed, and during the last period of his life he looked for illumination elsewhere." This is the shape Holroyd elects to impose on the life, a somewhat arbitrary choice since Shaw could as easily and perhaps more profitably be observed within his sociological context rather than as eternal protagonist in the family drama. It is true, however, that Shaw's character was bizarre enough to warrant a psychological approach, and that the roots of many of his eccentricities are traceable to his early life.

The Shaws had belonged to the Protestant upper class, but Bernard Shaw's branch of the family had grown embarrassingly déclassé by the time of his birth in 1856. His father, an unsuccessful merchant, became an ineffectual drunkard during the course of Shaw's childhood, and Shaw's mother, Lucinda Elizabeth Shaw, treated her husband more and more as an inconvenient household pet. She turned instead to George John Vandeleur Lee (who eventually shortened his name simply to Vandeleur Lee), a Svengali-like music teacher of some repute in Dublin. She became Lee's minion and disciple, and though Holroyd finds it doubtful that the two enjoyed a sexual relationship, Lee took up residence with the Shaw family in 1866, creating the prototype for the odd, semi-sexual three-cornered relationships that Shaw as an adult was to establish with various couples.

Shaw was an emotionally neglected boy, the outcast among the children of the family. Lucinda lavished love on her daughters, Lucy and Agnes, but seemed permanently hardened against her little son. "Fortunately I have a heart of stone," Shaw wrote in 1939, "else my relations would have broken it long ago." The heart of stone, of course, was a pose developed over decades to cope with parental rejection, and the story of Shaw, as told by Holroyd, is in large part a story of that developing pose. Whatever heights Shaw scaled, whatever adulation he received from the world, he was never able to squeeze a jot of approval from his own mother.

Nor did anyone in the family attempt to stimulate intellectual or artistic curiosity in the young Bernard, or "Sonny" as he was called at home. "He had no access to a library and no money with which to buy books," Holroyd says. "Nobody at Hatch Street read." And while music and singing were not only the household business but also its passion, it is an incredible fact that it never occurred to anyone to teach Sonny to read music or play an instrument. He was entirely self-taught in this as in everything, and his eventual emergence as one of the greatest music critics in the language is not only a monument to determination and push, but a fine form of revenge against his family's scorn.

Sonny attended both Protestant and Catholic schools and hated both

equally, calling his first school, the Wesleyan Connexional, a "futile boy prison." At the age of fifteen he became an office boy for the estate agents Uniacke Townshend, work he approached with a predictable want of enthusiasm, and when his mother followed Vandeleur Lee to London—leaving George Carr Shaw for good—young Shaw joined them there in 1876. After a stint of work for the Edison Telephone Company, he abandoned wage slavery for good in 1880, determined upon a profession in letters. With no capital and only the tiniest income, Shaw set out to become a novelist, educating himself for the task in the Reading Room of the British Museum.

His early efforts were not auspicious. Five novels were returned by the publishing houses with uniformly negative reports, typified by Macmillan's summing-up of *The Irrational Knot*:

> [A] novel of the most disagreeable kind. . . . There is nothing conventional either about the structure or the style . . . the thought of the book is all wrong; the whole idea of it is odd, perverse and crude. . . . So far as your publication is concerned, it is out of the question. There is too much adultery and the like matters.

Shaw rather bitterly parodied these readers' reports: "I feel I'd rather die than read it." The quality of his thinking, however, did not go entirely unnoticed; Edward Garnett, who towered over his fellow-readers in percipience and culture, noted of *Love Among the Artists* that "the literary art is sound, the people in it are real people, and the fresh unconventionality is pleasing after the ordinary work of the common novelist: but all the same—*few people would understand it, & few papers would praise it.*"

Shaw's conversion to socialism in the 1880s was a personal and professional turning point. It gave him a *raison d'être* and a religion. "I became a man with some business in the world," he later wrote, and from this business he never diverged. Shaw was not a Christian, and indeed he held that there was "not a single established religion in the world in which an intelligent or educated man could believe," but his character was nevertheless a passionately religious one. He assumed that the religious impulse was not only inevitable, but necessary and good—a questionable assumption, perhaps. He set up socialism and what he called "Creative Evolution" as his personal faiths, and he was later to sum up his attitude toward his life's work in the "Epistle Dedicatory" to *Man and Superman*:

> This is the true joy in life, the being used for a purpose recognized by yourself as a mighty one; the being thoroughly worn out before you are thrown on the scrap heap; the being a force of Nature instead of a feverish selfish little clod of ailments and grievances complaining that the world will not devote itself to making you happy.

Shaw turned to socialism under the influence of Ruskin, Morris, Blake, and Shelley, and became a founding member of the Fabian Society in 1884, along with Beatrice and Sidney Webb, who would become his closest friends (Shaw wrote of this friendship that "apart from marriage, it has certainly been the biggest thing in my life"), Graham Wallas, Sidney Olivier, and Hubert Bland. That same year he began work as a music critic.

Shaw's development as a journalist went hand in hand with his development as a socialist. Criticism was no mere aesthetic display but an exercise in morality and politics. Like Matthew Arnold, he believed that men could become "better or worse morally for going to the theatre or reading a book" and he openly championed the critic's proselytizing mission. "A criticism written without personal feeling is not worth reading. It is the capacity for making good or bad art a personal matter that makes a man a critic." Increasingly brilliant as a critic, Shaw also became well known as a public speaker promoting the Fabian cause. He could hold an audience in thrall for two hours at a time, fascinating listeners with his outrageous rhetoric, his flaming beard, and his dead white face that one friend likened to "an unskillfully-poached egg." His rhetorical skills are abundantly displayed in *Fabian Essays in Socialism* (1889), which Shaw edited, and his own contributions contain some of the most stirring words on poverty to come out of the nineteenth century, words to rival those of Carlyle, Ruskin, Dickens, and every other Victorian prophet.

> Your slaves are beyond caring for your cries: they breed like rabbits; and their poverty breeds filth, ugliness, dishonesty, disease, obscenity, drunkenness, and murder. In the midst of the riches which their labour piles up for you, their misery rises up too and stifles you. You withdraw in disgust to the other end of the town from them; you appoint special carriages on your railways and special seats in your churches and theatres for them; you set your life apart from theirs by every class barrier you can devise; and yet they swarm about you still: your face gets stamped with your habitual loathing and suspicion of them: your ears get so filled with the language of the vilest of them that you break into it when you lose your self-control: they poison your life as remorselessly as you have sacrificed theirs heartlessly.

Shaw's approach combined activism with the use of the intellect. "Socialism," he wrote, "is not charity nor loving-kindness, nor sympathy with the poor, nor popular philanthropy . . . but the economist's hatred of waste and disorder, the aesthete's hatred of ugliness and dirt, the lawyer's hatred of injustice, the doctor's hatred of disease, the saint's hatred of the seven deadly sins."

In 1884 Shaw finally had a novel accepted for publication: Belfort Bax and J. L. Joynes serialized *An Unsocial Socialist* in *To-Day*, their "Monthly

Magazine of Scientific Socialism." They subsequently serialized Shaw's earlier novel, *Cashel Byron's Profession*, while Annie Besant published *The Irrational Knot* and *Love Among the Artists* in her own socialist magazine, *Our Corner*. Beginning to be well known both as a speaker and a writer, the thirty-five-year-old Shaw wrote *The Quintessence of Ibsenism* in 1891. In this polemical work he followed Arnold and divided mankind into three categories: philistines (the majority), idealists (dangerous intellectuals), and the one-in-a-thousand realist or Great Man. This theoretical division was to dominate Shaw's thinking, in one guise or another, for the rest of his life, and the realist was to reappear in Shaw's later work as the superman. His preoccupation with this mythical beast was eventually to lead him into political hot water with his admiration of Force, typically embodied in such sinister personages as Joseph Stalin and Oswald Mosley.

Throughout the 1880s and '90s Shaw's music criticism had been attracting attention, and in 1895 he joined the *Saturday Review* as the dramatic critic, a move that coincided with his own turn toward playwriting as the genre most congenial to him and in which he felt he could wield the most influence. Taking up the torch of Ibsenian realism, Shaw's aim was to replace the hack melodramas and farces that made up contemporary British theatrical fare with a new theater of ideas. He entered the ring at a moment when Pinero and Wilde were the most highly-thought-of playwrights: he respected neither. "I cannot say that I greatly cared for The Importance of Being Earnest," he wrote. "It amused me, of course; but unless comedy touches me as well as amuses me, it leaves me with a sense of having wasted my evening. I go to the theater to be moved to laughter, not to be tickled or bustled into it."

The business of the playwright, he believed, was that of the politician:

> To strive incessantly with the public; to insist on earnest relations with it, and not merely voluptuous ones; to lead it, nerve it, withstand its constant tendency to relapse into carelessness and vulgar familiarity; in short, to attain to public esteem, authority, and needfulness to the national welfare . . . instead of the camp-follower's refuge of mere popularity.

And Shaw was by now himself fully engaged in the playwright's vocation. In 1892 he had completed *Widowers' Houses*, a play that dealt with slum-landlordism, and followed this commerical failure with *The Philanderer*, for which he could not find a producer, and *Mrs. Warren's Profession* (1893), to which, since it dealt openly with prostitution, the Censor of Plays refused a license. (The play was not performed in Britain until 1925.) *Mrs. Warren's Profession*, with its long monologues and characters who act primarily as mouthpieces for various philosophical positions, set the tone for subsequent Shavian drama and established the distinctive Shavian

style. It also established Shaw's characteristic position of externalizing evil into a general, *social* guilt.

> Do you thank God that you are guiltless in this matter? Take care. . . . The wages of prostitution are stitched into your button-holes and into your blouse, pasted into your matchboxes and your boxes of pins, stuffed into your mattress, mixed with the paint on your walls and stuck between the joints of your water-pipes . . . you will not cheat the Recording Angel into putting down your debts to the wrong account.

The biting tone of Shaw's first plays had brought him attention but hardly popularity. He began to see that if he wanted a wide audience he might have to compromise a little in the direction of that audience's expectations; it was no use writing shocking and provocative material if no one came to see it. Thus he momentarily abandoned his "Plays Unpleasant"—plays that "force the spectator to face unpleasant facts"—and made the transition to his "Plays Pleasant". But not too pleasant, for though Holroyd finds cynicism in "Shaw's skill in writing for a theatre that, in the *Saturday Review*, he was simultaneously campaigning to destroy," no one could call Shaw's "pleasant" efforts, *Arms and the Man* (1894), *Candida* (1894, performed 1897), *The Man of Destiny* (1895, performed 1897), and *You Never Can Tell* (1896, performed 1899), popular pabulum. W. B. Yeats's description of the première of *Arms and the Man* should assure us of that.

> [T]he whole pit and gallery, except certain members of the Fabian Society, started to laugh at the author, and then, discovering that they themselves were being laughed at, sat there not converted—their hatred was too bitter for that—but dumbfounded, while the rest of the house cheered and laughed. . . . I listened to *Arms and the Man* with admiration and hatred. It seemed to me inorganic, logical straightness and not the crooked road of life, yet I stood aghast before its energy.

With his early decision to publish his plays in book form, Shaw seized an opportunity to *force* his opinions upon the public that had so far refused him popular success. Taking nothing for granted from his readers, Shaw bolstered the text of the plays with lengthy prefaces and replaced traditional stage directions with discursive narrative. Thus he created an entirely new and still unimitated genre, part play, part essay, part oratory.

Of course Shaw's style could be uncongenial not only to the conventional theater-goer but to some of his most discriminating contemporaries. Max Beerbohm, Shaw's successor on the *Saturday Review*, complained that "flesh and blood are quite invisible to Mr. Shaw . . . to all intents and purposes, his serious characters are just so many skeletons,

which do but dance and grin and rattle their bones," and Shaw's longtime friend and sparring-partner, G. K. Chesterton, quipped that "Shaw is like the Venus de Milo: all that there is of him is admirable."

A distinct cold-bloodedness both in his work and in his character was off-putting to many, and found obvious form in his vegetarianism and his teetotalism (Beerbohm spoke of, and caricatured many times, Shaw's "temperance beverage face"). Most of all, though, it was in his relations with women that Shaw attempted to set himself above and beyond ordinary humanity. Holroyd stresses the fact that Shaw, unable to inspire love in his own mother, studiously inured himself to the pangs of sexual love and loss, but it is also possible that Shaw was simply less highly sexed than other men. He remained a virgin until the age of twenty-nine, and his forty-five-year marriage to Charlotte Townshend remained unconsummated (though he and his wife did have sexual relations before their marriage). The "affairs" he participated in both before and during his marriage involved a good deal more talk than love-making, and during his bachelorhood he showed a peculiar tendency to launch teasing, provocative flirtations with married women, initiating chaste triangles that recreated that of his parents and Vandeleur Lee. Notable rehearsals of this scenario included relationships with Hubert and Edith [Nesbit] Bland, William Morris's daughter May and her husband Henry Sparling, and his effort, both professional and sexual, to lure Ellen Terry away from her longtime partnership with Henry Irving. Both in life and art, Holroyd points out, Shaw created "a stereotype, Woman-the-Huntress," and himself played the alarmed innocent fleeing her grasp. He glamorized his own role when he created Henry Higgins, who refuses to fall into the trap of romantic love with his Galatea.

> "I wont stop for you . . . I can do without anybody. I have . . . my own spark of divine fire. . . . I care for life, for humanity; and you are a part of it that has come my way and been built into my house. What more can you or anyone ask? If you cant stand the coldness of my sort of life, and the strain of it, go back to the gutter."

Of course, no man is ardently pursued by women unless he desires their pursuit, and Holroyd shrewdly formulates Shaw's method by saying that he "made himself attractive to women by informing them he was attractive—then warning them against this damnable attractiveness." But it seems unarguable that Shaw either feared or was repelled by full-force sexual love. "Everyone who becomes the object of [sexual] infatuation shrinks from it instinctively. Love loses its charm when it is not free: . . . it becomes valueless and even abhorrent, like the caresses of a maniac." His only descent into full-scale romantic passion—his affair with Mrs. Patrick Campbell—ended unhappily and confirmed his belief that "the quantity

of Love that an ordinary person can stand without serious damage is about 10 minutes in 50 years." Dick Dudgeon in *The Devil's Disciple*, the superman who is able to make the *beau geste* out of the coldness of his intellect rather than the warmth of his emotions, is as much Shaw's alter-ego as Higgins.

Shaw was now entering his most productive period as a playwright, and his plays became more popular despite his continued insistence on forcing unpleasant realities down his audiences' throats. His new connection with the Royal Court Theatre under the management of Harley Granville Barker and John Vedrenne provided the most congenial working situation that he was ever to enjoy. *Caesar and Cleopatra* (1898, performed 1901) restored Caesar after his Shakespearean drubbing to the status of "Great Man," another in Shaw's line of supermen; *Man and Superman* (1903) continued his examination of that theme, notably in the "Don Juan in Hell" dream sequence; *John Bull's Other Island* (1904) flew in the face the neo-Gaelic movement to give "a very uncompromising presentment of the real old Ireland"; *Major Barbara* (1905) contrasted Christian pietism with the realities of the munitions industry; *The Doctor's Dilemma* (1906) was a satire on the medical profession still wholly pertinent to our situation in 1993. (Sheridan Morley has said, correctly, that "almost all of Shaw's plays are at almost all times timely.")

Each of these plays addressed Shaw's current political passion. His summing-up of *Major Barbara*'s theme, for example, in his defense of its anti-hero, the munitions manufacturer Undershaft, brings up a point that had haunted him for years. "Spiritual values do not and cannot exist for hungry, roofless and naked people. Any religion that puts spiritual values before physical necessities is what Marx meant by opium and Nietzsche called a slave morality." Sixteen years earlier he had objected violently to a plan for "Music for the People" in very much the same voice.

> What we want is not music for the people, but bread for the people, rest for the people, immunity from robbery and scorn for the people, hope for them, enjoyment, equal respect and consideration, life and aspiration, instead of drudgery and despair. When we get that I imagine the people will make tolerable music for themselves.

Throughout this period of intense artistic activity, Shaw's political work continued unabated. Though he always refused to stand for Parliament, he was elected to the Vestry Committee of St. Pancras, holding the seat for six years. "I love the reality of the Vestry," he wrote to Ellen Terry, "and its dustcarts and H'less orators, after the silly visionary fashion-ridden theatres." He was still the most vociferous of the Fabians, rivaled only by H. G. Wells during the latter's attempted putsch of the Society between

1906 and 1908. (Wells described Shaw's political methods cynically: "He got his excitement by rousing a fury of antagonism and then overcoming & defeating it. At that game, which covered a large part of his life, he was unsurpassable.") Though he resisted Wells's move to replace the Society's traditional philosophy of the gradual "permeation" of British society with one of noisy publicity, Shaw was well aware that permeation was in practice becoming passivity. The unwillingness of the Fabian executive to have socialism polluted by trades-unionism had caused it to keep aloof from the birth of the Labour Party, an aloofness that would effectively remove it from the mainstream of British socialism in the new century. The Fabians' unlikely political alliance with Arthur Balfour emphasized their uncertainties, and when Labour gained its first Parliamentary base with the Liberal victory of 1906, the Fabians, still attempting to form their own Party, were not there to share the spoils. By 1911 the Fabian Society had, in Beatrice Webb's words, reached a crisis "not of dissent, but of indifference," and Shaw, along with Bland and three others, resigned from the executive (though he always remained an active member).

Shaw continued to produce more or less a play a year. Among them were *Getting Married* (1907–8), *Misalliance* (1909, performed 1910), *Overruled* (1912; Noël Coward took it as his prototype for *Private Lives*), and *Androcles and the Lion* (1912). *Pygmalion* (1912) was first performed in Vienna in 1913 and had its London première in 1914 with Beerbohm Tree in the role of Henry Higgins and Mrs. Patrick Campbell as Eliza Doolittle. With this play, Shaw was finally established as an out-and-out commercial success. It had been his doubtful privilege up until this time to have the critics deem his work successful only in retrospect. *Pygmalion*, though Shaw insisted in its Preface that it was as didactic as any of his plays, was in fact as witty and passionate a treatment of the British class system as has ever been written; it was also, of course, intensely romantic. Higgins and Eliza had run away with their author, a fact that everyone except Shaw himself seemed to acknowledge, and for the rest of his life the playwright fought a losing battle against the actors and producers, beginning with Beerbohm Tree himself, who attempted to sidestep Shaw's unromantic ending. (The producers of the film won their round, and so did the authors of *My Fair Lady*, with Shaw no longer alive to keep up the fight).

On the outbreak of World War I, Shaw adopted a Swiftian role: that of uncompromisingly stating ruthless, often cruel truths. He became one of the most voluble and, in retrospect, perhaps the most trenchant critic of the war. This of course did nothing to bolster his popularity, not at least during the country's jingoistic, anti-German phase before the bloody events of 1916.

Shaw's position had not changed since the Boer War.

I regard war as wasteful, demoralizing, unnecessary, and ludicrously and sordidly inglorious in its reality. This is my unconditional opinion. I *dont* mean war in a bad cause, or war against liberty, or war with any other qualification whatever: I mean war. I recognize no right of the good man to kill the bad man or to govern the bad man.

He wasted no forum, no opportunity for criticizing and even ridiculing the war and, unforgivably, he heaped blame on militarists of all nations, not only the Germans. British *amour propre* was wounded, and Shaw's refusal to mitigate logic with sentimentality made him much hated at a time when young Englishmen in many thousands were giving their lives. Shaw got the reputation for being pro-German because of his refusal to indulge in rhetoric against the German people, and because of gestures like the telegram he sent to Siegfried Trebitsch, his German translator, upon the declaration of war. "WHAT A HIDEOUS SITUATION CIVIL-IZATION TEARING ITSELF TO PIECES. . . . YOU AND I AT WAR CAN AB-SURDITY GO FURTHER MY FRIENDLIEST WISHES GO WITH YOU UNDER ALL CIRCUMSTANCES."

In 1914 Shaw published *Common Sense About the War*, a pamphlet modeled on Thomas Paine's *The Rights of Man*. His apparent flippancy horrified many readers, and he was forced to retreat from the pages of the *New Statesman* and to resign from the Society of Authors. With hindsight it is clear that Shaw was indeed preaching common sense, and this did not go unnoticed by his more astute contemporaries: Stockton Axson, President Wilson's brother-in-law, believed that "Shaw is often ten minutes ahead of the truth, which is almost as fatal as being behind the time." Shaw knew that the real battle would be to achieve an equitable and far-reaching peace, and he published another pamphlet in March 1919, *Peace Conference Hints*, in which he insisted that the Versailles Conference would have to incorporate an embryo League of Nations. The next war, he said, would be a "scientific attempt to destroy cities and kill civilians." He knew that Germany's healthy presence in the League would be essential for its functioning. In vain he insisted that England should "set the world an example of consideration for vanquished enemies," and said that "if [the Kaiser's] rights are not as sacred as those of the poorest peasant in Europe then the war has been fought in vain."

During the last two years of the war it had become evident that Shaw was speaking sense rather than treason. He regained his popularity and far more; it was in the immediate postwar era that Shaw ascended his throne as sage and prophet, "the World's most famous intellectual Clown and Pantaloon in one," as Winston Churchill called him. Revivals of his plays were produced all over Europe, and his new plays were now received with intense interest. *Heartbreak House* (1916–17, performed 1920) was his Chekhovian presentation of the spiritually hollow prewar upper classes;

Holroyd suggests, convincingly, that in this play the values of Blooms-
bury and the "Souls" are presented with especial scorn. Once again,
however, critical success eluded Shaw, and the press cruelly rechristened
the play "Jawbreak House."

Nothing daunted, Shaw launched into a five-play metaphysical cycle.
He called *Back to Methuselah* "my Ring," and in it he dramatized his phi-
losophy of Creative Evolution, an implausible mixture of Darwin, God,
and Samuel Butler concocted to satisfy Shaw's personal craving for a phi-
losophy of optimism. His next play was *Saint Joan* (1923, performed
1924), in which he rehabilitated the Joan he believed to have been mis-
represented by Voltaire, Twain, Andrew Lang, and Anatole France into a
Shavian heroine, and a specifically Protestant one. (T. S. Eliot complained
that Shaw had committed sacrilege by turning Joan into "a great middle-
class reformer . . . [whose] place is little higher than Mrs. Pankhurst's.")
Shaw received a Nobel Prize for *Saint Joan*, thus ascending the next rung
on the ladder of his apotheosis.

The accession of Ramsay MacDonald as the first Labour Prime Minister
in 1924, with Sidney Webb as President of the Board of Trade, proved
disappointing for Shaw, who soon perceived that MacDonald was in fact
more a liberal than a socialist, and it was at this juncture that Shaw en-
tered the murky political waters that were to compromise him for the rest
of his life and weaken his future influence. Reacting to what he saw as the
ineffectiveness of the Labour Party, Shaw decided to back Oswald Mosley,
who in 1930 presented a bold national recovery plan in the style of the
New Deal. Shaw's impatience at the snail's pace of Fabian political
progress led him, dangerously, to support men he saw as strong. Mosley,
Mussolini, and Stalin may not have had coherent programs or philoso-
phies, but they had the strength and personality to change the world;
Mosley he saw as "the only striking personality in British politics." Shaw's
long Carlylean flirtation with the superman was coming to a very danger-
ous fruition, and Beatrice Webb was alarmed by the shift in her friend's
sympathies.

> As a young social reformer, he hated cruelty and oppression and pleaded for
> freedom. He idealized the rebel. Today he idealizes the dictator, whether he
> be a Mussolini, a Hitler or a Stalin, or even a faked-up pretence of a dictator
> like Mosley. . . . And yet G.B.S. publicly proclaims that he is a Communist.
> . . . What he really admires in Soviet Communism is the *forceful* activities of
> the Communist Party.

Shaw had long written sympathetically about the Soviet leaders, largely
to counter the influence of what he saw as Churchill's "Russophobia."
Stalin, in Shaw's old formulation, was a realist, as opposed to the mere

idealists MacDonald, Snowden, and Kerensky, and in 1931 Shaw accepted Nancy and Waldorf Astor's invitation to join them on an official visit to the Soviet Union.

Shaw's behavior during and after his Russian trip borders on the insane. His immutable philosophy of optimism, confronted with the realities of Soviet policy, retreated into fantasy: "his imagination bleached away all signs of pain and horror," says Holroyd. Shaw in Moscow presents a terrifying parody of Shavian glee. "Our question is not to kill or not to kill, but to select the right people to kill . . . the essential difference between the Russian liquidator with his pistol (or whatever his humane killer may be) and the British hangman is that they do not operate on the same sort of person." A far cry indeed from the unconditional pacifist of the First World War. The spectacle of Shaw's grim gaiety in the presence of oppression and murder is fearful, and shows the lengths to which he would go to preserve his faith in optimism and human perfectibility. Shaw professed, bizarrely, to have found religion in Moscow. "Jesus Christ has come down to earth. He is no longer an idol. People are gaining some sort of idea of what would happen if He lived now."

Shaw's literary output continued undiminished in his seventies, though his work was no longer of the consistently high quality of his middle years. Political writing included the influential *Intelligent Woman's Guide to Socialism, Capitalism, Sovietism, and Fascism* (1928) and *Everybody's Political What's What* (1944); his later plays, all on political themes, included *The Apple Cart* (1928, performed 1929); *Too True to Be Good* (1931, performed 1932); *On the Rocks* (1933); and *The Simpleton of the Unexpected Isles* (1934, performed 1935). He also directed numerous productions of his own work, in a style refreshingly out-of-step with the era's Stanislavskian purism: Ralph Richardson remembered being told that "You've got to go from line to line, quickly and swiftly, never stop the flow of lines, never stop. It's one joke after another, it's a firecracker." Shaw took an active interest in the production of films of his work, and won an Oscar for his screenplay of *Pygmalion*.

Shaw's political perorations continued to pour out, for better or worse. He called for "Africa for the Africans!" as early as 1938; after Hiroshima he showed an extraordinary clairvoyance when he said that "the wars that threaten us in the future are not those of London or Berlin or Washington or Tokyo. They are civil wars . . . to say nothing of wars of religion . . . fundamentalists and atheists, Moslems and Hindus, Shintos and Buddhists." Yet this man of vision simultaneously recommended Joseph Stalin for the Nobel Peace Prize.

After the death of his wife in 1943, Shaw lingered on, physically frail but still mentally active. In his last letter to Sidney Webb—who was himself aged eighty-nine—he wrote "I hope we have been a pair of decent

useful chaps as men go; but we have had too short a lifetime to qualify for real high politics." Shaw died on November 2, 1950, at the age of ninety-four. "I believe in life everlasting; but not for the individual," he had said the week before. His old enemy H. G. Wells's vicious posthumous obituary of him appeared in the *Daily Express* like "a piercing scream from the grave," according to St. John Ervine. But the world mourned. Statesmen from Pandit Nehru to Harry Truman gave tribute, and Broadway dimmed its lights. The cremation at Golder's Green was simple, without religious ceremony, and Sydney Cockerell read the last words of Mr. Valiant for Truth from *The Pilgrim's Progress*. Shaw the Creative Evolutionist would have been pleased by an exchange heard between two bystanders outside the crematorium. A Cockney woman cried, "We'll never see his like again," but she was corrected by an Irishman: "Madam, we must never underrate posterity."

Shaw's celebrity reached its apex at the moment of his death. Now, over forty years later, we are able to look at his monumental achievements with more perspective and to begin to measure his stature on the world stage. There is no doubt that Harold Nicolson was mistaken when he opposed giving Shaw's house over to the National Trust on the grounds that he would not "be a great literary figure in 2000 A.D." But in what does Shaw's permanent greatness consist? It failed him, of course, in his role of prophet, as it has failed every other would-be prophet of the twentieth century: his conscience was great, his political judgments often untenable.

Shaw will always remain eminent as his generation's greatest quipster, the man who could cut off film negotiations with Samuel Goldwyn by saying that "the problem, Mr. Goldwyn, is that you are interested only in art and I am interested only in money." The excellence of his plays will go unquestioned for many years to come, particularly *Pygmalion*, *Major Barbara*, *Arms and the Man*, *Candida*, and *Man and Superman*. He will always remain one of the most important figures in the history of socialism; his eloquence on social inequity and responsibility rivaled Dickens's, and his heart and spirit were very much greater than those of Dickens. Edmund Wilson's description of Shaw's "stirring new intellectual appetites, exciting our sense of moral issues, sharpening the focus of our sight on the social relations of the world" comes close to capturing the man's importance—an importance that lives on in spite of the political folly of his last years.

Shaw inevitably failed his own test: he was an idealist rather than a realist. But which of us can claim to be a realist in Shaw's sense of the word? We are all driven by ideals, and in spite of Shaw's own protestations, it was his idealistic fervor rather than any attempted cold-blooded realism that drove him to achieve greatness.

September 1993

Raymond Williams in Retrospect

Maurice Cowling

Between 1965 and 1985 there was a major transformation of the English intellectual Left: R. H. Tawney and Archbishop Temple were forgotten, C. A. R. Crosland and Roy Jenkins were edged aside, and a new body of sages delivered a more uncompromising and more revolutionary message in their place.

Of these new sages, Raymond Williams, Eric Hobsbawm, and E. P. Thompson were the most important. All three were "tenured radicals," and all three used academic subjects as instruments of persuasion—literature in Williams's case, history in the other two cases—and all three had a stimulating effect on the English student revolutionaries of the late 1960s and their successors, who came to maturity without the restraint and respectability that the English student revolutionaries of the 1930s had acquired through participation in the "just and unavoidable war against fascism."

Williams (1921–1988) earned his first reputation from the publication, in 1958, of *Culture and Society: 1780–1950*. But it was through the student revolution that he achieved fame, not only in England but also in the United States, where he has had as devoted a following as in England. Indeed, his American followers have been more devoted, since none of them has been as disrespectful as the literary critic Terry Eagleton, his most distinguished follower in England and now his memorialist,[1] who in *Criticism and Ideology* (1976), along with much praise, made withering criticism of Williams's "pragmatism," "muted intellectualism," and "residual populism," of his "provincialism," "humanism," and "idealism," and of the deplorable "parody" he had given of the "classic relations between the revolutionary and the proletariat."

Williams adapted himself sartorially to the revolution as readily as Eagleton did, borrowing as his symbols the duffle coat, the leather jacket, and the Mosley-ite black sweater in which he was photographed in 1982.

1 *Raymond Williams, Critical Perspectives*, edited by Terry Eagleton (Northeastern University Press, 1989).

But those who glamorize him as a proletarian should remember that modern England is a suburb in which rural working-class solidarity is anachronistic, and that Williams was in essence a "scholarship-boy"—one of the most important cultural categories in England in the last sixty years—who, like Mr. Enoch Powell, had risen through education but, unlike Mr. Powell, felt guilt about his elevation.

In the 1970s and 1980s Williams came to stand for feminism, ecology, Welsh nationalism, and the armed struggle against imperialism in the Third World. In the 1950s and early 1960s—before he was carried away by the euphoria of the student revolution—he was symbolized by his schoolmaster's tweeds; he embodied an earnest, secular version of the inherited decencies and resentments of Welsh nonconformity and the Welsh Labour movement; and he had as his leading intellectual characteristic the amiable but slightly rancid seriousness of a believer in culture and literature who displayed a puritan, or Marxist, mistrust of anyone who had power or position in education, politics, and society.

From the mid-1960s Williams was in continuous demand, wrote more than he ought to have done, and found outlets for almost everything that he wrote. One result was an endless *oeuvre* which dealt in the broadest way with culture, language, politics, and society. Another was that he repeated himself, became both fluent and reminiscent, and finally assumed the rectitude of opinions that he had originally felt obligated to argue for. In the three volumes published since his death, there are interesting essays and addresses about the Labour Left and the Labour Party, about the significance of modernism, and about the connections between popular opinion and the "ordinariness of culture."[2] But "what he came to say"[3] has for so long been so obvious that only devoted disciples, hagiographers like Professor Alan O'Connor[4] or mutually self-congratulatory old comrades like Professor Edward Said, who appears in both *The Politics of Modernism*[5] and the Eagleton memorial volume, will find very much to detain them.

Williams wrote at two levels—colloquially and self-confidently in confirming for audiences of his own persuasion the truths that they shared with him; opaquely and mistily in works that attempted to establish the truth and coherence of these persuasions. Intellectually he was without power; he wrote no work that persuaded by the cogency of its argument. His originality was an originality of manner: his achievement was to

2 *Resources of Hope*, by Raymond Williams, edited by Robin Gable (Verso, 1988).

3 *What I Came to Say*, by Raymond Williams (Hutchinson Radius, 1989).

4 *Raymond Williams, Writing, Culture, Politics*, by Alan O'Connor (Basil Blackwell, 1989).

5 *The Politics of Modernism*, by Raymond Williams, edited by Tony Pinkney (Verso, 1989).

deploy ordinariness and reasonableness in recommending opinions that were neither ordinary nor reasonable, and that became entirely unreasonable in response to the nightmare of abnormality that swept the universities of the Western world when he was in his middle forties.

Williams's ideas were few and simple. They had all been stated by 1977 and, even at their most emphatic, involved either retreats from positions he had seemed to be occupying earlier or accommodations to climates created by others. He may, as Eagleton claimed, have had an "intuitive knack of pre-empting intellectual positions," but he was at least as good at picking up already existing positions, and it is difficult to believe that *Culture and Society* would have been as conservative as it was without the anti-revolutionary climate of the 1950s, or that the cultural Marxism of *Marxism and Literature* (1977) would have been achieved at all if others had not arrived at it earlier. It was also of first importance for Williams's reputation that the young in the mid-1960s were willing to hear from an attractive lecturer who had working-class credentials and active service as an officer attached to the Coldstream Guards, and that what they wanted to be told was that revolution could be justified morally and intellectually, and the caution of *Culture and Society* swept aside by the violence that was advocated in *Modern Tragedy* (1966).

Williams was the son of a rural Welsh railwayman and went from a Welsh grammar school to read the Cambridge English Tripos at the end of the 1930s. He became a member of the Communist Party in his first year as an undergraduate and collaborated with Eric Hobsbawm—an undergraduate contemporary—in writing a pamphlet in defense of the Russian invasion of Finland. Two undergraduate years at Cambridge were followed by conscription into the British Army in 1941, active service as a tank officer during the Allied invasion of Europe, and a further undergraduate year at Cambridge when the war was over. After a short period spent editing small-circulation magazines in London, he settled first in Sussex and later in Oxford as a salaried lecturer for the Oxford Extra-Mural Delegacy (Oxford's organization for adult education), expounding for the benefit of (putatively) working-class audiences that trust in culture and mistrust of capitalism, and that belief in D. H. Lawrence which some Marxists and ex-Marxists shared with the followers of F. R. Leavis.

On joining the army, Williams seems to have lost touch with the Communist Party. Later he became a supporter of the Labour Party, but appears for a long time to have been interested less in the political than in the cultural objections to capitalism. After the Labour victory at the general election of 1966, he resigned from the Labour Party in protest against the elitist cynicism or ruling-class character of Mr. Harold Wilson's leadership. In spite of resuming support for Labour later, he then became one of the half dozen or so freestanding Marxists who fostered the

analytical outrage with which the English New Left and the Campaign for Nuclear Disarmament have embarrassed the Labour leaders, eased Mrs. Thatcher's way electorally, and made the Labour Party as unelectable as like-minded Democrats have made successive Democratic presidential candidates in the United States.

From an early stage, Williams wanted to be a writer rather than a don and a novelist as well as a critic, and from his first period in Cambridge was a journalist and public speaker. Public speaking and small-circulation journalism remained with him for the rest of his life, along with an interest in film and television, while *Border Country* (1960)—his first and only tolerable novel—gave confusing insights into what he was trying to say morally and politically.

Border Country gave a low-keyed account of relations between a father and a son. Though it dealt with politics, it was dominated not by politics but by gratitude, nostalgia, and death, and by its account of the idyllic solidarity of a rural Welsh village. The novel resisted the idea that the meritocratic son or the entrepreneurial trade unionist was better than the dying railwayman, and there was an anti-intellectual implication that a natural, unreconstructed, conservative way of life was more real than the academic way of life which the son had adopted.

Border Country, though published later, was written at the same time as Kingsley Amis's *Lucky Jim*, which dealt with the academic problem from the academic end. But Amis had no experience he was willing to disclose in order to match the experience that Williams disclosed in *Border Country*, no yardstick except a satiric yardstick with which to compare a farcical university with the University of Oxford, and no more interest in explaining what he had learned from his mandarin education in Oxford than Williams had, as a novelist, in explaining what he had learned from his mandarin education in Cambridge.

In 1961 Williams returned to Cambridge for a third time, now as a lecturer (later a professor) in the Faculty of English. At the same time he became a fellow of Jesus College, to which he was brought by M. I. Finley, the American Marxist historian, who was a fellow of the college already. In a similar way, Williams himself was later to bring Eagleton, who, in five works published in his twenties in the atmosphere of Vatican II, expounded a liberationist Catholicism which, though it looked to "Marxist, Third-World, Black-power and Hippie intensity" for help in converting "monopoly capitalism" into a "just community," stood in contradiction to Williams's irreligion.

In a review of works by Eagleton and his collaborators in 1966, Williams gave a mistrustful welcome to "radical Catholicism"'s attempt to "find Christ in the world." But nothing in the review or the rest of his writings suggests any interest in Christ or any wish to relate Christianity to the "civilized paganism" with which he half-identified himself then.

In Williams's writings religion scarcely existed and it was a central principle that a "common language" was more important than a "common faith." At no point did he consider religion in its own terms, certainly not in *The Long Revolution* (1961), where it would have given backbone to boneless arguments, in *The Country and the City* (1973), where the Church of England would have been of central significance, or in *Culture and Society*, where many of the thinkers discussed were obsessed by Christianity.

Williams's mind was historical and meditative rather than theoretical; such standing as he had as a theorist derived from *Marxism and Literature*, in which he woke up to the fact that Lukacs, Gramsci, Plekhanov, Goldmann, Althusser, Benjamin, Barthes, Chomsky, Brecht, and Sartre (among others) had created a cultural Marxism, and that the amalgamation of linguistics, semiology, and Freudian psychology into "cultural materialism" had liberated Marxism from the "deformations" associated with Stalinist practice.

Marxism and Literature denied that Marxism was reductive, or that Marx and Engels had had a rigid belief in a base/superstructure model of culture. It underscored their emphasis on "creation and self-creation," questioned the idea that they had made a simple equation of the "social" with the "collective," and argued that Marxism could overcome the "reified" or "abstracted . . . psychological" conception of determination" which was said to have been forced on it by capitalist society.

What this meant was that thought and culture were to be understood not as "distortion" or "disguise" but as a Gramscian "hegemony" which "saturated the whole process of living" and came to exist "in the fibres of the self." This was important, however obscurely expressed, because it suggested that theory could develop a "general consciousness within what was experienced as an isolated consciousness," and that "tradition," which orthodox Marxism had normally dismissed as "superstructural," could now be seen to have been "the most evident" or "shaping expression" of "hegemonic pressures and limits." In other words, that "theory" could be exonerated from the charge of being ineffectual and could meet the perennial Marxist demand for criticism that would "change the world."

In the 1970s Williams was catching up—doing to Marxism what others had been doing in the 1950s and 1960s and what Carlyle, Matthew Arnold, and many others had been doing to Christianity between 1840 and 1880—ridding it of features that made it unacceptable to the modern mind. But just as Carlyle, Arnold, and other fellow-laborers had thrown out so much of dogmatic Christianity that nothing distinctively Christian was left, so *Marxism and Literature* threw out so much of dogmatic Marxism that what was left was either vacuous and banal or not distinctively Marxist.

In this connection, there is no need for conservative thought to be afraid of Marxism or to fail to turn its insights to advantage. To take only one example, the idea of hegemony—even of class hegemony as an element in culture—can be deeply illuminating so long as it is understood that hegemony, though distressing for those who wish to have hegemonic authority but are excluded from it, is necessary in the modern world not only in the interests of peace and stability but also, where historic liberties and equalities have been established, in the interests of liberty and equality.

Williams was too limp a thinker to understand this as either a Marxist or a conservative truth, and wobbled uneasily between wishing to protect intellectual autonomy within a Marxist or socialist consciousness and accepting Mao Tse Tung's vision of writers being absorbed into "new kinds of popular . . . collaborative writing." So much so that the more closely one looks at *Marxism and Literature*, the more difficult it is to see what was left of Marxism, beyond the name, once Williams's "complexities . . . tensions . . . shifts . . . uncertainties and confusions" had been applied to it as Carlyle and Arnold had applied theirs to Christianity.

If *Marxism and Literature* lacked bite and edge, it also carried Williams out of his depth. He had been much more in his depth in discussing the English situation that had led up to *Culture and Society* twenty years earlier. In *Culture and Society*, English society had been the victim of the cultural corruption of which Leavis had made himself the enemy, industrial society had been the enemy of both culture and community, and the English language—the only real guarantor of community—was being emasculated by the class-oriented imposition of Standard English. *Culture and Society* took the form of critical exposition of the social doctrine that Williams found in approximately fifty British thinkers since Burke, and in making his critical dispositions he worked with three conceptions. First, that English society before the eighteenth century had been "organic," however defective it had been in humanity; second, that the English thinkers with whom it dealt had been reacting primarily to the upheaval created by industrialization and democracy; and, finally, that "culture" had provided these thinkers with a "court of appeal" and a "scale of integrity" for evaluating the "way of life" and "driven impulse" of the new kind of society that had been "reaching for control." Burke and Southey from one side, and Owen and Cobbett from the other, were shown writing from their experience of "the old England" in criticism of the new. "One kind of conservative thinker" and "one kind of socialist thinker" were shown uniting subsequently to criticize laissez-faire ideology by reference to the life of society as a whole, and "organic" was declared to be a central term through which "Marxist thinking" and "conservative thinking" could identify "liberalism" as the common enemy in the 1960s. It was hardly

surprising, in these circumstances, that William Morris was said to be "pivotal," since he, more than anyone else—according to Williams—had found a political role for art and culture in contrasting with established forms of life the possibility of an alternative form of life in the future.

In the closing pages of *Culture and Society* Williams made the first widely read statement of his political opinions, defending a "democratic attitude" against "fear and hatred" and inserting into the aging socialism of the 1950s a Luddite or Leavisite version of the resentments of the 1930s. Williams did not have to invent for himself the working-class persona which public-school Marxists like Auden and Spender (or an alienated Etonian like Orwell) had had to invent for themselves twenty-five years earlier, and he was thus in a better position to write sympathetically about the "ethic of service" and "real personal selflessness" which had been inculcated by the public schools, the professions, and the regular army. On the other hand, he attacked the scholarship "ladder" which working-class boys like himself had been able to "climb," denouncing it not only because it "sweetened the poison of hierarchy" but also because it pretended that the "hierarchy of birth and merit" was different from the "hierarchy of birth and wealth," when in fact both were hierarchies (or elites) that were diminishing "community" and obstructing the "effort" that "every man" ought to make to value his own skill and the "skill of others."

In *Culture and Society* Williams did not advocate violent revolution, which it would have been ridiculous to do in England in 1958. What he said instead was that democracy was "in danger," that there was a "sullenness" and "withdrawal" which would end in the "unofficial democracy" of the "armed revolt" if they were not dealt with, and that the only way to deal with them was to deprive newspapers, television, cinema, and radio of the "dominative character" that was enabling the "insincerity of a minority" bent on protecting its own culture and power to persuade the masses to "act, think and know as it wished them to."

About equality *Culture and Society* was vague. "A common culture" was not "at any level an equal culture," there was no need for equality in "knowledge, skill and effort," since "a physicist would be glad to learn from a better physicist" and "a good physicist" would not think himself "a better man than a good composer . . . chess player . . . carpenter or runner." Equality was nevertheless crucial, and societies from which it was missing were said not only to "depersonalize . . . and degrade" but also—as though Japan had never existed—to raise "structures of cruelty and exploitation" that "crippled human energy."

Williams was a class warrior as surely as Orwell had been. He had Orwell's sense of complexity, and also Orwell's mistrust of panaceas. In the discouraging circumstances of 1958, his virtuous but self-defeating conclusions were that freedom was "unplannable," that the "human crisis" was always a "crisis of understanding," and that culture was a "natural growth"

which could only be achieved by comprehending the "long revolution" that had been going on since the eighteenth century "at a level of meaning which it was not easy to reach."

Culture and Society supplied a historical and theoretical basis from which *The Long Revolution* vacuously, *Communications* (1962) piously, and the May Day Manifesto of 1967 politically, deduced policy conclusions about the ways in which public ownership and control could make the media minister to a commmon culture. These did not, however, expand the structure that *Culture and Society* had established. It was only in *Modern Tragedy* that expansion was effected.

Like *Culture and Society*, *Modern Tragedy* discussed texts—the main tragic texts and texts about tragic theory that had been written in Europe and the United States since Ibsen—and extracted from them a political message about the inadequacy of individuation and about the desirability of revolution.

Modern Tragedy was written in a dense, coded prose. Decoded, it manifests the confusion between the cultural elite and the people which was a feature of Williams's doctrine throughout his work and which became particularly troublesome in this book, where dramatic and fictional tragedy were presented as realizations of the "shape and set" of modern "culture," and the dramatists and novelists who had produced it were assumed to represent "our" minds and experience.

This thesis was both elitist and anti-elitist, naïve about the prospect of bridging the gap between the cultural elite and the people but emphasizing the affiliations that kept Williams, as a member of the former, in conscious empathy with the latter. The effect was nevertheless odd, implying that Strindberg, Brecht, and Arthur Miller, for example, were not arcane, and amalgamating the "we" who went to their plays or listened to Williams's lectures in Cambridge with the "we" who had been described appreciatively in *Border Country*. However deep Williams's desire was to make "critical discrimination" relevant to the people among whom he had grown up, moreover, it neglected the consideration that critical discrimination was in fact a minority activity which spoke meaningfully only to those who had already heard Leavis's voice.

In *Drama from Ibsen to Eliot* (1952) Williams had criticized the English theater as a manifestation of literary decline and for failing to achieve either "the communication" of an "experience" and a "radical reading of life," or that "total performance" which reflected "changes in the structure of feeling as a whole." In *Modern Tragedy* the central contentions were that "liberal" tragedy, while being liberal because it emphasized the "surpassing individual," and tragic because it recorded his defeat by society or the universe, reflected the inability of the money-oriented privacy of the bourgeois ethic to provide a "positive" conception of society. It was the "in-

dividual fight against the lie" embodied in "false relationships, a false society and a false conception of man" that Ibsen had made central, but it was the liberal martyrs' discovery of the lie in themselves and their failure to relate themselves to a "social" consciousness that heralded the "breakdown of liberalism" and the need to replace its belief in the primacy of "individualist" desire and aspiration by a socialist perception of the primacy of "common" desire and aspiration.

Williams wished to give tragic theory a social function. He pointed out that "significant suffering" was not confined to persons of "rank," and that personal belief, faults in the soul, "God," "death," and the "individual will" had been central to the tragic experience of the present. It was the "human agency" and "ethical control" manifested in revolution and the "deep social crisis through which we had all been living" that were the proper subjects of "modern" tragedy, and it was human agency and ethical control that tragic theory needed to accommodate.

The first point that had to be explained was the Burkean point that revolution caused suffering. The second point was the anti-Burkean point that revolution was not the only cause of suffering, that suffering was "in the whole action" of which "revolution" was only "the crisis," and that it was suffering as an aspect of the "wholeness" of the action that needed to be considered. And this, of course, disclosed the real agenda in *Modern Tragedy*—the use of tragic texts to formulate a socialist theory of tragedy in which revolution would receive a literary justification and society would become more important than the individual.

In all this Williams was moving out from the defensiveness of *Culture and Society* and making a central feature of the argument that, when the revolutionary process was complete, "revolution" would become "epic," suffering would be "justified," and pre-revolutionary institutions, so far from being the "settled . . . innocent order" that they had claimed to be, would be seen to have been rooted in "violence and disorder." This was the route by which tragedy and tragic theory could remove cynicism and despair, could give revolution the "tragic" perspective that Marx had given it, and could show what tragedy had hitherto failed to show, that "degeneration, brutalization, fear, hatred and envy" were endemic in existing society's "tragic" failure to "incorporate . . . all its people as whole human beings." It was also the route by which tragedy and tragic theory could incorporate the fact that further "degeneration, brutalization, fear, hatred and envy" would be integral to the "whole action"—not just to the "crisis" and the revolutionary energy released by it or the "new kinds of alienation" which the revolution against alienation would have to "overcome . . . if it was to remain revolutionary," but also, and supremely, to the connection between "terror" and "liberation."

Williams's rhetoric was ruthless, and yet in retrospect looks faintly silly. Nor were the tasks that he attributed to tragic theory plausible. It remains

true, nevertheless, that *Modern Tragedy*, while reiterating the formal denial that revolution was to be identified with the violent capture of power and identifying it rather as a "change . . . in the deepest structure of relationships and feelings," implied, more than any other of Williams's works, a circuitous but indubitably evil attempt to encourage the young to think of violence as morally reputable."[6]

In evaluating Williams, one wishes to be just. He should not be dismissed merely because his followers have helped to keep their party out of office, since many of them, and perhaps he also, regarded party politics as merely a convenient way of inserting their moral messages into the public mind. Like the theorists of the student revolution of the Sixties, Williams was "against liberalism," but those who are against liberalism for conservative reasons do not need his sort of support. They should not be misled by the "organicism" of *Culture and Society*, which ignored the moral solidarity of twentieth-century English society and used the language of solidarity in order to subvert such solidarity as monarchy and two world wars had created by denying that it existed.

In later life Williams made something of the malice he claimed to have encountered on his final return to Cambridge in 1961 from what he thought of as its middle-class establishment, and contrasted its brassiness and careerism with the cultural superiority of the community in which he had grown up. The review of *The Long Revolution* that appeared in *The Cambridge Review* in May 1961,[7] and which Williams found it convenient to attribute to such an establishment, was written in fact by a conservative dissident who believed no less than Williams in the desirability of moral solidarity, but thought it vulgar and hypocritical to pretend that Williams's working-class background and experience of adult education around the Sussex Downs exempted him from the elitist character inseparable from occupancy of a tenured appointment in a serious university. Indeed, the animus behind the review, which Professor Alan O'Connor describes as "icy," was the belief that those who benefit from such appointments have a duty to expose humbug rather than to disseminate it, and that the quality in Williams's thinking which a recent reviewer in the *Times Literary Supplement* (Chris Baldick, November 3–9, 1989) described as its "extending humanistic impulse," was more properly described as an "innocence about the scope of political activity, ignorance of the diversity of contemporary society, and capacity for ignoring the quality of life of those of whose condition . . . Williams . . . had no experience which ought

6 Williams's afterword to *Modern Tragedy* is reprinted in *The Politics of Modernism*, page 95.

7 "Mr. Raymond Williams," by Maurice Cowling; *The Cambridge Review*, May 27, 1961, pages 546–551.

. . . to have disabled a prophet of that 'better human order' which he sought to bring before us."

The writer of the review did not know then that there was to be a student revolution, or that Williams was to be one of its sages. But he was right to believe—and he repeats now—that Williams's condemnation of existing society was a trick, that it raised expectations for the future by ignoring the expectations that were fulfillable already, and claimed academic or tragic authority for its condemnation of existing capitalist society while being uncritical about the prospect of an imagined post-capitalist society in the future. Who but the theorist of a "children's crusade" would justify the infliction of pain and suffering on the off chance that the pain and suffering entailed in existing hegemonies might be replaced by a hegemony from which pain and suffering had been eliminated? And is it not good to know that from one "mighty voice" at least there will in the future be no *fresh* misrepresentations of the nature of power and position?

Williams is best understood as the politicizer of Leavis, as the man who, while he criticized Leavis, brought him out of the closet and converted "critical discrimination" into a set of Marxist slogans. Williams lacked Leavis's power and his pretense that critical discrimination was not political. He also lacked Eagleton's fluency and intelligence, and the intellectual brutality that has saved Eagleton from being merely the playboy of the movement of the 1960s.

Mr. Neil Kinnock is already imposing on the socialism of the English Labour Party a moralistic liberalism to which Williams's mistiness is so eminently conformable that his influence may well survive the 1960s. Nevertheless, it is Williams, among others, whom Mr. Kinnock is emasculating. It is the violent and revolutionary nature of the doctrine that Williams shared with these others in those years which is being abandoned, and it is for this reason that this article has highlighted the content of the doctrine that he preached then to a generation for whom it was "bliss to be alive" at that odious moment.

February 1990

Tough Buttons:
The Difficult Gertrude Stein

Guy Davenport

A few months ago Gertrude Stein was at a Lexington, Kentucky, book-store, promoting her latest. I learned this by overhearing one sorority sweetheart shouting to another on campus: "It was fab seeing her in per-son! I mean, you know, Gertrude Stein!"

It was Gloria Steinem at the bookstore, but what other American writ-er, forty-seven years dead, can claim a place in the sparse learning of the intrepidly illiterate? Gertrude Stein is firmly wedged in the American mind, together with Alice Babette Toklas. Her salon at 27 rue de Fleurus (between the Boulevard Raspail and the Luxembourg Gardens) is an echo of the eighteenth century. There, in a room as famous as any in our time, hung with Picassos, Cézannes, Matisses, and Derains, one might en-counter Hemingway, Lipchitz, or Sherwood Anderson. Even Ezra Pound (he broke a chair, and was never invited again).

She is a vivid figure in the history of art, of writing, of the two world wars, of music, of popular culture, and of academic folklore. Yale printed all of her posthumous writing, six volumes of them. Periodically there are compendia, like this one edited by Ulla Dydo,[1] published in the thin hope that somebody will read her. Random House has kept a *Selected Writings* in print for decades. The general opinion is that *The Autobiography of Alice B. Toklas* (1933) is charming, that *Three Lives* (1908) is significant, that her operas (scores by Virgil Thomson) are great fun, but that the large part of her copious works is unreadable. It takes heroic effort to make one's way through the thousand pages of *The Making of Americans*, and conscien-tious students who have read *A Long Gay Book* and *Stanzas in Meditation* and *How to Write* should be issued a medal by the American Academy.

The century will end with our having to admit that we have learned how to read some, but not all, of its writing. Joyce and Pound demanded a redefinition of the act of reading. It is still not clear what Gertrude Stein was trying to do. Where we can understand her, she repays attention in

1 *A Stein Reader*, by Gertrude Stein, edited and with an introduction by Ulla E. Dydo (Northwestern University Press, 1993).

great measure. We can specify fairly accurately what of hers we can and can't read, and to what degree her pages make sense. At one extreme is the easy style of the *Autobiography*, and at the other the "Cubist" nonsense of repetitions and agrammatical phrases of *A Long Gay Book* (whose title does not mean what you think). In between, we have the epic echolalia and logorrhea of *The Making of Americans*, and the plays and operas. We can understand *The Mother of Us All* in the same way that we understand Mother Goose and Edward Lear (and shall we add Wallace Stevens?).

Many children and even a dull professor can enjoy "Doctor Faustus Lights the Lights" if only to laugh at the little dog who says "Thank you!" to everything. Ulla Dydo has put together a selection of Stein's writing quite different from previous ones (though Richard Kostelanetz had broken ground in this direction). It is all Difficult Gertrude Stein, and very hard to read. Except for excerpts from *The Making of Americans* and *Stanzas in Meditation*, all the texts are complete.

Those who, like William Carlos Williams, saw Gertrude Stein as a revolutionary shaking-up of writing, claimed that she was scrubbing words clean, so that we can see them anew. She was, to her own mind, being a Cubist. That is, she was making a fractal sketch of things, the way Picasso and Braque could draw a mandolin with a few suggestive lines. Her most successful technique was teasing, making us guess, alerting us to the traps in language that we normally avoid or can't be bothered to think about. Here Stein moves parallel to Wittgenstein, who saw that language is a game with agreed-upon rules.

If Gertrude and Ludwig had ever met, apparently they could have talked for hours about the sixth Act IV of *An Exercise in Analysis* (1917). The act in its entirety is: "Now I understand." This is the sort of statement that worried Wittgenstein for the last thirty years of his life. It involves the problem of other minds, of certainty, of epistemology, and the language game. We can supply many contexts for such a statement.

"Here is plenty of space" is another bit of dialogue in this play. I hear William James in his Harvard classroom, with Miss Stein alone paying attention. There is the same amount of space everywhere, evenly distributed. But not, Samuel Beckett would say, in this world. Is the speaker arranging the furniture or arriving in California? "Can you see numbers?" "Call me Ellen." "Extra size plates."

Gertrude Stein was a great reader. In novels, Henry James's for instance, characters talk, and in their nuances lurk the subtlest intricacies of the author's web. Imagine a text of a novel, say James's *The Sacred Fount*, from which everything has been extracted except the dialogue.

The difficult pieces collected here have puzzled readers and stymied critics since they were known. What are they? The music of Philip Glass can help us, a little: repetition with slight variants can be mesmerizing or tedious, according to your nerves. The sheer cheekiness of it commands

respect. We realize that we are in the presence of a sophisticated and cunning technique, of an achieved style. Stein is, with her array of styles, asking to be put beside Picasso. *Stanzas in Meditation*, read aloud in a good voice, is eerily like Shakespeare's sonnets for sonority and majesty of line. These poems *say* something, but what? It's like overhearing an actor two rooms away. You can feel the cadences and the power, but you can't hear it well enough to know if it's Donne, Milton, or Marlowe. It's like watching a photograph develop in the tray before it is recognizable.

If only we could make her texts come alive as they do in Virgil Thomson's music. We can get somewhere by suspecting comedy practically everywhere and laugh with Gertrude rather than at her. Her writing is always elated, spirited, good-humored.

James Laughlin, who was once Gertrude and Alice's errand boy, automobile mechanic, and typist (under injunction to bathe daily, as "men smell"), has described Gertrude at work. She wrote in an exercise book resting on her thigh, and the writing did not interfere with her carrying on a conversation (Laughlin timed her: two and a half minutes to fill a page). Alice was in the next room, typing the previous exercise book. Do not be put off by the conversation; Dickens worked the same way. What we should see is the sureness of what she was doing. She trusted her style.

There were, however, agonies. Ulla Dydo's excellent headnotes to these pieces reveal unsuspected, extensive revision in the earlier work. They also identify occasions and names with some critical observations. Citing an event in relation to a text is frustratingly unhelpful. What we need is a way to read Gertrude Stein. My experience has been that there's sense there. In one of Picasso's densest Cubist works a scholar has recently been able to discern the figure of Arcimboldo's *Librarian*, so that we can now see the visual logic of what had seemed an abstract shingling of small, busy angles. This is not finding the bunny in a puzzle picture; it is recognition of aesthetic organization.

My sense is that Stein began with what in another writer would be an idea. She does not, however, propose to develop the idea into a plot, a poem, or an essay, but to submit it to the chemistry of her considerable intellect. One day she must have heard, or herself remarked, that Byron's life would make an interesting play. She is not going to write the play; she is going to think about the intricacies of historical figures in plays, and what a play is. So, in 1933, she wrote "Byron A Play," which seems to be about Byron, plays, and the problem of what we mean when we say a famous name. *Seems.* To read it we need to find a part of our brain that we have never used, where the synapses are differently designed. It is the very literate equivalent of children playing in a sandbox. They are happy, busy, purposeful in their own way, but only angels know what they think they're doing.

November 1993

The Many Lives of Frederick Douglass

James W. Tuttleton

That we live in a decadent age will seem evident to anyone who has been numbed by the moral horrors that occur on a daily basis, all over this country, and that are reported with a bland reportorial neutrality by all the news media. These horrors—involving open drug-dealing and prostitution, shootings in the schools, fetal abortions, doctor-assisted suicides —evoke hardly more than a shrug. Passivity in the face of such evils is in fact nowadays admired as evidence of "open-mindedness," "compassion," and "tolerance" for differing "values" and "behaviors." In fact, to believe that evil is a reality and to have strong convictions about how to deal with the forms that evil takes in the national life is usually to be dismissed as an absolutist, a crank, and a bigot. Public moralists are a nuisance and we usually do not like to listen to them. I am therefore led to wonder whether, if this were the nineteenth century, we would be capable of recognizing, *as evil*, something so huge and monstrous as the institution of slavery. Probably not.

In any case, such reflections on the ubiquity of evil and the too human readiness to deny it—even when its grotesque visage is mirrored in the lines of one's face—occur to me as a result of rereading the autobiography of Frederick Douglass.[1] This tragic and truly extraordinary black American had the bad fortune to be born a slave, near Tuckahoe Creek, Maryland, in 1818. For most Americans in the early years of the Republic, it was perfectly "natural" that an "inferior race," like the blacks, should be enslaved to the "superior whites." After all, the Founding Fathers, in their constitutional wisdom, had—for all their declarations about born equality —provided the "natural law" of slavery with many American legal and political protections. And these constitutional guarantees to slavery were long supported by many of the other institutions of Northern and Southern society—the Protestant churches, the universities, the press, the "intellectual community," and the vast majority of just plain folks like you

1 *Frederick Douglass: Autobiographies*, edited by Henry Louis Gates, Jr. (The Library of America, 1994).

and me. Slavery an evil? Hardly. Only insolent blacks and the Northern religious right (Yankee moral cranks) thought so. But in the light of the highest ethical principles, they and a few others had it right.

The author of *Narrative of the Life of Frederick Douglass, an American Slave* (1845) was one of those "insolent" blacks whose account of slavery made inescapably plain to many of his contemporaries that this "peculiar institution" was in fact a socially organized manifestation of Evil. While nearly everyone with the capacity of moral reason recognizes this now, few enough did in the 1830s, when Douglass ran away from his owner. But the publication of this autobiography—in conjunction with many other kinds of abolitionist activism by Douglass and others—eventually moved many Northerners and some Southerners to agree with Lincoln's decision to publish the Emancipation Proclamation in 1863. The *Narrative* is thus a major document in the racial, social, and political history of the nation. Its historical importance aside, however, it is also the best of the American slave autobiographies—a work of extraordinary psychological, moral, and *literary* importance.

How splendid it is, then, to have the *Narrative* available in a newly prepared edition in the Library of America series. And not just this *Narrative* but also Douglass's subsequent autobiographical writings—the volumes *My Bondage and My Freedom* (1855) and *Life and Times of Frederick Douglass* (1881; revised 1892). These autobiographies constitute a remarkable unfolding account of the life of an exceptional black American. The first takes him from slavery in the South to freedom in the North; the second from servile anonymity to worldwide renown as the most powerful black abolitionist orator in the world; and the third autobiography expands these earlier accounts in taking him through the Civil War and the triumph of black emancipation to great personal celebrity, high government office, and international fame—even as America was relapsing into Jim Crow laws, resegregation, and what Mark Twain was to call "The United States of Lyncherdom." Douglass's was a remarkable life. His narrative of that life was likewise remarkable in its moral vision, social judgment, and psychological power.

Born in 1818 the son of Harriet Bailey, Douglass never knew who had fathered him. He was thus named Frederick Bailey. He was rumored to be the son of his mother's master, the white man Aaron Anthony, who worked as the general overseer of the immensely wealthy planter Edward Lloyd, who owned five hundred slaves and thirteen farms in Talbot County, Maryland. Separated from his mother at the end of his first year, Douglass was reared by his grandmother, Betsey Bailey, while his mother was sent back to the fields. Then at the age of six he was removed from his grandmother's cabin and taken to live on the Lloyd plantation on the Wye River. He was befriended by the twenty-year-old white woman Lucretia

Anthony Auld, wife of Thomas Auld. She was, quite possibly, whether she knew it or not, his half-sister. In any case, the light-skinned Douglass was made the companion of Daniel Lloyd, the twelve-year-old son of the white master, and had the run of the planter's "Great House." The two boys were inseparable and came to love each other; and Douglass must have fantasized about his likewise being the son of the rich man Edward Lloyd. But no one stepped forward to enlighten Frederick about his father; and when he was seven or eight his mother—who might have told him—died unexpectedly; in all he had seen her only four or five times. Shortly afterward, he was told that he was no longer needed for Daniel.

Because he was a favorite of Lucretia Auld, Douglass was sent to Baltimore in 1826 to live with her brother-in-law, Hugh Auld, a ship carpenter, and his wife, Sophia. Now, at age eight, Douglass was to be the companion of the Aulds' infant son, Tommy. Life in Baltimore was much safer than on the plantation; there was more food to eat; Douglass had a bed of his own for the first time; and Sophia Auld's kindness melted him. Life for a slave, however, was never secure. His master, Aaron Anthony, died almost immediately, and his daughter Lucretia, who had taught and protected him, died the next year. Such turning points were often catastrophic for the slaves. Their families were often broken up and individuals were sold and dispersed, sometimes into the deep South, in the cotton states, where agricultural life was much harder. Aaron had in fact sold a number of the boy's relatives to deep South planters. Douglass was inherited by Thomas Auld, Lucretia's widower. At the moment he did not want the boy, but instead of selling him off, Thomas Auld luckily returned young Douglass to the Hugh Aulds in Baltimore.

Douglass remarks in the *Narrative* that soon after he went to live with the kindly Sophia Auld, she began to teach him the ABCs. But Hugh put his foot down, reprimanding his wife that

> "If you give a nigger an inch, he will take an ell. A nigger should know nothing but to obey his master—to do as he is told to do. Learning would *spoil* the best nigger in the world. Now," said he, "if you teach that nigger [Hugh is here speaking of Douglass] how to read, there would be no keeping him. It would forever unfit him to be a slave. He would at once become unmanageable, and of no value to his master. As to himself, it could do him no good, but a great deal of harm. It would make him discontented and unhappy."

These words were a revelation to young Douglass of how the white man had managed to enslave the black. From that moment on, literacy represented for Douglass "the pathway from slavery to freedom"; and, during the next seven years while he lived with the Hugh Aulds, the passion to read and write became all-consuming. Douglass "appropriated"

little Tommy's copy books and readers, "borrowed" the Webster's speller, and got white youngsters on the street to show him how the letters were made. He got into a Bible study group at the Bethel A. M. E. church in Baltimore in order to read further, and he bought and devoured a used copy of *The Columbian Orator* (1797), a well-known collection of prize speeches. He memorized long passages from Richard Brinsley Sheridan, Caleb Bingham, and other great orators. Some of the speeches dealt with slavery and emancipation from oppression.

> The reading of these documents enabled me to utter my thoughts, and to meet the arguments brought forward to sustain slavery; while they relieved me of one difficulty, they brought on another even more painful than the one of which I was relieved. The more I read, the more I was led to abhor and detest my enslavers. I could regard them in no other light than a band of successful robbers, who had left their homes, and gone to Africa, and stolen us from our homes, and in a strange land reduced us to slavery. I loathed them as being the meanest as well as the most wicked of men. As I read and contemplated the subject, behold! that very discontentment which Master Hugh had predicted would follow my learning to read had already come, to torment and sting my soul to unutterable anguish. As I writhed under it, I would at times feel that learning to read had been a curse rather than a blessing. It had given me a view of my wretched condition, without the remedy. It opened my eyes to the horrible pit, but to no ladder upon which to get out. In moments of agony, I envied my fellow-slaves for their stupidity.

This burning self-consciousness of his servile condition ate upon his soul, alienated and embittered him, but what could the child do? From time to time young Douglass had heard sinister things about Northern abolitionists; they piqued his curiosity, and he vowed to learn more about them.

In 1832, at age fourteen, Douglass was summarily returned to his owner, Captain Thomas Auld, who was still living back in Talbot County. This was a disastrous development, inasmuch as Auld was a cruel, cowardly, and inconsistent master who did not care for his slaves or feed them enough. Throughout both the *Narrative* and *My Bondage and My Freedom*, Douglass relentlessly condemned Thomas Auld as an evil, mean-spirited master who was the embodiment of the evil of slavery as such and the incarnation of all irreligion. Here is Douglass on Captain Auld, after Auld's conversion at a Methodist camp meeting:

> I have seen him tie up a lame young woman, and whip her with a heavy cowskin upon her naked shoulders, causing the warm red blood to drip;

and, in justification of the bloody deed, he would quote this passage of Scripture—"He that knoweth his master's will, and doeth it not, shall be beaten with many stripes."

Master would keep this lacerated young woman tied up in this horrid situation four or five hours at a time. I have known him to tie her up early in the morning, and whip her before breakfast; leave her, go to his store, return at dinner, and whip her again, cutting her in the places already made raw with his cruel lash. The secret of master's cruelty toward "Henny" is found in the fact of her being almost helpless.

All slaves were more or less helpless, but Henny's hands had been injured in a horrible fire and she was unable to work fast and efficiently. Pornography was taboo in the nineteenth century, but something like soft porn was allowable in the description of the whipping of these female slaves. The point was twofold. In whipping, these masters were not merely brutal monsters. We are to understand the whippings as an elaborate displacement of the sexual degradation of these vulnerable women slaves, mixed in, as it was, with sadistic sexual impulses. Since Auld's conversion seemed to have made him even more ruthless, Douglass turned against Christianity, became a cold rationalist, and put his seething anger and calculating rationalism to the service of destroying the institution that had enslaved him.

Witnessing such whippings made Douglass "insolent" and obstreperous; he often spoke out of turn and was frequently whipped himself for his troubles. Eventually Auld determined to punish Douglass by renting him out as a field hand to Edward Covey, a well-known local "niggerbreaker." And at Covey's farm, over a period of several months, Douglass was beaten so often that he finally snapped. "Mr. Covey succeeded in breaking me," he wrote:

> I was broken in body, soul, and spirit. My natural elasticity was crushed, my intellect languished, the disposition to read departed, the cheerful spark that lingered about my eye died; the dark night of slavery closed in upon me; and behold a man transformed into a brute!

Douglass ran away, back to Auld's farm, and begged his master to hire him out to another. But Auld refused and ordered Douglass back to Covey's farm.

One of the most interesting passages in the *Narrative* concerns Covey's attempt, three days later, to get revenge by whipping Douglass, and the ensuing fistfight with the sixteen-year-old boy. Douglass by this time had grown tall, muscular, and strong. He had been beaten many times, but this time he did not intend to be whipped again. Covey did not expect a fight and got more than he could handle: Douglass drew blood and

bested him. For that the slave might have been killed then or later; he might have been sold downriver to the cotton states. But strangely enough, after being beaten by the boy, Covey left him alone; he growled and threatened but he did not try to whip him again, and the slave rental agreement expired at the end of the year. The effect of the fistfight was that Douglass's self-confidence returned, his spirits rose, and he decided to gain his freedom by escaping. This he finally tried with five other slaves in 1836, but he was betrayed by one of his own and jailed in Easton. Thomas Auld kept him from being lynched by telling the jailers that he was retrieving Douglass in order to sell him to a slaveholder in Alabama. But then, inexplicably, he sent Douglass back to the Hugh Aulds in Baltimore to learn a trade.

The situation of blacks in Baltimore at the time Douglass returned to live there was a confusing matter. Perhaps only 20 percent of the population—some twenty-five thousand people—were black; but of these perhaps three fourths of the blacks were free, having been manumitted by their owners or been born to free parents of color. Blacks therefore came and went without much or any white supervision. A number of the blacks who remained slaves were, like Frederick Douglass, apprenticed out to learn a trade. After serving his apprenticeship as a caulker in a shipyard, Douglass in fact was allowed to hire himself out and to board where he chose, although he was obliged, once a week, to surrender most of his wages to Hugh Auld. Once he had mastered his trade and saved enough money, Douglass, in these loosened circumstances, planned his escape. In 1838, at age twenty, he went underground, headed north, evaded the prowling slave-catchers and bounty hunters, and made his way to freedom in New Bedford, Massachusetts.

One might expect that the story of the actual escape would be the center-piece of the *Narrative*, but in fact Douglass gives it short shrift. We must remember that in 1845, when the autobiography was published, Douglass was still a fugitive vulnerable to arrest at any time and susceptible to a forced return to his Maryland owner. Hence, he did not identify his relatives or masters by name, nor did he disclose his way stations north-ward on the journey to freedom.[2] In fact, when he arrived in New Bedford, he was traveling under the name of Stanley; but he and his new bride, Anna Murray, set up as the Fred Johnsons. But his local contact was a Nathan Johnson, who told him that there were already too many black

2 Douglass is no more explicit in *My Bondage and My Freedom* (1855). The intervening Fugitive Slave Act of 1850 had now turned all officers of the court into slave-catchers and Douglass's situation was even more perilous since his fugitive status was now published. The 1881 *Life and Times of Frederick Douglass*, written well after Emancipation, gives a fuller account of his escape to freedom.

Johnsons in New Bedford and that another name would be preferable.

What's in a name? The slave has nothing but his body, his labor, and his name. Some slaves had secret African names, but Douglass did not. He had been born Frederick Augustus Washington Bailey but had himself dropped the middle names. Yet in running away, this slave Fred Bailey had had to renounce his name, his patronymic (or rather matronymic), in order to become *par excellence* an actor, an imposter, and a confidence man all rolled into one. By pulling up stakes, moving to a new location, and changing his identity, this slave had begun to participate in what has always been a very distinctively American *rite d'identité*. Douglass reports that

> I gave Mr. Johnson the privilege of choosing me a name, but told him he must not take from me the name of "Frederick." I must hold on to that, to preserve a sense of my identity. Mr. Johnson had just been reading the "Lady of the Lake," and at once suggested that my name be "Douglass." From that time until now I have been called "Frederick Douglass"; and as I am more widely known by that name than by either of the others, I shall continue to use it as my own.[3]

There is perhaps another reason that this newly named Douglass gave the actual escape such scant treatment in the first two narratives. A close reading of the two prewar autobiographies suggests that Douglass's essential emancipation had in fact already occurred four years earlier, at age sixteen, after that fistfight with Edward Covey, the "nigger-breaker." "This battle with Mr. Covey," Douglass wrote in the *Narrative*,

> was the turning-point in my career as a slave. It rekindled the few expiring embers of freedom, and revived within me a sense of my own manhood. It recalled the departed self-confidence, and inspired me again with a determination to be free. . . . It was a glorious resurrection, from the tomb of slavery, to the heaven of freedom. My long-crushed spirit rose, cowardice departed, bold defiance took its place; and I now resolved that, however long I might remain a slave in form, the day had passed forever when I could be a slave in fact. I did not hesitate to let it be known of me, that the white man who expected to succeed in whipping, must also succeed in killing me.

This is a remarkable redefinition of the meaning of freedom. Here freedom is equated with the mere possession of one's ownmost spirit, with psychological self-confidence, and with autonomous interior self-

3 It is not clear whether Nathan Johnson or Douglass added the final *s* to the name of Sir Walter Scott's Lord Douglas.

hood. Freedom is not so much a matter of who controls one's body as who has control of the soul. As such, this definition of liberty is not unlike the Stoicism of the philosopher-slave Epictetus, to whom the imprisoned and enslaved, in many nations, have oft turned for consolation.

Nor is this definition of freedom alien to one strand of Christian thought, which sees us all as slaves to the body, to the appetites, and to perversions of the will. (Under this conviction, St. Paul could counsel patience and obedience to one's masters, in the expectation of eventual heavenly deliverance.) After 1845 Douglass appears to have sensed the extremity of this subjective definition of freedom and so backed off from it in the 1881 *Life and Times of Frederick Douglass*. There he writes: "I was a changed being after that fight. I was *nothing* before; *I was a man* now. It . . . inspired me with renewed determination to be a *free man*." He wrote that he was resurrected

> from the dark and pestiferous tomb of slavery, to the heaven of comparative freedom. I was no longer a servile coward, trembling under the frown of a brother worm of the dust, but my long-cowed spirit was roused to an attitude of independence. I had reached the point at which I was *not afraid to die*. This spirit made me a freeman in *fact*, though I still remained a slave in *form*. When a slave cannot be flogged, he is more than half free. He has a domain as broad as his own manly heart to defend, and he is really "a power on earth."

One likes the adjective in "comparative freedom," but it is followed by a recourse to considerations of form and fact and to percentages of liberty that do not add up in my own calculations. Still, the point seems preserved, even in Douglass's final and more florid 1881 figure: the essence of freedom is always a condition of the heart.

Between 1838 and 1841 Douglass supported his family by unskilled labor —sawing wood, shoveling coal, and loading ships. (The white New Bedford shipyard workers would not tolerate a black caulker.) Yet he was now reading *The Liberator*, attending speeches by William Lloyd Garrison and Wendell Phillips, and occasionally speaking himself from the pulpit of the local Zion Methodist Church. In 1841, at the Massachusetts Anti-Slavery Society convention in Nantucket, Douglass was invited to describe his life as a slave. The performance was electrifying and so enthusiastically received that he was hired by the Society to be its general agent and to tour the country—with Garrison, Phillips, Abby Kelley, Stephen S. Foster, Parker Pillsbury, and other radical abolitionists—advocating the non-violent emancipation of blacks, their civil equality, and their right to live in America (rather than suffering exile to a distant black colony). In 1845, he published the *Narrative* and, because he disclosed his true identity,

movement leaders deemed it prudent to send him on a lecture tour to Great Britain, where, during the following two years, he was an immense success.

While abroad, some of his English friends (notably, Anna and Ellen Richardson and John Bright) negotiated with the Aulds to secure his freedom—thus initiating the first of many great public furors over Frederick Douglass. Hugh Auld, who in 1846 had bought Douglass for $100 from his brother, agreed to free Douglass in return for £150. After Douglass secured his freedom in this way there was an immense outcry, many purists arguing that the English anti-slavery radicals had trafficked with—and indeed enriched the coffers of—the hated slave power. But Douglass and his friends justified the negotiation on the ground that Douglass had not been *purchased* by the English. Instead, for a consideration, Hugh Auld had merely agreed to *manumit* him. The irony in all of this is that some of the abolitionists would have preferred Douglass to remain a fugitive slave.

Back in America in 1847, a free man, Douglass resumed lecturing and touring the country. But he was becoming restless with the tight controls placed on him by Garrison and the Massachusetts Anti-Slavery Society. He wanted to edit his own abolitionist newspaper, but the Society had other ideas. They wanted to use and control him, to employ his talents for their own programs and purposes. But Douglass, who already had a reputation for being uppity, was his own man. And it was with some irritation that the Garrison abolitionists finally acceded to Douglass's moving Anna and his household to Rochester in 1848, where he commenced his own radical newspaper, the *North Star*, a competitor with *The Liberator.* We know next to nothing, incidentally, about Anna's response to these matters because she was very withdrawn and did not participate in movement activities. All the evidence points to her being illiterate, and, despite many unsuccessful efforts to teach her to read, she was apparently of little public value to her husband in his developing career.

The Garrisonians did not like the *North Star*, but they were frankly appalled by developing events in Douglass's personal life. He had brought to America and installed in his own house the white radical Julia Griffiths, who was a member of the English anti-slavery movement. She was to serve as his business manager for the *North Star*, but there seems no reason to doubt that she was also his mistress, living in the same household with the illiterate Anna and their five children. None of these relationships is clarified in the autobiographies; in fact, Douglass was wonderfully reticent about his courtship of Anna, their marriage, and his own sexuality. But what seems unmistakable is that many women, of both races, found Frederick Douglass sexually attractive.

Douglass was a remarkably tall, muscular, and handsome young man with thick, black, curly hair, a pair of piercing eyes, a straight nose, thin

and well-formed lips, a musical voice, and a light mulatto complexion—a combination that melted hearts on two continents. In addition, he was the brightest and most articulate slave ever to have joined the movement, almost too talented and exceptional to be believed. Some were so struck with his talents that they doubted that he had ever been a slave. Many did not believe that Douglass himself had written the 1845 *Narrative*. Since most slave narratives were dictated or ghost-written, Douglass's is preceded by the usual "Attestation" of its authenticity: two stirring prefaces —one by Garrison, the other by Wendell Phillips—confirming that, yes, Douglass was really a black slave and, yes, he had written the work himself. (In subsequent editions, these were replaced with introductions by black friends.)

Douglass's mixed blood, light complexion, and sexual charisma were a problem for many abolitionists, black and white. The Englishman Thomas Clarkson worried: "I wish he were full blood black for I fear pro-slavery people will attribute his preeminent abilities to the white blood that is in his veins." And so some of them did. Douglass, whose identity was securely that of a black man, wrote back comically from England that "I am hardly black enough for the british taste, but by keeping my hair as wooly as possible—I make out to pass for at least a half a negro at any rate." But the argument about the source of his talent went on and on. In the preface to *My Bondage and My Freedom*, the black James M'Cune Smith undertook to answer in print whether "Mr. Douglass's power [was] inherited from the Negroid, or from what is called the Caucasian side of his makeup"—only to conclude, naturally enough, that "for his energy, perseverance, eloquence, invective, sagacity, and wide sympathy, he is indebted to his negro blood." William S. McFeely, in his excellent biography, *Frederick Douglass* (1991), has reported some of the other wonderful but paradoxical responses to this remarkable slave:

> One of Douglass's Dublin admirers had a somewhat different slant on the problem: "Faith, an' if half a Naigar can make a speech like that, whut could a whole Naigar do?" At least one American knew the right answer to this excellent question: years later, Lizzie Lavender, a former slave herself, reflected "that if a man who is only half black can become great like that, what may not be achieved by a person who is all black like me?"

In any case, Douglass the man attracted quite a number of radical groupies in England and America; and, in Julia Griffiths, he had brought one of them home to live with him in Rochester. As Douglass was by this time too well-known, popular, and successful to be controlled by the white anti-slavery establishment, he thought that he could weather the sexual scandal. But, with even *The Liberator* publicly critical of this

ménage, the pressure became too much and in 1855 Julia Griffiths returned to England.[4]

In Douglass's eyes, the Garrisonians were coming to seem more and more irrelevant to American political developments. Garrison and the *Liberator* group saw the Constitution as an evil document that enshrined and protected slavery. Any participation in American politics was therefore corrupt and immoral. Some abolitionists wanted the North to secede from the South and its slave-defending federal government; others wanted Massachusetts to secede from the Union; the most radical of the Garrisonians even wanted Essex County to secede from Massachusetts. A long train of events had convinced Douglass that this hostility to the political process had not achieved any positive results. So in 1853 he threw in his lot with Gerrit Smith, merged his *North Star* with Smith's *Liberty Party Paper* so as to produce a new journal (*Frederick Douglass' Paper*), joined in with many others in an open *political* dialogue, and so provoked a bitter break with Garrison and the Massachusetts Anti-Slavery Society.

Douglas's activities thenceforward, until the outbreak of the Civil War, are what might have been expected from an ardent abolitionist. He continued to tour the country giving lectures on anti-slavery and urging other liberal causes in the "Sisterhood of Reforms" (Northern desegregation, temperance, anti-vivisectionism, female suffrage, more generous labor laws). Very often Douglass and his fellow speakers were heckled and shouted down, set upon by mobs, or beaten by racist thugs. Nevertheless, courageously, he persisted in his calling. In 1855, he published the second version of his autobiography, *My Bondage and My Freedom*, and urged the nascent Republican Party to become the party of abolition. He knew and supported John Brown in his assisting escaped slaves to reach Canada. But when in 1859 Brown told him of the plan to assault the Harpers Ferry Arsenal and to arm the slaves for an insurrection, Douglass knew that his friend had gone round the bend and declined to participate in the raid. Brown's confiscated papers mentioned the name of Douglass, and a request for his arrest was issued. This led Douglass to take an immediate unplanned voyage to Europe, where he met up with Ottilia Assing, and, on the lecture circuit he acclaimed, from afar, the martyrdom of John Brown.

When it was safe to do so, Douglass returned to America to support Lincoln for president. This was in 1860. Lincoln's opponent, that *other* Douglas—Stephen—had shrewdly foreseen, in the Second Debate in 1858,

4 Julia Griffiths, it should be said, was not the only white woman with whom Douglass's name was romantically linked. Another was Ottilia Assing, a German revolutionary journalist who came to him in 1856 and remained an intimate friend until her death in 1884, the year that Douglass was remarried—this time to a white woman, Helen Pitts.

how a vote for Lincoln would result in the social equality of blacks; and Frederick Douglass was his warning to America.[5] Arguing that Lincoln was the tool of black abolitionists, Judge Douglas said,

> I have reason to recollect that some people in this country think that Fred. Douglass is a very good man. The last time I came here to make a speech, while talking from the stand to you, people of Freeport [Illinois], as I am doing to-day, I saw a carriage and a magnificent one it was, drive up and take a position on the outside of the crowd; a beautiful young lady was sitting on the box seat, whilst Fred. Douglass and her mother reclined inside, and the owner of the carriage acted as driver. (Laughter, cheers, cries of right, what have you to say against it, &c.) I saw this in your own town. ("What of it?") All I have to say of it is this, that if you, Black Republicans, think that the negro ought to be on a social equality with your wives and daughters, and ride in a carriage with your wife, whilst you drive the team, you have a perfect right to do so. (Good, good, and cheers, mingled with hooting and cries of white, white.) I am told that one of Fred. Douglass' kinsmen, another rich black negro, is now traveling in this part of the state making speeches for his friend Lincoln as the champion of black men. ("White men, white men," and "what have you got to say against it." That's right, &c.) All I have to say on that subject is that those of you who believe that the negro is your equal and ought to be on an equality with you socially, politically, and legally; have a right to entertain those opinions, and of course will vote for Mr. Lincoln. ("Down with the negro," no, no, &c.)

Despite the widespread public conflict aroused by these debates and by provocative abolitionist agitation, Frederick Douglass did not foresee Secession and the Southern attack on Fort Sumter. He did, however, welcome it. During the war—while Lincoln played that devious game with both whites and blacks, and Northerners and Southerners, over what would be done with the slaves—Douglass held Lincoln's feet to the fire. Emancipation, desegregation, education, and equality of opportunity were Douglass's objectives. He wanted blacks enlisted into the Union army, paid equally with whites, and accorded all the rights of citizenship. Douglass hoped to receive a commission himself and wanted to recruit black volunteers, but when the commission did not materialize he withdrew to his home and resumed his civilian agitation on behalf of black emancipation.

The nineteenth century was a great age of oratory, and, even in an era of extraordinary public spellbinders, Frederick Douglass was a master. He

5 I quote here from the Library of America edition of *Abraham Lincoln: Speeches and Writings, 1832–1858*, which includes a reporter's account of crowd reaction.

modeled his delivery on that of William Lloyd Garrison, one of the best speakers of the age. But Douglass commanded an even more impressive rolling stentorian style and employed a remarkably fluent vocal range. There are many reports of "the magnetism and melody of his wonderfully elastic voice." He had in fact a repertory of voices, and roles, and dialects that could evoke wonderful affects of pity and fear, joy and laughter. His gift for satirical mimickry—of Southern slaveholders, redneck overseers, and pompous pulpit defenders of slavery—was wicked and brought down the houses in constant laughter.

Douglass could mesmerize an audience of two thousand and more for two or three hours at a time. (How different are modern politicians, who aspire to master the thirty-second sound bite!) Elizabeth Cady Stanton, who acclaimed the "burning eloquence" of this fugitive slave, said that, when he warmed to the topic of the evils of slavery, he stood on the abolitionist platform "like an African prince, majestic in his wrath": "Around him sat the great antislavery orators of the day [Garrison, Pillsbury, and Phillips], earnestly watching the effect of his eloquence on that immense audience, that laughed and wept by turns, completely carried away by the wondrous gifts of his pathos and humor."

After the war Douglass continued to lecture on the lyceum circuit and publicly campaigned for successive Republican candidates—Grant, Hayes, Garfield, Blaine, and Harrison. He wrote widely and well on a wide range of topics—from the need for education and self-help to segregation, race relations, the failures of Reconstruction, and international politics. He stood for equality and saw the advancement of his people as a matter of equal opportunity. Though he hoped to be appointed to high office, Douglass was perhaps too abrasive and independent (if not too scandalous) for most Republican administrations. Grant gave him only a post with the 1871 commission investigating the idea of annexing the Dominican Republic for blacks. Hayes made him the U.S. Marshal for the District of Columbia in 1877, but Garfield demoted him to the post of recorder of deeds.

After Anna died, the sixty-six-year-old Douglass shocked nearly everyone by marrying, in 1884, Helen Pitts, a white woman from New York twenty years younger than he. Neither his children nor her family approved of this match, and the interracial marriage was widely criticized in the American press. Many blacks thought that he had turned his back on his race; while many whites saw it as another step toward the "mongrelization" of the Caucasian race. But Douglass knew in his own parentage that neither law nor custom can control desire or prevent love and affection from crossing racial lines; and without apologizing or explaining he simply acted on the principles by which he had always lived. (Meanwhile, in Paris, Ottilia Assing, the German friend who had translated his *My Bondage and My Freedom*, inexplicably committed suicide,

leaving Douglass her library of personal books and an income of $13,000 a year.)

Frederick and Helen Douglass comported themselves with the greatest dignity, were very happy together, won over many of their detractors and, in 1889, Douglass was appointed minister resident and consul general to Haiti, a post he held until 1891. The appointment contained much meaningful symbolism since, in many respects, Douglass was to his people something of what Toussaint l'Ouverture had meant to Haitians. His final years were quiet. But toward the end he made the friendship of the young black journalist Ida B. Wells and, spurred by her ardor and burning indignation, he recovered his passion for reform with a prolonged and effective attack on the appalling wave of black lynchings in the South. He died in 1895 and was buried with Anna in Rochester, New York.

In retrospect, it is clear that Frederick Douglass was the most important black in nineteenth-century America. His courage, conviction, and fiery eloquence created admiring audiences all over the United States and in Britain. He will therefore always have a place in the history of black emancipation and of American eloquence and platform oratory. Douglass's public performances are lost to us, since he lived before the invention of voice or audio recordings. But a distinct personality well worth knowing was created in these autobiographies, which are the work of a remarkable, versatile, and accomplished *writer.*

One of the most affecting passages in the autobiography appeared in the *Life and Times of Frederick Douglass,* where he described his return in 1876 to Talbot County, Maryland, to meet with the eighty-year-old Thomas Auld, his former master. After his escape Douglass had relentlessly and publicly attacked Captain Auld, by name, as the sadistic personification of slavery itself. By the outbreak of the Civil War, Auld was almost as well known as Douglass himself. But now the dying Auld had requested an interview. Although Douglass had nursed a lifetime of bitterness against his master, the visit produced a remarkable turn.

We addressed each other simultaneously, he calling me "Marshal Douglass," and I, as I had always called him, "Captain Auld." Hearing myself called by him "Marshal Douglass," I instantly broke up the formal nature of the meeting by saying, "not *Marshal*, but Frederick to you as formerly." We shook hands cordially, and in the act of doing so, he, having been long stricken with palsy, shed tears as men thus afflicted will do when excited by any deep emotion. The sight of him, the changes which time had wrought in him, his tremulous hands constantly in motion, and all the circumstances of his condition affected me deeply, and for a time choked my voice and made me speechless. We both, however, got the better of our feelings, and conversed freely about the past.

For all Douglass's lifelong bitterness and acute recollection of every humiliation he suffered, this was a scene of mutual forgiveness and final reconciliation. Auld told Douglass new facts about his slave family that he had not known before, and Douglass discovered Auld to be blameless of some of the fiercest accusations Douglass had earlier brought against him. In fact, far from turning out Douglass's grandmother "like an old horse," as Douglass had charged, Auld had taken her in and provided for her to the end. Douglass discovered, in short, that he could no longer hate his former master.

Slavery *was* a monstrous evil, but within the interstices of any such barbaric network there will always slip that incalculable element—human feeling. It was the human equation—affection, to give it a name—that led Lucretia Auld to see that the young Douglass was assigned to the service of Master Lloyd and his son; it was affection that led Sophia Auld to want to lift the appealing young Douglass toward literacy; and it was affection, perhaps, in some warped and distorted form, that moved Captain Auld to rescue Douglass from that Easton jail in 1836—when he was on the point of being lynched for trying to escape—and return him to the Hugh Aulds in Baltimore. It takes nothing away from Douglass, who used expertly the occasions presented to him, but in some corner of his mind Douglass always knew that at crucial moments the Aulds, perhaps unconsciously, had opened doorways and created unexpected opportunities for his advancement. While the intent of Douglass's writing is always relentless antislavery propaganda, all three narratives move us, psychologically, toward this withheld acknowledgment of Auld's essential if fallen humanity and toward Douglass's final reconciliation with him. "He was to me no longer a slaveholder either in fact or in spirit," Douglass wrote, "and I regarded him as I did myself, a victim of the circumstances of birth, education, law, and custom." Douglass was of course denounced by some blacks for making his peace with a former slaveholder. But in transcending the desire for revenge and perpetual punishment, and in realizing this peaceful reconciliation of their differences, Douglass gave us our best hope for American racial harmony.

February 1994

John Maynard Keynes:
The Nietzsche of Economics

David Frum

During the writing of his biography of Mountbatten, Philip Ziegler posted a little reminder to himself above his desk: "Despite everything, he was a great man." Unfortunately for the anecdote, in Mountbatten's case the reminder was untrue. It would have made for a much better story had the note been written by Lord Robert Skidelsky to guide him as he chronicled the life of John Maynard Keynes.[1]

Keynes was one of the most influential thinkers of our century, and his influence has been almost entirely bad. Since time immemorial, governments have debased their currency, misappropriated their people's wealth, and diverted the proceeds from productive investment to garish monuments to themselves. It was Keynes who supplied governments with arguments—and since Keynes was Keynes, brilliant arguments—to *justify* this outrageous conduct. If John Maynard Keynes had never lived, the Western world might still be the overtaxed, inflationary, statist mess that it is, but at least the people responsible for the mess would have to pretend to be embarrassed by it.

Instead, Keynes's fertile and subtle mind manufactured a huge armory of clever defenses of bad public policy. Since the publication of his 1936 masterwork, *The General Theory of Employment, Interest, and Money*, opponents of profligacy in government and state manipulation of the economy have had to contend not merely with the usual selfishness and cowardice of politicians but also with the subversive power of Keynes's mordant and glittering mind.

Keynes did for economics what Nietzsche did for morals: he demonstrated that the absolute moral truths that earlier generations had believed in were merely intellectual constructs, and constructs that could do with a great deal of improvement. Pre-Keynesian economics saw economies as

1 Robert Skidelsky's *John Maynard Keynes* is a biography-in-progress. So far, two of a projected three volumes have appeared: *Hopes Betrayed, 1883–1920* (1983) is available as a Penguin paperback; *The Economist as Savior, 1920–1937* (1992) is available from Allen Lane/The Penguin Press.

naturally self-adjusting. Whatever dislocations and disturbances might flare up from time to time, over the long run an economy would perform as well as the skill, effort, and accumulated capital of the community permitted. This was the complacent theorem that provoked Keynes's famous jeer that "in the long run we are all dead."

Keynes argued that economies could underperform their potential for worryingly long periods of time, and that their tendency toward underperformance had grown worse since 1914. The problem was money: in the frightening postwar world, wealth-owners too often held their wealth in cash, handy in case of emergency. According to pre-Keynesian orthodoxy, this was no problem: if the owners of wealth did not invest it, the banks in which they stored it would lend to someone who would. If large numbers of wealth-owners succumbed to the jitters, the amount of cash in banks would grow; with cash plentiful, interest rates would fall; and falling interest rates would encourage entrepreneurs to borrow and get the economy moving again. Keynes argued that this happy cycle need not occur—at any rate, it could not always be relied on to occur. A pound saved was, he contended, not automatically and by necessity a pound invested; it was potentially a pound stolen from productive purposes, a pound buried in the dark and denied to those who could put it to use.

Keynes prescribed two principal policies to set capital to work in a stagnant economy. First, interest rates must as a general rule be kept low, so as to minimize the temptation to hoard. (The "euthanasia of the rentier.") Second, governments must be prepared to invest directly in the economy to make up for the faintheartedness of private businessmen. Keynes astutely foresaw that cheap money and lavish government expenditure could lead to trouble—inflation, depreciation of the currency, and so on. He was more than willing to sanction extraordinary interventions in economic life, including protective tariffs, in order to head those troubles off.

Some of the more conservative admirers of Keynes—dazzled by his vaulting imagination, his many valid insights, and his gorgeous literary style—have tried to salvage him for the cause of sound economics by insisting that his "general theory" was not really general at all. It was a *special* theory, adapted to the peculiar situation of Britain in the sluggish 1920s and grim 1930s. Just as Einstein conceded that Newtonian physics worked pretty well most of the time, only needing the help of the theory of relativity at very high speeds, so too, say conservative Keynesians, did Keynes accept the validity of classical market economics under normal conditions. But that's not how Keynes himself saw things, according to Skidelsky. Keynes was a temperamental radical, who relished the thought that he had overturned and rendered obsolete the entire existing structure of economics.

Skidelsky's first volume documented Keynes's animosity to the Victorian order of things, not just in economics but in all aspects of life. Keynes never escaped the self-congratulatory world of Bloomsbury—a sanctuary from which Edwardian aesthetes, emancipated women, and homosexuals poured condescending scorn on the philistinism and stupidity they perceived to surround them. Skidelsky plainly finds Bloomsbury a great deal less appealing than its zillions of contemporary chroniclers, and in both volumes of the biography he approvingly quotes Keynes's 1938 lecture "My Early Beliefs" as proof that the economist outgrew the callow ideas of the Cambridge Apostles and Gordon Square. "In retrospect," Skidelsky wrote in Volume I,

> Keynes felt that "his early beliefs" had brought him both gain and loss. The gain was that "we were amongst the first of our generation, perhaps alone amongst our generation[,] to escape from Benthamite tradition," with its "over-valuation of the economic criterion." This had protected "the whole lot of us from the final *reductio ad absurdum* of Benthamism known as Marxism." The loss lay in a "disastrously mistaken" view of human nature. He and his friends, repudiating original sin, had believed that human beings were sufficiently rational to be "released from . . . inflexible rules of conduct, and left, from now onwards, to their own . . . reliable intuitions of the good." This view ignored the fact that "civilisation was a thin and precarious crust erected by the personality and will of the few, and only maintained by rules and conventions skillfully put across and guilefully preserved."

Unfortunately, it's not clear that Keynes fully lived up to this more mature point of view. He went to his death caring more for the good opinion of Vanessa Bell and Lytton Strachey than that of anyone other than (just possibly) his wife. To the end he was a scoffer and a sneerer. Skidelsky does not deny this aspect of Keynes's personality, but he offers the ingenious defense that Keynes "was not, after all, improbably cast as 'the savior of capitalism.' Social systems are never saved by true believers, the virtues appropriate to going down with the ship rarely being suitable for the arts of navigation."

Of course, in one of history's too-obvious ironies, Keynesianism in due time evolved into a social system as calcified as Victorian capitalism, and Keynes's intellectual legacy came to be defended by true believers every bit as willing to go down with the ship as the hardfaced mid-nineteenth-century disciples of David Ricardo. Without being too fanciful, one can even say that Skidelsky's two volumes about Keynes eerily parallel Keynes's own writings. Keynes first important work, *The Economic Consequences of the Peace*, was published in 1920, while the world made by nineteenth-century capitalism lay shattered by the catastrophe of the First World War but before men's minds had yet caught up. When Skidelsky's

253

first volume was published in 1983, the world made by Keynesian demand management and artificially cheap money was likewise a wreck, the victim of stagflation and the near-meltdown of the world banking system in August 1982. By the time Keynes's *General Theory* was put out, nineteenth-century economics was as defunct intellectually as it had been practically sixteen years before. And equally, as Skidelsky's second volume appears in the post–Berlin Wall era, Keynesianism has not only stopped working, it is nearly universally seen to have stopped working. The scoffer and sneerer is himself now scoffed at and sneered at.

Perhaps the most interesting thing about Skidelsky's biography—and it's packed with interesting things—is the way the author grapples with this movement of economic thought away from Keynes. The entry for Hayek in the index of Volume II is twice as long as the entry for Marx. It is the right-wing criticisms of Keynes that Skidelsky anticipates and attempts to answer. He is at pains to show that Keynes did indeed appreciate the dangers of inflation, that he welcomed entrepreneurship, that he opposed excessive taxation, and that he attached virtually no value to equality as an end in itself. As Skidelsky tells it, Keynes may have disliked Britain's particular inequalities, which put a decadent landed class at the top, but he emphatically did not want to level individuals. In a particularly pungent mood Keynes declared, "I do not want to antagonize the successful, the exceptional. I believe that man for man the middle class and even the upper class is very much superior to the working class." At times, Skidelsky's Keynes sounds oddly like a contemporary neoconservative: if the economy of postwar Europe stuttered and stammered, it was—Skidelsky's Keynes perceives—because the virtues that had made the nineteenth-century economy work had been blasted out of existence in 1914–18. Skidelsky's Keynes believes that the Victorian economy worked not because it complied with the laws of economics but because Victorian personalities made it work. Post-Victorian personalities, whom Skidelsky's Keynes finds rather less admirable than some other Keyneses, had lost their forefathers' virtues and needed a new kind of economy—a more authoritarian economy, one that allowed weaker characters less scope. Skidelsky quotes from Virginia Woolf's diaries an account of a dinner in honor of T. S. Eliot in 1934. "I begin to see," Keynes said to Woolf, "that our generation—yours & mine . . . owed a great deal to our father's religion. And the young, like Julian [the son of her sister Vanessa Bell], who are brought up without it, will never get so much out of life. They're trivial: like dogs in their lusts."

For all its eloquence and impressive textual authority, for all its generous willingness to take seriously critics of Keynes whom Keynesians laughed at until little more than a decade ago, Skidelsky's attempted rescue of Keynes's economics founders on the single greatest practical deficiency of

Keynesian policy: its blind faith in the wisdom, justice, and competence of civil servants. At some deep level, Keynes seems to have divided the world into two groups: people like himself and his Cambridge friends—intelligent, aesthetically sensitive, imbued with advanced opinions—and people like the despised "hearties" of his undergraduate days—athletic, stolid, conventional. In his mind, the first group was more naturally attracted to government, the second to business. And he had no doubt as to which group was more to be trusted. As scathing and funny as he could be about the investment decisions that businessmen might make with their own wealth, it never occurred to him to ponder with equal skepticism what clever art-loving grown-up undergraduates might do with other people's wealth once put in charge of a state program of house- and road-building.

At some level, this great man—a man who dedicated himself to ruthless truth-telling, no matter what the consequences; a man who put workability and the evidence of experience at the very center of his personal thought—can fairly be convicted of the error that would have appalled him most: naïveté. Damningly, his naïveté was born not out of ignorance or gullibility but out of vanity. He was naïve about government, and the risk of governmental error, because he expected that the upper reaches of government would be staffed by men rather like himself, in sensibility if not in genius. Skidelsky calls Keynes the last of the great English liberals. In at least one sense, the accolade—if it is an accolade—is well deserved. Despite the condemnation of precisely this sort of error in "My Early Beliefs," Keynes could never shake himself free of the prejudice that the world was governed by more or less reasonable chaps, and that no part of the world was more likely to be governed by reasonable chaps than one's nation's enemies.

As a senior Treasury official in the First World War, Keynes was an important organizer of British survival and the eventual Allied victory. But all through the war he held fast to the pacifist dogma that the military rulers of Germany wanted a compromise peace every bit as much as Bloomsbury did. "Indeed," Skidelsky comments sadly, "a gross overestimate of the strength of the German moderates, as well as a misunderstanding of their aims, was characteristic of the whole British middle-class peace movement." They projected their own image upon a hostile and dangerous world. If not naïveté, this was at least narcissism—an involvement with oneself so all-consuming that one could not absorb the information that other people held radically different opinions and behaved in entirely different ways. It is this weakness, more than any other trait of Keynes's, that convinces the reader of this biography that, had Keynes somehow survived to a riper age, he would not, no matter what his more conservative admirers claim, ever have migrated rightward. A liberal Keynes was, a liberal he would have remained.

But give him credit for this: Keynes showed no such naïveté in the

1930s. He grasped the Nazi menace from the start, and shot the Labour Party's arguments to pieces when it adopted fear of fiscal deficits as a reason to oppose British re-armament. Nor, aside from a brief flurry of over-optimism about the prospects for relatively rapid economic growth in Russia as a result of a visit there in 1925, was Keynes ever seduced by Communism. "Marxist socialism," he wrote in 1924, "must always remain a portent to the historians of opinion—how a doctrine so illogical and so dull can have exercised so powerful and enduring influence over the minds of men and, through them, the course of history." A decade later, he was warning Cambridge undergraduates that Marxism stood far below social credit as economic quackery, and mischievously wrote to George Bernard Shaw:

> My feelings about *Das Kapital* are the same as my feelings about the *Koran*. I know that it is historically important and I know that many people, not all of whom are idiots, find it a sort of Rock of Ages and containing inspiration. Yet when I look into it, it is to me inexplicable that it can have this effect. Its dreary, out-of-date, academic controversialising seems so extraordinarily unsuitable as material for the purpose . . . How could either of these books carry fire and sword round half the world? It beats me.

Despite his mockery, Keynes well understood the attractions of Communism to the affluent young. "When Cambridge undergraduates take their inevitable trip to Bolshiedom, are they disillusioned when they find it all dreadfully uncomfortable? Of course not. That is what they are looking for." In his liberal way, however, he found this conversion to Marxism comical rather than horrifying.

As Keynes's funny but deadly animadversions on Marxism suggest, much of the impact of his ideas originated in his remarkable personal charm. In a small society like that of interwar England, personality counted. Keynes's was evidently delightful. He treated his Bloomsbury friends with extraordinary generosity, generosity that was seldom returned. Cambridge followed his ideas at least in part because it liked him so much. It makes one wonder whether the course of modern economic life would have been different had Ludwig von Mises not been such a pedantic and irascible old man, or if Hayek had been quicker with a joke.

To Skidelsky's credit, much of Keynes's charm is captured on the page, which one would have thought to be an almost impossible task. But then, Skidelsky accomplishes one impossible task right after another. His biography combines the telling of Keynes's fascinating life with penetrating and surprisingly accessible analysis of his economic ideas, of his times, of the philosophy from which Keynes's own work proceeded. (More technical discussions are appended to the ends of the appropriate chapters.)

Along the way, Skidelsky pauses for some illuminating reflection on the biographer's historiography.

> An inescapable conundrum of biography is to know what allowance to make for the *Zeitgeist* in directing one's subject's thought and life. People are children of their times, as well as of their parents. . . . But the implicit biographical assumption is that for most explanatory purposes, the *Zeitgeist* can be held constant; that it changes more slowly than the individual life; and that, therefore, family, education and class are the main systematic external influences the biographer needs to consider. . . . The assumption . . . is that biographical subjects are much more frequently products of their *backgrounds* than of their *times*.

In Keynes's case at least, Skidelsky maintains, the usual assumption is wrong.

Altogether, this is a very successful biography. Is it too long? Biographies nowadays nearly always are. I sometimes wonder whether excessively long biographies are not a side effect of the decline of public sculpture. The Victorians gave their heroes statues; we don't know how to do that anymore, and so we build our monuments in bookshop windows. But long as it is, this is a book worth the time it consumes. The reader who works his way through it will emerge with a keener understanding not just of Keynes's time, but of his own.

April 1994

The Importance of T. E. Lawrence

David Fromkin

In 1988, on the centenary of Thomas Edward ("T. E.") Lawrence, *The Economist* observed that he "remains—in the curious company of James Dean—the most widely publicized folk-hero of the century." Especially in Great Britain, but in the United States and Europe as well, books about him continue to flood the market. The BBC, which broadcast a television documentary about him in the 1960s, broadcast another in 1986; and the haunting David Lean film *Lawrence of Arabia* was re-released recently, in a fuller version, to continuing acclaim. A new selection of Lawrence's letters was published in 1988. *Seven Pillars of Wisdom*, his partly fictional account of the Arab Revolt and his role in it, continues to sell in bookstores more than a half century after its first publication, and is said to be one of the most widely read books in the English language. A massive authorized biography of him published in 1988 did not succeed in saying the final word, although it was intended to do so; yet another biography—perhaps the fortieth to be published in English or French—appeared the following year.[1]

The puzzles he set, and the ambiguities of his life and thought, continue to fascinate and to baffle. They are likely to do so well beyond his second centenary. In a slim volume of scholarly essays[2] that appeared in 1989, he was compared to Homer, Xenophon, Rousseau, Kipling, Lord Byron, Goethe, Rimbaud, James Joyce, and T. S. Eliot. Liddell Hart, theorist of military strategy, compared him to the Great Captains: a select group that, most would say, includes only Alexander, Caesar, Napoleon, and no more than a handful of others.

So important was his prestige to that of the British Empire that when a book exposing some of his personal secrets was about to appear two

1 *Lawrence of Arabia: The Authorized Biography of T. E. Lawrence*, by Jeremy Wilson (Atheneum, 1989), and *The Golden Warrior: The Life and Legend of Lawrence of Arabia*, by Lawrence James (Weidenfeld & Nicolson, 1990).

2 *T. E. Lawrence: Soldier, Writer, Legend*, edited by Jeffrey Meyers (St. Martin's Press, 1989).

decades after his death, there was a movement to stop it; the artist Eric Kennington wrote to Sir Ronald Storrs, "Would not publication . . . do great harm to Great Britain (and the white races) . . . among friend & enemies, & weaken our prestige & power with all dark-skinned races?"

He was idolized. The novelist John Buchan, who ought to have known that some of Lawrence's tales were fabrications, wrote: "I am not much of a hero-worshiper . . . but I would have followed Lawrence over the edge of the world." The historian James Shotwell, an American delegate to the Peace Conference (1919), called Lawrence the "successor of Muhammad." An Anglican clergyman, conducting Oxford services for T. E., said he was making no direct comparison, but did so anyway: he claimed that in life and work, Lawrence was another Jesus Christ.

Who was Lawrence? What made him so important?

Lawrence, as the world now knows, was not Lawrence. The illegitimate child of an illegitimate child, he was the son of Thomas Chapman, later to become Sir Thomas Chapman, the seventh Baronet of his line. The Chapmans were Protestant squires in Ireland, where they had acquired their first lands centuries before through the patronage of their kinsman Sir Walter Raleigh. Chapman, who already had a wife and daughters, ran away with Sarah, the family governess. The offspring out of wedlock of a Norwegian father and an English mother, she was a woman as powerful and almost as fiercely religious as his wife. Thomas and Sarah took the surname "Lawrence" and had five sons together, of whom the second was T. E., born in 1888.

Unlike his brothers, who grew up in ignorance of the deception, T. E. learned at some point during his boyhood that his outwardly respectable churchgoing parents, despite all his mother's puritanical religious sermonizing, were living in sin, using assumed names, and acting out a lie. Aspects of T. E.'s behavior often have been explained as an outgrowth of this: of his knowledge that his parents were frauds, and of his having to play a false role himself by answering to the name Lawrence. Decades later he tried calling himself by other names—Ross and Shaw—but they seemed wrong, too. Writing of himself in the third person, he said: "The friends of his manhood called him 'T. E.' for convenience and to show him that they recognized how his adopted surnames—Lawrence, Ross, Shaw, whatever they were—did not belong."

He was a born double agent. He loved deceptions, puzzles, and disguises. But so did others in the England of his time. It was the age of Frederick Rolfe, who passed himself off as Baron Corvo and wrote an autobiographical fantasy in which he became Pope Hadrian the Seventh. When Lawrence was a child, impersonation took its timelessly best-selling form in Anthony Hope's *The Prisoner of Zenda* (1894).

All his life, Lawrence told tales, passing off his inventions or exaggera-

tions as the truth. But so did a surprising number of his noted contemporaries. It is notoriously difficult to find a completely true sentence in the multi-volume memoirs of David Lloyd George, the Prime Minister under whom Lawrence served. Ford Madox Ford, who was central to London's literary set when Lawrence tried his hand at writing, bragged of friendships with people he did not know, and described encounters that never took place. Harold J. Laski, theoretician of the Socialist Left, friend and correspondent of Justice Holmes, did the same thing.

In fabricating stories, Lawrence cheated as a child cheats, with no essential dishonesty, meaning no harm, but passionately desiring the attention and recognition that the achievements bragged of will bring. He sought the approval of adults. As a boy, he was the perfect Scout (though the Scout movement had not yet started), disciplining himself to learn stealth, craft, and all sorts of survival skills that he was unlikely to be called upon to use in his home town of Oxford. He taught himself self-denial and endurance, gave up eating meat for years, practiced going without sleep, built muscles, and rode a bicycle a hundred miles a day. Later he learned to be a crack shot.

With a head disproportionately large, he looked shorter than his five feet four inches. With his puckish grin, his impish love of teasing, and his irreverence, the shortness made him look like a boy who never grew up. Indeed he was in some ways a case of arrested development. Emotionally he never reached puberty; typically, his lifelong attitude toward the opposite sex was that of a twelve-year-old who thinks that including girls in activities spoils the fun.

Perpetual boyhood was a theme that ran strongly through the British imagination in his time (and afterward). It found its full expression in Barrie's *Peter Pan*, which appeared in 1904, when Lawrence was in his teens. Adult Britons lingered, in continuing fascination, in the world of their childhood, as witness the enormous hold on public attention exercised by Kipling's tale of school days, *Stalky & Co.*, and by Kenneth Grahame's *The Wind in the Willows*. Lawrence's contemporaries P. G. Wodehouse and A. A. Milne (creator of Winnie-the-Pooh) were like him in refusing to become adults; and like him, too, in creating imaginary worlds—for the Arabian desert portrayed by Lawrence is a work of art—into which the schoolboy in every reader can escape. So T. E. Lawrence's strong appeal to the imagination of Englishmen, at least in part, may well have been due—may still be due—to his having tapped this powerful vein of sentiment buried beneath the surface of British life.

The heroines in Wodehouse's novels win approval only if they are good sports: one of the lads. Lawrence's tastes ran in similar directions. As a very young man, without preliminaries, he proposed marriage to a girl he knew only slightly; what seems to have been distinctive about her was that she was a tomboy.

It is not that he was homosexual, at least in the usual sense, although he often appeared to be, perhaps unconsciously, flirting in that direction. Vyvyan Richards, a friend of his young manhood who felt a homosexual passion for him, later wrote: ". . . for me it was love at first sight. He had neither flesh nor carnality of any kind; he just did not understand. He received my affection, my sacrifice, in fact, eventually my total subservience, as though it was his due. He never gave the slightest sign that he understood my motives or fathomed my desires." Of sex with other men, Lawrence said: "I couldn't ever do it, I believe: the impulse strong enough to make me touch another creature has not yet been born in me." Of sex with women, "I haven't ever: and don't much want to." Concern with "our comic reproductive processes" should not be "a main business of life," he wrote; but it bothered him a lot, and, in army days, he found the coarse sex talk in the barracks more than upsetting: to him it was maddening.

His sexual puritanism was not dissimilar to that of his religious mother— which is ironic, for he directed his life toward freeing himself from her. Even in the last phase of his life, he spoke bitterly of how she tried "to break into the circle" of his "integrity." He wrote her: "You talk of 'sharing my life' . . . but that I won't allow." He wrote of her: "I have a terror of her knowing anything about my feelings, or convictions, or way of life. If she knew they would be damaged: violated: no longer mine . . . Knowledge of her will prevent my ever making any woman a mother . . ." But at last, because she survived him, she won; above his dead body she placed a tombstone with a text from the Bible—her holy book, not his.[3] All his life he had fought to free himself of her, but at the end of it he found himself entombed forever beneath his mother's pieties.

At university—Jesus College, Oxford—Lawrence found a mentor in David Hogarth, Keeper of the Ashmolean Museum, who led him to a career as an archeologist in the Middle East. When the First World War broke out, Lawrence became a junior officer and was sent out to Cairo as an interpreter and mapmaker—and Hogarth appeared as Lt.-Commander in the Royal Navy and a key figure in British intelligence in the Middle East, who later was assigned to head the Arab Bureau, the special unit established to deal with the Arab Middle East. As such Hogarth worked under Gilbert Clayton, who in the autumn of 1914 was made head of all British civilian and military intelligence in Egypt, and alongside Ronald Storrs, a Foreign Office official who held the especial confidence of Lord Kitchener, England's proconsul in Egypt, "temporarily" in London as War Minister.

3 An observation made in 1977 in *T. E. Lawrence*, by Desmond Stewart (Harper & Row, 1990).

Though destined for eventual independence, Egypt was then a British protectorate. It was at the front line in the war that had broken out against the Ottoman Empire, the Turkish sultanate which then ruled the Arab Middle East as well as the lands now called Turkey and Israel.

Cairo seethed with intrigue. Arab exiles from Syria and elsewhere dangled alluring possibilities of action behind enemy lines before British intelligence officials who were credulous and ill-informed. The Turks had extensive spy networks behind British lines, but the English had none behind theirs: the British commanding general in Egypt confessed to Kitchener that "I can get no information . . . — our agents cannot get through —those we had on the other side have been bagged."

It was from the Cairene world of schemes and dreams, in which things were rarely what British officialdom believed them to be, that tiny young T. E. Lawrence began his rise to world fame.

Lawrence did not come in at the beginning of what he called "the show"; he came in at the middle. To understand what he achieved, and why his government found the exploits he invented as useful as those he actually accomplished, one must know what had come before.

There was no good reason for England to be embroiled in a war with the Ottoman Empire, which had been her ally and protégé for a century. The war against Germany and Austro-Hungary had broken out in Europe, between Europeans, and had no connection to the Ottoman Sultan or his domains. It was an accident, the details of which need not be gone into here, that brought the Empire into collision with the Allies— who had no quarrel with the Sultan, and no desire to fight him.

Britain underestimated the Ottoman Empire, and regarded the Sultan's war against England as a nuisance rather than a danger. Britain's War Minister, Lord Kitchener, was determined not to allow the Middle East to distract attention from the real war: the war that raged in Europe. All forces would be concentrated on the western front. Only when Germany and Austria surrendered would the Allies send troops to the Middle East.

Kitchener and his lieutenants in Egypt, who were Lawrence's mentors, had grown up in the service of the Great Game, the century-long conflict that pitted Britain against her rivals France and Russia in the Middle East. In the 1914 war, France and Russia were England's allies; but Kitchener and his followers looked ahead to the postwar world, in which the Middle Eastern rivalry with Russia and France would resume. It was in this context that Kitchener in 1914 initiated a secret correspondence with Hussein ibn Ali, the Turkish-appointed Emir of Mecca. As Emir, Hussein was the protector of the Holy Places of the Mohammedan religion located in the Hejaz, a province in the west of what is now Saudi Arabia, then governed by the Ottoman Empire.

Anticipating that, when the war was over, Russia would seize control of Islam by setting up a puppet Turkish Sultan as Caliph of the Faithful,

Kitchener schemed to set up the Emir Hussein as a rival, Arabian, Caliph who would be Britain's puppet—a sort of anti-Pope, to be used as French monarchs once employed the Pontiffs of Avignon.

This madcap scheme had to be kept secret, for in India, Britain ruled the largest Moslem population in the world, and were it to be known that the English were meddling in their religion, Mohammedans there and everywhere might rise in rage against Britain.

To his dying day, Lawrence kept the secret. In the introductory sentence to *Seven Pillars of Wisdom*, he wrote that "some Englishmen, of whom Lord Kitchener was chief, believed that a rebellion of Arabs against Turks would enable England, while fighting Germany, simultaneously to defeat her ally Turkey." On the contrary, Kitchener's was the strategy of not fighting the two simultaneously, but of defeating Germany first. For most of his tenure at the War Office, he was not interested in pitting Arabs against Turks but in pitting Britain's Moslems against Russia's Moslems. He did not believe in Arab nationalism.

Kitchener and his followers believed that in the Middle East religion was everything. But—and here, though misleading, Lawrence's introductory sentence is literally accurate—from the autumn of 1915 until the summer of 1916, they were tricked into believing otherwise. Retelling the details of it would take too long; suffice it to say that British officials in Cairo now believed—for about nine or ten months, until they realized that they had been deceived—that a vast nationalist Arab network existed behind Ottoman lines, including several hundred thousand Arab-speaking Ottoman troops (perhaps as much as half the Ottoman army); and that they would rebel against the Ottoman Empire and come over to the Allied side of the war at the call of the same Hussein of the Hejaz whom Kitchener had imagined to be a religious leader. Moreover Hussein was willing to do it; unbeknown to the British, he had discovered that the Ottoman government planned to depose him, so he had no choice but to rebel while he could.

In June 1916, supported by Abdullah, Feisal, and his other sons, Hussein proclaimed the Arab Revolt. It proved to be a dud. Hussein, it turned out, had no following at all. Moslems did not respond to his call, nor did Arabs. Under his banner—or rather, the one that a British official designed for him—those who rallied were closer to one thousand than to one hundred thousand, and they were tribesmen, not soldiers.

The Arab Revolt was supposed to rescue Britain, but instead Britain had to rescue it. Kitchener died before he could be blamed; but the reputation of Clayton, Storrs, and its other British sponsors in Cairo plummeted. In the autumn of 1916, Storrs journeyed to the Hejaz to see what could be salvaged from it. Clayton apparently wanted Lawrence—who was far more enterprising than Storrs—to go along, but could not

get official permission; so Lawrence took his accumulated leave time, and traveled with Storrs as a vacationer. He had never been to Arabia before.

In the two years that followed, Lawrence was to be instrumental in keeping Hussein's movement alive and in directing it along lines that proved helpful—though not of any vital importance—to the Allied war effort. It was creditable service that, however, had no material effect on the conduct or outcome of the war. It was rather in shaping the peace that T. E. and the Hejaz movement that he inspired made their mark. Britain's new Prime Minister, David Lloyd George, wanted to take the whole of the Arab Middle East for the British Empire in the postwar world; and it was here that Lawrence, with a gift for self-glorification that served his country's purposes, was to prove so useful. Lawrence's real achievement in his two years with the Arabians in the World War was to invent a role for the Emir Hussein's small band: a role so visible, that commanded so much attention and proved so easy to exaggerate, that, when the war was over, Britain could make claims on Hussein's behalf, could pretend that she could not honor her promise to deliver Syria to France, because Hussein (said the British, lying outrageously) had won Syria in the war. Hussein was Britain's man; in pushing Hussein's claims, Lawrence was advancing Britain's.

At 7 A.M., October 16, 1916, the vessel bringing Storrs and Lawrence from Egypt docked at the port of Jeddah on the coast of Arabia. Lawrence—his own master, for he was on leave—made it his business to go upcountry to meet the sons of the Emir Hussein. Having done so, he became convinced that Feisal was the son who should lead the Arab cause. Lawrence also was converted to the views of the then-commander of Hussein's forces—a former officer in the Ottoman army, brought in by the British to try to make soldiers out of Hussein's tribesmen—that the bedouin of the Hejaz would be better employed in fighting a guerrilla war than in trying to fight a conventional one.

On his return from Arabia, Lawrence persuaded his superiors of these views. Consequently Prince Feisal became the Arab field commander; at Feisal's request, Lawrence was assigned to be British liaison officer with him; and the campaign they waged was a guerrilla one. Their object was to take the city of Medina, which lay to the north of them and blocked the Hejaz forces from riding north to Palestine, where the Middle East war was to be fought. To force Medina's surrender, Feisal's forces raided the single-track railway from Transjordanian Palestine that was Medina's sole source of reinforcements and supply. A British officer named Herbert Garland taught the Arabs how to dynamite the railroad, and Garland and other officers (including Lawrence, who later received most of the credit for it) went on to dynamite it repeatedly.

But the campaign failed. The Turks repaired the railway after each attack, and kept it running. Medina never fell to the Arabs or the Allies; its

garrison held out until the end of the war, blocking the land road to Palestine.

So Lawrence thought of another plan. Since Feisal could not take Medina, he would go around it. Like others, Lawrence had noted the importance of Aqaba, the sleepy fishing port at the southern tip of Palestine. But Lawrence, who had seen aerial photographs of it, was alone in realizing that it could only be taken from behind: from the land, not the sea. Lawrence therefore purchased the support of a bedouin sheik—a desert raider of local renown—who executed the plan. When Aqaba fell to the sheik's war band, Lawrence, who rode with them, performed feats of endurance and courage in crossing enemy-held Palestine and Sinai to report the news to the new British commanding general, Edmund Allenby.

Now that the Arabs had a port in Palestine, the Royal Navy could bring Feisal and his followers to it by sea. Feisal no longer had to keep trying to fight his way there by land—which was a good thing, because Medina continued to stand in Feisal's way, and had Lawrence not thought of a way around it—the sea road—the Hejaz movement would have remained bottled up in the Hejaz for the rest of the war. As it was, Allenby, at Lawrence's request, sent ships to bring Feisal and about a thousand followers to Aqaba. There they were fleshed out by about twenty-five hundred Arab deserters from the Ottoman army to form a camel-cavalry corps that harassed the Turkish flank when Allenby's Egypt-based army invaded Palestine and marched on Syria.

The camel corps contributed something to the campaign, but much more to the pretense that Syria was liberated by the Arabs themselves. Pretense indeed: there were a million British troops fighting in the Middle East in 1918, and only thirty-five hundred Arabs, so on the face of it, it was Britain's war. In part to dramatize the role of the Arabs, Allenby's headquarters ordered the Australian and New Zealand (Anzac) cavalry spearheading the Allied advance to go around Damascus, the metropolis of Syria, not through it, so as to let Feisal take the city. But the plan miscarried. The Ottoman armies fled Damascus, and local Arabs unfriendly to Feisal took possession of it. Then Anzac units, unaware of orders or ignoring them, rode into the city and occupied it. The Allies now had it. Feisal and his cavalry were still three days away, while Lawrence, who had been transferred to the staff of the Australian commander, went A.W.O.L. and had to drive into the Allied-occupied city in his battered Rolls-Royce to find out what was going on.

A few days later, Feisal and a few hundred followers arrived in Damascus and staged a media event: a triumphal camelback entry into the city. Out of this material and some inspired lies, Lawrence fabricated the liberation of Damascus by Feisal and himself, in anonymous dispatches to the London *Times*, and in the several books written by him or with his help.

Lawrence's account was backed up by the personal secretariat of Prime Minister David Lloyd George, whose instructions in briefing the press were to emphasize that the cities of Syria had been liberated by Feisal's forces, which were largely made up of Syrians; so that Syria had freed herself, and in conscience Britain could not turn her over to France.

Sour grapes, distilled in the imagination of T. E. Lawrence, became an intoxicating brew for the twentieth century. The more Lawrence thought about his failure to destroy the Hejaz railroad or to take Medina, the more he realized he was better off not having done so. He had diverted Turkish resources, and had tied down tens of thousands of enemy troops, who had to be on the alert at all times because they did not know when or where he would attack.

Lawrence, working with the military thinker Liddell Hart, developed what became one of the most influential strategic theories of our time in a magazine essay that was later made into an article for the 1929 edition of the *Britannica*. To a world coming out of a senseless European trench war in which battles had been little more than mass butchery, Lawrence offered an attractive alternative strategy of warfare without battles. Instead of attacking enemies, he wrote, you go around them, immobilizing and isolating them, wearing them down as their sentries peer into the darkness searching for attackers who might or might not be lurking in the night.

Lawrence skirted the question of why Allenby's campaigns rather than his own had won the Middle Eastern war. He wrote that Allenby's "too-greatness deprived the Arab revolt of the opportunity" of defeating Turkey. In fact, Aqaba aside, the bedouins with whom Lawrence rode were never able to defeat the Turks at all; it took a million-man British army to deliver a knockout blow to the Ottoman Empire—a blow the hit-and-run bedouins were not remotely capable of delivering themselves.

It was to a different kind of war that Lawrence's strategy applied. Lawrence did not know how to destroy or even defeat an enemy, so that his strategy was of no use against a country fighting for survival: a country that will not or cannot give up or surrender and has to be crushed by force. Lawrence taught how to wear down an opponent: a strategy that will win only against an enemy that will surrender if tired, an enemy, therefore, fighting to hold on to something it can afford to give up. In situations to which it applies, the advantage of Lawrence's strategy of attrition is that it permits a smaller, weaker force to sap the resources—and therefore the will to continue fighting—of a Great Power that cannot be defeated face-to-face in the field.

So Lawrence's strategy suits the particular needs of rebels against colonial powers; and his writings have stimulated the thinking of revolutionary strategists throughout the century and are studied alongside the works of Mao Zedong, the campaigns of Vo Nguyen Giap, and the theories of Che Guevara. It is an aspect of Lawrence's special genius to

have created a theory that would be so relevant in the years to come. And it is a typical paradox of his career that he, the hero of British imperialism, should have become an inspirer of the Third World's revolt against the imperial West.

It was an ambitious young American showman and jack-of-all-trades, Lowell Thomas, who invented "Lawrence of Arabia" and made him into one of the world's first film stars. Thomas was about twenty-five at the end of 1917, when he raised enough money to send himself and a cameraman to the Middle East in search of a story with romance and local color that he could sell. He had been pointed toward the Middle East by Britain's information director, John Buchan, author of the novel *Greenmantle* (1916), in which a young Oxford scholar in native turban leads a Moslem uprising against the Ottoman Empire.

Almost immediately on arriving in the Middle East, Thomas found his man. At first even Thomas questioned the far-fetched tales that Lawrence told him, but (according to Thomas) T. E. "would laugh with glee and reply: 'History isn't made up of truth, anyhow, so why worry?'" Later, Lawrence was to remark: "On the whole I prefer lies to truth, particularly where they concern me." Lawrence claimed that the fictions he passed off as accounts of his adventures satisfied his "craving for self-expression in some imaginative form"; and when a friend objected, he countered with "What does it matter? History is but a series of accepted lies."

Lawrence, with his romantic fantasies, and Lowell Thomas, with his hyperbole and ballyhoo, together concocted a story that took the world by storm. Using the photos as lantern slides as he narrated, Thomas created a show that toured the globe and broke entertainment-business records. In London alone, a million people came to see it.

To an audience sickened for years by the sordid grime and hopeless slaughter of trench warfare on the western front, Lowell Thomas brought a hero in gleaming white robes who rode to victory. Thomas's story of a young Oxonian in native garb becoming a warrior-prince of the desert, to some extent prefigured in *Greenmantle* and A. E. W. Mason's *Four Feathers*, struck a deeply responsive chord, much like that struck by Edgar Rice Burroughs in *Tarzan*. It was as though the story had been there all along, waiting to be told; and the role of Oxford's desert prince was there, too, waiting for Lawrence to play it.

But the story was false fundamentally. Neither T. E. nor any of his colleagues could have passed for Arab in the Middle East. As Lawrence admitted in 1927 to his biographer, the poet Robert Graves, "I've never heard an Englishman speak Arabic well enough to be taken for a native of any part of the Arabic-speaking world, for five minutes."

Mrs. George Bernard Shaw, a confidante of Lawrence's, to whom he confessed much that was false, once exclaimed in exasperation that "he is

such an *infernal* liar!"; but her husband disagreed. T. E. "was a born and incorrigible actor," wrote Shaw. "He was not a liar. He was an actor."

The celebrity brought about by Lowell Thomas's "Lawrence of Arabia" show propelled T. E. into the political limelight. Long before George Murphy became a U.S. Senator or Ronald Reagan became America's President, Lawrence was a sort of actor in politics. He threw himself into his roles wholeheartedly. Dressed in the uniform of a British officer, he spoke cynically of how he would manipulate the peoples of the Middle East, but wearing his native robes, he was the only prominent Englishman in favor of genuine independence for the Arabs.

In 1919 Lawrence was Feisal's confederate at the Peace Conference, maneuvering to get Hussein's son the crown of an independent Syria and causing some on the British side to wonder whose team he was on. In 1920, T. E. became a public critic of Britain's Middle East policy. Attacking the central justification of imperialism—that native peoples are incapable of self-rule—he wrote to the *Times* that "Merit is no qualification for freedom." Of the Arabs in Syria and what is now Iraq, he wrote that "They did not risk their lives in battle to change masters, to become British subjects or French citizens, but to win a show of their own."

In 1921–22, Lawrence was called back into public service, despite objections that he was unconventional, chronically insubordinate, and not a team player. Appointed an assistant by the new Colonial Secretary, Winston Churchill, Lawrence helped Churchill to turn around the government's approach and devise a changed Middle East policy that gave Feisal the newly created kingdom of Iraq and gave Transjordanian Palestine (now Jordan) to Feisal's brother Abdullah. Lawrence was proud of the settlement, and admired Churchill for making it possible; he remarked repeatedly that the Arabs now had been given what they had been promised—and more.

But while his public life prospered, his private life disintegrated. He was overcome by guilt. One can only guess at the reasons. Guessing was what he wanted us to do; he only flirted at telling. He confessed frequently, variously, and inconsistently. In this he was much like a ballerina widely known in New York City during the 1940s, who required the services of a particular psychiatrist because he was the best, but dared not tell him about herself because he was a notorious gossip. Her solution was to tell the doctor invented stories of what she had done: things that, to her way of thinking, were exactly as sick or as bad as what she had actually done, so that the doctor's analysis of her fictional behavior would apply equally well to her real behavior. That is more or less what Lawrence did, providing enough employment to psychohistorians to last well beyond the turn of the next century.

Whatever the reason, Lawrence discovered a need to be physically beaten. His descent into the sexual underworld of sado-masochism was

dizzyingly dangerous. While still very much in the public eye as a Middle East peacemaker, he took to attending flagellation parties in Chelsea organized by a German panderer who went by the name of Bluebeard. Soon Bluebeard was offering his confessions for publication, and Lawrence was driven to use government connections to stop him.

Seemingly driven by inner forces, T. E. made a sudden turn in life. He had been a romantic, writing of the peoples of the Middle East as though he were an artist and they, his work; seeking to make them in some sense an extension of his personality. But in 1922–23, he turned his back on such nineteenth-century aspirations, in favor of yearnings more appropriate to the eleventh or twelfth centuries. His aim—or at least so he wished his public to believe—was to annihilate his individuality: to merge his personality, as medieval man had done, in collective efforts. In that quest, under assumed names to achieve anonymity, he cloistered himself as a simple trooper in the Tank Corps, and later, in the airforce. But whereas monks of the church had been capable of mortifying the flesh without assistance, Lawrence brought along with him a hired hand whose duties were to beat him—in accordance with letters from a fictitious relative, produced by Lawrence, detailing his latest sins and prescribing punishments for them.

The public knew nothing of this. What the public knew was that he was pursuing a life inspired by some vague and undenominational spiritualism—the sort of thing the twentieth century finds immensely appealing. Moreover his attempts to avoid publicity, journalists, and photographers—like the similar efforts in later years of Greta Garbo and Jacqueline Kennedy Onassis—kept him constantly in the news.

Though he wrote a distinctive novel, *The Mint*, and an ever-popular prose translation of the *Odyssey*, the work in which Lawrence made his bid for immortality was one in which he told of his wartime adventures: *Seven Pillars of Wisdom*. He wrote it—confusingly, since it dealt with real events—as a novel, intending it (he told Edward Garnett) "to make an English fourth" to an exclusive bookshelf that contained only *The Brothers Karamazov*, *Thus Spoke Zarathustra*, and *Moby-Dick*. In writing to E. M. Forster, he lengthened his bookshelf, omitting *Zarathustra*, but adding *War and Peace*, *Leaves of Grass*, *Don Quixote*, and Rabelais.

It has been greatly praised. "It ranks with the greatest books ever written in the English language," said Winston Churchill, who was not alone in that view. But if it ranks so high, it can only be because it was written in a century in which its flaws increasingly are regarded as virtues.

It is the work of an author unwilling to tell which of his statements are fact and which fiction, and unable to decide what story, whether fact or fiction, he wants to tell. So he outlines several stories, but they contradict one another.

The title is from a quotation that Lawrence loved and long had wanted to use as a title for something. But it did not suit this book. "Seven Pillars of Wisdom" refers to the achievement of wisdom: wisdom made complete and perfect. But the book of which it is the title tells no such tale. So the title suggests one story, the text, another.

Lawrence prefaces the book with a poem that Robert Graves helped him write and that tells a story of its own. In the poem, the hero strives to win a victory for the sake of someone or something he loves, does in fact win, but finds the victory hollow because the someone or something for whom it was won has died. An afternote repeats this account.

But that story, too, is inconsistent with those told in the text. In the original first chapter of the text, deleted at the suggestion of Bernard Shaw, but subsequently published, Lawrence told two more stories, which were mutually inconsistent. In one of them, the Arabs had been used as pawns by the British during the war, and he was guilty of acting for his government in this, and of making promises to the Arabs that he knew his government had no intention of keeping. In the second story, he was not guilty; his government had duped him as well as the Arabs. The idealistic young men of whom he was one, he wrote, had won a bright triumph, but then "the old men came out again and took our victory."

In a later chapter he amplified this second story. The Arabs, he wrote, "had begun to dream of liberty," and a small group of Englishmen ("We were not many; and nearly all of us rallied around Clayton . . .") had determined to help them achieve it. In addition to Gilbert Clayton, he listed Aubrey Herbert, Sir Mark Sykes, David Hogarth, and several others associated with the Arab Bureau in Cairo—"all of the creed," he wrote. He claimed that "we meant to break into the accepted halls of English foreign policy, and build a new people in the East."

That was factually false; that was not their creed. Apart from Lawrence himself, none of them believed in an Arab nation or in Arab independence. Aubrey Herbert was pro-Ottoman Empire and happy with the notion of Arabs being ruled by Turks. Sir Mark Sykes was an author of the Sykes-Picot-Sazanov Agreement, the treaty that Lawrence regarded as a betrayal of the Arabs and the promises made to them. Hogarth and Clayton both believed that Arabs could not govern themselves and ought to be ruled by Europeans.

Lawrence was equally muddled about his own role. At different places in the book he makes three claims: that he secretly intended, when the moment came, to keep faith with the Arabs by defeating his own government's machinations; that, on the contrary, he had lost his soul in the greed for victory and did not intend to keep faith with the Arabs; and that, again on the contrary, betraying the Arabs was justified by the overriding need to win the war. In other words: he did not betray the Arabs,

and that was good; he did betray the Arabs, and that was bad; and he did betray the Arabs, and that was good.

In reality the issue was false. Hussein had never trusted Britain, and therefore had not been deceived; he never relied on the heavily qualified phrases in which British officials suggested they would do great things for the Arab peoples after the war. Feisal knew of the secret treaty in which Britain supposedly betrayed the Arabs to France; Lawrence had told him of it. Each on his own (for they betrayed one another, too), Hussein and Feisal had negotiated to betray the Allies and go back to the Ottoman side. T. E. told Liddell Hart that "Feisal was definitely 'selling' us"; so he knew his one-sided story of betrayal was fiction.

In any event, the story had become moot. Since the events recounted in *Seven Pillars*, Churchill, with Lawrence's help, had negotiated new arrangements for the Middle East that T. E. believed provided full justice for the Arab claims. So in the end there was no betrayal, and *Seven Pillars* —a cry of political guilt—was politically out of date long before it was published.

But as literature it broke new ground. In the *Ashenden* stories, Somerset Maugham took up Lawrence's theme that the role of an intelligence agent, even for our side, is morally tarnished. Others then took it up, too, in a line that leads to the novels of John Le Carré. Similarly Lawrence's story of officers in the field (such as himself) acting in good faith, but then discovering that their own political or military or intelligence leaders are at least as cynical and immoral as the enemy's, is one recounted time and again in American popular literature and films of the past few decades. The exploration of the moral ambiguity, or even moral guilt, of our own side, a province taken as his domain by Graham Greene, can be traced to *Seven Pillars*.

Lawrence's obsession with guilt as a personal theme runs parallel to the political one throughout *Seven Pillars*, which begins in a Nietzschean spirit with the author's observation that in the extreme circumstances of the desert war he and his companions were driven to actions that in normal circumstances would be immoral. Did their exceptional circumstances license them to transcend the moral code? The author—it is his essential weakness that he will never commit himself—gives no clear answer.

The emotional center of the book is a story that Lawrence began telling in 1919, giving several different accounts of it, that explained why he had whip marks on his body. Lawrence claimed that, unknown to others, he had been taken prisoner for a time on the night of November 21–22, 1917, in a place called Deraa, and was homosexually assaulted, bayoneted, and beaten by command of a sadistic Turkish commander. Lawrence told it in several versions, admitting that some of them were untrue; and there has always been a strong case that the whole tale was false. That case is

strengthened by the apparent discovery of documentary evidence detailed in the Lawrence James biography of Lawrence. It seems that the official War Diary kept by a British army unit shows that Lawrence and a fellow officer, Colonel Joyce, were in Aqaba, some four hundred miles away from Deraa, on November 21 and 22; and that the memory of a Lieutenant Samuel Brodie, who met Lawrence and Joyce in Aqaba then, confirms this.

Does it matter if the Deraa story is fantasy? or that Lawrence misrepresents the politics of his characters? or that the three reasons he gives to deny that the Anzacs liberated Damascus are—all of them—false as well as inconsistent?

If *Seven Pillars* is indeed a novel, it is disqualified from greatness because its author fails to pay the price of admission: he refuses to run the risk of saying who he is or what he believes or what story he is telling. As history, it lies and distorts; T. E. knew that, but somehow did not feel guilty—here, where he should have felt it—for giving his Arabs credit for what the Australian/New Zealand cavalry in fact had accomplished.

Nietzsche, an intellectual hero of Lawrence's who taught that history consists of myths rather than facts, provided a link with André Malraux, who placed Lawrence, the writer and thinker, beside the exemplary twentieth-century hero, the Arab nationalist, and the guerrilla strategist. Malraux, who seems to have known about Lawrence since 1920, modeled himself after Lawrence and wrote of himself as T. E.'s spiritual son.

Malraux became obsessed by Lawrence. The parallel ran closer than Malraux knew, for, believing Lawrence's lies, Malraux himself lied by claiming to have accomplished similar feats. Malraux falsely claimed to have been a leader of the Chinese revolution, in Canton in 1925 and in Shanghai in 1927, although (other than a trip to Hong Kong) he had never been in China at all. Just as Lawrence sat down to write a novel about his leadership of the illusory Arab revolt as a "fourth" to *Karamazov*, *Zarathustra*, and *Moby-Dick*, so Malraux sat down to write a masterpiece flowing from his claimed participation in the Chinese revolution, *Man's Fate*, as a "fifth gospel" to Lawrence and the other three. Like Lawrence, Malraux did perform acts of valor, but also claimed to have performed others that he had not.

Lawrence's boyhood dream—doing great things both "active and reflective," as he told Liddell Hart—became Malraux's adult creed of the intellectual committed to action, a creed that also informed the works of Ernest Hemingway (if in somewhat debased form), and of which Lawrence was at once the inspirer and the exemplar. Liddell Hart, while writing that "the perfect balance may be unattainable," claimed of T. E. that "no man has come so close to equal greatness in action and reflection." In the world of the 1920s and 1930s, as fascism, Nazism, and Com-

munism rose from the embers of a Europe ravaged by war, social strife, and depression, Malraux portrayed Lawrence as the last liberal hero of the West.

In the first chapter of a book he was writing about T. E.—a book, the existence of which has been doubted for years, but which is now scheduled for publication—Malraux quotes Lawrence as saying "somewhere there is an absolute, that's the only thing that counts; and I haven't succeeded in finding it. Hence this pointless existence." That is the great theme that Malraux wanted to explore: Lawrence's quest for meaning in a universe in which, as Nietzsche's Zarathustra proclaimed, *"God is dead!"* In this conception, Lawrence became an existentialist hero; and both Jean-Paul Sartre and Simone de Beauvoir are said to have been fascinated by him.

T. E. died, like Albert Camus, to whom he bore resemblances, in a traffic accident. Speeding as usual, he veered on his motorbike to avoid hitting two children, and was thrown over the handlebars to his death. It was 1935; parliamentary regimes all over Europe were falling to men on horseback whose military dictatorships promised national greatness; and there were forces interested in using T. E. as their figurehead in coming to power. So there were rumors that he had been murdered, and others that —tempted by the immortality that fame as a dictator would bring, but unwilling to compromise his democratic ideals—Lawrence had crashed deliberately, committing suicide.

A few years later, Liddell Hart wrote of Lawrence: "Not long ago the young men were talking, the young poets writing, of him in a Messianic strain—as the man who could, if he would, be a light to lead stumbling humanity out of its troubles. . . . [I]t is difficult to see any way, compatible with his philosophy, in which he could have played such a role. . . . But at least I can say that, so far as I knew him, he seemed to come nearer than any man to fitness for such power—in a state that I would care to live in."

In the one meeting he claimed to have had with T. E.—but which it now seems Malraux invented—Malraux provides a clue as to Lawrence's enduring interest and appeal. "He was extraordinarily elegant. With an elegance of today, not of his own time. A roll-neck sweater, for example, a kind of nonchalance and distance."

It was his special quality: he does not age or date. He belongs to today. Even his theory of strategy is as current as this morning's headlines. He had a genius for taking the road we would want to follow. His attitudes and interests anticipated those of the 1960s, the 1970s, the 1980s, the 1990s; and so did his style. He was casual. He was cool. He never stopped being young. He shared the modern crazes: motorbikes; speed; celebrity.

Like public figures of today, he was launched by the news media and the entertainment industry, now so intertwined and pervasive. In writing fiction in which real characters make an appearance, he looked ahead to

the popularity in our time of novels, television series, and films that are situated on the frontier between fact and fiction; in some ways *Seven Pillars* is like a Costa-Gavras movie—a setting of apparent historical truth into which untruths are inserted without being labeled as such.

As a citizen of the twentieth century, Lawrence valued history little and entertainment a great deal. Fiction is stranger than truth, and T. E. found it more fun: due to him, there are those who believe that Damascus was liberated in 1918 by a band of Arabs led by someone who looked like Peter O'Toole.

Though he wrote and read a great deal, his imagination was more graphic than literary, more concerned with images than with words: that too is a hallmark of this part of the twentieth century. He was at least as much concerned about the design of a book as about its contents, and as a young man planned to found a private press. A sometime vegetarian; self-exiled, and engaged in a vaguely spiritual quest; like the generations beginning with 1960, he wanted to rediscover artisanry, craftsmanship, handmade work.

His themes were those popular with today's readers: confusion of sexual orientation; illicit sex practices; and identity crisis. He was an intelligence agent—and we adore spy stories. When he sped to his death, he left behind the sort of ending that most intrigues the twentieth century—the officially denied conspiracy—and, as with President Kennedy's assassination, there were troubling details that did not fit with the official account.

Bernard Shaw wrote that "through an accident in his teens Lawrence never grew up. He looked like a boy. His great abilities and interests were those of a highly gifted boy. He died, not as a great thinker, but as a boy tearing along on a motorcycle at 80 miles an hour." Only a fine line separates an existentialist hero from what the London press has taken to calling "a crazy, mixed-up kid"; and T. E. was so much of his century that he could be said to be on either side of the line.

Lawrence could not have been further from the towering figures of his time. The great men of the century—Winston Churchill, Charles de Gaulle—were creatures of another age, born out of time. The awe they inspired, and their ability to impose themselves, derived in large part from qualities and resources they brought with them from the past.

T. E., in contrast, was of his time and ours. Of all the public figures of the twentieth century, across a wide range of interests, issues, and attitudes, he best expresses the century, and it is best studied through him. He is a prism through which the spectrum of twentieth-century tastes, fads, foibles, insights, and outlooks can be sorted out. If his life were a work of art, some collector a thousand years hence might take it down from its shelf, saying: "Now here is a pure example of twentieth century—

a perfect specimen!" For that, if for nothing else, T. E. Lawrence is, and will remain, important.

It is the answer to his prayer. Lawrence was haunted by the knowledge that life is ephemeral. Insofar as anything endures, he believed, it is the art of a Dostoevsky or the fame of an Alexander, and he aspired to both; indeed he wanted them so much that he cheated to get them. *Seven Pillars* is a cheat either as a novel—for a novelist's job is to decide what he wants to say, but T. E. would not run the risk of doing that—or as history, for it does not tell the truth; and the campaigns of Lawrence of Arabia were a cheat because T. E. fabricated them. So it may not be for his works or deeds, considerable though their influence has been, that he will be known in distant ages.

It is as a voice of our time that he is certain to be heard. As other men lust for power or wealth or women, he craved to be noticed and to be remembered—and he was and he is, and he will be.

September 1991

Max Beerbohm: A Prodigy of Parody

John Gross

Parody is a delicate art, but it has a way of falling into the hands of coarse practitioners. Think, for example, of the ghastly burlesque of *The Waste Land* perpetrated in the 1950s by the Cambridge don who wrote under the pen-name of "Myra Buttle." How can anyone have taken pleasure in such stuff (except on the principle that any stick to beat the dog would do)? It is enough to make you despair of the genre as a whole. But then think instead of Henry Reed's brilliant parody of *Four Quartets*, *Chard Whitlow* (much admired by Eliot himself, incidentally), and a sense of balance is restored. There are happy exceptions—parodies that are worthy of their subjects, that yield as much or more on a third or fourth reading as they do on a first; and the happiest of all are the seventeen sketches that make up *A Christmas Garland*.[1]

Beerbohm's book had its origins in 1896, when he was twenty-four. (An unusually mature twenty-four, needless to say: he was even younger when Wilde observed that the gods had bestowed on him the gift of perpetual old age.) In the Christmas supplement of the *Saturday Review* for that year, he published five parodies of contemporary authors, ranging from Ouida to himself, all on a Christmassy theme. Ten years later he brought out a similar but generally superior batch in the same magazine. Finally, in 1912, came *A Christmas Garland* itself: seven parodies from the 1906 group, nine new ones, and an improved version of his parody of George Meredith—the lone survivor from the 1896 contingent.

In spite of the praise it regularly receives, the book has been out of print for a long time, and Yale has performed a noble deed in bringing out a new edition. It is a handsome piece of work, too, with the same typeface as the original, the same lavish margins, the same chunky format, even the same gilt-embossed binding. In addition, by way of a bonus, there are a sheaf of related caricatures—some of them a bit muddy (as is often the way with Beerbohm reproductions) but most of them delicious, and all of

1 *A Christmas Garland*, by Max Beerbohm, with illustrations by the author and an introduction by N. John Hall (Yale University Press, 1993).

them worth having. Above all, there is a lengthy essay by the editor, N. John Hall, in which he considers the parodies one by one and supplies a good deal of background information. This is particularly useful in the case of the forgotten men in the collection—the novelist Maurice Hewlett, the essayists A. C. Benson and G. S. Street: you may feel you already know them simply on the basis of Beerbohm's skits, but it doesn't hurt to be possessed of a few of the actual facts as well. And while Beerbohm usually set out to parody the distilled essence of his subjects, rather than specific works, he did sometimes have such works in mind, and it helps to know which. Only a specialist, for instance, would be likely to recognize that "The Feast," the story by "J*s*ph C*nr*d" in *A Christmas Garland*, is partly modeled on Conrad's early tale "The Lagoon."

Given the general excellence of the edition, the one undoubted gap is hard to account for. Nowhere is there any indication, not even in the four-page bibliography, that in his old age (his real, non-perpetual old age) Beerbohm brought out a second edition of *A Christmas Garland*, containing an additional parody—only one, but one of his best, a chapter from an imaginary novel by Maurice Baring entitled *All Roads*—. Even if the decision to reproduce the 1912 edition in facsimile means that it wasn't possible to include this piece in the main text, one might reasonably have hoped that it would be printed as an appendix.

There was a case, too, though a more debatable one, for devoting another appendix to "The Guerdon," the parody of Henry James which Beerbohm wrote in 1916, on the occasion of James being awarded the Order of Merit. It is as dazzling a performance as the James parody in *A Christmas Garland*, "The Mote in the Middle Distance"; the two belong naturally together. And it would have been nice, if only for the sake of completeness, to have found space for the uncollected 1896 parodies, or at least for some representative extracts.

Still, these are relatively minor grumbles. The important thing is that the collection is now available again, and that its virtues still shine as brightly as ever.

It would be as foolish to attempt to draw up rules about what constitutes a good parody as it would be to attempt to draw up rules about what constitutes a good joke. Beerbohm owes much of his superiority to other parodists to qualities which resist analysis—to greater precision, finer inspiration, keener wit. But his work also exemplifies two sound general principles. First, true parody, at any but the most rudimentary level, mimics substance no less than style; if it fastens on mannerisms, it also embraces choice of subject matter and habits of mind. Second, a successful parody must be interesting or satisfying on its own account. If it is a story, we want to know what happens next; if it is an essay, we must be caught up in its argument. Either way, we must feel that the imagined

author—G. K. Ch*st*rt*n or Arn*ld B*nn*tt or G**rge B*rn*rd Sh*w —has taken as much (or as little) trouble to shape his material as the real Chesterton or Bennett or Shaw would have done.

Style is what hits you first, even so. Before you have worked out exactly what Beerbohm's victims are saying, you are likely to find yourself engrossed by the way they are saying it, by their verbal tics and tricks. Belloc: "The man, as men will, went in." Shaw: "This—I say it with no deference at all—is bosh." George Moore, explaining how Dickens "disengages the erotic motive" in *The Pickwick Papers*. H. G. Wells, in pamphleteering mode: "The joyous hum and clang of labour will never cease in the municipal workshop . . ." Each and every one of them, perfect. Yet even at this micro-level, Beerbohm goes beyond outward impersonation. He enters deep into the spirit of his authors; he seems to be not so much parodying them as pushing them in the direction of self-parody. The scrap of verse from *Police Station Ditties* which R*dy*rd K*pl*ng uses as the epigraph for his short story, for instance—"Then it's collar 'im tight,/ In the name o' the Lawd!/. . ./ An' it's trunch, trunch, truncheon does the trick!" You feel it is the kind of thing that might actually have floated into Kipling's mind—only he would have suppressed it. Or take M*r*d*th's elaborate circumlocution for farmland—"leagues of Hodge-trod arable or pastoral." It's a succulent phrase: you can see what's absurd about it, but you are also enabled to understand the pleasure which the real Meredith took in rolling such phrases round his tongue.

The organizing principle of *A Christmas Garland* is of course Christmas itself (an almost wholly secular Christmas, one might add). In a sense, the book is a set of exercises, seventeen styles applied to the same theme. The device has often been used, mostly mechanically, though from time to time with genuine inspiration—by Chesterton in his variations on "Old King Cole," for example. For Beerbohm, it serves principally as a means of demonstrating that whatever the subject, ruling passions and individual temperaments are bound to reassert themselves. Before you know where you are, Conrad is peeling away layer after layer of illusion, Galsworthy is agonizing (in gentlemanly fashion) over the dilemmas of a well-heeled humanitarian, James is preparing his characters for *il gran rifiuto*—in this case (they are children) for magnificently renouncing the opportunity to take a peek at their Christmas stockings. George Moore launches into a reverie about Balzac and Tintoretto (who always makes him think of Turgenev) and Renoir and Palestrina and narrow flanks and sloping thighs. Frank Harris, taking it for granted that the Man Shakespeare had an unutterable loathing for Christmas, proves to his own satisfaction that it must have been because Christmas Day was Anne Hathaway's birthday.

And the pieces mysteriously "work," as something other than burlesques—as not-quite burlesques, at any rate. The Meredithean heroine

Euphemia Clashthought ("pagan young womanhood, six foot of it") plies her fiancé with port in order to avoid going to church, and the effect is not so much that of a satire on Meredith as that of a slightly different kind of comic novel. The characters in the Galsworthy skit go through absurd moral hoops, yet the scene rises before you as clearly and solidly as anything in Galsworthy himself. When you come to the end of Maurice Baring's Chapter V, you feel a pang of disappointment at the realization that there isn't going to be a Chapter VI. You even allow yourself to be carried along, once you are absolved from having to take them seriously, by the gentle flow of A. C. Benson's platitudes. (Did Beerbohm know, or guess, that Benson was desperately depressive and that from his own point of view his writing was literally anodyne—a much-needed sedative?)

The most purely amusing piece in the book is the fictitious memoir by Edmund Gosse, "A Recollection." (Beerbohm said that it was the only thing apart from "'Savonarola' Brown" that he ever wrote "with joy— easily," and one can well believe it.) The young Gosse, taking "a brief and undeserved vacation" in Venice, calls on one of his idols, Robert Browning, who is installed in a handsome palazzo. Later that day he encounters another of his idols, Ibsen, in the Piazza San Marco. Browning, though he has never heard of "this brother poet and dramatist," insists that Gosse bring him round for Christmas lunch, and the stage is set for an exquisite little comic drama. A three-sided drama: on the one hand the hearty optimist and poet of married love, on the other hand the glowering pessimist and playwright of marital disaster, and hovering in between Gosse the literary man, professionally committed to appreciating them both.

The comedy in the Arnold Bennett parody, "Scruts," is even more preposterous. "Scruts" are bits of defective pottery; folk in Bennett's Five Towns have a custom—a custom invented by Max Beerbohm—of putting them into Christmas puddings, and if you were to paraphrase what happens to them in the course of the story it would sound like something out of Monty Python. But Beerbohm's purpose goes beyond farce. As N. John Hall says, he also manages to capture Bennett's feeling for strong-minded, stoical women, and the characteristic flavor of his best work—"pessimistic, but with a kind of resignation not altogether sad." The urge to poke fun is tempered by a certain amount of sympathy and respect.

Only two of the parodies could in fact be considered wholly hostile, the Kipling and the Shaw. In the case of Kipling, Beerbohm concentrates almost exclusively on the brutality: a policeman catches Santa Claus climbing out of a chimney and frog-marches him to the station, egged on by the gleeful Kiplingesque narrator. As criticism, this is hardly the whole story—Kipling had access to areas of feeling that Beerbohm didn't begin to touch; but it is true as far as it goes, and it provides the basis for a splendid self-contained lampoon, one of the best pieces in the book. The Shaw skit, a preface to "Snt George: A Christmas Play," is much weaker.

Beerbohm has no trouble reproducing Shaw's knockdown manner and his athletic turns of phrase, but he is so intent on pillorying his vanity, pseudo-modesty, and mock-ironic boastfulness that he has almost no time for anything else.

There will always be readers for whom the whole business of parody, wherever the parodist's sympathy lie, is negative and parasitic. I think that they are wrong; but after rereading *A Christmas Garland* at one go—which N. John Hall says you shouldn't—I must admit to feeling a certain unease. Beerbohm did after all have a streak of unyielding philistinism, and high among his talents was a talent to belittle. The mood soon passes; but there are times, reading him, when you find yourself craving a good cold draught of seriousness.

On settled reflection, only two of the parodies strike me as troublesome, the Hardy and the Conrad. The Hardy is a sequel to *The Dynasts*—the cosmic Spirits revisit the earth; the Conrad is a macabre jungle yarn. Both are extremely skillful, as you would expect; both focus on a narrow set of idiosyncrasies—and their narrowness seems to me more objectionable than that of the Kipling sketch, where the aggression is out in the open. It's not that you are left feeling that Hardy and Conrad are poor writers; you just aren't given any real indication that they might be great ones.

The other parodies still stand, however: miniature works of art in their own right, most of them flawless. And in the case of Hardy, at least, Beerbohm made amends, in a later and much better parody, "A Luncheon." It was inspired by an account of the Prince of Wales—the future Edward VIII and eventual Duke of Windsor—being entertained by Hardy during a visit to Dorchester in 1923, and it is perhaps unfamiliar enough to be worth quoting:

> Lift latch, step in, be welcome, Sir,
> Albeit to see you I'm unglad
> And your face is fraught with a deathly shyness
> Bleaching what pink it may have had.
> Come in, come in, Your Royal Highness.
>
> Beautiful weather?—Sir, that's true,
> Though the farmers are casting rueful looks
> At tilth's and pasture's dearth of spryness—
> Yes, Sir, I've written several books—
> A little more chicken, Your Royal Highness?

Lift latch, step out, your car is there,
To bear you far from this antient vale.
We are both of us aged by our strange brief nighness
But each of us lives to tell the tale.
Farewell, farewell, Your Royal Highness.

January 1994

Walter Gieseking Plays Ravel and Debussy

Samuel Lipman

The recent release, on the invaluable Pearl label, of a CD containing many of the pianist Walter Gieseking's magnificent pre–World War II recordings of Debussy and Ravel[1] once again brings home to us the fact that, on rare occasions, performance can rise to a level of art indistinguishable from that of the composition itself. All music—even the most abstruse, such as Bach's *Art of Fugue*—is written to be performed. Nonetheless, music, and especially great music, is always more than its performance. Music exists as notation, and its notation becomes a palpable object; this object does not replace performance, but provides a guarantee of eternality, in contrast to the transience of the performance which seems to be uniquely responsible for giving the music life. And so the small number of Bachs, Mozarts, and Beethovens, and all the rest of the masters, are greater than all the myriad of those who have labored, often with great success, to perform their masterworks.

But to every rule there is an exception. Sometimes, and that sometimes is very rare indeed, a performer brings so much genius to a composer, not just in technical skill but also in elective affinity, that for a blinding instant performer and composer seem inseparable, a single art created by a single artist. For more than two hundred years now, music lovers have spoken with awe of such triumphs of performance; since the coming of the phonograph as a musical phenomenon at the turn of the century, it has been possible to document this miraculous interpenetration of the disparate realms of creation and re-creation.

Of course, despite the innumerable recordings that have been made and preserved, the instances of this miracle remain rare. But rare as these instances are, one thinks immediately of a list including the tenor John McCormack singing Mozart and Hugo Wolf, the soprano Kirsten Flagstad and the baritone Friedrich Schorr singing Wagner, the violinist Fritz Kreisler playing Mendelssohn, the teenage violinist Yehudi Menuhin playing Bruch, the scarcely older violinist Josef Hassid playing numerous

1 Pearl GEMM CD 9449.

encore pieces, the violinist Adolf Busch conducting Bach, the pianist Arthur Rubinstein playing Chopin, the pianist Vladimir Horowitz playing Rachmaninoff, the pianist Alfred Cortot playing Liszt, the conductor Arturo Toscanini performing Beethoven, the conductor Pierre Monteux performing all manner of French and Russian music.

It has long been suspected that Gieseking's playing of Debussy and Ravel belongs on this illustrious list. Born in 1895 to German parents living in France, Gieseking was educated in Hanover, and first began to make his international career in the 1920s. His repertory was wide, ranging from Bach through Mozart, Beethoven, Brahms, Schumann, and Grieg to Rachmaninoff; from at least the 1930s his particular specialty was what is called, perhaps imprecisely, the French impressionist music of Debussy and Ravel.[2]

Gieseking's playing of this music was quickly recognized by the public and his fellow musicians. By the beginning of World War II, he had recorded—in addition to such standard works as the Liszt E-flat Concerto and the Franck *Symphonic Variations*—a great deal of Debussy, including both books of the Preludes, the *Children's Corner Suite*, the *Suite bergamasque*, several pieces from both sets of *Images*, *Estampes*, and the titanic tone-poem, albeit in miniature, *L'Isle joyeuse*. Gieseking's Ravel recordings, though few, included the monumental suite *Gaspard de la nuit* and two parts of the suite *Miroirs*, including the famous *Alborada del gracioso*.

Gieseking spent World War II in Germany and continued his concert activities both there and in the rest of Europe. Several live-performance recordings from this period have survived, including not very idiomatic 1940 performances of the Rachmaninoff Second and Third Concertos with Willem Mengelberg and the Amsterdam Concertgebouw Orchestra.[3] There can be no doubt that Gieseking was loyal to the Nazi regime; for example, it appears—and I quote here from the notes to the CD release of the Rachmaninoff concertos—that Gieseking "dismiss[ed] Nazi atrocities

2 A digression is in order here to explain that impressionism, for all its reasonably precise application in painting, has always been a vexing term in music. By it is always meant Debussy and Ravel, two composers whose lives overlapped and whose compositions are widely thought to resemble each other in their cascades of seemingly improvised notes, blurred harmonies, subtle and shifting tone colors, and lack of obvious formal organization. But so far from being impressionist peas in a pod, Debussy and Ravel, for all their employment of the common harmonic language of early-twentieth-century post-romanticism and pre-modernism, were vastly different in their attitude toward musical structure and musical expression. If anything, it was Debussy who was the true impressionist, rebelling against the demands of traditional musical forms, and Ravel was a classicist, concerned with precise formal structure and expression.

3 Music and Arts CD-250.

as incredible inventions of Jewish hysteria." After the war, according to *The New Grove Dictionary of Music and Musicians*, "he was accused (but eventually cleared) of cultural collaboration with the Nazi regime." His first postwar appearances in the United States were delayed by a massive campaign assisted by the newspaper columnist and radio commentator Walter Winchell, but by the early 1950s, he was playing widely in this country, and was once again fully accepted as one of the master pianists of the age. He died suddenly in 1956 during a recording session in London.

It was fitting that his death occurred while he was making records. For beginning about 1950, Gieseking embarked on a series of recordings that by his death a very few years later were to include the complete keyboard music of Mozart, the solo music of Debussy and Ravel, assorted solo works of Bach, Schubert, Brahms, Schumann, and Grieg, three Beethoven concertos, four Mozart concertos, the Grieg and Schumann concertos, a remake of the Franck *Symphonic Variations*, a disc of Mozart songs with Elisabeth Schwarzkopf, and some Mozart chamber music. Furthermore, at his death, Gieseking was engaged on a recording of all the thirty-two Beethoven sonatas; by the end, he was only able to complete the recording of twenty-three.

But despite this huge volume of activity, it cannot be said that any of Gieseking's postwar recordings—save those of Debussy and Ravel—were accepted as undisputed masterpieces. His pianistic abilities were hardly in question; his absolute control of tone and articulation, of dynamic contrast and subtle but sharp rhythm, were never in doubt. Nevertheless, critical and professional admiration were one thing, and love was another. Gieseking's Mozart was widely perceived as small-scale and dry; in other repertory, as the late pianist and critic Abram Chasins commented in his authoritative 1957 *Speaking of Pianists*: "Beethoven, Brahms, and Schumann emerged closer to the summit of Gieseking's interpretative realizations, but they too were not wholly his composers. He was not so comfortable, not so convincing or enlightening in this repertoire." All in all, there can be no doubt that in life as in death, it was Gieseking's playing of French music that has accounted for the perception of his greatness. The postwar Debussy and Ravel recordings at the time of their appearance were indeed the best available; only the French pianist Robert Casadesus (1899–1972) seemed to approach the level of Gieseking, but in contrast to Gieseking's effortless but always lucid blending of sounds and moods, Casadesus's playing sounded just a bit disjunct and effortful.

For forty years now, Gieseking's triumphs in the music of Debussy and Ravel have been known through his postwar recordings. The Debussy Preludes, made in 1953 and 1954, are standard, and they have now been released on CD;[4] his traversal of the complete solo music of Ravel, made at

4 Angel CDH 7610042.

about the same time, was widely available some years ago on LP,[5] and will doubtless soon appear on CD, as will the remainder of his later Debussy recordings. In their ease, their seductive rhythmic flexibility, their gorgeous splashes of color, all these recordings form one of the landmarks of recorded pianism, and as such will doubtless last as long as this great music can find a public.

Now, however, our assessment of the Gieseking Debussy and Ravel recordings I have just been discussing has been changed by the Pearl reissue of his prewar recordings of some, though sadly not all, of this music. So transcendent is Gieseking's playing on this Pearl disc that it comes to us as a shock, not a shock of surprise or of pain but what Edmund Wilson, quoting Herman Melville, called a "shock of recognition." Our recognition-through-shock is at once of the possibilities of the piano as an instrument, of the possibilities of music in general and of piano music in particular as forming complete emotions, and of our own abilities to go beyond the perception of the beautiful to the perception of the perfect.

I apologize for the perfervid rhetoric. Yet nothing less seems appropriate to describe my own reaction to the Ravel *Gaspard de la nuit* which opens the Gieseking Pearl disc. *Gaspard* is a suite of three pieces, written by Ravel under the inspiration of a set of three prose poems (of the same title) by the minor French writer Aloysius Bertrand (1807–1841). Bertrand's extravagant, sometimes macabre, hyper-romantic writing was recognized by Baudelaire as a precursor of Symbolism. The three works that Ravel chose, "Ondine," "Le Gibet," and "Scarbo," deal respectively with a water-sprite who attempts to seduce a man away from the love of a mortal woman, a corpse dangling from a creaking gibbet, and a dwarf-goblin whose "body would turn blue, and translucent like the wax in a candle, and his face grow pale—then suddenly he would vanish." To describe these apparitions and horrors, Ravel employed the full panoply of post-Liszt pianistic virtuosity, in particular multinote chords, double notes, and huge, whooshing, glissando-like scales, all encased in the most lush but always consonant chromaticism. Ravel's goal was to write a work for the piano that outdid in difficulty for the performer the nineteenth-century Russian composer Mily Balakirev's *Islamey* (first version 1869, second version 1902); it must be said too that behind *Islamey* must have lain Balakirev's desire to write a work more difficult than the Liszt B-flat major Transcendental Etude *Feux follets*, to this day the summit of unwieldy and complicated pianistic double-note technique. The first notes of "Ondine," for the right hand alone, are a tremolo, opposing a C-sharp major triad with a single A natural immediately above the triad. But the tremolo is not a simple alternation of triad and single note; sometimes the

5 Angel LP 5S-3541.

triad is repeated before the single note is struck. The effect of this complexity, which sets the tone for all of "Ondine," is neither one of regularity or irregularity, but rather of a seamless wash of sound, sometimes sufficient in itself, and sometimes as an accompaniment for a ravishing melody, ultimately without any satisfying conclusion. In "Le Gibet," the sound of the bell tolling for the dead, and the noise of the gallows in the wind, make up a devilish funeral procession. And in "Scarbo," the flash of the evil spirit as he first appears and then disappears becomes through the virtuosity of the player a manifestation of the spectral and the unnatural.

It was Ravel's genius to express, through the most careful and accurate musical thought and notation, what has been called the *Esprit décadent*, the languor, the seeking after sensation, the pursuit of sensuality, so characteristic of the high culture of the end of the nineteenth century. It was Gieseking's genius in this 1939 recording, through the magic of his use of the left and right pedals of the piano, the plasticity of his hands and his mind, to merge his spirit with Ravel's, and express the composer's mood of world-weariness through the eighty-eight keys of the piano. By comparison with this prewar recording of *Gaspard*, his postwar recording is careful, limited in range, and stiff; what had once seemed wonderful in the postwar recording now seems merely excellent, and in art mere excellence always takes second place to revelation.

As with the *Gaspard* on this Pearl CD, so with the rest of the Ravel, and the Debussy as well. The two short Ravel pieces, the first book of the remarkably evocative Debussy Preludes, and the two excerpts from the Debussy *Estampes* seem nothing short of perfection; even the once-hackneyed Debussy prelude "The Girl with the Flaxen Hair" becomes at Gieseking's hands an enchanted visit to the French folk-song of earlier ages. And *L'Isle joyeuse*, an evocation of Watteau's painting *L'Embarquement pour Cythère*, seems without any mechanical restraint at all, and subject only to the unbounded craving for ecstasy typical of the *fin de siècle*. And so close comparison between the prewar recordings and the postwar remakes shows the younger Gieseking to have been an incomparably greater pianist, not because when he was older he was anything but a great interpreter of this wonderful music, but because in the 1930s he managed to become so much more than a pianist, and to become, in a manner of speaking, the composer of the music he was playing.

Pearl, I believe, has now reissued all of Gieseking's prewar Ravel. But there is a great deal of his prewar Debussy recordings awaiting reissue; these recordings include, as I mentioned earlier, the second book of the Preludes, excerpts from the *Images*, the remaining part of *Estampes*, the *Children's Corner Suite*, and the *Suite bergamasque*; there are, in addition, early Gieseking recordings of the two *Arabesques* and the *Rêverie*. One can only look forward to these reissues with the keenest anticipation.

October 1991

Mary McCarthy and Company

Hilton Kramer

What is missing is a certain largeness of mind, an amplitude of style, the mantle of a calling, a sense of historical dignity.
— Mary McCarthy, in "The Vassar Girl," 1951

When a writer with a large reputation and a strong public personality quits the scene after many years in the limelight, there inevitably follows a period of uncertainty in which posterity—the cruellest of all critics—has not yet determined its verdict, and briefs for the defense are given every opportunity to dominate the discussion. The eulogies sound the appropriate note of piety and praise; the remaining manuscripts, ceremoniously augmented by glowing testimonials, are rushed into print; the favor of a friendly assessment is more or less assured; and the author's name is everywhere draped in respectful mourning. The literary world makes its obeisances to one of its own, and even the writer's enemies refrain from casting doubt upon the manufacture of encomia.

Nowadays, moreover, there is likely to be added to this chorus of acclaim a promptly produced biography of the subject as well, for today's biographers gather their materials long before the body is buried and are no longer deterred by a sense of delicacy about the feelings of the immediate survivors. It might even be said that the timely publication of such a biography, precisely because it is certain to raise even more questions than it answers, is likely to bring this period of respectful mourning to a close. For biography, especially as it is practiced today, is a genre that specializes in laying bare its subject's imperfections and delinquencies, and it is these, rather than the tale of achievement that is the ostensible *raison d'être* of such books, that commands attention. Biography of this kind, no matter how respectful its intention, is therefore bound to clear the air of incense and restore its subject to the realm of reasonable debate.

In the case of Mary McCarthy, who died in 1989 at the age of seventy-seven, the customary rituals have all been lavishly observed. Even before her death, she had been hailed as America's "First Lady of Letters," quite

as if this were an official position in our national cultural life that had been owed to her. It hardly mattered that McCarthy had spent a lifetime ridiculing such honors, or that the national cultural life of which she was now to be thought an ornament was something she held in very low esteem. She embraced her elevation with an evident sense of vindication—the bad girl of American letters, who had always been forgiven her misdeeds, had again gotten away with it this one last time—and this feeling of vindication, which had an important political dimension to it, was clearly shared by her many admirers. So it came as no surprise that McCarthy's passing would bring an amplification of a sentiment so patently at odds with the character of her writing and the spirit of her temperament, and she would be presented to us in retrospect as a paragon of literary probity, intellectual independence, and political sagacity.

Now the expected biography has appeared with a promptitude that is all the more remarkable because of its exorbitant length.[1] Carol Brightman's *Writing Dangerously: Mary McCarthy and Her World* is by no means the longest book of its kind to come off the press in recent years, but it does run to some seven hundred pages, which is rather a lot about a writer who never produced a single major work. For Ms. Brightman, however, McCarthy is clearly more interesting as a figure of history than as a writer per se. This no doubt has a good deal to do with the specific historical circumstances under which the biographer first met her subject. It was during the Vietnam War, and Ms. Brightman, as she says, "had become a foot soldier in the revolution"—that is, a writer-activist in the antiwar movement. "I had left a fledgling career as a film and book reviewer to start an antiwar magazine, *Viet-Report*," she writes, and it was in this capacity that she was introduced to McCarthy in 1967 by Robert Silvers, the editor of *The New York Review of Books*. McCarthy was about to leave for Hanoi on a political reporting assignment for the *Review*, and Ms. Brightman, who had just returned from Hanoi, was brought in to advise "the famous author of *The Group*" on what she would find there. *Hanoi*, the book that resulted from that political pilgrimage, idealized the Vietnamese Communists in the most sentimental fellow-traveling fashion, characterizing their regime as a "virtuous tyranny" to be admired, and castigated both the American prisoners-of-war and America itself with that mixture of snobbery, condescension, and self-aggrandizement McCarthy had perfected thirty years earlier in her caustic reviews of lousy Broadway plays. It was the most shameful of all her books, and proved to be distasteful even to her buddies on the Left—even, alas, to Dwight Macdonald, who had a strong stomach for such political nonsense.

1 *Writing Dangerously: Mary McCarthy and Her World*, by Carol Brightman (Clarkson Potter, 1992).

It should be understood, then, that it is the bond once established be-
tween Ms. Brightman and her subject in that halcyon moment of radical
solidarity that provides the basic historical *donnée* from which *Writing
Dangerously* is written. Which is to say, it is a book about an earlier gen-
eration (what Ms. Brightman calls "the granddaddy generation") of the
American intellectual Left written by a member of the Sixties radical Left
who, though still loyal to the ethos of the Left, is now trying to make
sense of the debacle that has overtaken its most cherished articles of belief
and left its sacred ideology in ruins. In this respect, the book that *Writing
Dangerously* most closely resembles is Elinor Langer's *Josephine Herbst*
(1984), an earlier attempt on the part of a disaffected Sixties radical to look
for answers as well as absolution in the failures of her predecessors.[2]

There are great differences, of course, between the two books and the
two subjects. Josie Herbst was a Stalinist, and McCarthy was not (though
she gave a good impersonation of one in *Hanoi*). Herbst would never
attack the Communists in public, however much she criticized them in
private, whereas McCarthy was (shall we say?) more adaptable to the
needs of the moment, allying herself with the anti-Communists and the
anti-anti-Communists according to the shifting fortunes of the radical
Left and her own career. *Josephine Herbst* is therefore the story of a failed
life as well as a failed ideology, whereas *Writing Dangerously* is a tale of
worldly success in which the heroine survives every misfortune—a
wretched childhood, an army of discarded lovers, three disastrous mar-
riages, bad books, political misadventures, and even a famous law suit—to
achieve in the end both literary fame and fortune and bourgeois marital
bliss. There is also another important difference: whereas Josie Herbst was
the kind of radical who lost everything as a result of her actions and her
beliefs, McCarthy was always the kind of smart, Left-leaning opportunist
who managed to turn every personal attachment and every shift in the
Zeitgeist to her own advantage. She had a knack for escaping the wreckage
unscathed.

It is for this reason, by the way, that the title of Ms. Brightman's biog-
raphy—*Writing Dangerously*—strikes me as ridiculous, for McCarthy's
were the kind of "risks" that, in life as well as in literature, always ad-
vanced her career. Indeed, the more pain she inflicted by means of her
pen, the more she betrayed her friends, her lovers, and her husbands, the
more praise she reaped in the process. (*Hanoi* was virtually the only ex-
ception.) In a century in which many writers better than Mary McCarthy
have put themselves in real danger through their writing—the danger of
poverty, the gulag, and even death—it demeans the whole idea of literary
risk to place her in their company, and it is a measure of Ms. Brightman's

2 See "Who Was Josephine Herbst?" in the September 1984 issue of *The New
Criterion*.

identification with her subject and what may fairly be described as her in-
fatuation with the glamour of McCarthy's career that she does not seem
to understand this. On this issue, as on others—McCarthy's three failed
marriages, for example, and the writings on Vietnam—she lapses into the
role of "authorized" biographer, suspending judgment in favor of her
subject. As Ms. Brightman acknowledges herself, she felt "the tug of
McCarthy's personality" in the interviews that were conducted with her
subject—eighteen in all—and the sway of that personality makes itself felt
on every page of the book, which is not always to the book's advantage.

Still, it is Ms. Brightman herself who introduces the theme of failure in
writing about McCarthy and her generation of New York intellectuals.
Although she speaks admiringly of this generation as "the last one to sus-
tain an imaginative and critical involvement with the world around it"—
which means, I suppose, that she still approves of what they made of their
politics—she adds that "I wanted to understand how and why its writers
pulled back from their early promise." I think she is right about the unful-
filled promise of that generation, which is what we mean by failure, but
we don't actually hear much more about it in *Writing Dangerously*, which
tends in the course of its lengthy narrative to dissolve into a series of vivid
vignettes of personalities, political debates, literary projects, love affairs,
publishing arrangements, and intellectual social life, not to mention the
sex life of McCarthy herself, without ever coming to grips with the nature
of the "promise" or the reasons for its failure.

 To account for this omission, which leaves a moral and intellectual void
at the center of Ms. Brightman's very long book, it is necessary to examine
exactly what she means when she speaks so approvingly of the "imagi-
native and critical involvement with the world" that she attributes to
McCarthy's generation of New York intellectuals. McCarthy herself was
never a leader in the intellectual and political initiatives of that generation.
She took her cues from the men in her life—lovers, mentors, colleagues—
who were themselves deeply divided in their attitude toward the world
they wished to engage in their work. While on the one hand they tended
to be rebels of the Left who were fiercely critical of American society and
bourgeois life, they were also, on the other, ambitious to secure a place of
preferment in the American cultural establishment they looked down
upon with a good deal of intellectual scorn and political distaste. In the
beginning—that is, in the Thirties, and to a lesser extent in the Forties
—the greatest obstacle to their success was their opposition to Stalinism,
which in its cultural manifestations dominated the literary world that held
the keys to preferment. Stalinism was, in its literary and artistic standards,
philistine and middlebrow, whereas the writers in *Partisan Review*, the
principal organ of the anti-Stalinist Left, were ferociously highbrow.
McCarthy herself made her literary debut as the drama critic of *Partisan*

Review by playing—and brilliantly, too—the highbrow scourge of a Broadway theater still firmly tethered to the standards of Stalinist philistinism.

What changed all this, oddly enough, was the Cold War. It was the Cold War that gave this generation of New York intellectuals—McCarthy included—its entrée to the larger cultural stage that it both coveted and condescended to. Suddenly there were jobs in universities, in publishing, and in the mainstream media that had formerly been closed to writers of their persuasion. There were fellowships, subsidies, conferences, contracts, and the other emoluments of an established intellectual class. The irony was, of course, that the New York intellectuals now qualified for the mainstream because of their politics—that is, their anti-Stalinism—at the very moment when the vicissitudes of the political situation—the military threat coming from the Soviet Union—greatly diminished their radical commitment. It was discovered that in an increasingly perilous world, the United States could no longer be considered the principal enemy and might even be worth defending against the libels and slanders of the European—especially the French—Left, which placed itself in militant opposition to American interests.

As was her custom in such matters, McCarthy enthusiastically joined in this reversal of opinion, writing essays on "America the Beautiful" and "Mlle. Gulliver en Amérique" (an attack on Simone de Beauvoir's criticism of America) that some readers believed marked a "conservative" turn in her thinking. Later on, of course, when a radical critique of America was once again the intellectual fashion of the Left, she returned to the subject with a far more savage criticism of America than "Mlle. Gulliver" had ever been able to muster. McCarthy had become, so to speak, a political pen for all seasons.

What has to be understood about the political demeanor of the New York intellectuals in the heyday of the Cold War was that they were never entirely comfortable in the support they rendered to—and received from —the United States in its struggle with the Soviet Union. While fully availing themselves of the benefits of their new position, they could never really give up the idea that political virtue was still in some sense the preserve of the radical Left. They remained, emotionally even more than intellectually, secret believers in the radical dream. This made them extremely touchy about and indeed vulnerable to attacks from the Left— especially those of Norman Mailer, Harold Rosenberg, Irving Howe, et al.—which they publicly scorned but which privately caused them a lot of grief. I saw a good deal of Philip Rahv in the Fifties, when I first began writing for *Partisan Review*, and I was always struck by the great gap that separated his private conversation from his public pronouncements on these matters. He had a morbid fear of being nailed as a renegade.

This split came to be symbolized for me in what was said privately about Lionel Trilling. No writer was more highly esteemed by the readers of *Partisan Review* than Trilling was in the Fifties. Yet his appearances in the magazine were frequently accompanied by a campaign of disparagement that was conducted behind the back, and often by the very people who were publishing him in the magazine. Trilling was seen to have completely severed his ties with the radical ethos. He was considered too bourgeois, too respectable, too square, too "conservative," yet because *Partisan Review* seemed to need him, he could not be expelled from its pages without causing a scandal that would have cost *PR* some of its support. Some of this anti-Trilling sentiment was publicly expressed by Delmore Schwartz, Harold Rosenberg, and Irving Howe, but the really vicious talk was carried on *sotto voce* in a way that absolved its speakers from responsibility. They didn't really get up the nerve to dump Trilling until many years later when, owing to the resurgence of radicalism in the late Sixties, it no longer cost them anything.

It was the radical movement of the Sixties that brought the New York intellectuals back into the political limelight as avowed partisans of the Left. It didn't happen all at once, and there were many poisonous feuds to be negotiated along the way. Rahv, for example, abominated both Norman Mailer and Susan Sontag, who had emerged as the intellectual darlings of the radical movement, and his relations with Irving Howe were none too cordial, either. He had also split with *Partisan Review*, and started a magazine of his own called *Modern Occasions*. (One of his first priorities was to commission a blistering attack on Trilling.) But under the diplomatic auspices of Robert Silvers at *The New York Review of Books*, which had now supplanted *Partisan Review* as the principal intellectual organ of the highbrow Left, all was smoothly accomplished. Rahv re-emerged as—in Frederick Crews's wonderful phrase—a "born-again Leninist," and Dwight Macdonald, too, after years of political sleep-walking through the pages of *The New Yorker*, rediscovered the pleasures of radical militancy.

Right on cue, Mary McCarthy followed suit. If not exactly a "born-again Leninist" herself—years earlier she had confessed that "it was too late for me to become any kind of Marxist. Marxism, I saw . . . was something you had to take up young, like ballet dancing"—she nonetheless knew how to mimic the gestures and ideas that went with the position, and harness them to the rhetoric of social snobbery, which was her principal instrument as a political writer. In this respect, the Vietnam War should have been an ideal subject for her gimlet eye, allowing her to exercise the gift for caricature that she had used on her intellectual friends in *The Oasis*, on her Vassar classmates in *The Group*, and even on the art and culture of Venice in *Venice Observed*, on the hapless American military personnel in Saigon and Hanoi. But it turned out not to be such an ideal

subject, after all. It couldn't be turned into a social comedy of manners—the material was too stark—and the art of caricature doesn't, in any case, live on easy terms with the kind of bathos she brought to her account of the "virtuous tyranny" she professed to adore in North Vietnam. The bad faith of the whole enterprise had finally capsized her style, which was the only thing she had brought to it in the first place.

In the end, Mary McCarthy's politics were like her sex life—promiscuous and unprincipled, more a question of opportunity than of commitment or belief. Because the author of *Writing Dangerously* is writing herself from inside the ethos of the radical movement that must be elucidated and judged if her subject's relation to it is to be understood, she cannot really deal with the central questions of McCarthy's life and work or with those of the intellectual generation to which McCarthy belonged—the so-called "last one to sustain an imaginative and critical involvement with the world around it." Ms. Brightman is in many respects a good writer, a diligent researcher and readable prose stylist who knows how to shape a narrative. But she has been disarmed by her experience and her pieties from asking the deepest questions about her material. (This was the problem with Elinor Langer's *Josephine Herbst*, too.) About neither McCarthy nor her generation does she ever discover "how and why its writers pulled back from their early promise." The subject is simply lost in a blizzard of anecdote and annotation.

Because she cannot see her subject from the outside, moreover, Ms. Brightman's book also fails on other counts. For one thing, she misses the comedy of Mary McCarthy's career. It was only in writing about herself that McCarthy ever struck a really authentic note, and it is for this reason that the only books likely to survive are *The Company She Keeps* and *Memoirs of a Catholic Girlhood*. (By the time she came to write *How I Grew* and the unfinished *Intellectual Memoirs*, it was too late. She had lost touch with her material, and was inclined to prevaricate.) I don't regard *The Company She Keeps* as good fiction, but it is excellent social reportage and written on a scale appropriate to the very small compass of the author's talent. When she tried to do something larger in the same vein—*The Group*—it was a literary failure modeled on the clichés of the best-seller list of the day. Which is why the only thing ever recalled from that book—unless you are a Vassar alumna—is the account of Dottie and her pessary, which is very much in the vein of *The Company She Keeps*.

As for the later novels, I doubt if they will ever be reread by anyone who isn't paid to do so. *Birds of America* is particularly awful, and underscores what I mean by the comedy of McCarthy's career. When it came to her account of American society and its interest in food, which looms very large in that book, she simply didn't know what she was talking about. The whole country was in the grip of a culinary revolution while *Birds of*

America was being written, and Mary McCarthy simply didn't know anything about it. She thought a pot of basil in the kitchen window was some sort of challenge to convention when the magazines and newspapers were already crowded with tips on what to do with it. It was the same, really, when she turned to the subjects of Venice and Florence—subjects far beyond her depth. She was never again the writer she had been in her early contributions to *Partisan Review*. Without intending to, of course, she too had "pulled back" from that "early promise," but Ms. Brightman has left it to the reader to figure out why and how.

January 1993

A Footnote for Housman

Brad Leithauser

One of the most fascinating, and frustrating, footnotes I've ever come across—to my mind, one of the most beguiling footnotes in English literature—is found in A. E. Housman's "The Name and Nature of Poetry," a lecture he delivered at Cambridge in 1933. As its title suggests, the lecture was speculative and broad-ranging, and hence was a departure for Housman, who repeatedly called himself "no literary critic" and who usually restricted his lectures to tightly focused examinations of classical texts, about which he spoke, according to one of his students, in a "level, impassive voice . . . without enthusiasm but with an athletic spareness." By temperament a surpassingly wary and punctilious man, Housman had profound reservations about presenting to the public anything that might resemble breezy, insupportable generalizations, and the composing of his lecture caused him, as his biographies attest, no end of inner trouble and turmoil.

Before unfolding his central thesis (the notion that poetry "is not the thing said but a way of saying it," that it "is more physical than intellectual"), Housman informed his audience that his immediate impulse had been to select another topic entirely, that of The Artifice of Versification. This is a subject, he assured his listeners, that belongs to the methodical mind—to "the man of science," in fact, who would be "fitter for the task than most men of letters." He went on: "This latent base, comprising natural laws by which all versification is conditioned, and the secret springs of the pleasure which good versification can give, is little explored by critics: a few pages of Coventry Patmore and a few of Frederic Myers contain all, so far as I know, or all of value, which has been written on such matters." He then enumerated, in his memorable footnote, the sorts of issues he might have undertaken:

> I mean such matters as these: the existence in some metres, not in others, of an inherent alternation of stresses, stronger and weaker; the presence in verse of silent and invisible feet, like rests in music; the reason why some lines of different length will combine harmoniously while others can only be

so combined by great skill or good luck; why, while blank verse can be written in lines of ten or six syllables, a series of octosyllables ceases to be verse if they are not rhymed; how Coleridge, in applying the new principle which he announced in the preface to *Christabel*, has fallen between two stools; the necessary limit to inversion of stress, which Milton understood and Bridges overstepped; why, of two pairs of rhymes, equally correct and both consisting of the same vowels and consonants, one is richer to the mental ear and the other poorer; the office of alliteration in verse, and how its definition must be narrowed if it is to be something which can perform that office and not fail of its effect or actually defeat its purpose.

Well, it's an endlessly thought-provoking list. Some of his conclusions look dubious (if we accept that Bridges metrically "oversteps," what in the world are we to make of Hopkins?) and others (like his doubts about un-rhymed octosyllabics) seem shrewd but are left maddeningly unexplained. What a shame it is that Housman, with his fierce industry and methodical scholarship, never addressed such questions! The unfortunate fact is that prosodic analysis of the sort he was advocating has not advanced far since the days when he declared himself ready to throw out all but "a few pages." Why is this? Surely it is odd that in a century of exceptional criti-cism by practicing poets—Eliot, Auden, Jarrell, Bogan, Lowell, Winters, et al.—so little energy has been given to a systematic expounding of The Artifice of Versification. Perhaps, had Housman followed up his initial impulses and provided us with a maker's guide to verse-writing, other poets of equal or even greater eminence would have been tempted to ex-tend or contend with him. Housman might have left us an essay that would have not only illuminated the underpinnings of his own verse but also generated a rich, independent field of study.

Whatever questions or quibbles we might raise about the conclusions en-capsulated in the footnote, we sense in it unmistakably the simultaneous firmness and subtlety of Housman's approach toward prosody. He had fervent feelings about what ought to be essayed and what "wasn't done." In his own verse, for example, lines concluding with an unstressed syll-able—feminine endings—could be left unrhymed; masculine endings generally *demanded* a rhyme (there are only something like half a dozen unrhymed masculine lines in his entire oeuvre). And he held to these at-titudes throughout his artistic career; prosodically, no less than themati-cally, his verse stayed constant. The poems of his second book, the mis-titled *Last Poems*, which appeared in 1922 (fourteen years before the post-humous *More Poems*), are stylistically all but identical to those of his first book, *A Shropshire Lad*, which had appeared in 1896.

This constancy—sometimes referred to as a "failure to develop"—may be less of a drawback than it would first appear. Admittedly, those artists

who never change forfeit a particularly intense form of excitement—the reader's pleasure in tracing the pathway of an unexpected evolution—but they sometimes offer, as Housman does, a compensatory sharpening of minute pleasures. In an atmosphere of fixity, one naturally notices smaller, finer details than in the creations of a constantly metamorphosing artist. Consider, for instance, a passage from *Last Poems*:

> For nature, heartless, witless nature,
> Will neither care nor know
> What stranger's feet may find the meadow
> And trespass there and go,
> Nor ask amid the dews of morning
> If they are mine or no.

These lines, with their "light rhyme" of know/meadow/go, represent an extremely unusual effect in Housman, who typically insisted that his end-rhymes be "clean," that end-words either clearly rhyme or clearly not rhyme. He rarely allowed himself a simple off-rhyme, let alone anything more exotic. In the case of another poet, a reader might race right past a stray echo of this sort; with Housman, one is pulled up short. He allows himself so little of this particular variety of clangor that each instance speaks with an amplified resonance.

Is there another English-language poet so foursquare in his constructions? His favored meter was the iambic tetrameter, and there are strikingly few run-overs; line after line stands on its own as a syntactical or sense unit. His favored stanza was the quatrain, and again there are strikingly few run-overs; stanza after stanza concludes not with a colon or semicolon (still less with a comma or dash) but with a period. Everywhere one looks, even in those lyrics set in other meters and stanzaic patterns, the impression is of solidity, symmetry, precision, control.

Our literature comprises notably few poems of merit composed in unvarying meters. Even in those poets, like Pope or Dryden, known for their conservative metrics, minor deviations—a trochee, a rough elision, a trisyllabic substitution—are forever turning up; most formal poets never come close to writing any wholly regular poem. The conventional wisdom, of course, is that such uniformity is stultifying—a view implicit in Pope's attack on those who "equal syllables alone require." Nonetheless, Housman (like Frost, whose "Stopping by Woods on a Snowy Evening" proceeds with the unswerving clack of a metronome) frequently composed poems that are all but regular, and occasionally got by without even the slightest of metrical variations, as in "XXVI" from *A Shropshire Lad*:

> Along the field as we came by
> A year ago, my love and I,

The aspen over stile and stone
Was talking to itself alone.
'Oh who are these that kiss and pass?
A country lover and his lass;
Two lovers looking to be wed;
And time shall put them both to bed,
But she shall lie with earth above,
And he beside another love.'

 And sure enough beneath the tree
There walks another love with me,
And overhead the aspen heaves
Its rainy-sounding silver leaves;
And I spell nothing in their stir,
But now perhaps they speak to her,
And plain for her to understand
They talk about a time at hand
When I shall sleep with clover clad,
And she beside another lad.

In forgoing most forms of prosodic surprise, Housman placed a sizable burden on himself: he ensured that his poetry would be more than usually dependent on rescues or releases in the guise of a thematic "twist." These tend to fall, by my lights, into three camps. The twist sometimes takes the form of a paradox, often of an amusing sort, as in a perfect joy like "XVIII" from *A Shropshire Lad*:

Oh, when I was in love with you,
 Then I was clean and brave,
And miles around the wonder grew
 How well did I behave.

And now the fancy passes by,
 And nothing will remain,
And miles around they'll say that I
 Am quite myself again.

The poem depends utterly on a small joke: when someone is "himself again" it's usually a cause for rejoicing rather than, as here, lamentation. But the jest, as with so much of Housman's bitter humor, carries a walloping poignancy. Into the space of two quatrains he has condensed a tale not merely of heartbreak but of the loss of personal salvation.

In many poems, as Christopher Ricks points out in the introduction to his hugely welcome new anthology of Housman, *Collected Poems and*

Selected Prose,[1] much of the energy derives from blasphemy. When not doubting His very existence, Housman is continually questioning God's fairness or adequacy. The heat in such verses is generated by the friction between the genteel versification and the bleak message. When, by contrast, Gerard Manley Hopkins challenges God, he wrenches his forms — often the sonnet — into overloaded lines and turbulent distensions; Housman does the same without dislodging a single iamb.

Finally, and again in potent contrast to the poetry's polished surfaces, the twist may take the form of the horrible or grotesque. Housman's verse abounds in revelations of quiet grisliness (murders, hangings, suicides, moldering flesh, mutilations) often linked to amorous designs:

> 'Oh lad, what is it, lad, that drips
> wet from your neck on mine?
> What is it falling on my lips,
> My lad, that tastes of brine?'

> 'Oh like enough 'tis blood, my dear,
> For when the knife has slit
> The throat across from ear to ear
> 'Twill bleed because of it.'

Desire is never far from pain and retribution in Housman's world.

Some of the admirable ways in which he combines the predictable and the surprising are on display in "XIII" from *A Shropshire Lad*:

> When I was one-and-twenty
> I heard a wise man say,
> 'Give crowns and pounds and guineas
> But not your heart away;
> Give pearls away and rubies
> But keep you fancy free.'
> But I was one-and-twenty,
> No use to talk to me.

> When I was one-and-twenty
> I heard him say again,
> 'The heart out of the bosom
> Was never given in vain;
> 'Tis paid with sighs aplenty
> And sold for endless rue.'

1 *A. E. Housman: Collected Poems and Selected Prose*, edited, with an introduction, by Christopher Ricks (Penguin Books, London, 1988).

And I am two-and-twenty,
And oh, 'tis true, 'tis true.

The twist here, a wry and heart-sore joke, lies in the poem's dispropor-
tions. The wise man is granted most of the space and eloquence—but the
young lover still manages to say all that need be said. The first six lines of
the poem are given over to the wise man, who speaks elegantly and per-
suasively. But in the stanza's final two lines he is, in effect, confounded ut-
terly. What use is advice, however apt and sagacious, in the face of youth-
ful ardor? The second stanza mirrors the first almost exactly (even down
to minor matters of punctuation), but with a sharp increase in intensity:
the wise man's warning is more explicit and detailed, the young man's
confession of heedlessness more fervent and anguished.

This intensification is marked prosodically: the second stanza contains
the one moment when the meter falters, when the iambics give way. The
reader comes to "The heart out of the bosom . . ." and is pulled off kilter.
Inertial propulsion—the steady singsonging of the previous lines—en-
courages us to trample on ordinary speech rhythms and to read it as "the
heart out *of* the *bo*som . . ." Meter tugs us one way, idiom another. This
momentary difficulty arises, happily, at an ideal juncture: the lyric shud-
ders just at that tremulous, hazardous instant when one person's feelings
go out to another. A reader need only attempt to "correct" the meter
("The heart from out the bosom . . ." or "The feelings from the bosom
. . .") in order to see how Housman, a master craftsman, accomplishes
very much with very little. Correct the meter, and half the poem's energy
spills away.

Housman's own heart was "given" in his early twenties, when he fell in
love with a fellow student at Oxford, Moses Jackson. Housman was ex-
tremely reticent about his homosexuality, never broaching the matter even
to his brother Laurence, who was—considering the era—boldly undis-
guised about his own homosexual life. All the evidence suggests, however,
that Jackson was the one consuming passion of Housman's romantic life;
as an elderly man, he once remarked, of the possibility of falling in love
more than once, "anyone who considered that he had done so had simply
never really loved at all." The evidence also suggests that Housman's pas-
sion for Jackson went not only unconsummated but unrequited. (One
might propose—somewhat unchivalrously, perhaps, in the light of that
stirring declaration of one-in-a-lifetime love—that Housman's affections
were so durable because unrealized; Keats could have told him something
about the superiority of unheard melodies and unkissed lovers.)

For all his reticence, Housman's unhappiness at love is written all over
his poems. Passion in his verse is a source of guilt, anger toward fate,
anger toward the unresponsive loved one, bitterness, resigned sadness,

and violence—pretty much everything except pleasure. Auden, who wrote with deep sympathy and trenchancy about Housman, proposed that his anguish lay not in his homosexuality *per se* but in the particular form of his impulses:

> If Housman did feel shame and guilt, this was caused not by the Bible but by classical literature. I am pretty sure that in his sexual tastes he was an anal passive. Ancient Greece and Rome were both pederastic cultures in which the adult passive homosexual was regarded as comic and contemptible.

Auden does not say whether he draws this conclusion from Housman's poems, his essays, his letters, or from hearsay. In any case, this is not an interpretation found, so far as I know, in any of Housman's biographies, most of which have suggested that, given prevailing attitudes in Victorian England, his homosexuality was itself a sufficient cause of severe distress. (That "If . . ." of Auden's looks faintly disingenuous. Even without the indications we have that Housman was tormented by the Wilde persecution, the poems themselves are suffused in "shame and guilt.")

Whatever forms Housman's desires may have taken (a recent biographer turned up ambiguous notations in Housman's hand suggesting that in middle age he may have engaged male prostitutes during vacations to Paris), his homosexuality seems to lie at the core of the confederacy that his poems create among the victimized and the damned. His soul's compatriots are, over and over again, the condemned criminal, the insomniac, the doomed soldier, and those who sleep forever alone under the earth. (There are an extraordinary number of beds in Housman's poems, but few joyful ones.) His poems repeatedly play upon the realization—cold comfort!—that a person in solitary misery belongs to a brotherhood of those who likewise have felt alone and miserable. However confined he may have been in his daily personal dealings, his imagination—no doubt enlarged by his classical studies—commanded a strikingly open and fluid view of the sweep of time. He seems to have felt himself, with special keenness, a brother to the doomed of every era, including those who were not yet born, as exemplified in his epigraph to *More Poems*:

> They say my verse is sad: no wonder;
> Its narrow measure spans
> Tears of eternity, and sorrow,
> Not mine, but man's.
>
> This is for all ill-treated fellows
> Unborn and unbegot,
> For them to read when they're in trouble
> And I am not.

Housman in his verses often appears to be speaking man to man—or, more accurately, lad to lad. His particular focus on youth was noted by Auden in his concluding words on Housman: "I don't know how it is with the young today, but to my generation no other English poet seemed so perfectly to express the sensibility of a male adolescent. If I do not now turn to him very often, I am eternally grateful to him for the joy he gave me in my youth." Housman's hold on the young male mind is analogous, perhaps, to that which Sylvia Plath exerts over young women (or so it appears in my position as a lecturer at a women's college). Theirs is an ability to engender in the young reader the sensation that *These poems were written for me*. The male-to-male tenor in Housman's poems need not exclude women, of course; according to a young woman poet of my acquaintance, it may provide part of their charm. She tells me there's "something bracing in this feeling of eavesdropping on a conversation directed elsewhere." Still, in the long run it may be difficult to engage oneself fully in an overheard conversation.

Housman's attempt through poetry to pass along to young men a cold but thrilling joy—that which is provided by surpassingly bleak and surpassingly beautiful verses—might well be seen, in the life of an artist whose work was centered in unrequitedness, as a substitute for sexual activity. He is saying to his "lads," in effect, *I'll give you what I can*. And it's a deeply cheering irony that what this poet who was forever singing about death had to give remains immortal and undiminished.

Still, the unrelieved gloominess of Housman's outlook at times cries out for parody. Even his admirers can hardly muster indignation at some of the lampooning he inspired, like Pound's "Mr Housman's Message":

> The bird sits on the hawthorn tree
> But he dies also, presently.
> Some lads get hung, and some get shot.
> Woeful is the human lot.

Surely, any poet who would conclude his most famous book with "When I am dead and gone" (the final line of *A Shropshire Lad*) is asking for trouble.

Last lines were a problem for Housman. Probably nowhere else is the narrowness of his subject matter, and his treatment of it, so damningly apparent. One poem ends so much like another that they sometimes run together in the mind. You would have to be more than a Housman devotee—would have to be a Housman fanatic—to identify which of these last lines go with which poems:

> But you will die to-day.

A Footnote for Housman

And there they died for me.

And died because they were.

And all you folk will die.

Before I die for ever.

To lay me down and die.

And I lie down alone.

And there lie they.

To-night to lie in the rain.

And cannot come again.

'No, my lad, I cannot come.'

And wilt cast forth no more.

Sleep away, lad; wake no more.

Sleep on, sleep sound.

Lays lads underground.

There's nothing but the night.

But this will last for long.

Whence he never shall arise.

 Some poets provide their critics with ready-made and seemingly un-avoidable duties. Those who take up Wordsworth, for instance, usually feel a need to "explode the myth" of his decline (patent though that decline may have been); Pound's explicators often feel compelled to defend him from charges of fascism and anti-Semitism (indefensible though his attitudes were); and so forth. In the case of Housman, the obvious task is to unify the "two Housmans"—the reserved classical scholar and the open-hearted lyric poet. On the face of it, he seems to have done a remarkably thorough job of bifurcating his existence.

Actually, this may be a case of one more myth that is in no pressing need of being exploded. On the whole, I'd agree with John Berryman's assessment that it's "incredible" that the poems and the criticism were written by the same man. For those readers whose primary interest is the poetry, rather than the classical scholarship or the life, it seems clear that Housman was sufficiently "divided" as to be able to shut down utterly his critical side when he was creating. How else account for the abysmal depths to which his verses could occasionally plummet? He was capable of composing lines that Housman the feared and formidable critic might naturally have ripped into with feral glee. Imagine what the critic might have done with a couplet like this:

> And brooding on my heavy ill,
> I met a statue standing still.

or a quatrain like this:

> Then, 'twas before my time, the Roman
> At yonder heaving hill would stare:
> The blood that warms an English yeoman,
> The thoughts that hurt him, they were there.

or opening stanzas like this one:

> Once in the wind of morning
> I ranged the thymy wold;
> The world-wide air was azure
> And all the brooks ran gold.

or this one:

> When I meet the morning beam
> Or lay me down at night to dream,
> I hear my bones within me say,
> 'Another night, another day.'

In truth, Housman's verse could be atrocious in all sorts of ways; it might even be argued that the bad poet was a more varied artist than the superb one. His old-fashioned phrasings and archaisms can seem not so much quaint and charming as stilted and lifeless. It's a little hard to believe that any serious poet was using "lief as rather" and "hark, the belfried tingle" and "we both must hie" (phrases which Wordsworth or Coleridge, a hundred years earlier, would probably have deemed insupportably quaint) a decade after Eliot's "Prufrock." His poems abound in sentimen-

tal turnings—"rose-lipt maidens," "leaping lads," girls who "go maying," souls that "linger sighing," and so forth. Cyril Connolly, one of Housman's harshest and most compelling critics, actually went to the trouble of tallying how often "lad" ("one of the most vapid [words] in the language," according to Connolly) appears in *Shropshire Lad*. The answer is sixty-seven times in sixty-three poems—a statistic that must send a shudder up the spine of even Housman's staunchest admirers. But to my mind, a still more damning show of sentimentality arises in Housman's self-congratulatory toughness. Is there in all the world a more cloying form of sentimentality than the conviction that, while peering at life with dead-eye accuracy, one has cast off the solace of sentiment?

Other shortcomings are much less showy. At times Housman is simply bland. When the twist in one of his poems fails to come off, he can wind up expressing conventional thoughts in conventional meters. Much of his later work falls short in just this way.

Curiously—redeemingly—there's often a charm even to his blandness. We must be grateful to any poet of Housman's plentiful talents who seeks to move us with the most infinitesimal and refined modulations. He calls on us at all times to listen closely, lest we lose him utterly. Few poets have such power to induce us to attend so raptly to the music of their verse. And for Housman music is—as "The Name and Nature of Poetry" tells us—the heart of the matter.

However great our regret that Housman never got around to The Artifice of Versification, the lecture he chose to deliver in its place is a valuable and tonic document. It asks us to reappraise our approach to verse and challenges the character of poetry criticism in our time. If its emphasis on the need to stop "maltreating and corrupting language" gives it an old-fashioned feel, it nonetheless raises vexatious, important doubts that have not been answered so much as ignored.

The study of poetry today—which belongs less and less to general-interest magazines and the amateur reader, more and more to specialized journals and the university classroom—is so overwhelmingly a matter of content that its musical components are almost lost altogether. Book after book of what is ostensibly poetry criticism arrives in which the reader has almost no sense that what is under examination is something other than prose—that it is *verse*, and hence a matter of meter, rhythm, rhymes, enjambments, and so forth. Time and again poets are converted into proto-philosophers, upon whose murky pronouncements the critic labors to liberate what the poet was "really saying" or (worse, still) "trying to say." This is a mode of criticism that hardly knows what to do with Housman's pellucid, crux-free lines. Poor Housman, it turns out, has little to offer except beauty and pleasure. In his finicky exactitude, he didn't even have the grace to leave behind uncertainties of punctuation!

There is an irony in Housman's being inhospitable to the critics, for literary scholarship was the defining professional passion of his life. One can imagine his never having attempted to write poems (or, more likely, his having begun a few and then, with typical rigor, deeming himself inadequate), but one cannot quite envision for him anything but a scholar's life. All the more interesting, then, is one's suspicion that he would have reacted with scorn to so much contemporary scholarship, with its emphasis on intellectual content and the author's private life. (He once wrote: "Even when poetry has a meaning, as it usually has, it may be inadvisable to draw it out.") Anyone who attempts to write Housman's biography—and there have been something like half a dozen studies—must proceed under a dark certainty that the result would probably leave Housman seething in his grave.

Actually, readers who focus not upon his life but his verses may be doing not only Housman but themselves a favor. As a man, Housman had a good many charms—he was witty and loyal and appreciative. But he was at times such a thoroughly rebarbative man—so laced with snobberies, cruelties, condescensions, rancors—that a prolonged exposure to his personality can temporarily pollute the well of his verses. There are moments in his biographies when the only thing that keeps him from being totally unlikable is that he appears so completely miserable.

Fortunately, one's impatience or dislike dissipates quickly in the presence of his best verses. They act on the reader quickly, for one of their greatest appeals is their distilled concentration. How many poets, major or minor, have written so many little gems, most of them shorter than a sonnet?

My own list of favorite Housman poems consists of twelve lyrics, of which the longest runs only sixteen lines. One of them, "XXXVI" from *More Poems*, is a mere quatrain. On the first couple of readings, I thought it lovely, but I now feel it's something better than lovely:

> Here dead lie we because we did not choose
> To live and shame the land from which we sprung.
> Life, to be sure, is nothing much to lose;
> But young men think it is, and we were young.

Many familiar Housman images and themes are here—dead soldiers, the futility of heroism, and a dark suspicion that courage and cowardice, virtue and vice, are almost the same, since life doesn't matter anyway. *Almost* the same . . . The beautiful and young and foolish naturally think otherwise, and again Housman would give the beautiful young fools the final word. *They* think that in dying young they have suffered a tragedy —have lost everything—and in the end he isn't about to contradict them.

September 1991

Vladimir Nabokov: The Russian Years

John Simon

Opinions about all writers are divided; even Shakespeare has had his detractors, from Voltaire to Tolstoy. But on few writers are they as widely and evenly divided as on Vladimir Nabokov. From some, he commands a vassal's fealty; from others, he elicits shudders of revulsion. Philip Rahv, no flighty hothead in his mature years, kept passionately urging me to perform radical surgery on Nabokov's reputation, which he judged to be as hypertrophic as the man's ego. And Rahv, who flatteringly but mistakenly considered me the man for the demolition job, could simply not understand my hesitation.

Partly, I was daunted by the magnitude of the task; even then there was too much material, both primary and secondary, for a less than rabid nonbeliever to slog through. And although I had, and continue to have, grave doubts about Nabokov's greatness, I balked at being handed a ready-made conclusion to which I only had to fit a beginning and middle. Moreover, I have the merest smattering of the language in which Nabokov began to make his literary career, and though I have made feeble stabs at comprehending Andrey Bely's theory of versification, which at one time preoccupied Nabokov, I have no grounding in Russian poetry and could never even battle my way through Nabokov's venerable four-volume translation-*cum*-elucidation of Pushkin's *Eugene Onegin*.

Besides, there are works by Nabokov that I enjoy and respect, even though these do not include that gargantuan rodomontade, *Pale Fire*, or that tiresome bid to out-Joyce Joyce, *Ada*, to name only the two most hallowed masterpieces. Sadly, I had to tell Rahv that the person with the stomach and stamina for his suggested undertaking was less likely to be a fastidious skeptic than the sort of true believer Brian Boyd proves himself to be with his vast two-volume critical biography. Its first installment—some six hundred capacious pages—has just come out under the title *Vladimir Nabokov: The Russian Years*.[1] What Boyd, a senior lecturer in

1 *Vladimir Nabokov: The Russian Years*, by Brian Boyd (Princeton University Press, 1990).

English at the University of Auckland in New Zealand (or is it Nova Zembla?) who was clearly inspired to learn Russian by his passion for Nabokov, has produced is not, to do him justice, out and out hagiography. Indeed, he prides himself on his "independence and . . . right to . . . sometimes severe judgments." True enough, there are reservations, and Boyd is manifestly a serious scholar who has done stunning research while manfully endeavoring to keep his worshipfulness under control.

Do, however, consider some of the judgments scattered throughout his book, and bear in mind that this is only the first volume; later works by the master are likely to call forth even greater outbursts of adulation. Already we learn, though, that even if Nabokov admired Shakespeare's way of mixing comedy and tragedy, "he wanted them more radically confounded," and did so confound them, putting him, in one respect at least, ahead of Shakespeare. One of Nabokov's stories, "Terror," may have influenced Sartre's *Nausea*, though, as Boyd approvingly quotes Nabokov himself, "without sharing any of that novel's fatal defects." And when it comes to dialogue, Nabokov's can be "barer and more realistic than Pinter's." Nabokov, then, is more existential than Sartre, more absurdist than Pinter.

In Nabokov's first novel, *Mary*, "Ganin's memories do not depend on the accident of tasting a madeleine from the *patisserie Proust*"; we are, I assume, to conclude that Ganin is a finer hero than Marcel, and, since he does not stuff himself with French pastries, a trimmer one as well. "Already as a schoolboy, Nabokov had reinterpreted the Hegelian dialectic of history," Boyd reveals, though he neglects to tell us whether this occurred in homework or in class recitation. Nabokov, moreover, is more economical than Balzac, substituting as he does "rapid shifts of focus" for more ponderous "Balzacian amassment of information." These shifts allow Nabokov to "mix the exact detail of a Van Eyck with the casually unfilled space of a Hokusai"; plainly, Balzac never moved in such fast—or, at any rate, rapidly shifting—company.

It is true that "Nature was one rival Nabokov knew he could not outdo at its own game," Boyd tells us; but not to worry, there are plenty of other games in town. One of them is surprise. Poor Tolstoy, "at the top of a page [of his] we know the mood at the foot of the page," even as on "a page of *Ulysses*, we can expect in advance the style of the coming paragraph." Too bad for the defending Russian champion and the Irish contender; they may slug as hard as anyone, but they lack Nabokov's fancy footwork.

"Nothing could be further" from Nabokov's characters "than the automata of Beckett" or Faulkner's "communities of quarter-wits, half-wits, and three-quarter-wits." Tick off one more Hibernian heavy-weight and a challenger from the New World: "Nabokov, the first entomologist to count under the microscope the scale-rows on a butterfly's wing

marking, insisted as an artist too on a new precision of the senses." But Nabokov outboxes (he was, in fact, quite a good amateur boxer) not only fellow writers; he can as easily take on champions from other fields: "The patterns of *The Defense*," which Boyd considers Nabokov's first incontestable masterpiece, "have Bach's melodic beauty and bracing vigor of design, but to this exhilarating combination Nabokov adds more." Indeed, the characters based on himself and his real-life spouse "are among the warmest and most touching . . . in fiction." Put that in your harpsichord, Johann Sebastian!

Nabokov's story "Terra Incognita," we are told, "might have been merely a Borgesian conundrum, had not Nabokov's passion for exploration and for nature made it something more," and down goes the sight-impaired lariateer of the pampas. So few writers can lay a glove on Vlad(imir) the Impaler that, once again, challengers from other areas must be pressed into service. Completed, *The Gift* would be Nabokov's "ninth Russian novel, and like Beethoven's Ninth it would be immensely more massive and more formally daring" than his previous efforts. Well, at least the deaf German fares better than the purblind Argentine: *this* fight seems to be a draw.

So back to literature for a return bout with Gentleman Jim Joyce: *The Gift* offers us not a mere capital, Dublin, but "a capital *and* a continent, Berlin and Eurasia," as well as—among many other things—"a portrait of the artist as a young man": the poor Dubliner has clearly lost his title. And again, Nabokov proves more daring than Joyce, who impressed Hugh Kenner by presenting Stephen Dedalus "with *lice* in his hair." That's nothing: "Nabokov introduces Zina, heroine of a novel of genuine romance, through the sound of her flushing the toilet."

Anyone holding such a royal flush (if I may change my trope) can easily outplay a mere lumbering Swede; accordingly, Nabokov in his drama "avoids the ponderous symbolism of Strindberg's *A Dream Play.*" Nabokov even surpasses his own beloved master: in the opening of *The Gift*, "he goes one further than Gogol" in the opening of *Dead Souls.* After that, Boyd pulls out all the stops: Nabokov has "perfected a . . . sinewy suppleness [of language] and discovered fictional forms unprecedented even in the great tradition of Pushkin, Gogol, Chekhov, and Tolstoy, that allowed him to express new kinds of literary truth." In his belief in literary perfectibility, Boyd is clearly the Auguste Comte of lit crit.

But he is cannier. Nowhere does he spell out in so many words Nabokov's eternal, universal supremacy. This is merely—discreetly, tactfully—implied. More concise than X, more imaginative than Y, more rapid than Z, Nabokov emerges the undefeated, not-to-be-dislodged champion without any need for blunt statements. Well, something does slip out in one place: "By the mid-1930s, and even more by the 1950s, he had developed in his fiction an uncanny freedom of part from consecutive

part, and at the same time more complex relations of part to part than perhaps any writer before him." That "even more by the 1950s" is especially ominous: Will the second volume bring even greater revelations? Will the master of part song be confirmed also as the master of *cantus firmus*?

The critical biographer, after all, has three tasks: to tell the story of his subject's life, to elucidate his works, and to evaluate his ultimate stature. Broadly speaking, this corresponds to being a historian, a teacher, and a critic. Though Boyd fails in the last category, he does impressive work in the first two. And what a life Vladimir Nabokov had for a biographer to sink his teeth into! Born in 1899 into a family of fabulous wealth and fabled distinction—powerful statesmen and publicists on his father's side, verst-rich landowners on his mother's—young Volodya was the favorite among several siblings. "I was born . . . a precocious genius, a *Wunderkind*," who disported himself in the best quarter of St. Petersburg and on the grand family estates, such as his statesman-journalist father's Vyra, and his uncle Ivan Rukavishnikov's Rozhdestveno not far away. There was the added prestige of Papa V. D. Nabokov's being the leading liberal in the Czar's government, with a jail sentence and other scars to show for it.

Already as a small child Volodya has "an almost pathological ability to conjure up the past," and exercises his imagination by projecting himself into others, "trying to follow the contours of their thoughts and sensations," as Boyd, somewhat orotundly, puts it. He sprouts an extra tooth in the middle of his palate, and, at the age of five, falls precociously in love with a coeval sub-Lolita and fancies the prettiest of his governesses, Miss Norcott, "whose sudden dismissal (she was found to be a lesbian) left him inconsolable." Significantly, the child's favorite toys are *matreshki*, the hollow wooden peasantwoman dolls, each containing a smaller one within it—a foreshadowing of the games with reality the grown novelist was to play. By age eleven, Nabokov's "butterfly passion had fully taken wing," and Volodya had become a Vladimir *in parvo*.

So, too, in his love of nature around Vyra and his love of luxury. The love of nature culminates in butterfly collecting; as Boyd has it, Nabokov's lepidopterology "would help to fix the contours of his mature epistemology, his metaphysics, even his politics"—an interesting statement that is not sufficiently elaborated on. He was to impart "to his fiction the delights he found in entomology. . . . Having learned through his butterflies that the world is much less to be taken for granted, much realer *and* much more mysterious than it seems, he made his worlds to match."

But the spoiled-rich-boy side develops *pari passu*. Whereas his sisters begged their chauffeur to deposit them somewhere behind their school to avoid envious attention, Vladimir insists on being conspicuously driven to the school doorstep and helped out of the car by a chauffeur doffing his

cap. Boyd comments: "It was not a parade of wealth but a refusal to suppress differences," a splendid euphemism for what starts revolutions: if only the Czar could have suppressed a few differences! At age thirteen, Volodya would "lean back in his chair for his valet to remove his shoes for him," but that difference at least his sternly democratic father made him suppress. The boy was severe and unforgiving with the teachers he disliked, teasing and humiliating them. He hated school and derived most of his education from private tutors and his own reading and pursuits.

The great artist Dobuzhinsky vainly tried to teach him to paint in private lessons, but at least conveyed a sense of visual exactitude to the future writer. Rejecting his father's orthodox religion, the boy espoused his mother's nonreligious mysticism, as well as her heavy smoking. He had his first two important love affairs, and began to publish his verse, which earned him the contempt of the famous poet Zinaida Gippius and the eulogies of a sycophantic journalist; this, he was to claim, cured him permanently of all interest in literary fame and the reading of reviews. Hmm?

By age seventeen, Nabokov inherited from homosexual Uncle Ivan the manor and two-thousand-acre estate Rozhdestveno; by next year, alas, he was an exile in the Crimea, never to see any of his old homes and haunts again. Crimea was exciting in those early revolutionary days, and, in recounting them, Boyd, as usual, keeps Russia's history and that of the Nabokov's and their friends in perfect equipoise. Vladimir has numerous entomological and erotic adventures, but none to compare with the chancy, perilous escape of the family by boat to the West. Crimea also inspired Nabokov's first chess problems (later he was to publish them along with his prose and verse), and in that "intensity of cerebration" he evolved, as Boyd radiantly expresses it, "a concentration of mental rays sufficient to burn a hole through time itself."

Nabokov's notebooks of this period reveal, along with careful studies of Russian versification, the metaphysical speculations that were to accompany him everywhere; Boyd Nabokovizes about his subject's "phonic patter and cryptic pattern." Here, too, Nabokov's lifelong enemy, *poshlost* (philistine vulgarity), begins to become an object of scorn and satire.

By 1920, Vladimir Nabokov the Elder has moved his family to Berlin, though Volodya is mostly at Cambridge University, where, it seems, he never learned the whereabouts of the main library, or whether his college, Trinity, had an undergraduate reading room. An English poem by Vladimir appears in *The Trinity Magazine*. As his father is now active in émigré journalism in Berlin, young Vladimir begins to be published in Russian newspapers and journals all over Western Europe; in years to come, under the pen-name Sirin, he'll become the brightest star of émigré literature. A knockout in the ring at Cambridge leaves his right nostril permanently S-shaped, which does not stop his amatory conquests or impede his looking down his nose at as many people and things as before.

He does well on his Cambridge tripos, obtaining second-class honors; one question especially delights him: describing Plyushkin's garden in *Dead Souls*, "which perfectly suited his preference for exact knowledge, precise visualizations, detailed recall."

Back in Berlin, he supports himself by tutoring in French, English, tennis, and boxing. He also does translations into Russian; his version of *Alice in Wonderland*, we're told, is rated the best rendering of that work into any language. He gets engaged to Svetlana Siewert, a sweet seventeen-year-old, but when his promised steady job fails to materialize, her parents break off the engagement. When a former colleague publishes a "vile" review of Sirin's second volume of verse, the poet challenges him to a duel, but receives no reply. There are at least a couple of other occasions on which Nabokov issued similar challenges, but, unlike Pushkin and Lermontov, he never had to face a duelist's pistol.

And now Nabokov meets Vera Slonim, the young Russian Jewess whom he will eventually marry. She preferred to spell her name "Véra," to avoid its being pronounced so as to rhyme with "queerer," was a crack shot with a pistol, and had a fine literary sensibility. Boyd lists the roles she was to perform for Nabokov: wife, muse, ideal reader, secretary, typist, editor, proofreader, translator, biographer, agent, business manager, legal counsel, chauffeur (driving was one of the few things Nabokov could not master; the German language was one of those he refused to), research assistant, professorial understudy. What he doesn't mention is that she also cut up his meat into bite-sized morsels at table. But this woman with the best sense of humor Nabokov had ever encountered was never his model; as she says, "he had the good taste to keep me out of his books." And yet Boyd repeatedly tells us such things as "*Look at the Harlequins!* pays grateful homage to a woman modeled upon Véra. . ." But, for all that, throughout their marriage except for a brief period of near-poverty in a one-room apartment, Nabokov, "a solitary sleeper by principle and inclination," slept in a separate bedroom.

By now Nabokov, who called himself a poet in prose—not just for his style but also for his way of looking at the world—was writing plays as well, and publishing both stories and verbal riddles; in private, he was not above reciting "unprintably licentious poems." Needing money, he appears as an extra in movies, wowing starlet's with his English-prince look. He tries unsuccessfully to get screenwriting jobs; his father is assassinated by a right-wing fanatic. His widowed mother and sisters are now living in Prague, and he writes them that not a day passes without heads turning in the street and whispering "Sirin!" He visits his mother in Prague and dislikes that most beautiful of cities. What he likes about living in Berlin is that, by not learning German, he can keep his Russian "vacuum-sealed." He writes his mother that they'll see his murdered father in "a completely natural heaven." Does he believe this? Boyd doesn't tell.

Already a secure storyteller, Nabokov turns to writing novels. He "still had to reinvent the arts of narrative, of character, of structure," Boyd declares, "but he was well on his way." Vladimir describes the novelist's role to his mother: "We are translators of God's creation . . . we dress up what he wrote, as a charmed commentator sometimes gives an extra grace to a line of genius." It seems that he always carried an entire evolving novel in his head, and could at will write down large chunks of it—in this respect, too, falling scarcely behind God.

Boyd likes to indulge in the stylistic grandeur handed down to him by his master: "Not a thick cement of fact under each step of the story," he tells us about Nabokov's style, "but a sharp stone here or there to jolt the soul." (A pun on "sole," I assume.) Again: "He thought he was simply taking up handy tools to rob the grave of its secrets, but it looked as if he were stocking a tomb with propitiatory images." Sometimes Boyd slips up, not surprising from one whose souls keep walking on sharp stones. He tells us in one sentence about a rare moth Nabokov catches in Charlottenburg; in the next, about the "moth-eaten" couch in his rented room. Surely, rare-moth-eaten.

Concerning the story "The Fight," Boyd wonders whether it is critical of its narrator or backs up his "inhuman indulgence in living as if others' pain and joy were merely for his own artistic delectation." It strikes me that *Schadenfreude* is a major component of Nabokov's make-up. Whether he writes in a 1948 letter to Edmund Wilson, "Your having taken up chess is good news, I hope you will soon be playing well enough for me to beat you," or whether he has the blind hero of *Laughter in the Dark* tortured by his wife and her lover, whom he can hear carrying on but cannot lay a hand on, sadistic glee is frequent in his repertoire. It is all over *Lolita*, for example; but I cannot deny that something in the reader's nature responds to this. And Nabokov may even exhibit a complementary masochistic streak when he writes about "the pleasant sensation of being knocked out on the chin."

Sometimes Boyd's adulation races way ahead of him. He describes a scene in a Nabokov play wherein "a newspaper sheet hangs halfway off the top of the wardrobe, a sign that a suitcase stored there has been removed. Nabokovian detail at its most suggestive." Why a suitcase, necessarily? Why not a pile of newspapers removed in haste? There is always the nose-thumbing, had-you-there-didn't-I? aspect to Nabokov. Contracting to write a Russian grammar, he begins the first exercise with "Madam, I am the doctor, here is a banana." Then he dumps the assignment on Véra.

Interestingly, Boyd points out that Nabokov's best novels were almost always those he set aside to write another before resuming work on the first. The reactivated novel would then, by some strange cross-fertilization, emerge more complex, richer than originally envisioned. Boyd matches such sound, but infrequent, critical observation with staggeringly

industrious research. We learn that once, in London, Vladimir danced the foxtrot with Pavlova; or that, another time in Berlin, he was on the panel to select the six women to vie for the title of Miss Russian Colony of 1928.

His memory, especially the visual one, was exceptional; at times he complained of its overtaxing him. It is memory that helps us out of one of our two prisons—that of the present, which forbids access to the past; it is love, especially married love, that springs us from the second, the prison of self, which forbids access to other people. And in death, it seems, both these constraints are transcended. Such, at any rate, is the philosophy Boyd reads out of Nabokov's early novels, *Mary* and *King, Queen, Knave*. Whereupon, midway into this first volume of his biography, and about to accost what he calls Nabokov's first masterpiece, *The Defense*, Boyd launches into a sizable and not uncomplicated chapter, "Nabokov the Writer."

Here all pretense at biography is abandoned and we get nearly thirty pages of straight critical analysis. This is structurally unsettling—not only because it comes at this point, but also because it comes at all. A critical biography should be able to—as Boyd's does before and after this chapter—slip in the criticism amid the biography without noticeable loss in narrative momentum. What happened here? Did Boyd's conscience, or his publisher, or Nabokov's ghost (the biographer never met the biographee) remonstrate that, as the biography was extremely long, some claim for absolute greatness had to be made early on—preferably in the first volume, so that readers would be encouraged to buy the second?

So we get, among other things, a statement about Nabokov's compulsion, in order to map human consciousness in the round, "to collapse the world into one or two dimensions or to expand it into four or five," which "imparts the characteristic wobble to [Nabokov's] universe. . . ." That, apparently, is what angers readers who feel metaphysics to be *passé*, even though, Boyd assures us, "metaphysics will not die until humanity does." I, too, believe that; what I don't believe is that all kinds of metaphysics are equally good. Though I myself don't buy any, I am particularly put off by the collapsible and expansible kind.

"Nabokov finds the past alive with patterns," we learn, "to a degree no one before him has ever imagined." Whereupon Boyd sensibly wonders whether these patterns are perceived or created, and whether they have meanings. To this, I'm afraid he has no answer, but he does praise Nabokov's proffering certain patterns so slight "that no reader could even notice these matching clusters until a careful re-rereading [*sic*]. Even then they may be overlooked as mere incidental decoration—*until* we discover how they take their place in a larger design that insists on an urgent explanation."

Yes, I know that Joyce made equally intemperate demands on his reader, but that excuses neither him nor Nabokov in my view. I am espe-

cially riled by that "insists on an urgent explanation"; if it's so urgent, why is it so artfully hidden as to be overlooked even on a third reading? Worse yet, what *may* then emerge is still only the question, not even a tentative explanation. All this brings out the worst in Boyd as well: "Between the tick we have heard and the tock we can expect, Nabokov shows us, our minds can make any choice they want"; and "Nabokov wants to test thought at its highest . . . thought anything but spontaneous, but boiling all around the event with a heat the instant alone could never generate." And so on and on.

I am reminded of two statements about Vladimir by his cousin and friend, the composer Nicolas Nabokov, in the latter's autobiography, *Bagázh*. First, "Volodya always did everything with *un superbe sans égal*"; second, a reference to Vladimir's "bottomless, punctiliously precise memory." Unequaled haughtiness and inexhaustible memory may indulge themselves in the novel as chess problem or verbal puzzle; but must the damage be compounded by the biographer's making similarly inordinate demands in basing many of his arguments on works by Nabokov he does not discuss until the second, as yet unpublished, volume?

Presently Boyd pulls out one of the grandest rabbits—almost an elephant —from his, or his master's, hat: "Only those who decide on art's indirection, its plexed ways and reversed images, seem *almost* to peer through the periscope into something beyond." (Italics mine.) After all that plexing of rays and flexing of muscles, not even to peer—only almost to peer? Such almost-peering is far too peerless for me. And when Boyd tries to forestall and disarm the opposition that may find Nabokov "too cerebral, romantic, or sensual," he is rather off the mark; the main opposition would address the smugness, the superciliousness, the arrogance that so often remove him from humaneness. This, after all, is the man who— from the Palace Hotel, Montreux, where his last years more or less recapitulated the luxuries of his first ones—wrote to Andrew Field: "It really is remarkable how many poets of our day, including Blok, Annenski, Mandelshtam, Hodasevich, Gumilyov, Shishkov, Bunin, and of course Pasternak, allowed vulgarisms and downright blunders to disfigure their best verse. One day I'll list and discuss the examples." That day, apparently, never came; meanwhile, we cannot fail to notice whose name does *not* figure on that list.

This, too, is the man who, Boyd reminds us, began to refuse interviews in the 1960s unless the questions were supplied in writing and well in advance. In which case, why bother with the interview at all? Again, Boyd leaps to the defense: "It isn't that Nabokov was vain, but that, as he said, 'I speak like a child.'" And should the child in man not be heard? Boyd concludes his defense with what he seems to consider a pelucid algebraical schema for Nabokov's craft:

Just as in nature one discovery may precipitate others or upset old ortho-
doxies, so Nabokov linked solution to solution, so that each answer could
trigger or inhibit another: *b* becomes problematic only when *a* has been
solved; *c* and *d* suddenly seem clear, though until now we had not even
thought them obscure, only after *e* has been answered; *f* and *g* and *v* we
recognize in a flash are related to each other [correctly "one another"] and
to the old puzzle of *m* and *n*.

Every nightmare has an end, and we finally emerge from the chapter on
writing into the chapter on *The Defense*, only to be hit with "this time his
novel sheds all the ungainliness of definition to become poetry and drama
and much more." One is reminded of Voltaire's comment on Pico della
Mirandola's proclaiming himself master of all things knowable: "And
several others." "Sheds the ungainliness of definition," at any rate, is a
phrase that should make its way in today's world. Further, we are told that
Nabokov "pays us the supreme compliment of assuming we can play like
champions" and "so allows us—and this is the secret of his art—to ex-
perience the exhilaration of outperforming ourselves." Quite aside from
the fact that this must be (I have lost count) the eighth or ninth secret of
his art, the trouble with such a challenge is that once people start outper-
forming themselves, there's no stopping them. Pretty soon they have left
the text and author behind and are floating somewhere in the stratosphere
and shedding the ungainliness of the last shred of common sense.

In *The Defense*, it seems, we find Nabokov putting together parts of the
world "with a speed, a fluidity, and harmony fiction has rarely attained."
But Nabokov tells us about Luzhin's (the hero's) grandfather that he was
"susceptible . . . to the doubtful splendors of virtuosity," a word of war-
ning the author himself might have pondered. And forthwith there is
Boyd instructing us, "Even after several rereadings, the participation in
Luzhin's life of this dead grandfather, his dead father, and a force beyond
them orchestrating their counterpoint might well seem a preposterous
idea." Well, no; after sufficient rereadings, even the participation of un-
born grandchildren will remain uncontested by the browbeaten and mes-
merized mind.

Yet these critical extravagances do not vitiate Boyd's remarkable bio-
graphical research, his inspired detective work. Even in periods that are
poorly documented, Boyd is able to reconstruct Nabokov's daily rounds,
literary and lecturing activities, chores and struggles, and assorted ex-
periences in love, friendship, and enmity. It is all there, laid out perspicu-
ously and compellingly told, eliciting our admiration both for Nabokov's
talent for survival and for Boyd's herculean spadework and skillful or-
ganization.

Soon, however, we are back to criticism and heading for trouble. Con-
cerning the story "Pilgram," we are told: "Best of all, perhaps—and one

cannot read Nabokov without grasping such facts—is that for all Pilgram's gloom at his drab street, his shop, his dingy apartment, his uncomprehending wife, the story somehow turns every one of these into a prize as rare and strange as any treasure in his shop or on the jungle slopes of Surinam." Let's see now: We can't read Nabokov without grasping certain elusive, paradoxical facts proving that constraint and shabbiness can be as glorious and rewarding as nature's most prodigally lavished bounties—indeed, more so. How? *Somehow*. "The story somehow turns . . ."

What is this Somehow—what are all these Nabokovian Somehows—really about? They are about authorial authority: It is so because I, Vladimir Vladimirovich Nabokov, say so. This authorial, authoritarian say-so dictates how a story or novel is to be read. In the case of "Pilgram," the point is to vindicate the author's straitened circumstances, his émigré existence: hand-to-mouth, if you will, but head-in-the-stars. As Dabney Stuart put it in an essay in *TriQuarterly's* famed Nabokov issue, "an important part of reading [*Laughter in the Dark*] is the reader's consciousness of . . . the authorial presence, the controlling intelligence that is at work in every facet of the book. Things happen because the author makes them happen . . ."

Though not so wonderful as Stuart, Boyd, and their likes seem to think, this is not contemptible. All fiction is a conscious or unconscious attempt to remold reality in some personal, special way. The true question is how skillful and valid this special kneading or pleading is—how stimulating, revelatory, and also self-effacing. If Nabokov does not pass this test with flying colors it is because writing for him is the restoration, or restitution, of the seignorial rights the revolution stripped him of, which, all too often, spells sneering, sniggering intellectual superiority. Or else it becomes, no more appealingly, a slightly self-pitying benignity—the avuncularly lecherous prologue to *Lolita*, for example.

The archenemy, needless to say, is Freud, who would deny supremacy to the Nabokov superego and make it share billing with some obscure id: the dark, undifferentiated need common to all the unwashed, rather than the fully conscious creation *ex nihilo* by the god-like author. "Nabokov," Boyd informs us, "did not see Freud in literature except for fashionable vulgarians like Stefen Zweig," who are not literature. And, parroting his master, Boyd tells us that love of William James "helped shield Nabokov against the archaic mythmaking and witchcraft of Freud." Yet Nabokov himself has been called (not displeasingly to him) The Enchanter, and there is nothing like the murderous fury of rival magicians, competing mythmakers.

It is the condescending smile of the Supreme Enchanter that ruins much of Nabokov's fiction. It shows up even in the unlikeliest places, such as Nabokov's moviegoing. Sirin had scant use for serious films (in a letter, he even refers to Eisenstein as "Eisenstadt"), but he adored any inept

American movie. "The more casually stupid it was, the more he would . . . shake with laughter," sometimes to the point of having to leave the hall. *Schadenfreude* and patronization are the principal types of tone in Nabokov. Devout followers, to be sure, don't notice such things; it's marvelous to find Boyd speaking of "Lolita's pain—for the sake of which Nabokov wrote the whole novel," and, apropos *Despair*, of "a sympathy for others perhaps even richer than life allows."

Just how does one get this message from *Despair*? By proclaiming it— and other Nabokoviana—the gleeful inversion of values Nabokov holds dear: a parody, full of gusto, of one's own sense of art. Nothing, I think, could be further from the truth. But Boyd can even find affinities between Nabokov and Chekhov—in that they both on occasion released mice caught in traps. Can you imagine Anton writing to his mother as Volodya does to his from Paris: "Already my *bons mots* are coming back to me"? He hobnobs with the poet Khodasovich, the novelist Aldanov, and the newspaper editor Ilya Fondaminsky, and enjoys the company of the other literary and political lights of the emigration, but is saddened by his brother Sergey's homosexual lifestyle. Staying with the Fondaminskys, he is treated like a king:

> . . . he slept thirteen hours, and Fondaminsky was waiting . . . to run a bath for him when he awoke. Amalia Fondaminsky . . . provided him with a special dressing table with his own talc and eau-de-cologne and soap. She typed up the thirty-odd pages of *Despair*—its revision just completed—that he planned to read [in public]. She even said nothing when his constant smoking badly effected her lungs.
>
> As he dressed for his reading, Sirin found [his friend] Kyandzhuntsev's tuxedo jacket too short, leaving exposed both the cuffs of his silk shirt (which Kyandzhuntsev had also lent him) and the belt of his trousers. Amalia . . . quickly made some elastic armbands, Zenzinov gave him his braces, though his own trousers kept falling down, and when Sirin could at last be pronounced elegant, all three of them took a taxi . . . to the Musée Sociale [*sic*].

At the reading (Nabokov was to give many such over the years), "a dreadful woman reeking unbearably of sweat approached him and said something he did not catch"; it was a former mistress "who later in the week sent him two scolding letters." Shamelessly, Nabokov gave a three-hour reading. Back in Berlin, he started work on *The Gift*, and came down with excrutiating neuralgia intercostalis: "It is a rare illness, as is everything about me." Does the "everything" refer to "rare," or to "rare illness"?

Problems with English translations prompted Nabokov to start writing in English. "To translate oneself is a frightful business," he writes at a time

when looking after his little boy, Dmitri, was quite a chore, too: "looking over one's insides and trying them on like a glove, and discovering the best dictionary to be not a friend but the enemy camp." Still, even in Nabokov's own translation, *Despair* does not make Boyd's hit parade; the masterpieces, he tells us, are *The Defense, Invitation to a Beheading, The Gift, Speak, Memory, Lolita, Pale Fire,* and *Ada.* Meanwhile the Nabokovs are living in straitened circumstances but, as Vladimir puts it, they "always had enough for clean, comfortable quarters [a proud prevarication, see below] and good food, including as much fresh orange juice as baby could imbibe."

In Paris again, Nabokov, at age thirty-seven, has what seems to have been his one extramarital affair. It was Irina Guadanini's mother who, rather farcically, set it up; but the affair with Irina became a serious, bittersweet story that made him break out with psoriasis and drove him to the verge of suicide. Boyd notes that "Nabokov was never a person who knew how to take love lightly," and even after he rejoined his wife and son in Prague, he and Irina conducted a clandestine correspondence, in which, however, "there was never a hint of criticism of his wife." When an anonymous letter from Paris alerted Véra, Vladimir had to lie; later he confessed, but refused Véra's offer to set him free. Still, the letters continued, Véra found out, and there were many stormy scenes.

By the time the Nabokovs moved to France, the affair was over. Nevertheless, defying Vladimir's wishes, Irina came to Cannes, and there was a sad confrontation and altercation with her lover. For hours, she stayed on the beach to watch him disport himself with Véra and Dmitri; finally she left, never to see Nabokov again. He, meanwhile, had finished *The Gift,* "in the eyes of many, the greatest Russian novel of the century," a statement that strikes me as criticism by Gallup poll. Owing to the timidity of émigré publishers, it took fifteen years for the work to be published in full. Marital peace, however, was fully restored: "Ahead lay another forty years of serenely happy marriage."

The thirty pages that Boyd devotes to *The Gift,* though excessive, are intelligent, thorough, generally persuasive criticism even for those less enamored of the book than he is. Still, his writing, does at times become a Nabokov pastiche: ". . . almost every sinuous sentence bulges with parentheses, like a snake rendered sluggish after swallowing too many plump, irresistible mice." Unlike Boyd's or Nabokov's, Chekhov's sentences would have set those mice free.

Nineteen thirty-eight and 1939 were to be years of near-destitution. But Nabokov, undeterred, kept writing, often in top form. Not so Boyd, when he describes Nabokov's play *The Event* as moving "like a Chekhov drama played at 78 R.P.M., with all the gesture jerkier and the voices either more squeakily comic or more gratingly shrill." This trope is doubly unfortunate: first, because a Chekhov drama is not an LP record; second, be-

cause jerkier gestures have to do with film projection, not sound reproduction. It is, however, nice to learn, speaking of music, that Rachmaninov so admired Sirin that, hearing of his financial woes, he sent him, sight unseen, twenty-five hundred francs.

For a while, the three Nabokovs lived in a one-room Paris flat where, what with Dmitri's needs coming first, Vladimir wrote on a suitcase placed across the bidet until, after sundown in the unheated bathroom, his fingers turned numb. With presumably unimpaired fingers, Boyd writes: "More than any other Nabokov work, *The Real Life of Sebastian Knight* bares its devices, like an X-ray of a grinning conjurer." But you don't detect conjuring tricks by X-ray, except in the unlikely case of a magician's using his own bones to conjure with. Altogether Boyd's diction, never flawless, gets sloppier toward the end of the book; we read of "a brush near death," of "V.'s dissolving into Sebastian and Sebastian [*sic*] into Nabokov," and so on.

It is one of literary history's piquancies that Nabokov worked on his first English novel with Lucie Léon Noel on the same table on which her husband had worked with Joyce on *Finnegans Wake* for twelve years. Nabokov did in fact meet Joyce at a party, without anectdotal results. Modestly, he admits, "I am always a disappointing guest, neither inclined nor able to shine socially." Though home life with the spoiled and obstreperous Dmitri is hard in cramped quarters, Nabokov writes away busily, turning out, among other things, his last Russian works: an unsuccessful early version of *Lolita*, and an equally misfired first shot at *Pale Fire*. As the first volume of Boyd's book ends, Nabokov has pretty much mastered writing in English, and, just a jump ahead of the rapidly advancing Germans, embarks with wife and child for America. "Their worries," Boyd concludes, "were over."

Not, however, the reader's. Will the concluding volume be even longer? Will Nabokov be declared in it the second—nay, first—Shakespeare? Will Boyd, so good at resurrecting vanished places and people, run amok when confronted with surviving persons and settings? Will we be treated to descriptions of every Cornell University brick Nabokov's gaze glided over? The true name and location of every motel that figures in *Lolita*? Interviews with every waiter at the Palace Hotel in Montreux?

What we are unlikely to get is full treatment of Nabokov's narcissistic gamesmanship and Olympian arrogance—what Sartre put his finger on when he said that Nabokov "never writes without *seeing himself* write, as others listen to themselves speak." True, this observation comes from a hostile critique, but one may come away with identical strictures from even the most reverential tributes. For example, William Woodin Rowe, in *Nabokov's Deceptive World*, writes: "Elusive inter-echoes from line to line, from book to book subtly expand. . . . [Nabokov] writes from a grandly isolated pinnacle." And Julia Bader, in *Crystal Land: Artifice in*

Nabokov's English Novels, observes: "The search for pattern is both chronicled by and projected onto the made-up world of self-conscious literary games. Since this world is an interior mirror of the artist's imagination as filtered through his manipulation of novelistic tools, the surface texture is the most telling reflection of a personal vision."

Do we really want a fiction full of such "inter-echoes" that requires reading and rereading the master's every self-serving word? Might we not be tempted to let him play his literary solitaire by himself on his "grandly isolated pinnacle"? Are too much "manipulation," too many "interior mirrors," more than we can use outside a megalomaniacal magician's fun house? Could "surface texture" have been elevated to heights where non-Sherpa readers cannot follow?

I think that three books constitute Nabokov's not inconsiderable legacy: *Lolita*, *Pnin*, and *Speak, Memory*. In them, Nabokov's forte, playful self-pity leavened with mocking humor, is at its strongest, as is the evocation of lost worlds. Onanistic wordgames and patronizing ostentation are kept in relative check, in contrast to, say, *Pale Fire* and its nonfiction counterpart, the *Onegin* translation and commentaries, or in *Ada* or ardor to outdo everyone from Proust to Borges.

And whatever one may think of Nabokov, Boyd's book will be, in the eyes of many, the greatest Russian-novelist's-biography of the century. It is certainly minutious and monumental, splendid at rendering the details of Nabokov's life, thorough in interpreting his works, and evocative in conveying family background, historical panoramas, and personal relations. From *Wunderkind* to wanderer in exile, from *enfant terrible* to enchanter, from lepidopterist to lover, from dilettante to diligent writer, from Vyra to Véra, everything and everyone is copiously here. The evaluations may overshoot the mark, the style may fall short; but the loving scrutiny does not miss a single pattern on this rare butterfly's wings.

February 1991

The "Ecstasy" of Jean Baudrillard

Richard Vine

It is easy to see that the moral sense has been bred out of certain sections of the population, like the wings have been bred off certain chickens to produce more white meat on them. This is a generation of wingless chickens, which I suppose is what Nietzsche meant when he said God is dead.

—Flannery O'Connor

Something in all men profoundly rejoices in seeing a car burn.

—Jean Baudrillard

Picture this droll scenario. Two hundred and thirty-nine young men are writing to their families, drinking with their buddies, shining shoes, talking to their girlfriends on the phone. They do not know that on October 23, 1983, a truck will slam through the gate of their Marine compound in Beirut, exploding to kill them gruesomely, without a fight. During this same period, partisans, and bystanders are being shot daily in Ireland, El Salvador, Angola, Iran, and countless other bewildering locales. The United States and the Soviet Union, nurturing contrary interests in several of these regional abattoirs, confront each other with extravagant nuclear arsenals. And meanwhile, a certain sociology teacher at the University of Paris facility in Nanterre records a few rueful complaints: "what no longer exists is the adversity of adversaries, the reality of antagonistic causes, the ideological seriousness of war" and "entry into the atomic club, so amusingly named, very rapidly removes . . . any inclination towards violent intervention." Within pages, warming to his conviction that deterrence, safety regulations, and even ecological precautions are merely symptoms of an insidious oppression, he declares:

> Paradox: all bombs are clean—their only pollution is the system of control and security they radiate *when they are not detonated*.

These humane sentiments are soon translated into English and published with the aid of Columbia University. So venerated is the author at such elite American colleges that his theories are often discussed in graduate seminars, his works sought out for anthologies and study, his signature concepts—"hyperreality," "implosion," "the orders of simulacra," etc.—taken up in stylish intellectual journals. The gist of his thinking—that "there is no reality . . . other than that directly produced by the system as its ideal reference"—quickly captivates a number of young critics, who apply it to the self-referential world of postmodernist art. Deeply enchanted (or, in their own terms, "seduced"), they proselytize with such fury that many artists feel compelled to adopt their bizarre lingo and even to produce "simulationist" works in accord with their master's singular vision.

In 1987, on a triumphal lecture tour sponsored by the Whitney Museum, Columbia University, and the School of the Art Institute of Chicago, this self-described "metaphysician" and "moralist" enthralls large audiences of contemporary art devotees, who reportedly regard his books as divine writ. (Divine despite the writer's sincere—and accurate—protestation that he cannot explain current art practices linked to his name, despite a nearly complete lack of professionally credible aesthetic or art historical analysis in his work, and despite his published contention that "all of art since the Renaissance has been rot" and, in any case, "art is dead.") Ultimately, within five years of the American appearance of the "clean bombs" statement, Stanford University honors the theorist with publication of the twenty-year survey *Jean Baudrillard: Selected Writings.*[1]

All of this occasions here a modest critical query: how did the unlikely Jean Baudrillard achieve such an exalted intellectual status? We have glimpsed part of the answer already. In a world of rampant academic celebrity (as opposed to earned fame), there is no cachet equal to that of the mysterious French intellectual. Whatever else one may say of Foucault, Barthes, Derrida, Lacan, Bataille, Lévi-Strauss, and now Baudrillard, they have certainly perfected the oracular wiles necessary to win abject American admirers. But for a fuller understanding of the Baudrillard phenomenon we must turn to his writing—as painful as that prospect may be. Only there can we discover the peculiar attraction of Jean Baudrillard's nihilistic romance.

Born in Reims, France, in 1929, Jean Baudrillard spent two decades, 1966 through 1987, teaching at the satellite university in Nanterre, site of the student uprising that precipitated the May 1968 disruptions in Paris and beyond. Since that epochal spring, he has produced a score of (mostly short) books dealing in a quasi-structuralist, quasi-semiotic manner with

1 *Jean Baudrillard: Selected Writings*, edited by Mark Poster (Stanford University Press, 1989).

the impact of the mass media on economic and social commerce. In this body of work, Baudrillard's thinking has passed through three phases— actually shifts of strategy, tenor, and emphasis rather than content—comprising a hysterical escalation from the post-Marxist (1968–71), to the socio-linguistic (1972–77), to the techno-prophetic. Even limiting our examples to the principal titles available in English (since our topic is Baudrillard's sway over certain American intellects), we can witness the author beginning with qualified statements and reasonable—sometimes almost testable—axioms, passing quickly to pure speculative assertion, and ending with sci-fi prophecy of a sort intended to induce the very effects it predicts.

The two books of Baudrillard's post-Marxist phase, *The System of Objects* and *Consumer Society*—published in France in 1968 and 1970—examine the psychological imperatives of consumption in an advanced capitalistic economy. The first argues that meaning, not use, is primarily transferred through consumer objects and that the individual in effect buys a group identity and a metaphysical order with each over-determined purchase. The second contends that the individual—to the extent that he matters at all—merely fulfills the needs of the productive system under the *illusion* that he is servicing his private wants.

Baudrillard's impatience with Marx (who, after all, believed that need and scarcity were genuine) bloomed into explicit dissociation in *For a Critique of the Political Economy of the Sign* (1972) and *The Mirror of Production* (1973). Here Baudrillard announces not only that the sign prevails over social and economic activity, but that—in an improvement over Saussure—all alleged connections between referent (the real thing), and signifier (the marker for the concept of the real thing) have been definitively ruptured, if indeed they ever obtained. In this schema, signifiers "implode" to interrelate arbitrarily, in and of themselves, with no necessary correspondence to anything beyond their own chaotic but sovereign permutations. Of these we are observers at best, hypnotized slaves at worst.

If all of this sounds a bit like a Japanese monster movie entitled "Television: Master of the Universe," it should. From this point onward— through *Symbolic Exchange and Death* (1976), *The Beaubourg Effect* (1977), *Forget Foucault* (1977), *On Seduction* (1979), *Simulations* (1981), *Fatal Strategies* (1983), *The Ecstasy of Communication* (1987), and *The Evil Demon of Images* (1987)—Baudrillard's argument, though subject to a dizzying array of variations, remains essentially constant. Television, advertising, and cybernetic technology are making the world safe for solipsism. "Fatal"—i.e., inconsequential—events arise and die in "ecstasy" (pure, empty, self-parodying form) without changing the exploitive equilibrium in which we are held, except to make us helplessly aware of our state

through their "catastrophes." We are "seduced" by the charm of appearances, only to realize that there is nothing beyond appearances and that our own best maneuver is to practice surface manipulation ourselves, to seduce in turn some portion of the system by becoming so much like it, so perfect a clone, that it is forced to change or to reveal some new facet in order to maintain its authority over us. Of this strategy, no better example could be cited than Baudrillard's recent *America* (1986), in which the United States is treated not, in the manner of Tocqueville, as a noble and thrilling (though necessarily imperfect) experiment in democratic rule but as an hallucinatory spectacle whose greatest virtue is its glorification of trash: "The latest fast-food outlet, the most banal suburb, the blandest of giant American cars or the most insignificant cartoon-strip majorette is more at the center of the world than any of the cultural manifestations of old Europe."

Even this compressed survey makes Baudrillard sound much more systematic than he actually is. In fact, his thought does not develop at all. He is simply an aphorist who seized upon half a dozen borrowed concepts twenty-odd years ago and has rung changes on them ever since. Thus it is both frustrating and deceptive to seek progressive modulations between one text and another. They are all basically one book, and any fifty consecutive pages of Baudrillard are essentially the *whole* of Baudrillard. We are confronting a trendier version of Salman Rushdie's "the Untime of the Imam"—a fixed mentality which expressly repudiates dialectic and nurtures a cluster of preconceptions variously stirred at various moments but completely innocent of a vital dynamism.[2]

A lack of organic growth does not, however, preclude a myriad of jazzy effects. Baudrillard is determined to dazzle his way out of the professional ghetto. His longing, though not exactly that of the moth for the star, unceasingly draws him into ever more florid formulations. Thus his critique of society only *begins* with the academic orthodoxy of our day: "In order to function," Baudrillard writes in *The Mirror of Production*,

> capitalism needs to dominate nature, to domesticate sexuality, to rationalize language as a means of communication, to relegate ethnic groups, women, children and youth to genocide, ethnocide and racial discrimination.

2 Many of Baudrillard's books are substantially translated in his *Selected Writings*, including *The System of Objects*, *Consumer Society*, *Symbolic Exchange and Death*, *On Seduction*, and *Fatal Strategies*. Semiotext(e), in New York, has published *Simulations* (1983), *Forget Foucault* (1987), and *The Ecstasy of Communication* (1988). Telos Press, in St. Louis, has published *The Mirror of Production* (1975) and *For a Critique of the Political Economy of the Sign* (1981). Verso, a London-based publisher, has just brought out the U.S. edition of *America* (1988). *The Beaubourg Effect* appeared in the Spring 1982 edition of the quarterly journal *October*.

Clearly, this litany contains, properly speaking, no ideas at all, only unex-
amined articles of faith. But no matter. This is a credo; these are the things
one must *say first* in order to gain a hearing among our vanguard culturati.
Students and young artists tend to find such "truths" self-evident, even
comforting, since they comprise the lore most consistently heard from
their "deepest" teachers and intellectually raciest friends. Real titillation
begins only when the writer promises to go farther, to share forbidden
pleasures even more lurid than these refurbished Marxist clichés.

We now live, Baudrillard claims, in a culture of the hyperreal. Our lives
are shaped, indeed constituted, by symbols functioning without reference
to tangible objects, individual identities, or biological needs, all of which
have in every important sense ceased to exist. Only signifiers *are* in this
essentially dematerialized universe. Mere simulacra—the distant imita-
tions of, or pure signs for, a lost and often already phony reality (the
"country breakfast" at a shopping mall, the off-the-shoulder blouses worn
by every waitress in a franchised "Mexican" restaurant)—combine and
recombine in an apparent "free play." Yet even the interactions of
simulacra are dictated by an irresistible DNA-like social "code" that fosters
"consummativity," the perpetual motion of a humanly pointless but sys-
temically self-sustaining capitalism.

Baudrillard's prime metaphor here is Disneyland. Everything in this
magic kingdom conspires to enrapture the unquestioning through the
deployment of more-real-than-real simulations. Such a world, such a fan-
tasyland, beguiles us while exercising a surreptitious repression. To be
sure, it frees us from the tiresome myths of individuality, originality, and
authenticity. "All the great humanist criteria of values," Baudrillard exults,
"all the values of a civilization of moral, aesthetic, and practical judgment,
vanish in our system of images and signs." But it also mires us in a
homogeneous stasis controlled by and for the phantasm itself. The greater,
more mysterious, more impetuous portion of our being, our non-prag-
matic "ambivalence," goes unacknowledged and untapped. Ontologically,
we count for nothing. The system, by means of its all-powerful code—
expressed especially through advertising, television, and the news media
—steadily generates the arbitrary and controlling "models" from which all
that we experience and do is derived; we are defined and coerced by end-
less, falsely "unique" replications à la the relentless serial imagery of Andy
Warhol.

Against such pervasive tyranny, Baudrillard declares, active resistance
and the old hope of political revolution are worse than futile. Any mar-
shaling of forces only perpetuates the sick paradigm: labor dispropor-
tionately expended for trifles, pure selfhood sacrificed to the cruel lie of
future material salvation, communal play perverted into grim productivist
effort. Hope is how capitalism binds us to the wheel, and Marx was
wrong to think that its energies could be turned against exploitive

functionalism. The socialist utopia, at its best, still requires work and discipline in exchange for its rewards.

One cannot overcome such a system: one can only refuse its blandishments and desist—desire nothing, cease production, seek no rewards and steadfastly refuse them when offered, become a postmodern stoic. Only then can one possibly return to the primal reciprocity—the "reversibility" and "responsibility"—of true symbolic interaction. Not the univocal, unidirectional "discourse" of media to audience, of government to citizen, of manager to employee, of advertiser to hungering psyche; but the direct, immediate, whole person to whole person give-and-take of primitive gift exchange, of the May '68 message walls, of pure conversation, of sex. Only such a transformation is able to "rescue us from the demands of rationality and to plunge us once more into absolute childhood."

There you have it, the whole of Baudrillard's seductive philosophy and the common weakness at which it aims: absolute childhood—a craven exemption from thinking, responsibility, and physical effort.

Who, then, takes Baudrillard seriously? Who most needs and wants to believe that the world actually operates in this fairy-tale fashion? The short answer is, of course, would-be children. More precisely, due to the dismal state of American liberal-arts education and to the concurrent bearishness of our visual arts market, the most vulnerable individuals tend to be practicing artists under the age of thirty-five and young semi-academic critics on the make. Who could be more susceptible to the notion that, though they lack regular political power (being unwilling to engage in anything so mundane as popular electioneering and governance), they can nevertheless—through their signs and their images alone—literally control the world? Never mind that such an idea is the classic rationale of the propagandist and that it has repeatedly been proved wrong by the recalcitrance of the "infinitely malleable" proles. For the voluntarily disenfranchised it is enough that Baudrillard describes—indeed celebrates—culture as a trading pit.

Those for whom signification is all and facture is nothing have made Baudrillard the fulfillment of his own prophecy. He has become an aesthetic commodity, one whose sign value bears no relationship to its alleged referent. "Baudrillard" no longer signifies a man or a body of work but a speech-act of tribal identification on the part of the speaker. It translates as: "I know what's happening on the art scene today. I have read—or at least heard about—hip deconstructionist theory and am eager to explain the former in terms of the latter (since, God knows, it doesn't make much sense to me otherwise). I know that trashing the system while living off its surplus the way Andy did is extremely cool." Certainly the Baudrillard corpus could itself serve as a veritable handbook on how to be an *au courant* intellectual. In it, all the major components fall dutifully into

place. Indeed, thanks to Baudrillard, we can now spell out the seven commandments of contemporary social analysis.

1. Dissociate yourself from conventional life, capitalism, and the vulgar bourgeoisie—preferably by discovering in the unlikeliest places half-hidden machinations of repressive control.

Eager to be ever more *maudit* than thou, Baudrillard manages to surpass the imaginative fecundity of even the magisterial Foucault. First he weighs in with the now familiar claim that the definition of madness is but a ploy, that "every 'psychological dysfunction' *vis-à-vis* 'normality' (which is only the law of the capitalist milieu) is open to a *political* reading." He then proceeds, via a social interpretation of physical disease, to caution us against the pathological dangers of bourgeois hygiene. Conveniently, no mention is made of what science and attendant public health measures have accomplished against cholera, typhoid, smallpox, diphtheria, yellow fever, malaria, influenza, polio, leprosy, syphilis, etc. Instead, Baudrillard's argument, such as it is, resembles a bizarre crossbreeding of Christian Science with those lunatic Communist-conspiracy tirades launched in the 1950s against the fluoridation of city water supplies:

> The artificial purification of all milieus, atmospheres, and environments will supplant the failing internal immune systems. If these systems are breaking down it is because an irreversible tendency called progress pushes the human body and spirit into relinquishing its systems of defense and self-determination, only to replace them with technical artifacts. Divested of his defenses, man becomes eminently vulnerable to science. Divested of his phantasies, he becomes eminently vulnerable to psychology. Freed of his germs, he becomes eminently vulnerable to medicine.
>
> It would not be too far-fetched to say that the extermination of mankind begins with the extermination of germs.[3]

In short, medical progress is a plot—like other bourgeois inventions, it's just another way of stifling naturalism and exerting control.

2. Purport to extend and correct the prevailing vanguard position. (Add ten points if you can do so through a "reflexive" argument that turns key doctrinal precepts back upon themselves.)

A major preoccupation of radical thinkers, from the founding of the Frankfurt School onward, has been the search for an alchemic formula

3 *The Ecstasy of Communication*, translated by Bernard and Caroline Schutze (Semiotext(e), 1988).

that would somehow rid critical theory of such real-life Marxist impurities as chronic low productivity, avant-garde condescension toward "the masses," brute censorship, and, most embarrassing of all, the nettlesome Gulag. Baudrillard's solution is the magic of "transparency," which renders all such difficulties instantly unreal. Had Marx only had the benefit of modern semiotics, he would have realized that commodification explains not simply one element of the capitalist system but the system in toto, along with its very presuppositions. There is no biological essence of man, according to Baudrillard, hence no constant and irreducible requirement for food, shelter, and safety: "the 'vital anthropological minimum' doesn't exist." It is an illusion conjured up after the fact to justify and perpetuate the productivist enterprise: "there are only needs because the system needs them." Everything essential to humankind transpires symbolically, as is evident when Baudrillard asks, rhetorically, "is loss of status—or social non-existence—less upsetting than hunger?"

The monstrosity of such a conception in light of, say, the recent famine in Ethiopia is best contemplated in purely humorous terms. Imagine, then, Monsieur Baudrillard in a restaurant. He peruses the menu fastidiously, selecting at last, with the waiter's recommendation, medallions of veal accompanied by lightly buttered haricots verts, followed by a simple green salad, fruit and mixed cheeses, espresso, and a sliver of apricot tart—complemented by a delicate Chablis and, to finish, a noble but little-known Armagnac. Then, without a quiver, and without so much as having *seen* any food, Baudrillard languidly calls for his check, says a gracious farewell to the maître d'hotel, and departs, having "consumed" the signs of a satisfying repast and fulfilled all the essential requirements of symbolic exchange.

3. Disdain quantitative measures and hard evidence. Spin elaborate theories out of a few anecdotes.

Baudrillard cannot afford to concede the validity of empirical standards of proof, for to do so would invite a great many unsettling questions. Exactly how, for example, is my grandmother's need to sleep *caused* by the manufacture of beds? Does her sleepiness increase with a rising rate of box spring production? Anyone can see that this kind of thinking might lead directly to science, which Baudrillard considers merely "a system of defense and imposed ignorance." For him, positivism, that hereditary curse of the Enlightenment, sets up criteria which, in their alleged objectivity, create a false "reality" by excluding whatever does not conform to a limiting, conventionalizing language: "the object of a (given) science is only the effect of its discourse."

Now you and I might take it for granted that science is nothing more or less than a way of talking about the world—the entire point being that

this particular way of talking (in the second law of thermodynamics, for example) more accurately and consistently approximates the way things actually happen in the cosmos than do the winsome speculations of a three-year-old, of an Eskimo shaman, or, for that matter, of the Archbishop of Canterbury. But to Baudrillard this circumspection is precisely what invalidates science. If empiricism cannot give him everything, and at once, it is worse than useless: it is an impediment.

Perhaps this anti-positivism accounts for the proliferation of flat-footed errors throughout Baudrillard's *oeuvre*. The howlers include a belief that in an art auction "one cannot participate without being present," that "in the United States couples are encouraged to exchange wedding rings every year," that a credit card "frees us from checks, cash, and even from financial difficulties at the end of the month." Perhaps, too, it is why slipshod or cavalier are probably the kindest words that can be applied to Baudrillard's purported scholarship. Here, even his proponents express reservations, as in the anonymous "Notes on the Translation" prefacing *Selected Writings*: "Baudrillard rarely provides full citations in his own notes. . . . At other times [his] quotations have not been located anywhere in the text he cites."

4. Find inventive new applications for some standard postulates from today's master disciplines, anthropology and structural linguistics.

Baudrillard does not think about the world; he thinks about what current hit-parade intellectuals have thought about the world. And like the Pop serialists he occasionally mentions, he appropriates most readily from the tabloid celebrities, the academic equivalents of Liz and Marilyn, Jackie and Troy. Saussure, Lévi-Strauss, Bataille, McLuhan—simply to evoke their names is to account for four-fifths of Baudrillard's research, the rest apparently consisting of long, selfless hours in front of a television set.

Such a procedure almost understandably gives rise to a vision of society as an outsized suburban high school, where all are forced, willy-nilly, to consume and all are judged by the sophistication of their material dialect. ("Which designer label do you wear?" having become, apparently, the prevailing version of "What's your sign?") Baudrillard's sense of history is, as we might expect, woefully inadequate. Thus he can, with complete aplomb, drop a remark like "since time immemorial, from Marx to Marcuse," or, without the slightest verification, adopt the now politically de rigueur position that savages once lived a physically, socially, and psychologically idyllic life to which only a liberation theology of the sign can ever restore us: "There is properly neither Necessity nor Scarcity nor Repression nor the Unconscious in the primitive order, whose entire symbolic strategy aims at exorcising the apparition of Law." Were modernist Britain's sternly provocative philosopher-poet T. E. Hulme among

us today, he would surely observe that this is nothing but spilt Romanticism—of a sort that would probably bring a blush to Lévi-Strauss's own anthropological hero, the sainted Rousseau.

5. *Systematically invert—or "transvalue"—all major tenets comprising the dominant doctrine of the previous generation. (If you are writing in France after 1968, subvert existentialism.)*

They all want to kill Sartre. Kill him and step into his exalted, world-historical place. Baudrillard's oedipal blood lust is so strong that his entire theory is structured in reaction to the great father's ghost. Thus "existence precedes essence" becomes "the precession [*sic*] of simulacra"; "authenticity" becomes "the individual is non-existent"; "good faith" becomes "*truth does not exist*"; "man is freedom" becomes "the hegemony of the code"; choice, responsibility, and anguish become "ambivalence" and "free play"; "man is nothing else than his plan" becomes "there are no longer any projects"; "to choose . . . is to affirm at the same time the value of what we choose" becomes "value is totalitarian." Et cetera.

6. *Sensationalize your language. When in doubt, be murky. When stating the ludicrous, be melodramatic.*

Aristotle talks like this: "What is the highest of all practical goods? Well, so far as the name goes there is pretty general agreement. 'It is happiness,' say both ordinary and cultured people; and they identify happiness with living well or doing well." Jesus talks like this: "Beware of false prophets, which come to you in sheep's clothing, but inwardly they are ravening wolves." Freud talks like this: "Every man must find out for himself in what particular fashion he can be saved." Baudrillard, by contrast, talks like this: "Identity is untenable: it is death, since it fails to inscribe its own death. Such is the case with closed, or metastable, or functional, or cybernetic systems, which are all eventually waylaid by laughter, instantaneous subversion (and not by a long dialectical labor), because all the inertia of these systems works against them."

Shall we conclude from this that Jean Baudrillard has a more complex mind than Aristotle, Jesus, or Freud? An alternative—and more plausible —explanation is that Baudrillard is steeped in the politically useful aesthetics of gibberish. His obfuscation is a matter of taste, of training, and of expediency.

In the contemporary culture wars, an abstruse style is the surest hallmark of a degenerate mind—an intellect ultimately governed by some motive other than truth. A prolix, ideologically impacted poetics *would* quite naturally oppose a classic tradition that has long honored dispassionate reason expressed with conciseness, precision, and memorable

grace. Bad writing of the right sort—i.e., employing the "right" vocabulary toward the "right" political ends—has therefore become both a mark of membership and a weapon. This charged obscurity, when it is not the result of sheer incompetence, derives from a will to convert or to subjugate. It creates a false aura of profundity and at the same time enables the author to elude full responsibility. In a masterly fashion, it combines (1) a faulty syllogism with (2) the coward's defense of a reasonable doubt, to wit:

> (1) All profound works are difficult. (False major premise)
> This work is difficult. (Undistributed middle)
> Therefore, this work is profound. (Invalid conclusion)

> (2) If we don't know for sure what a man said, we can't hang him for it.

Pharisaical writers count heavily upon our desire for psychic economy. If a reader must invest great effort to trick out the author's meaning, he will—particularly if he is academically insecure—be predisposed to accept it, rather than admit the utter waste of some portion of his intellectual energy and ever-diminishing life. Yet even this is a relatively healthy response. For there is often something infinitely crueler at work in truly execrable prose—a verbal sadism, a calculated terrorism of the word.

Baudrillard proceeds not by logic and evidence, but by a prophetic insistence appropriate to his role as the Kahlil Gibran of post-industrial France. Such writing imposes upon the reader rituals entirely of the author's devising, "purification" ceremonies addressed to the gullibility and self-loathing of the intellectually callow. Normalcy, expressed in the consensual meaning of words and in the practice of language as a communicative (and hence communal) act, is derogated as naïve. The reader is cut out and cut off, immured like Justine/Juliette in a dark world of totalitarian rule where political "discipline" is applied to—and eventually welcomed by—those who are not as smart as they should be, nor as "good."

The special irony is that here we are dealing with an author who is himself obsessed with intimations of repression and control on every side. Those who most dread manipulation, it would seem, are those who know what *they* would do, given the chance. "*The discourse of truth is quite simply impossible,*" Baudrillard tells us. There is no "truth," no "reality" for language to convey; but there is, apparently, much for it to invent, and to inflict.

7. *Never face a problem when you can define a new problematic. Offer your disciples deliverance "beyond good and evil," once they agree to be ideologically devout.*

Clearly, we cannot decide what is right until we know what is true. But by setting up a mode of inquiry that precludes true and false judgments, Baudrillard makes moral choice and action unthinkable.

The gimmick-mongers of contemporary French thought are guilty of many logical and factual errors, but these are as nothing compared to their fundamental moral dereliction. For their infatuation with the indeterminacy of texts, the decentralization (and denaturing) of the authorial subject, the provisional quality of every explication, etc., yields a Vichy interpretation of literature—wishfully proposing a world in which no particular individual is responsible for any particular act, in which the capitalist *system* ruins lives day and night, while no upstanding leftist intellectual, whatever his views, could possibly be accused of complicity in the slaughters of the Khmer Rouge or the admissions policies of Soviet psychiatric hospitals. For twenty years now we have suffered the ascendancy of the congenitally evasive. They have taught us their fear of social virility, their horror of *virtù*.

What is it Baudrillard so ardently wants? Something simple and impossible—a revision of the basic terms of existence, "a revolution that aims at the totality of life and social relations." This philosophic pathology weaves its web between the myth of the Golden Past (primitivism) and the myth of the Utopian Future (unfettered symbolic exchange, ambivalence, worldwide youth liberation). "Take your desires for reality," Baudrillard quotes approvingly from the rhetoric of May 1968. Thus he condones the commission of *any* act, so long as it conduces to a privately defined state of Grace.

This overview cannot, in good conscience, be concluded without an apology. Baudrillard's most thorough, most sensitive readers will know that many important points have been passed over in silence, and that the whole of his work has been treated with indefensible kindness. What excuse can there be, the informed may indignantly ask, for such tactfulness toward a man who writes that "atomic war, like that of Troy, will not take place" because—as he explained to an Australian audience in 1984—we have already consumed its images on TV? (Perhaps someone should remind Baudrillard that, in historical fact, not only one but many wars were fought at Troy.) Is gentlemanly deference the proper response to a man who can speak of "the inconsequential violence that reigns throughout the world"—"inconsequential" because it merely tears bodies open without altering, to his satisfaction, "a system of planetary control"? Genteel diplomacy, perhaps, is unsuited to a man who, in a rapture over the telepathic and telemetric precociousness of the disabled, laments that the rest of us are "condemned by our lack of disabilities to conventional forms of work," and holds that the fortunate afflicted "can become wonderful instruments precisely because of their handicap. They may precede us on the path towards mutation and dehumanization."

Perhaps Nanterre is a world fundamentally different from the one the rest of us inhabit—i.e., the world where real beggars cadge real food on real New York subway cars. We are justified in suspecting, however, that the primary difference lies in the perceiver. Baudrillard, like every professional intellectual, is a creature of privilege. He has not had to sacrifice the most alert hours of his most active years to labor or commerce, to the sheer business of earning a living. He is not subjugated to the common life, commuting to office or factory and forced to do his human thinking on the fly. He is, rather, a prime beneficiary of the system he claims (perhaps ingenuously) to detest—one who enjoys luxuries of time and mental cultivation unmatched in all of history, except among the aristocratic and ecclesiastic estates. Baudrillard was paid by the nation of France—which is to say, largely through the taxes of working women and men—to spend his days and nights reading, thinking, writing, and talking to students and professional peers. Such dissipation may have been his undoing, and ours, to judge from the attitude he developed toward his fellow citizens:

> For a long time, I was very "cool" about producing theories. . . . I didn't think it had very much to do with anything. It was a kind of game. I could write about death without it having any influence whatsoever on my life. When someone asked me, "What can we do with this? What are you really analyzing?" I took it very lightly, with great calm. . . . I maintained a position of distrust and rejection. That's the only "radicalness" I can claim. It might have something to do with my old pataphysical training: I don't want culture; I spit on it.[4]

And there, in contempt for everyday people leading everyday lives, the simulationist's smug autocracy begins.

Clearly, Baudrillard has disqualified himself from serious intellectual regard. Yet no small number of commentators insist upon dragging him back before our eyes with each new art season, with each new book, like so many proud kittens with a moribund mouse. And why? Simply because his dream is entrancing. Simply because he is voguish, talking of television, amusement parks, and "fatal strategies" rather than such retardataire issues as justice and meaning.

Certain of these supporters believe that they have a moral out, an "alibi," to use the Baudrillardian term. They are critics of art, which they consider an amoral endeavor—as though any activity which affects the mental condition of a democratic public could be void of ethical import. Granted, at times it does seem that an invisible wall surrounds SoHo, isolating a hybrid species within. It is bad enough when Baudrillard's

4 *Forget Foucault*, translated by Phil Beitchman, Lee Hildreth, and Mark Polizzotti (Semiotext(e), 1987).

abettors remain in these confines, inflicting harm on the entire tradition of pictorial meaning and artistic integrity. But it is infinitely worse when they presume to make pronouncements on global arms policies, general economics, and the "illusory" survival needs of mankind. Once aesthetes and dreamy professors begin to act as though their minor segment of the luxury trade were a model for the whole of productive life, they have left the preserve. They are fair game.

It is time for Baudrillard and his American apologists to stop making themselves ridiculous, time for them to stop luring the impressionable into a fun house that we who have lived to re-emerge know to be a chamber of horrors. Their vaunted infantilism—based on the fatuous notion that man uncontaminated by law and civilization is a creature of sweet temperament, a generous if occasionally mischievous flower child—would be quaintly laughable were it not so dangerous.

May 1989

"Just Let Me Put This Bastard on the Skids": Andrew Motion's Philip Larkin

Christopher Carduff

They are creatures of the moment, and they've created an end-of-the-century literary genre all their own. If you haven't actually read their books, you've surely skimmed their reviews or perhaps even seen them on the afternoon television talk-show circuit. Their story is always the same, these writers, and it's always delivered with the same straightforward, controlled, and terrible bitterness: *I loved him, he was in many ways a great man, but Daddy wasn't the little tin angel he led us to believe he was.*

Andrew Motion, though he is also a distinguished poet, critic, and editor, is, in his new biography of Philip Larkin, just another such writer.[1] His book is the high-art critical-bio version of *Daddy, Dearest*, but it's *Daddy, Dearest* all the same, and the English-language audience for poetry has been snapping it up like some sort of hardcover tabloid, clucking their tongues with condescending pleasure over just how bad the Old Man really was. Nugget-diggers will find the excellent index invaluable, especially, under "Larkin, Philip Arthur" (1922–1985), the subheadings SEX ("attitude to women . . . complains about expense . . . sexual log books . . . pornography") and ATTITUDES AND OPINIONS ("dislike of children . . . fear of marriage . . . loathing of abroad . . . right-wing politics . . . racism"). It's a map to what Tom Paulin, the British press's foreman nugget-digger, calls "the sewer under the national monument Larkin became."

In his introduction, Motion, sketching the connections among Larkin's art, life, and public persona, lays out the major theme of the book in three memorable sentences: "[M]any of Larkin's inner conflicts evolved in ways his work can only hint at. When he found his authentic voice in the late 1940s, the beautiful flowers of his poetry were already growing on long stalks out of pretty dismal ground. Describing this ground must necessarily alter the image of Larkin that he prepared so carefully for his readers." In other words: How perfect the art. How imperfect the life. And oh what a sham all that charming, curmudgeonly, "Hermit of Hull"

1 *Philip Larkin: A Writer's Life*, by Andrew Motion (Farrar, Straus & Giroux, 1993).

crap he served up on a pub-lunch platter. Motion's chief aim as biographer is not to devalue Larkin's *oeuvre*—on the contrary, most of his reading of it is appreciative—but to make us marvel at the paradox of its very existence: for Motion, it's the improbably gorgeous product of a wholly loathsome mind. "To follow [Larkin's] development"—and here Motion means emotional and ideological development, not artistic—"is to have our sense of his achievement sharply increased."

Motion, of course, is not Larkin's son—not, that is, in the literal sense. But to Motion's generation of poets, Larkin was the father-figure, the standard-setter. To Motion himself, as to much of the public, he was the greatest contemporary English poet—indeed, "one of the great poets of the century." And Motion was Larkin's protégé—if Larkin can be said ever to have had one. Thirty years Larkin's junior, Motion first met the poet in 1976 when he, Motion, was twenty-four and newly appointed a lecturer in English at the University of Hull. Larkin was then fifty-three, and had been the university's librarian for over twenty years. The two became good friends, and in 1983, not long before his death, Larkin asked Motion to become one of his literary executors. "At no time during the nine years of our friendship did we discuss his biography," Motion writes. "He did not ask me to write this book."

Neither did Larkin ask another of his executors, his old friend Anthony Thwaite, to collect and edit his letters. (Whether he wished the letters to be collected at all is uncertain; his will, which has much vexed the trustees of his estate, is contradictory on this and other matters pertaining to the posthumous fate of his unpublished writings.) Thwaite's eight-hundred-page selection, first published in England last fall, will be brought out here this winter by Farrar, Straus. It is very much a companion piece to Motion's *Life* in that it gives us, in great detail and at great length, the same "new" picture of Larkin. This Larkin is not the public Larkin of the magazine interviews, who, with self-deprecating humor, presented us with a highly attractive case of stiff-upper-lip in the face of life's shortcomings and of self-sacrifice in the name of art. This Larkin is the private Larkin, and his picture is painted in darker tones of "racism, misogyny and quasi-fascis[m]" (Tom Paulin again). Both the *Life* and the *Letters* may have been begun by friends wishing to do honor to Larkin's achievement, but in the end, and on the bookshelf together, their combined fourteen hundred pages seem intended to crush the three skinny books of poems—*The Less Deceived*, *The Whitsun Weddings*, and *High Windows*—that remain the heart of his *oeuvre*. More exactly, the books seem intended to vandalize —and certainly have had the popular effect of vandalizing—the familiar, shyly smiling image that peered out at us from Larkin's jacket photos. Like the idealized girl on the poster in "Sunny Prestatyn," this image of the poet was too good for this life. It proved an irresistible target to

Motion and Paulin and all the other conflicted scribblers who both take excitement from Larkin's work and, consciously or not, hate him for it.

"You know," Larkin once wrote to Thwaite, "I was never a child: my life began at 21, or 31 more likely. Say with the publication of *The Less Deceived.*" This was one of Larkin's many ways of saying that only his art really mattered; all else, including the "biographical sources" of that art, was dross. But Larkin was, of course, a child once, and he remained always his parents' son. Motion is at his most sympathetic when writing of Larkin's early years and the ways they shaped his sensibility.

Larkin's father, Sydney, a government accountant in Coventry, filled his son with the faults he had, but also imparted his virtues. He was, in Motion's words, "intolerant to the point of perversity, contemptuous of women, careless of other people's feelings or fates, yet at the same time excitingly intellectual [and] inspirationally quick-witted." Larkin's mother, Eva, a cosseting parent and a cowed wife, was passive, snobbish, and forever bewailing her lot. In an unpublished memoir, Larkin wrote that "the marriage left me with two convictions: that human beings should not live together, and that children should be taken from their parents at an early age."

According to Motion, Sydney Larkin's chief legacy to his son was twofold: a taste for literature, especially Thomas Hardy, and a tendency toward what Motion calls "reactionary politics." (Sydney was a Nazi sympathizer, may have been part of a British para-Nazi organization called the Link, and kept a mechanical statuette of Hitler on the mantelpiece at home that, at the touch of a button, sprang into the "*Sieg Heil!*" salute.) He died in 1948, when Larkin was twenty-five. Eva Larkin's legacy was a good deal more complicated. Motion makes her out to be both Larkin's deepest emotional attachment and, more than any other woman in his life, his muse. "Although [she] was often silly," he writes, "although she often drove Larkin into agonies of boredom and frenzies of rage, the ties which bound her to her son were not merely comforting but inspirational. They connected Larkin to his past, to memories of hope and excitement, and to the creative 'sense of being young.' Until the end of her life"—she lived on to the age of ninety-one, and Larkin didn't long survive her—"Eva . . . crucially influenced the accents and attitudes of his poems." Indeed, says Motion, "many of his best [poems] were either triggered by her or about her: 'Love Songs in Age,' 'Reference Back,' 'To the Sea,' 'The Building,' 'The Old Fools,'" and, finally, "Aubade." This said, it strikes one as decidedly odd that Larkin's letters to his mother—there are several hundred extant, for after his father died, he wrote her at least twice a week—are scarcely quoted by Motion and don't figure into Thwaite's collection at all.

After Coventry came Oxford, where Larkin struck out with the girls,

flirted with at least one young man, and, at the prompting of his friend Kingsley Amis, began to write imaginative prose—mock-lesbian romances, mostly, set in a girl's school. Despite his best efforts to play the Bad Boy—to keep his reading strictly off the syllabus and to spend his nights in jazz cellars—Larkin took a First. He left Oxford without plans, longing to become a great writer and hunting for a trade that would both complement that desire and suit his temperament. Quite by accident, while paging through the Help Wanted section of the *Birmingham Post*, he discovered an opening for a librarian position in Wellington, Shropshire. He applied for the job and got it, beginning a distinguished career in librarianship that would take him, in 1955, to the University of Hull.

By that time—he was then thirty-two—he had already completed the bulk of his writing. There had been two remarkably accomplished novels, *Jill* and *A Girl in Winter*, and the beginnings of a never-to-be-completed third. He had brought out a book of poems, *The North Ship*, and found a publisher for his first mature collection, *The Less Deceived*. In an interview with the London *Observer*, Larkin would later call this "probably the 'intensest' time of my life"; for Andrew Motion, who once remarked that "obviously I regret not having known him when he was writing more fluently," they were also his most admirable. What followed, much to Motion's "obvious regret," were three decades of fame, frustrated creativity, and, consequently, lack of authenticity. "All the faces, voices, attitudes, beliefs, jokes and opinions that had evolved during his growth to maturity were," with the popular success of his second book of poems, "suddenly enshrined in the personality which the public decided was 'him.' Like the characteristics he later described in 'Dockery and Son,' they hardened into all he'd got." Larkin suddenly became "Larkin," a character of whom his biographer disapproves.

"Fame," writes Motion, "endangered [Larkin's] poems by threatening the delicate balance between a desire for private rumination and a longing for a public hearing. He wondered how he could continue to 'be himself' if his self depended on remoteness and disappointment, neither of which he could truly be said to possess any more." Here and elsewhere throughout the latter half of the book, Motion is arguing that Larkin, by winning what every poet hopes for (readers, reviews, and respect) and yet rejecting all the perks of the modern poet's "profession" (writer-in-residence sinecures, television appearances, public readings, book tours, etc.), was being hypocritical or even clinically perverse. All that poet-of-deprivation stuff should have been abandoned after 1955, and Larkin should have "developed" beyond it, moved on to other and perhaps sunnier incarnations. He should have "improved" himself, but instead he patented "Larkinism," a private-label poetic shtick. Increasingly, "he was tempted to freeze his life in postures of continuing unhappiness. As far as his work was concerned,

this meant making things out to be worse than they actually were, and at the same time denying that there was anything redemptively strange or unique involved in writing about them."

Even worse, Larkin's fame justified him in his selfishness. "The success of *The Less Deceived* strengthened his resolve to live alone," to have no obligations but to himself and his art. "Never mind that his rate of production was so low (only two poems in 1956) — he now regarded every [positive] development in his career as proof that he was right to behave as he did." And, Motion argues, Larkin behaved very badly, especially toward his women.

In his adult life, there were four. There were Patsy Strang, the free-spirited wife of an acquaintance in Belfast; Maeve Brennan, a member of his staff at Hull; and Betty Mackereth, his personal secretary. But first and foremost there was Monica Jones, whom he met in 1947, when he was a librarian at the University College of Leicester and she a lecturer in English. Except for his mother, she was the most important person in Larkin's life, and she survives him as co-trustee of his estate and, with Thwaite and Motion, one of his literary executors. Though I'm certain the author doesn't see it this way, she emerges as the true heroine of Motion's book when, after being asked by the dying Larkin to do so, she arranges to have his diaries fed to the Hull University Library shredder. She also appears to have been admirably stingy about sharing her most intimate letters from Larkin with her fellow-executors.

What did Larkin get out of these relationships with women, none of which, he was adamant, would ever end in marriage, and three of which, those with Monica, Maeve, and Betty, he juggled at one time? Beyond providing the pleasures of sexual companionship, these love affairs "activated," Motion argues, "a dramatic struggle between life and work on which his personality [and his poems] depended." By dividing his affections among two or more women at once, Larkin ensured emotional disappointment for every party involved, disappointment he could then (sometimes) turn into poetry. Furthermore, his candid acknowledgments of faithlessness, like his openness about his habit of masturbating to pornography, made it clear to would-be wives that he was promised to no one but himself.

Larkin's taste in pornography, like his taste in everything else, was essentially conventional. (His friend Robert Conquest called it "really very unchallenging. Perhaps a bit of spanking, that's all.") Unchallenging or not, that Larkin had *any* kind of taste for it clearly unsettles Motion, as does the wildly abusive language about women (and "wogs" and "socialists" and so on) that peppers many of Larkin's letters, especially those to old schoolmates such as Kingsley Amis. That Larkin the letter-writer was often playing to his recipients' expectations — that he was trying to keep a wartime school-chum camaraderie and a damn-the-world ado-

lescent's worldview alive for old time's sake—is cold comfort to Motion. For Larkin to have used such language in his youth, back when the world was less enlightened about "the other," is one thing. For him to have used such language even into the 1980s is unforgivable.

This is why Motion saves his most severe blasts for the last years of Larkin's life, the years between the publication of his final book of poems, *High Windows* (1974), and his death, at age sixty-three, in 1985. It was during these years, when the poems were no longer coming, that his "anger and sense of futility kept pace with each other, driving the comedy out of his extravagant opinions and clouding the pleasures that remained to him." In other words, "his frustration as a writer had by now affected all his judgements." That Larkin professed in an interview to "adore" Margaret Thatcher is offered up as definitive proof of his jadedness, of his having gone totally beyond the pale. Motion cites this tidbit no fewer than four times, with the word "adore" always in scare quotes.

Martin Amis, writing about the *Life* in a recent issue of *The New Yorker*, wrote that "in Andrew Motion's book we have the constant sense that Larkin is somehow falling short of the cloudless emotional health enjoyed by (for instance) Andrew Motion." As an effort to catch the between-the-lines condescension of biographer to subject, this sentence can scarcely be improved. But Motion is not merely condescending, he is, by the book's final pages, wholly out-of-sympathy, unable or unwilling to imagine Larkin from the inside out. Larkin saw him coming, or someone very much like him, when he dreamed up "Jake Balokowsky, my biographer," in the poem "Posterity." Balokowsky is the jeaned-and-sneakered embodiment of the Sixties-generation literary professional, a careerist who laments that, in writing Larkin's life, "I'm stuck with this old fart at least a year." "Just let me put this bastard on the skids," he says, "I'll get a couple of semesters leave/ To work on Protest Theater." What's Larkin *really* like? a friend enquires. "Christ, I just told you," he replies:

> "Oh, you know the thing,
> That crummy textbook stuff from Freshman Psych,
> Not out of kicks or something happening—
> One of those old-type *natural* fouled-up guys."

At the end of his *Observer* interview, Larkin says: "I should hate anybody to read my work because he's been told to and told what to think about it." For my part, I should hate anybody *not* to read Larkin because he's been told what to think about the man and so thinks he needn't bother. There's a brand-new generation of readers that believes, and is being instructed to believe, that flowers grown from dismal ground are not worth picking. Well, Larkin's flowers are of a hardy strain, and they will survive the present miasma in which they must live, the poisonous

and obscuring atmosphere created by the *Letters* and the *Life* and the Paulins among their reviewers. "Church Going," "Dockery and Son," "The Whitsun Weddings," "An Arundel Tomb," "Aubade": go read them again, now, and *aloud*. To do so is to be moved by them afresh and to drown out all the irrelevant noise about the "unfortunate" circumstances of their composition.

September 1993

C. P. Cavafy: A Poet in History

Joseph Epstein

Freaks of literature, like freaks of nature, turn up in odd and unpredictable places. Why, after all, should Buenos Aires produce a Borges, Palermo a Lampedusa, Trieste a Svevo? The only—and perfectly unsatisfactory—answer is, Why not! Nothing in the traditions out of which any of these writers derive could have anticipated their becoming, as all did, writers of world interest. No very good explanation is available, really, just the brute fact of their arrival, writing quite unlike anyone else before them and producing enduring work of universal value. As they come upon the scene out of nowhere, neither do these writers begin or leave anything like a tradition behind them. *Sui generis*, in a class by oneself, is, after all, only another phrase for freakish.

C. P. Cavafy, the Greek poet who lived in the ancient Egyptian city of Alexandria, is another such freak of literature—perhaps the most interesting, idiosyncratic, and unexplainable of them all. Along with Borges, Lampedusa, and Svevo, Cavafy is a poet whose life, whose subject matter, whose point of view is inextricably bound up with his city. "Outside his poems," the Greek poet and critic George Seferis has said, "Cavafy does not exist." But without Alexandria, neither would the poems exist. "For me," Cavafy wrote, referring to Alexandria in "In the Same Place," one of his late poems, "the whole of you is transformed into feeling."

Even though he wrote his poems in Greek, there is a sense in which Cavafy was more an Alexandrian than a Greek. Proud though he was of his Greek heritage, he did not in fact care to be described as a Greek, much preferring to be thought a Hellene. Alexandria, that city built by Alexander the Great and ruled by the Ptolemies, the site of Cleopatra's grandeur and Mark Antony's destruction, was for centuries the vessel through which so much world history flowed. This, the historical Alexandria, a city always more Mediterranean than Egyptian, was the Alexandria that Cavafy loved. He himself came, through his poetry, to resemble it in being yet another vessel through which history, this time in the form of his extraordinary poetry, flowed.

When Cavafy—whose dates are 1863–1933—lived in Alexandria, it was

343

much less a classical than a preponderantly commercial city. Judeo-Hellenic and Franco-Levantine, it was, in the richly crowded sentence of Patrick Leigh Fermor, "a cosmopolitan, decadent, and marvellous hybrid, old in sin, steeped in history, warrened with intrigue, stuffed with cotton, flashing with cash, strident with cries for baksheesh, restless with conjuring tricks, and, after sunset, murmurous with improper and complicated suggestions." In his day, Cavafy must have made a few of those improper and complicated suggestions of his own.

Constantine Cavafy was the youngest of nine children born to a family that, by the time he came into the world, had already seen somewhat better and soon would see much worse days. In partnership with his brother, Cavafy's father was one of the leading merchants in the Greek colony in Alexandria; the family firm specialized in cotton and textiles. In this colony, all that counted was wealth, which the Cavafys had in sufficient quantity for the young Constantine to be raised with a French tutor and an English nurse in the house. Constantine's older brothers were sent abroad for their education. Their father, a free spender, died when Cavafy was seven, leaving his wife with very little money and his son with scant memories of him and the mixed blessing of continuing to think himself a rich man's son. Although the family retained something of its old social standing in Alexandria, having been thought upper-class, its position without wealth would henceforth be insecure, living with only the furniture and the memories of former luxuriance. Later Cavafy would tell E. M. Forster that aristocracy in modern Greece was the sheerest pretense, being built exclusively on cash: "To be an aristocrat there is to have made a corner in coffee in the Piraeus in 1849."

Cavafy's mother was now dependent on her sons for survival. At one point, when Cavafy was nine, the family moved to Liverpool, where the family business had a branch. Later the family moved to London, then back to Liverpool, only returning to Alexandria in 1877, when Cavafy was fourteen. In 1882, during the riots of Egyptians against Europeans in Alexandria, the family fled to Constantinople, where it remained for three years. The result was that between the ages of nine and fourteen, Cavafy lived in England, and between nineteen and twenty-two he lived in Turkey. Afterward he returned to Alexandria, where he remained, with infrequent visits to Greece, what might be called a firmly rooted cosmopolitan.

Cavafy, lucky fellow, did not leave many letters behind, nor an extensive diary. He wrote very little prose in his life and easily forbore the literary man's temptation of autobiography. Little is known about some of the most basic facts of his youth: where, for example, he went to school, apart from a year spent in a commercial school for Greek children in Alexandria. I say "lucky fellow," for the paucity of biographical information about Cavafy has spared him the cruelty of biographers poking into

his life and career chiefly to find ways of advancing their own. The hurdle of intrusive biography is the last that any writer has to jump, and any decent-minded reader nowadays has to hope that the writers he admires will find a way to cheat their biographers. In good part, Constantine Cavafy seems to have done so.

The most complete biography of Cavafy in English is a slender (by contemporary standards) volume of 222 pages by the English writer Robert Liddell.[1] It is mainly concerned with putting to rout a good number of falsifications about Cavafy concocted by Greek writers of Freudian or Marxistical bent. An honest writer, Mr. Liddell has composed a book that, in the nature of the case, is full of "seems" and "supposes." Thus: "Cavafy seems never to have had confidants, and unfortunately we do not know whether his emotions were in any way involved in his sexual life." And: "There is no reason to suppose that he was an obsessional homosexual, the slave of his appetites." Mr. Liddell supplies those facts about Cavafy that can be nailed down, and the scarcity of these facts sets one's own imagination to work and turns inquiring minds—as *The National Enquirer* calls them—to the work itself, from which one is left to do one's best to extrapolate the life.

What is known about Cavafy as a young man is that, upon his return to Alexandria, he had, as Mr. Liddell reports, two things to hide from his friends: "homosexuality and acute poverty." He did what he could to alleviate the latter by working briefly as a journalist, then as a broker at the city's Cotton Exchange. (He supplemented his income by dabbling in the market throughout his life.) He began to work in 1889 as an unpaid clerk at the city's Irrigation Office, in the hope of catching on as a salaried employee, which, after showing his usefulness in dealing with documents in foreign languages, he did about three years later. He remained at the Dantesque-sounding location of the Third Circle of the Irrigation Office until his retirement thirty years later. Robert Liddell speculates that his job at the Irrigation Office gave him the kind of freedom he required.

This was the freedom to be Cavafy, which was a leisurely yet full-time job. E. M. Forster, who was in Alexandria during World War I and who was an early admirer and promoter of Cavafy's poetry, described Cavafy as a fixture in the city: "a Greek gentleman in a straw hat, standing absolutely motionless at a slight angle to the universe." Forster was here describing the poet going either from his home to his office or from his office to his home, perhaps stopping to deliver himself of a sentence of extraordinary syntactical complexity and impressive precision. Cavafy's home was an apartment in the old Greek quarter on the Rue Lepsius, where he lived after the death of his mother, with whom he had resided until he was thirty-six; on a lower floor was a brothel, not the sole such institution on

1 *Cavafy: A Critical Biography*, by Robert Liddell (Duckworth, 1974).

the street, which was also known as the Rue Clapsius. A hospital and a church were nearby. Cavafy more than once told visitors: "Where could I live better? Below, the brothel caters to the flesh. And there is the church which forgives sin. And there is the hospital where we die."

Cavafy's was the settled bachelor life of the homosexual *homme de lettres*. In Alexandria, people remember him as never being in a hurry. He wore dark suits with vests and thick glasses behind which his large eyes were draped by heavy, hooded lids. He lived in an apartment crowded with old furniture and rugs from his mother's apartment, but, surprisingly for a man steeped in history, not all that many books, and those mostly devoted to ancient Greek history, which he knew exceedingly well. He was an occasional gambler. He is said generally to have paid for his sex; his taste, Robert Liddell reports, ran not to Egyptian or Arab *ingénes* but to young Greek men. From the ages assigned to the men in his more erotic poems, one gathers that his ideal was that of Greek men in their twenties.

As Cavafy grew older and as his vigor diminished, so did his fear of scandal, and he began writing—and promulgating—poems about the emotions surrounding homosexual love. With age, he grew rather seedy. Owing to the cancer of the larynx that finally killed him, toward the end of his life he walked about with his neck swathed in not always clean bandages. He dyed his hair with a solution of his own invention. (Voluptuaries take even less kindly to aging and death than the rest of us, and Cavafy's early poems show him when still at a young age already imagining himself a dessicated old man.) His conversation was measured, affable, and apparently memorable, judging by the number of people who met him who have recalled various of his utterances. All must have sensed that, in this odd duck Cavafy, they were in the presence of a great man. Right they were, too.

Cavafy would supply a fine if anomolous chapter in a book on the history of literary reputation. He was, at least among the cognescenti, a famous poet who in his lifetime never published a book, or at least never offered one for publication. Early in his career he published only a half dozen of the nearly two hundred poems he had already written, many of which he would later repudiate. (The final Cavafy canon, in Edmund Keeley and Philip Sherrard's excellent translation, consists of 175 poems.)[2] Cavafy later brought together a pamphlet of his own devising consisting of only twenty-one poems, which he gave to relatives and a few friends. "Thereafter," writes Professor Keeley, who is Cavafy's best critic, "his method of

2 *C. P. Cavafy: Collected Poems*, revised edition. Translated from the Greek by Edmund Keeley and Philip Sherrard, edited by George Savidis (Princeton University Press, 1992).

disseminating his work, along with periodical publication, was through increasingly heavy folders containing broadsheets and offprints, the folders kept up-to-date year after year by Cavafy himself and distributed by his own hand to his select audience of readers, sometimes with revisions inserted by pen." When Cavafy died at seventy, there was no collected edition of his poems, nor had he left instructions for one.

Edith Wharton once claimed that she was fortunate when young not to have been considered promising: all sorts of pressures were removed. Cavafy took this a step further and claimed that he was fortunate to have been neglected. For one thing, a writer in a society where there are no obvious institutions of recognition for artists is automatically released from currying favor; nor need he worry about expressing things that might be impolitic from the standpoint of advancing his career. For another, in such a society a writer may develop at his own pace; he is unlikely to feel, as he might in a different setting, that if he hasn't won this prize by that age, or published that much by this age, he is a dismal failure. A neglected poet, in other words, has time to develop.

Cavafy required such time. The watershed year in his career, all his critics recognize, and as he himself would avow, was 1911, when he was forty-eight years old. (By forty-eight, a poet in America should already have had five books of poems published, an NEA and perhaps a Guggenheim grant behind him, be awaiting a MacArthur, and have tenure locked in. By fifty, if on schedule, he already begins to write much worse.) Not only did Cavafy produce a number of his best poems in the year 1911 — including "The God Abandons Antony," "The Glory of the Ptolemies," and "Ithaka" — but, as if by magic, he had found his style: plain, spare, dramatic.

Cavafy found his subject in the Greek world of the Eastern Mediterranean. Many of the best of his poems are set in the two hundred years following the conquests of Alexander the Great. "The great age of Hellas," as C. M. Bowra wrote, "was no subject for his subtle taste." Bowra is surely correct when he adds that Cavafy "was interested not in the great lessons of history but in its smaller episodes, in which he saw more human interest than in the triumphs of heroes." Cavafy had a splendid instinct for capturing the perfect historical detail that demonstrated the continuity of human nature. Often, the deeper Cavafy's poetry takes a reader into history the more the poem makes him think of the present. His famous poem "Waiting for the Barbarians," in which the rulers and citizens of an unnamed ancient city, awaiting at the city walls, are disappointed at the failure of the barbarians to arrive, ends with the lines:

> Why this sudden restlessness, this confusion?
> (How serious people's faces have become.)

Why are the streets and squares emptying so rapidly,
everyone going home so lost in thought?

Because night has fallen and the barbarians have not come.
And some who have just returned from the border say
there are no barbarians any longer.

And now, what's going to happen to us without barbarians?
They were, those people, a kind of solution.

Today it is difficult to read that poem without thinking of the West *vis-à-vis* the crumbling of Communism. Great poets write poems applicable to events and situations that they themselves could not ever have foreseen. Cavafy's achievement was somehow to write outside time by anchoring his writing as firmly as possible inside time.

Style helped Cavafy immensely in this endeavor. Once he hit his stride as a poet, Cavafy's poems became more and more shorn of ornament. He scarcely ever wrote about nature, and never, *à la* Lawrence Durrell (another of Cavafy's admirers), indulged in Middle Eastern exotica. He wrote in modern Greek, of course, but at least one of Cavafy's critics has suggested that he "thought" his poems in English. (After his early years in England, his Greek was spoken with a slight English accent, and his English, though fluent, was said not to be free of small mistakes—or not always, as an immigrant woman I knew once said, "impeachable.") Reading Cavafy in translation, one doesn't feel—despite Robert Frost's remark about poetry being what is lost in translation—too keen a loss. W. H. Auden has written on this point:

What, then, is it in Cavafy's poems that survives translation and excites? Something I can only call, most inadequately, a tone of voice, a personal speech. I have read translations of Cavafy made by many different hands, but every one of them was immediately recognizable as a poem by Cavafy; nobody else could possibly have written it.

In their foreword to the *Collected Poems*, Edmund Keeley and Philip Sherrard speak of attending to Cavafy's "formal concerns, for example his subtle use of enjambment and his mode of establishing rhythm and emphasis through repetition." But in their limpid translation, Cavafy's poems read with the clarity and ease of a kind that seems trans-national and outside time. Howard Moss said of Cavafy's historical poems that "the tone [is] contemporary, but the voice timeless." Few of Cavafy's poems are more than two pages long; most are much shorter than that. "Nero's Deadline," if not one of his best, is a characteristic Cavafy poem:

Nero wasn't worried at all when he heard
the utterance of the Delphic Oracle:
"Beware the age of seventy-three."
Plenty of time to enjoy himself still.
He's thirty. The deadline
the god has given him is quite enough
to cope with future dangers.

Now, a little tired, he'll return to Rome—
but wonderfully tired from that journey
devoted entirely to pleasure:
theatres, garden-parties, stadiums . . .
evenings in the cities of Achaia . . .
and, above all, the sensual delight of naked bodies . . .

So much for Nero. And in Spain Galba
secretly musters and drills his army—
Galba, the old man in his seventy-third year.

This poem demonstrates Cavafy's stripped-down method, what Joseph Brodsky has called "the economy of maturity": no imagery, no metrical tricks, no rhyme, no surprising or even striking adjectives, nothing ornate; a flat account of an event is given—sometimes told by a participant in the drama of a poem, sometimes (as here) by an offstage narrator—sometimes but not always with an ironic twist added at the end. "Cavafy," wrote George Seferis, "stands at the boundary where poetry strips herself in order to become prose."

But wherein, one might ask, lies the poetry? Often it is in the drama of Cavafy's poems, but not invariably even in that. Strangely, uniquely, I believe, it lies in the absence of metaphors in Cavafy's poems. Cavafy's poems are free from metaphors for the good reason that each of his poems is a metaphor unto itself. In Eliot, in James Joyce, in Yeats, one must, in effect, decode or parse or unpack symbols and myths to extract meaning. The very content of Cavafy's poems requires no such decoding or parsing or unpacking, to learn that this equals that, or that parallels the other.

Through his irony, sometimes through his drama, with the aid of his historical precision and his refusal of undue emphasis or over-dramatization, Cavafy can take a small historical incident, or even a person of tertiary significance, and raise it or him to an impressive general significance. Easier said than done, of course. The details have to be got exactly right, the meaning of the event described perfectly understood.

One of the my favorite among Cavafy's poems is "Alexandrian Kings," which is about a ceremony in which Antony declares Cleopatra's children

349

kings of the known world, which is divided up among them. Kaisarion, the reputed son of Cleopatra and Julius Caesar, is declared the most powerful of them all, King of Kings. Cavafy describes the child Kaisarion's clothes ("dressed in pink silk,/ on his chest a bunch of hyacinths,/ his belt a double row of amethysts and sapphires,/ his shoes tied with white ribbons/ prinked with rose-colored pearls"). He reports that the ceremony was a theatrical success, but makes plain that, in the eyes of the worldly Alexandrians, who enjoyed the event thoroughly on a day when the sky was "a pale blue," it was never more than sheer theater: "they know of course what all this was worth,/ what empty words they really were, these kingships."

Plutarch's account of the event, told in his life of Mark Antony, is rather different. In it, the emphasis is on the two gold thrones Antony has set up for himself and Cleopatra. Plutarch describes the clothes of Antony and Cleopatra's children, Alexander and Ptolemy, but not, as does Cavafy, those of Kaisarion. Plutarch tells us that the Alexandrians were offended by the entire performance: "it seemed a theatrical piece of insolence and contempt of his country." In Cavafy, the Alexandrians are less enraged, more cynical. The entire episode is made all the more poignant by the fact, reported later and laconically by Plutarch, that "so, afterwards, when Cleopatra was dead he [Kaisarion] was killed." The attention, in Cavafy's version, is where it ought to be: on the child, who, being history's plaything, is pure victim.

Is this touching up history? Better perhaps to think it poet's history. Cavafy, toward the end of his life, declared himself "a historical poet." He added: "I could never write a novel or a play; but I hear inside me a hundred and twenty-five voices telling me that I could write history." Living in an ancient city, Cavafy had a feel for history, found his inspirations and deepest perceptions in history. The historian's function, in this view, is to show what happened in history; the poet's is to make plain its significance, but in the particular, oddly angled way of poets. In a later poem entitled "Kaisarion," Cavafy recounts how he came to write "Alexandrian Kings." He recounts killing an hour or two on a book of inscriptions about the Ptolemies, where he happened to come upon Kaisarion's name. The poem continues:

> Because we know
> so little about you from history,
> I could fashion you more freely in my mind.
> I made you good-looking and sensitive.
> My art gives your face
> a dreamy, an appealing beauty.
> And so completely did I imagine you
> that late last night,

as my lamp went out—I let it go out on purpose—
it seemed you came into my room,
it seemed you stood there in front of me,
 looking just as you would have
in conquered Alexandria,
pale and weary, ideal in your grief,
still hoping they might take pity on you,
those scum who whispered: "Too many Caesars."

Not all Cavafy's poems have a classical setting. A handful are set in the Byzantine Empire. A few are of the kind that Marguerite Yourcenar, who translated Cavafy into French, calls his "poems of passionate reflection." (Only one in the *Collected Poems* is uncharacteristically comic: "King Claudius," which considers the Hamlet story from the uncle and step-father's point of view.) Many more are erotic, some among them plainly autobiographically erotic. Connoisseurs of Cavafy almost unanimously rate this latter category least interesting of the various categories of his poems. One is inclined to agree with Mme Yourcenar that these poems tend toward the sentimental.

To be sure, Cavafy is a highly erotic poet, but his is an eroticism recol-lected in tranquility. None of his poems is in the least pornographic; all of them are post-coital, and generally offer a reminiscence of one or another lover now gone. The ancient world was scarcely bereft of hedonism, and art and the erotic were there almost everywhere intertwined. So were they in Cavafy's own conception of poetry. In such poems as "Very Seldom" and "Understanding" ("In the loose living of my early years/ the impulses of my poetry were shaped,/ the boundaries of my art were laid down"), he makes unmistakably clear the importance of his homoerotic life to his art. The erotic in Cavafy takes two forms: it is only fleetingly obtainable—and often not even that—and then it evanesces. Art was for him consolation, at moments even compensation, for all that was unobtainable and lost to him in the erotic realm. In a poem with the telling title of "Half an Hour," about a lover whom he would never know, one finds the lines: ". . . But we who serve Art,/ sometimes with the mind's intensity,/ can create—but of course only for a short time—/ pleasure that seems almost physical."

Joseph Brodsky is probably correct when he says that Cavafy's poems, without their "hedonistic bias," would have lapsed into mere anecdotes. Mme Yourcenar, a close student of these matters, felt that Cavafy had gone from the romantic view of homosexuality—"from the idea of an ab-normal, morbid experience outside the limits of the usual and the licit"— to the classical view, in which, in her words, "notions of happiness, fulfill-ment, and the validity of pleasure gain ascendancy." This, too, on the evidence of the poems, seems probably true. Robert Liddell writes that Cavafy's homosexuality "made him what he was" and at the same time

warns us that "it can be exaggerated and read into his work where it is not present." Contradictory though it may sound, Liddell is correct on both counts.

Yet the significance of homosexuality in Cavafy's poetry, in my view, cuts deep. I think his homosexuality helped develop his vision of a world in which, first, the gods are fond of playing tricks on mortals: one of his earliest poems refers to men as "toys of fate," and another to "this unfair fate." Second, I think Cavafy's homosexuality intensified his sense that all that is not art is fated to die in this world. Cavafy's is a world that is all past and present and no future. Without religion—and, it is true, Cavafy was born into and died with the rites of the Greek Orthodox Church —without religion, which implies a continuous future, who can escape the grim knowledge that human existence is birth, life and loss, death and oblivion? Homosexuals, having no children, who are the key agency of futurity, get this sad news first. It comes to many of the rest of us rather later. The bone knowledge that everything in life is created to disappear is the beginning of what is known as the tragic sense—and Cavafy had this sense *in excelsis*.

Edmund Keeley makes the point that the tragic sense operates more strongly in Cavafy than does the moral sense. Some commentators have gone further and spoken of Cavafy as amoral. Marguerite Yourcenar speaks of his "absence of moralism," and E. M. Forster even speaks of his "amoral mind." Forster wrote:

> Courage and cowardice are equally interesting to his amoral mind, because he sees in both of them opportunities for sensation. What he envies is the power to snatch sensation, to triumph over the moment even if remorse ensues. Perhaps that physical snatching is courage; it is certainly the seed of exquisite memories and it is possibly the foundation of art. The amours of youth, even when disreputable, are delightful, thinks Cavafy, but the point of them is not that: the point is that they create the future, and may give to an ageing man in a Rue Lepsius perceptions he would never have known.

Cavafy himself seemed to believe that his sensual experiences—however fleeting, however superficial—gave him not only memories on which he could live for long afterwards but put him outside time. One sees this in a poem such as "Very Seldom," written in 1914, when Cavafy was only forty-one but surely anticipating his own old age:

> He's an old man. Used up and bent,
> crippled by time and indulgence,
> he slowly walks along the narrow street.
> But when he goes inside his house to hide

the shambles of his old age, his mind turns
to the share in youth that still belongs to him.

His verse is now recited by young men.
His visions come before their lively eyes.
Their healthy sensual minds,
their shapely taut bodies
stir to his perception of the beautiful.

This is, in my view, Cavafy at his most unconvincing. An old man shoring up a few memories of quick jousts against the ruins of old age, indeed of oblivion, is more pathetic than persuasive. In "Their Beginning," a poem recounting the aftermath of an illicit tryst, the two men part, each going off in his own direction, and Cavafy concludes: "But what profit for the life of the artist:/ tomorrow, the day after, or years later, he'll give voice/ to the strong lines that had their beginning here." After quoting from this poem, W. H. Auden, a strong admirer of Cavafy, laconically remarks: "But what, one cannot help wondering, will be the future of the artist's companion."

This seems not ever to have been a question for Cavafy, to whom the world was not organized into moral compartments. Standard morals, regular virtues, were to him not central; sin, original or unoriginal, was of no interest. In the world of his poems, politics plays as no more than the comedy of state, one man, group, or state squabbling with another man, group, or state for the power to control others. Politics allowed men to behave cruelly to one another but it did not free even those in control from the even crueller twists of fate.

Cavafy tends to admire those who accept fate like King Dimitrios, in the poem by that name, who, when the Macedonians deserted him, slipped off his golden robes, slipped into simple clothes, and "just like an actor who,/ the play over,/ changes his costume and goes away." In "The God Abandons Antony," the poet invokes Antony to read the writing on the wall, and "Above all, don't fool yourself, don't say/ it was a dream, your ears deceived you:/ don't degrade yourself with empty hopes like these."

In so many Cavafy poems, disaster lies round the corner, catastrophe waits in the wings. Although action is usually hopeless, inaction is itself a defect. Defeat in life is all but inevitable, and success, when it arrives, cannot for long be sustained. We are, in short, in the hands of the gods, the fates—call them what you will, they are full of dark surprises. The biggest mistake is to think one is in control of one's life for very long. "Fate is a traitor," says the narrator of the poem "Kimon, Son of Learchos," and *perepateia*, or reversal of fortune, is, in Cavafy's world, no more than business as usual. Nothing for it but to be honest about one's emotion, accept one's limitations, and live as best one can without illusions.

This sounds very dark, but, somehow, as it comes through Cavafy's poems, it is not. Marguerite Yourcenar has called Cavafy's "a perspective without illusions, but not desolate even so." He never lets one forget that only fools think the world is arranged for their convenience. His poems fortify one in one's determination never to underestimate life's manifold traps and treacheries; to be grateful for the simple absence of tyranny and terror; to count oneself fortunate to exist in the delight of the moment.

Cavafy provokes one to think about what truly matters in a life, and to brood on what remains when it is over. His poems cause one to consider which is more regrettable in one's life: the things done, or those left undone? Cavafy provides no answers to these questions. His achievement was to create out of historical particulars universal types who never let one forget the essential mystery of human nature. Cavafy admired those who could face this mystery without flinching, and his own poems lead one to think one has a chance to grasp that life truly is a mystery without necessarily making it any easier to face it on one's own. It was Henry James who said that "it is art that *makes* life, makes interest, makes importance . . . and I know of no substitute whatever for the force and beauty of its process." Constantine Cavafy might have said the same—in fact, his poetry says exactly that.

January 1994

The Poetry of Robert Graves

Robert Richman

I stood beneath the wall/ And there defied them all.
> —Robert Graves, in "The Assault Heroic"

At the time of his death in December 1985, at the age of ninety, on the island of Majorca, Robert Graves had long been a legendary figure in the literary world. This was due in part to his immense production: nineteen novels and short-story collections, sixty-three books of nonfiction (including translations), and fifty-six volumes of poetry. Because of this extraordinary productivity, Graves is the only serious writer of our time whose career was on a scale we associate more with the previous century than with our own.

Yet there is another and more important reason why Robert Graves became a figure of legend in the literary world of his time. This was his reputation as a rebel. Graves's fame as a cranky individualist derives, first of all, from his well-known autobiography, *Goodbye to All That*, published to coincide with his departure from England in 1929. (He went to Majorca, where he remained until the Spanish Civil War caused him to leave in 1936; ten years later he returned to the island and lived out the rest of his life there.) No reader of *Goodbye to All That* will forget Graves's bitter account of his youth in Edwardian England—especially the grim years at Charterhouse, the public school he attended between 1910 and 1914—or his moving portrayal of the war that devastated his generation and almost cost him his life.

Graves was part of the literary generation that was profoundly altered by the war. For some, the response took a political form. In the case of Graves, the war only confirmed what he had learned to despise at school. To him, the nastiness of the generals was a larger and more lethal version of the nastiness of his masters at Charterhouse. As he writes in *Goodbye to All That*: "We [the soldiers] could no longer see the war as one between trade rivals: its continuance seemed merely a sacrifice of the idealistic younger generation to the stupidity and self-protective alarm of the elder."

Especially vile to Graves was the generals' cynical misuse of the army's regimental pride. His war experiences resulted in Graves's permanent alienation from his country.

When Graves left England in 1929, however, he was fleeing something more than painful memories. He was also running away from the modern world. Poetry, he said, was his "ruling passion," and he had come to believe that the modern world had little use for poetry, or for the myths that, in his view, it was derived from. The literary and historical works Graves began producing once he settled in Majorca—works which consistently confounded critics and scholars—were clearly conceived by Graves as a means of avenging himself on the modern world he found so loathsome.

These books were not the only strange things emanating from the island, however. Rumors of a liberated sexual atmosphere in the Graves's household also filtered to the world beyond Majorca. It was said—correctly—that Graves shared his bed with numerous "muses." It was also said—incorrectly—that Graves had fathered half the children born on Majorca between 1929 and 1975. So well known were Graves's emancipated views on such matters that in the Sixties Majorca became a mecca for hippies seeking escape from conventional moral taboos. Some no doubt also came for advice on the proper consumption of hallucinogens, the use of which Graves had advocated in his *Oxford Addresses on Poetry* (1962).

There are some ironies, to be sure, in Graves's posture as a rebel. For one thing, although the content of many of his books is unconventional, the writing itself isn't. The poems are in fact written in a traditional style. His prosody might even be described as conservative. In *Goodbye to All That*, he attempted to account for his dual literary nature by pointing to his family history. His father's side of the family, he said, was cold, rational, and "anti-sentimental to the point of insolence," while his mother's side was gentle, "gemütlich," "noble and patient."

Another irony is that Graves in his own life craved guidance. This is nowhere better seen than in his thirteen-year association with the American poet Laura Riding. In the early Twenties, Riding was affiliated with John Crowe Ransom and Allen Tate, and with their Fugitive group, which espoused regionalism in literature. Ransom used the occasion of a review in *The Fugitive* of Graves's *On English Poetry* to praise the English poet for his ability to express his "charming personality . . . without embarrassment in prosodical verse," something certain unnamed "brilliant minds" (i.e., Pound and Eliot) were, in Ransom's view, unable to do. At Ransom's urging Graves initiated a correspondence with Riding in 1924. Two years later she arrived in England and moved into Graves's house. Graves's growing attachment to Riding resulted in his separation in 1929 from his first wife, Nancy Nicholson.

The Graves–Riding partnership was a curious one, to say the least. Judging from Martin Seymour-Smith's biography of Graves, it could easily be characterized by the title of one of Graves's poems: "Sick Love." For Graves, Riding was, variously, the incarnation of an ancient Mediterranean moon goddess, the embodiment of the perfection of poetry itself, and a feminist advocating the overthrow of male-dominated society. Whatever role she played, she demanded, and received, total fealty from her subject. The Graves–Riding bond involved far more than Graves's relinquishing the household to her, or submitting his poems to her for approval, or accepting a subordinate role in their "joint" literary endeavors—all of which he did. The fact is, she treated him, as Tom Matthews, an American writer who stayed with the couple in 1932, observed, "like a dog. There was no prettier way to put it." Matthews, whose testimony is recorded in Seymour-Smith's book, wrote that Graves

> seemed in a constant swivet of anxiety to please her, to forestall her every wish, like a small boy dancing attendance on a rich aunt of uncertain temper. . . . Since I admired him and looked up to him as a dedicated poet and a professional writer, his subservience to her and her contemptuous bearing towards him troubled and embarrassed me . . . she was not so much his mistress as his master.

So enthralled was Graves with Riding that he even emulated her in a (pre-Majorca) 1929 suicide attempt, undertaken because she loved a third party (one Geoffrey Phibbs) and Phibbs loved Nancy Nicholson. Graves leapt from a third-story window after Riding had jumped from the floor above. (This had been preceded by Riding's drinking Lysol, to no effect.) Graves escaped unscathed; Riding suffered a compound fracture of the spine. According to Seymour-Smith, the police's grilling of Graves after this incident was "one of the experiences that made him want to leave England."

The sources of Graves's idealization of and submission to Laura Riding are well documented in the recently published *Robert Graves: The Assault Heroic, 1895–1926* by Richard Perceval Graves, the first installment of a proposed three-volume biography of Graves by his nephew.[2] This volume, which is based on heretofore unreleased family letters, diaries, and extracts from a memoir of Robert by Perceval Graves's father, is a biographical undertaking of a different kind from Seymour-Smith's. Seymour-Smith's

1 *Robert Graves: His Life and Work*, by Martin Seymour-Smith (Holt, Rinehart & Winston, 1982).

2 *Robert Graves: The Assault Heroic, 1895–1926*, by Richard Perceval Graves (Viking, 1987).

narrative is a more or less objective rendering of events. Perceval Graves's book, on the other hand, is a chronology of Robert's shifting psychological states. As a means of understanding the poetry, this approach leaves much to be desired. But it is invaluable for comprehending the childhood sources of Graves's bizarre behavior toward Riding. One is certainly given a sense, by both Seymour-Smith and Graves himself in *Goodbye to All That*, of the moralistic tenor of the Graves family household. "We learned to be strong moralists, and spent much of our time on self-examination and good resolutions," writes Graves in *Goodbye to All That*.

But the revelations in those two volumes pale in comparison to what Perceval Graves divulges. It appears the demand for moral perfection in the Graves home was constant and shrill. The letters Robert's mother wrote to her children at school are the best evidence of this. These letters, none of which are quoted, "were so emotional and intense," writes Perceval Graves,

> that as I read them more than seventy years later I cannot help feeling terribly sad that my father's generation of the family were subjected to such intense moral pressure. So often, Amy [Graves's mother] seems to be equating personal worth with the almost impossibly saintly behavior and self-sacrifice which she was accustomed to demand of herself. Any falling short of the highest ideals is greeted with a terrible sorrow, all the more devastating for being couched in such loving language.

The mania for purity pervaded every aspect of the children's lives. According to Perceval Graves, Robert's father would become enraged when he saw "a corner of a page folded down to mark a place, or—still worse—a book left open and face down." The attempt to make the children morally spotless, Graves says in *Goodbye to All That*, gave him and his siblings "no hint of [the world's] dirtiness and intrigue and lustfulness." As Perceval Graves says about this remark: "the very words Robert chooses to describe this show the extent to which he had been affected by [his mother's] moralizing." The result is that it was "very hard," according to Perceval Graves, "For [Robert] to come to terms with the world as it really is."

This puts the matter too benignly, however. What Graves was left with was a truly disabling horror of reality, particularly sexual reality. The disgust Graves expresses in *Goodbye to All That* at the soldiers' custom of picking up local girls offers some indication of this, as does his reaction to a girl's advances in a Brussels pension in 1913: "I was so frightened," he said, "I could have killed her." Seymour-Smith observes that "physical desire and the sexual act, the 'thing,' is what terrifies [Graves]."

Graves's craving for purity was undoubtedly one source of his poetry, in which he creates a timeless realm beyond history. (In *Poetic Unreason*,

his Oxford thesis that was published in 1925, Graves describes poetry as something as "remote and unrealizable an ideal as perfection.") It also helps one understand Graves's taste for Laura Riding's poetry, the principal feature of which is her self-chastisement for not having attained the requisite flawlessness.

Graves's craving for purity also sheds light on his attraction first to Nancy Nicholson—a feminist crusader—and then to Riding. In both cases, Graves tried to escape the world's "dirtiness and intrigue and lustfulness" by submitting himself to someone he invested with redemptive, cleansing powers. (So numinous a realm did Riding inhabit that after a point in their relationship she refused to sleep with him.) Riding's "unquiet nature and propensity to criticize," says Seymour-Smith, "was something that Graves was no doubt unconsciously seeking out." Perhaps it is not all that surprising that Graves, who went to such lengths to spurn what he deemed to be the suffocating moralism of England, became involved with strong-minded women like Nicholson and Riding. The fact is, in England or out, Graves could never escape the stern moralism of family, school, or military; he took it with him wherever he went.

Randall Jarrell believed that Graves's poetry, along with the theory of poetry he constructed around it, was a sublimation of his life with Laura Riding. There is little reason to disagree. At the heart of Graves's theory is the idea that all "true" poetry is an invocation of the Mother-Goddess who ruled the world up to the thirteenth century B.C. What Mother-Goddess? you might ask. Well, Graves claimed to have discovered evidence of an ancient matriarchal cult while reading for *Hercules, My Shipmate* (1945), a retelling of the travels of Jason and the Argonauts. With clues taken from Sir James Frazer's *The Golden Bough* and other anthropological works, Graves concluded that the Mother-Goddess had been ousted by thirteenth-century B.C. invaders of what is now Greece. These invaders installed in her place the Olympian gods. The legacy of this momentous shift in spiritual power is Western civilization as we know it, with its (in Graves's view) undue emphasis on rationality and order, and distrust of magic and myths—indeed, all forms of "poetic unreason."

The White Goddess: A Historical Grammar of Poetic Myth, Graves's 1948 study of Britain's own dethroned Goddess and her connection to the Mediterranean one, is without a doubt the author at his crankiest. In the words of the critic Douglas Day, the book is "a curious blend of fact and fancy, an often impenetrable wilderness of cryptology, obscure learning, and apparently *non sequitur* reasoning brought to bear on the thesis that has its roots partly in historic fact, partly in generally accepted anthropological hypotheses, and partly in pure poetic intuition." Suffice to say that Graves's attempt to prove the existence of this matriarchal religion— which involved him in readings of medieval Welsh poems, analyses of secret Druidic alphabets, musings on ancient tree-worship, and correla-

tions between Greek and Celtic myth—was fervently rejected by anthropologists and literary critics alike. But this never shook Graves's confidence, for *The White Goddess* was in his eyes a document of faith. And its debunking by "rational" critics—who (Graves would assert) are products of a patriarchal society and therefore on a covert search-and-destroy mission for every contemporary manifestation of the Goddess—only served to intensify his devotion. It was the same kind of devotion he had evinced for Riding, who appears to have been for Graves a rare embodiment of the long-lost Goddess.

Poetry, an invocation of this beleaguered antique Muse, was, according to Graves, the most meaningful writing a Goddess-worshiper could undertake. As a result, Graves was quite candid about the ancillary role his books of nonfiction and historical fiction played in his life. These volumes, Graves said, were the "show dogs I breed and sell to support the cat." This does not mean,however, that Graves ever passed up the chance to use these books as a means of correcting the false history propagated by various anti-Goddess forces. In *Wife to Mr. Milton* (1943), for example, the English poet is portrayed as a ranting Puritan and his wife Marie as the epitome of charm. (The reverse is closer to the truth.) *Hercules, My Shipmate*, the British title of which is *The Golden Fleece*, argues that the triumphs of Jason and the Argonauts in the Mediterranean, and their recapture of the fleece, occurred because Jason had been blessed by the White Goddess. *Homer's Daughter* (1955), takes off from Samuel Butler's conviction that the *Odyssey* was written not by Homer but by the woman who calls herself Nausicaa in the story. Not surprisingly, the books written before Graves's mythological "discovery"—*I, Claudius* (1934), *Claudius the God* (1935), *Count Belisarius* (1938), and *King Jesus* (1943)—show a deep need for some redeeming force. Throughout these popular historical novels is Graves's preoccupation with the unhappy fate of a pure soul in a corrupt and lustful world.

Graves's rewriting of the past was not his only means of demonstrating his obeisance to Riding and the White Goddess. It can also be seen in his refusal to develop original plots or psychologically persuasive characters. Judging from these novels, at least, it would appear that the muse tolerated from her vassal no extra-poetic invention. "There is one story and one story only," goes the first line of Graves's well-known poem "To Juan at the Winter Solstice," and Graves seems to have believed this with all his heart. As entertaining as many of these novels are—*I, Claudius, King Jesus,* and *Count Belisarius* are certainly good reads—all have an extremely short imaginative reach.

Most of Graves's nonfiction is similarly scarred. The underlying assumption of both *The Greek Myths* (1955) and *The Hebrew Myths* (1964) is the suppression of the various manifestations of the Goddess in antiquity. Graves's literary criticism, the bulk of which is collected in *The Crowning*

Privilege (1955), has the same narrow focus. Many of the essays seek to expose the rational impulse that has helped undermine "true" poetry throughout the centuries. As one would expect, Graves detests the poetry of Eliot, Pound, and Stevens. In his view, the motives of these modernist poets are critical, not creative.

Perhaps the most important contribution Graves makes in his criticism is his advocacy of the plain style. In a letter from 1920, Graves declared that he wanted to be "able to write . . . with as much economy of words & simplicity of expression as possible." Whatever the other defects of his prose, his loyalty to this principle was unwavering.

The one book that does survive as a prose classic is *Goodbye to All That*. Graves's autobiography, which was revised thoroughly in 1957—the original edition was written hastily and poorly—is without a doubt his most important book. It captures the spirit of rebellion—of a young man's bursting free of the shackles of his elders—in a way that few other books of our time do. In the very first pages, Graves writes:

> About this business of being a gentleman: I paid so heavily for the fourteen
> years of my gentleman's education that I feel entitled, now and then, to get
> some sort of return.

This refreshingly heady swagger continues to the end of the book.

Nevertheless, posterity will remember Graves best not as a novelist, mythographer, or biographical legend, but as a poet. Graves himself insisted on this, and his critics have obliged. But even if they are right to focus principally on the poetry—for it *is* the part of Graves's *oeuvre* that has the greatest claim on our attention—many have been inclined to make extravagant and faulty judgments of it. Jarrell declared "To Juan at the Winter Solstice" to be one of the century's greatest poems. Martin Seymour-Smith referred to Graves as "the foremost English-language love poet of this century—and probably of the two preceding ones, too." And Perceval Graves writes that his uncle "has come to be regarded as one of the finest poets of the twentieth century."

These claims are unwarranted. Reading through the 1975 edition of Graves's *Collected Poems*, one is struck by how fine some of them are. But one is also struck by how much the verse sinks from the weight of the "one story and one story only," especially the later poems. What impairs the majority of the poems, however, is not the presence of the Goddess theme so much as its treatment. For in a way, Graves is correct: good poetry is on some level an invocation of the Muse, if the Muse is indeed the embodiment of poetic intuition. The bulk of Graves's verse is marred because he persists in addressing the Muse directly instead of allowing the poem to invoke her implicitly. If Graves had not been so often compelled

to be literal—that is, anti-symbolical and anti-metaphorical— he probably would have been freer to take on a wider range of emotional and thematic concerns in his verse. As it is, too large a percentage of his poems are like "In Her Praise":

> This they know well: the Goddess yet abides.
> Though each new lovely woman whom she rides,
> Straddling her neck a year or two or three,
> Should sink beneath such weight of majesty
> And, groping back to humankind, gainsay
> The headlong power that whitened all her way
> With a broad track of trefoil—leaving you,
> Her chosen lover, ever again thrust through
> With daggers, your purse rifled, your rings gone—
> Nevertheless they call you to live on
> To parley with the pure, oracular dead,
> To hear the wild pack whimpering overhead,
> To watch the moon tugging at her cold tides.
> Woman is mortal woman. She abides.

On the level of language and technique, this poem is unobjectionable. What undoes "In Her Praise" is its content. By discussing his conception of the Goddess, rather than presenting his emotional response to her, Graves diminishes the poem's effectiveness, and he shuts out those readers who do not share his almost religious devotion to her.

"To Juan at the Winter Solstice," the poem Randall Jarrell thought so much of, is a much better poem, if not a great one. It works as well as it does because its charged, resonant language redeems the "one story and one story only":

> There is one story and one story only
> That will prove worth your telling,
> Whether as learned bard or gifted child;
> To it all lines or lesser gauds belong
> That startle with their shining
> Such common stories as they stray into.
> > Is it of trees you tell, their months and virtues,
> Or strange beasts that beset you,
> Of birds that croak at you the Triple will?
> Or of the Zodiac and how slow it turns
> Below the Boreal Crown,
> Prison of all true kings that ever reigned?
> > Water to water, ark again to ark,

> From woman back to woman:
> So each new victim treads unfalteringly
> The never altered circuit of his fate,
> Bringing twelve peers as witness
> Both to his starry rise and starry fall.
> Or is it of the Virgin's silver beauty,
> All fish below the thighs?
> She in her left hand bears a leafy quince;
> When with her right she crooks a finger, smiling,
> How may the King hold back?
> Royally then he barters life for love. . . .

"On Portents," another fine poem, also survives the Goddess/Riding theme, not only because of its superb language and technique, but also because the female figure in the poem is more generalized than in "To Juan at the Winter Solstice." The fact that "she" could refer to any anyone is crucial to the success of the poem:

> If strange things happen where she is,
> So that men say that graves open
> And the dead walk, or that futurity
> Becomes a womb and the unborn are shed,
> Such portents are not to be wondered at,
> Being tourbillions in Time made
> By the strong pulling of her bladed mind
> Through that ever-reluctant element.

"A Love Story" works well because in it Graves sketches a symbolic landscape—rare for him—which gives the reader an equally rare chance to get extra-literal sense of the poet's internal emotional state:

> The full moon easterly rising, furious,
> Against a winter sky ragged with red;
> The hedges high in snow, and owls raving—
> Solemnities not easy to withstand:
> A shiver wakes the spine. . . .

Much more common is Graves's literalism, which spoils many of his love poems. "Three Times in Love," "Crucibles of Love," and "Depth of Love" are almost entirely devoid of imagery. What one is left with are dry arguments that squeeze most of the inspiring passion out of the poem. Typical in this respect is "The Falcon Woman," in which love's power is depleted by Graves's purely intellectual apprehension of it:

It is hard to be a man
Whose word is his bond
In love with such a woman,
 When he builds on a promise
She lightly let fall
In carelessness of spirit.
 The more sternly he asks her
To stand by that promise
The faster she flies.

"The Visitation," on the other hand, succeeds because it is invigorated by an image of a living presence: "Your slender body seems a shaft of moonlight / Against the door as it gently closes. . . ."

To my mind, Graves's best poems are the early ones, the majority of which predate his post-Thirties absorption in the Goddess. "Like Snow," "The Pier Glass," "Love in Barrenness," "The Terraced Valley," and "The Cool Web" are some of the best among them. "The Cool Web," in particular—in which the poet expresses his gratefulness for the protection from reality that language affords—is exquisitely written. It is also compelling for the way it seems to set the stage for the later poems—the poems in which Graves seeks similar protection from a fallen world in the cold arms of an abstract Goddess:

Children are dumb to say how hot the day is,
How hot the scent is of the summer rose,
How dreadful the black wastes of evening sky,
How dreadful the tall soldiers drumming by.

 But we have speech, to chill the angry day,
And speech, to dull the rose's cruel scent.
We spell away the overhanging night,
We spell away the soldiers and the fright.

 There's a cool web of language winds us in,
Retreat from too much joy or too much fear:
We grow sea-green at last and coldly die
In brininess and volubility.
 But if we let our tongues lose self-possession,
Throwing off language and its watery clasp
Before our death, instead of when death comes,
Facing the wide glare of the children's day,
Facing the rose, the dark sky and the drums,
We shall go mad no doubt and die that way.

Robert Graves never let his tongue "lose self-possession," but his worship of the Goddess prevented him from securing major status as a poet, largely because it led him to adopt an anti-metaphorical, anti-symbolical stance toward poetry. (He once characterized this in a letter as his habit of discussing things "truthfully and factually.") The limited imaginative range of his work—the "one story and one story only"—obviously owes everything to her as well.

As reductive as it was, Graves's fixation seems to have been derived from the terror of reality instilled in him as a child. Laura Riding only exacerbated an existing condition. Reading through Graves's poems, one finds oneself aching for a dose of the hated world the poet seeks protection from—even that portion of reality which is no more than "dirtiness and intrigue and lustfulness."

It is the element of "real" emotion that gives the poem "Through Nightmare" its hint of greatness. Like "On Portents," the poem is generalized enough to make the reader wonder if Graves is perhaps addressing himself, especially in the final stanza. If "Through Nightmare" is indeed Graves's confession of his timorousness in the face of the nightmare of the modern world, the poem could easily serve as his epitaph, and as a kind of lament for the unfulfilled promise of this enormously gifted, and tragically tormented, writer:

> Never be disenchanted of
> That place you sometimes dream yourself into,
> Lying at large remove beyond all dream,
> Or those you find there, though but seldom
> In their company seated—
> the untameable, the live, the gentle.
> Have you not known them? Whom? They carry
> Time looped so river-wise about their house
> There's no way in by history's road
> To name or number them.
> In your sleepy eyes I read the journey
> Of which disjointedly you tell; which stirs
> My loving admiration, that you should travel
> Through nightmare to a lost and moated land,
> Who are timorous by nature.

October 1988

365

Jean Genet: The Apostle of Inversion

H. J. Kaplan

Some forty-odd years ago, in my office at the chancery of the American Embassy in Paris, I was visited by a young man who looked like a bantamweight boxer just past his prime: balding and broken-nosed, in a byronic collar, a light gray suit, and flashy yellowish pumps which must have caught my eye because they were the kind one saw at the Bal Nègre, or the Bar des Apaches on the Rue de Lappe, some such place, where you went to inspect the underside of the newly liberated French capital and hobnob with pimps and whores. This was Jean Genet, sent (if memory serves) by Jean-Paul Sartre, the brightest new star on the literary horizon; and bearing a huge typescript or galley proof of what would have been *Notre Dame des Fleurs* or *Le Miracle de la Rose*, probably both, the autobiographical novels he had written in the Santé or Fresnes, the least terrible of the prisons in which he had been confined during the German Occupation—not as a resistant, he hastened to assure me, but as a felon, a common thief. Indeed, he was currently living in the shadow of another condemnation, which might entail what the French called relegation, i.e., life imprisonment as a four-time loser, unless the magistrate's hand could be stayed by Genet's growing reputation and the intervention of his many admirers in the world of literature, the theater, fashion, etc. In short, le Tout-Paris and Saint-Germain des Prés were mobilizing in his favor and he wasn't too worried about the outcome. What he needed at the moment was money. Perhaps, since there was nothing in my office worth stealing, and I was not about to invite him into my home—right?—I could help him find a publisher. Not a legitimate one, of course; he knew his stuff wasn't publishable legally in my benighted country; but illegitimate was preferable anyway, providing we could get him a good translator and a generous advance.

His texts, which I read that evening and late into the night, were indeed not publishable in the America of that time, but their documentary content—the manners, morals, and language of his milieu—was riveting; and their literary quality was undeniable. Truly, a *frisson nouveau*: rhythmic classical prose, precise and learned to the point of preciosity, but then

startled to life by argot and obscenity and lightning flashes of intensity and power; a dizzying descent into what Genet had remembered or dreamed up, but in any case rendered, as at once an inferno and a Paradise Lost of abjection and beauty: the tiny rural village of his childhood, the boulevards and squares of a Montmartre haunted by prostitutes and petty crooks, the reformatories and prisons in which he and his homosexual lovers had spent their youth and in the end their lives in a desperate search for . . . what? *They* had no idea. They were for the most part inarticulate and stupid young toughs. But Jean Genet knew—because he was a poet and because he was literally and figuratively locked up with them and ceaselessly dreamed of them. He saw them as dedicated to an intransigent elegance and style and even, in the case of the bravest and most desirable of them, prepared to suffer martyrdom to attain the state of grace which for Genet was inherent in sin—not just any sin but the saintly sin which involved the deliberate and defiant rejection (negation) of our world and its morality—but which for them could only mean mindless tumescence and desire leading inevitably to violence and crime and the apotheosis of retribution: the guillotine.

The rest is history. The unpublishable texts of forty years ago are the best sellers of today. Saved from relegation by a presidential pardon, Genet went on to write *The Maids*, *Deathwatch*, *Funeral Rites*, and the *Thief's Journal*; and then, after a long period of silence, the famous last plays: *The Balcony*, *The Blacks*, and *The Screens*. He never entered the French Academy, but in 1983 he received one of France's most prestigious literary prizes, and three years later Roland Dumas, Mitterrand's foreign minister, was at the airport to see his casket off to Morocco for burial among the Arabs whose cause he had espoused in the last years of his life. Not exactly an apotheosis, but then he was only a writer and had never murdered anyone, after all, not even a little peasant girl, like the first victim of his hero, Harcamone.

The publisher Claude Gallimard was also at the airport to see Genet off in 1986. I doubt whether he ever reproached his father for publishing Genet—it was the Catholic poet Paul Claudel who sadly predicted to Gaston Gallimard that he would one day have to face his children and explain how a respectable French businessman could have brought himself to publish such stuff—but there is no question that the successive editions of the Collected Works, first brought out in 1952–53 with a seven-hundred-page preface by Sartre, have been very good business for Gallimard, whose list this autumn includes Edmund White's new biography of Genet and a new edition of the *Thief's Journal*, *Querelle de Brest*, and *Funeral Rites*, this time with a preface by Philippe Sollers, novelist, essayist, former editor of *Tel Quel*—the Maoist, Structuralist, Deconstructionist review—and arguably the trendiest writer on the current scene.

An enduring paradox of our high culture, especially since the waning of the middle ages, has been its double and contradictory role—on the one hand as a respected Institution, a pillar of the established order reflecting and transmitting communal experience and values, and on the other as the favored instrument of the adversarial forces inherent in the Western idea of society as an ongoing enterprise of autonomous individuals in which time (history) is of the essence and the only constant is change. What is true of high culture in general is especially true of literature, and even more so of the so-called advance-guard literature of Renaissance Europe and thereafter, the more radical *Dichter und Denker* of Germany, culminating in Marx, Nietzsche, and Heidegger, and the post-revolutionary "outcast poets" (*poètes maudits*) of England, Italy, and France.

This phenomenon is all too familiar to us; we live, as it were, in its wake. To be sure, the gravity and gravamen of the advance guard tend to be trivialized in the age of mass culture. The hieratic themes of the high priests of Surrealism turn up in Bergdorf Goodman window displays; and the revolutionary nihilism of Jean-Paul Sartre becomes—in some popular theater of the Parisian grands boulevards—entertainment, like everything else. Old Rabelais could proclaim in the sixteenth century that he would defend his ideas with determination "up to the stake, exclusively," but now, in the West at least, it is the stakes that have gone up in smoke. The writer who would produce a *frisson nouveau*, let alone a reaction of outrage or dismay, finds himself frustrated, not by the Inquisitors but by the law of diminishing returns.

Such, alas, was the fate of Jean Genet, who spent his long and busy life—1910–1986—seeking (in vain, despite his remarkable talent) to solve this problem and, in the process, producing the widely sold and translated prose works and poetic dramas mentioned above, together with a number of lesser known political tracts written on behalf of the American Black Panthers and the Palestinian Arabs. He did manage on occasion to get under French skins, less by celebrating homosexuality and criminality than by communicating the intense and unrelenting hatred he felt for his native country; and he at least once set off a public uproar—in 1977, with an article he published in *Le Monde*, a respectable Parisian daily, in defense of the Baader-Meinhof terrorist gang; but the indignation was shortlived and the enduring upshot of his literary labors was not only to enrich himself, his publishers, and his theatrical producers but also, however the irony of it might have galled him, to become a monument, an honored exemplar of French civilization, indeed of Western civilization, in our time.

And now, thanks to Edmund White, an American novelist who is also the co-author of *The Joy of Gay Sex* and (as I learn from his hometown newspaper, the Paris-based *International Herald Tribune*) a founder of the Gay Men's Health Crisis, we have what purports—quite convincingly,

since it runs to 728 pages with its bibliography, footnotes, and index, plus forty-odd pages of acknowledgments, chronology, and introduction—to be a definitive biography of this remarkable man,[1] whose failure to become a *poète maudit* in the tradition of Villon and Rimbaud must be attributed to a deplorable *Zeitgeist*, or ideological climate, certainly not to any lack of talent or energy or courage. Genet did what he could, and that was plenty; he reworked his prose again and again and White spares us not a single revision; and if his poetic entrancement with crab lice, his lyrical enthusiasm for male organs of various shapes and colors, his ecstatic admiration of betrayal and crime, all expressed in language which now (after forty years!) often reads to me like a parody of Bishop Bossuet by a mischievous high-school student named Marcel Proust—if all this was overvalued on its appearance by Cocteau, Bataille, and Sartre, and later by such worthy professors as Michel Foucault and Jacques Derrida, it was certainly no fault of his; nor could the earnest promoters of Jean Genet have been expected to anticipate that, however old hat they themselves have become in France, where they have indeed faded from view in recent years, they would be elevated to heroic status by the Modern Language Association and a hundred English Lit departments in a country which Genet despised quite as much as his own.

White's biography of "Saint Genet," as Sartre called him in his introduction to the Gallimard edition, partly in joking reference to Genet's hieratic tone, is by no means hagiographic or even uncritical, although the length and detail of the book do mean what they seem to mean; and we must assume that White accepts not only the received opinion about his subject— i.e., that Genet is a major writer, a poet of the highest order—but also the notion, so prevalent in modern literary circles, that there is indeed something saintly in the passionate assertion of any individual freedom, whatever its purpose, against the forces of repression and tradition. If White were pharisaical enough to see these ideas as absurd on their face, as I do, he would never have spent six years and mobilized the help of hundreds of witnesses, scholars, bibliographers, and publishing people in order to construct this monument; and this, be it said in all seriousness, would have been in one respect, at least, a pity: it would have deprived us of a solid piece of work, a biography that speaks very tellingly about the culture and society in which we live.

First published by Chatto & Windus in Great Britain, and soon to be available in all the major European languages, the book begins with a fascinating account of the poet's childhood as a ward of the Assistance Publique, the French welfare system which cares for foundling children by placing them, as in Genet's case, in foster homes. This is valuable social

1 *Genet: A Biography*, by Edmund White (Knopf, 1993).

history, although it can hardly tell us how this particular child became, first, an outstanding pupil in the local grade school, which he left at the age of twelve, and then, in rapid succession—in the period between two great wars—a habitual thief, delinquent soldier, jailbird, and vagabond, who never held a job but spent years in barracks and prisons reading his way through world literature and spinning out masturbatory fantasies about his comrades and cellmates. It cannot tell it us how he then went on, after he had begun writing these fantasies and, between prisons, frequenting booksellers and stealing from them—in the peculiarly Parisian *demi-monde* of con men, shady art dealers, and prostitutes mostly male, the world evoked by writers like Francis Carco and (after World War II) in the memoirs of Maurice Sachs—to attract the attention of Jean Cocteau and members of his circle, the one group that could launch him in the twilight of the German Occupation, just before Sartre and his friends emerged to pick up the torch.

At this point, with the first copies of *Notre Dame des Fleurs* circulating, albeit clandestinely, Genet awoke—in prison again—to find himself famous. From then on, as we have seen, the combination of his prose and his recurring problems with the law made him an object of tender solicitude on the part of the French literary elite. Not all of it, to be sure, and in different degrees, but the fact remains that the foundling boy from the Morvan was thereafter to be befriended and protected, as White extensively shows, "by some of the leading minds of his day: the philosophers Sartre, Derrida and Foucault; the writers Cocteau and Jouhandeau, Juan Goytisolo and Moravia, the composers Stravinsky and Boulez; the stage director Roger Blin; the painters Leonor Fini and Christian Bérard, the sculptor Giacometti; the political leaders Pompidou and Mitterrand." And this, one hastens to add, is an extremely abbreviated list.

Genet's characteristic attitude toward these people was one of arrogance and challenge. His genius and his circumstances had made him the poetic apostle of inversion, and this—since none subverted the social order as radically as he did—simply set him beyond their ken. After the incandescent writing of the war years—he would never write so well again—he pretended to turn his back on literature and to care only for his friends and lovers and, from time to time, for the assertion of his "ideas," such as they were, in the theater or elsewhere, e.g., in support of the Black Panthers or the Palestinian Arabs or the insurrectionary students in Paris during May 1968. His doubts, apparently quite genuine, about the enduring value of his work never seemed to affect his belief in his moral mission.

White presents him, nonetheless, as a major figure, and whatever one thinks of Genet's art the man's itinerary can hardly leave us indifferent. At its outset, in the atmosphere of a tiny village in rural France on the eve of World War I, we become aware of the foundling's anguished question

about who and what he was, sexually and socially; and this concern about his role and role-playing provides us with an essential key to his character, which turns out, just as Heraclitus said it would, also to be his fate. Like his fictional heroes, Genet is always dressing up, acting out; and the one great constant of his life is his refusal to be dominated and determined by his nature and the given social order—locked up, as it were, within his preordained persona. His boys play at being girls, become girls; his maids become mistresses, his blacks wear white masks; and so it goes, good is bad and vice is virtue and betrayal is faith; everything is—in the end quite predictably—turned back to front and upside down. Genet's career keeps reminding us that the Nietzschean "transvaluation of all values" is, among so much else, an eminently *theatrical* idea.

All of which suggests that Edmund White's *Genet*, while providing us with the material we need in order to know what is going on, rather fails to do justice to its comic dimension, as exemplified in the production of Genet's plays by the (subventioned) National Theater, or in Genet's statement to the effect that, if ever the Palestinians won out and achieved statehood, he would be obliged to part company with them, since he was implacably opposed to all states. A final example: when Jean-Paul Sartre said or did something irritating to our hero, Genet wrote to a correspondent that the eminent author of *L'Etre et Le Néant* was really a bit *faux-jeton* (meaning treacherous), and quickly added: "a characteristic I've always admired in him, of course."

I am quoting from memory, but the precise words hardly matter. *Se non è vero*, as the Italians say . . . but what does matter is that Edmund White's *Genet* is an excellent book about an important figure; a dead white European male, to be sure, like Dante, Cervantes, and Shakespeare, but nevertheless a representative man of our time.

November 1993

The Career of Harold Laski

Edward Shils

From about 1920 to about 1950, Harold Laski was one of the best-known academic intellectuals in the English-speaking world. After Oxford and after two relatively obscure years at McGill University in Montreal, he came to Harvard in 1916, where he remained for four years. He might have remained for the rest of his career, for he dazzled the academic world of the East Coast and particularly of Harvard with his exceptional learning, his spoken and written fluency, his deference to his elders, and his delightfully pleasing personality. He won the admiration and affection of Felix Frankfurter (who discovered him), Justice Oliver Wendell Holmes, Jr., and Louis Brandeis, and he stood very well with Roscoe Pound, Charles MacIlwain, and other great figures of the Harvard of that day. He was also greatly cherished by the first generation of the guiding spirits of *The New Republic*, which was founded in 1912.

It all ended in an uproar when Laski, with his characteristic knack for arousing a furor and for gaining public attention, became a very visible partisan of the police in the Boston police strike of 1919. This brought down on him the denunciations of numerous journalists, some business-men, and a few professors; he was saved from a vehemently demanded dismissal by the refusal of A. Lawrence Lowell, then the president of Har-vard University, to allow Laski's academic freedom to be restricted. Laski might well have been able to stay on at Harvard, but he was invited to become a lecturer at the London School of Economics, thanks to the support of Graham Wallas, at that time a leading figure among Anglo-American liberal intellectuals and a professor of political science at the School. In a short time Laski became a reader, and in 1927, at the age of thirty-four, he became a professor, which he remained until his death in 1950 at the age of fifty-seven.

In his years at Harvard, Laski's reputation for erudition, originality, and even depth was based on his prolific scholarly production. Between the ages of twenty-three and twenty-seven, he published at least two books, a number of articles in law reviews, and a monograph. He pro-claimed himself to be a "pluralist," an enemy of the omnipotent and om-

nicompetent, omniprovident and omniscient state. His views were closely akin to those of the French syndicalists H. Pelloutier and V. Griffuehles, the English guild socialists G. D. H. Cole, A. R. Orage, and A. J. Penty, and a professor of law at Bordeaux, Léon Duguit. He claimed to have derived his ideas from the great British legal historian Frederick Maitland and the sagacious and almost inhumanly erudite German legal historian Otto von Gierke. In the small circle of Boston Brahmins and Jewish Americans—Morris Raphael Cohen should be included among them—Laski was made much of. They were not entirely ignorant and they were surely very intelligent. They thought they had a great treasure in Laski. He did not disagree with them.

Perhaps I ought to add as a surmise that Laski's physical appearance added to his distinction. He was short and extremely thin; he had narrow shoulders joined by a thin neck to a very small head with black hair slicked down and divided in the middle by a wide white avenue. He had a small black mustache. His bright black eyes, seen through black horn-rimmed spectacles, gave him the appearance of an adolescent prodigy. That he was indeed. In some respects, that is what he remained over his entire life.

Laski's biographers, Professor Isaac Kramnick and Mr. Barry Sheerman, have done as well by him as they could.[1] They are obviously not unqualified admirers and they do not overstate the case for him. They concede throughout that Laski did not always bend himself to tell the truth and nothing but the truth; in the course of time, Laski's fabrications became one of his main features. The biographers treat it as a foible. They do not ask whether somewhat lighthearted respect for truth might not have entered into his more serious writings. They say too little about the intellectual qualities of Laski's academic writings. The strongest parts of the book are those that describe his political activities.

In the end, Messrs. Kramnick and Sheerman quote a letter from Laski's devoted and beloved wife, Frida, in which she says that Laski "lived a full life," that they "were wonderfully happy," and that they had had "a lifetime of adventure and interest." That is not a strong conclusion to a six-hundred-page book on one of the most eminent figures of Anglo-American intellectual life of the first half of the present century.

Much of what they tell has been fairly well known to those who knew him, and sometimes they tell less than they should have told. They have, however, done a service even to those who knew him and who lived through his times by reminding them of things they once knew and have since forgotten; they have also produced some quite new and very interesting information, especially about Laski's relations with Jews, Judaism, and Zionism.

1 *Harold Laski: A Life on the Left*, by Isaac Kramnick and Barry Sheerman (Allen Lane/The Penguin Press, 1994).

When Laski returned to England, the London School of Economics was just beginning its illustrious period under the direction of William Beveridge, who many years later became the author of the "Beveridge Report," which provided for everyone "from the cradle to the grave." For twenty-five years the School had been a sort of night college for ambitious civil servants in Whitehall and no less ambitious clerks in the City (the School was located about midway between these two sections of London). It was a darling of the Webbs and, at the beginning, of George Bernard Shaw—its original premises had been in his house. Although before the First World War the School had had some distinguished teachers and directors, it was not taken seriously in the academic life of Great Britain and it was scarcely known to American academics and publicists. But once Beveridge, who had been an outstanding civil servant under Lloyd George, took the School in hand, it became one of the major centers of social science studies in the world. It attracted students from all over: from the United States and Canada, from India in large numbers, and, a little later, from Africa and China. In short order it added to its staff R. H. Tawney, Eileen Power, Lionel Robbins, Friedrich von Hayek, Charles K. Webster, Bronislaw Malinowski, et al. It became a hive of learned men and women. In economic theory and economic history and in anthropology, it became renowned.

Although it was not Oxford, which Laski would probably have preferred, the School was a very satisfactory place for an ambitious young scholar. Laski soon built up a fairly good department at a time when political science was scarcely studied in Great Britain.

Laski himself soon became one of the brightest stars in the School's galaxy. He was a very remarkable lecturer, a speaker of unbroken fluency, patterning himself on the elaborate style of Victorian parliamentarians. He never paused to hem or haw, he never left a sentence unfinished, and he never spoke from notes or a script. His voice was clear and carrying. He enunciated every syllable; he never seemed to lose his way. His lectures were replete with an easily borne and confidently dispensed erudition. All sorts of authors unknown to his audience were spoken of with familiarity. His lectures became a great feature of life at the School; students flocked to them; they loved to hear him and they came to love him too. By the time he became a professor he was also a socialist and that, too, appealed to his innocent students. Later in the 1930s, he announced that he had become a Marxist; that appealed even more to the students of that generation. To his great skill as a lecturer, and his interest in and his knowledge of his students, he added the less worthy charm of making humorously derogatory remarks about his colleagues Robbins and Hayek, who were very antipathetic to socialism and even more so to Marxism. This strengthened further the bond by which his students were attached to him. But as much as anything else, his great kindliness to his students, his

generosity, often done secretly but quite properly known through rumors, the fact that he remembered their names and seemed to interest himself in their careers, in which he tried to help them—all this endeared him to them. In addition, his real and fabricated intimacy with the great of the land—and of the United States as well—made him even more attractive to his students.

I surmise that Laski's teaching probably deteriorated in his later years because his exceptionally retentive memory and his undiminished fluency led him to give up fresh preparation and additional study. Of course, that did not show itself to his students because of the rhetorical excellence of his lectures, and because the students were not yet sophisticated enough. Because they did not remain with him for more than a few years before taking their degrees, they did not discern the downward direction. That he was a famous man, and that he was a disrespector of great figures as well as their proclaimed intimate, more than compensated for the deteriorating intellectual substance of his lectures and books.

Laski's intellectual deterioration is more evident from his writings than it was from his lectures. In the books, which continued to appear almost uninterruptedly—there were about twenty-five in all—the deterioration is very evident. Laski was never a hard thinker nor was he a ruminator who pondered at length on ever-deepening problems. He either had an immediate answer to a given problem or he dismissed the problem, often with a witty and knowing remark. His early books, *Studies in the Problem of Sovereignty* (1917), *Authority in the Modern State* (1919), *The Foundations of Sovereignty* (1921), and *A Grammar of Politics* (1925), were serious books; there was also a well-written and well-documented introduction to an edition of *A Defense of Liberty Against Tyrants*, a book written in the sixteenth century. All this before he was thirty-three years of age. These works all showed unmistakable learning in a wide body of the literature of political philosophy in English and French—much less in German or Italian. They were not profound, they had no overtones, but they were clearly expressed. Whatever the superficiality of his analyses, he was certainly a genuine scholar with a very alert and fresh intelligence and exceptional industriousness.

But even then, he seems not to have been a scholar of great accuracy. Laski had a superb memory. It was said that he could read two hundred pages in an hour and could remember most of what he read. He thought that he had a perfect memory, but it was not perfect. He never checked the facts that he cited or the references to the works from which he drew his facts. In his last years he could write an interesting paper with all the semblance of careful study but it was all from the memory of writings read many years earlier, probably not reread since he first read them, and undoubtedly not reread before writing the paper.

Just as he spoke, so he wrote without emendation. In my own limited experience with him, I never knew him to revise his manuscripts. One manuscript that I saw—a fairly long one—was written out in his tiny handwriting without a single erasure or crossing-out. I have been told that he delivered book-length manuscripts to the publisher in the same condition.

Even if Harold Laski had been aware of the imperfection of his memory, however, he lived a kind of life that would have made it difficult for him to find the time to restudy the more important books he had already read, to read new ones, to produce new lectures based on new preparations, to verify references, and to check footnotes. (I think Laski never had a research assistant.) He was a proud proponent of the traditional style of scholarship done by one individual working alone, in contrast with now common team research or with one person assisted by a staff of younger scholars who are his "dog-robbers." He did not seek financial support for employing an assistant or secretary. He disliked the influence that philanthropic foundations exercised on the organization of research, i.e., on the new forms of team and assisted research that were beginning to penetrate into the social sciences in the 1920s. At the School, Beveridge was determined to promote this kind of research and to obtain financial support for it from private foundations. This was one of the sources of tension that developed between Beveridge and Laski after a rather happy beginning.

The coming of funds to the London School of Economics from the Rockefeller Foundation and its related foundations was actually a minor matter for Laski. It did not affect him; it was just something to talk and write about. There was something else that affected Laski's achievements as a scholar and that also affected his relations with Beveridge. This was his very prolific journalistic activity.

From very early on, Laski had been a publicist as well as a scholar. When he was at Harvard, he entered into very close relationships with *The New Republic*, particularly with Herbert Croly and Walter Lippmann. When he returned to England, he became a frequent contributor to *The Nation* and a friend of the great liberal journalist H. W. Nevinson. This activity soon expanded to the point where Laski wrote fairly brief articles in great numbers for popular newspapers on the Labour side and for many minor and a few important periodicals in which he analyzed recent political developments in Great Britain and the United States. He wrote about British politics from the point of view of a radical—increasingly radical—member of the Labour Party. By the 1930s, these publications ran into the scores and scores in each year. Many of them were very brief and he wrote them very speedily. In them he often wrote disparagingly of the leadership of the Labour Party; he did not spare the Tories either. These articles written from the point of view of a person who wanted every

governmental action to be that of a socialist government or at least to be conducive to the realization of socialism.

Laski often put Great Britain as a whole into the dock. His pronouncements aroused severe criticism in the popular press and resentment among businessmen, some of whom were also members of the governing body of the School. Beveridge, who was probably an irritable person in any case, was irritated by Laski's actions. Beveridge had his heart set on the expansion of the buildings and the work of the School and he wished to raise funds for it from private donors, from businessmen as well as foundations. There was practically no question of raising money from the government for the universities. The new funds had to come from private patrons or they would not come at all. Beveridge was troubled by Laski's incessant socialist criticism of capitalism, which he feared might reduce the financial patronage that he sought for the School.

There might also have been a more personal element in the tension because Laski became increasingly critical of Mrs. Mair, the secretary of the School, who was on very intimate terms with Beveridge. (They were married to each other as soon as Mrs. Mair's husband died.)

Nevertheless, Beveridge was unalterably determined to protect Laski's freedom to say whatever he wished to say in political matters and defended him against the intimations of various persons that Laski should not be allowed to continue as a teacher. This was a difficult dilemma for Beveridge: on the one side, he would allow no infringements of Laski's academic freedom; on the other side, he was much annoyed by Laski's "outside" activities.

When he was finally brought to book by Beveridge, Laski responded by stating that he spent many hours every day at the School, intimating that he was not stinting his duties there. He was probably right about this: he seems never to have missed a scheduled class; he also saw numerous students, attended meetings of the various boards of studies of which he was a member, and generally did his ordinary duty by the School. (Whether he did it as a scholar is another matter.) He was also a considerable asset to the School; he helped to make its reputation as a major center of the social sciences. He also made it notorious as a place of "Red agitation." (He was in fact the only person who could, although even then only with some exaggeration, be called an "agitator"; the socialists in the School, R. H. Tawney, H. L. Beales, W. A. Robson, and H. R. G. Greaves, were mild Christian or Fabian socialists.)

Beveridge was successful in his resistance to those who would have abridged Laski's academic freedom, but he did obtain from Laski a promise to reduce his publicistic writing. I doubt whether this gave Laski any notable increase in time for his scholarly studies. All through the latter 1920s and throughout the 1930s and the years of the war, Laski was extremely active in the affairs of the Labour Party, attending and addressing

conferences, lecturing to workers education classes, and lecturing to the broader public. He was extraordinarily active whenever there was a general election. The Labour Party had practically no other speakers of equal devotion and popularity at its electoral meetings. In the second half of the 1930s, he added to his tightly packed schedule activities as a member of the Socialist League, a radical group under the leadership of Sir Stafford Cripp within the Labour Party. For a number of years he was a member of the National Executive Committee of the Labour Party. For one very important year he was its chairman. He occupied that position during the year of the dissolution of the coalition that had governed Great Britain under Winston Churchill. After the formation of the Labour government in 1945, he busied himself so attentively and intrusively with the affairs of the Labour Party and the government that he had to be brusquely reminded that it was the government that made policy, not the National Executive Committee of the Party. And of course, despite his promise to reduce his publicistic writing, he still did an extraordinarily large amount of it. All these activities, taken altogether, amounted to a very strenuous mode of life. It left little time for scholarship.

Laski was a frequent visitor to the United States, especially to the eastern states, where he was an enthusiastically welcomed guest in many colleges and universities. At the time of the New Deal, he again felt much at home in the United States, as he thought that Franklin Roosevelt was ending the capitalistic system. He wrote prolifically in and about the United States. Everywhere he was surrounded by collectivistic liberal Anglophiles; such people were very strong in the States in the period between the wars, and after the Second World War, they were linked with plain fellow-traveling. During this period, Laski saw his old friends and was again embraced by *The New Republic*. He made, however, only one new intellectual friend, Max Lerner; this was rather a comedown from Oliver Wendell Holmes, Jr., Felix Frankfurter, Louis Brandeis, and Walter Lippmann.

Toward the end of the 1930s, Laski declared himself to be a Marxist. That was true only in a limited sense; he never avowed any devotion to dialectical materialism or to the theory of increasing impoverishment or to any of Marx's economic theory or to any of the other nonsensical Marxist tenets. But he did lay great emphasis on the primacy of "class interests" in the determination of governmental policies. He had however been saying that over and over again, long before he became a Marxist.

The real change occurred in his more frequent use of the word "revolution." There is no doubt that he liked the idea, whether simply as a means to "shock the bourgeoisie" or because he liked the overtones of blood and thunder. He did not say that the "working class" or the Labour Party should make a revolution; he only said that it was probable that they would make a revolution if the government, dominated by property

owners, conservative politicians et al., and the civil service, recruited from Oxford and Cambridge, resisted a socialist program enacted by a democratically elected socialist government.

This was a regrettably foolish proposition that he repeated quite frequently. Whatever the niceties of any explanation that would refute accusations that he sought to promote violent revolution, it is a plain fact that he did indeed entertain with some sympathy the prospect of a socialist revolution in Great Britain.

Winston Churchill took advantage of Laski's ambiguous views about revolution and made them a central issue of the Tory campaign in the general election of 1945. After the immense victory of the Labour Party, Laski thought he would revenge himself on those publishers who had reproduced and affirmed Churchill's argument. He therefore instituted a libel suit against a provincial newspaper, probably intending that, once victorious in this minor suit, he would take similar action against the prosperous lords of the gutterpress of London, who had given far greater prominence to the accusations against him than that petty provincial paper had done.

This action against the provincial paper was the greatest misfortune of his career. His adversary engaged the services of the leading libel lawyer of the country, Sir Patrick Hastings. Hastings seized the initiative and, following a procedure of contemptuous rudeness and exercising great skill in all the dubious practices of sharp-witted lawyers, humiliated Laski and hamstrung him from the very beginning. The eloquent Laski was badgered and insulted throughout the trial and he was unable to produce any rhetorically effective counter-arguments to offset Sir Patrick Hastings's diabolical skill. Accordingly, the jury found for the defendant. Laski was left with the humiliation of defeat where he had counted on a brilliant victory. He was also left with the necessity of meeting the legal costs of the defense.

This was a crushing blow to Laski; he was degraded and defeated and was placed under a financial burden that would have required that he sell the library of which he was so proud. Fortunately for him, friends and admirers came to his rescue and the sale of the library was averted. But his poor showing in the interchange with Hastings was an almost mortal blow. It coincided with the Labour Party's pursuit of a policy very contrary to what Laski wanted.

Laski hated Foreign Secretary Ernest Bevin's determination to support the American policy of containment of the Soviet Union. Laski was never a fellow-traveler of the ordinary sort. He admired what he thought were the economic and social achievements of the Soviet Union but he also criticized, quite forthrightly, the utter suppression of intellectual and political freedom there. He was always critical of although not wholly unsympathetic with the Communist Party of Great Britain. His published

statements about the United States after the Second World War did not differ greatly from those made by unreserved fellow-travelers. His affectionate and intimate relations with Felix Frankfurter, the friendship of which he was most proud, became more distant. He was also told in very firm terms by the leaders of the Labour government that he was talking too much and was giving a false impression. Laski's defeat in the libel suit and his political relegation by the Labour government for which he campaigned so energetically greatly damaged him. Although he continued with his usual eloquence to teach and to see his students with the same kindness as before, the life went out of him. Likewise, he continued to write but more emptily than before. His death marked the end of the "age of Laski" at the London School of Economics. Michael Oakeshott, a genuine and deep ruminator of original conservative convictions, not at all a party-man, was elected to succeed Laski as a professor of political science. He proved to be as beloved a teacher as Laski had ever been and except among members of the teaching staff and older graduate students, who remembered him with affection, Laski's name ceased to count. The new generation of students knew practically nothing of him or his work. The fact is that his work had been fading steadily.

There is no direct evidence that he read very much of the current literature of his subject, for which he could not really be blamed, or that he re-studied the classics, or that he spent much time pondering the problems that he dealt with. As a result, his books from the 1930s onward leave a definite impression of a warmed-over meal, the courses of which were cooked a long time before, and the distinctive features of the ingredients dissipated by repeated re-heatings.

Today, all that is left of Harold Laski is his books; his teaching and his personal qualities are remembered only by those who were his pupils or by the very few of his still-surviving colleagues who were starting out around the end of the Second World War. His publicistic writings can interest only academic biographers and writers of doctoral dissertations; his public lectures are of course long since gone. For those who would see a monument, looking at the books of his last two decades reveals no such monument.

It is not unusual for an eminence of one generation to be turned against by the next one. Anatole France's fortunes are much like those of Harold Laski except that some of Anatole France's writings can still be read, even though the best of them are fairly faint. He has nevertheless recently been reprinted in La Pléiade. I doubt whether similar distinction will come to any of the works of Harold Laski, although the better ones of his young years at Harvard are still worthy of being read.

Laski's biography had to be done, and Professor Kramnick and Mr. Sheerman have done it in a scholarly way. It would have been better had

they placed Laski more clearly in his intellectual environment and been a bit more forthcoming about the merits, such as they were, of his intellectual achievements.

Although this might not have been their intention, they have provided a cautionary tale of an intellectual in politics, a tale of self-undoing by vanity and by neglect of an intellectual's obligation not to sacrifice his intellectual calling to daily politics. They have also called to the attention of the new generation an account of a person who with all his foibles and foolishness was much loved by many individuals and not without good reason.

So what is left of Harold Laski, who was once the linchpin that held together Anglo-American collectivistic liberalism, who was a striking example of an intellectual in politics and an intimate of the great? Apart from the legendary exaggerations or plain fabrications in his half of the *Holmes–Laski Letters* (1953), all that is left are the several interesting works of his earliest years and the recollection of his kindly interest in and his generosity to his students. His publisher Charles Furth of Allen & Unwin—not a radical publisher as the biographers say—once uttered the following words to me: "Harold Laski—the biggest heart in London." To have revived the image of such a man is a worthy achievement and readers should be grateful to the biographers for their accomplishment.

April 1994

V. Recapturing Traditions

Arnaldo Momigliano and the
Human Sources of History

Donald Kagan

Arnaldo Momigliano, who died in 1987, was the world's leading student
of the writing of history in the ancient world. He examined the historiog-
raphy not only of the Greeks and Romans but also of the Hebrews, Per-
sians, Babylonians, and Assyrians, among others, and the breadth of his
curiosity and learning was unmatched. Born and educated in Italy, he was
appointed to the chair of Roman history at the University of Turin at the
age of twenty-eight, but as a Jew he was removed from the position by
Mussolini's racial laws. Most of his subsequent work was done in
England, first at Oxford and then at University College, London, where
he held the professorship of ancient history from 1951 to 1975. From then
until his death he was a regular visiting professor at the University of
Chicago. He wrote several books: biographies of Philip II of Macedon,
father of Alexander the Great, and of the Roman Emperor Claudius, and
works on *The Development of Greek Biography*, on *Alien Wisdom: The Limits
of Hellenization*, and on *The Conflict Between Paganism and Christianity in
the First Century*. Each is written with grace and is full of learning, careful
scholarship, and wisdom, but each is a slim volume that tends to read
more like a collection of separate essays about a common subject than like
a fully integrated account that sets a problem and proposes a solution. In
fact, Momigliano's favorite form was the learned essay, and he fortunately
left us eleven volumes of them in his *Contributi alla Storia degli Studi
Classici e del Mondo Antico*.

The title of his last, posthumous, volume, *The Classical Foundations of
Modern Historiography*, could raise the reader's hopes for a final summa-
tion of a great life's work.[1] But such was not Momigliano's genre. Like
several of his earlier books, this is the publication of a series of lectures,
namely the Sather Lectures at the University of California, Berkeley. They
were given in 1962, revised over the next fifteen years, but even then with-
held for an annotation that was never completed. The publication is with-

1 *The Classical Foundations of Modern Historiography*, by Arnaldo Momigliano, with a
foreword by Riccardo Di Donato (University of California Press, 1991).

out notes from the text as the author left it. Revision of so brief a book cannot have taken very long nor should the search for notes have been arduous. Why should Momigliano have delayed publication for almost three decades and until his death? Was he dissatisfied? Did he hope to return to the full treatment of the subject for which this volume seems a bare sketch?

We shall probably never know, but there is much to appreciate in what we have. There are essays on the influence of Persian historiography on that of the Greeks and the Hebrews, on the historical tradition of Herodotus and Thucydides, on the rise of antiquarian research, on the Roman historian Fabius Pictor as the founder of national history, on Tacitus and the tradition he established, and on the origins of ecclesiastical history. The first essay compares Persian historiography, chiefly known to us from inscriptions, with the character of the history we find in the Old Testament and in the Greek historians. Both Jews and Greeks had contact and were familiar with the Persians and their society, but their historiography represents a reaction against its tradition of royal chronicles:

> Both the Jewish and the Greek type of political history broke with the Persian or more generally Oriental type of history centred on the performances of individual kings or heroes: it expressed the life of societies deliberating and acting with clear purposes under the leadership of far-seeing men.

Both reacted against the ecumenical, multinational imperial outlook of the Persians and turned inward to focus on their own peculiar traditions, but in other respects the Greek and Jewish historiographical approaches were very different.

The Hebrew Bible tells a single continuous story from the beginning of the world. Although its writers were concerned with the truth, it was God's Truth; each generation has the responsibility of preserving "a truthful record of the events in which God showed his presence," and passing it on to the next was a religious duty. For the Jews reliability depended on the truthfulness of the transmitters and on the ultimate truth of God. There came to be only one tradition; the biblical historians took no note of different versions of the same event. Yet that single account was sacred and vital for the Hebrews. "To the biblical Hebrew, history and religion were one." Once the canon of biblical history was set, moreover, the Jews largely lost interest in the study of history. They focused their attention on the Torah, the eternal law. "History had nothing to explain and little to reveal to the man who meditated the law day and night."

History among the Greeks was very different. For them, the sources of history were human, not divine, and they were many and varied. To discover historical truth it was necessary to compare them and decide among them by means of painstaking research (*historia*) and unaided human rea-

son. Historians wrote of limited, although sometimes grand, topics, treated in such a way as to illuminate the causes and consequences of events. History was meant to explain, "to provide an example, constitute a warning, point to likely developments in human affairs."

Momigliano makes it clear that the Greek tradition is the inspiring source of modern historical writing. At its heart is the critical attitude that distinguished "between facts and fancies." This is the most important contribution, and "no historiography earlier than the Greek or independent of it developed critical methods, and we have inherited the Greek methods." For Momigliano, as for most historians, this was the essential and necessary starting point for anything properly called the writing of history. In our own day we see the very distinction between "facts and fancies" undermined by literary critics and even professional historians. This kind of skepticism, of course, is nothing new. As part of the political and religious controversies of the seventeenth century skeptical critics called Pyrrhonists (named after Pyrrho, the ancient Greek father of skepticism) declared all historical writings to be mere partisan tracts. Like their modern descendants, they thereby freed themselves to treat the past in any way they liked, or to ignore it altogether. Momigliano saw the Pyrrhonist movement as having "an adverse effect" on historical studies. For all his extraordinary breadth and tolerance for new approaches, he would also have judged the modern Pyrrhonists as terribly retrogressive.

Momigliano attributes the invention of Greek, and therefore of modern, historiography to the sixth century B.C. and emphasizes two developments. At some point between Hesiod (*c.* 700 B.C.) and Hecataeus of Miletus (*c.* 500 B.C.) "a revolution happened." The political part of that revolution was the discovery of law and its importance in distinguishing between different societies. Unlike the Hebrew law, which was "beyond history," Greek law, in spite of early claims for its divine origin, emerged from human history.

> It is no chance that historiography developed in the fifth century in the full maturity of Ionian and Attic democracy. The victory of democracy was the victory for social mobility and reform: it was the victory for free and rational choice. It sharpened the interest in political theories and constitutional changes, it invited comparison between Greek and non-Greek institutions and between the various types of Greek institutions.

The second part of the revolution was philosophical, arising from contact with other peoples and an intensive questioning of received traditions and opinions. This did not, however, lead to empty relativism or to skepticism, but to a "search for new principles of explanation, the rise of doubt as an intellectual stimulus to new discoveries." Hecataeus, therefore, began his *Genealogies* with a challenge to tradition: "I Hecataeus will say

what I think to be the truth; the stories of the Greeks are many and ridiculous." That did not lead him either to make up whatever story he liked or to despair of finding the truth. It led him to questioning and research and the reasoned quest for accurate knowledge and understanding—that is, toward history.

It is not Hecataeus, however, whom we call the father of history but Herodotus, and Momigliano explains why. Hecataeus appears to have confined himself to the comparison and reasoned criticism of what was thought to be known. In his effort to preserve valuable memories of great deeds of the past, Herodotus undertook inquiries, even traveling to foreign countries to gather new evidence. "The task of preserving traditions implied the aim of discovering new facts. Both together entailed a new methodical approach in which the reliability of evidence mattered more than rational evaluation of probabilities." For all that, Herodotus did not enjoy a reputation for accuracy, truthfulness, and objectivity among ancient writers. They pointed to factual inaccuracies, many called him a liar outright, and Plutarch wrote an essay on his "malignity," charging him with a lack of patriotism and a prejudice in favor of Athens.

The "Father of History," in fact, with his meandering style full of discursive side trips into the customs and habits of various peoples, his serious consideration of the causal role of the gods in human affairs, did not become the model for what was thought to be the best historical writing in the ancient world. Polybius and the Roman's Sallust, Livy, Tacitus, and Ammianus Marcellinus were the great historical writers of antiquity, and they wrote chiefly about their own times, their own nations, and, especially, about war and politics.[2] As a model Herodotus was eclipsed. The responsibility for this Momigliano places squarely on the shoulders of Thucydides, who "put himself between Herodotus and his readers." Without directly naming the historian of the Persian Wars, Thucydides corrected some of his factual errors, dismissing him as one who wrote "a prize-essay to be heard for the moment," compared to his own more serious effort, which was meant to be a "possession for all time." Where Herodotus delved deeply into the distant past, painted on a broad canvas the picture of many nations and peoples, and was interested in their religious, social, and cultural practices, Thucydides focused his powerful critical eye on the present and on the recent past; he fixed his gaze intently on the Greeks, and especially on his own Athenians; finally he concentrated the reader's attention on the war, its diplomacy and its politics. For him, as Lord Acton put it, "History is past politics."

2 Livy was exceptional in writing of a more distant past. Polybius, since his subject was the rise of the Roman Empire, wrote much about the Romans, and, necessarily, a bit about their enemies. His main subjects, however, were the Romans and the Greeks.

Polybius, whose history of Rome's conquest of the Mediterranean world followed the Thucydidean model, and Tacitus, who focused on politics in Rome, were much esteemed during the Renaissance and the early modern period of European history. The writers of the eighteenth century, with their interest in the manners and civilization of earlier periods and of the entire world, rediscovered Herodotus, although as philosophical historians themselves they also admired Thucydides' search for a useful history that sought the causes of events in the lasting elements in human nature and the human condition. The nineteenth century, however, especially in Germany, saw the triumph of political history and the eclipse of Herodotus by Thucydides.

Momigliano, with his broad and generous understanding of historiography, his sense that it must combine the story of politics, diplomacy, and war with that of society, culture, and civilization, deplored that development and approved the change that had come along in his own time. Writing in the early 1960s he said with satisfaction that "the need for a comprehensive, extrapolitical history is admitted by almost everyone," and, in the same spirit, that "we must not concede to Thucydides that he really replaced Herodotus." Thirty years later the world of historical writing has changed so much as to make these remarks seem dated. In much of the American academy "extrapolitical history" has all but pushed political history out the door. The most famous and influential of the social historians, Fernand Braudel, dismissed the elements of politics, diplomacy, and war as mere *événements*, transient and trivial in comparison with the greater and longer-lasting issues posed by geography, demography, and social and economic developments over long periods of time. In his best known work, *The Mediterranean and the Mediterranean World in the Age of Philip II*, the political decisions, events, and developments are of small moment compared to the inanimate and impersonal forces that shape societies over the very long run.

Now it is clear enough that such forces exist and that they have considerable impact on politics, war, and diplomacy, chiefly in establishing the limits of what is possible. Within those limits, however, individuals and groups of human beings make decisions that are of vital importance, and those decisions that are military, diplomatic, and political, moreover, influence ever larger groups of people in ways that can affect the very existence of peoples, nations, and the human race. It is important that we understand the underlying conditions and forces, geographic, demographic, anthropological, psychological, etc., that help to frame and influence the choices that people make in these decisive realms. But if it is to be helpful, this knowledge must be connected with the specific facts, decisions, and events made in the public arena, that is, in the world of politics. "Extrapolitical" historians have not made those connections, pre-

ferring to leave unasked the great political questions that have always been the spark that ignited interest in history altogether.

It is important to remember that Herodotus, for all his wanderings into geographical, sociological, and anthropological descriptions and analyses, tried to connect them, however remotely, with his major purposes as set forth at the beginning of his history of the Persian Wars:

> This is the result of the inquiry (*historia*) of Herodotus of Halicarnassus, published so that time may not erase the memory of past events from the mind of mankind, so that the great and marvelous deeds of the Greeks and the barbarians should not be without fame, and especially to explain why they fought against one another.

It was those "great and marvelous deeds" and the attempt to explain why they came about that justified the whole effort, including the broader inquiries into earlier times and distant peoples. That is the historiographical legacy left both by Herodotus and Thucydides and by their successors in the ancient world of Greece and Rome. I believe that Momigliano would have argued that it should guide all good historical writing. It is our great loss that he is not here to apply his wisdom and learning to the question.

March 1992

"The Two Cultures" Today

Roger Kimball

It is not a question of annihilating science, but of controlling *it. Science is totally dependent upon philosophical opinions for all of its goals and methods, though it easily forgets this.*

—Friedrich Nietzsche

[T]he more that the results of science are frankly accepted, the more that poetry and eloquence come to be received and studied as what in truth they really are,— the criticism of life by gifted men, alive and active with extraordinary power.

—Matthew Arnold

"The Corridors of Power" and "The Two Cultures": these phrases are essentially what remains of the once towering reputation of Sir Charles Percy Snow, novelist, pundit, and—as his harshest critic, F. R. Leavis, put it—"public relations man" for science. C. P. Snow (1905–1980) was the son of a provincial church organist who rose to public acclaim and a life peerage through a mixture of geniality, application, and talent—more or less in that order. He was the embodiment of a certain type of educated philistine: bluff, well-meaning, clubbable, so well-rounded as to be practically spherical. In the Thirties, Snow abandoned an incipient scientific career in order to devote himself to writing. He published his first novel, a whodunit called *Death Under Sail*, in 1932. During the war, Snow's technical background helped win him the important post of overseeing recruitment for Britain's scientific research (hence his acquaintance with "the corridors of power"). And the novels kept appearing. By the Fifties, Snow's novel sequence *Strangers and Brothers* was occasionally compared to *A la recherche du temps perdu*.

Today, the word that seems most often used to describe his novels—on the rare occasions that they *are* described—is "inert." In a generous moment, Edmund Wilson defended Snow but anticipated the judgment of history in finding his novels "almost completely unreadable." "The corridors of power" furnished the title for one of Snow's novels; it is all that

is left of the work. Things are a little different with "the two cultures." The phrase has lived on as a vague popular shorthand for the rift—a matter of incomprehension tinged with hostility—that has grown up between scientists and literary intellectuals in the modern world. Lack of precision has been part of its appeal: to speak of "the two cultures" is to convey regret, censure, and—since one is bold enough to name and appreciate a presumably unfortunate circumstance—superiority all at once.

Snow first used the famous phrase in 1956 as the title for an article in *The New Statesman*. The article provided the germ for his 1959 Rede Lecture at Cambridge University, *The Two Cultures and the Scientific Revolution*,[1] which was subsequently printed in *Encounter* magazine in two installments. It is a brief, avuncular work. In book form it fits comfortably into fewer than sixty printed pages and is full of men who "muck in as colleagues," behavior that's "just not on," etc. Yet as as soon as it appeared, *The Two Cultures* became a sensation on both sides of the Atlantic. The edition I have was published in 1961; by then the book was already in its seventh printing.

Its fame got an additional boost a year later when the critic F. R. Leavis published his attack on *The Two Cultures* in *The Spectator*. Originally delivered as the Downing Lecture at Cambridge, "Two Cultures? The Significance of C. P. Snow" is a devastating rhetorical fusillade. It's not just that no two stones of Snow's argument are left standing: each and every pebble is pulverized; the fields are salted; and the entire population is sold into slavery. Leavis spoke of "the preposterous and menacing absurdity of C. P. Snow's consecrated public standing," heaped derision on his "embarrassing vulgarity of style," his "panoptic pseudo-categories," his "complete ignorance" of history, literature, the history of civilization, and the human significance of the Industrial Revolution. "[I]t is ridiculous," Leavis wrote, "to credit him with any capacity for serious thinking about the problems on which he offers to advise the world." So much for Snow the sage. What about Snow the artist, Snow the novelist? "Snow is, of course, a—no, I can't say that; he isn't: Snow thinks of himself as a novelist," Leavis thundered, but in fact "his incapacity as a novelist is . . . total": "as a novelist he doesn't exist; he doesn't begin to exist. He can't be said to know what a novel is." It gets worse. Snow is "utterly without a glimmer of what creative literature is, or why it matters." "[N]ot only is he not a genius," Leavis concluded; "he is intellectually as undistinguished as it is possible to be."

1 *The Two Cultures* was recently reissued in paperback by Canto Books (Cambridge University Press), with a new introduction by Stefan Collini. This edition also includes Snow's essay "A Second Look," his "afterthoughts" on the two-cultures controversy.

Literary London was stunned and outraged by Leavis's performance (which was something of an official swan song, since he retired from teaching that year). At that time, a certain degree of rhetorical *politesse* still marked British literary journalism; Leavis had been the opposite of polite. In the weeks that followed, *The Spectator* printed more than thirty irate letters, many from eminent personages, most of them siding firmly with Snow. It was an extraordinary outpouring. One correspondent deplored Leavis's "insincerity, incapacity and envy." Lord Boothby, claiming that there was "not a single constructive thought in his lecture," spoke of Leavis's "reptilian venom." Stephen Toulmin wrote that the lecture was "an insult to the audience and to Snow himself." Other indignant commentators dismissed Leavis's lecture as "ludicrously overdone," "a demonstration of ill-mannered, self-centered and destructive behaviour," or, more simply, "bemused drivelling."

The extreme reaction was partly a response to Leavis's own extremity: Lionel Trilling, reflecting on the controversy in *Commentary*, summed it up when he spoke of the "unexampled ferocity" and "bad manners" of Leavis's attack. In fact, Trilling agreed with much that Leavis had to say; but he could not abide the scorched-earth rhetoric: "it is," he wrote, "a bad tone, an impermissible tone." Perhaps so. But in the English response there was also a large element of snobbery: by 1960 Sir Charles was, well, Sir Charles: a member of the Athenaeum, a reviewer for *The New Statesman*, someone whom one *knew*. Thus Dame Edith Sitwell: "Dr. Leavis only attacked Charles because he is famous and writes good English." *Charles*, indeed.

The ruffled feathers of London's intellectual elite make for an amusing footnote to the cultural history of the period. But the questions raised by *The Two Cultures*—and by Leavis's searching criticisms of Snow's position—are something more serious. It is not simply that the gulf between scientists and literary intellectuals (and the general public, too, of course) has grown wider as science has become ever more specialized and complex. Because of the extremely technical nature of contemporary scientific discourse—think, for example, of its deep reliance on abstruse mathematical notation—that gulf is unbridgeable and will only widen as knowledge progresses. The more pressing issue concerns the fate of culture in a world increasingly determined by science and technology. Leavis described C. P. Snow as a "portent" of our civilization because, in his view, Snow's argument epitomized modern society's tendency to trivialize culture by reducing it to a form of diversion or entertainment. Not that diversion and entertainment are necessarily bad things: they have their place; but so do art and high culture. The problem, as Leavis saw, is that the confusion of art and entertainment always proceeds in one direction: toward the adulteration, the trivilization, of art. For him, it was not

surprising that *The Two Cultures* captured the public imagination: it did so precisely because it pandered to the debased notion of culture championed by established taste.

This year marks the thirty-fifth anniversary of Snow's essay. As we look around the cultural landscape today, we see the debris of a civilization seemingly bent on cultural suicide: the triumph of pop culture in nearly every sphere of artistic endeavor, the glorification of mindless sensationalism, the attack on the very idea of permanent cultural achievement—in the West, anyway, the final years of the twentieth century are years of unprecedented material wealth coupled with profound cultural and intellectual degradation. C. P. Snow is hardly to blame for all this. He is merely a canary in the mine. But as such—as a symptom, a "portent"—he still has much to tell us.

Perhaps the first thing that one notices about *The Two Cultures* is its tone, which vacillates wildly between the cozily anecdotal and the apocalyptic. On the one hand, we find Snow busy meeting the physicist "W. L. Bragg in the buffet on Kettering station on a very cold morning in 1939." Without the narrative prop of High Table dinner conversation at Cambridge, Snow would be lost. On the other hand, he insists that the problem he has outlined is a "problem of the entire West." "This is," Snow writes toward the end of his lecture, "one of the situations where the worst crime is innocence." In some "afterthoughts" on the two-cultures controversy that he published in *Encounter* in 1960, Snow refers solemnly to his lecture as a "call to action."

But what, exactly, is the problem? And what actions does Snow recommend we take? At one moment it's nothing much; the next it's everything and more. There is that "gulf of mutual incomprehension" between scientists and "literary intellectuals," of course. But it soon turns out that there are also the "three menaces" of nuclear war, overpopulation, and the "gap" between rich and poor nations. (There are many gulfs, gaps, chasms, caesurae in *The Two Cultures*; it sometimes seems that Snow's entire argument has fallen into one of of them.) On one page the problem is reforming the schools so that "English and American children get a reasonable education." Well, OK. But a few pages later the problem is mobilizing Western resources to industrialize India. And Africa. And Southeast Asia. And Latin America. And the Middle East—all in order to forestall widespread starvation, revolution, and anarchy. Snow envisions tens of thousands of engineers from Europe and North America volunteering "at least ten years out of their lives" to bring the "scientific revolution" to the underdeveloped parts of the world. Reality check: in Snow's mind, the Soviet Union was way ahead of the West in dealing with these vast imponderables. This is, he says, partly because the Russians have a "passionate belief in education." But it is also because they have a "deeper insight into the scientific revolution than we have, or than the Americans

have." That explains why the world is clamoring for Russian automobiles and airplanes, you see, and also why the Soviets happened to manage their own economy so much more brilliantly than did the West.

If all this seems like a terrible muddle, it is. In truth, there are three sorts of problems in *The Two Cultures*: trivial, non-existent, and misunderstood. Some, such as the famous gulf, gap, or chasm between scientists and literary intellectuals, are both trivial and misunderstood. Sure, it would be nice if "literary intellectuals" knew more science. But the gulf, gap, chasm that Snow deplores will never be bridged—from this side of the gulf, at any rate—by anyone lacking a good deal of highly specialized training. And, *pace* Snow, it's not at all clear that the gulf really matters.

As several critics have pointed out, Snow's terminology can be exceedingly slippery. He begins with a dichotomy between the world of literary intellectuals and the world of physical scientists. (And he eschews anything more elaborate: "I have thought a long time about going in for further refinements," Snow writes, "but in the end I have decided against it": No wonder the biochemist Michael Yudkin, in a perceptive article on *The Two Cultures*, noted that Snow often seems "more concerned with the number two than the term 'culture.'") But in order to further his gulf-gap-chasm thesis, Snow is soon using "literary intellectual" interchangably with "traditional culture." This fusion yields the observation that there is "an unscientific," even an "anti-scientific" flavor to "the whole 'traditional' culture." What can this mean? Aristotle, Euclid, Galileo, Copernicus, Descartes, Boyle, Newton, Locke, Kant: are there any more "traditional" representatives of "the whole 'traditional culture'"? There's not much anti-scientific aroma emanating from those quarters. The real burden of Snow's thesis was accurately summed up by Leavis: "there are the two

2 Among other things, Snow's lecture illustrates the fact that a mountain of confusion can be built from a grain of truth. For there *is* an ingredient of irrationalism in Western culture that regularly manifests itself in anti-scientific biases of one sort or another. Certain varieties of romanticism belong here, as do many less agreeable phenomena. But Snow, while he dances around this issue—it is what gives his whole "two cultures" thesis a superficial plausibility—never really comes to terms with it. In contemporary academic culture, a widespread suspicion of the achievements of science—often extending to an outright rejection of the idea of factual truth—can be seen in many radical movements and "theories." "Cultural constructivism," deconstruction, radical feminism, and many other fashionable *ists* and *isms* are aggressively anti-empirical. Paul R. Gross and Norman Levitt expertly anatomize these disparate phenomena in *Higher Superstition: The Academic Left and Its Quarrels with Science* (for a discussion of this book, see *supra*, pages 123–134). They show that this new hostility to science is part of a more general hostility to Western values and institutions, an anti-Enlightenment hostility that "mocks the idea that . . . a civilization is capable of progressing from ignorance to insight."

uncommunicating and mutually indifferent cultures, there is the need to bring them together, and there is C. P. Snow, whose place in history is that he has them both, so that we have in him the paradigm of the desired and necessary union."

At the beginning of his lecture, Snow affects a generous even-handedness in his attitude toward scientists and literary intellectuals. There's a bit of criticism for both. If literary types tend to be quite appallingly ignorant of even rudimentary scientific concepts (Snow seems astounded that his writer friends cannot define such basic concepts as mass, acceleration, etc.), then it turns out that many scientists are unacquainted with the novels of Charles Dickens. But this show of even-handedness soon evaporates. The "culture" of science, Snow tells us, "contains a great deal of argument, usually much more rigorous, and almost always at a higher conceptual level, than the literary persons' arguments." Literary intellectuals are "natural Luddites"; scientists "have the future in their bones." This is a formulation that Snow rather likes. "If the scientists have the future in their bones," he writes later, "then the traditional culture responds by wishing the future did not exist." To clinch his argument that literary intellectuals (a.k.a. "the traditional culture") "wish the future did not exist," Snow holds up . . . George Orwell's *Nineteen Eighty-four*—as if that harrowing admonitory tale could have been written by anyone who did not have a passionate concern for the future!

Snow is especially impatient with what he takes to be the politics of "the traditional culture." He quotes approvingly an unnamed "scientist of distinction" who opined that literary intellectual writers tended to be "not only politically silly, but politically wicked. Didn't the influence of all they represent bring Auschwitz that much closer?" In this context, Snow explicitly mentions Yeats, Wyndham Lewis, and Ezra Pound. But his indictment is actually much broader: "nine-tenths" of the great literary figures of the early twentieth century (he specifies the period 1914–1950) are on his reckoning politically suspect. The "culture" of science, on the contrary, is optimistically forward-looking. But not, Snow hastens to add, *shallowly* optimistic. Scientists, too, appreciate the tragic nature of human life—that each of us "dies alone." But they are wise enough to distinguish, with Snow, between the "individual condition and the social condition" of man. There is, Snow writes, "no reason why, just because the individual condition is tragic, so must the social condition be." The prospect of social improvement (what Snow, echoing a character from *Alice in Wonderland*, picturesquely calls the prospect of "jam tomorrow") is a galvanizing force that allows the individual to transcend, or at least to forget, his private destiny.

Snow's argument operates by erasing or ignoring certain fundamental distinctions. He goes to a literary party, discovers that no one (except

himself) can explain the second law of thermodynamics, and then concludes triumphantly: "yet I was asking something which is about the equivalent of *Have you read a work of Shakespeare's?*" But, as Leavis notes, "there *is* no scientific equivalent of that question; equations between orders so disparate are meaningless." The second law of thermodynamics is a piece of specialized knowledge, useful or irrelevant depending on the job to be done; the works of Shakespeare provide a window into the soul of humanity: to read them is tantamount to acquiring self-knowledge. Snow seems blind to this distinction.[3] A similar confusion is at work in Snow's effort to neutralize individuality by assimilating it to the project of "social hope." That may sound nobly altruistic. But, as Leavis asks, "What *is* the 'social condition' that has nothing to do with the 'individual condition'?"

> What is the "social hope" that transcends, cancels or makes indifferent the inescapable tragic condition of each individual? Where, if not in individuals, is what is hoped for . . . to be located? Or are we to find the reality of life in hoping for other people a kind of felicity about which as proposed for ourselves ("jam," Snow calls it later—we die alone, but there's jam to be had first) we have no illusions?

Leavis here exposes the central philistinism, the deeply *anti*-cultural bias, of Snow's position: the idea that the individual is merely a fungible token, a representative type, whose ultimate value is purely a function of his place in the tapestry of society.

In the end, Snow is a naïve meliorist. For him, a society's material standard of living provides the ultimate, really the only, criterion of "the good life"; science is the means of raising the standard of living, ergo science is the arbiter of value. Culture—literary, artistic culture—is merely a patina or gloss added to the substance of material wealth to make it shine more brightly. It provides us with no moral challenge or insight, because the only serious questions are how to keep increasing and effectively distributing the world's wealth, and these are not questions culture is competent to address. "The upshot" of Snow's argument, Leavis writes, "is that if you insist on the need for any other kind of concern, entailing forethought, action and provision, about the human future—any other kind of misgiving—than that which talks in terms of productivity, material standards of living, hygienic and technological progress, then you are a Luddite."

3 Curiously, he also seems oblivious of the extent to which the second law of thermodynamics has impressed itself—vividly if not always accurately—upon the imaginations of modern artists, philosophers, and theologians via the concept of entropy: the thought that the universe is ineluctably "winding down" has proven to be a deeply unsettling but also fertile metaphor.

It is worth pausing at this point to note that Leavis grants Snow's subsidiary argument that improvements in scientific education would be a good thing. Leavis is not "anti-scientific." *Of course* "standards of living, hygienic and technological progress" are important. None of that is at issue. Nor is Leavis in any way suggesting that one should "defy, or try to reverse, the accelerating movement of external civilisation . . . that is determined by advancing technology." Barring a world-extinguishing catastrophe, the progress of science is inexorable. Leavis accepts that. What he denies is that science is a *moral* resource—he denies, that is to say, that there is any such thing as a "culture" of science. Science tells us how best to do things we have already decided to do, not why we should do them. Its province is the province of *means* not *ends*. That is its glory—and its limitation.

This is something that the editors of *The Spectator* grasped much more clearly than the many correspondents who wrote in to complain about Leavis's essay. One word that is missing from Snow's essay, they note in an unsigned editorial, is "philosophy"—"that effort to impart moral direction that was found in the best nineteenth-century English writers." Chief among "the best nineteenth-century English writers" was Leavis's own model and inspiration, Matthew Arnold. It is one of history's small but delicious coincidences that in 1882, nearly eighty years before C. P. Snow's Rede Lecture, Arnold was chosen for that honor. His Rede lecture—"Literature and Science"—was itself a kind of "two cultures" argument. But his point was essentially the opposite of Snow's. Written in response to T. H. Huxley's insistence that literature should and inevitably would be supplanted by science, Arnold argued that, "so long as human nature is what it is," culture would continue to provide mankind with its fulcrum of moral understanding.

The *tenor* of Arnold's lecture could not have been more different from Leavis's. "The tone of tentative inquiry, which befits a being of dim faculties and bounded knowledge, is the tone I would wish to take," Arnold noted with un-Leavisite modesty. But his argument anticipates Leavis in striking detail. Both are concerned with what Leavis calls "the cultural consequences of the technological revolution." Both argue passionately against the trivialization of culture, against what Arnold dismissed as "a superficial humanism" that is "mainly decorative." And both looked to culture to provide a way of relating, in Arnold's words, the "results of modern science" to "our need for conduct, our need for beauty." This is the crux: that culture is in some deep sense inseparable from *conduct*—from that unscientific but ineluctable question, "How should I live my life?" Leavis's point was the same. The stunning upheavals precipitated by the march of science and technology had rendered culture—the arts and humanities—both more precarious and more precious. Leavis understood that the preservation of culture—not as enter-

tainment or diversion but as a guide to "conduct"—was now more crucial than ever. If mankind was to confront the moral challenges of modern science "in full intelligent possession of its humanity" and maintain "a basic living deference towards that to which, opening as it does into the unknown and itself unmeasurable, we know we belong," then the realm of culture had to be protected from the reductive forces of a crude scientific rationalism.

The contemporary relevance of this argument can hardly be overestimated. We live at a moment when "the results of science" confront us daily with the most extreme moral challenges, from abortion on demand and the prospects of genetic engineering to the more amorphous challenges generated by our society's assumption that *every* problem facing mankind is susceptible to technological intervention and control. In this situation, the temptation to reduce culture to a reservoir of titillating pastimes is all but irresistible. Rock music, "performance art," television, video games (not to mention drugs, violence, and promiscuous sex): we are everywhere encouraged to think of ourselves as complicated machines for consuming sensations—the more, and more exotic, the better. Culture is no longer an invitation to confront our humanity but a series of opportunities to impoverish it through diversion. We are, as Eliot put it in *Four Quartets*, "distracted from distraction by distraction." C. P. Snow represents the smiling, jovial face of this predicament. Critics like Arnold and Leavis offer us the beginnings of an alternative. Many people objected to the virulence of Leavis's attack on Snow. But given the din of competing voices, it is a wonder that he was heard at all.

February 1994

Selling Henry James

Joseph Epstein

The judges have spoken, and I am declared a clear winner. "Don't worry, Mom," as victors by knockout used to say on the old Gillette Friday-night-fight broadcasts, "I'll be home early." The judges in this instance are the students in a Henry James course I taught for the first time to under-graduates at Northwestern University this past spring, and their judg-ments come in the form of student evaluations. I have just been presented with a packet of these evaluations. To switch from boxing to poker, read 'em and leap, which my heart did, at least briefly, in appreciation for find-ing my own pedagogical efforts so warmly received. Allow me to quote from a few of these evaluations, partly to give some rough notion of what students who study literature are up against and partly out of sheer pa-thetic vanity:

- Excellent. Perhaps the best course I've taken in college.
- It was refreshing to look at the work [of Henry James] as just *good* literature, and not to have to worry about Marxist, capitalist, feminist interpretations.
- Each class period was among the shortest 110 minutes of my week. Interesting. Stimulating. Controversial.
- It was refreshing to talk about what an author was actually saying, rather than what he wasn't saying or didn't know he was saying. This class was one of the high points of my four years at Northwestern— I'm glad I had it during my final quarter.
- Top-notch—the champagne of academic experience.

That last item reminds me that Mumm's the word—or perhaps ought to have been about such obviously inflated praise. But then I am so pleased that this course seems to have gone over with its audience that perhaps I am a bit out of control. I set out to teach it, I must confess, with some trepidation. I say "with some trepidation," but it occurs to me that I have done most of my teaching with some trepidation, though I have been told

that such nervousness as I might feel doesn't show. Something else that doesn't show, at least so long as one is teaching other than foreign languages in the humanities, is one's effectiveness. How much of what one is saying is getting through to students? How much thinking of a subtle or textured kind can one expect to be absorbed by students between the ages of eighteen and twenty-two who, if memory serves, have a few other things on their minds?

Confidence in these matters is for fools. Five or six years ago, a colleague, not normally given to bragging, told me that something quite magical had been happening to his teaching. He didn't quite know how to explain it, but suddenly it all seemed to be coming together for him. In class he would find himself making startling connections, things flowed as never before, fascinating, possibly even original insights that had not hitherto occurred to him seemed to be there when he needed them.

That same afternoon I ran into one of the most impressive of the then-current batch of undergraduate literature students. She was quick at acquiring foreign languages; was writing a senior paper on Rilke for Erich Heller; had been earnest enough to sit through an entire course of mine, for no credit, on the sociology of literature, for which she did all the reading and contributed brilliantly to classroom discussion. In a casual, merely making-conversation way, I asked her how her quarter was going. "All right," she said, "but for Professor L.'s class [the colleague mentioned in the above paragraph]. He's so dry, so dogmatic, so clearly talking to himself." Whoops, I took—and continue to take—the moral of that story to be, Never say you are teaching well.

I was not about to say that I do, but I do say that I especially wanted to teach Henry James well. As a graduate student once said to me of another student in a different class who was floundering and about whose fate she was worried, so I now say about Henry James: "I love him, you see." James seems to me the most artistically intelligent, the most subtle, finally the greatest American writer. No other writer has given me so much pleasure nor, I believe, taught me so much about literature and life. I wanted ardently to get my appreciation for James across. I wanted converts, not to my precise views, but to at least a rough recognition of Henry James's immense achievement.

Before this could be done, I suspected, there was a need to scrape free the barnacles of cliché that have clung to the vessel of James's reputation. The cliché that he was a very great snob—"an effete snob," into the bargain, in Theodore Roosevelt's phrase—must be chipped away. So, too, the notion that Henry James's subject was an impossibly rarified one, that he wrote almost exclusively about people who could really never have existed: unanchored in work, nationally rootless, without financial concern, detached in nearly every way, sheer engines of pure and apparently inexhaustible cerebration. Although Henry James was an immitigably high-

brow writer—some would say the first American modernist writer, given his tireless interest in the formal properties of his art—he also happens to have been an extraordinary comedian, in my opinion one of the funniest writers going. The cliché of Henry James as a great square stiffo, the ultimate stuffed shirt, this, too, had to be quickly swept away.

Were my students even aware of these clichés? Difficult to know. But then it is a bit difficult to know what, exactly, is taught to undergraduates nowadays. In the course descriptions that go out each quarter, which I admit to reading in good part for the unconscious humor I find in them, one often encounters offerings promising the latest theory-a-go-go written in the most rococo gibberish. But then there are also standard survey courses and teachers who haven't gone in for the *nouvelle* intellectual diet. My guess is that an undergraduate majoring in English at Northwestern today is likely to have been taught a single work by James—*Washington Square*, perhaps *Portrait of a Lady*, just possibly "Turn of the Screw."

I recalled my own introduction to Henry James as an undergraduate at the University of Chicago in the middle 1950s. It came when I was twenty years old in a course in the modern novel taught by Morton Dauwen Zabel. The novel was *The Spoils of Poynton*, a book of 1897, when James had already begun to write in his late—which is to say, more complex and circumambulating—style; and its subject, that of the passing on of a lovingly gathered collection of antique furniture, doubtless must have seemed rarefied in the extreme to a Middlewestern boy to whom the entire notion of "antique" held not the least interest. How much of the novel I could be said to have comprehended I cannot say. Yet I came away with respect for it, which was in part owing to the respect I had for the respect in which my teacher held it. I did at least grasp that Henry James was serious stuff, and that if I were one day to consider myself a serious literary man I should have to return to him.

It's probably a bad idea to ask how much anyone gets out of a book. ("None of us," writes Ned Rorem, "can ever know how even our closest friends hear music.") The question is especially complicated when applied to the young. I think of myself at nineteen reading Proust. What was going through my mind? Probably chiefly delight at the notion of myself reading Proust. When young, one does a great deal of reading that, if one is going to be among that small portion of people who go on to take books seriously, will have to be done again. As an earnest student of mine once put it shortly before his graduation, "God, I wish I had a chance to do a second draft on my education." Some of us have been lucky enough to be able to arrange our lives spending the rest of our days putting draft after draft on our education.

Yet a teacher of the young must not dwell on the question of what, even roughly, his students derive from the books he teaches them. My own assumption is that they, or at least the best among them, do not get

much less than I do; and I have always tried to teach to the best in the class. To do less would be to lapse into condescension of a kind that would be defeating. This doesn't mean that I don't stop to explain and discuss fundamental matters—how symbolism works, what constitutes style—but I do assume that my students read for the same reasons that I do: aesthetic pleasure and spiritual profit.

Not that this need preclude a certain quiet cozening on this teacher's part. In teaching Henry James I viewed myself as a salesman. Like a salesman, I saw no point in making it any more difficult than necessary for a customer to say Yes. No point, in my view, in throwing anyone in at the deep end of the pool. Not that Henry James's pool has a shallow end; he adored, he positively wallowed in complexity, and toward the end of his life he told his niece that he wished he could find a more elaborate way to pronounce his name. But some Jamesian works are a good deal less daunting than others, and I planned to begin with these, working my way through and up to the more complicated. Here is my reading list in the sequential order that students would be asked to read James:

1. "The Art of Fiction"
2. "The Figure in the Carpet"
3. "The Aspern Papers"
4. *Washington Square*
5. "Daisy Miller"
6. "The Pupil"
7. *The Europeans*
8. "The Turn of the Screw"
9. *The Princess Casamassima*
10. *The Ambassadors* (to be read for the final exam)

Class enrollment was set at thirty students. I wanted the course to be built around discussion of works, for I thought that straight lecturing would be deadly. Something like forty-seven students registered for it, but I closed out enrollment at thirty-six. What their motives—beyond course credit—were in taking the course, I do not know. Most were upperclassmen, four were graduate students; the student who wrote far and away the most brilliant examination in the course turned out to be a sophomore.

First day of class, right out of the chute, the sales pitch began. After setting out the ground rules—examinations, papers, grades, attendance—I announced what I took to be the point of the course. This was to establish in their minds an appreciation for the work of one of the most subtle of American writers, an understanding of what constitutes an exemplary

career in literature, and, somehow, through all this, I hoped they would take away something that, in ways that could not be predicted, would alter, however slightly, their ways of thinking about life and make them a little bit smarter.

I next touched briefly on a question that, fifteen or twenty years ago, would simply never have arisen—that of "how" we shall read Henry James. "I suppose my answer to this question," I said, "is, 'As intelligently as possible.' I do not myself read him as a Marxist, a Freudian, a Decon-structionist, a Post-structuralist; I don't read him to discover that he might be 'elitist,' or 'pro-capitalist,' or 'anti-feminist,' or anything of the sort. One of the interesting things about Henry James is that he makes all these ways of reading seem rather beside the point. I read him for the pleasure of his language, for his wit, for his meaning, which, if I may say so, is not always that easily caught. A critic named Philip Rahv [surely no one in the class, graduate students included, is likely to have encountered that name], who once remarked that James was a secular New Englander, interested in the same moral questions that his fellow New Englanders had been interested in, once formulated James's way of coming at these questions thus: For Henry James 'any failure of discrimination is sin, whereas virtue is a compound of intelligence, moral delicacy, and the sense of the past.'"

Raising the sales pitch slightly, I began, in a brief lecture on Henry James's life, by calling him a genius. A genius, though, I emphasized, of a particular kind. There are no Mozarts in literature, nor Einsteins for that matter, so that Henry James's genius was not of the natural kind but came about as the result of fortunate circumstances—chief among them being born into the James family—and the most careful self-cultivation. And I quoted James himself, in *The Tragic Muse*, on the nature of genius in the arts: "Genius is only the art of getting your experience fast, of stealing it, as it were. . . ." It is also, of course, the ability to make the most of this experience, to have the energy and determination to make that experience count and to make it tell in works of art. I also quoted James on another character in the same novel: "Life, for him [one Mr. Carteret], was a purely practical function, not a question of phrasing." To which I added that they, my students, ought to know right off that for Henry James not entirely but in good part life was a matter of phrasing—the right phrasing. I'm fairly sure no one in the room quite knew what I meant.

The second session of class I brought in a photograph of Henry James in his early sixties, my only visual (non-audio) aid. In this photograph, which I acquired some years ago from the Smith College Archives, James wears pince-nez and is without his beard. I asked the students to take a minute or so with the photograph so that they might recall that the man they would be reading all quarter really was of flesh and blood, however godlike at times he may seem. I also suggested that the more penetrating

among them might just discover, behind what at first glance seems a most formidable late-nineteenth-century countenance, a slight but very sly humor lurking.

Together the class and I worked our way through the essay James titled "The Art of Fiction." He wrote it in 1884, when he was forty-one, well launched on his career but far from having attained the heights he would soon reach. The essay is too rich to summarize here, but it is about what James calls the "artistic idea" and the variety of possibilities that novels—which "are as various as the temperament of man, and [are] successful as they reveal a particular mind, different from the others"—and all that the glorious form of the novel, then attaining its pre-eminence as a literary form, was capable of achieving in the hands of serious practitioners. Best as I remember it, the discussion was not exhilarating—it is generally easier to teach imaginative than critical works—but earnest, and at least nothing flat-out stupid was said. I also handed out Xerox copies of a sheet of quotations. The most impressive of these, from James's essay on Turgenev, I read aloud, prefacing it by saying that James himself, in the same essay, remarks that when we read a writer of real power we want to know what he thinks about the world. This quotation, I think, comes as close as any single passage from James that I know to answering that question.

Life *is* in fact, a battle. On this point optimists and pessimists agree. Evil is insolent and strong; beauty enchanting but rare; goodness very apt to be weak; folly very apt to be defiant; wickedness to carry the day; imbeciles to be in very great places, people of sense in small, and mankind generally, unhappy. But the world as it stands is no illusion, no phantasm, no evil dream of a night; we wake up to it again for ever and ever; we can neither forget it nor deny it nor dispense with it. We can welcome experience as it comes, and give it what it demands, in exchange for something which it is idle to pause to call much or little so long as it contributes to swell the volume of consciousness. In this there is mingled pain and delight, but over the mysterious mixture there hovers a visible rule, that bids us learn to will and seek to understand.

I closed that second class, our first working session, by quoting James yet again: "In every novel the work is divided between the writer and the reader; but the writer makes the reader very much as he makes his characters . . . the reader would be doing his share of the task; the grand point is to get him to make it." Would James be able to turn this trick with these students? Remains, as political journalists hedging their bets say, to be seen.

"Taught what seemed to me a decent class yesterday," my journal for March 30, 1990, reads. "Some bright and earnest kids in the room, I

think." The fact is that, over the years, I have had little to complain about in my students at Northwestern. There have been the usual contingent of the mediocre; a vastly smaller contingent of the genuinely hopeless; but always I have come upon a small number of superior students who are capable of passion and intelligence about art and other artifacts of the mind. Northwestern does not do all that well in the snobbery sweepstakes that I think undergraduate education in the United States has become; in rankings that appear in newspapers or news magazines from time to time, it is usually listed in some such slightly dreary position as fourteenth or eighteenth best school in the country. Who knows what this means—and who cares? But what I do know is that, in order to get into Northwestern, which asks high grades and SAT scores, these students have had to acquire the habits of achievement—which is to say, they do the work. Ask them to read a novel by next Thursday, and generally almost all will have done so; and those few who have not will feel damned guilty about it. I, for one, am glad they do feel guilty.

Originally, the James course was to meet from 9:00–10:30, but then I thought perhaps Henry James at nine in the morning might be pushing it, and so I changed the time to 10:30–12:00. The room we met in was on the fourth floor of an old Charles Addams-like building called University Hall, which has good light and for some reason thirty or so extra chairs, all metal and plastic, many of which seemed to be massed up at the front of the room, giving the joint the feel of an abandoned warehouse once owned by a Scandinavian furniture company. Within a week or so, I learned the names of the students, whom as always I addressed as Mr. and Miss, and had my initial hunches about their differing intellectual quality. A graduate student named Pataky, who spoke ardently and well, could be depended upon to come in anywhere from five to ten minutes late. Soon it began to feel like that strange academic social unit—a class.

I generally began each session by gassing away for twenty or so minutes on a general subject, such as the distinctions between highbrow, middlebrow, and lowbrow art, the meaning and use of irony as a literary method, the relation between morality and the novel, the best short formulation of which, in my opinion, remains that of R. P. Blackmur: "Novels do not supply us with morals, but they show us with what morals have to do." Sometimes I would use my twenty or so minutes to talk about a more strictly Jamesian subject: James's friendhip with Edith Wharton; the history of his reputation; his working methods, including the switch from handwriting his novels to dictating the later books to a typist. But the greatest portion of time in class was given to discussion of Henry James's stories and novels.

Henry James is nothing if not discussable. He never comes straight out to tell you what to think, though those of us who have lived long with his fiction have a pretty good notion of his partialities. He had a positive hor-

ror of generalization. When T. S. Eliot famously said that Henry James had "a mind so fine no idea could violate it," he did not mean that James couldn't understand or handle general ideas, but instead that his mind was too finely textured ever to be dominated by an idea and that he carried on his own aesthetic operation at a level well above the ideational. "It is the business of literature," wrote Desmond MacCarthy, "to make ideas out of facts." James was content to work with the facts alone—the lush, languorous, lovely facts—and let his readers discover in his writing such ideas as they deemed useful. So that many a Henry James story or novel, ending in renunciation or death, leaves a reader to work out the true meaning of what he has read on his own. Some people hate this challenge; others among us feel that this is precisely how sophisticated commerce between a novelist and his audience ought to be carried on. Naturally, I hoped my students would develop the respect for Henry James and the aesthetic patience required to join the latter camp.

Certainly, the very first story in the course, "The Figure in the Carpet," called for aesthetic patience in the extreme. It is a story about a search for the deep and underlying meaning of a writer's work. "My little point," the writer in question calls it, then enlarges upon his meaning:

> "By my little point I mean—what shall I call it?—the particular thing I've
> written my books most *for*. Isn't there for every writer a particular thing of
> that sort, the thing that most makes him apply himself, the thing without
> the effort to achieve which he wouldn't write at all, the very passion of his
> passion, the part of the business in which, for him, the flame of art burns
> most intensely? Well, its *that*!"

Readers of James's splendid story will recall that, although most of it is about trying to discover what that little point, the figure in the writer's carpet, really is, we never finally find out. We can only surmise, which is far from everyone's idea of how a story ought satisfactorily to end. What is more, it is very difficult to be human and not draw parallels with the writer in the story and its author and wonder what the figure was in Henry James's own carpet. At least I hoped it was difficult. I put this story first on our reading list because I wanted students to begin thinking of James's general intention, the passion of his passion, the part of the business in which, for him, the flame burned most intensely.

I teach by what is very loosely called the Socratic method, though I am much better dressed and epically less intelligent than the man after whom it is named. Chiefly, I interrogate, sometimes pressing fairly hard, asking four, five, six questions of the same student, yet stopping, I trust, well short of the general tone of the Gestapo. I ask a question, then call on those students who raise their hands. If no one raises his or her hand, I call on someone anyhow. I try quietly to convey that it is a mistake to

come to one of my classes unprepared. Nothing wrong with injecting a small element of fear in education. I know fear contributed greatly to my own.

Building gradually in complexity and in length, the course next took up "The Aspern Papers," a *nouvelle*, "the beautiful and blest *nouvelle*," James called it. He was much enamored of the form, for it allowed him to undertake serious psychological examination while practicing what he termed "exquisite economy in composition." I hadn't read "The Aspern Papers" in more than twenty years and on rereading this "other story about Venice" it struck me as even better than I remembered it: more subtle, more powerful, more beautiful. I attempted to teach it around a general issue—that of the correctness of digging into the past of the personal lives of famous people to make them public in the name of scholarship, biographical interest, art, or what have you. I did not neglect to mention, by way of introduction, how lively this issue remained in our own day (the Mencken *Diary* had just been published against Mencken's own wishes with serious consequences for the author's reputation), and I brought up the fact that Henry James himself had at one point burned forty years of his own correspondence, lest it fall into the hands of a "publishing scoundrel" like the narrator of "The Aspern Papers."

A number of other ways of approaching the work were available, not least among them as a study into the nature of an *idée fixe*, or, as F. W. Dupee puts it in his book on James, as a book about the "power [of the past] to bargain with the present." But I could have lingered as well on the sheer beauty of James's rendering of his story, fondling details, highlighting descriptions, noting the scores of delicate phrasings. When James speaks of Juliana Bordereau, the aged lover of the dead poet Jeffrey Aspern, he remarks that, as an American, she had first come to Europe before "photography and other conveniences [had] annihilated surprise." Forgive a bit of gushing, but that phrase "annihilated surprise" seems to me worth the entire price of the ticket. I pointed this out in class; I mentioned other lovely Jamesian touches. But when teaching the work of a genuinely elegant prose writer I have always felt that I have never done this element in their work sufficient justice. If poetry is what is left out of translation, it is the fine and artful details that tend to depart in teaching.

The student response to "The Aspern Papers" seemed to me generous in its appreciation. I felt that there was a strong sense in the room of the quality of the work that we had just read and of the superiority of the artistic intelligence that had produced it. Meanwhile, personalities began to emerge, and they were not uninteresting. Of a class of thirty-six students, twelve or so were fairly impressive talkers, and three or four were capable of saying things of the kind that kept the old professor on his own wobbly toes. The class, in other words, had begun to take on character, and it was not a displeasing one. "Students in my Henry James course seem filled

with good will," I note in my journal for April 7. "Don't know if my Henry James sell is working, but thus far no one is walking out."

Washington Square, the next book in the course, is a novel that James chose not to include in the New York Edition of his works, *The Novels and Tales of Henry James*, which he prepared for publication between 1905 and 1909. Around the time the Edition began to appear, James wrote to the novelist Robert Herrick that "by the mere fact of leaving out certain things (I have tried to read over *Washington Square* and I *can't* and I fear it must go!) I exercise a control, a discrimination, I treat certain portions of my work as unhappy accidents." Not a good decision, in my view, for this slender novel, written when James was thirty-seven, continues to stir the mind and agitate the heart of an attentive reader. Dealing with one of the great Jamesian themes—the immorality of an attempt by one human being to dominate the spirit of another, or to use another as a means to his or her own ends—the novel also provides a potent argument against theoretical modes of thinking in its attack on the figure of Dr. Austin Sloper, the successful physician who kills the love and respect in which he was held by his own daughter by treating her as essentially a pawn in a chess game of his own theoretical devising. Scientific by training, the doctor is a man used to dividing people into classes and types, and as he avers at one point in the novel, nineteen times out of twenty he is right. The problem is that the twentieth case can be decisive—it can be, this twentieth case, your own daughter. Implicit in this I read James's criticism of scientific—and in our day, social-scientific and psychoanalytic—thought. "Never say you know the last word about any human heart," James wrote, and it ought to stand as the permanent motto for those, great writers and all readers alike, who take their instruction from literature seriously.

In class, discussion of *Washington Square* revolved around the question of how James had taken a relatively small cast of what looked to be fairly stock characters—an ugly-duckling daughter, a busybody aunt, a severe father, a handsome fortune hunter—and made them vivid and serious and immensely interesting. I recall the talk about this question being of good quality. I raised the question, too, of how James was able to transform his heroine, Catherine Sloper, the ugly-duckling daughter, from a rather dreary, misbegotten young woman to a formidable, quite admirable woman of resolute character. I mentioned a formulation of Desmond MacCarthy's in this connection, which runs, if I have it correctly, that in the novels and stories of Henry James only the good are beautiful and there is no shortcut to being good. All that it generally takes to qualify as good in James is consistent kindness, heightened awareness, scrupulosity of behavior, and just possibly an act of renunciation that at the time it is made is likely to seem the moral equivalent of amputation. Yet in James it always, in the elaborate working out of his plots, seems persuasive.

I was putting in a good deal of time in class preparations, and I found I

was enjoying myself greatly, looking forward to entering class and feeling a slight drop in emotional temperature after each session was over. This was owing in part to the students, but even more, I believe, to Henry James. A few months before the course had begun, I read some of James's novels that I had not read before (*Watch and Ward, Confidence, The Reverberator, The Tragic Muse*) and reread others that over the years had become blurry in memory (*Roderick Hudson, The American, The Bostonians*). I also read the one-volume abridgment of Leon Edel's original—and, in my opinion, triumphant—five-volume biography of Henry James. I read some of James's art criticism and reread some of his travel pieces. I read a fair amount of the vast body of criticism of James; and in so doing was reminded how the revival of James's reputation in the 1920s and 1930s, consequent upon the creation in the university of American literature as a respectable academic subject, happily paralleled the emergence of a brilliant group of critics, including T. S. Eliot, Yvor Winters, Lionel Trilling, Philip Rahv, F. W. Dupee, Joseph Warren Beach, William Troy, Edmund Wilson, and Jacques Barzun, all of whom much admired James and wrote interestingly on him. For four or five months, then, I had been living on an almost exclusively Henry James literary diet and felt myself flourishing on it.

Odd but I have found that I can write with enthusiasm about things I dislike—anger, after all, can be an inspiration—but I can only teach with delight what I love. Part of the reason for this may be that, with undergraduate life so brief, it seems pointless to me to waste any portion of it asking students to read and think about third- and fourth-rate things. One can scarcely hope to acquaint them, in the span of four years, with more than a soupçon of the ample quantity of the first-rate available in art and thought. Perhaps this is why the heavy dosage of recent academic talk about changing the canon in undergraduate education has always seemed to me a sad (usually political) cheat, where it has not been altogether beside the point. Besides, I have my own selfish motives for teaching. Apart from doing one's job—teaching the *Kinder* properly—I need to feel some sense of intellectual progress while doing so, usually in the way of feeling I am getting a bit smarter myself, and possibly learning a thing or two about writing. Teaching Henry James allows one to think one is progressing in both ways.

Not that all was euphoria. "Daisy Miller," which I taught to introduce James's international theme—or, as he called it, "the Americano-European legend"—presented a few bumps in the road. ("Daisy Miller" was the story that gave James his initial jolt of fame: the character of the American girl loose on the Continent established a type, as F. Scott Fitzgerald was later to do for the flapper; and James was asked to provide stories of the same kind for other magazines, which, being Henry James, of course he

didn't.) One of the difficulties the story provided was that many of James's little jokes about the vulgarity of the Miller family sailed blithely over the heads of students for whom vulgarity isn't currently a vivid category. A small business early in the story, for example, has Daisy's younger and thoroughly spoiled brother announce the names of the members of his family each with his or her middle initials: Annie P. Miller, Ezra B. Miller, Randolph C. Miller. The use of the middle initial is a wholly American phenomenon, and James brings it in merely to show the comic combination of American naïveté and pomposity. Explaining this admittedly minor point, I distinctly felt a collective fish eye upon me, as if the entire class were asking itself, "Why is this man bothering to tell us this?"

But the problem went deeper. It felt somewhat strange to explain to a roomful of students who, so far as I knew, had been going at it with their boy and girl friends since high school that there was something quite scandalous about a young American woman going about Rome unchaperoned but otherwise quite innocently with a lower-middle-class Italian. In "Daisy Miller" Henry James wrote a comedy of manners, a rather dazzling one at that, but when manners change radically, as they have in our time, other comedies are played. Or so I felt up there in front of the class explaining what exactly it was that Daisy did to scandalize the American colony in Rome in the last third of the nineteenth century.

Things picked up with "The Pupil," one of James's middling-long stories, written when he was forty-seven and very much at the top of his game. It is a pure Jamesian tale, fascinating in and for itself. It tells that story of a boy of vastly precocious sensibility and intelligence who is being brought up by a family of failed social climbers who are monstrously unreliable. The tutor quickly senses how extraordinary the boy is, and rather more slowly discovers how shabby is the family. Meanwhile, the two of them, tutor and pupil, in moments of shared fantasy, talk about how fine it would be if they could one day escape the family and live together on their own.

At the close of the story precisely that opportunity arises, and the tutor, vacillating ever so slightly, is caught doing so by the boy, which causes his already weakened heart to fail. It is a story that demands the utmost attention, particularly at the very end, lest the tutor's vacillation be missed. Many students did miss it, and a good discussion followed upon the subject of whether a young boy would have been so delicately attuned as to be able to pick it up. "Why," said one of the best students in the class, who didn't really think so young a boy could pick up so subtle a hint as James provides, "in order to do so, he'd had to be a little Henry James." (As the odious radio performer Art Linkletter used to say, "Don't kids say the darndest things?")

Not long after this I ventured a quotation about "The Pupil" from F. W. Dupee: "A kind of fraternal-homosexual affection unites the boy and

the tutor in 'The Pupil.'" Anything to it?, I asked. I myself didn't think there was, though I did not just then say so. But suddenly the discussion in the room was once again enlivened; the class in fact, divided. A few students came forth to say they felt that homosexuality was the key to the story. Another student said that he hadn't really thought of it before, but now that it had come up he discovered a few passages—one of which he read out to the class—that sounded rather homosexier than he had at first realized. On and on it went, unresolved as the bell rang to end the class. In the hall, Miss Jennie Davidson, who has been in another of my classes, remarked dryly that perhaps there ought to be a statute of limitations on discovering homosexuality in literature. No dope, Miss Davidson. At the next class session I simply announced that, for my money, the element of homosexuality in the story, if indeed it could be said to exist, was quite beside the point. But then, I added, you must realize that a critic's work is never done. How many students in the class picked up the irony of that last comment I am not prepared to say. I felt, though, that I owed it to them not to explain it.

It was in "The Pupil," too, that that miserable old hag, Auntie Semitism, staggered into the room. In a line toward the middle of the story James notes of the boy's family: "They were good-natured, yes—as good-natured as Jews at the doors of clothing shops! But was that the model one wanted one's family to follow?" Several were the Jewish students in the class. The teacher's last name is Epstein. What was to be done? I offered a brief sermonette—the question had come up near the end of the class—saying that I wished Henry James's work was entirely clear of this sort of blotch, but it wasn't. In this he did not, as he did in so many other ways, rise above his time and social class. I then went on to say that it might assuage people much disturbed by this to know that, in the Dreyfus Affair, James was absolutely on the correct side, applauding Emile Zola's *J'accuse* and deploring the anti-Semitism of such longtime French friends as Paul Bourget, which quite sickened him.

When I asked how many in the class had ever heard of the Dreyfus Affair, none had. Everyone who teaches has stories about what shockingly obvious knowledge the current generation of undergraduates doesn't have. For my part, I must report that I no longer get much worked up by this sort of thing. If I knew anything about the Dreyfus Affair as an undergraduate, it couldn't have been much. Such historical material as most of us possess we come to through our special interests or by simple accident. Thus I know a fair amount about the Russian Revolution but not a single fact about the administration of President James Polk. Perhaps the one serious difference between my students and me at their age is that, I suspect, I was more embarrassed about my ignorance than they, and I still may be.

More significant is what the lack of experience owing entirely to being young does to one as a reader. This came up when we read *The Europeans*, another novel James claimed not to think much of but which impressed me (and F. R. Leavis, among others). In this slender novel, in which the international subject runs the other way round, with two immensely Europeanized Americans visiting their New England cousins, the conduct of the characters and the nature of the situation into which James has inserted them, calls for a reasonably strong flow of generalization on the author's part. "It must be admitted . . . that nothing exceeds the license occasionally taken by the imagination of very rigid people" is a mild example. But the generalization that incited the most strenuous comment was that which reads: "a woman looks the prettier for having unfolded her wrongs or sufferings." What about it, I asked, is this true? Do women look prettier under such conditions?

The young women in the room with conventional—and none were rabid—feminist views felt not. They were generally committed to denying that there are any serious differences between men and women, which may or may not be sound social policy but is certainly tough on literature, which is in good part the historical record of these very differences. Others, male and female, who thought of themselves as operating solely on reason, said that they just didn't see how this generalization could hold up. A few students—all of them women—said, yes, that it seemed to them true, at least when they recalled women they knew who recounted genuine sufferings to them. (Mere kvetching, I insisted, didn't count.) I said that I thought James's generalization true, too, though my word on this point didn't come anywhere near carrying the day.

I asked what checks there were on generalizations, and when no one come forth with any, I said that I could myself think of only two: reason and experience. The interesting problem, I noted, was that experience, as Pascal and other powerful thinkers have testified, frequently outrages reason. I cited an instance from an Anthony Powell novel. In the novel the narrator remarks of another character that he was very quick at picking up speaking knowledge of foreign languages and that, like every other man whom the narrator knew who had this skill, this man, too, was fundamentally untrustworthy. "Crazy," I said to the class, "quite nuts, right?" Much shaking of heads in agreement. "Very well, then, what am I supposed to do if the only four men I have known who are similarly quick at picking up speaking knowledge of foreign languages are also, yep, fundamentally untrustworthy?" No advice was offered.

As for the hard sell, I thought it going very nicely indeed when, the week that we read "The Turn of the Screw," the class overwhelmingly rejected Edmund Wilson's theory that everything the governess saw and felt during the course of the story was imagined, the result of neurotic sexual repression. The theory was rejected, moreover, on the interesting

grounds that, in the class's view, it made the story itself less interesting; that it somehow degraded James's artistic intention; and that, finally, Henry James being Henry James, his intentions ought to be assumed to be of the highest. (Philip Rahv, writing about "The Turn of the Screw," similarly remarked: "So far as intention goes, we should keep in mind that in James we are always justified in assuming the maximum." Don't grownups say the darndest things?)

I also sensed, in our discussion of "The Turn of the Screw," a patience with James's ambiguity. Perhaps it had come with all else that we had earlier read of James, but there seemed to be an understanding that for Henry James ambiguity, along with irony and penetrating observation, had its own rich artistic uses. "The Turn of the Screw" is the ultimate tale of ambiguity. Edmund Wilson was not wrong when he said that in it "almost everything from beginning to end can be read equally in either of two senses." The story's devastating ending, in which the governess, hitherto entirely a force for good, contributes to the child Miles's death, is itself a paradigm of the ambiguity in the human soul, where good and evil often cohabit. But without the student's respect for James's intentions and understanding of his use of ambiguity, I don't think we could have worked our way through this great *tour de force* of James's with anything like the appreciative reading that emerged.

"May 23, 1990. Taught first flat Henry James class yesterday. Too few students finished reading the 591-page *Princess Casamassima*, the little dears. Too late in the quarter to yell at them." In fact, I was angrier than this journal entry reveals; lest there be any doubt, "little dears" is pure euphemism. The academic quarter was drawing to a close; papers were due in other courses; examinations in other courses would soon have to be taken. Let us not speak of love lives, emotional crises, and simple lassitude, complications not unknown to phylum *studentia*. Still, with the greed of every selfish teacher, I wanted these students to save their very best for me, which, up till now, I think the majority of them had done.

I also wanted to make good use of *The Princess Casamassima* to help nail down my quarter-long hard sell. In many ways it is among my favorite of Henry James's novels. He never availed himself of a larger canvas. Not only is the book filled with rich and beautiful things, but in it James puts to rout almost all the arguments that have been used to make him seem a less complete writer than he really is. The dark third chapter of the novel, with its terrifying tour through Millbank Prison for women, is as good as anything Dickens ever did in the same line and worthy of the great Russians. The cast of characters in the novel ranges through the entire English class system. James's depiction of working-class characters is beautifully brought off, and without a trace of snobbery. "I take no interest in the people," says Mme Grandoni, a secondary yet important character in the novel, "I don't understand them and I know nothing about

them. An honorable nature, of any class, I always respect; but I won't pretend to a passion for the ignorant masses, for I have it not." *The Princess Casamassima* is, in fact, a philippic in novel form against political snobbery and shows its dread consequences in the world. It is also the ultimate defense of the literary mode of thought, as opposed to the political or social-scientific, and sets out, with no ambiguity this time round, the forces that, for the literary imagination, rule the world. As another character in *The Princess Casamassima* puts it:

> The figures on the chessboard were still the passions and jealousies and superstitions and stupidities of man, and thus positioned with regard to each other at any given moment could be of interest only to the grim invisible fates who played the game—who sat, through the ages, bow-backed over the table.

Well, perhaps no salesman can expect utter satisfaction. Better to close the deal and move on to the next customer. I think that with perhaps a third of these students I got across what it meant for Henry James to be "the historian of fine consciences" that Joseph Conrad called him. Maybe, too, at the end of our nine weeks together reading this one writer, several of these students would depart with a glimmer of what James himself meant when he said that "It is art than *makes* life, makes interest, makes importance, for our consideration and application of these things, and I know of no substitute whatever for the force and beauty of its process." At the end of the course, they wrote those generous student evaluations. The two sets of examinations they wrote for me were strong, with an occasional James-like formulation popping up in them. "James's endings," wrote one student, "seem often to be a twist of the knife rather than the actual stab." "In this story, as in so much of James," wrote another, "The victories are small and often so much more valuable because of it."

What sticks? Will there be residue? What remains? Will any of these students eventually join the narrator of James's story "The Next Time," who remarks of the select band of readers devoted to high literary culture, "We're a numerous band, partakers of the same repose, who sit together in the shade of the tree, by the plash of the fountain, with the glare of the desert round us and no great vice that I know of but the habit perhaps of estimating people a little too much by what they think of a certain style"? These are questions the answer to which a teacher of Henry James wishes to but cannot know. Still, the prospect of having possibly put two or three more Jamesians in the world, from the standpoint of a high-pressure, hard-sell literary salesman, makes all those mornings talking one's head off seem, just possibly, worth it.

November 1990

O Pioneers!
Picasso and Braque 1907–1914
Karen Wilkin

In the spring of 1907, Georges Braque visited the studio of Pablo Picasso for the first time. In the years that followed, the two artists, apparently so unlike in background, temperament, and possibly even in aesthetic, became essential to each other, forging a relationship that was part intimate friendship, part rivalry, part two-man expedition into the unknown. The young men were constantly in each other's studio, scrutinizing each other's work, challenging, stimulating, and encouraging each other. They went off to paint in different places and returned to compare results. They invented nicknames for each other, shared jokes and pranks, dressed up in each other's clothes and took photographs. Along the way they invented a new language of painting that destroyed time-honored conventions of representation: they invented what came to be known as Cubism.

The remarkable symbiosis between the two artists is the subject of the exhibition "Picasso and Braque: Pioneering Cubism," organized by William Rubin, director emeritus of the department of painting and sculpture at the Museum of Modern Art this fall.[1] It's a wonderful show—intelligent, illuminating, tightly focused, comprehensive. Best of all, the exhibition makes its point not with rhetoric, but with the inexorable accumulation of visual evidence. Picasso and Braque said little about the years they spent together and left little written documentation. They wished to be judged by what they made rather than by what they said, and, happily, "Pioneering Cubism" allows us to do just that, with what must be an ideal selection of works assembled from literally everywhere—private and public collections across Europe and the United States, from Eastern Europe and Japan—and sensitively juxtaposed. Praising an exhibition for permitting the art to speak for itself should be unnecessary, but the current fashion in museum exhibitions for treating paintings and sculptures as il-

1 "Picasso and Braque: Pioneering Cubism" was on view at the Museum of Modern Art, New York, from September 24, 1989, through January 16, 1990. A catalogue, with an essay by William Rubin, was published by the Museum of Modern Art and Harry N. Abrams.

lustrations of theory makes Rubin's approach noteworthy. We can only hope that it will serve as a model for his successors at the Museum of Modern Art.

"Pioneering Cubism" makes the viewer work. It includes nearly four hundred works—paintings, drawings, *papiers collés*, constructions, prints— all produced in the relatively short time between March or April 1907, when Picasso and Braque first met, and August 1914, when Picasso saw his friend off to war at the Avignon railroad station. It's a large show with no padding. Not all the works are on the same level, but the lesser efforts often clarify just what Picasso and Braque were after and underline just how extraordinary the masterpieces are. "Pioneering Cubism" requires concentration and certainly more than one visit. The works in question are complex, severe, not overtly seductive; their palette is frequently austere, their structure difficult. And there is a sense of intellectual or perhaps aesthetic pressure about the show. It's the first time that this crucial aspect of Cubism has been the subject of an exhibition and, since we are unlikely ever to see these works together again, "Pioneering Cubism" demands doubly that we pay close attention.

Curiously, for anyone who has studied art history, many of the works are so familiar that it requires an effort to *see* them rather than merely recognize them. In 1989, Cubism doesn't shock the way it did earlier in this century. We are all sophisticated enough not to be disturbed by fragmented forms, not to equate shattered images with literal violence. Even Picasso's aggressive primitivism is less startling than it must have been in 1907, although *Les Demoiselles d'Avignon*, even imprisoned under glass as it is for this exhibition, remains an arresting and disquieting picture. But we know all about Cubism. We can glibly discuss multiple views, tipped space, transparent planes, dissected form, and all the rest of it. Knowing about Cubism is simply part of visual literacy. The reduced palette of the early years can still be discomfiting (a member of MOMA's board is supposed to have referred to the show as "all those little brown pictures"), but even that is understood by formalists as a deliberate restriction that allowed concentration on issues rather than color and by contextualists as evidence of the artists' poverty, since earth colors are the cheapest available. I've had art history students complain about having to spend so much time on Cubism in courses on twentieth-century art, declaring that once they had grasped its principles, nothing more need be said, and adding that they didn't see how they could be expected to tell a 1911 Braque from a 1912 Picasso in any event.

If we look hard, "Pioneering Cubism" makes it plain that there is a great deal more to be said. The exhibition breaks down conventional wisdom, makes us question our assumptions. Telling Braque from Picasso becomes obvious—except when each seems to have tried deliberately to

paint like the other—if we pay close enough attention. "Picasso and Braque: Pioneering Cubism" is clearly the definitive statement on the subject. It changes forever how we see Cubist pictures, even how we think about Picasso and Braque.

The popular notion that Picasso was the leader, the protean inventor in whose shadow Braque labored, turns out to be untrue. But it's not surprising that Picasso should be assumed to have been the dominant figure, even in such a patently cooperative effort as the development of Cubism. Picasso's astonishing virtuosity, his productivity, his razzle-dazzle changes of style all lay claim to the imagination. His life is littered with the stuff of the novels they sell in supermarkets—discarded mistresses, illegitimate children, a suicidal widow—to say nothing of the palatial houses stuffed with art, the studios in which nothing was allowed to be touched. "Picasso" is the nearest thing we have to a household word for modern art or, at least, for the modern artist. Braque, by contrast, seems a plodding fellow. He demands to be judged by his art, not his life. He lived unostentatiously, stayed married to the same woman until his death, left no agonized journals, no litigious offspring. Braque simply devoted himself to painting. Period. He explored a far narrower range of territory in his art than Picasso did, single-mindedly pursuing the implications of Cubism for most of his life, but he did so with a seriousness, lucidity, and intensity that make his best pictures unforgettable. In "Pioneering Cubism," Braque's intelligence and importance are immediately visible. So are his originality and his ability to invent. Braque was manifestly an equal partner in the Cubist venture, not a follower. It's not simply a question of who did what first—although Braque is demonstrably the inventor of some crucial notions—but of how limits were expanded, how faint suggestions were carried to full realization.

In the view of William Rubin in his excellent catalogue essay, "Braque is one of the great modern painters, but we must go back to the most prodigious Renaissance masters for the like of Picasso." Nonetheless, Rubin says, qualitative distinction is beside the point. What matters is the unique dialogue between the two artists, a dialogue that extended over six years and permitted or forced the evolution of Cubism. In the catalogue, Rubin declares that his purpose "will be not so much to argue the relative merits of these artists as to suggest the manner in which precisely their differences, in temperament, mind, and pictorial gift, contributed to a shared vision of painting that found them both at their best when they were closest to one another—a vision which neither, I am convinced, could have realized alone."

Braque, just short of his twenty-fifth birthday when he met Picasso, was intensely French, raised in Le Havre, from a family of house painters and decorators. He had come to Paris originally to widen his repertoire of

decorative painting techniques for the benefit of the family business. With only a smattering of formal fine art training, Braque owed his visual sophistication initially to his friends Othon Friesz and Raoul Dufy, who introduced him to Fauvist ideas; but at the time of Braque's first meeting with Picasso, the most powerful influence on him was Cézanne. Deeply impressed by the 1907 exhibitions honoring Cézanne, who had died the previous year, Braque had gone on a pilgrimage to the south of France, painting in "Cézanne places." As we can see from the works in the exhibition's introductory section, Braque was attempting to solidify the color patches of Fauvism into a more rational articulation of form. The pictures from this period offer graphic evidence of a new clarity and angularity of structure in Braque's paintings before he met Picasso, a new sense of underlying geometry and solidity that began to take precedence over intense color contrasts.

At the time of their meeting, Picasso was still something of an outsider, small, fierce, notorious for his erratic French and his persistent Spanishness, if Gertrude Stein and other contemporary observers are to be believed. Only six months older than Braque, Picasso was a far more accomplished artist, a virtuoso with thorough academic training who had been raised among artists. Like Braque, Picasso was striving for more rigor in his paintings. By 1907 he had completely rejected the delicacy and near-sentimentality of his Blue and Rose period pictures and, as Rubin's selection of introductory work demonstrates, he had already begun to simplify and harden forms to the point of making them appear crude or brutal. Picasso was certainly aware of Cézanne's work when he met Braque, but his own self-imposed apprenticeship was to less civilized art: the pared-down geometry of Iberian sculpture and the abrupt, unpredictable forms of African carving.

These affinities between the two artists were no doubt what inspired Braque to write "anticipated memories" on the visiting card he left, in Picasso's absence, on his initial studio visit; yet the differences between them were vast and remain readily apparent. Braque, lacking Picasso's facility, spent months on his canvases, adjusting, altering, refining. He saw his pictures through to the end, rather than letting them stand as records of inspired improvisation. Picasso, on the other hand, worked rapidly, setting down a conception, developing it only as far as necessary to capture a pictorial idea, and then hurrying on to the next image. This is not to say that his pictures are carelessly made. In the years when he worked closely with Braque, there is often a sense of urgency in Picasso's paintings, but none of the indifference so common in his late work—the look of a picture's having been abandoned because the artist knew how it would turn out. In the works of "Pioneering Cubism," Picasso is still a discoverer, the inventor of a new formal language that cancels out his extraordinary facility. Everything we see in these pictures seems fresh, newly

hatched. Nothing has yet turned into the mannerism that haunts his last decades.

Picasso, not surprisingly, was far more prolific than Braque. There are approximately three times as many Picassos as Braques from the early years of Cubism, yet the exhibition has no sense of imbalance. Rubin is fair to each artist. Pairs of contemporaneous major works are set side by side throughout the show, forcing viewers to compare, to measure them against each other, to see for themselves the likenesses and unlikenesses between them. The rest of each gallery is divided into Picasso and Braque zones, presenting a context for the dramatically isolated "featured" works.

It's evident almost from the beginning that Braque is the *painter*, Picasso the draftsman. Braque is always more aware of the total expanse of his picture, more aware that he is moving pigment over surface, constructing a two-dimensional whole. Picasso is more willful, more concerned with rendering illusionistic forms (however unrealistic) in illusory space. Picasso depicts invented structures and detached planes with the same solidity that he accorded to the classical casts he drew at the School of Fine Arts in Barcelona. How dependent he is on drawing becomes clear in the remarkable series of portraits, executed in 1910, of the collector Wilhelm Uhde (Private Collection) and the art dealers Ambroise Vollard (The Pushkin State Museum of Fine Arts, Moscow) and Daniel-Henry Kahnweiler (The Art Institute of Chicago). The likenesses are uncanny, despite the reduction of body forms and setting to non-specific, fluctuating planes. We would know Vollard anywhere, recognize Uhde in a crowd. Picasso's shorthand drawing gives us Vollard's pug nose, Uhde's pout, Kahnweiler's wide-set eyes. Cover the drawn faces and the paintings become virtually abstract; mentally eliminate the drawn elements of the faces and their planar structure tells you little. Even when Picasso's line serves a less descriptive function, it still defines planes sharply, making everything appear as though it could be lifted from the surface of the canvas and assembled as a three-dimensional structure.

Braque was never the natural draftsman Picasso was, never capable of invoking complex, volumetric forms with a few effortless strokes, as Picasso could. In his drawings, Braque's line is all edge, all boundary, but in his paintings it floats free of the planes it purports to define, interrupting and warping the shallow space of the painted surface, setting up new, independent rhythms.

"Pioneering Cubism" allows us to see the young Picasso and the young Braque struggling with their new aspirations, checking their inventions against their memory of Cézanne's work and against each other's. Sometimes, when Picasso seems doubtful, he retreats a little, to a more solid, uninterrupted rendering of form. When Braque questions, he usually turns to Cézanne for guidance. Even when he is forging ahead quite in-

dependently, he seems to keep Cézanne in mind. Braque's cool palette of ochre and viridian green owes as much to Cézanne's example as it does to the local color of the landscape, just as the wrenched forms of *Musical Instruments* (1908, Private Collection), the picture Braque considered his first Cubist painting, are as much indebted to Cézanne's tipped elongated compotes and pitchers as they are to new spatial and pictorial conceptions. Cézanne's ghost haunts, too, a series Braque painted in the summer of 1909; the towers of the castle of La Roche-Guyon became a centralized mass that is a direct homage to Cézanne's countless views of Mt. Ste. Victoire.

Braque concentrated on still lifes and landscapes, or rather townscapes, perhaps in imitation of Cézanne, but Picasso preferred more traditional academic subject matter: nudes, complex figure compositions, portraits. It may have something to do with his persistent conception of painting as an accumulation of independent images against a background—as opposed to Braque's sense of a picture as a continuous inflected expanse. Throughout 1908 and 1909, while Braque strove to turn the entire surface of his canvases into coherent, prismatic planar constructions, returning often to arrangements of buildings that he found provocative, such as the pointed roofs and turrets of La Roche-Guyon or the viaduct of L'Estaque, Picasso painted portraits and full-length nudes. He invented a new, jagged anatomy, the antithesis of the sinuous figures that populated his exquisite paintings of a few years earlier. Forms had begun to dry and harden even before his meeting with Braque, when he worked in Spain during the summer of 1906, but full expression of the impulse had to wait until 1907, in *Les Demoiselles* or the staggering *Three Women* (1907–8, The Hermitage Museum, Leningrad). The three monumental nudes in the latter painting, tightly intertwined, seem carved from a single block of red stone, like an angular, modern-day Laocoön. There is less air around these women than there is around *Les Demoiselles*, none of the crystalline blue atmosphere that separates the figures in the earlier picture. Instead, the three women became a single looming mass that forces everything else out of the picture. Elsewhere, Picasso slims down these massive earth mothers, turning them into agile, "tubular" nudes that at once recall the simplifications of primitive carving and the slender, jacket-clad arms of Cézanne's card players.

Even though William Rubin's declared intent is "not to argue the relative merits of these artists," it is impossible, given the opportunities for comparison afforded by "Pioneering Cubism," to resist making value judgments. But it is difficult to decide whether one painter is unquestionably better than the other. In the early years, Braque's paintings are often more harmonious, more rich and unexpected in color, more luminous, and even more satisfying as complete *pictures* than Picasso's; witness the delectable

Plate and Fruit Dish (1908, Private Collection) with its sprightly pears, its detached, rhythmic curves, its surprising pink knife handle. Picasso, in the same period, achieved some truly abominable results in is attempt to force figures into Cubist structures: for example, the proletarian cartoon *Farmer's Wife* (1908, The Hermitage Museum, Leningrad), or the kitschy playing card *Queen Isabeau* (1909, The Pushkin State Museum of Fine Arts, Moscow). But perhaps Picasso risks more than Braque. And when he hits, he hits hard. *Woman with a Fan* (1908, The Hermitage Museum, Leningrad) is a stunner. The solemn, frontal figure, eyes cast demurely down, one shoulder raised, is as implacable as any Egyptian deity. Figure and chair are flattened into essential planes, slammed against the surface of the canvas and nailed for eternity by the stiffly held fan.

Bread and Fruit Dish on a Table (1908–9, Kunstmuseum, Basel) is another knock-down drag-out masterpiece, a relentlessly dense, rock-like construction that may derive from Cézanne's card players. The table squats across the center of the canvas, like Gertrude Stein in Picasso's celebrated portrait. And then, suddenly, on the right-hand side, the picture begins to breathe, in the loosely drawn ghost version of the baguette, propped up to counterbalance the compote with its tight pyramid of pears. The contradiction between the picture's four-square, rather formal structure and its varied, expressive *facture* stops you dead in your tracks.

Good as Braque is, he doesn't make such stunningly forceful pictures until much later. His strength in those early years lies in paintings that sparkle and slide across the surface—the Tate Gallery's *Clarinet and Bottle of Rum*, 1911, for example, in which fragments of images float against staccato brushstrokes, momentarily coalescing into the suggestion of a still life and then drifting away again, only to be definitively fixed in place by the horizontal clarinet, threaded like a pin across the shifting planes. Braque really came into his own when he invented the *papier collé*. Cutting planes out of a single sheet freed him from the necessity of drawing and allowed him to compose with great economy and daring. There is graphic evidence of how well the method suited Braque: his production keeps pace with Picasso's at this point, and his nearly sixty collages are among his best and most consistent works. Picasso was quick to adopt the technique, but he used it to different ends. The pasted elements, the newspaper and trompe l'oeil patterns in Braque's *papiers collés*, are always subsumed by their new context. They become inextricable parts of a new whole. (Yes, Braque does sometimes use headlines and word fragments for private messages and jokes.) Picasso's use of collage is more self-conscious. We are meant to recognize the head or the guitar and, at the same time, to realize that it has been made by a cunning assembly of improbable elements. In Braque's work, we are primarily absorbed by the invented image and only secondarily made to think about the intelligence and intuition behind it. Picasso, like a precocious child, makes us first and

foremost aware of the immense cleverness of the artist who turned that triangle of paper into a portrait.

There are marvelous moments throughout the show: the shock of seeing side by side pictures clearly made in response to one another, but never seen together because they come from far-flung private collections or remote museums; or the pleasure of comparing collages from many sources with a selection of the small, intimate constructions that are the main strength of the Museé Picasso, Paris. We can see color beginning to creep back into Cubist painting, pointing toward the full-blown chromatic constructions of the late Teens. We can watch Picasso become exasperated with the self-imposed restrictions of his geometric style. We can see how the *papier collés* turn the fragmented planes of Analytic Cubism into more defined and coherent shapes, prefiguring the advent of Synthetic Cubism, with its bold, essential silhouettes. We can even catch Picasso painting like Braque, relaxing the contours of his drawing, loosening his touch, allowing his picture to open up and breathe, and we can see Braque, in turn, making his pictures crisper, more defined, more Picasso-like, as though each artist were reacting to advice given by the other.

The cumulative effect of the exhibition, as I have said, is to make us question what we thought we knew about Cubism. I'm convinced, after several visits, that with few exceptions Cubism doesn't make for good figure painting. Even landscape is problematic, since the artist is forced to reduce an enormous chunk of actuality to the size of the canvas, just the way Renaissance painters did. Space may not be rendered according to a system of three-point perspective, but it is still a fairly traditional process of depiction. Cubist landscapes tend to forego deep space, filling up the center with piled up buildings, aqueducts, and the like, and with very good reason. The more Cubist landscapes resemble still lifes, structurally, the better they are as a rule. But when Picasso or Braque takes as his point of departure the familiar objects of the studio or the café table, something unprecedented happens. Most of the time, the objects "rendered" are translated into images that are the same size as the originals. There's no scaling down, no depiction, simply invention of a new reality at full size. A Cubist "shattered" wineglass has as much physical presence as its actual counterpart; what we know about real wineglasses (or absinthe glasses or bottles or guitars) must be tested against the painted image, and the radical differences between them become part of the meaning of the Cubist picture.

When the tabletop is made congruent with the surface of the picture itself, then the canvas, whether rectangular or oval, becomes not a background but a tipped-up, confronting plane, and the painted still life becomes not an improvisation on something observed but an autonomous,

real object. In Braque's hands, in a series of stunning tabletop still lifes painted in Paris in the winter of 1912–13, the familiar Cubist iconography of musical instruments, newspapers, wineglasses, playing cards, and the like, set on oval tables, is turned into some of the most eloquent, intelligent, and beautiful painting of the twentieth century. The clustered objects on their implied tabletops, skewed a bit against the canvas, are reduced to ambiguous gatherings of planes. The conceit of alluding to an open drawer in the front of the table simply adds to the complexity of the image. The tension between what is literally there and what is implied becomes palpable; the painting's meaning, its very presence, resides somewhere in the zone between what we associate with what was painted and what we recognize as pure invention. Like Joyce's portmanteau words, which compress a host of associations into not quite intelligible sounds, the unstable imagery of the best Cubist still lifes refers both to our everyday, observable world and to an intangible but resonant visual world. Everything comes up to the surface and then backs away, in an elegant war between fact and fiction.

Could either painter have done it alone? What we know of the later work of Picasso and Braque suggests that Rubin is quite right: the pressure each artist imposed on the other was critical to the radical inventions that we call Cubism. Braque's later work is supremely elegant, cool, dependent upon extraordinary nuances of tone, texture, and color, while Picasso's is irrepressibly inventive, capricious, personal to the point of self-indulgence. Braque, no doubt, offered Picasso helpful discipline at the same time that he may have made him more aware of the possibilities of painterly painting. Picasso, in turn, must have acted as a gadfly to Braque, goading and prodding his friend, but Picasso's nickname for Braque, "Wilbourg," from Wilbur Wright, suggests that he saw him as a pioneer and adventurer in his own right.

Some of the criticism generated by "Pioneering Cubism" has asked what relevance Cubist painting can have in 1989. The answer to this is simple. The exhibition presents us with fresh evidence that painting at its best can be passionate and cerebral, profoundly serious and witty, radically new and respectful of tradition. "Pioneering Cubism" offers vindication of the unfashionable belief in the importance and potency of art neither as social commentary, political tract, nor personal advertisement, but as something that addresses both intellect and emotion through the eyes. That's a lot. And it's relevant.

December 1989

A Defense of Translation

Martin Greenberg

Translation's standing as literature is low. Even among the educated—who are not, today, the same as the cultivated and have limited acquaintance with other languages—it is thought of as a mechanical activity: the translator finds the word or phrase in his language that corresponds with the one in the foreign language and sets it down. Astonishment is the common reaction of such people when confronted with the wide disparities among translations of the same work. Astonishment is followed by some irritation and impatience; one is not getting what one bargained for: the original as it is in its own language but transferred to, duplicated in, one's own. Maybe what's needed is a super-computer. In its most prosaic function of passing along facts and information of every kind from one language to another, translation is indeed mechanical; in such translation, literalness and fidelity, here better called accuracy, go pretty much hand in hand. But in the translation of literary works, and especially of poetry, fidelity is a complex thing calling for the exercise of imagination, for transformation, not reproduction. A clarifying term has always been needed here. "Equivalence" is often used, but is, I think, too vague. I suggest "virtuality": a faithful translation gives one virtually—that is, in effect but not in fact, not literally and never in all respects—the original poem.

However, it is not only the uncultivated who are dismayed to find that the best that translation is able to achieve in bringing over a poem from one language to another is "virtuality." Shelley famously remarked in his *Defense of Poetry* that trying to translate a poem was like casting a violet into a crucible so as to discover the principle of its color and odor. In his new book, *The Poetics of Translation*, Willis Barnstone lists Benedetto Croce, Ortega y Gasset, Robert Frost, and Vladimir Nabokov, with Shelley, as being among the "great doubters" of verse translation.[1] Notice that these are names that don't go back to before the nineteenth century. This doubt about the possibility of verse translation wasn't something Roman,

1 *The Poetics of Translation: History, Theory, Practice*, by Willis Barnstone (Yale University Press, 1993).

medieval, Renaissance, or the English Augustan poets felt, planted as they were without question in their own poetic sensibilities and styles and confidently transferring work of another style and language into their own. Frost said that translation gives you all of a poem but the poetry. Nabokov, that stylist, said that "the clumsiest literal translation is a thousand times more useful than the prettiest paraphrase." He is quoted as calling his own (clumsily literal, almost unreadable) translation of *Eugene Onegin* "Dove-droppings on your [Pushkin's] monument."

Nabokov's violence of expression, doubly shocking for being committed against himself as translator, brings out the sense of violation that underlies the negative feeling about verse translation, the sense that translations are an outrage committed on great originals. "Traduttore, traditore," goes the saying. Translation betrays; that's its nature ever since the Lord confounded the one language of mankind. Well, many times it does; but surely it doesn't always, surely we are not deluded when we honor as great translations poems we read with immense delight, often forgetting (in our feelings if not in our heads) that they are translations. There is a yearning absolutism in the denigration of verse translation, a disappointed longing for the tower with its top in heaven. On earth we translate and try not to betray the sense and spirit of the original. This doesn't mean sticking to the letter. The idea that being literal is being faithful is, as Professor Barnstone says, a stubbornly enduring misconception. And even when we do betray the original, even when we set out to betray it, it can be a fortunate betrayal. That fine poet Edwin Muir, not himself a translator of verse but of prose, and (with his wife, Willa Muir) still Kafka's best translator by far, doubted the possibility of translating poetry but saw an advantage in this.

> How to translate poetry, where the actual words, the music, and the movement signify so much more than they do in prose, I find it hard to understand. The verse translator obviously must be allowed far more freedom (including freedom to invent) than the translator of prose. Perhaps the final thing one can ask from a translation of poetry is that it should be a good poem in English. A prose translation rendered back into its own language should be quite recognizable as a cousin of its original. But Chapman's Homer, and Pope's, turned into ancient Greek, if that were imaginable, would not be Homer at all. Yet Chapman's *Iliad* is a great poem. There are advantages in this impossibility of translating poetry: scores of Homers and Dantes and Shakespeares and Goethes scattered over the world, all different while in their origin the same. Verse translation does sometimes produce great literature.

Another reason for the persistent low regard in which literary translation is held, closely related to the idea that it is an impossible undertaking,

at least in the case of poetry, concerns its lack of originality. Translation is servile; it is a servant of the text it renders. If it departs too much from the text it is a bad servant. If the translator is a Pope turning the *Iliad* into an eighteenth-century English poem glittering with the dazzle of its rhymed couplets, he is a clever fellow who knows how to smuggle in his own poetic goods under the Homeric label. Nevertheless Pope's *Iliad* is Homer's too, a translation, and not simply another of Pope's poems.

> So many flames before proud Ilion blaze,
> And lighten glimm'ring Xanthus with their rays:
> The long reflections of the distant fires
> Gleam on the walls, and tremble on the spires.
> A thousand piles the dusky horrors gild,
> And shoot a shady lustre o'er the field.
> Full fifty guards each flaming pile attend,
> Whose umber'd arms, by fits, thick flashes send.
> Loud neigh the coursers o'er their heaps of corn,
> And ardent warriors wait the rising morn.
> –BOOK VIII

The distinction between creative poet and servile translator breaks down here, as indeed it breaks down in all good translation, whether close or free. The translator is a servant but not servile; his exercise of his imagination, that godlike liberating power, makes him free.

Willis Barnstone, a professor of comparative literature at Indiana University, has constructed a wide-ranging defense of the translation of poetry, based on broad, polyglot learning and practical translating experience. His *Poetics of Translation* has roughly three parts. One part has to do with translation as a universal activity, the elemental transformative and interpretive work of perception first of all, and then of "all thinking, writing, reading, and communication." In a sense the whole universe, and all literature with it, are translation. This perhaps serves to raise the dignity of translation, but, as he himself says, it is general to the point of vacuity and suggests nothing about a poetics of translation. Nor does modern translation theory, he writes, have much to say that affects, or is affected by, the practice of literary translation; it is all linguistics and semiotics, and often, my ignorant impression is, jargonizes the obvious. For this reason Professor Barnstone gives little space to translation theory, though rather too much of that space to Walter Benjamin's mystical-metaphysical nonsense about a pure, universal language to be recovered through uncompromising literal translation (interlinear gloss); the object of this language not being to communicate meaning but to exalt non-meaning into a heavenly "expressionless and creative Word, that which is meant in all languages,"

but which is meaningless in any one of the languages that make the earth a clamorous Babel.

The second part of Professor Barnstone's defense also has to do with translation's ubiquitous yet little recognized or little acknowledged presence, but now with what is usually called translations. His "paradigm" here, fascinatingly discussed at length, is Bible translation. Consider the New Testament: it is a translation into Greek from unknown "Aramaic oral and Hebrew written sources"; Jesus and the Jewish Christians of Palestine didn't after all speak and act in Greek. But when translations become sacred they turn into originals; any taint of secondhandedness would derogate from their sanctity. So the New Testament becomes a first thing. Another kind of translation took place when "Christian exegetes read the Hebrew Bible . . . as Christian prehistory. The material text lies unchanged but . . . its meaning alters profoundly. By guided reading, misreading, and rereading, the Jewish Bible became [was translated into] a Christian document." And this is proclaimed by the strictly Christian terms of Old Testament and New Testament. Hebrew scripture is reinterpreted as the old, subordinated and superseded, witness to God's love of humanity in Christ, Christian scripture is the new, triumphant witness—although "testament" was a mistranslation into Latin of the Greek word in Mark for covenant (*diatheke*), which translated the Hebrew *berith* and was unaccompanied by the word "new." And before the New Testament the Hebrew Bible, too, was a translation—a grand compendium of every kind of translation, drawing on a multiplicity of Near Eastern sources "but concealing throughout its universal dependence." For it wouldn't do to see any of God's words as having first been uttered by Sumerian, Babylonian, Akkadian, or Egyptian lips.

Religious orthodoxy is horrified if a text that has become sacred should be violated by translation. There is a first-century Jewish writing that says three days of darkness descended on the world when the Law was translated into Greek. St. Jerome's Vulgate translation gradually acquired the standing of an original and was made the official Catholic Bible; it could only be translated into a vulgar tongue (another "vulgar" tongue!) at the peril of one's life. The great translator William Tyndale, to whom the King James Version owes so much, owes its heart, was burnt at the stake in the sixteenth century for a heretic. At the end of the eighteenth century, orthodox rabbis denounced Moses Mendelssohn's translation of the Pentateuch into German as being blasphemous. Modern revisions of the King James, which is aesthetically sacred today, are heatedly attacked for falling so far below the Authorized Version in beauty and strength. So they do; their language is painful, the more painful the more they depart from the traditional text. But I shouldn't for that reason wish them canceled. They are usefully consulted about the many obscurities and difficulties you find as you read along in the King James.

Secular literature, too, abounds with little acknowledged translation. "Euripides, Virgil, Chaucer, Shakespeare, and Dryden, and more recently Constantine Cavafy, Joyce, and Nikos Kazantzakis, all took earlier stories" and made them over into works of their own. "Since these were authors within well-defined civilizations, consciously following a tradition, they were performing the expected tasks of great original authors. They were, by the more ample medieval view, also translators." Shakespeare took from Geoffrey of Monmouth, Boccaccio, Gower, Chaucer, Marlowe, Sidney, Golding's translation of Ovid, North's of Plutarch, etc., etc.; the list is a long one. To do so today would get you sued. We are very conscious, in our entrepreneurial age, of literature as property and press its legal rights too hard. If you wish to quote a poem by Yeats you have to pay his heirs, though most poets would want to go on being quoted freely, the more the better, and damn all heirs. The beginning of one of Yeats's own poems, "When you are old and grey and full of sleep,/ And nodding by the fire," is taken straight from Ronsard's poem beginning "Quand vous serez bien vielle, au soir, à la chandelle,/ Assise auprès du feu . . ." At the end of the poem, I learn from Professor Barnstone, Yeats rephrased a line from another Ronsard poem that is a translation into French from Horace's translation into Latin of a Pindar ode. The current of tradition has run from Greek to Latin to French to English.

The current of tradition runs, whether the times are traditional or innovational, because literature is unalterably, irremediably traditional. And a powerful current within that current, recognized or not, is translation. Professor Barnstone rightly lays it down as a fundamental truth: "No one is absolutely original." The centuries-long growth of individualism has obscured in literature as in other things how dependent single selves are. It is instructive that the word "create" should now be commonplace. It used to mean something only God did when he created the world *ex nihilo*, that original production. But we creatures today create right and left, daily. The word is used much too loosely, though we can't do without it because it expresses the originating power of the human imagination. But that power is not absolute like God's, it depends on precedents, on what has come before it, on what lies around it. Original poems are original only in a relative sense. Yet when we call the power that brings them into existence "creative," there is a lingering suggestion of absolute power, the power to bring something into existence out of nothing. William Collins said in his *Ode on the Poetical Character* that the human imagination was born on the same day God exercised his imagination to make the world—"on that creating day"

> When he called with thought to birth
> Yon tented sky, this laughing earth,

And dresst [it] with springs, and forests tall,
And pour'd the main engirting all.

This ambiguous sense of the near-absolute power of the imagination is still with us. But since no such ambiguity attaches to the activity of translating, it seeming absolutely clear that it brings something into existence only out of something else, the modern disposition to deny translation important artistic standing is reinforced.

A great virtue of *The Poetics of Translation* is the distinctions it introduces into a very muddied subject. This is its third part. These distinctions are based on Dryden's fundamental classification of translations into metaphrase, paraphrase, and imitation. Metaphrase is literal translation; paraphrase a *via media* aiming at what I have called virtuality; imitation is free translation, adaptation, license. The author extends Dryden's classification (which he calls "translation level") into "structure, or degree of source text in translation"; and "authorship, or dominant voice." Structure and voice also run a gamut from close to free, from dependence on the original to independence. Of course these distinctions aren't hard and fast, nor do they denote artistic value. We find good and bad verse translations in any of these categories, even in literal metaphrase.

How, for example, does Robert Lowell's translation of Racine's *Phèdre* look in the light of these distinctions? First Racine's original; Hippolytus speaks the opening lines:

> Le dessein en est pris: je pars, cher Théramène,
> Et quitte le séjour de l'aimable Trézène.
> Dans le doute mortel dont je suis agité,
> Je commence à rougir de mon oisiveté.
> Depuis plus de six mois éloigné de mon père,
> J'ignore le destin d'une tête si chère;
> J'ignore jusqu'aux lieux qui le peuvent cacher.

Now Lowell, translating these lines:

> No, no, my friend, we're off! Six months have passed
> since Father heard the ocean howl, and cast
> his galley on the Aegean's skull-white froth.
> Listen! The blank sea calls us—off, off, off!
> I'll follow Father to the fountainhead
> and marsh of hell. We're off. Alive or dead,
> I'll find him.

In this first speech, as in the whole play, Lowell doesn't proceed line by line but seizes whole paragraphs, whole chunks, in his fist and drastically

remakes them with little regard for the particulars of the French. Looking at this speech, one would surely think we have here another of his "imitations" (as, following Dryden, he called them). But the story that Lowell's translation tells is still the story of *Phèdre*. The lines break out of the confines of Racine's lines, yet are still confined in Racine's story. So what is it, paraphrase or imitation? Both: in detail, an imitation; as a whole, a paraphrase.

In his structure, as in the sense of individual lines, Lowell is perforce free, using rhymed iambs rather than Racine's alexandrines; perforce, because there's no doing alexandrines in English. As for voice: has anyone, can anyone ever catch Racine's voice? What Lowell's translation has, as Racine so eminently has, is speed, though his own kind of speed. And the éclat of his lines is his own, not Racine's. This éclat, in Lowell's own poetry, often strikes me as put on. But a translator needs to "put on," to try for force with Racine, who is himself so forceful. Lowell's translation adds up to a very spirited version of Racine's *Phèdre*, though one unpleasing to pedants. It was ousted after some years from its position in the *Norton Anthology of World Masterpieces* for a dreary, pedestrian version, I presume to placate the pedants concerned that students should "study" an "accurate" version of Racine's tragedy (they would need to read it in French for that); they are not concerned that students should read language having vividness and force. In America today great classical works are published for students, not for readers. In the large-scale economy of modern publishing, the number of such readers of classical works weighs little, the number of students weighs much. Hence the increased role of academic presses.[2]

How often in the matter of translated classics pedantry ousts pleasure! *Don Quixote*, for example, was translated with sparkling verve and humor in the eighteenth century by Peter Motteux for one and by Smollett for another. The nineteenth- and twentieth-century translations steadily improved in scholarship and steadily declined in verve. The latest that I know, Samuel Putnam's, done in the 1940s, at last succeeds in being boring. But finally after two centuries, what was plain to any reader— plain to me as a teenager laughing out loud over Motteux's translation—is now acknowledged against the pedants, and the eighteenth-century translations are being reissued. By all means let us have fresh translations of *Don Quixote*, but let us have them *fresh*.

Professor Barnstone has a section that is intensely interesting because of its concrete engagement with five translations of a poem by Sappho. The five are by Catullus, Horace Gregory, Lowell, Barnstone himself, and

2 And in trade publishing, the many-headed multitude weighs more and more and the minority of the cultivated weighs less and less.

William Carlos Williams. Catullus's version is close to the Greek, we are told, although he changes the poem radically by making himself the speaker and introducing "Lesbia" (who is Sappho) as the name of the woman he is addressing. The lesbian love expressed in the original is thus turned into an expression of Catullus's love and veneration for Sappho. His translation, because he is the great classical poet Catullus and because more people read Latin than Greek, always figured as an original poem. Of course it is both: a translation, and a poem in its own right. That is what Professor Barnstone calls the "double art" of translation, good translation. Lowell classed his translation of Sappho's poem an imitation, which Barnstone disputes, in spite of some striking liberties Lowell takes (too striking, in my opinion, too eager to *strike*). The great, the startling beauty among the four English translations is William Carlos Williams's, who had the help of Greek-reading friends. It is truer to the original than Lowell's (Barnstone says), yet is very much a Williams poem. Here it is:

> Sappho
> that man is peer of the gods, who
> face to face sits listening
> to your sweet speech and lovely
> laughter.
>
> It is this that rouses a tumult
> in my breast. At mere sight of you
> my voice falters, my tongue
> is broken.
>
> Straightway, a delicate fire runs in
> my limbs, my eyes
> are blinded and my ears
> thunder.
>
> Sweat pours out: a trembling hunts
> me down. I grow
> paler than grass and lack little
> of dying.

Williams's translation is what Dryden called a paraphrase. Dryden called his own magnificent translation of the *Aeneid* a paraphrase; in it he had "endeavored to make Virgil speak such English as he would have spoken, if he had been born in England, and in this present age." This did not lessen in any way his claim that what he had produced was Virgilian, the Latin epic rendered into English. As I understand him, Dryden is saying that his poem speaks English, but is not an English poem. [3] In our own

age, his *Aeneid* looks very much like an English poem of a past age, the Augustan, and to that degree un-Virgilian—in short, it should now be called an imitation. It is time that has made the change. His English, for him, was as natural as the air; but for us, though its naturalness and ease are very striking, it belongs to history. Williams's Sappho poem, too, in a future age may look—and be—very much an American poem of a certain time and seem to lose in its Sapphic quality, lose in its virtuality. It won't, however, lose as a poem by Williams, just as Dryden's *Aeneid* doesn't lose as a work by Dryden. This is why every age needs to retranslate the classics for itself—to recover a nearer sense of the original. Nevertheless the great translations of the past continue to live on as great poems, even if losing something for us as translations.

Before passing on I should like to quote the example of an imitation or adaptation which makes a fine contrast with Williams's American paraphrase of Sappho. It is G. S. Davies's version of the Catullus poem "Lugete, o Veneres Cupidinesque." It sticks close to the sense of the original, but because of its structure: stanza, rhyme, and meter; and voice: Scots English, is purely English. It is not only a poem in English, it is an English poem, a Scots English poem.

> Weep, weep, ye Loves and Cupids all
> And ilka Man o' decent feelin':
> My lassie's lost her wee, wee bird,
> And that's a loss ye'll ken, past healin'.
>
> The lassie lo'ed him like her een:
> The darling wee thing lo'ed the ither,
> And knew and nestled to her breast,
> As ony bairnie to her mither.

3 Translation enlarges one's own language by bringing into it modes of feeling and thinking not native to it, by which they become native. The Bible is a great example of this. Translations breathe a sense of another cultural world to a greater or lesser degree, in part reflecting the greater or lesser degree of cultural difference. But a good translator must have a solid basis of confidence in his own language. Recently, predictably, there has been some admonishment (I understand) of translators to "respect the otherness of the other," not to take a "patronizing" (colonialist?) attitude toward the foreign author. I know examples of works that have been "too Englished" in translation—that is inferior translating. But the overwhelming kind of failure in literary translation goes the other way, the way of bad, unnatural, unidiomatic English. Is this call to respect otherness a call to translate literally into unidiomatic English? If so, it's unnecessary. (See Peter France's review of translations of *La Princesse de Clèves* in *The Times Literary Supplement*, January 1, 1993.)

Her bosom was his dear, dear haunt—
So dear, he cared no lang to leave it;
He'd nae but gang his ain smal' jaunt,
And flutter piping back bereavit.

The wee thing's gane the shadowy road
That's never travelled back by ony:
Out on ye, Shades! ye're greedy aye
To grab at ought that's brave and bonny.

Puir, foolish, fondling, bonnie bird,
Ye little ken what wark ye're leavin':
Ye've gar'd [made] my lassie's een grow red,
Those bonnie een grow red wi' grievin'.

What an enchanting poem! How it sings, because Scots English, closer than English English or American English to its past, can still sing in this way. William Carlos Williams's Sappho poem sings, too, in its way, beautifully. However, there is precious little singing left in American poetry today, which neither knows how nor wishes to sing. Who should have imagined that poetry, which sang before the history of the world began, would ever renounce the wish to sing!

The last sixty years in this country have been an outstanding period in translation, thanks largely to translations from the Greek and Latin classics. T. S. Eliot lit the fuse by his criticism of the translations of Euripides made by Gilbert Murray, the classics scholar and minor poet. Eliot assailed Murray for "stretching the Greek brevity to fit the loose frame of William Morris and blurring the Greek lyric to the fluid haze of Swinburne"—for writing superannuated language that came out of a superannuated sensibility. Americans took the lead in classics translation because American poetry led the modern movement in revitalizing the language of poetry. Some of the names are Dudley Fitts, Richmond Lattimore, Robert Fitzgerald, William Arrowsmith. They make a roll of honor. Fitzgerald's translations of Homer, especially, have been recognized as notable achievements. But scholarship, where a quasi-sacred text is concerned, sees freedom of the imagination in translation as presumption, irreverence. In the course of a review of recent Homer translations, the eminent scholar Hugh Lloyd-Jones extols Richmond Lattimore as the premier translator of the Greek epics because of his greater fidelity to Homer's words and verse. [*] Lattimore, writes Professor Lloyd-Jones (quoting Lattimore himself), doesn't "rate his own word ahead of the word which translates the Greek," whereas Fitzgerald thinks he can improve on Homer; Lattimore's six-beat line gives a truer impression of

Homer's swift-flowing dactylic hexameters (which are impossible to transpose into English) than the iambs Fitzgerald employs; and Lattimore, like Homer, is, as Fitzgerald is not, noble.

Professor Lloyd-Jones's standard is fidelity to the Greek, as he understands fidelity. I, who am Greekless, reading these translations as poetry in English, find that Fitzgerald is much the better writer. And in any rating of translation as art—art, which aims at giving pleasure—the best writing is what is best (barring egregious deficiencies in other respects). What does a comparison show? First Lattimore. I choose one of the passages cited by Professor Lloyd-Jones in his review. We are in Book I, Thetis has just appealed successfully to Zeus to have him back the Trojans until Agamemnon is compelled to restore the prize he has snatched from her son Achilles. Hera, suspicious of their private conversation, loudly protests, and the Father of the Gods has come down hard on her.

> He spoke, and the goddess the ox-eyed lady Hera was frightened
> and went and sat down in silence wrenching her heart to obedience,
> and all the Uranian gods in the house of Zeus were troubled.
> Hephaistos the renowned smith rose up to speak among them,
> to bring comfort to his beloved mother, Hera of the white arms:
> 'This will be a disastrous matter and not endurable
> if you two are to quarrel thus for the sake of mortals
> and bring brawling among the gods. There will be no pleasure
> in the stately feast at all, since vile things will be uppermost.
> And I entreat my mother, though she herself understands it,
> to be ingratiating toward our father Zeus, that no longer
> our father may scold her and break up the quiet of our feasting.
> For if the Olympian who handles the lightning should be minded
> to hurl us out of our places, he is far too strong for any.
> Do you therefore approach him again with words made gentle,
> and at once the Olympian will be gracious again to us.'

Now, Lattimore's *Iliad* is very respectable work and broke a path for the modern translation of Homer. But I note, first, the unidiomatic tendency of so many phrases: "wrenching her heart to obedience" (line 2), "This will be a disastrous matter and not endurable" (line 6), "bring brawling among the gods" (line 8), "vile things will be uppermost" (line 9), "words made gentle" (line 15) instead of "gentle words"—to fill out the line, I suppose. Then there is an awkwardness in the syntax, which I shan't detail. The diction is plain as Homer is plain, but flat, needing more nar-

4 *The New York Review of Books*, February 14, 1991. The review pronounces this and other judgments with notable weightiness of manner—"As who should say, 'I am Sir Oracle,/ And when I ope my lips, let no dog bark.'"

rative specificity: the gods were "troubled"; "stately feast"; "our places."
The six-beat lines are too long and give one a feeling of drowning in language. The lines run indeed, but rock, too, on the anapests. The lines run
but the narrative lags; Fitzgerald, as we shall see, moves the story along
with much more vigor. The overall effect, as a consequence of Lattimore's
literalist bias, is solemn, stiff, ungainly. Lattimore has marked dignity,
even call it nobility, but his nobility is tedious.

And now Fitzgerald.

> At this the wide-eyed Lady Hera feared him,
> and sat quite still, and bent her will to his.
> Up through the hall of Zeus now all the lords
> of heaven were sullen and looked askance.
> Hephaistos,
> master artificer, broke the silence,
> doing a kindness to the snowy-armed
> lady, his mother Hera.
>
> He began:
> "Ah, what a miserable day, if you two
> raise your voices over mortal creatures!
> More than enough already! Must you bring
> your noisy bickering among the gods?
> What pleasure can we take in a fine dinner
> when baser matters gain the upper hand?
> To Mother my advice is—what she knows—
> better make up to Father, or he'll start
> his thundering and shake our feast to bits.
> You know how he can shock us if he cares to—
> out of our seats with lightning bolts!
> Supreme power is his. Oh, soothe him, please,
> take a soft tone, get back in his good graces.
> Then he'll be benign to us again."

How much more natural, more elegant is Fitzgerald's English! The verse
has more vividness thanks to a more concrete diction and a bolder, more
dramatic handling of the locutions. There is a smile in the verse, the smile
that is always so charming in Fitzgerald's Homer, especially in his *Odyssey*.
I don't know if Fitzgerald is noble, but his verse has its own dignity. And
last of all—or I should say first of all—Fitzgerald, like Homer, is a *story-teller*. He knows how to tell Homer's story.

Professor Barnstone, against Lloyd-Jones, writes that "Fitzgerald came
as close to an accurate literal version [of Homer] as possible *without the
least compromise with a profoundly aesthetic achievement*." He praises Latti-
more's translation of the Gospels and Revelation as "a masterly instance of

close translation"; but he finds that his Homer is freer than Fitzgerald's in the bad sense of "often padding to maintain tone and six-beat meter." We can see this in the passage I have quoted.

A last word about the presumption of "improving on" a great original. A translation is not the original. "Improvements" improve the translation, not the original, improve it as art. Anything that makes it better art is all to the good. A literary translation is a work of art. That must be the foundation principle of any poetics of translation. Which is the point of Willis Barnstone's very instructive book.

May 1993

Returning to the Founders:
The Debate on the Constitution

Harvey C. Mansfield, Jr.

The publication of *The Debate on the Constitution*, in two new volumes of the Library of America, is an occasion for reflection.¹ Edited by Bernard Bailyn, now the foremost professor of American history, these books are not intended for historians, who would turn up their noses at a mere selection of sources, but for us non-historians. What do we have to learn from the debate on the Constitution?

Most Americans regard the Constitution as an authority, as a success; so for them the debate is closed. Most American academics do not agree. Unimpressed with America's relatively long survival, to say nothing of its greatness, they will praise the Constitution only for its openness, which consists mainly in its ability to inspire new invention. But a debate on the Constitution supports neither position: it shows the Constitution before it became an authority, but argues over its merits as if it might deserve to become one.

The Debate on the Constitution does not include the deliberation that went into it; so next to these volumes on the shelf of any serious observer of American politics will be Farrand's *Records of the Federal Convention of 1787* as well as *The Federalist* in book form. The *Debate* takes us through the period of ratification day by day from September 1787 to August 1788. It contains hundreds of newspaper articles, pamphlets, speeches, and letters authored by both the famous and the forgotten, printed in chronological order so that the reader sees how the debate developed, indeed lives through it in his imagination. In Farrand's *Records* we have the Framers; in *The Federalist* we have the Framer-Founders (except for Jay); and in the *Debate* we have the Founders understood broadly as the contributors to the debate over the American founding.

One result of the *Debate*'s presentation is that *The Federalist* appears as but one voice among many, paper by paper (though not all are included)

1 *The Debate on the Constitution: Federalist and Antifederalist Speeches, Articles, and Letters During the Struggle over Ratification*, edited by Bernard Bailyn (The Library of America, 1993).

—a kind of deconstruction that is both good and bad. It is good that we see the many alternatives to *The Federalist*, both for and against the Constitution; and indeed the superiority of *The Federalist* shines all the more in the comparison with its rivals and opponents. But, though first published as a serial, *The Federalist* was intended to be a book and it has the parts and the rhetorical motion of a book. Thus its original context in the constitutional debate as re-created is less than its share in the debate as we recur to it now.

The *Debate* includes a useful chronology, biographies of the participants, and the editor's notes, which inform rather than interpret. Keeping to the practice of the Library of America, Bailyn provides no introduction. He leaves his readers as poor, wandering souls, deprived of authoritative guidance. I think I can guess the reason for his neglect. Perhaps he is conscious that anything he might have said would have settled the matter and terminated the discussion, contrary to the intent of the publication. So he left us unguided but free to take the measure of a generation of American politicians. The consequence is not to humanize the Founders, for though they may not be demigods, they are far above us. The contrast with our own generation is marked. To read anywhere in these volumes is to be overcome with a shameful sense of inferiority, in both substance and style. It is to be confronted with the appalling toll exacted on us by the invention of television, by the use of speech writers, and more generally by our opinions and our education.

Today there are two main reasons given for returning to the debate on the Constitution: one is to find the "original intent" of the Founders in order to support the Constitution's authority; and the other is to see how to imitate the Founders in order to be able to redo the Constitution. The first is an academic restatement of the popular respect for the Constitution that I mentioned, dating from the Reagan administration. "Original intent" was an attempt to curb the judicial activism that has caused so much harm to our government and indeed to our common life by inciting the passion for litigation. Eager judges, unconscious of their own ambition and reckless of the consequences, encouraged resort to the courts and have brought us close to a condition in which a citizen is someone who sues. (Ralph Nader's group of suers is called "Public Citizen.")

It was only reasonable to look for a formula to serve as a line of defense against encroaching judges and to make them aware that the Constitution is an instrument of limitation as well as a license to act. But the need to pin down the judiciary, which was the original intent of "original intent," impelled the notion of judicial restraint toward literalness and away from principle. The plain words of the document could be held immune from expansive interpretation, but a principle is always open to debate and hence to exploitation. So the literal or positive version of original intent

439

propounded by Robert Bork gained currency over the principled version put forth by the author of the phrase, Gary McDowell, who was an assistant to Edwin Meese (Reagan's second attorney general). Bork's version seemed to say that the Constitution, because it had been a democratic decision, was authoritative (i.e., especially over the judiciary).

Curiously, the opposing view—at least the views of those like Bruce Ackerman and Sanford Levinson—also rested on democratic decisionism. It admitted the relevance of the Constitution to contemporary social problems and took on the the task of interpreting the Constitution: a burden that requires many hours of clerk and paralegal time. This "interpretivist" position held that what the people had decided once it could decide again, and otherwise, and with equal authority. So judicial activism was justified because it merely applied another Constitution—that of the New Deal, for instance—which had been democratically elected.

This sketch is of course simplified, but it shows that both sides tend to reduce *intent* to *decision*, in order either to establish or to undermine the authority of the Constitution. But why should the Constitution have authority over us? What is largely missing in today's debate on the Constitution is the claim—found in different forms throughout these volumes—that the Constitution, as Noah Webster put it, would inaugurate a new era, an *empire of reason*. It is not enough simply to assert that a democratic decision should prevail: why democracy? And specifically, which kind of democracy? The latter especially was the subject of the original debate on the Constitution and deserves to be reconsidered today. For we cannot know in which light to consider the authority of the Constitution—as constraint against innovation or inspiration for it—until we know what we require from a democracy. The first answer I shall give to why we should return to our beginnings is the need to question whether democracy, and in particular our democracy, has a basis in reason. The original debate makes a very ambitious claim for America's greatness that we still need to appreciate and assess.

To explore the matter we have to return to a beginning long before the Constitution in modern political philosophy. That beginning is none other than the "state of nature" described by Thomas Hobbes and John Locke, a concept that has lost most of its force today but that still had currency among the Founders. It was their beginning. The state of nature was a pre-political condition, to which it was necessary to recur in order to find the basis of politics: politics must be based on what comes before politics. Why? To see the reason for this fateful conception, we need to compare it to the thought it opposed and replaced, which is conveniently found in Aristotle. For Aristotle, there is no beginning behind or before politics that provides a guide or basis for politics; every beginning of politics is political. That is one thing intended by his statement that man is

by nature a political animal. Every kind of politics, every regime, is guided by the principle which rules it from the beginning: a beginning in accordance with a principle and a rule in accordance with the principle of the beginning. To justify this elaboration, I mention that the Greek word *arche* means rule, principle, and beginning. From Aristotle's standpoint, then, to understand America one would first look for its principle of rule in the speeches of its rulers, in the Constitution, and also in the Declaration of Independence.

To this political view of politics, which looks at politics in its own terms, there is indeed a nonpolitical background out of which every regime comes, to which it returns. This is the cycle of regimes, in which regimes rise and fall. Regimes arise because previous regimes have fallen. Why do they fall? In every case they fall for accidental causes but also, and especially, for one essential cause: they are all imperfect. They are imperfect because they are partial and partisan. Although they claim to advance the common good, in fact they represent the good of a party, typically the party of the few or of the many. All regimes are typically oligarchies or democracies. Aristotle mentions the possibility of a mixed regime that would have the advantages of both parties, and he urges it on the partisans; but he does not have much confidence that it will be adopted. Although every regime is debatable, the debate will be judged by the very partisans who carry it on; and they will surely judge in their own partisan interest.

No actual regime is likely to represent an impartial common good. And yet it is very important to judge regimes by the standard of the truth of their partisan claims. For their partialities will eventually catch up with them and bring them down. For example, a regime based on the self-evident half-truth that all men are created equal will eventually founder because of its disregard of the many ways in which men are created unequal. Even if such a regime seems powerful at the moment, it will be subject to revolution by the partisans, in this case those of the few, whom it ignores. Sooner or later they will gather their forces, pick on a convenient pretext, overthrow the regime and set up their own—only to make a compensating error, leaving their regime also open to future revolution or destruction. In the long run, therefore, human beings repeat the same mistakes and learn nothing from their political experience. They live in a cycle of regimes that turns from one regime to another without ever achieving gains that cannot be lost. Some regimes are surely better than others, but no regime is capable of establishing irreversible "progress," as we call it.

The great promise of modern political philosophy, reflected in the great hopefulness that inspired Americans on both sides of the debate on the Constitution, was that such irreversible progress could be made. All their realism was enlisted in the service of their idealism. Their historical studies

and their political experience were directed by the belief that the truths they knew could be made effective and lasting in this—or another—Constitution. They agreed with the ancients that the truth matters in politics, so much so that they thought, contrary to the ancients, that they had found a true solution for the partisan ills that put a term to regimes. Their grounded hopes are echoed by shrill voices expressing the groundless hopes of our time.

If the constitutional debate were held today, the parties would exchange declarations of "values" or "preferences" as if it were enough to assert them regardless of truth. In matters of public policy we constantly claim that this or that scheme will "work," implying often unconsciously that it accords with the truth. But in larger, constitutional questions we seem to suppose that the whole system rests on a wish, above all the wish for democracy. Our pragmatism differs from that of the Founders, who of course did not use the word. Their pragmatism said that a constitution works if it's true; ours says that it's true if it works, or even, in recent liberal philosophy, that it doesn't matter whether it's true if it works.

The great confidence of the constitutional generation—Our Fathers, Lincoln called them—arose from the modern idea of constructing politics from the pre-political beginning I mentioned, the state of nature. The foremost advantage to be had from beginning in this way was to banish partisan opinion from constitution-making, for partisan opinion not only keeps us from discerning but also from applying truth in politics. Partisan opinion is confusing because it is diverse; partisan opinions differ over the nature of happiness, over the *ends* of action. By following Hobbes and turning to the passions that allegedly precede opinions, above all to the passion of *fear*, we can discover a universal, non-partisan foundation for politics. We may not know what happiness is, but each of us can know or imagine the fear of death we would feel without a government to keep the peace. The shift from "we" to "each" (since each fears dependably for his own death) expresses the individualism of modern politics and also gives rise to its emphasis on liberty together—uneasily—with peace.

With a very powerful (though imaginary) fear, a new situation (the state of nature) is created in which we will be too frightened to insist on our political opinions and will therefore be able to begin anew unencumbered by them. That non-partisan beginning provides the ground for a new non-partisan constitution, promising the "new era" in politics that Noah Webster announced. Aristotle thought that politics is essentially partisan, but Hobbes and Locke believed that they had found a way to tame partisanship by restraining its excesses and harnessing its energies. Their entire programs—for indeed they differed strikingly—included a new education (in science and religion) and a new economics. The political part was the construction of a model constitution (now I speak of Locke and Montesquieu) from existing material, the English constitution,

so as to prove this was a workable scheme and not a utopia. The English constitution was reinterpreted as an impartial republic, a republic in fact but not in name, a republic without republican animus, not resting on republican opinion. If England, where republican opinion was scarce and held repugnant, could nonetheless have a republican constitution in effect, then the possibility of distinguishing politics from political opinion would seem to be validated.

What is the general character of the modern impartial regime? For Aristotle, the typical partisan conflict is between the many and the few, the people and the nobles. To replace that conflict, the general formula for the modern impartial regime is to remove one of the two parties, the people, as a political actor. Then let the elite compete before the people for its favor. When the people elects the government, it becomes the judge of government. It does not form a government itself; the people does not rule. In our understanding, the people is no longer a party, no longer the demos that is just one part, if the majority, of a city. With us, everyone belongs to "the people," even those who supposedly serve it. Instead of setting the few against the many, the impartial republic puts the few among the many, doing them benefits while advancing their own ambition. In government, the few formally *represent* the many and are prevented from *ruling* the many by a constitution of checks and balances. That constitution will have variations, and will always need to be ratified if not constituted by the people; but in its general formula, in principle, it is permanent. Its discovery is not only a boon to mankind, since it benefits —and to the necessary degree reconciles—the two political parties. It is also irreversible because the benefits are visible to all and do not depend on doubtful rhetoric, much less on a particular culture, for support.

Such is the ambition of modern political science, which inspired the debate on the Constitution. This was the beginning behind the beginning of the Constitution. The choice between the Constitution of the Federalists and whatever alternative the Anti-Federalists might have agreed on—perhaps the existing Articles of Confederation somewhat modified— does not simply repeat the old debate between the few and the many, or any such partisan conflict in the Aristotelian mode. It is a debate on the character of the impartial republic, of the single regime, however varied in detail, which is to change the nature of politics from then on. Americans wished to constitute a regime that would take from the English constitution the honor of serving as a model for mankind. The debate carried on in these volumes, though laden with references to American interests, was not solely or mainly concerned with what was good for America. Nor, on the other hand, was it a debate solely among philosophers with no practical intent. The debate had all humanity in mind and each particular people, beginning with the American people, in view. The monumental

ambition expressed in that debate is the second reason for returning to it.

Nowadays we hear little of the state of nature that was supposed to secure the impartial modern republic. Fearful self-interest has lost its political role of taming partisan stubbornness; it has been reduced to economic incentive, and in the process fear has been replaced by avarice. The seventeenth-century state of nature has been replaced by "culture," as we have called it since the nineteenth century, a new realm of opinion understood as having *no* relation to nature. Pure nature, distinct from opinion, has yielded to pure culture, which is nothing but opinion. So today many academics think that the American beginning has no relation to the truth about human nature but merely expresses parochial American values. From this faulty premise the inference is drawn that every constitution "works" because it suits the values that determined its conception and acceptance. How could it not work? If we were free to posit values regardless of truth and nature, every regime should be self-validating for those who posit; and those who refuse are equally justified. There would be no debate because there would be no possibility of argument. But the recent collapse of Communism, said to have happened because Communism "didn't work," suggests that truth matters after all. That wondrous event was a great victory for America not least because it sustained the premise of our Constitution that nature is more powerful than culture.

Nonetheless, culture is in a way more important than nature in the Constitution. For although the Constitution is based on the state of nature, it is not a natural constitution in the sense of being determined by nature. It had to be constituted, and the choice of how to do so between Federalists and Anti-Federalists was a real one: the outcome was not a foregone conclusion. Then again, after the Constitution was constituted, it produced a way of thinking—a culture—favorable to itself. This disposition of mind was what the Federalists wanted and the Anti-Federalists were afraid of. The Federalists hoped that the American people, having made a reasonable choice in favor of the Constitution, would come in time to *venerate* it, no longer treating it as a choice they could take back.

A constitutional culture of this kind is the very opposite of the culture discussed above. It is the culture of which the Constitution is the cause, not the effect. It is deliberately produced even if unexamined and accepted through habit by later generations. Instead of replacing or opposing nature, this culture cooperates with nature, with the self-interest in ambition and security natural to human beings. It takes advantage of natural impulses and inclinations instead of denying them. It thereby admits a standard in nature by which to compare and judge regimes. The debate on the Constitution was over the form and direction of American politics thereafter; it was over the nature of the *founding*. A founding is a political beginning or principle that comprises the natural basis of the regime and allows it to be humanly chosen. We can live a life that is reasonable be-

cause it is based on nature and yet our own because it has its own culture that is not determined by nature.

To understand the enduring character of American politics is the third reason for returning to the beginning. Anyone who wishes to know about American politics has much to learn from contemporary events; but there is no substitute for careful reflection on the founding. Everything begins from the founding, and the subsequent changes have occurred to America as founded. Even the attributes of our politics said to have changed since 1787—democratization, heterogeneity, complexity, centralization, bureaucracy—were either set in motion then or took their particular character from the founding. Even when ineluctable necessities such as bureaucracy are imposed on us, we submit to them in our own way, creating an *American* bureaucracy. Here I have been speaking in Aristotelian terms because the American regime is not simply a theoretical, impartial republic modeled on mankind's necessities. It has its own character and has made its own culture.

Abraham Lincoln described the relationship between the Declaration of Independence and the Constitution in biblical language (Proverbs 25:11) as the apple of gold in the frame of silver. The apple is the natural principle of human equality; the frame surrounding it is the conventional or cultural structure that displays the principle, gives it life, and makes it ours. The two together are a whole, necessary to each other. But they are also separate parts: one that in 1776 declared the principle, another that in 1787 made it work politically. Their separateness makes a point of the act of constituting, done with calm and, despite the heated words, with a certain noble elevation in both the deliberation of the Constitutional Convention and the debate over ratification afterward.

We can be glad that the Federalists won the debate. As I said above, by the standards of contemporary political debate the argumentation was unattainably higher on both sides. But the Federalists were clearly superior. The essential question between Federalists and Anti-Federalists was over the source of great danger to republics: does it come from the many or the few? The Anti-Federalists consistently (if variously) maintained the traditional republican opinion that the few are the main enemy of republics. But the Federalists disagreed with this bromide. They offered the paradoxical judgment that the many are their own worst enemy, that the bane of popular government, in the statement of Federalist 10, is "majority faction"—a phrase that sounds like a contradiction in terms to traditional republicans. The ambitious few are also dangerous, but mainly because they can get the backing of an aroused majority. For their innovative view the Federalists were accused by their opponents during the constitutional debates, by Thomas Jefferson in the 1790s, and by later historians of lacking faith in the people, of being unrepublican. But they were intel-

ligent republicans looking for ways to make republics more viable, and so raise them in the esteem of respectable opinion in the civilized world.

The Federalists accepted the risk of appearing to be doubtful republicans; they were a party concerned to reduce the partisanship of republics. In their Constitution they created an *introspective republicanism* not preoccupied with denouncing the enemies of republics but alive to the dangers from within the principle. In their view the worst faction in a republic was the one that looked like a republican majority, and they fashioned a republic that could defend itself against the republican danger, using "republican remedies." Merely to mention the makers of the French Revolution evokes the contrast between American introspection—I will even say sophistication—and men who had no proper notion that republics too could be tyrannies. That thought combines the three reasons for returning to our beginnings, and it is still valid now.

September 1993

Contributors

BROOKE ALLEN is the co-author of *The Big Love*, which was produced on Broadway in 1990. She reviews books for *The Wall Street Journal*, *The New York Times Book Review*, and other publications.

JAMES BOWMAN writes the "Media" column for *The New Criterion*. He is the American editor of the London *Times Literary Supplement* and the film critic of *The American Spectator*.

CHRISTOPHER CARDUFF joined the staff of *The New Criterion* in 1989 and is now the magazine's associate editor.

MAURICE COWLING was for thirty years a Fellow of Peterhouse, Cambridge, and is now Visiting Professor at Adelphi University. Among his many works are *Mill and Liberalism* and *Religion and Public Doctrine in Modern England*.

GUY DAVENPORT is a fiction writer, essayist, poet, and translator. His most recent book is *A Table of Green Fields: Ten Stories*.

JOSEPH EPSTEIN is the editor of *The American Scholar*, a quarterly publication of Phi Beta Kappa. He is the author, most recently, of *The Goldin Boys*, a collection of short stories, and *Pertinent Players: Essays on the Literary Life*.

MARK FALCOFF is Resident Scholar at the American Enterprise Institute in Washington, D.C., and the author of *Modern Chile, 1970–1989: A Critical History*.

DAVID FROMKIN is chairman of the Department of International Relations at Boston University and the author of *A Peace To End All Peace: The Fall of the Ottoman Empire and the Creation of the Modern Middle East*. His new book, *In the Time of the Americans*, will be published this spring.

DAVID FRUM, a former editor of *The Wall Street Journal* and a columnist for *Forbes*, is the author of *Dead Right*, an analysis of post-Reagan conservatism.

ERIC GIBSON is the executive editor of *Art News* and the author of a monograph on Clement Meadmore.

MARTIN GREENBERG has been awarded a citation from the American Academy and Institute of Arts and Letters for his "versatility, skill, and probity as both critic and translator." Among his recent translations are Heinrich von Kleist's *Five Plays* and Goethe's *Faust, Part One*.

DAVID GRESS, John M. Olin Professor of History at Adelphi University, is completing *The Evening Country*, a history of the idea of the West and its critics.

JOHN GROSS, former editor of *The Times Literary Supplement*, is the theater critic for the London *Sunday Telegraph*. He is the author of *The Rise and Fall of the Man of Letters* and *Shylock*, and the editor of several anthologies, including *The Oxford Book of Comic Verse*.

DONALD KAGAN is Colgate Professor of History and Classics at Yale. He is the author of a four-volume history of the Peloponessian War, *Pericles of Athens and the Birth of Democracy*, and, most recently, *On the Origins of War*.

H. J. KAPLAN, a retired foreign-service officer living in Paris, is the author of two novels, *The Mohammedans* and *The Plenipotentiaries*. He is also a contributor to *Partisan Review*, *Commentary*, and other publications.

ROGER KIMBALL is the managing editor of *The New Criterion* and the author of *Tenured Radicals: How Politics Has Corrupted Our Higher Education*. He is a frequent contributor to *The Wall Street Journal*, *The Times Literary Supplement*, and other publications.

HILTON KRAMER is the editor of *The New Criterion* and the author of *The Age of the Avant-Garde* and *The Revenge of the Philistines*. He is the art critic of *The New York Observer* and writes the weekly "*Times* Watch" column for *The New York Post*.

BRAD LEITHAUSER is a poet, a novelist, and the editor of *The Norton Book of Ghost Stories*. His most recent book is *Penchants and Places*, a collection of essays and criticism.

SAMUEL LIPMAN, 1934–1994, was the publisher of *The New Criterion* and the music critic of *Commentary*. He was the author of four volumes of criticism, the most recent being *Music and More*, and the editor of a new edition of Matthew Arnold's *Culture and Anarchy*.

DONALD LYONS writes on theater for *The Wall Street Journal* and on films for *Film Comment*. He is the author of *Independent Visions: A Critical Introduction to Recent Independent American Film*.

HEATHER MAC DONALD is a contributing editor of *City Journal*, the urban-affairs quarterly of the Manhattan Institute.

HARVEY C. MANSFIELD, JR., is a professor of government at Harvard University. He is the author of *Taming the Prince: The Ambivalence of Modern Executive Power*.

JED PERL is the art critic of *The New Republic* and the author, most recently, of *Gallery Going: Four Seasons in the Art World*. He is now at work on *New Art City*, a study of art in Manhattan between 1950 and 1970.

ROBERT RICHMAN, the poetry editor of *The New Criterion*, has published poems and critical articles in *Commentary*, *Partisan Review*, and other magazines. He is the editor of *The Direction of Poetry*, an anthology of contemporary rhymed and metered verse.

CHRISTOPHER RICKS teaches English at Boston University. He is the author of several studies in literature, including *T. S. Eliot and Prejudice* and, more recently, *Beckett's Dying Words*.

EDWARD SHILS is Professor of Social Thought at the University of Chicago and an honorary fellow of Peterhouse, Cambridge. Among his many books are *The Academic Ethic*, *The Calling of Sociology*, and *Tradition*.

JOHN SIMON reviews theater for *New York* magazine and films for *National Review*. His essays on literature are collected in *The Sheep from the Goats*.

TERRY TEACHOUT is the arts columnist of the New York *Daily News*. He recently edited *A Second Mencken Chrestomathy* and is currently writing *H. L. Mencken: A Life*.

JAMES W. TUTTLETON, a professor of English at New York University, is the author of *The Novel of Manners in America*. His essays on literature appear frequently in *The New Criterion*, *The Hudson Review*, and other publications.

RICHARD VINE is the associate managing editor of *Art In America*.

KAREN WILKIN writes regularly on art for *The New Criterion* and *Partisan Review*. The author of several monographs, she is now at work on a book about Giorgio Morandi.

Index

Abdullah ibn Hussein, 263, 268
Achebe, Chinua, 88
Ackerman, Bruce, 440
Adams, Hunter, 130
Adams, John, 16
Adorno, Theodor, 8
Afrocentrism, 101, 107, 120, 121, 125, 129
Agee, James, 156
Ahlstedt, Börje, 176
Aldanov, Mark, 318
Aldington, Richard, 3
Alegría, Claríbel, 61, 62
Allen, Woody, 174
Allenby, Edmund, 265, 266
Alter, Robert, 84
Althusser, Louis, 226
Amado, Jorge, 56
Amis, Kingsley, 225, 339, 340
Amis, Martin, 341
Anderson, Sherwood, 177, 233
Andersson, Bibi, 176
Andre, Carl, 171
Annenberg, Mrs. Walter, 192
Annenberg, Walter, 190, 191
Annenski, Innokenti Feodorovich, 315
Anthony, Aaron, 237, 238
Arcimboldo, Giuseppe, 235
Arendt, Hannah, 11
Argento, Dominick, 20
Aristophanes, 176
Aristotle, 121, 331, 395, 441, 442, 443, 445
Armstrong, Louis, 108
Arnold, Matthew, 79, 212, 213, 226, 227, 391, 398, 399
Arrowsmith, William, 434
Artschwager, Richard, 167
Assing, Ottilia, 246, 248–249

Astor, Nancy, 220
Astor, Waldorf, 220
Asturias, Miguel Angel, 56
Atlas, James, 67
Auden, W(ystan) H(ugh), 72, 228, 296, 301, 302, 348, 353
Auld, Hugh, 238, 241, 244, 250
Auld, Lucretia Anthony, 237–238, 250
Auld, Sophia, 238, 250
Auld, Thomas, 238, 239–240, 241, 249–250
Auld, Tommy, 238, 239
Austen, Jane, 72
Avery, Milton, 43
Axson, Stockton, 218

Bach, Johann Sebastian, 13, 14, 15, 21, 22, 23, 282, 283, 284, 309
Bacon, Francis (essayist), 137
Bacon, Francis (painter), 140, 142
Bader, Julia, 320–321
Bailyn, Bernard, ed., *The Debate on the Constitution*, 438–446
Baker, Houston A., Jr., 117; *Black Studies, Rap, and the Academy*, 101–108
Balakirev, Mily, 285
Balfour, Arthur, 217
Balthus, 38
Balzac, Honoré de, 278, 308
Barber, Benjamin, 67, 153
Barber, Samuel, 16, 156
Barenboim, Daniel, 17
Baring, Maurice, 277, 279
Barker, Harley Granville, 216
Barnes, Albert C., 187–190
Barnes Foundation, "Great French Paintings from the Barnes Foundation: Impressionist, Post-Impressionist, and Early

Modern" (National Gallery of Art exhibition), 186–192

Barnes, William, 72

Barnstone, Willis, *The Poetics of Translation: History, Theory, Practice*, 425–437

Barr, Alfred H., Jr., 79

Barraqué, Jean, 201

Barrie, J(ames) M(atthew), 260

Barthes, Roland, 68, 226, 323

Bartlett, Jennifer, *South Gardens*, 165–168

Barzun, Jacques, 410

Bataille, Georges, 323, 330, 369

Bate, Walter Jackson, 75

Baudelaire, Charles, 142, 285

Baudrillard, Jean, 149, 322–335

Bawer, Bruce, 106

Bax, Belfort, 212–213

Beach, Joseph Warren, 410

Beales, H. L., 377

Bearden, Romare, 108

Beaumarchais, Pierre, 154–155

Beckett, Samuel, 72, 176, 234, 308

Beerbohm, Max, 214–215; *A Christmas Garland*, 276–281

Beethoven, Ludwig van, 21, 94, 96, 282, 283, 284, 309

Beitchman, Phil, 334

Belaunde Terry, Fernando, 61

Bell, Julian, 254

Bell, Vanessa, 253, 254

Benda, Julien, *The Treason of the Intellectuals*, 3–7, 12

Benedetti, Mario, 56

Benedict, Stephen, 26

Benjamin, Walter, 41, 71, 226, 427

Bennett, Arnold, 278, 279

Bennett, William J., 48, 84, 123–124

Benson, A(rthur) C(hristopher), 277, 279

Bérard, Christian, 370

Berenson, Bernard, 79

Bergman, Ingmar, production of Ibsen's *Peer Gynt* (Brooklyn Academy of Music), 176

Bergsma, William, 16

Berkeley, Edward, 177

Berlin, Irving, 157

Bernal, John Desmond, 96

Bernal, Martin, *Black Athena: The Afroasiatic Roots of Classical Civilization*, 91–100

Bernstein, Leonard, 17, 18

Berryman, John, 304

Bertrand, Aloysius, 285

Besant, Annie, 213

Beveridge, William, 374, 376–377

Bevin, Ernest, 379

Biko, Steve, 151

Birnbaum, Norman, 67

Black studies, 101–108

Blackmur, R(ichard) P(almer), 406

Blake, William, 212

Bland, Edith Nesbit, 215

Bland, Hubert, 212, 215, 217

Blin, Roger, 370

Blok, Aleksandr, 315

Blomstedt, Herbert, 17

Bloom, Allan, 74, 82, 84, 103, 124

Bloom, Harold, 73

Boardman, John, 97

Boccaccio, Giovanni, 429

Bogan, Louise, 296

Bonnard, Pierre, 137, 139

Borges, Jorge Luis, 53, 309, 321, 343

Bork, Robert, 440

Bosch, Hieronymus, 170

Boswell, James, 73

Boulez, Pierre, 15, 370

Bourgeois, Louise, "Louise Bourgeois: The Locus of Memory, Works 1982–1993" (Brooklyn Museum exhibition), 179–185

Bourget, Paul, 412

Bowra, C(ecil) M(aurice), 347

Boyd, Brian, *Vladimir Nabokov: The Russian Years*, 307–321

Brahms, Johannes, 23, 283, 284

Brandeis, Louis, 372, 378

Brando, Marlon, 170

Braque, Georges, 35, 149, 188, 234; "Picasso and Braque: Pioneering Cubism" (Museum of Modern Art exhibition), 416–424

Braudel, Fernand, 389

Brawley, Tawana, 115

Brecht, Bertolt, 176, 226, 229

Brennan, Maeve, 340

Bright, John, 244

Brightman, Carol, *Writing Dangerously: Mary McCarthy and Her World*, 287–294

Britten, Benjamin, 16

Brodsky, Joseph, 349, 351

Brombert, Victor, 102

Bromwich, David, 72

Brooks, Cleanth, 80

Brown, John, 246
Browning, Robert, 279
Bruch, Max, 282
Buchan, John, 259, 267
Buchanan, Patrick, 49
Buchloh, Benjamin H. D., 43
Bunin, Ivan, 315
Burckhardt, Rudy, 137
Burke, Edmund, 227
Burkert, Walter, 97
Burroughs, Edgar Rice, 267
Busch, Adolf, 283
Bush, George, 47, 49
Butler, Samuel, 219, 360
Buttle, Myra, 276
Byron, Lord, 235, 258

Cabezas, Omar, 56
Cabrera Infante, Guillermo, 58–59
Cage, John, 15
Cahill, Holger, 137
Callas, Maria, 18
Callicles, 5–6, 12
Campbell, Maryanne, 131
Campbell, Mrs. Patrick, 215–216, 217
Campbell-Wright, Randall K., 131
Camus, Albert, 273
Cantor, Gilbert M., *The Barnes Foundation: Reality vs. Myth*, 190, 191–192
Capitalism, 251–257, 323–327, 377, 378
Caravaggio, 38, 170
Carco, Francis, 370
Carlyle, Thomas, 212, 226, 227
Carpentier, Alejo, 53
Carroll, Lewis, 160, 312
Caruso, Enrico, 27
Casadesus, Robert, 284
Cassirer, Ernst, 7
Castro, Fidel, 53
Cato, 124–125
Catullus, 431, 433
Cavafy, C(onstantine) P., 343–354, 429
Cervantes, Miguel de, 52, 269, 371, 431
Cézanne, Paul, 34, 147, 186, 188, 233, 419, 420, 421, 422
Chapman, George, 426
Chapman, Thomas, 259. *See also* Lawrence, Thomas (Chapman)
Chasins, Abram, 284
Chaucer, Geoffrey, 88, 429
Chekhov, Anton, 309, 318, 319

Cheney, Lynne V., 74, 75, 84
Chesterton, G(ilbert) K(eith), 215, 278
Chicago Lyric Opera, 153
Chocano, José Santos, 53
Chomsky, Noam, 60, 200, 226
Chopin, Frédéric, 22, 283
Christin, Judith, 163
Churchill, Winston, 218, 219, 268, 269, 271, 274, 378, 379
Clark, Graham, 163
Clarkson, Thomas, 245
Claudel, Paul, 367
Clay, Andrew Dice, 104
Clayton, Gilbert, 261, 262, 270
Cliburn, Van, 18
Clinton, Bill, 83, 101, 175
Clinton, Hillary, 101
Cobbett, William, 227
Cockerell, Sydney, 221
Cocteau, Jean, 369, 370
Cohen, Morris Raphael, 373
Cole, G. D. H., 373
Coleridge, Samuel Taylor, 296, 304
Collini, Stefan, 392
Collins, William, 429–430
Communism, 12, 219, 224, 256, 288, 289, 348, 444
Compton-Burnett, Ivy, 72
Comte, Auguste, 309
Conboy, Kenneth, 101
Conklin, John, 163
Connolly, Cyril, 305
Conquest, Robert, 340
Conrad, Joseph, 277, 278, 280, 415
Constitution, U. S. *See* U. S. Constitution
Cook, James, 97
Cooke, Lynn, 185
Copland, Aaron, 16
Corigliano, John, and William M. Hoffman, *The Ghosts of Versailles*, 153–164
Coronel Urtecho, José, 56
Cortázar, Julio, 56
Cortot, Alfred, 283
Costa-Gavras, 274
Courtivron, Isabelle de, 198
Covey, Edward, 240–241, 242
Coward, Noël, 217
Crews, Frederick, 292
Cripp, Stafford, 378
Croce, Benedetto, 425
Croly, Herbert, 376

Crooks, Richard, 17
Crosland, C. A. R., 222
Cruz, Amada, 172
Cuadra, Pablo Antonio, 62
Cubism, 142–143, 234, 235, 416–424
Cultural studies, x, 24, 129
Culture wars, ix, 82–90

Dahl, Tracy, 163
Dante, 371, 426
Darío, Rubén, 53
Darwin, Charles, 219
Davies, G. S., 433
Davis, Anthony, 20
Davis, Douglas, *The Museum Transformed: Design and Culture in the Post-Pompidou Age*, 40–42
Day, Douglas, 359
Dean, James, 170, 258
Dean, Tim, 130
de Beauvoir, Simone, 273, 291
Debussy, Claude, 282–286
Declaration of Independence, 445
Deconstruction, x, 85–86, 88, 122, 124, 125, 129, 195, 327
Defert, Daniel, 199, 204, 206
Degas, Edgar, 140, 142
de Kooning, Lisa, 143
de Kooning, Willem, "Willem de Kooning: Paintings" (National Gallery of Art exhibition), 137–143
de Man, Paul, 85, 86
Denby, Edwin, 137
Derain, André, 233
Derrida, Jacques, 85, 86, 88, 195–196, 323, 369, 370
Dewey, John, 188, 189
Diamond, David, 16
Dickens, Charles, 221, 235, 278, 396, 414
Dickinson, Emily, 87, 88
Di Donato, Riccardo, 385
Diebenkorn, Richard, 43
Djilas, Milovan, 63
Dohnányi, Christoph von, 17, 19
Dolmetsch, Arnold, 20
Domingo, Plácido, 19
Donne, John, 235
Donoso, José, 59
Dorfman, Ariel, 56, 63
Dostoevsky, Fyodor, 269, 272, 275
Douglas, Mary, 68–69

Douglass, Anna Murray, 241, 244, 248
Douglass, Frederick, *Autobiographies* (Henry Louis Gates, Jr., ed.), 236–250
Dover, Kenneth, 97
Dreyfus Affair, 412
Dryden, John, 297, 429, 432–433
D'Souza, Dinesh, 82, 84, 124
Duchamp, Marcel, 137
Dufy, Raoul, 418
Duguit, Léon, 373
Dumas, Roland, 367
Dumézil, Georges, 93–94
Dupee, F(rederick) W., 408, 410, 411–412
Durrell, Lawrence, 348
Dydo, Ulla E., ed., *A Stein Reader*, 233–235

Eagleton, Terry, 222, 225, 232
Eakins, Thomas, 143
Easterling, Pat, 96
Eastman, John, 143
Eastman, Lee, 143
Edel, Leon, 410
Edwards, Jorge, 59, 62–63
Einstein, Albert, 134, 252, 404
Eisenstein, Sergei, 317
Eliot, T(homas) S(tearns), 71, 88, 219, 254, 258, 276, 296, 304, 349, 356, 361, 399, 407, 410, 434
Ellison, Ralph, 88
Empson, William, 67–68
Engels, Friedrich, 226
Enlightenment, 7–9, 11–12, 134
Epstein, Joseph, 85, 86
Ergmann, Raoul, 37
Eribon, Didier, 197, 205
Ervine, St. John, 221
Estrada Cabrera, Manuel, 53
Euripides, 429, 434
Eurocentrism, x, 109, 112, 113, 119

Fabian Society, 208, 212, 214, 216–217, 219
Fanon, Frantz, 121
Farrand, Max, 438
Faulkner, William, 88, 308
Federalist, The, 438–439
Feisal, 263, 264, 265, 266, 268, 271
Feminism, 88, 120, 125, 126, 129, 131–133, 179, 223
Fermor, Patrick Leigh, 344
Fest, Joachim, 145
Field, Andrew, 315

Filler, Martin, 37, 40
Fini, Leonor, 370
Finkielkraut, Alain, *La Défaite de la pensée (The Undoing of Thought)*, 6–12
Finley, Karen, x, 45–46
Finley, M(oses) I., 96, 98, 225
Fischer, R. M., 167
Fischl, Eric, 171
Fish, Stanley, xi
Fitts, Dudley, 434
Fitzgerald, F. Scott, 410
Fitzgerald, Robert, 434, 436, 437
Flagstad, Kirsten, 282
Fleming, Joseph, 106
Fleming, Renée, 163
Fondaminsky, Ilya, 318
Fondo de Cultura Economica, 54
Fontane, Theodor, 146
Ford, Ford Madox, 260
Forster, E(dward) M(organ), 269, 344, 345, 352
Foster, Stephen S., 243
Foucault, Michel, 68, 88, 195–207, 328, 369
France, Anatole, 219, 380
France, Peter, 433
Franck, César, 283, 284
Frankfort, Henri, 98–99
Frankfurter, Felix, 372, 378, 380
Frazer, James, 359
Frazier, E. Franklin, 108
Freedberg, Sydney, 79
Freud, Sigmund, 88, 188, 317, 331
Friedländer, Saul, 145–146
Fried, Michael, 184
Friesz, Othon, 418
Frohnmayer, John E., 171–172
Frost, Robert, 297, 348, 425, 426
Fry, Roger, 189
Fuentes, Carlos, 63
Furth, Charles, 381

Gable, Robin, 223
Galbraith, John Kenneth, 47
Galeano, Eduardo, 56
Gallimard, Claude, 367
Gallimard, Gaston, 367
Galsworthy, John, 279
Garbo, Greta, 269
García Márquez, Gabriel, 56
Garland, Herbert, 264

Garnett, Edward, 211, 269
Garrison, William Lloyd, 243, 244, 245, 246, 248
Gates, Henry Louis, Jr., 104; ed., *Frederick Douglass: Autobiographies*, 236–250
Gauguin, Paul, 186, 188
Gellner, Ernest, 207
Genet, Jean, 366–371
Genovese, Eugene, 107
George, David Lloyd, 260, 264, 265, 374
Giacometti, Alberto, 140, 142, 370
Gibran, Kahlil, 332
Gieseking, Walter, 282–286
Gippius, Zinaida, 311
Glackens, William, 188
Glanton, Richard H., 187, 192
Glass, Philip, 15, 16, 234
Glazer, Nathan, 113, 117, 118–121
Gobbi, Tito, 18
Goethe, 7, 176, 258, 426
Gogol, Nikolai, 309, 312
Goldberger, Paul, 166
Golding, Arthur, 429
Goldwyn, Samuel, 221
Gopnik, Adam, 141
Gordon, Edmund, 102, 107, 114, 115
Gore, Tipper, 104–105
Gorky, Arshile, 137, 140
Gosse, Edmund, 279
Gossett, Philip, 22
Gould, Glenn, 21
Gower, John, 429
Goya, Francisco, 123, 134, 197
Goytisolo, Juan, 370
Graff, Gerald, *Beyond the Culture Wars: How Teaching the Conflicts Can Revitalize American Education*, 83–90
Graham, Colin, 159
Graham, John, 137
Grahame, Kenneth, 260
Gramsci, Antonio, 226
Graves, Amy, 358
Graves, Richard Perceval, *Robert Graves: The Assault Heroic 1895–1926*, 357–362
Graves, Robert, 72, 267, 270, 355–365
Greaves, H. R. G., 377
Greenberg, Clement, 102, 137–138, 149
Greene, Graham, 271
Gregory, Horace, 431
Grieg, Edvard, 283, 284

Griffiths, Julia, 244, 245, 246
Gross, Paul, and Norman Levitt, *Higher Superstition: The Academic Left and Its Quarrels with Science*, 124–134, 395
Guadanini, Irina, 319
Guillén, Nicolás, 56
Guillory, John, 69–72
Gumilyov, Nikolai, 315
Guys, Constantine, 142

Hagegård, Håkan, 163
Hall, N. John, 276, 277
Hals, Frans, 142
Hampson, Thomas, 17
Hanson, Howard, 16
Haraway, Donna, 133, 134
Harding, Sandra, 130
Hardy, Thomas, 78, 280, 338
Harris, Frank, 278
Harris, Roy, 16
Hart, Liddell, 258, 266, 271, 272, 273
Hartman, Geoffrey, 70
Hassid, Josef, 282
Hastings, Patrick, 379
Hayakawa, S(amuel) I(chiye), 105
Haydn, Franz Joseph, 21
Hayek, Friedrich von, 254, 256, 374
Hayles, N. Katherine, 132, 133
Hazlitt, William, 72
Hecataeus, 387–388
Heidegger, Martin, 141, 368
Heller, Erich, 401
Hemingway, Ernest, 233, 272
Heraclitus, 371
Herbert, Aubrey, 270
Herbst, Josephine, 289, 293
Herder, Johann Gottfried, 6–7
Herodotus, 99, 386, 388–390
Herrick, Robert, 409
Hesiod, 387
Hess, Thomas B., 138
Hewlett, Maurice, 277
Higginson, Henry Lee, 32
"High and Low: Modern Art & Popular Culture" (Museum of Modern Art exhibition), 11
Hildreth, Lee, 334
Hille, Hermann, 188
Hilliard, Asa, III, 117
Hirsch, E. D., 74, 84
Historiography, 70, 98, 99, 257, 385–390

Hitler, Adolf, 8, 145, 146, 147, 173, 219, 338
Hobbes, Thomas, 440, 442
Hobsbawm, Eric, 222, 224
Hoffman, William M., and John Corigliano, *The Ghosts of Versailles*, 153–168
Hofmannsthal, Hugo von, 157, 163
Hogarth, David, 261, 270
Hogwood, Christopher, 21
Hokusai, Katsushika, 308
Holmes, Oliver Wendell, Jr., 372, 378
Holocaust, 144–152
Holroyd, Michael, *Bernard Shaw*, 208–221
Holzer, Jenny, 185
Homer, 258, 360, 426, 427, 434–437
Hope, Anthony, 259
Hopkins, Gerard Manley, 296, 299
Horace, 208, 429
Horkheimer, Max, 8
Horne, Marilyn, 159, 163
Horowitz, Vladimir, 27, 283
Hotter, Hans, 18
Housman, A(lfred) E(dward), 295–306
Housman, Laurence, 300
Howe, Irving, 291, 292
Howells, William Dean, xiii
Hughes, Robert, *Culture of Complaint: The Fraying of America*, 45–50
Hull, Mrs. Lytle, 32
Hulme, T(homas) E(rnest), 330
Hume, Paul, 24
Hussein ibn Ali, 262, 263, 264, 271
Huxley, T(homas) H(enry), 398

Iannone, Carol, 105
Ibsen, Henrik, 229, 230; *Peer Gynt*, 176
Imbrie, Andrew, 16
Impressionism, 140, 283
Irving, Henry, 215

Jackson, Kenneth T., 120
Jackson, Michael, 170
Jackson, Moses, 300
James, Henry, 234, 277, 278, 354, 400–415
James, Lawrence, *Golden Warrior, The: The Life and Legend of Lawrence of Arabia*, 258, 272
James, William, 188, 234, 317
Janis, Sydney, 137
Jarrell, Randall, 45, 80, 296, 359, 361, 362
Jefferson, Thomas, 445
Jeffries, Leonard, 101–108

Jenkins, Roy, 222
Johnson, Nathan, 241–242
Johnson, Paul, xii
Johnson, Samuel, 68, 73
Jones, Monica, 340
Jouhandeau, Marcel, 370
Joyce, James, 233, 307, 308, 309, 314, 320, 349, 424, 429
Joynes, J. L., 212

Kafka, Franz, 426
Kahn, Otto, 32
Kahnweiler, Daniel-Henry, 420
Kapell, William, 18
Kazantzakis, Nikos, 429
Keaton, Buster, 176
Keats, John, 157, 300
Keeley, Edmund, 346–347, 348, 352
Keene, Christopher, 20
Kelley, Abby, 243
Kelley, Mike, "Mike Kelley: 'Half a Man'" (Hirshhorn Museum exhibition), 169–172
Kennedy, John F., 151, 274
Kenner, Hugh, 309
Kennington, Eric, 259
Keynes, John Maynard, 251–257
Khodasevich, Vladislav, 315, 318
Kidson, Peter, 98
Kiefer, Anselm, "Anselm Kiefer" (Museum of Modern Art exhibition), 144–152
Kierkegaard, Søren, 141
Kimball, Roger, 82, 84, 103, 124
Kimmelman, Michael, 170
King, B. B., 108
King, Stephen, 72
Kinnock, Neil, 232
Kipling, Rudyard, 258, 260, 278, 279
Kitchener, Lord, 261, 262, 263
Kleiber, Carlos, 19
Koons, Jeff, 170, 171
Kossoff, Leon, 149
Kostelanetz, Richard, 234
Kotik, Charlotta, 180, 185
Koussevitzky, Serge, 18
Kramer, Hilton, 67
Kramnick, Isaac, and Barry Sheerman, *Harold Laski: A Life on the Left*, 373–381
Krasner, Lee, 43
Krauze, Enrique, 63
Kreisler, Fritz, 282

Kristeva, Julia, 68, 72
Kunstler, William, 115
Kushner, Tony, *Angels in America, Part I: Millennium Approaches* and *Part II: Perestroika*, 173–175

Lacan, Jacques, 68, 88, 130, 323
Laclotte, Michel, 37, 40
Lampedusa, Giuseppe Tomasi di, 343
Landowska, Wanda, 20
Lang, Andrew, 219
Lang, Fritz, 167
Lang, Jack, 40
Langer, Elinor, 289, 293
Larkin, Eva, 338
Larkin, Philip, 72, 207, 336–342
Larkin, Sydney, 338
Larthomas, Pierre, 154
Lascelles, Mary, 72
Laski, Frida, 373
Laski, Harold, 260, 372–381
Lattimore, Richmond, 434–435
Laughlin, James, 235
Lavender, Lizzie, 245
Lawrence, D(avid) H(erbert), 224
Lawrence, Sarah, 259
Lawrence, Thomas (Chapman), 259
Lawrence, T(homas) E(dward) (Lawrence of Arabia), 258–275
Lean, David, 258
Lear, Edward, 234
Leavis, F(rank) R(aymond), 69, 224, 227, 232, 413; Snow–Leavis controversy, 392–399
Le Carré, John, 271
Lee, George Vandeleur, 210, 211, 215
Lehman, David, 124
Leigh, Christian, 180, 185
Lenard, Philipp, 134
Leppert, Richard, 22
Lermontov, Mikhail, 312
Levi, Primo, 149–150
Levine, James, 17, 19, 153
Levinson, Sanford, 440
Lévi-Strauss, Claude, 10, 323, 330, 331
Levitt, Norman, and Paul Gross, *Higher Superstition: The Academic Left and Its Quarrels with Science*, 124–134, 395
Levy, Marvin Davis, 153
Liberator, The, 243, 244, 246
Lichtenberg, Georg Christoph, 3

Liddell, Robert, *Cavafy: A Critical Biography*, 345
Liebmann, Lisa, 151
Liebman, Ron, 175
Lincoln, Abraham, 237, 246–247, 442, 445
Linkletter, Art, 411
Lipchitz, Jacques, 233
Lippman, Walter, 376, 378
Liszt, Franz, 283, 285
Lloyd, Daniel, 238
Lloyd, Edward, 237, 238, 250
Lloyd-Jones, Hugh, 434–435
Lloyd Webber, Andrew, 174
Locke, John, 440, 442
Lockwood, William, 29
London School of Economics, 374, 376–377, 380
Lopez-Castillo, Miguel, 177
Lowell, A. Lawrence, 372
Lowell, Robert, 72, 296, 430–431, 432
Lukács, György, 226
Ludlum, Charles, 174

Ma, Yo-Yo, 18
Maazel, Lorin, 17
MacCarthy, Desmond, 407, 409
McCarthy, Lillah, 209
McCarthy, Mary, 287–294
McClary, Susan, 22–23
McCormack, John, 282
Macdonald, Dwight, 288, 292
MacDonald, Ramsay, 219
McDowell, Gary, 440
McFeely, William S., 245
MacIlwain, Charles, 372
MacIntyre, Alasdair, 67, 196
Mackay, Clarence, 32
Mackereth, Betty, 340
MacKinnon, Catharine, 105
Mackintosh, Cameron, 174
Mailer, Norman, 291, 292
Mailloux, Steven, 90
Maitland, Frederick, 373
Malinowski, Bronislaw, 374
Malraux, André, 272, 273
Mandelshtam, Osip, 315
Manet, Edouard, 188
Mapplethorpe, Robert, x, 47, 50
Marcuse, Herbert, 198–199
Marlowe, Christopher, 235, 429
Martino, Francesco de, 91

Marx, Karl, 43, 46, 63, 216, 226, 230, 254, 256, 326, 368
Mason, A. E. W., 267
Massachusetts Anti-Slavery Society, 243, 244
Masur, Kurt, 17
Matisse, Henri, 137, 186–187, 233
Matthews, Tom, 357
Maugham, Somerset, 271
Maurer, Alfred, 188
Mazzarino, Santo, 91
Meese, Edwin, 440
Mehta, Zubin, 19, 25
Meier, Christian, 99
Melville, Herman, 269, 272, 285
Menchu, Rigoberta, 48, 49
Mencken, H(enry) L(ouis), 408
Mendelssohn, Felix, 282
Mendelssohn, Moses, 428
Mengelberg, Willem, 283
Menuhin, Yehudi, 282
Meredith, George, 72, 276, 278
Merquior, J. G., 207
Metropolitan Opera, 16, 19, 28, 153
Meyer, Doris, ed., *Lives on the Line: The Testimony of Contemporary Latin American Writers*, 53–64
Meyers, Jeffrey, 258
Midori, 18
Miller, Arthur, 185, 229
Miller, James, *The Passion of Michel Foucault*, 195–207
Milne, A(lan) A(lexander), 260
Milnes, Sherrill, 17
Milton, John, 88, 121, 122, 235
Miss, Mary, 168
Mistral, Gabriela, 53
Mitchell, Stephen, 178
Modigliani, Amedeo, 186, 188
Moles, Abraham, 145
Momigliano, Arnaldo, 91, 96; *The Classical Foundations of Modern Historiography*, 385–390
Mondrian, Piet, 140
Monet, Claude, 139, 188
Montesquieu, Charles Louis, 442
Monteux, Pierre, 283
Moore, George, 278
Moravia, Alberto, 370
Morenz, Siegfried, 99
Morley, Sheridan, 216
Morris, Robert, 150

Morris, William, 212, 215, 228, 434
Mosley, Oswald, 213, 219
Moss, Howard, 348
Motion, Andrew, *Philip Larkin: A Writer's Life*, 336–342
Motteux, Peter, 431
Moynihan, Daniel Patrick, 118
Mozart, Wolfgang Amadeus, 13, 14, 16, 21, 153, 154, 157, 163, 282, 283, 284, 404
Muir, Edwin, 426
Muir, Willa, 426
Multiculturalism, xi–xiv, 26, 31, 38, 47–48, 94, 109–122, 125, 129
Munch, Charles, 18
Murray, Gilbert, 434
Murray, Oswyn, 92, 97
Muti, Riccardo, 19
Myers, Frederic, 295

Nabokov, Nicolas, 315
Nabokov, Vladimir, 307–321, 425, 426
Nabokov, V. D., 310, 311
Nader, Ralph, 439
National Endowment for the Arts, 31, 50, 169, 171–172
National Endowment for the Humanities, 74, 75, 123
Nehamas, Alexander, 196, 198
Nero, 148
Neruda, Pablo, 53, 56
Nesbit, Edith, 215
Nevelson, Louise, 185
Nevinson, H. W., 376
Newhouse, Samuel I., 192
Newton, Isaac, 130
New York School (of painting), 137, 138, 139, 140, 142
Nicholson, Nancy, 356, 359
Nicolson, Harold, 221
Nietzsche, Friedrich, 5, 128, 198, 205, 206, 216, 251, 269, 272, 322, 368, 391
Noel, Lucie Léon, 320
Noguchi, Isamu, 168
Norrington, Roger, 21
North, Thomas, 429
Nott, Michael C., 154
Nussbaum, Martha, 67

Oakeshott, Michael, 380
Ocampo, Victoria, 60
O'Connor, Alan, 223, 231

O'Connor, Flannery, 322
O'Keeffe, Dennis, 6
O'Keeffe, Georgia, 180
Olitski, Jules, 148, 149
Olivier, Sidney, 212
Olson, Gary A., 85
Onassis, Jacqueline Kennedy, 269, 330
Orage, A. R., 373
Orff, Carl, 153
Ormandy, Eugene, 18
Ortega, Daniel, 56
Ortega y Gasset, José, 425
Orwell, George, 49, 50, 228, 396
O'Toole, Peter, 274
Ovid, 429
Owen, Robert, 227
Ozawa, Seiji, 17, 19

Page, Denys, 96
Paglia, Camille, 124
Pasternak, Boris, 315
Partisan Review, 290–91, 292, 294
Pater, Walter, 32–33
Patmore, Coventry, 295
Paulin, Tom, 336, 337
Pavarotti, Luciano, 14, 19
Paz, Octavio, 59–61, 63
Pei, I(eoh) M(ing), 37, 40
Penty, A. J., 373
Perahia, Murray, 18
Pericles, 92
Perlman, Itzhak, 14, 18
Petrarch, 121
Phibbs, Geoffrey, 357
Phi Beta Kappa, 86
Phidias, 92
Phillips, Kevin, 47
Phillips, Wendell, 243, 245
Picasso, Pablo, 137, 186, 188, 233, 234, 235; "Picasso and Braque: Pioneering Cubism" (Museum of Modern Art exhibition), 416–424
Pico della Mirandola, Giovanni, 316
Pillsbury, Parker, 243
Pincus-Witten, Robert, 151
Pindar, 429
Pinero, Arthur Wing, 213
Pinkney, Tony, 223
Pinnock, Trevor, 21
Piper, Adrian, 185
Pissarro, Camille, 188

Piston, Walter, 16
Pitts, Helen, 246, 248, 249
Plagens, Peter, 143
Plath, Sylvia, 302
Plato, 5, 6, 48, 49, 121, 122
Plekhanov, Georgi Valentinovich, 123, 226
Plutarch, 195, 350, 388, 429
Poe, Edgar Allan, 88
Political correctness, xi–xiv, 83, 101, 113, 117, 124, 125, 197
Polizzotti, Mark, 334
Pollock, Jackson, 137, 141, 148
Polybius, 388, 389
Ponselle, Rosa, 17
Poons, Larry, 148, 149
Pope, Alexander, 297, 426, 427
Popper, Karl, 131
Porter, Andrew, 161, 163
Porter, Fairfield, 137
Poster, Mark, 323
Postmodernism, 7, 11–12, 114, 125, 127, 128–129, 179
Poulantzas, Nicos, 46
Pound, Ezra, 20, 233, 302, 303, 356, 361
Pound, Roscoe, 372
Powell, Anthony, 413
Power, Eileen, 374
Prather, Marla, 139
Price, Leontyne, 17
Prokofiev, Sergei, 15, 24
Proust, Marcel, 308, 321, 369, 391, 402
Public art, 165–168
Puccini, Giacomo, 16, 17
Puig, Manuel, 58
Pushkin, Alexander, 307, 309, 312, 321, 426
Putnam, Samuel, 431
Pyrrho, 387

Quayle, Dan, 49–50
Quilico, Gino, 163

Rabelais, François, 269, 368
Rachmaninoff, Sergei, 283, 320
Racine, Jean Baptiste, 430–431
Radman, Maria, 177
Rahv, Philip, 291, 292, 307, 404, 410, 414
Raleigh, Walter, 259
Ramey, Samuel, 17
Ramírez, Sergio, 56
Rampersad, Arnold, 102

Ransom, John Crowe, 356
Ravel, Maurice, 157, 282–286
Raven, J. E., 96
Ravitch, Diane, 106, 115–116
Reagan, Ronald, 47, 49, 75, 173, 174, 175, 268, 439
Reagan, Ronald, Jr., 175
Reed, Henry, 276
Reise, Jay, 20
Renan, Ernest, 7
Renoir, Pierre Auguste, 139, 278
Renouvier, Charles, 12
Revel, Jean-François, 6
Rich, Frank, 173, 174, 175
Richard, Paul, 191
Richards, Vyvyan, 261
Richardson, Anna, 244
Richardson, Ellen, 244
Richardson, Ralph, 220
Richter, Gerhard, 147
Rickey, George, 168
Ricks, Christopher, 298, 299
Riding, Laura, 356–359, 360, 365
Rifka, Judy, 151
Rilke, Rainer Maria, 177, 401
Rimbaud, Arthur, 258, 369
Robbins, Lionel, 374
Roberts, Francis, 114, 115
Robertson, Bryan, 141
Robson, W. A., 377
Rodin, Auguste, 184
Rolfe, Frederick, 259
Ronsard, Pierre de, 429
Ronselle, Rosa, 17
Roosevelt, Franklin, 378
Roosevelt, Theodore, 401
Rorem, Ned, 402
Rorty, Richard, 196
Rosaldo, Renato, 121
Rosenberg, Harold, 141, 142, 291, 292
Rosenthal, Mark, 144, 146
Ross, Andrew, 131, 134
Ross, David A., 43
Rossini, Gioacchino Antonio, 153, 154, 156, 157, 161
Rostropovich, Mstislav, 17
Rousseau, Henri, 186, 188
Rousseau, Jean Jacques, 154, 258, 331
Rowe, William Woodin, 320
Rubens, Peter Paul, 142
Rubin, William, 416, 418

Rudge, Olga, 20
Rukavishnikov, Ivan, 310, 311
Rushdie, Salman, 105, 325
Ruskin, John, 212
Russell, Bertrand, 189

Sábato, Ernesto, 56
Sachs, Maurice, 370
Sade, Marquis de, 197, 203
Said, Edward, 223
Sainte Croix, Geoffrey de, 91
Salle, David, 170
Salonen, Esa-Pekka, 17
Sanford, Adelaide L., 115–116
Santayana, George, 189
Santos Zelaya, José, 53
Sappho, 157, 431–434
Sartre, Jean-Paul, 96, 196, 226, 273, 308, 320, 331, 367, 368, 369, 370, 371
Saussure, Ferdinand de, 324, 330
Savidis, George, 346
Sawallisch, Wolfgang, 17
Schaufuss, Jane, 160
Schlesinger, Arthur M., Jr., 110, 120
Schnabel, Julian, 170
Schnitzler, Arthur, 160
Schoenberg, Arnold, 15, 20
Schorr, Friedrich, 282
Schubert, Franz, 284
Schuman, William, 16
Schumann, Robert, 283, 284
Schutze, Bernard, 328
Schutze, Caroline, 328
Schwartz, Delmore, 292
Schwarz, Gerard, 17
Schwarzkopf, Elisabeth, 18, 284
Scott, Walter, 242
Searle, John, 89
Seferis, George, 343, 349
Sellars, Peter, 16, 30
Serota, Nicholas, 139
Serra, Richard, 165, 166, 168, 185
Seurat, Georges, 186, 188
Seymour-Smith, Martin, *Robert Graves: His Life and Work*, 357–358, 361
Shakespeare, William, 11, 48, 85, 88, 105, 121, 142, 159, 235, 278, 307, 308, 320, 371, 397, 426, 429
Shaufuss, Jane, 160, 163
Shaw, Agnes, 210
Shaw, Charlotte Townshend, 215, 267–268

Shaw, George Bernard, 208–221, 256, 268, 270, 274, 278, 374
Shaw, George Carr, 210, 211
Shaw, Lucinda Elizabeth, 210, 211
Shaw, Lucy, 210
Sheerman, Barry, and Isaac Kramnick, *Harold Laski: A Life on the Left*, 373–381
Shelley, Percy Bysshe, 212, 425
Sherrard, Philip, 346, 348
Sherry, Fred, 28
Shiff, Richard, 139, 141
Shils, Edward, 8
Shishkov, Vyacheslav, 315
Shostakovich, Dimitri, 15
Shotwell, James, 259
Sidney, Philip, 429
Siewert, Svetlana, 312
Sills, Beverly, 20
Silvers, Robert, 288, 292
Sitwell, Dame Edith, 393
Skelton, John, 72
Skidelsky, Lord Robert, *John Maynard Keynes*, 251–257
Slatkin, Leonnard, 17
Slonim, Véra, 312, 313, 319
Smith, David, 43
Smith, Gerrit, 246
Smith, James M'Cune, 245
Smith, Kiki, 182
Smith, Patrick, 19, 156, 163
Smithson, Robert, 168
Smollett, Tobias, 431
Snow, C(harles) P(ercy), *The Two Cultures* and the Snow–Leavis controversy, 391–399
Snyder, Joan, 150, 151
Sobol Committee Report, 109–122
Sobol, Thomas, 101, 109
Socrates, 6, 200
Sollers, Philippe, 367
Sontag, Susan, 150, 292
Sophocles, 92
Southey, Robert, 227
Soutine, Chaïm, 149, 186, 188
Sparling, Henry, 215
Sparling, May, 215
Speer, Albert, 145
Spender, Stephen, 228
Spielberg, Steven, 174
Spinella, Stephen, 174
Staël, Nicholas de, 149

Stalin, Joseph, 24, 96, 208, 213, 219, 220, 289
Stanton, Elizabeth Cady, 248
Starn Twins, 150–151
Stein, Gertrude, 141, 419, 422; *A Stein Reader* (Ulla E. Dydo, ed.), 233–235
Steinem, Gloria, 233
Stephan, Gary, 151
Stevens, Wallace, 234, 361
Stewart, Desmond, 261
Stimpson, Catharine, 67
Stockhausen, Karlheinz, 15
Stokowski, Leopold, 18
Stone, I(sidor) F(einstein), 60
Storrs, Ronald, 259, 261, 263, 264
Strachey, Lytton, 253
Strang, Patsy, 340
Stratas, Teresa, 156, 163
Strauss, Richard, 20, 157, 163
Stravinsky, Igor, 20, 370
Street, G. S., 277
Strindberg, Johan August, 229, 309
Stuart, Dabney, 317
Stubbings, F. H., 96
Sultan, Terrie, 180, 185
Svevo, Italo, 343
Swift, Jonathan, 123
Syberberg, Hans-Jürgen, 146
Sykes, Charles, 124
Sykes, Mark, 270
Sylvester, David, 139–141, 142
Szell, George, 18

Tacitus, 386, 388, 389
Taine, Hippolyte, 79
Taruskin, Richard, 24
Tate, Allen, 80, 356
Tawney, R(ichard) H(enry), 222, 374, 377
Tchaikovsky, Piotr Ilyich, 24
Temple, William, 222
Terry, Ellen, 215, 216
Thatcher, Margaret, 225, 341
Thomas, Lowell, 267, 268
Thompson, E. P., 222
Thomson, Virgil, 233, 235
Thrasymachus, 200
Thucydides, 386, 388–390
Thwaite, Anthony, 337, 338
Tibbett, Lawrence, 17
Timpanaro, Sebastiano, 91
Titian, 139, 142
Toklas, Alice B(abette), 233, 235

Tolstoy, Leo, 208, 269, 307, 308, 309
Torres Fierro, Danubio, 62
Toscanini, Arturo, 18, 27, 283
Toulmin, Stephen, 393
Toulouse-Lautrec, Henri de, 188
Townshend, Charlotte, 215, 267–268
Townshend, Larry, 202
Traub, James, 101, 102, 107
Trebitsch, Siegfried, 218
Tree, Beerbohm, 217
Trilling, Lionel, 79, 292, 393, 410
Troy, William, 410
Tucker, Richard, 17
Twain, Mark, 219, 237
2 Live Crew, 104
Tyndale, William, 428

Ueda, Reed, 113, 117
Uhde, Wilhelm, 420
U. S. Constitution, 120, 121, 438–446

Van Eyck, Jan, 308
Van Gogh, Vincent, 140
Vargas Llosa, Mario, 52, 55, 57, 61, 63
Vasconcelos, José, 54
Vedrenne, John, 216
Ventris, Michael, 97
Verdi, Giuseppe, 16, 17, 22, 158
Veyne, Paul, 196
Villa, Francisco (Pancho), 53
Villon, François, 369
Virgil, 429, 432–433
Vivaldi, Antonio, 13, 14, 20
Vollard, Ambroise, 420
Voltaire, 6, 219, 307, 316
von Gierke, Otto, 373

Wadsworth, Charles, 28
Wagner, Richard, 17, 160, 282
Walker, Alice, 85, 106, 121
Wallace, Michele, 101–102, 107
Wallas, Graham, 212, 372
Walter, Bruno, 27
Warhol, Andy, 37, 147, 326
Warren, Leonard, 17
Warren, Robert Penn, 80
Watteau, Jean-Antoine, 286
Wattenmaker, Richard J., 189, 190
Watts, Alan, 202
Webb, Beatrice, 212, 217, 219, 374
Webb, Sidney, 212, 219, 220–221, 374

Webster, Charles K., 374
Webster, Noah, 440, 442
Wells, H(erbert) G(eorge), 216–217, 221, 278
Wells, Ida B., 249
Wharton, Edith, 347, 406
Whipple, Kathie Ann, 106
White, Edmund, *Genet: A Biography*, 367–371
Whitman, Walt, 269
Wilde, Oscar, 159, 213, 276, 301
Wilder, Thornton, *Wilder, Wilder, Wilder* ("The Long Christmas Dinner," "The Happy Journey to Trenton and Camden," and "Pullman Car Hiawatha"), 176–178
Will, George F., 84
Williams, Raymond, 222–232
Williams, William Carlos, 177, 234, 432–433, 434
Wilson, Edmund, 79, 221, 285, 313, 391, 410, 413–414
Wilson, Harold, 224
Wilson, Jeremy, 258
Wilson, Robert, 16
Winchell, Walter, 284
Wing, Betsy, 197

Winters, Yvor, 296, 410
Witkin, Jerome, 150, 151
Wittgenstein, Ludwig, 130, 141, 234
Wodehouse, P(elham) G(renville), 260
Wolf, Hugo, 282
Wolfe, George C., 173
Women's studies, 124
Woolf, Virginia, 254
Wordsworth, William, 70, 303, 304
Wright, Richard, 106, 108
Wright, Wilbur, 424

Xenophon, 258

Yeats, W(illiam) B(utler), 214, 349, 396, 429
Yoshitomi, Gerald D., 26
Yourcenar, Marguerite, 351, 352, 354
Yudkin, Michael, 395

Zabel, Morton Dauwel, 402
Zapata, Emiliano, 59
Zinman, David, 17
Zola, Emile, 56, 412
Zukerman, Pinchas, 18
Zweig, Stefen, 317